THE RUSSIAN ICON

Viktor Nikitich Lazarev

THE
RUSSIAN
ICON

FROM ITS ORIGINS
TO THE SIXTEENTH CENTURY

Edited by G.I. Vzdornov

Translated from the Italian by
Colette Joly Dees

English text edited by
Nancy McDarby

A Liturgical Press Book

THE LITURGICAL PRESS
Collegeville, Minnesota

1	2	3	4	5	6	7	8

Library of Congress Cataloging-in-Publication Data

Lazarev, Viktor Nikitich, 1897–1976.
 [Russkaia ikonopis '. English]
 The Russian icon : from its origins to the sixteenth century / Viktor Nikitich Lazarev ; edited by G. I. Vzdornov ; translated from the Italian by Colette Joly Dees ; English text edited by Nancy McDarby. — English language ed.
 p. cm.
 Includes bibliographical references.
 Contents: The discovery of early Russian icons and their study — General observations on Russian iconography — Icons of the eleventh to thirteenth centuries — The Novgorod School and the "northern manners" — The Pskov School — The Moscow School — The artistic centers in the principalities of Central Russia.
 ISBN 0-8146-2452-9
 1. Icon painting—Russia (Federation) 2. Icons, Russian. I. Vzdornov, Gerol 'd Ivanovich. II. McDarby, Nancy.
III. Title.
N8189.R9L3813 1997
755'.2—dc21
 97-25470
 CIP

Table of Contents

From the Editor

For many years, the author of this volume, Viktor Nikitich Lazarev (1897–1976), was one of the major historians of Russian art, a specialist in the artistic culture of Byzantium, Italy, and early Rus. His writings deal with the Middle Ages, the Renaissance, and the art of Eastern Europe of the seventeenth and eighteenth centuries. The diversity of his scientific interests, his ability to use the data from political history, culture, and ideology to explain artistic phenomena gave his works a very solid basis. This is why Lazarev's books and articles, even those written fifty years ago, still retain their informative value in our own time.

Lazarev's scientific activity is also widely recognized. He taught international art at the State University of Moscow for many years. He was a corresponding member of the Russian Academy of Sciences; a foreign member of the Italian, British, Austrian, and Serbian Academies of Sciences, of the Florentine and Sicilian Academies of Fine Arts, of the Venetian Institute of Sciences, Literature, and Arts; and the honorary President of the International Association of Byzantinists.

Lazarev has been a classical figure in the history of Russian science for a long time. His books are read and studied in universities and institutes of scientific research. His range of interests was so broad that he wrote about Russian or European fine arts with the same ease, although his special preference went to painting rather than to drawing or engraving. Only in his most important works, such as the monumental monograph in three volumes *Proischozhdenie italyanskogo Vozrozhdeniya* (The Origins of the Italian Renaissance) (1956, 1959, and 1979), did he take sculpture and architecture into consideration, rather than just painting. Lazarev's obvious predilection for painting corresponded to his impulsive and dynamic personality, which was inclined by nature to consider art and life through colors and plastic strokes. To his relationship, on his father's side, with the noble Armenian family of the Abamelek — Lazarev, he owes his special sensitivity which can be captured in his best articles and scholarly essays.

To some extent, Lazarev's creative path was formed under the influence of N.I. Romanov, A.N. Benois, and P.P. Muratov. All of them had studied Italian art in depth and had published several works on Italian culture. Muratov's work, *Obrazy Italii* (Images of Italy) (the first edition, in two volumes, came out in 1911–1912) is especially relevant. It was read by the generation of the first decades of the century and dozens of scholars of Italian art were formed under its influence. Lazarev's first scientific publication (1922), devoted to an unknown youthful portrait of Salviati, already showed the orientation of his interests. Following this work, there were articles on Jacopo di Cione, Bachiacca, Bronzino, Tintoretto, Solimena, Lorenzo Monaco, Parmigianino, Boticelli, Guardi, and many other Italian artists. Italian art was also the topic of one of Lazarev's last books, the fundamental collection of articles *Starye italyanskie mastera* (Early Italian Masters) (1972), especially significant since in the preface to his work, Lazarev stated that he was writing about his favorite painters: Giotto, Piero della

Francesca, Antonello da Messina, Mantegna, Cosmé Tura, Bellini, Giorgione, Titian, Michelangelo, and Jacopo Bassano.

Just as Lazarev had studied Italian art, he also studied Byzantine art in depth. Byzantine painting was therefore the center of his attention in the 1920s and 1930s. Much later, in 1947–1948, 1967, and 1983, his fundamental monograph *Istoriya vizantiiskoy zhivopisi* (History of Byzantine Painting) (Turin 1967) was published in one Italian edition and two Russian editions. The work of the learned Russian was internationally welcomed with critical acclaim as the best and most exhaustive study on the subject.

It is impossible to engage in a study of Byzantine art without considering the national schools which came under Byzantine influence. In addition, a whole series of masterpieces of Byzantine painting appeared in Slavic territories and to some degree also in the land of Rus: in Kiev, Pskov, Vladimir, and Moscow. From here, it is only a short step to typically Russian art. And so Lazarev began his work of studying Russian icons, mosaics, and frescoes which he continued until he died.

His encyclopedic knowledge enabled him to capture the development of artistic cultures in their mutual interconnections. This typically historical sensitivity is particularly evident in Lazarev's studies of Byzantine and early Russian painting. He focused his attention above all on works in whose creation local traditions and the active participation of masters passing through gave life to an entirely new and extraordinarily novel artistic form. Such works are, for example, the Castelseprio frescoes, Theophanes the Greek's painting in Novgorod and Moscow, and the works of Italian architects in the Kremlin of Moscow. The theme of collaboration was also the focus of a vast report, "Iskusstvo srednevekovoy Rusi i Zapad (XI–XV veka)." (The Art of Medieval Russia and the East [11th to 15th Centuries]), presented by Lazarev at the plenary session of the Thirteenth Congress of Historians, which took place in Moscow in 1970. And even in his travels abroad, giving lectures and conferences in different places, Lazarev always sought to promote first of all the idea of the usefulness of a collaboration between the artists of different countries. In 1963, at an international congress organized in Rome by the National Academy of the Lincei on the topic "The Christian East in History and Civilization," Lazarev participated with a brilliant exposé entitled "Byzantine Art and Especially Painting in Italy in the Early Middle Ages."

The Italian edition of Lazarev's book on icons was published twenty years after the author's death and almost a hundred years after his birth. This is why the text must be presented with some explanations.

Like any great scholar, Lazarev considered the publication of individual works, articles, and books on various masters as valuable material for expanding his own research. This was true for Italian and Byzantine art and it was the same thing for early Russian art too. From 1947 on, Lazarev wrote one work of synthesis after another: *Iskusstvo Novgoroda* (The Art of Novgorod) (1947); many extensive chapters in a work of several volumes, *Istoriya russkogo iskusstva* (The History of Russian Art) (1953–1955); *Drevnye russkie ikony* (Early Russian Icons) (1958); *Feofan Grek i ego shkola* (Theophanes the Greek and His School) (1961); *Andrey Rublyov i ego shkola* (Andrei Rublev and His School); *Novgorodskaya ikonopis* (The Iconography of Novgorod) (1969); *Moskovskaya shkola ikonopisi* (The Iconographic School of Moscow) (1972); *Dvustoronnie tabletki iz sobora sv. Sofii v Novgorode* (The Bilateral Panels of the Sophia Cathedral of Novgorod) (1977). But his most significant publication along this line was *Russkaya ikonopis: Ot istokov do nachala XVI veka* (Russian Iconography: From Its Origin to the Beginning of the Sixteenth Century) (1983), his most definitive work on Russian icons.

Published twice in Russian and now translated into Italian, the monograph was originally intended for the English publisher, Phaidon Press, as the continuation of Lazarev's text, *Old Russian Murals and Mosaics,* published by Phaidon in London in 1966. But the publication of the monograph in England was indefinitely postponed due to internal restructuring of the publishing house; and as a result, Lazarev started to prepare the text for its publication in Russian. This very manuscript was on his desk

the day of his unexpected death (February 1, 1976). Therefore, one might say that *Russkaya ikonopis* is the last work of this eminent scholar and, without a doubt, one of the best works about early Russian iconography.

In a clear, accessible way and using considerable documentary material, Lazarev described the dawn of national panel painting; he spoke of the technique and aesthetics of icons, of individual masters, and of their best works. One chapter in particular is dedicated to the history of the discovery of Russian icons and to the major scholars who dealt with Russian iconography (P.P. Muratov, N.M. Shchekotov, I.E. Grabar, A.I. Anisimov, Yu.A. Olsufev, A.I. Nekrasov, M.V. Alpatov, N.A. Demina, and others). While he always kept a scientific, expository, and even academic style, the text is nevertheless written in such a way as to justly deserve the public's preference for it to all the other works on the same theme.

Lazarev's text has no nationalistic overtones. Russian icons are presented as one of the great branches of the universal tree of the arts. His own approach to this art was undoubtedly stimulated by his fondness for early Italian and Byzantine painting. For him, early Russian icons possessed the same immediate value found in the altarpieces of Duccio, Giotto, Simone Martini, the Lorenzetti brothers, Agnolo Gaddi, Paolo Veneziano, and other anonymous masters of the Sienese, Florentine, Pisan, and Venetian schools.

Toward the early 1970s, while he was finishing writing the book, scientific literature on Russian fine art recorded the introduction of many recently discovered icons. Thus, the tendency to reconsider established historical data and artistic phenomena became outlined. We are referring in particular to the origin and dating of the iconostases of Theophanes the Greek (Cathedral of the Annunciation in the Kremlin, Moscow); the chronological classification of the two famous icons by Dionysii representing the Metropolitans of Moscow, Peter and Alexius (Cathedral of the Dormition in the Kremlin and Tretyakov Gallery); and finally, of the provenance of five magnificent icons with an evangelical theme which belonged to the collections of I.S. Ostrouchov, V.N. Chanenko, and A.V. Morozov (Tretyakov Gallery and Kiev Museum of Russian Art). All of this required Lazarev, who always kept abreast of the evolution of science, to keep reworking the text of his monograph. Fortunately for readers, the scholar succeeded in making almost all the necessary corrections and additions. The few inaccuracies and contradictions have been corrected by me and they are not prejudicial to the author's text.

Since the manuscript was not completely ready to be published in Russian, there were obvious omissions in the body of the text and its adjuncts: discoveries not taken into account and without which it was impossible to interpret the works correctly. To make up for these omissions, I have included my own additions in brackets so that the reader may clearly distinguish the author's text from the editing insertions. They are not very numerous and they came mostly from the need to mention articles and books published after the monograph was finished, or simply after the death of the author. Only the General Bibliography has been substantially expanded with the insertion of dozens of new and old titles. We hope that this new General Bibliography represents the most complete source of all the scientific literature on Russian iconography from the eleventh to fifteenth centuries and, as a complement to Lazarev's study, that it will be useful to all those who are interested in the history of Russian icons.

I would like to add a few words concerning another particularity of the book. Readers who follow recent scientific literature will probably find some discrepancies in the dating of many icons by Lazarev and authors who wrote on this theme after him. Such differences often involve a considerable time span: up to fifty years and in a few cases even a hundred years. The precise dating of many famous icons represents one of the primary tasks of today's art historians. In the past few years, this work has been conducted by E.S. Smirnova for the Novgorod iconography, and many valuable observations concerning the artistic patrimony of Moscow and Tver come from E.S. Smirnova and G.V. Popov. Finally, we should mention the new catalogue of works of early Russian art in the Tretyakov Gallery. Lazarev himself was well aware of the need for a critical revision of old opinions concerning the place of origin and date of some works. He was doing that work with extreme prudence and so the chronological

variation of some dates remains. Nevertheless, we think that these differences do not in any way affect the substance of Lazarev's text, whose main objective is to provide a general characterization of Russian icons at the time of their greatest flourishing. Without getting lost in details, as is unfortunately the case of many recent and more voluminous works devoted to early Russian art, Lazarev has offered a brilliant and memorable work on Russian iconography.

The most fascinating aspect of Lazarev's investigations is found in their literary form. The author was able to find a sound balance between a rigidly scientific style, with its specific lexicon, and a method of exposition which allows any educated reader to understand his works. The main text and the notes referring to Lazarev's books and articles form a unified body, yet they can easily be taken apart. The bibliographical information, the list of the works, the discussion of the time and place of origin, the polemics, the debates on obscure questions which have not been definitively resolved: all of this makes up an informative apparatus with universal significance; it is gathered in the notes covering dozens and even hundreds of pages primarily intended for specialists. On the other hand, the main text, relieved of figures and tedious details, becomes easily accessible the first time around. The description of the works of art, the characterization of the most important artists, and the major iconographic schools; interconnections of cultural phenomena, connotations of the period, and economic and social transformations are presented clearly, convincingly, and with plenty of concrete references. A clear, concise, lively, and engaging style is the reason why Lazarev's books are appealing to readers. His works will prevail for a long time because they are devoid of pedantic abstractness and academic contempt for the public at large. The texts are written by a person who loved art and knew it well and who did his best to pass on his own knowledge in a clear and understandable way.

December 26, 1995
G.I. Vzdornov

Introduction

Russian icons are a discovery of the twentieth century. It was only when people learned to remove from ancient icons the layers of paint from a later time that icons became authentic works of art in their own right and it became possible to study them scientifically. Matisse was one of the first artists to adequately appreciate the beauty of Russian icons. He had arrived in Moscow in 1911 and he was able to see various collections of icons. At once, he became a passionate admirer of that art. He was especially impressed by the Novgorod icons, about which he said: "This is authentic popular art at the origin of artistic research. Contemporary artists should draw their inspiration from these primitive. . . ."* Right away, especially after the exhibitions of 1913, 1927, and 1967, Russian icons began to attract growing attention. Among the painters who attained bright creative heights, Nataliya Goncharova, Mark Chagall, and Petrov-Vodkin come first. Icons were fascinating because of their original coloristic and compositional schemes, their profoundly inspired images, their concept of a simple and patriarchal life, and this is why Russian icons were very consonant with the research of contemporary artists.

In this volume, the reader will find the history of Russian iconography from its origin to the beginning of the sixteenth century. I placed these chronological limits on myself intentionally since the "Golden Age" of Russian iconography included the fourteenth and fifteenth centuries, a period followed by a rapid decline. This does not mean that there were no works of extraordinary beauty (especially the icons attributed to the Stroganov school) in the sixteenth and seventeenth centuries, but the general level started to decline substantially. This involved a mostly didactic statement, the reduction of the images, and the loss of the ancient chromatic expressiveness in the colors. The influx of realistic elements into icons formed a deep contrast with its ideal level and soon transformed the icon into a phenomenon of an eclectic type. Icons survived, since they were not able to be transformed into realistic painting, as was the case in Western Europe. With Peter the Great, a clear distinction was established between secular and religious art, and even in the Christian East, icons lost their artistic value and became only objects of worship. So, for all these reasons, the chronological limits of my work coincide with the art of Dionysii, the last great early Russian artist.

In order not to overburden the main text with too many notes, I have included references to works of analysis only when they deal with icons not included in the present edition. The analysis of the icons reproduced here is found in the Notes on the Text and the Notes on the Plates.

In conclusion, I would like to thank those who have helped me in writing this book: G.I. Vzdornov, O.S. Popova, M.A. Reformatskaya, E.S. Smirnova, V.V. Filatov, S.V. Yamshchikov. As usual, restorers, whose sound advice is very valuable in undertaking the study of medieval painting, have also been of great assistance to me.

The Discovery and Study of Early Russian Icons

The study of early Russian icons has had a rather tortuous path. Until the end of the nineteenth century, the legacy of early icons was limited to a few works of the sixteenth century, but mostly to those of the seventeenth century. The oldest icons were still almost unknown and any consideration of early Russian painting was based on the study of these relatively recent works. Moreover, the origins of the modern systematic study of early Russian painting are related to a scholar who lived in the nineteenth century, Fedor Ivanovich Buslaev (1818–1897).[1]

A brilliant philologist, a person of great culture, Buslaev was among the first to appreciate the unique beauty of early Russian literature and painting, having also shown their consistent relation to Byzantine culture. At a time when official academic doctrine was prevalent, he was sensitive to the attractiveness of primitive popular art. Russian iconography, which he considered a "young, fresh art, not prone to exaggerated pomp," was appealing because of the "lively movements of its forms" and because of its profound, poetic quality.[2] Buslaev wrote, "The whole life of ancient Rus was permeated by poetry because all the spiritual concerns were conceived on the basis of a sincere faith, although it was not always purely Christian."[3] People of those days were convinced of the existence of some magical, supernatural force which "can exercise its extraordinary power, in a completely unexpected way, at every moment of existence, in the main circumstances of life. During the epic period of the life of the people, this conviction was expressed in the *miraculous* as the principal source of the popular epics."[4] Buslaev considered fervent and sincere faith as "the only and most luxuriant fountain of all poetry during its primitive, unconscious, and epic stage."[5] From his perspective, Russian iconography "reflected the solid individuality and originality of the Russian people in all their indestructible power, developed through many centuries of stagnancy and immobility, in their unshakable fidelity to principles adopted long ago, in their original simplicity and austerity of customs."[6]

Buslaev was not the only passionate lover of early Russian art. Other great admirers were the writer N.S. Leskov and the artists V.M. Vasnetsov, M.V. Nesterov, and M.A. Vrubel. This interest in early Russian painting, at a time when its artistic value had not yet been completely brought to light, was constantly stimulated by the use of collections of icons, widely spread among "Old Believers."[7] These Old Believers, firmly attached to the faith of their ancestors, used to collect ancient icons either as sacred objects or as rare and precious pieces. The icons of the Stroganov school were their favorites in comparison to other examples of iconographic art because of their obvious "preciousness." Along with the icons "of the Stroganovs," some older pieces are also sometimes found in the possession of collectors and in the house chapels of Old Believers: icons of Moscow and Novgorod. The taste inherited from the seventeenth century was conducive to acquiring small icons in particular; besides, the great Novgorodian icons were too cumbersome for a small house chapel. Thus, the renowned Postnikov, Pryanishnikov, Egorov, and Rachmanov collections came into existence. It is interesting to note that

apart from the patient and assiduous work of a few Old Believers who were very fond of icons, state and ecclesial institutions were completely indifferent to early Russian art.

D.A. Rovinskii's famous study, *Obozrenie ikonopisaniya v Rossii do kontsa XVII veka* (Overview of Iconography in Russia until the End of the Seventeenth Century) (Saint Petersburg, 1856; second integral edition, Saint Petersburg, 1903) is based on the accumulated experience of the Old Believer collectors. Following in the footsteps of the collectors, D.A. Rovinskii identified a series of schools which he compared with the more generic concept of the "manners" (from Novgorod, Ustyug, Moscow, Siberia, Mstera, Palech, and so forth) widespread among the Old Believers. In order to define the characteristics of these "manners" with precision, scholars resort to an accurate enumeration of their specificity (Rovinskii called it "distinctive signs"). But since, in the first half of the nineteenth century, almost all the works of easel painting were anonymous and their place of origin was not known and, in addition, the icons themselves were concealed under several layers of paint, Rovinskii's theory of the "distinctive signs" turned out to be largely devoid of a solid scientific foundation. Sometimes these signs corresponded to distinctive aspects actually existing in all icons, but more often they were so general and indefinite that they did not provide any useful elements for contemporary scholars who find themselves in the presence of completely new material which is, furthermore, already manipulated. In spite of this, the experience of the Old Believers is quite valuable and it is impossible not to take it into account. It is not by accident that we still find among the disciples of the Old Believers one of the greatest connoisseurs of early Russian icons, N.P. Lichachev, a person in whom the gifts of being an eminent scholar and an expert collector are harmoniously blended. His extraordinary collection constitutes the main basis of the section on early Russian art in the Russian Museum of Saint Petersburg.

Among the Russian scientists of the nineteenth century who dedicated themselves systematically to the study of iconography, one of the most serious, with the obvious exception of N.P. Kondadov, was G.D. Filimonov (1828–1898).[8] Today, his study on Simon Ushakov is still a model of a rigorous, scientific method. Also interested in decorative arts (enamel, silver, filigree), Filimonov greatly contributed to the progress of our knowledge of the art of the seventeenth century and of the work methods used at that time, with the widespread use of "manuals," collections of iconographic models already prepared. Along with F.I. Buslaev, V.F. Odoevskii, and A.E. Viktorov, Filimonov founded the Society of the Lovers of Early Russian Art in 1864 and became an active member. Thanks to his diligence, a section on early Christianity, enriched by donations from P.I. Sevostyanov, was organized in the nearby Rumyantsev Museum and scientific research started in the Armory Palace. Filimonov carried out his work at a time when general attention was focused on works from the seventeenth century and when the discovery of icons from an earlier time had not yet taken place. This would occur later after Filimonov had already died.

In the last decade of the nineteenth century, no doubt under the influence of the writer N.S. Leskov, P.M. Tretyakov (1832–1898) also started to collect icons. Tretyakov, who was purchasing works primarily from the sixteenth and seventeenth centuries, had a very particular approach to icons. In his renowned collection of Russian icons, he also wanted the earliest examples of painting to be represented because they reflected the people's way of life. Therefore, Tretyakov was not so much interested in the artistic aspect of icons as he was in their themes. He gladly acquired icons with complex iconographic roots and with compelling themes from which one could easily deduce what daily life was like in early Russia.[9] In a certain sense, it is possible to say that Tretyakov interpreted icons from the perspective of the *peredvizhniki* [painters from the contemporary realistic Russian trend of the second half of the nineteenth century who were taking part in traveling exhibitions].

In 1905, something of great importance took place: the Old Believers were forbidden to open their churches or to build new ones. This event had a totally unexpected impact on the study of Russian iconography. Suddenly there was a request for large icons, which had been rejected by collectors of the previous century. This time, the new wave of antiques which came to Moscow from the North brought with it many very large icons from Novgorod. The dirt, soot, and blackened *olifa* [drying oil] began

to be removed from the icons in the same way it was usually done with the icons of the Stroganovs. But the cleaning did not stop there. While the icons of the Stroganovs came to collectors in their original forms without alterations because, for a long time, their art was the ideal of iconographers — not only those from the eighteenth century, but also from the nineteenth century — the attitude was quite different towards the earliest icons. In the seventeenth century, artistic taste suddenly changed and all the early icons were inexorably touched up. In the eighteenth and nineteenth centuries, early works were not protected by anyone, and when they were not destroyed, they were at the very least "restored" by superimposing yet another layer of paint over the original one. Therefore, when the problem of restoring the original aspect to early icons arose, in addition to cleaning them from the dirt, soot, and blackened *olifa*, the removal of the various layers of paint superimposed in successive periods began. It is difficult to establish now who were the first people to do this. They were probably A.V. Tyulin and E.I. Bryagin, in the service of S.P. Ryabushinskii and I.S. Ostrouchov, soon followed by many younger restorers (G.O. Chirikov, A.A. Tyulin, V.P. Gutyanov, P.I. Yukit, I.A. Baranov, and others). In any case, around the year 1905, the cleaning of icons was a common and very widespread practice. All important collectors had their favorite restorer and the sale of icons rather quickly became a profitable business.

When early icons began to be rid of the late renovations which altered them, it became evident that the old paint had been permanently preserved under the countless successive layers and that it had acquired the hardness and the consistency of ivory. The removal of the blackened *olifa* and especially of the successive renovations from the great Novgorodian icons of the fifteenth century turned out to be a real discovery in itself, and this new, magnificent, and almost unknown art found admirers at once. The first to know how to appreciate it were the untiring builders of the new Old Believer churches, the brothers A.I. and I.I. Novikov and S.P. Ryabushinskii, followed by a number of Muscovite enthusiasts and iconographers (A.V. Morozov, O.I. and L.K. Zubalov, G.O. Chirikov, A.V. Tyulin, I.L. Silin, and others). As early as the 1890s, the renowned artist I.S. Ostrouchov began to take an interest in the collections of icons and kept enriching his collection in the first years of the twentieth century.[10] He was among the first to appreciate the icons' aesthetic appeal, their artistic significance, and their importance as pure works of art. It was Ostrouchov who introduced Matisse, who had come to Moscow in October 1911, to the world of early Russian iconography and whose beauty he perceived in a special way: he succeeded in communicating his enthusiasm to anyone capable of grasping what was new outside of traditional academic canons. On account of his own sensitivity, Matisse was the sort of person instinctively attracted to primitive art and in particular to early Russian icons, which fascinated him not only because of the naturalness of their colors but also because of their expressive spontaneity and emotional intensity.[11]

The public at large really began to understand the beauty of early Russian painting only in 1913 when a great exhibition devoted to early Russian art was prepared in Moscow. It included many icon masterpieces from the fifteenth and sixteenth centuries, which had been cleaned and restored. And right here, for the exhibition's visitors, all of a sudden the veil which had concealed from their eyes the authentic face of Russian iconography for many centuries was finally lifted. Instead of the obscure, dismal icons covered with a thick layer of *olifa*, they saw splendid works of painting on wood which would have made any people very proud. With their clear colors, these paintings were glittering like precious stones, blazing with their flaming vermillions, caressing the eyes with their delicate nuances of a soft pink, violet, and golden yellow color. The extraordinary beauty of their white and blue tonality attracted people's attention. And at once, it became evident to everyone that this art was neither severe nor exalted, that popular creativity was clearly reflected in it; that in its serene luminosity and the special clearness in the construction of its forms, it was very reminiscent of the painting of the ancients. Therefore, this art was considered to be one of the most perfect manifestation of the Russian national genius.

The contemporary iconographic methodology prevailed for a long time in the study of Russian icons. The Russian school of iconographic analysis, which flourished from the close of the nineteenth

to the beginning of the twentieth century, boasted a series of eminent scholars (N.P. Kondakov, 1844–1925; D.V. Ainalov, 1862–1939; N.P. Lichachev, 1862–1936) who gave a decisive impetus to the knowledge of early Russian painting. Through a meticulous analysis of the individual iconographic typologies (especially those of the Mother of God), these scientists showed evidence of the rigorous continuity which links Russian painting to Byzantine painting; they outlined the evolution of these typologies and the changes they underwent in the course of many centuries and brought into light their organic link with literature. It is important to note that the membership of this iconographic school of analysis was not of one mind. For example, Ainalov quickly went beyond its limits, which were too narrow, dedicating his efforts to stylistic analysis (although V.N. Shchepkin moved away from it in many respects), while others (for example, A.I. Kirpichnikov, N.V. Pokrovskii, M.I. and V.I. Uspenskii, N.D. Protasov) brought such rigidity to the iconographic methodology that they made its weak points suddenly obvious. Ignoring new discoveries and most of the time basing their findings on late or repainted icons, these exponents of the iconographic school seemed to have almost forgotten that they were dealing with works of art as they focused all their attention only on the thematic content of the icons. By arbitrarily separating form from content, they disregarded form on one hand and on the other interpreted the content in an extremely unilateral and superficial way, taking it back to the simplistic iconographic typologies which were interpreted only from an external perspective as simple outlines of classifications. As a result, the profound and inner meaning of these types was lost. For example, instead of investigating the deep content of the *Deesis,* those who belonged to this iconographic school limited themselves to the history of the development of the *Deesis* and to the enumeration of the various wooden panels of this representation. Still, this iconographic school made a valuable contribution to the study of early Russian painting, especially in the person of its main exponent, N.P. Kondakov, who taught us to look carefully at the thematic aspect of the icons, thus making it easier to understand their complex, spiritual world.

The 1913 exhibition and all the discoveries which had preceded it allowed a new approach to the problem of early Russian painting. Even though the iconographic school dealt principally with more recent and repainted icons, it was now possible to look at fifteenth-century icons from a scientific perspective. Having been cleaned of all successive restorations, the icons had recovered their exquisitely artistic quality. The change of approach concerning early Russian art was also considerably helped by the publication in Russian of books by Walter Pater, Vernon Lee, Bernard Berenson, A. Hildebrand, H. Wölfflin, thanks to whom the public at large could follow the classical examples of English art criticism and German formalism. They contributed a great deal to the development of a critical attitude toward purely iconographic studies. Thus, the study of Russian iconography gradually moved from the hands of iconographers to those of art critics. P.P. Muratov, N.Shch. Shchekotov, N.N. Punin, the poet Maksimilian Voloshin, and the artist A.V. Grishchenko wrote a series of brilliant articles and essays on Russian icons in which they sought to discover their unique beauty; to show how the early masters conceived the composition, colors, shape, rhythm; to make their discoveries available to the vast public of Russian readers. The studies by P.P. Muratov (1881–1950) were especially important. A brilliant stylist endowed with an exceptional literary talent and a person of refined and impeccable taste, Muratov was writing in a period dominated by the slogan "art for art's sake," and he looked at icons from these perspectives, interested first of all in their artistic language, almost completely disregarding their ideal world, their concrete ties with historical reality. And so, the 1916 publication of two perceptive essays by E.N. Trubetskoy came at a most opportune time. In these works, he investigated the ideal world of Russian iconography, emphasizing the "ethical fulcrum" of Russian icons, their "religious fervor," their "ecumenical" principle, their lofty spirituality, and their architectonic structure. Although in his interpretation of icons Trubetskoy frequently runs the risk of falling into its modernization, the two texts contain many profound reflections, offering a starting point to several writers and above all to those who preferred an organic examination of icons, rather than a fundamentally scientific study.

Art critics who wrote from 1905 to 1917 passed many harsh judgments on the representatives of the iconographic school. However, in the heat of the polemics, they were unable to separate what was valid in what N.P. Kondakov and his companions had done from the truly negative aspects of their work. Excessively attracted by the artistic aspect of icons, art critics did not contribute at all to progress in the knowledge of early Russian art: they discovered its beauty and stopped right there. Instead of preparing themselves to present an accurate study of the new works and their stylistic classification, to ascertain their date, to explain the role of the specific schools and of the various masters, they were satisfied with summary aesthetic characterizations in which the repetition of the same concepts served to make up for the absence of strictly scientific data. Denying Buslaev's importance, Muratov and his group suddenly broke away from the traditions of Buslaev's school and thus also from the traditions of the scholarly study of early Russian art which had formed throughout the nineteenth century. This rupture was totally underhanded, since the study of early Russian art could already boast of great results and the iconographic methods that it had elaborated were based on the profound motivations rising from the very nature of this art. Instead of scorning the accomplishments of this iconographic school of analysis, they should have used them in their proper place by combining the analysis of content with the analysis of form.

This is the point the study of early Russian icons had reached at the time of the revolution, which brought about the separation of church and state: an extremely important fact for the future development of the work of restoration. Before the revolution, icons were from time to time stockpiled in the provinces or secretly removed from churches; thus, their place of origin remained unknown. On the contrary, after the revolution, the state assumed the right to confiscate the most famous icons openly and systematically in order to submit them to restoration. Vast horizons were also opened concerning the restoration of frescoes in churches. The Russian Commission for Restoration, founded in 1918 and renamed "Central Studios for State Restoration" in 1924, engaged in intense activity under the direction of I.E. Grabar (1871–1960). More than ten expeditions were planned to Novgorod, Pskov, Kiev, Zvenigorod, Vologda; to the Monastery of the Trinity of Saint Sergius; to Yaroslav; to the Northern regions and the cities beyond the Volga. These expeditions were organized according to a carefully drawn-up program. The first icons to be cleaned were the most important works which could shed light on crucial problems in the history of early Russian painting. An entirely new circumstance in these expeditions was the discovery of icons whose origins were clearly known. Thus, the classification of the material according to place of origin benefited from a solid support: the rudimentary concept of "manner" could now be replaced by the more strictly scientific concept of "school." And these schools were no longer hanging in the air but were beginning to lean on the solid basis of facts. Because the people participating in these expeditions were major exponents from the world of science and individual aficionados who in their passion for icons had the gift of finding masterpieces in places where nobody thought they could find any icons of value, the results were almost immediate. Restorers also greatly contributed; some of them started to work again in the first years of the twentieth century, while others belonged to the younger generation already pursuing their own activity during the revolution. Thus, ten or so icons from the twelfth and thirteenth centuries were discovered. They had been totally unknown prior to the revolution. The renowned frescoes of Vladimir, Novgorod, and Pskov from the same period were cleaned and restored. The iconography of the fifteenth century was seen from a new perspective, and the figures of Theophanes the Greek, Andrei Rublev, and Dionysii took on a greater historical concreteness.

At once, the study of early Russian art became concentrated in the chairs of art history at the Universities of Saint Petersburg and Moscow, in the Institute of Archeology and the Institute of Art History of the Academy of Sciences of the USSR, in the I.E. Grabar Central State Artistic Studios of Scientific Restoration, founded in 1944, in the Soviet Institute of Scientific Research for Restoration, as well as close to museums, where preparations were begun for important sections devoted to early Russian art systematically integrated with new acquisitions. The major museums organized their own

in-house studios which restored several masterpieces. The most valuable collection of icons, started by P.M. Tretyakov, was formed near the Tretyakov Gallery, where N.E. Mneva and V.I. Antonova worked for many years. In the sixties, the collection of the famous painter P.D. Korin, containing several very valuable icons, was opened to the public as a separate section of the Tretyakov Gallery. Also, at P.I. Neradovskii's initiative, the large collection of icons in the Russian Museum of Saint Petersburg, to which the splendid collection of N.P. Lichachev had been added, started to be reorganized. Under the guidance of N.P. Sychev and Yu.N. Dmitriev, this collection was transformed into an authentic treasure of early Russian art. Intense work also went on in Novgorod, where even before the revolution, a magnificent eparchial Museum was established, thanks to the dynamic support of Archbishop Arsenii, and subsequently expanded and enriched in the post-war years. The Andrei Rublev Museum of Early Russian Art was founded in Moscow in 1947, near the Andronik Monastery. In a short time, it became one the main centers for the gathering of icons since the expeditions organized each year to the most remote provinces of the country allowed the museum to always exhibit new works of art previously submitted to a skillful restoration. Gradually, even the museums of provincial cities like Vologda, Suzdal, Vladimir, Yaroslav, Gorkii, Velikii Ustyug, Petrozavodsk, Archangelsk started to prepare their own collections of icons and this indicated a further step forward in the concept of local, artistic centers. During the years of the revolution, a vast network of museums offering a valuable legacy of unpublished material to scholars was formed.

The great exhibitions of Russian icons organized in various countries from 1929 to 1932 attracted the attention not only of art critics but also of the public at large. Such exhibits were especially successful in Germany, England, and America. The renowned English art critics Martin Conway and Roger Fry devoted brilliant essays to them. They are particularly interesting because they constitute a first account of the impressions that refined European taste drew from early Russian painting. These studies contain many sharp and in-depth observations showing once again that the language of true art knows no national borders.

More recently, European museums have also attempted to obtain icons, but they arrived late since by this time the main works had already been acquired by Russian museums, which were no longer willing to let them go. This is why no European museum was successful in establishing a first-class collection of Russian icons. The best examples are found in the museums of Stockholm, Oslo, Bergen, and Recklinghausen with the foundation in 1955 of a museum exclusively dedicated to icons and the development of a valuable cultural endeavor for the systematic and far-reaching dissemination throughout Europe of the knowledge of the artistic legacy of early Russian art.

With the discoveries taking place during the revolution, the iconographic material known up to that time proved to be so rich that a revision of traditional theories taking into account the enormous amount of new facts became indispensable. Part of this work affected the first four volumes of the great *History of Russian Art* published by the Academy of Science of the USSR. The study of early Russian icons followed various lines of development. For example, some, like I.E. Grabar, N.P. Sychev, A.I. Anisimov, Yu.A. Olsufev, N.E. Mneva, and V.I. Antonova, were primarily interested in the cognitive aspects; others, like Yu.N. Dmitriev, G.V. Zhidkov, and the undersigned, sought to sketch an organic historical outline of the development of early Russian iconography; still others, like M.V. Alpatov and N.A. Demina, set out to discover the emotional quality of icons and for that purpose used a detailed, artistic analysis of individual works, open to question at times because of a subjective approach. In general, Russian scholars tend to interpret the content of the icon as something much broader than a mere ensemble of iconographic typologies. There was an ever greater demand to establish a connection between icons and historical reality; the taste of the persons requesting the icons; the prevailing theological, philosophical, and political ideas; the artistic practice and method of medieval work. These tendencies have a strong resonance in the iconology of E. Panolskii.

Unfortunately, yet another tendency, symptomatic of a return to the most damaging Slavophile traditions of the second half of the nineteenth century, has emerged recently in the study of Russian

icons. On the basis of an appraisal that is totally acritical, Russian iconography becomes isolated from the art of Byzantium and from Southern Slavia and begins to be viewed as a completely indigenous phenomenon having developed independently from any historical conditioning. General considerations on the "originality" of icons, determined only by adjectives in the superlative, replace a more rigorous study based on the methods of modern, scientific research on art. We need to wait for this Slavophile tendency to decline and for scholars to become able again to speak of icons, with serenity and in appropriate terms, as the objects of a scientific study.

In recent years, much has also been written abroad on Russian icons, even though most of these essays are superficial. Their authors, who for the most part took up the articles by E.N. Trubetskoy, made his thinking commonplace and prosaic, being primarily interested in "l'âme russe" and its reflection in icons. Not sufficiently familiar with the reality of Russian culture and its liturgy, they were content to constantly quote Greek sources, thus forgetting that there were considerable differences between Byzantine aesthetics and Russian artistic practice. This type of critical literature, with an obvious tendency to snobbish mysticism, can only succeed in distorting an authentic interpretation of Russian iconography. A much more scientific approach to Russian icons is found in the works of Ch. Chelin, L.A. Uspenskii, D. Talbot Rice, W. Weidlé, Zh. Blankov, J. Myslivec, K. Onasch, and W. Felicetti-Liebenfels, who have greatly contributed to spreading the knowledge of Russian iconography among the vast Western public.

Fortunately, the scientific study of Russian icons is progressing even though there is still much to do in terms of understanding the works recently discovered, the definition of the local artistic centers, the discovery of the authentic — rather than the imaginary — spiritual world of Russian iconography, the identification of its relation to historical reality, the analysis of a differentiated artistic approach (Russian icons' concept of space, surface, shape, color, and so on), the deciphering of the ideal content of particular iconographic typologies. All these problems are still present and the degree of our knowledge of Russian iconography depends on their being solved.

General Observations on Russian Iconography

A continuous line organically links Russian icons to Byzantine art. By the end of the tenth century, examples of Byzantine iconography already began to arrive in Rus. Not only did they become cultic objects, but they were also examples to be imitated. However, this does not mean that Russian iconography was a mere derivation of Byzantine iconography. For a long time, the former was within the field of attraction of the latter, but its process of emancipation had already started in the twelfth century. Local traits, accumulated over hundreds of years, slowly converged into a new characterization different from the national stamp. The process was a long one and it is very difficult to identify its chronological limits with accuracy.

The most intensive development occurred in the North, in cities like Pskov and Novgorod. Their being far away from Byzantium, as well as their form of republican government, allowed them to approach and resolve various problems, among them those of an artistic nature, in a more autonomous and bold way. Besides, in these northern regions, which had escaped the Tartar invasions, the traditions of popular art had remained particularly strong and their influence made itself felt differently in the thirteenth century when relations with Byzantium stopped almost entirely.

Within the Moscow principality, the process we are considering developed more slowly, but even here a particular artistic language was being elaborated. If this did not cause a decisive break with the Byzantine heritage, nevertheless, starting at the time of Andrei Rublev, Muscovite painting acquired a characteristic aspect. From that time on, we can refer to early Russian iconography as an already-established national school.

Compared to the Russians, the Southern Slavs were in a much more difficult position. Their proximity to Byzantium, the constant changes of political boundaries, the uninterrupted influx of Byzantine masters and icons, all this thwarted the crystallization process within the sphere of an art as traditional as iconography and of its original artistic language. This becomes clearly evident in the cleaning of Bulgarian and Serbian icons that has been done in the past decades. But the relations of early Rus with Byzantium were sporadic. Sometimes they ceased for long periods; Byzantine masters did not arrive as frequently[12] or Byzantine icons arrived in waves, depending on the general political situation. Consequently, it was easier for the Russians to find their own artistic path: the distance from Byzantium, which sought to get its hands on everyone and everything, opened broader perspectives to them. When Serbia and Bulgaria lost their independence and when Byzantium fell in 1453, early Rus became the only Orthodox country where iconography did not lower itself to the level of a mere occupation. Rather, it remained an art and a very lofty one.

The remoteness of Constantinople and the boundless distances determined the uneven development of early Russian iconography. If in Western Europe with its many cities, innovations introduced by one school were quickly adopted by other schools because of their geographical proximity, in Rus,

on the contrary, given the insufficient development of the means of communication and the predominance of a rural population, individual schools led fairly isolated lives as a rule and their reciprocal influences were rather infrequent. Territories located far from highways and rivers, the main arteries of the country, did in fact develop rather late. Here, the oldest and most archaic traditions were so deeprooted that icons of a more recent period linked to these regions are often considered very old. This uneven development makes the dating of these icons very difficult. We need to take into account the survival of archaic vestiges, especially deep-rooted in the North. Therefore, it would be an error in principle to attempt to organize the icons in a chronological order only on the basis of the development of their style.[13] However, with many exceptions, this can be done with the Moscow and Novgorod icons, but already much less with those of Pskov, not to mention icons from other northern regions (the so-called "Northern Manners").

Novgorod, Pskov, and Moscow were the main iconographic schools. We do not know anything about the early iconography of southern cities (Chernigov, Kiev), other than the fact that it did exist. Instead, such masterpieces, so many of them marked with similar stylistic traits, came from Novgorod, Pskov, and Moscow that it is correct to consider them as three separate iconographic schools. Of late, the outlines of other artistic centers, like Vladimir, Nizhnii Novgorod,[14] Tver,[15] Rostov, and Suzdal,[16] have also begun to appear. During the period of the political division of Rus, when it broke up into a number of independent principalities, icons were made not only in large centers, but also in smaller cities. However, this does not imply at all that there were iconographic schools in every city. For a school to exist, it was necessary to have solid, artistic traditions, a staff of well-trained iconographic masters, and quite a few orders, something which was rarely possible in smaller principalities. Therefore, in many cases, the actual existence of particular iconographic studios may not have coincided with the concept of a school. Considering the vast territories of Rus, these studios were also scattered in large villages.

The entire iconographic production of the northern regions generally comes under the sole definition of the "Northern Manners." The scientific expeditions of the past few years have definitely shown that icons were produced not only in Vologda, but also in Velikii Ustyug, Cholmogory, Tichvin, Kargopol, and in other adjacent territories beyond the Dvina and around the Onega area.[17] Here, we cannot speak of schools, but only of individual workshops still closely linked to the early days. This "country" art, which flourished for many years in the vast territories of Northern Rus, was distinguished by its ancient character and the ingenuousness of its perception of life, even though it was nourished by ideas imported from Novgorod, Rostov, and Moscow. A special fascination pervades its simple, often primitive, language. It is in this iconography of Northern Rus that we clearly see the substance of popular art, which was extremely important in the process of transforming Byzantine models on Russian soil.

Rus inherited all the fundamental iconographic types from Byzantium. For that reason, Russian icons may seem very much like Byzantine icons to observers not particularly expert in art: the same types of representations of the Mother of God, the same portrayals of gospel scenes, and the same types of Old Testament compositions. But the differences are immediately visible to the eyes of experts. The type, like the iconographic design, remains stable, but it acquires new emotional nuances because of the changes in concept and form. Faces become more gentle and open; the intensity of the pure color is reinforced by the resulting reduction in the range of tonal nuances; profiles become more outlined and precise; with the help of sudden highlights, the chromatic incisive modeling is replaced by even chromatic surfaces with "expressive strokes" which are barely perceptible. All of this explains why, after a long and gradual evolution, Russian iconography always moves farther away from its Byzantine counterpart. While preserving with accuracy the iconographic type inherited from Byzantium, Russian iconography imperceptibly transforms it, filling it with a new content, less aesthetic and less severe.

Close to the transformation of the traditional types, which took on a different emotional nuance with a corresponding formal elaboration, another process also occurred in Rus, but later: the creation

of original iconographic types independent of Byzantium. This phenomenon could be observed first of all in the veneration of local saints (like Boris and Gleb, for example) who were not depicted in Byzantium.[18] Some time later, completely original compositions with more figures, such as the "Virgin of Mercy,"[19] the "Synaxis of the Mother of God,"[20] and "In You Everything Rejoices,"[21] began to take shape. In them, we see the distinct emergence of that "ecumenical" principle mentioned by E.N. Trubetskoy,[22] something which found no expression in Byzantine icons. This universal straining toward God, involving angels, humans, and all creatures of the earth, is the straining to overcome the "loathsome division of this world" that Saint Sergius of Radonezh so firmly condemned.

However, in the land of Rus, the sudden changes in the images of Byzantine saints are even more significant. A new function, in keeping with the exigencies of rural life,[23] was attributed to them. George, Blaise, Florus and Laurus, the prophet Elijah, Nicholas started to be venerated primarily as protectors of the peasants, of their flocks, their houses with all their possessions. Paraskeva Pyatnitsa and Anastasia became the patronesses of trade and merchants. Popular tradition had assigned similar functions to most of these saints, even in Byzantium, but the clergy did not attribute any particular significance to them. The saints were venerated first of all as saints, and the strict Byzantine clergy preferred to overlook their relations with the real needs of believers. But in Rus, this relation became explicit, in part as a legacy from pagan worship. The process of bringing the images of saints closer to the immediate needs of rural people was especially quick in the northern regions of Rus, particularly in Novgorod and Pskov. Here, contrary to every rule, the images of the saints whom people requesting icons venerated as their protectors began to be introduced into the *Deesis,* taking the places of the Mother of God and John the Baptist. The donors' desire to secure the help of the saint in their daily affairs was so great that the artist was forced to violate the canons. This form of open interpretation of the traditional iconographic types is often found in Russian icons, especially in those from the remote northern regions.

In spite of all that has been said, we still have to recognize that until the end of the sixteenth century, Russian iconography, as a whole, continued to hold to the models consecrated since ancient times. For the Russians, as well as for the Byzantines, these models were not legendary representations but rather real events, pictures, in a way, of biblical episodes and of the features of holy martyrs and of people canonized by the Church; consequently, it was impossible to move too far away from this generally accepted iconographic type. This is at the root of the stability of iconographic types in Russian religious painting, something which was also of great concern to the Church, as the conciliar decrees of the sixteenth century testify.[24] But while pointing out this stability, at the same time, we cannot ignore the process of intense iconographic creativity which was always present in Rus, although developing from the eleventh to the fifteenth century in a slower and more obscure way and then much more rapidly from the sixteenth to the eighteenth century, in part because of Western influences.[25] The enrichment of themes with complicated, allegorical, and didactic subjects, so appreciated in the sixteenth century, is not a characteristic of the period of Russian iconography to which this study is devoted. Here instead, the main emphasis is placed on the stability of iconography, its perfection, and the maturity of its methods, with a classical conciseness polished by the centuries. This approach to the problem does not at all exclude the unexpected Russian transformations of the models imported from Byzantium, of which we spoke earlier, and we would like to call special attention again to this last circumstance, usually ignored by scholars who consider Russian icons as nothing more than mere copies of Byzantine icons.

Russians considered iconography to be the most perfect of all the arts. "The art of the icon," we read in a seventeenth-century source, "was not invented by *Gyges of Lydia* . . . , nor by Polygnotus . . . , nor by the Egyptians, the Corinthians, the inhabitants of Chios, or the Athenians . . . , but by God's very self, who adorned the sky with stars and the earth with flowers because of their beauty."[26] Icons were shown the utmost respect. It was deemed improper to speak of the purchase or sale of icons: icons were "exchanged with money" or they were donated and such a gift had no price.[27] People

did not say, "The icon is burned," but rather, "It is gone," or, "It ascended to heaven directly." Icons could not be "suspended" and for that reason they were always propped on a bracket. Icons were surrounded by an aura of great moral authority. They were bearers of lofty ethical principles. The Church held that icons could be made only by "pure hands." In the people's consciousness, the idea of Russian iconography was invariably linked to the image of morally pure Christians. The possibility of a woman — considered an "impure being" — iconographer was unthinkable and an iconographer belonging to a different religious group was branded a "heretic." The ideal profile of the early Russian artist emerges with supreme clarity from the forty-third chapter of the Council of the Hundred Chapters, which we quote from a sixteenth-century source: "Iconographers must be humble, meek, devout; they must not engage in empty talk; they must not be jokers, quarrelsome, envious, drunkards, thieves, or murderers. They must valiantly preserve their purity of body and soul with great fear of God. Whoever does not know how to abstain should marry according to the law. Iconographers must frequently have recourse to spiritual fathers and seek their advice in everything and live in accordance with their rules and their teachings in fasting, praying, and abstinence in all humility and without scandal or violence. And with great diligence they are to draw the image of our Lord Jesus Christ and of the Immaculate Mother of God [this is followed by the list of other images. *Author's note*] in the image and likeness and in conformity with the substance and best examples of ancient iconographers . . . and those iconographers [that is to say, the good ones. *Author's note*] are respected . . . and more honored than other men. Noble and ordinary people should show utter respect to iconographers because of the noble images they paint. And in their respective territories, bishops must make sure that the fine iconographers and their disciples paint according to the principles of ancient models and that they do not represent the divinity according to their own creativity and their own ideas. . . ."[28]

In this passage, we undoubtedly have a rather embellished "ideal portrait" of the iconographer, described in the stylized manner that is typical of the sixteenth century. But this is not what is essential; what is important is the fundamental tendency to present a "portrait," a tendency inherited from much earlier times. What is described here is the ideal the Church aspired to, but in reality, the practices in iconographers' studios were much more independent, especially in the earliest days when they were not under the state's direct surveillance and control. The iconographic studio was a workshop of a purely artisanal character. The work was organized in a completely systematic way and, if necessary, the production process varied. Icon painters were modest and simple artisans, and as such, it would have been difficult for them to observe very strictly all the rules advocated by the Church, all the more so because quite a few of them were lay people. However, the norms fixed by the Church had to have left a very precise imprint on the iconographers' work. Today icons are still fascinating because of that inimitable hint of moral purity which so successfully distinguishes the works of the fifteenth century from those of later periods.

Russian artists who viewed Western innovations and the influx of realistic elements into iconography with suspicion, religiously defended the ancient tradition until the end of the sixteenth century. For them, icons had to be something noble, rising above sensorial reality, and their images had to embody the sublime ideals of a pure and moral life. In the seventeenth century, when realistic elements quickly started to filter in without encountering any obstacles in the court milieu, this caused a great scandal among Old Believers attached to old traditions. Protopope Avvakum was particularly angered by this. In his forceful literary style, he clearly and effectively described what Old Believers deplored and what they most valued about Russian icons before they came into contact with "Latin" innovations. For Avvakum, there was in iconography only one ideal, which he described with the concreteness that characterized him. In his saints, "the faces, the hands, the noses, and all the feelings are purified and tested by fasting, fatigue, and all sorts of sufferings." For Avvakum, the icons permeated by realistic innovations and above all by a more solid chiaroscuro modeling were utterly intolerable: "They depict the image of the Savior Emmanuel, with a swollen face, vermilion lips, curly hair, powerful arms and muscles, swollen fingers, fat legs and hips, very stout and with a large stomach like a Ger-

man; the only thing lacking is the sword attached to his side." In his eyes, the icon of the "Crucifixion" is equally scandalous: iconographers depict "Christ on the cross with full features; he is plump and sweet and his legs are like columns!" Neither did he appreciate the way the saints were painted: "combed hair, the cloak held back, no longer as they once were, and the fingers' gesture: symbols of Malaksa, not of Christ."[29] Avvakum fought for a return to the early iconographic traditions, something which was impossible in the seventeenth century. His polemics is particularly interesting because it clearly brings out what Old Believers did not want to sacrifice since they totally rejected the new style of the icons of their time. And they were right, both in their aesthetic appraisal of the sudden change in the iconography of the seventeenth century, even though they were not too interested in purely aesthetic questions, and because of the loss by seventeenth-century iconography — involved in a process of development under the banner of compromise — of its classical clarity of expression and its sublime inspiration, which were its distinctive characteristics at the time of its greatest flourishing. But Avvakum denounced above all the loss of spirituality in the icons which were taking on a more earthly character, whereas he was accustomed to icons devoid of a third dimension and chiaroscuro modeling, where the whole composition developed in height rather than depth, where the entire representation was subordinated to the flat surface of the panel, and where spiritual principles prevailed.

In Russian iconography of the fifteenth century, a time of great splendor, the figures of saints were always represented as if they were incorporeal, cloaked in large, loosely-cut garments which concealed the body's plastic form. Their rounded faces had nothing to do with portraiture (unless they were actually portraits) and their individual features were rendered in a completely neutral way. The courtly principle, so characteristic of mature Gothic painting, was totally absent in iconography: Mary always remains the Mother of God.[30] If the figures are associated with a landscape, the latter is reduced to its simplest forms and is so stylized that it completely loses its living character.[31] And if architectural backgrounds are introduced, they are equally spare and conventional.[32] In Russian icons, there is the pathos of the distance which separates heaven from earth, the awareness of the abstraction from the represented events and things.

It would seem that an approach so disengaged from the artistic image would exclude the possibility of creating a joyful, emotional art capable of stirring simple human feelings. But in reality, Russian iconography of the fifteenth century is a joyful and radiant art. It is just as foreign to the contemplative Byzantine seriousness as it is to the intense expressiveness of the Gothic. The brilliant, strong, and clear colors of Russian iconography, its rhythmic, melodious, and harmonious profiles, its radiant, loving, and poetic faces, its epic, calm, and composed atmosphere, all this awakens in the beholder a sense of interior lightness where all contrasting passions are brought back to unity and that special sense of harmony evoked by the sounds of perfect music is born. It is no coincidence that the most popular theme of Russian iconography from the fifteenth century was the Virgin of "Tenderness." The icon representing the mother caressing her son is one of the summits of Russian artistic creation. Neither the French Gothic nor the Italian Renaissance knew how to instill more warmth into this subject. More human images were painted in the West but without involving the onlooker to the same degree. The Russian icons of the Virgin of Tenderness do justice to their name since, in contemplating them, onlookers are pervaded by a sense of profound tenderness. This feeling is best expressed in the words of Isaac the Syrian, who explained what the sign of a tender heart was: "The human heart is burning for the whole creation, for human beings, birds, animals, demons, for all creatures. In remembering them and in contemplating them, the eyes of human beings shed tears. Because of the immense and strong compassion which clutches the heart and the great passion which tightens it, people cannot bear to hear or see any evil or the slightest sadness endured by any creature. And therefore, with tears they constantly lift up their prayer for creatures without the gift of words and for the enemies of the truth, and for those who hurt them so that they may be taken care of and be forgiven. They even pray for the species of reptiles with great compassion, which wells up in their hearts, similar to God's."[33]

25

Russian iconographers' personal tastes manifest themselves with the greatest clarity in their concept of colors. Color is the authentic soul of Russian iconography from the fifteenth century. When we see an icon in a monochromatic reproduction, it loses a good part of its fascination. Color was the means which allowed Russian iconographers to instill the most exquisite emotional nuances in images. Thanks to color, they were able to express either force or special tenderness. The use of color helped them encompass Christian tradition within a poetic aura. In the end, color made their art so beautiful that it was difficult to resist its fascination. For Russian iconographers, colors were a precious material, no less precious than enamel. They were intoxicated by the beauty of their pure, simple colors, which they applied in extremely bold and complex combinations. For iconographers, as for all medieval painters, each color had its own symbolic significance, but this aspect left them rather indifferent and it would be incorrect to analyze their coloring in terms of the complex symbolic categories of Dionysius the Areopagite.[34] Instead, iconographers' rapport with color was much more immediate and spontaneous even though they had to take into account the traditional coloristic canons in the clothing of Christ and the Virgin. Fifteenth-century iconographers still loved flaming red, brilliant gold, golden ocher, emerald green, whites pure as snowdrops, the dazzling blue of lapis lazuli, soft pink shades, violet, lilac, and silvery green. They used colors in various ways according to their project, resorting at times to abrupt clashing contrasts and at times to delicate gradations of luminous tones so harmonious that they evoke an involuntary association with the musical scale. Each of the three main iconographic schools, Novgorod, Pskov, and Moscow, gave birth to its own coloristic traditions, and in spite of the stylistic uniformity of fifteenth-century icons, the coloring turns out to be exactly the most individual component of the style, which facilitated the classification of icons according to individual schools. The sublime level of this extraordinary coloristic culture is explained to a large extent by the link of continuity with the coloristic tradition of Byzantium — in this respect, Byzantium was always a great school for the use of colors, in which even artists like Titian and El Greco were formed — yet in this area there was a still stronger influence of popular tastes which altered strict Byzantine coloring toward an exultant joie de vivre giving it an entirely new character. This is why it is impossible to confuse Russian icons with Byzantine icons with their darker colors and their elaborate system of softened tonal transitions. At first sight, Russian icons reveal that they belong to the Russian school by their absolutely original, forceful, striking, and joyous chromatic system.

Line was an equally essential expressive means in the hands of Russian iconographers. They mastered it to perfection. They knew how to make it soft, angular, light, stylized, subtle, and monumental. Special importance was attributed to the line of profiles.[35] Deliberately rejecting the sculptural principle, modeling, "not wanting to copy blindly lines which they did not understand, which expressed volume, and not turning to nature for explanations, Russian masters found another guiding principle. Their love of friezes, their experience in searching for their own rhythm helped them put more care and enthusiasm into the execution of a true and typical 'description' of the figures. A further artistic task consisted in seeking combinations of strong and intense colors. Not finding this characterization of profiles in Byzantine painting, we are therefore inclined to think that it represented a national legacy of our art. It played a major role in the composition of Russian icons from the fifteenth century; enriching the characterization of the figures allowed the authors to express their artistic project in an extraordinarily complete and clear manner."[36] These subtle observations by N.M. Schekotov convincingly show that for early Russian iconographers, the concept of line was the exact opposite of the tendency of Florentine painters, who treated the line as an expression of solids (a classic example of this concept of line is found in Michelangelo's *Tondo Doni*). In Russian icons, we will never find anything like this. Here, lines are always flat and extremely standardized. Contributing to this standardization of line was the high iconostasis, definitively established in the fifteenth century. It led artists to value the "continuous" line which made the outline harmonious and gave it a special monumentality. Only when icons were separated from the iconostasis, explicitly becoming a work of easel painting, as in the Stroganov school, did they lose this expressiveness of outline. A meticulous calligraphic style re-

placed the skilled art of essential lines which in their spareness recalled the figures painted on Greek vases.

A distinctive characteristic of fifteenth-century icons, especially when we compare them with later icons, is certainly the simplicity and luminosity of the compositions in which there is nothing superfluous, nothing secondary. Predominant are representations of gospel scenes and figures of saints, often surrounded by borders with scenes from their lives along the cornice [the raised edges of the panel]. There are no known examples of icons with a didactic content or complicated allegories. The scenes with several figures, apart from those whose theme is the "Virgin of Mercy" or "In You Everything Rejoices," are numerically fewer than simpler compositions. Even in hagiographical icons inspired by literary texts, the narrative line is never overshadowed by details and as a result is always immediately clear. Not concerned about preserving chronological consistency, Russian iconographers relate with great courage and naturalness the episodes they consider the most important and substantial. They do not show these episodes as a brief moment, but rather as a permanent situation and thus succeed in bringing spectators close to the miracle reproduced by their brushes. This slow rhythm in the development of the events and the utmost conciseness of the account, in which only the most indispensable narrative elements are provided, contribute to the greatest simplification of the composition. With their expressiveness and plastic luminosity, icons of the fifteenth century are in no way inferior to the best compositions of other times. With extraordinary mastery, iconographers insert their figures within the rectangular cornice of the icon and they always find the precise proportion between profiles and empty background. They know how to make a skillful use of the intervals of space, that is, the distance between figures and objects — with a mastery comparable to that of Piero della Francesca — and these are an integral part of the general plan of composition since the absence of overcrowding allows them to create the impression of an open and absolutely weightless space. The artists know how to coordinate the height and width of their compositions with their reduced depth. This is why there is always a strong dependence between the proportions in the structure of the composition of a Russian icon and the proportions of the panel itself. Artists do not consider the panel of the icon as a "window on nature," but as a flat surface which the composition has to follow. It is no coincidence that icons do not need the frame which underlines the illusionistic moment. In icons, the frame is replaced by the side border scenes, slightly in relief on the surface of the image. If the frame helps one think of the painting as a "window on nature," the flat surface of the icon, on the contrary, fulfills exactly the opposite function. Thus, the transcendant world of the icon appears contained within a well-defined area where the least important dimension is depth, as is also the case of the very panel on which it is painted. Consequently, the figures almost seem to glide *over* the icon's surface, and when they are placed in the background, this is so close to the foreground that even in this case, the figures appear to be placed on the surface of the panel. Therefore, one of the main preoccupations of iconographers was the careful preparation of the surface to be painted.

The practice of Russian iconographic studios undoubtedly goes back to the experiences and methods elaborated in Byzantium. But even to this field, Rus brought its own modifications dictated by local customs and available materials.[37] The boards for the icons came mostly from linden or pine trees, much more rarely from fir or cypress (cypress started to be used after the second half of the seventeenth century). Boards were usually provided the iconographer directly by the person ordering the icon, or the artist had them prepared by a carpenter. The abundance of wood in Rus allowed the painting of large icons. In this case, the panel was prepared by joining several boards and was reinforced on the back by small glued strips or mortised wedges bolted transversely (staves of various forms). This system was used to prevent cracks or curvatures from forming in the glued planks. These reinforcements, called *shponki*, were glued in the twelfth and thirteenth centuries, whereas from the end of the fourteenth century, they began to be mortised in. A shallow cavity, called the "ark" *(kovcheg)*, with slightly raised edges, the "cornice" *(pole)*, was made on the front side of the icon. The sloping areas between the ark and the cornice were called "scales" *(luzga)*, and the coloring on the edges of the icon

was called "trimming" *(opush)*. To keep the panels from possibly cracking (either the primer or the paint), a cloth made of linen or hemp *(pavoloka)* was glued on them and over it a primer of gesso or alabaster *(levkas)* was spread.

Following a careful smoothing of the primer, they began the preparatory drawing, done first in charcoal and then with black pigment. The outlines of the halos and heads and even those of the figures and architectural elements were often cut or scratched (graffiti-like) on the background because when gold and pigment were applied, it was easier to guide them over the original design. The next phase of the work consisted in the gold-leaf work of the background and other parts of the composition where it was necessary to apply a uniform layer of extremely fine gold or silver leaves. After that, artists could start with the colors.

For the preparation of colors, mineral pigments were used most of all, but imported colors (the blue of lapis lazuli and others) were also used. Egg yolk was used as a thickener in tempera painting. Artists spread the pigments in a precise sequence: first they covered the background with layers of uniform colors of different hues, then came mountains, architectural elements, clothing, and last the uncovered parts of the body. With this system, iconographers could immediately perceive what effect they obtained by the arrangement of the areas of the composition's principal colors. Only then did they apply themselves to touching up details, always observing a fixed rule: proceeding from the whole to details and from elements of secondary importance to main elements.

They used several methods for clothing. After the initial spreading on of the colors, they would cover the entire lighted part of the fold with a basic color slightly lightened, and then, adding more white *(belila)*, they would cover a more reduced surface only in the most irregular points of the form. Then, in increasingly smaller areas, they continued to add layers of always lighter colors, frequently concluding the coloristic elaboration of the garments with fine brush strokes of white. After completing the lightening of the folds, artists often added to the shadows a fine layer of a dark pigment of loess, a loamy deposit, (the so-called "cross hatching") in order to strengthen them. In the oldest icons from the eleventh and twelfth centuries, along with the lightening technique in successive layers, another method was also followed, that of the gradual lightening of the tones in a specific area with the addition of yet more colors; and at the same time the passages from shade to light were obtained by fine brush strokes, almost fused into a single stroke.

Having completed the work of lightening the folds and buildings, artists devoted themselves to the "precision work" *(lichnoe)*, the execution of the parts of the figure not covered by clothing (head, hands, feet). A person's features were painted over a previously applied preliminary layer of a tan color of various shades *(sankir)*. As a rule, the *sankir* covered the entire surface of the body, but in older icons and until the sixteenth century, the *sankir* was sometimes limited to the shaded parts of the body while the lighted parts remained white (the background color). After the second half of the sixteenth century, this method fell into disuse. Details of the form were produced on the *sankir* with the help of lighter colors, the flesh-tones (a combination of ocher and white), a phase called "working the faces with ocher" *(vochrenie)*. In the oldest icons, along with ochers there were also reds; they were used to color the cheeks and for the outline of the nose, lips, eyelids and eyes. Faces were painted in two different ways: successively superimposing fine brush strokes of a light color or applying the strokes in a fine layer which thus seemed to be almost a single stroke. The lines of the boundaries between the single layers of colors were concealed with ocher to make them completely invisible. This method, which Rublev and Dionysii mastered to perfection, was called "shaded painting." The most salient details of the face were underlined by highlighting in pure white. Such highlightings were called "characters" *(otmetki)*, "expressive strokes" *(dvizhki)*, or "vivid strokes" *(ozhivki)*. When the work with pigments was done, they often used gold and silver to touch up the garments, applying them over the layer of colors with glue made from sturgeon or something else (the small golden leaves glued over the layer of colors were called "inocopy"). Finally, once completed, the entire image was covered by a film of flaxseed or hempseed oil or by *olifa*, which made the colors more intense and striking. This fine

coat of varnish was carefully spread with the palm of the hand; then the icon was exposed to the light for a few months until it was thoroughly dry. At that point the icon was finished.

The technique of iconography was characterized by a great attention and inner logic which assured the excellent quality of the execution, thanks to which, the original brightness of the colors remained totally unchanged in well-preserved icons. The methods developed by artisans in the course of the centuries were the result of an elaboration so careful that it did not need any correction in the light of modern techniques.

The same system of constructing the form which we find in Russian icons is also found in Byzantine and Southern Slavic icons, as well as some Italian icons of the thirteenth century. We cannot speak here of a total predominance of two-dimensionality. Faces are rounded in part; the clothes follow the shape of the body; buildings and mountains have a certain volume. Yet, all of this does not alter the flat surface of the panel since the chiaroscuro transitions are either totally imperceptible (shaded) or so clear that the design retains entirely its graphic aspect (we have a brilliant example of this in Novgorod icons, in their accentuated lightening of the garments). Pietro Cavallini's chiaroscuro modeling (which Ghiberti called "maximal relief") is totally absent in Russian icons until the seventeenth century. In these, light and shade are extremely neutralized and they reverberate softly, while in Cavallini they become an effective instrument to make a solid figure stand out on a flat surface. In fact, this marks the difference between the medieval world of icons and the first pre-Renaissance realism.

Like all medieval artists, Russian masters used, in their work, patterns called *exempla* in the West. Thanks to them, they could remain faithful to the iconographic tradition. Since paper started to be used in Rus only after the fourteenth century and parchment was very expensive, patterns were in all probability made on the same material normally used for writing, as the Novgorod archeological excavations have shown. These composition patterns had to be drawn in one stroke, cut on birch bark with a sharp instrument. Some patterns may have been made on parchment, but not one of them has been preserved, nor any on birch. Recently, the hypothesis has been put forward that this function of example might have developed from the so-called small panels done on a cloth well-coated with a filler.[38] However, these small panels were generally finished works and as such, did not lend themselves to the function of a model, in which only the skeleton of the composition was usually set down, sketched simply in outline. Moreover, the small panels were too heavy to be transported, especially when the work involved a fresco with an abundance of subjects. The Greek artists going through Rus undoubtedly brought with them books of examples which were copied by Russian masters. This is the only explanation for the rapid progress and wide diffusion of Byzantine art in Kiev's Rus.

These models (in Rus they were called *proris,* sketches) were also used by Rublev and Dionysii,[39] but with greater freedom than in the sixteenth and seventeenth centuries when the Church and the state established a centralized control over icon painting. As in the case of all medieval masters, models served only as general orientation. But in the seventeenth century, systematic collections of sketches done on paper, manuals *(ikonopisnye podlinniki),* started to appear. Little by little, they reduced iconographers' work to a mechanical imitation of the "illustrious models." In the Stroganov iconographic manual, there is a predominance of individual saints found in the ecclesiastical calendar. In the Sija manual, written by the monk Nikodim at the end of the seventeenth century, more than five hundred versions of icons are collected. When these manuals also provided a written commentary, they became a real burden for iconographers. We have good reason to believe that nothing similar existed in the fifteenth century.

How did Russian iconographers construct their compositions and what initial measurements did they use to determine their proportions? There are varying opinions on the subject.[40] It is certain that in constructing a composition, iconographers used subsidiary means like geometric lines, but it is also certain that later artists courageously abandoned this geometric structure to trust their intuition, working in "an approximate way." It is precisely here that they showed their skills by going beyond the mere imitation of a preestablished geometric sketch. However, the importance of this sketch should not be

overestimated, as many contemporary scholars do.[41] In medieval art, departure from the models is observed much more than the total subjection to them of the artist's creative "I." Had it been otherwise, all the icons on the same theme, done on panels of the same size, would be like peas in a pod. Instead, not a single icon is the exact copy of another. By varying the compositional rhythm, slightly shifting the central axis, increasing or decreasing the spaces between figures, iconographers easily succeeded in diversifying every single work. Artists had their own way of reshaping traditional forms and this was their great strength. This is why, even though their work was totally impersonal, that work still never appeared amorphous.

In icons of the fourteenth and fifteenth centuries, the proportions of the sides can usually be expressed as a ratio of 3 to 4 or 4 to 5 between width and height. In icons representing only one person in full length, the ratios 2 to 5 and 1 to 3 are used the most. Single half-length figures are often inscribed in a triangle, while those on foot are inscribed in three squares which are arranged around in a circle. However, what may have been the exact proportional arrangement of these triangles, squares, and circles is not totally clear; and a great deal is rather arbitrary in their interpretation, which does not come from the figure of the icon itself, but from the thorough and deliberate work of modern scholars who artificially place the proportional ratios which interest them at the service of an idea first formulated in their heads. In the composition, the vertical and horizontal axes were certainly established first, determining the center, from which a circle (which was obligatory for halos) was drawn and the dimensions of the halo fixed. In some cases, the halo could be taken as the unit of size (normally the radius of the halo was equal to $\frac{1}{10}$ or $\frac{1}{9}$ of standing figures and $\frac{1}{8}$ of those sitting. In Dionysii's case, with his tendency to create very elongated figures, the ratio became $\frac{1}{12}$ and $\frac{1}{10}$). More debatable is N.V. Gusev's hypothesis that in the construction of the scene, determining the position occupied on the icon's surface by the main figure's halo was always the starting point, that in a series of compositions, this halo is always found at the apex of an equilateral triangle whose sides are equal to the icon's width, and finally that in an icon with a half-length figure, the radius of the halo was always equal to $\frac{1}{6}$ or $\frac{1}{5}$ of the composition's diagonal. There is no doubt that the entire compositional structure developed according to a planimetric principle and that geometric lines played an essential function in the process. However, we are not in a position to determine exactly the constant values of the ratio between individual linear segments. Indeed, the personal deviations from the preestablished norm are so many that the norm ceases to be a norm.

Early Russian icons form a totally original artistic world which is not easy to penetrate. But whoever discovers the key to it will effortlessly begin to discover a beauty that is always new. The abstract language of icons, their apophatic aspect, their symbols become a little more understandable each time, and in our consciousness, they take on the flesh and blood of the concrete artistic image. Then, the simple observation of the icon is replaced by a real understanding of it.

Icons of the Eleventh to Thirteenth Centuries

The icons of the eleventh to thirteenth centuries were not known to earlier scholars, who usually dated the beginning of Russian painting on wood to the fourteenth and fifteenth centuries. It was not until the years of the revolution, when the state could confiscate the earliest icons from churches in order to restore them, that the task of systematic cleaning started. With that, the history of Russian art was enriched by a completely new chapter enabling us to shed light on the earliest phases of its development.

Many Greek icons, which served as models for iconographers, were certainly brought to Kievan Rus. Unfortunately, only one Constantinopolitan work from Kiev was preserved: the famous icon of the *Virgin of Vladimir,* which is kept today in the Tretyakov Gallery.[42] Together with another Greek icon of the Mother of God *(Pirogoshchaya)*[43] — according to the chronicles[44] — it was brought to Kiev from Constantinople, and then in 1155, Andrei Bogolyubskii brought it to Vladimir, where it was kept in the Cathedral of the Dormition. It was sent to Moscow in 1395 and there it soon became a kind of protecting icon of the Russian state. This icon, of a unique beauty, clearly attests that the most illustrious examples of Byzantine iconography[45] were known in Kievan Rus. This great tradition did not fail to produce rich fruits as attested by a series of excellent twelfth-century icons from Novgorod and Vladimir.

Bit by bit, several local iconographic studios where Russian masters were working started to be established in Rus. The name of one of these masters is reported in a thirteenth-century source, the *Paterik of the Monastery of the Caves in Kiev:* it was Alimpii.[46] According to the story of his life, in which much is legendary and imaginary, Alimpii studied with the Greek masters who decorated with mosaics the Cathedral of the Dormition in the Monastery of the Caves (around 1083). Alimpii painted new icons and restored old ones, and furthermore, he did not work alone. In fact, when the master became ill and his assistants started to accept orders on their own and to practice usury — as the *Paterik* reports — they were expelled from the monastery.[47] It is difficult to say if or how the work of iconographers was differentiated at that time, but undoubtedly there was not yet in icon painting that meticulous subdivision of work which would typify the iconographic studios of the seventeenth century.

Because they have many features in common, it is difficult to classify icons of the eleventh and twelfth centuries according to schools. Here, only an accurate stylistic analysis and a clear identification of the icon's place of origin will serve. Consequently, the founding dates of churches or monasteries often provide solid ground not only for the dating of icons but also for determining the school from which they came.

From an iconographic viewpoint, icons from the eleventh to thirteenth centuries are not very different from Byzantine icons of the same period. Many similarities are also noticeable from a stylistic viewpoint. Their rather dark coloring, somewhat gloomy, goes back to the Byzantine palette; and the

treatment of the form, relatively voluminous, especially when compared with fifteenth-century icons, goes back to Byzantine traditions. In the faces in particular, the transitions from shaded parts to lighted ones are gradual. The noses, lips, and eyes are frequently surrounded by red lines emphasizing the relief of the faces. Golden lines are abundantly used in depicting clothes and also locks of hair. All of this connects the earliest Russian icons with Byzantine ones; yet the former also have an original characteristic: they are much more monumental than Byzantine icons, not just in their larger dimensions, but also in their particular artistic character, more general and spare. Already in this first stage, Russian masters submit Byzantine images to a modification not as radical as it will be subsequently, but just visible, consisting in the simplification of the profile and a certain flattening of the form.

The vastness of the great forests throughout Rus territory made it easy to produce large icons. These forests provided the wood necessary for making monumental images instead of costly mosaics. Icons adorned the Kiev churches, which were also decorated with mosaics and frescoes. However, the costly technique of mosaics fell into disuse during the first decades of the twelfth century and was completely replaced by frescoes. If mosaics, with the brilliance and magnificence of their colors, were not inferior to tempera painting, but even superior to it (it is no wonder that Byzantium was so fond of mosaic icons!), then frescoes, with their opaque surfaces, could not compete with the coloring of the mosaic. Thus, the disappearance of mosaics in Rus gave a powerful impetus to the making of imposing icons, as if in an attempt at substitution. The icon of the *Virgin Great Panagia* in the Tretyakov Gallery is a particularly obvious example of how, in certain cases, monumental icons could take the place of mosaics.

In the pre-Mongolian period, high iconostases did not yet exist. They appeared only in the fifteenth century. In their place, there were marble or wood partitions made of slender columns alternating with small balusters and supporting an epistyle. In the center was the door opening looking onto the altar (the so-called royal doors). Based on similar Byzantine evidence,[48] we presume that formerly icons were not placed on the balusters between the columns; they were either along the walls (wall icons),[49] fixed on the eastern pillars supporting the dome (pillar icons),[50] enclosed in isolated shrines (in this case the icons were often painted on both sides),[51] or else placed on the epistyle *(Deesis).*[52] At that time, icons were not yet arranged in various orders as in later iconostases. Almost all the earliest Russian icons which have come down to us have no direct connection with the partition of the sanctuary, and judging from their remarkable dimensions, they were almost always intended for the walls or pillars. Based on the inventory of the assets of the Russian monastery of Saint Pantaleemon on Mount Athos, written on December 14, 1142,[53] we can infer that churches of that time kept a great number of icons. In fact, the inventory mentions ninety, among them one *Deesis,* twelve *Feasts,* and *Saints.* From the icons of the feasts in particular, there is a direct reference to the *templon* (the partition of the sanctuary). There were probably fewer icons in the churches of Kiev than in the churches of Mount Athos and the decoration of the sanctuary partition simpler, limited to the *Deesis.* In any case, no Russian icon of the feasts has come down to us from the pre-Mongolian period.

The icons of the eleventh to the thirteenth centuries stand out because of their monumentality and their particular solemnity. Figures are represented in calm, immobile poses, with austere faces, gold or silver flat backgrounds, and the hieratic "iconicity" of the images is underlined in every way. These icons were painted at the request of princes or the high clergy, and they adorned the large churches in which they glorified the saint or feast to which the church was dedicated. Images of Christ and the Mother of God were predominant, but icons of the donors' namesakes were also widespread, that is, icons representing their patron saints. This type of icon was highly valued in princely milieux.

Because of the repeated sackings of Kiev and Chernigov, no early icon from southern Rus has survived. The situation of Novgorod, located more to the north, was much better and so it escaped the Tartar invasions. It is no coincidence that the earliest Russian icons come precisely from this city.

Throughout the eleventh century, Novgorodians were not free to choose their princes: princes and governors were appointed by Kiev. Cultural links to this city were very strong and many icons which

became the subjects of study and imitation by local masters may have come to Novgorod from the south. Thus, the foundations of the Novgorod iconographic school were established and several artistic masterpieces were to come from there.

The earliest known Russian painting on wood is the icon of *Saints Peter and Paul*, painted toward PL. 1 the middle of the eleventh century (Museum of History and Architecture of Novgorod). The apostles are represented standing; in the middle at the top, the figure of Christ is shown in bust length. The apostles' heads are not in a strictly frontal position but rather in a three-quarter view. Paul has the book in his hand, whereas in his left hand, Peter is holding a long staff in the form of a cross, a roll of parchment, and three keys. The poor condition of the icon prevents our speculating on the style or the author of this monumental icon, surely inspired by images in frescoes. However, its gigantic dimensions suggest that the icon was painted right in Novgorod.

In the second half of the eleventh century and at the beginning of the twelfth, princes did not have any buildings erected in Novgorod. Only with Mstislav Vladimirovich (1088–1094, 1096–1117), who had a Grecophile bent, did the grand principality resume its architectural activity and begin the work of painting the frescoes of the Cathedral of Saint Sophia. It was probably in that period, near the princely court, that an artistic studio was established which received orders for icons, frescoes and miniatures. The frescoes of the dome of Saint Sophia (1108) and the miniatures of the *Evangeliary of Mstislav* (1103–1117) are associated with this studio, which was probably the Byzantine-enriched soil from which sprang the great Novgorodian iconographic flowering of the twelfth century.[54]

Among the Novgorod icons of this period, the earliest ones are two images of Saint George, one full-length (Tretyakov Gallery), the other, half-length (Cathedral of the Dormition in the Kremlin, Moscow). The powerful figure of Saint George, standing straight, is sketched on a golden background PL. 2 which is lost today. He holds a lance in his right hand and in his left clasps a sword at his hip; behind his shoulder we see a round shield. The numerous lacunae of the original painting, repeatedly filled up by restorers, do not allow a precise reconstruction of the type of face or the details of the military attire, but the outline of the figure and its strong, rather sturdy proportions have remained intact. Saint George's imposing figure is the emblem of strength and military bravery and it strongly recalls the heroic images of the epic accounts of early Rus.

The half-length icon of Saint George probably came from Novgorod as well. It was brought to PL. 3 Moscow at the order of Ivan the Terrible when he removed most of the sacred objects from the defeated city. Saint George is holding the lance in his right hand and in his left the sword which he presents as a precious relic. As is well known, the sword had a special significance for early Slavs, who considered it a kind of military emblem of Rus and a symbol of power, especially princely power. The icon was evidently ordered by an anonymous prince who wanted to see the image of his patron saint in the church.

The figure of Saint George occupies almost the entire area of the icon, so much so that the arms seem squeezed into the frame, indirectly underlining the power of the figure; in fact, one has the impression that the figure is too crowded within the space assigned to it. The saint appears in the clothes of a brave and strong warrior, protector of fighters. His countenance is very expressive, showing a blend of youthful freshness and manly strength. The perfect oval of the face is surrounded by a thick helmet of chestnut-colored hair. The large eyes gazing upon the observer, the dark, gracefully curved eyebrows, the straight nose, the vermilion lips: all these physical traits are treated by the artist to give a purely architectural structure to the figure. The complexion has a very clear and luminous tonality which becomes soft rose on the cheeks. Because of its proximity to the thick dark olive green shades and the strong red line of the nose, the light shade of the skin takes on an extraordinary translucence and radiance.

Three wonderful icons of the twelfth century, most likely from the same studio, form a rather precise stylistic group. The first one is the so-called *Ustyug Annunciation* from the Cathedral of Saint PL. 4 George in the monastery of the same name near Novgorod (today it is in the Tretyakov Gallery). The

scene of the Annunciation is rendered here in a very rare iconographic arrangement with the child entering the womb of the Mother of God. In a semicircle in the upper part of the icon we find a representation of the Eternal One, the "Ancient of Days," from whose hand emanates a ray of light which touches the Virgin's womb. The artist was showing, in an extremely concrete way for that time, how the incarnation of Jesus Christ had taken place through the will of the Almighty at the moment of the Annunciation. This iconographic type, of which the Moscow icon is the earliest example, obviously emerged after the iconoclastic period, influenced by the festive liturgy of the Annunciation (Synaxarion for March 25th) and the corresponding hymn to the Mother of God *(Oktoich)*. It was rather characteristic of the Novgorodians' concrete mentality that the artist or the person requesting the icon should dwell upon this iconographic variant. An account included in the first *Chronicle of Sophia* in 1347[55] comes to mind. It relates how Novgorodians went to the earthly paradise, which they wanted to see at all costs with their own eyes: in other words, they wanted to be convinced as in the icon, of the concreteness of something which was transcendent by its very nature.

The monumental figures of the Archangel Gabriel and Mary reveal the iconographer's profound familiarity with the Byzantine painting of the time. Although the figures are slightly heavy, thereby distinguishing themselves from the representations of true Greek icons, they are characterized by strict proportionality. The treatment successfully expresses the archangel's movement; his garment falls in elegant folds and the chiton's pleats are no less elegant. The *maphorion* [garment covering the head and shoulders] of the Virgin is also drawn with the same refined concept of the structure of draping. The modeling of the face shows a special sweetness. The dark, olive green base extends only to the shaded parts. A further plastic relief is obtained by applying successive layers of dark yellow ocher, adding an increasing amount of white to each layer, but in such an even manner that the transitions from one layer to the other are almost imperceptible. A rose tone is spread over the ocher to make the forehead, neck, and line of the nose stand out. As a whole, the coloring in the *Ustyug Annunciation* is rather dark, a typical characteristic of icons from the pre-Mongol period. The colors of the figure in the upper part, where we see the Ancient One, seated among cherubim and lauded by seraphim, are lighter. Here, the hues of cinnabar boldly combine with azures, blues, greens, and whites. Because of the intensity of its colors, this representation with inscriptions in old Slavonic stands somewhat apart from the general chromatic style of icons. Here, we already perceive the personal taste of the Novgorod artist who obtains a special vibrancy in the colors. Obviously, in this part of the icon, the artist was less bound by canonical models and could therefore resort to a richer chromatic range, but also to a freer pictorial style. The coexistence of two different styles of painting within the same icon is also found in other early examples of Novgorodian wood painting.

PL. 5 Stylistically close to the *Ustyug Annunciation* is the *Holy Face* [*acheiropoietic* = "not made by human hands"] (Tretyakov Gallery). This icon, painted on both sides, must have been kept in a separate shrine. The *Adoration of the Cross* is represented on the back and is executed in a totally different style from the image on the front side.

Christ's face, with thick hair highlighted by fine gold threads, is painted in a soft "nuanced" style, using imperceptible chiaroscuro transitions. The artist was extremely restrained in the choice of colors: the spare chromatic range is built upon a combination of olive and yellow colors. The main emphasis is focused on the large, very expressive eyes. With a perfect mastery of line, the artist, in order to obtain the utmost expressiveness, takes the liberty of giving the face an asymmetrical structure, which is especially reflected in the different curvatures of the eyebrows. The solemn "iconicity" of this face clearly indicates that in painting Christ's features, either the artist had the best Byzantine examples in front of him or had trained directly with Byzantine masters.

The image on the back of the icon is by a different painter. The hand of the Novgorod master, a contemporary of the artists who painted the frescoes in the church on the Nereditsa in 1199, is easily recognizable in the ample, natural, and bold style; in the sudden and powerful matching of light and shadow, in the rich palette with hues of lemon yellow, cinnabar, rose, light blue, and white.

The marvelous icon of the *Angel* (Russian Museum), which was probably part of a *Deesis*, belongs Pl. 6 to the same stylistic group. As we have already observed, these compositions were usually placed on the epistyle of the sanctuary partition. The relief construction of the angel's face and the trimming of the hair with gold threads is very close to the icon of the *Holy Face* and the *Ustyug Annunciation,* but the icon in the Russian Museum surpasses the latter in the refinement of its execution and a certain nobility in its aspect. In all early Russian art, it is difficult to find a more inspired face in which the grace of the features and a profound sadness are so originally blended. This icon is the work of a consummate master who essentially assimilated all the refinements of Byzantine painting.

It is difficult to assign a precise date to the icons just considered. The *Ustyug Annunciation* may have been painted shortly after the dedication of the Cathedral of Saint George (1130 or 1140); but it is impossible to prove this since it was not the main icon of the church (on the contrary, that was the full-length icon of *Saint George*) and it may also have been acquired later. The pictorial style of the *Exaltation of the Cross,* represented on the reverse of the *Holy Face,* goes back to the end of the twelfth century. However, this does not guarantee that the image on the reverse of the icon was not executed after the one on front. The somewhat dubious stylistic analogies (for example, the similarity of the Angel's head with the mosaic of the Monreale Cathedral [Sicily]) do not help either. It would be very tempting to make this whole group of Byzantine-style icons go back to the studio of "Gretchine Petrovits," mentioned in the first *Chronicle of Novgorod* in 1197, but even here many obscure and debatable questions remain (for example M.K. Karger and E.S. Smirnov[56] are inclined to consider the term *Gretchine* ["Greek"] a proper name rather than an indication of nationality). Given the debate over the circumstances just presented, it is more prudent to date the group of icons just described between 1130 and the last decade of the twelfth century.

Even if we concede a large import of Greek icons to Novgorod, this art, so strongly Byzantine-like, also demands an explanation. It is helpful to recall the strong cultural relations which Novgorod maintained with Constantinople. Bishop Nifont, who had Grecophile tendencies, settled near "Tsargrad." In 1186, Alexis Comnenus, the nephew of the Byzantine Emperor Manuel Comnenus, arrived in Novgorod. In 1193 and 1229, there were influential Grecophile parties in Novgorod who wanted to have a Greek bishop. Novgorodians often made pilgrimages to Jerusalem, Constantinople, and Mount Athos. Finally, between the twelfth and thirteenth centuries, Dobrynya Yadreykovich, the future Archbishop Antonii, stayed in Constantinople. All these dynamic relationships provided the best channels through which Byzantine influences penetrated Novgorod. We only need to consider that in the twelfth century the princes of Novgorod were still engaging in cultural relations with Kiev, which for a long time remained a depository of Byzantine forms. Byzantine art was especially valued by the princely court and high clergy; but fascinated by its artistic language, a much larger segment of the population of Novgorod was also moved by its beauty.

This "Byzantinizing" tendency did not completely disappear in the thirteenth century even though it lost much of its purity. Another local trend was appearing, and under its influence, Byzantine forms started to be used in a freer way. The monumental *Dormition* from the *Dessiatina* [tenth] monastery Pl. 7 of Novgorod dates back to the beginning of the thirteenth century. The theme is rendered by an intricate iconographic scheme: in the upper part, the Archangel Michael brings the soul of the Mother of God to Heaven; underneath, four angels in flight are portrayed; and at the sides, the apostles hasten over the clouds to the Virgin's deathbed. All the other elements of the composition have a more traditional character. The masters who worked on this large icon combined imposing, monumental forms with a style which has the elegance of miniature painting. In comparison to Byzantine icons, where the figures of the apostles form lively and picturesque groups, in our image the composition is strictly subject to the flat surface of the panel. The apostles and bishops are drawn in two rows and the figures have completely lost their volume. The more "Greek-like" part of the icon is the group to the right with the faces in the later "Comnenian" style. The faces of the group to the left are softer and more impersonal and the Greek likeness is less evident. The head of the apostle bending over Mary's

body and attentively observing her face is particularly well done. The slightly rigid structure; the dense, thick colors, not at all harmonious; the marked flatness of the composition and of the individual figures; the unsteady position of the feet: everything suggests the work of Novgorodian masters in whose hands Byzantine forms began to undergo more substantial alterations than the ones already observed in twelfth-century icons.

PL. 8 The icon of the *Virgin of Tenderness* in the Cathedral of the Dormition in the Moscow Kremlin has several points in common with the *Dormition*, especially the right side. This *Virgin of Tenderness*, reproducing the Byzantine prototype, was recently discovered. We find unusual details in the icon: the position of the fingers of Christ's left hand is vague; the dark veil over Mary's head is short, reaching only to the shoulders; the edge of the Child's garment almost seems to be fluttering. A Byzantine master would never have allowed similar deviations from the rules, but while following quite exactly the strict Byzantine type with the faces, the Novgorod master felt freer with the rest of the composition. It seems as if the iconographer had artfully combined two different iconographic types, the Virgin Hodegetria and the Virgin of Tenderness, in this work. Apart from his head resting on his Mother's cheek, Christ is pictured in the typical pose of the Hodegetria icons: holding the scroll in one hand and, with the other, making a gesture of blessing. But by placing the scroll in Christ's right hand, the artist could not represent the left hand in the gesture of blessing and was forced to leave the fingers open, as was usually done in the Tenderness icons where Christ's left hand stretches toward the neck of the Virgin. This sort of "contamination" among diverse iconographic types is another element suggesting the work of a local master who, unlike the Byzantines, was not used to copying prototypes with precision.

PL. 9 The author of the wonderful icon *Saint Nicholas the Wonderworker* (Tretyakov Gallery) went even further. The saint is blessing with his right hand and holding the Evangeliary in his left. The facial expression is unusually austere: in front of us we have the severe, intransigent, and unfriendly Byzantine theologian. The author of the icon openly imitated Byzantine models from which he grasped the spirit in depth, but the changes which he introduced into the work are even more interesting. To obtain greater expressiveness, the artist gave the head a flattened and elongated shape, curved the eyebrows making them two lines with acute angles, accentuated the hollow of the cheeks, increased the number of wrinkles, and drew an exceedingly high forehead free of hair. With their innate sense of harmony, Constantinople masters would never have so boldly broken with Hellenistic tradition.[57] But the Novgorod master could calmly take this liberty since that Hellenistic tradition, already adapted by usage, had not reached him directly. Hence, the artist was able to create a unique image which does not look like any of the Byzantine icons that have come down to us.

In keeping with his aesthetic principles, the artist chose somber, dark colors: the reddish brown garment with silver *assiste* (the hatching of light, usually done in gold), the silvery background, the olive flesh tone. The wrinkles are marked by a reddish tan color which also muffles all the shadows. In this thoughtfully prepared palette, we recognize a high degree of coloristic refinement. The images on the borders of the icon are done in a totally different chromatic range: characterized by bright areas on the white background, the figures in the margins are painted in a free and light style. Since the painter of the figures did not have an iconographic model at hand, he was evidently less inhibited. In the garments, he boldly combined tones of cinnabar, lemon yellow, deep azure, blue, and dark cherry red. Even in this case, we are dealing with a typically Novgorodian concept of colors. It is precisely in these small representations that there appeared stylistic features which would immediately predominate in Novgorodian iconography: the audacious separation from traditional Byzantine canons toward a greater brightness of images, a forceful and free painting style, a pure chromatic range, and striking colors.

In Novgorodian painting of the thirteenth century, two other icons, from Belozersk, are linked
PL. 10 to the Byzantine style. In one, the Apostles Peter and Paul are represented in full-length, and in the
PL. 11 other, the Virgin of Tenderness is shown surrounded by medallions with the busts of angels and saints.

Although the first one shows some stylistic affinity with the *Dormition* from the Dessiatina Monastery, it still maintains a varied range of light, pale, and diaphanous colors. The figures of the apostles are in a strictly frontal position, different from the freer poses which we find in the eleventh-century icon from the Cathedral of Saint Sophia. The *Virgin of Tenderness* is painted on a silver background with which the red clouds make a sharp contrast. The border of the icon is blue and the backgrounds of the medallions are rose and azure. This matching of colors alone already indicates the distancing from Byzantine tradition, and it is also evidenced by the flattening of the figures and the accentuation of the emphasis on line. The Virgin's sad face has a touch of uncommon intimacy which will become typical of Russian icons devoted to that theme.

The Byzantinizing trend in Novgorodian iconography reached its apex in the twelfth century. It still survived in the thirteenth, but as we have seen, was already beginning to undergo transformations. This accentuation of local features was certainly also determined by the general state of affairs which developed in Novgorod: the princes' position was becoming more and more unstable while that of the governors, opposed to the princes and defending the local boyars' interests, was being consolidated; merchants and artisans had a growing influence and frequently dictated laws in the *vetche* [the popular assembly in early Rus]; and in 1165, the bishops of Novgorod started to be called archbishops. Right after all these changes, a series of substantial transformations also occurred in Novgorodian art. The changes involved a gradual distancing from the Byzantine-Kievan traditions, which led to a crystallization of stylistic variants. Such a process also had an impact on iconography.

This new tendency developed alongside the Byzantine trend, reflecting more precisely the preferences of the princely courts and the ecclesiastical hierarchy. Having emerged in the first half of the twelfth century, it was at first limited to influencing the works of masters of the Byzantine trend, only to absorb it completely later on. Its most brilliant example may be the two-sided icon of the *Virgin of the Sign,* which, according to legend, played a role in the defense of Novgorod against the siege of PL. 12 Suzdal troops in 1169. A somewhat unusual composition is represented on the back of the icon: the Apostle Peter and the Martyr Natalya, both interceding with Christ. The figures are short of stature, with large heads. The nimble and picturesque style recalls slightly the fresco technique. The artist firmly brushed clear lines and small areas on the flesh tone without much concern about shading. The artisanship of the faces shows a softening of Byzantine rigor, leaving room for a greater intimacy in the images. Moreover, the faces present physical features that are clearly Russian.

This tendency was rapidly reinforced in the thirteenth century when relations with Southern Rus and Constantinople were almost completely interrupted after the Tartar invasions. And if echoes of the Byzantinizing trend of the twelfth century still resonate in a few works, they are no longer the determining factor. In this regard, the Russian Museum's icon of *Saint Nicholas the Wonderworker,* painted PL. 13 around the middle of the thirteenth century, is especially interesting. Its author certainly knew the iconography of the previous century to perfection. The saint's face still retains much of the Byzantine severity, but in this interpretation there is something new, the sign of an imminent development, for example, of the principle of the ornamental line (first of all to emphasize the wrinkles of the skin and locks of the hair). The lines seem almost imprinted on the surface of the panel, as if engraved. Byzantine masters would never have executed such a profound study of form. The coloring has few of the Byzantine characteristics, with its contrasts between light and showy colors. The partially trimmed figures of saints on the border (among whom Simeon Stylites, Boris and Gleb can be recognized), the bust figures in the upper part of the icon (the Archangels Michael and Gabriel) and in the medallions (Anastasius, Anicet, Paul, Catherine) are painted with naturalness and their expression is much sweeter than Nicholas'. It is especially in these small figures that the distancing from Byzantine models most clearly stands out.

The popular style, characterized by its preference for simpler and more primitive forms, began to emerge in the thirteenth century. The Byzantine heritage was subjected to such a drastic revision that strictly speaking, all that is left is the iconographic framework. Thus, on the two-sided icon of the *Virgin*

PL. 14 *of the Sign,* not executed before the thirteenth century, the figure of the *Martyr Juliana* on the back is marked by traits so obviously archaic that they remind us of works from the faraway Byzantine periphery. The facial lines are simplified to the extreme; the pleats of the clothing have been transformed into lines of a purely ornamental character serving to mask rather than to reveal the forms of the body concealed behind the garment. Without volume, standing against the red background, the figure remains a silhouette filled with that primitive force which is lacking in the fine spirituality of twelfth-century icons.

PL. 15 A kind of rebellion against the Byzantine tradition is also clearly seen in a large icon with a red background from the Russian Museum, with the full-length images of Saints John Climacus, George, and Blaise. The three are portrayed in motionless, rigid poses recalling idols painted on wood. John Climacus is two and a half times taller than the saints at his side, a choice probably dictated by the person or persons requesting the icon. In the same way as in the icon of Saint George in the Cathedral of the Dormition, here George is also holding the sword prominently. The entire composition, with its linear development, is projected on one plane. There is not the faintest trace of volume in the figures. The artist spread the colors in large uniform areas, without resorting to chiaroscuro modeling. The facial types, strongly reminiscent of the images in the Nereditsa church, are already typically Russian. Touches of white are applied on the flesh tone to form fine and distinct lines. These are the first signs of that painting technique which will anticipate "vivid strokes" and "characters." As a whole, the icon fascinates us by its striking coloring and the nuances of ingenuous simplicity, characteristic of many works of Novgorod painting.

PL. 16 Also dating from the last third of the thirteenth century are the royal doors, the earliest of those preserved in Russia, kept at the Tretyakov Gallery. The royal doors were at the center of the sanctuary partition and gave onto the presbytery *(altar)*. As a rule, they were decorated with the scene of the Annunciation and figures of the apostles or Fathers of the Church.

Only a few fragments of the *Annunciation* and the image of Basil the Great in full-length are preserved from the original painting on the Tretyakov doors. Here the figures are also completely flat; the uniform surfaces of colors are divided by fine lines drawn with a firm hand. The artist resorted to the clear contrast of dark and light colors, obtaining a special vibrancy; a white background was laid down in the upper part and a red one in the lower part; the white, red, lemon yellow, and emerald green colors contrast with the dark cherry red, dark olive, indigo gray, and black tones. The typical Novgorodian style clearly shines through in the terseness of the drawing and the resonance of the colors.

PL. 17 The series of Novgorodian icons from the thirteenth century concludes with a large image of *Saint Nicholas,* which preserves the 1556 inscription, the year in which it was "restored." This inscription refers to a text and an earlier, lost inscription according to which the icon was painted in 1294 by a certain Aleksa Petrov "in honor and in glory of Saint Nicholas." At Nicholas' sides, Christ and the Virgin are represented on a smaller scale. The border is adorned by figures of the Novgorodians' favorite saints and by busts of archangels and apostles on a still smaller scale. These busts are found on the two sides of the Hetoimasia [seat of the Last Judgment]. Saint Nicholas appears here as the patron of the person ordering the icon. His name (Nicholas Vasilevich) is mentioned in the inscription. The saint has lost the severity of the intransigent Father of the Church. We have in front of us a good Russian bishop, ready to help his protégé. The linear work of the rounded face is simplified, revealing the artist's preference for symmetrical forms and slightly parabolic lines. All this confers on the image an emotional vibrancy totally different from Byzantine icons. The abundance of ornamental motifs is also unusual in Byzantine icons. The bishop's vestments are decorated as if the artist had imitated popular embroidery. Even the halo is decorated with a very fine ornamental motif. This type of work reveals a very ingenuous insight of an almost rustic simplicity.

The early icons of Novgorod give us the most complete idea of the development of Russian painting from the eleventh to thirteenth centuries. With them as examples, the process of gradual distancing from Byzantine traditions and those traditions' transformations can be clearly followed. But unfortunately, the earliest icons from other artistic centers do not allow us to reconstruct a similarly

organized picture. Most of the time, it is a question of individual masterpieces which happened to survive. But they do not form a continuous line of development and it is most difficult to arrange them into very precise stylistic groups. The starting point for the formation of an iconographic style in these artistic centers was probably the Kievan legacy, which in the history of Russian art, had almost the same importance as the Carolingian period of the Middle Ages in the West.

Starting with the second half of the twelfth century, the city of Vladimir, consolidated by Prince Andrei Bogolyubskii (1160–1175) to counterbalance the importance of Rostov and Suzdal, was for Kiev an adversary to be feared. Andrei expanded and enriched his favorite city with buildings, raising a large residence, the famous Bogolyubovo Palace, in the surroundings; he also had a series of churches built, finished later by his brother Vsevolod Big Nest. Naturally, such fervid activity in the construction of sacred buildings also enriched the iconographic work which was to adorn the new churches. When Andrei Bogolyubskii left the paternal principality of Kiev to move to his native region of Suzdal, he took with him the most venerated Byzantine icon of the *Virgin of Tenderness (Virgin of Vladimir)* and installed it in the Vladimir Cathedral of the Dormition, richly adorning it with gold, silver, precious stones, and pearls. Andrei Bogolyubskii would always take this icon along with him on his military campaigns and he attributed all his successes and victories to it. There is another icon also associated with Andrei. Today it is kept in the Vladimir Museum, but unfortunately, it is in very bad condition. According to an old tradition, this icon, known as the *Virgin of Bogolyubovo,* was painted in memory of a vision the prince had in a dream (in 1158).[58] The icon represents Mary in the *Agiosoritissa* style:[59] she is holding the scroll in one hand while the other is raised in a gesture of prayer toward Christ, shown as a bust in the upper right of the icon. In the upper part of the panel, Christ, the Mother of God, John the Baptist, and two angels are depicted in half-length, part of a composition of a *Deesis* in half-length, undoubtedly inspired by the icons which normally decorated the epistle of the partition. Mary is the one interceding for the human race and for the person requesting the icon. It is therefore a votive image, and from what the preserved fragments suggest, the Bogolyubovo icon must have been an outstanding work of art, stylistically close to the *Virgin of Vladimir.*

Andrei Bogolyubskii's successor, Vsevolod Big Nest (1176–1212) had a profound knowledge of Byzantine culture. He had spent his youthful years in Constantinople, where he learned to appreciate the beauty of worship and Byzantine art. It is no coincidence that he invited masters from Constantinople to fresco the Cathedral of Saint Demetrius, which he had built. The icon with an unusually elongated form, which certainly decorated the partition of the sanctuary, may have been painted in their studio. The youthful Christ (Emmanuel) is represented between two angels whose heads are slightly PL. 18 turned toward him. Their fine, elegant faces express a profound sadness, as if they were inspired by the image of the *Virgin of Vladimir.* This kind of *Deesis,* together with the earliest icons of Novgorod, is listed in the group of the most strongly Byzantine works of Russian panel painting from the twelfth century. The borders without *levkas* suggest that at that time, they were designed to support an embossed silver cover which framed the image. This sort of cornice, covering only the icon's borders, appears to have been much in use in early icons, whereas later on, it started to be replaced by a more economical pictorial decoration.

Another *Deesis,* representing Christ between the Mother of God and John the Baptist, was proba- PL. 19 bly also executed in Vladimir. From an artistic point of view, it is quite inferior to the icon of *Christ Emmanuel with Angels,* but it was also intended to embellish the partition of the sanctuary. Here, the faces do not have that fine spirituality; their execution betrays the hand of a much less skilled master who followed rather archaic traditions. The style of this icon, probably done at the beginning of the thirteenth century, is somewhat isolated among the works of early Russian painting.

Oral tradition links the monumental icon of *Saint Demetrius of Thessalonica* (Tretyakov Gallery) to PL. 20 Vsevolod Big Nest. Unfortunately the icon has been quite damaged by the years. The best preserved part is the face with its fascinating expression of solemn nobility. The eyes, eyebrows, nose, mustache, mouth, and oval of the face are sketched with heavy lines superimposed over the greenish white flesh

tone with thick green shadows. These lines are so symmetrical that their rigid balance almost constitutes a heraldic composition. The artist evidently wanted to highlight the warrior's strength of mind and courage. His monumental and serene figure is forceful. A profound inner concentration is perceived in the gesture of the right hand unsheathing the sword. The enormous dimensions of the icon suggest that it belonged to the type of wall or pillar icons which were placed in shrines along the north and south walls of the church and near the east pillars supporting the dome. These large icons almost always show saints venerated locally. On feast days, these icons were adorned with veils made of multicolored precious fabrics.

Another icon, the *Virgin Maksimovskaya*, is also from Vladimir. Unfortunately, it is in very bad condition and has been crudely restored recently. At one time, the image was in the Cathedral of the Dormition in Vladimir, on the tomb of Metropolitan Maksim.[60] As can be read on the tomb's inscription, the icon was painted in remembrance of the "vision" Maksim had in 1299 when he decided to transfer the metropolitan cathedral of Kiev to Vladimir. The Mother of God with the Child is portrayed standing in the style of the Hodegetria. At her feet on a platform is Metropolitan Maksim, who is receiving the *omophorion* [a long scarf worn by bishops] from her hands. In Vladimir, as in other cities, icons were probably painted in studios attached to the princely court or episcopal palace and, at the end of the thirteenth century, to the metropolitan palace.

With the decentralization of the culture, associated with the expanding fragmentation of feudal society in the course of the thirteenth century, the cities of the Vladimir-Suzdal territory acquired an ever greater importance, and local artistic studios began to be established whose flourishing was cut off by the Tartar invasion. Located far from Vladimir, these studios developed quite autonomously. They paid less attention to the canons inherited from Byzantium and mostly drew on popular traditions. Thanks to this, their art communicates at times a great freshness and expressive spontaneity.

One of the greatest artistic centers of the Vladimir-Suzdal territory was definitely Yaroslav. The first rise of this city coincides with the principality of Konstantin Vsevolodovich (1207–1218). In 1218, Yaroslav became the center of an autonomous principality, the capital of the independent principality of Yaroslav. From that time on, its jurisdiction extended to Uglich, Mologa, and the lands beyond the Volga as far as Lake Kuben. In the second decade of the century, many churches were built in Yaroslav: in 1215, the foundations of the masonry Cathedral of the Dormition of the Virgin (consecrated in 1219) were laid. The year 1216 saw the beginning of construction on the Church of the Savior in the Monastery of the Savior of the Transfiguration (consecrated on August 6, 1224, by Bishop Cyril of Rostov). Also in 1216, the Church of the Archangel Michael was consecrated. The construction of Saint Peter's Monastery for men with the adjoining school (the latter being transferred to Rostov in 1214) also goes back to the principality of Konstantin Vsevolodovich. Such dynamic activity in the area of religious architecture must have necessarily promoted the development of a local painting school since the new churches had to be decorated with frescoes and icons. Yaroslav may have invited artists from Rostov, where the episcopal cathedral with its studios was located. Unfortunately, not a single early icon from that city has come down to us.

Some thirteenth-century icons of excellent quality from Yaroslav allow us to group other stylistically similar works around them. A freer and more natural painting style with smoother colors characterize the group. Russian features appear more clearly. These icons are more vivid and joyful than those of the twelfth century. The artists who painted them show their extraordinary love for decoration which, at times, runs the risk of being overdone.

Among the Yaroslav icons, the foremost place belongs to the imposing image of the *Virgin Orant* with the medallion of the Savior Emmanuel on her breast (Tretyakov Gallery). In Rus, this iconic type PL. 21 was called the *Virgin of the Sign* (but its more accurate name is *Great Panagia*). As N.P. Kondakov has shown, it goes back to the venerated image from the Blachernae Church in Constantinople,[61] which circulated into Rus no later than the twelfth century; but Kievan Rus maintained a preference for the image of the Virgin Orant without the Emmanuel medallion. Because of their solemn and monu-

mental character, with the accentuated central axis and the strictly symmetrical structure of the composition, the icons of the Virgin of the Sign were very appropriate for purposes of worship. In contemplating such majestic and severe images, the indissoluble link between Christ and the Mother of God was made particularly evident. In the *Virgin of the Sign,* the Yaroslav master distanced himself considerably from the Greek prototype, first of all by simplifying the linear system. In place of the Byzantine icons' gold lines, fine as a spiderweb, the artist used a great deal of golden highlights spread over the intense azure of the garment and left the sketch quite imprecise: the folds of the garment, especially over the waist and abdomen, are somewhat vague; the feet are turned too far to the right; the hands are small and out of proportion; and besides, the left oversleeve is too wide. The garment is richly decorated; the fabric of the *maphorion,* which frames the face, is dotted with a motif imitating pearls, and three plates are attached to it by precious stones; Mary's oversleeves are covered with dots, among which we see some little circles surrounded by more dots; the neck of Christ's garment is embroidered with a fanciful pattern. In this love for decorative ornamentation, we glimpse the constant leaning toward "arabesque" motifs which the Russians loved so much. The icon's showy, cheerful colors are a combination of azure, red, and brick red tones placed near the traditional gold and white (the halos, the archangels' *loros* and spheres, the outline of the medallions, and the icon's central section), which are used with a profusion not ordinarily found in the Byzantine palette. They are very indicative of the iconographic licenses taken by the artist of the *Virgin of the Sign.* Christ hardly looks like the severe judge of the universe in the Byzantine icons. Although he is portrayed in a gesture of blessing, we almost have the impression that he is extending his arms in a sign of greeting the observer. Moreover, his hands escape the edges of the medallion, stressing even more the forward movement of his figure. Byzantine artists would never have allowed themselves to violate the closed line of the border so boldly. But deviation from the canon did not embarrass the Russian master at all, and in this way the artist gave the Child's figure a nuance of unusual liveliness.

The painter of the Yaroslav icon was certainly familiar with the frescoes in the Vladimir Cathedral of Saint Demetrius, from which he obtained the models for his magnificent angels, painted with great naturalness and expressiveness. The faces of the Virgin and Christ are executed in another more uniform and precise style going back to the classical traditions of the twelfth century. Here, the ocher flesh tone is greatly lightened and made up of six to seven layers of colors spread over a solid greenish *sankir.*

The *Great Panagia* may be likened to the *Savior with Golden Hair,* which is in the Cathedral of PL. 22 the Dormition in Moscow. Its numerous lacunae render the face visibly flattened, and the further intensification of the decorative elements and lightening of color are immediately perceptible. Wherever it was possible, the artist introduced golden ornaments, like the medallions and circles outlined with pearls, especially in the background, on the arms of the cross within the halo, and on the chiton and himation. The edge of the chiton is also richly adorned and its design exhibits many similarities to the decorations on the neck of Christ's clothing in the *Great Panagia* icon. In the choice of colors, the artist showed his preference for pure colors: the light azure green background is near the white borders, which have red inside edges and black inscriptions; the brilliant green of the cross in the halo is framed with gold and outlined in cinnabar until it leaves the outer edge of the icon. Near these showy, heterogeneous hues, the dark blue cloak merges completely into the background. The unique element of this icon, from which it derives its name, is Christ's golden hair separated by very fine chestnut lines. Normally, the hair is painted with brown pigment over which gold hatching is applied.

In 1237, along with many other cities, Yaroslav suffered the Tartar assault, but it was not destroyed and was able to recover fairly rapidly. Under Prince Fyodor Rostislavich the Black (1259–1299), astute in negotiations with the Golden Horde, economic and cultural life experienced a new flourishing. An excellent example of Yaroslav painting, the icon of the *Savior* (Fine Arts Museum of Yaroslav) PL. 23 dates from the middle of the thirteenth century. Oral tradition places this icon in the years when Yaroslav was governed by Princes Vasilii Vsevolodovich (1238–1249) and Konstantin Vsevolodovich (1249–1257), relating it directly to them as a devotional image, perhaps because it was found near

their tombs. As a whole, the style of the icon does not contradict this date. As I.E. Grabar observed, the icon "has nothing of the gaudy Novgorodian vividness, painted as it is in a style that is muted, dream-like, and unassuming, but very refined, with a great sense of form."[62] The Savior's kind, typically Russian face, with its large eyes, has lost all trace of harshness and is marked by a captivating expression of intimacy.

PL. 24 Three other early icons are from Yaroslav: the *Archangel Michael,* the large icon of the *Virgin of Tolga* and the small *Virgin of Tolga.* The first image was in the Church of the Archangel Michael (on the Kotorosl River), built around 1299, and dates from the same period. The figure of the archangel, holding the *merilo* [scepter] and a medallion with a half-effaced image of the Savior Emmanuel, is represented in a strictly frontal and solemn position, the rapt face totally devoid of aggressiveness. The archangel is wearing imperial clothing, the *loros* studded with precious stones and the dalmatic richly adorned with stylized plant decorations which may be attributed to the predilection of the Yaroslav master. The icon's dazzling colors recall the bright tones of Yaroslav frescoes from a later period. The *sankir* of the face is a bright yellow over which the pink of the cheeks has been spread.

PL. 25 The two icons of the *Virgin of Tolga* were in the Tolga monastery near Yaroslav, hence the name given to them. In the larger icon *(the Tolgskaya I),* Mary is shown full-length, seated on the throne. Christ is sitting on her left knee, with his arms around his mother's neck, and eagerly pressing against her cheek. In the Tolga icon, we have a complex type of the Virgin of Tenderness characterized by an unusual spontaneity of expression. It is perhaps one of the thirteenth-century icons with the greatest emotional pathos. Even though it lacks a refined aristocratic character, its sincere warmth makes it fascinating. The slightly dark coloring is built upon a tonal combination of dark cherry, rose, dark azure, yellowish brown, and emerald green, in subtle harmony with the silver background. The same colors reappear in the ornamental parts of the clothing and in the precious stones of the cushion and throne. Strong highlights giving the face a more marked relief are applied over the dark flesh tone — under the eyes, around the mouth, on the nose, and above the eyebrows. The abundant use of ornamental elements is a typical characteristic of the Yaroslav style. Ph. Schweinfurt[63] attributed this icon to an Italian master of the Pisan school: it is difficult to imagine a more groundless hypothesis. Even though the icon of the *Virgin of Tolga* recalls Italian works of the thirteenth century in the affective intensity of its forms, there is nothing Italian in it, nor indeed anything Western. The similarities to Italian icons of the Duecento can be much more easily explained, both the Italian masters and those Russians drew from the same source, namely, the Byzantine painting of the late twelfth and the thirteenth century, from which they assimilated all the fundamental iconographic types of the Virgin. The more probable date for the Tolga icon would be the last quarter of the thirteenth century. It was probably transferred to the Tolga Monastery, established in 1314, when the icon was already old and venerated.

PL. 26 The small icon of the *Virgin of Tolga (Tolgskaya II)* dates from 1314, the year tradition places its miraculous appearance to Bishop Trifon of Rostov (Prochor, in the world).[64] The icon's style merely confirms this date. The *Tolgskaya II* is a reduced version of the *Tolgskaya I,* in which the Mother of God is depicted half-length and Christ is not standing but seated. As a result, the position of Mary's arms changes, perhaps inspired by the famous icon of the *Virgin of Vladimir.* The faces and pictorial manner have also changed. With the straight lines, Mary's face takes on a more sorrowful expression and the style has become more pictorial and richer. The powerful white strokes of lightening on the forehead and neck and under the eyes, nose, and chin blend with the highlighting spots applied lightly and naturally. If the transitions from lighted points to shadowy points appear gradual, "shaded," in the large *Tolgskaya,* in the smaller icon these boundaries are sketched more abruptly and the highlights become more intense and dynamic. The advent of a new period is already dawning.

The number of early Russian icons preserved until our time is so small and their assortment is so fortuitous that it would be very risky to attempt to reconstruct other iconographic schools. Almost nothing is left of Kievan panel painting and we know nothing about early iconography in Rostov and Moscow. There are no early examples of the "Northern Manners." But in all these cities and regions,

it is certain that icons were painted and there were iconographic studios. Nevertheless, as we have already observed, the presence of isolated studios is not equivalent to the idea of a school. Therefore, the assignment of the vast range of early icons we are dealing with to one school or another is totally relative and can easily be revised in the light of new findings and discoveries.

The icon of the *Virgin of Sven* (Tretyakov Gallery) is associated with Kiev. Tradition has it that it PL. 28 came from the Kiev Monastery of the Caves and recalls its "appearance" in 1218, when it was taken from Bransk to heal Prince Roman Michaylovich[65] from blindness. Seated on a high throne, the Mother of God is holding Jesus, in a gesture of blessing, on her knees. This iconographic type was very widespread in Byzantine painting (especially in monumental works where it is depicted above all in apsidal frescoes). The Greeks call it the *Platutevra*,[66] while N.P. Kondakov calls it *Virgin of Cyprus*.[67] In Rus, it is known as the *Virgin of the Caves*, after the famous "local" icon from the Monastery of the Caves which is lost.[68] This icon had miraculous attributes. Roman Michaylovich heard about them and asked the archimandrite of the monastery to send the venerated image to Bransk. In the Tretyakov Gallery icon, the founders of the monastery, Blessed Feodosii (to the left) and Blessed Antonii (to the right) are portrayed at the sides of the Virgin. They are both holding in their hands the unrolled scrolls whose inscriptions are lost or restored. The Virgin's face still retains much from the traditional Greek canon whereas the typically Russian faces of Feodosii and Antonii reveal a more lively and realistic concept of images. We have solid reason to suppose that the Kievan saints were not yet in the icon from the Monastery of the Caves. The iconographer gave the founders of the Monastery features so personal that their figures almost seem to be portraits. Stylistically, the icon occupies a special position among the earliest testimonies of Russian painting on panels. Its composition, lying flat on the surface, is very old; the design is vague and at times (especially in the Virgin's clothing) seems indistinct and nebulous; the figures' proportions have been somewhat altered. Painted in a natural style and on a large scale, the icon shows signs of a hasty execution: not wanting to part with their revered image, the monks of the Caves may have sent a copy hurriedly done to Prince Roman Michaylovich.

Even more obscure is the place of early Muscovite icons. Moscow was among the first cities to recover from the tremendous blow inflicted by the Tartars and took the place of Vladimir, which would not rise again. Unfortunately, we know nothing about Muscovite painting of the twelfth and thirteenth centuries. We can only suppose that already in the thirteenth century, Moscow had its own architects and painters who probably painted icons very similar to those done in Vladimir, Rostov, and Yaroslav. An icon from this group that tradition associates with the figure of Moscow Prince Michail Yaroslavich Choroborit (mentioned in the years 1238–1248) was probably executed in Moscow. The PL. 27 icon depicts the Archangel Michael in a strictly frontal position with Joshua kneeling. The archangel, as patron of the prince and of the military class, is represented in a martial pose, with the sheath in his left hand and the sword in his right. The dense, dark coloring of the icon is significant; it clearly imitates precious enamel. The thick golden hatching on the coat of mail and wings as well as the golden ornamentation on the cloak, leggings, and tunic give a particular elegance to this icon, in which a triumphant solemnity is combined in an original way with the profound spirituality of the severe face inspired by twelfth-century traditions.

An icon which has recently been discovered helps to shed light on the art of the northern Russian regions from which we know only later works. There were only hypotheses about the artistic activity taking place in those territories in the thirteenth century. But the cleaning of the icon of the *Synaxis of the Archangels* unexpectedly lifted the very veil from the early art of the North, that same North PL. 29 which will become the final custodian of the artistic heritage of rural Rus.

Northern Rus is generally identified with the vast territory which extends from the borders of Karelia to the Ural Mountains and from the shores of the White Sea to the lands distributed along the watersheds of rivers flowing into the Arctic Ocean and along the Volga River. Originally inhabited by Finno-Ugric peoples, this very vast territory was gradually colonized by the Slavs. That process began in the eleventh century, and toward the end of the twelfth, most of the northern territories were

already dependent on Novgorod and Rostov. Icons were sent to the North by eparchial centers, especially for very solemn occasions, such as the dedication of a new church. We know from documented sources that in 1290, Prince Dmitrii Vasilevich sent from Rostov to the Cathedral of the Dormition in Velikii Ustyug a bell and an icon of the Virgin Hodegetria which became the main object of veneration in the church and the patroness of the city. From approximately the same period, similar testimonies are preserved on the sending of illuminated manuscripts from Novgorod to a church on the Northern Dvina.[69] Artists coming from Novgorod and Rostov especially went north, although local iconographers also worked there. One of them painted the *Virgin of Kuben* (Vologda Regional Ethnographic Museum) in a somewhat primitive style.[70] Here Mary is portrayed in the style of the Virgin of Tenderness; the flesh tone has a white shade, the facial features are accentuated and heavy. The execution of the *Synaxis of the Archangels* (Russian Museum) is incomparably better. In many ways, its style already anticipates the later works in the "Northern Manners."

The archangels, shown in a strictly frontal position, have the *ripidion* [ceremonial fan] and a medallion with the bust of Christ Emmanuel. This round shield goes back to the traditions of ancient *imagines clipeatae*.[71] N.P. Kondakov interpreted it as the symbol of the veneration of images, restored after the iconoclastic period,[72] since these *imagines clipeatae* often hold miniature portraits of the defenders of orthodoxy. But even if this interpretation is correct, it is only partially true because the idea underlying this iconographic type is deeper, since this theme is seen only in works of the post-iconoclastic period. What is symbolically reproduced here is the Incarnation of the Divine Word, that is, the Child mentioned in the Gospel of Matthew (1:18-25, see Isa 7:14). An incipient form of the *Synaxis of the Archangels* is already found in a miniature in the *Evangeliary of Echternach,* preserved in the treasury of the Trier Cathedral (codex 61, folio 9, about 730).[73] Here, however, the archangels are on the sides of a platform with a tablet which bears a Latin inscription referring to the Gospel of Matthew. The archangels hold this tablet as later they will hold the medallion with the Savior Emmanuel. In the icon in the Russian Museum, the Synaxis of the Archangels has now acquired its complete form, characteristic of Byzantine art from the post-iconoclastic period.

Stylistically, the *Synaxis of the Archangels* does not look like any other extant early Russian icon. Its colors are totally unique, almost attenuated. The dense azure background is combined with a dark cherry and dark brown tonality. In this context, the red does not appear in all its force, and as a whole, the coloring is rather dark. But this darkened aspect has something unique about it, distinct from what we find in twelfth-century icons. There, the colors are flamboyant, even when dark. Here, they seem to be screened from our view. This impression is caused partly by an overly fluid pictorial style. The pigments are applied in such fine layers that they remind us of the watercolor technique. In certain areas, such as on the clothing, the retouching is visible in the light. These methods are radically different from the solid and fluid modeling of twelfth-century icons and they make the form flatter and more immaterial. In this pictorial style, it is not difficult to observe a qualitative deterioration of the mature Byzantine iconographic technique which came to Rus in the eleventh century, but at the same time, a new characteristic is also manifested. The execution becomes freer and is ruled less by canons; the upper layer of colors takes on an unusual fluidity due to the uneven spreading of the pigment. This pictorial tradition will be continued in the Pskov icons and in the later "Northern Manners."

In the icon of the *Synaxis of the Archangels,* there is a detail which indicates the infusion of popular tastes into iconography: the rich ornamentation decorating the ground. At first, an hypothesis was proposed claiming that it was a later addition; but as the icon was cleaned, it was ascertained that the ornamentation belonged to the original painting. Here the iconographer gave free rein to an ingenuous passion for "arabesques," audaciously violating all the traditional canons. The artist did not limit himself, like Byzantine artists, to a few shrubs but introduced floral motifs of supple little plants in bud, thus robbing the flat surface of the ground of its functional character.[74]

The Russian icons of the eleventh to thirteenth centuries do not form relatively different stylistic groups as in the case of the icons of the Italian Duecento.[75] This is due first of all to the meagerness

and fortuitousness of the works that have reached us, scattered besides over an enormous land. And yet, already in that first phase of development, when the iconographic style was still rather monolithic, the first outlines of the individual schools of Novgorod, Vladimir, and Yaroslav started to appear. Undoubtedly, Kiev also had its own iconographic school, but unfortunately, its works did not reach us.

In the earliest times, the main centers of artistic production were the studios near princely courts and archiepiscopal palaces, which had been able to assimilate Byzantine aesthetics more systematically. Almost all the icons we have mentioned until now came from these studios. They represent the first phase in the development of Russian painting on panels, still with a strong influence from Byzantium. The process of the crystallization of national features was only in its beginning. What we have tried to show in this chapter is that the development of this process was uneven and had multiple forms of expression.

The Novgorod School
and the "Northern Manners"

Because of the relatively scant development of its cities, Rus did not have as many iconographic schools as Western Europe. Moreover, for a long time Russian cities preserved a kind of patriarchal way of life and were closely associated with the surrounding rural population. Naturally, all of this is also reflected in their art by way of a reinforcement of the primitive component and obviously delayed the formation of individual schools with clearly expressed individual characteristics. If some have recently begun to speak of a plethora of schools in early Russian iconography, it is the result of the idle fancies of scholars who automatically transfer the categories of European art to the Russian artistic process, something which does not correspond to concrete historical reality. In Russian iconography of the fourteenth and fifteenth centuries, strictly speaking, there were but three great schools: Novgorod, Pskov, and Moscow. And especially in the more mature stages of their development, their works really display common traits typical of a single school. Neither Rostov, Suzdal, Tver, nor Nizhnii Novgorod ever gave rise to such important and large schools, even though there were several working studios in these cities. Concerning these secondary artistic centers, we can certainly say that each had its own group of iconographers who used a local dialect but they never succeeded in reaching the excellent artistic levels of the works of Novgorod, Pskov, and Moscow. Therefore, we will arrange our material according to the three principal schools. It is only in the last chapter that we will present a panoramic view of the principalities of Central Rus, artistic centers which never had a decisive role.

Having had the good fortune of escaping the Tartar invasion, Novgorod went through a period of great economic and cultural prosperity in the fourteenth and fifteenth centuries. This free city with a strong artisan class fostered extensive commercial relations overseas and a dynamic process of colonization in the vast northern territories, an inexhaustible source of wealth for the Novgorodians. Enterprising and determined, practical and efficient, they brought everywhere that spirit of private initiative which was especially reflected in their republican structure, with an elected governor at the head who limited the prince's power, with the archbishop chosen by "the entire city," and with the rowdy *veche* [legislative assembly], where the interests of the powerful class of the boyars and of the military clashed with the rich merchants, who were more and more often the donors of churches and the commissioners of icons.

The artistic legacy of the thirteenth century was enormously important for the Novgorodian iconography of the fourteenth. At a time when cultural and commercial relations with Byzantium were almost interrupted and, as a result, icons were not imported, it was of course easier to break away from Byzantine influence. This situation prepared the ground for a greater assimilation of popular motifs and forms. Thus, thirteenth century Novgorodian painting attained a more primitive, but at the same time, a richer and more varied style.

In Novgorod in the fourteenth century, frescoes were a more "Byzantinized" art than panel painting, drawing strong stimuli from the works of Greek masters passing through, two of whom are mentioned by name in the chronicles: "the Greek Isaiah and companions" who did the frescoes of the Church of the Entry into Jerusalem in 1338, and the famous artist, Theophanes the Greek, who decorated the Church of the Savior of the Transfiguration with frescoes in 1378. In comparing the fourteenth-century frescoes of Novgorod with the icons from the same period, we can observe how the local traditions were more firmly preserved in panel painting. Because of their low cost compared with frescoes, icons were a more popular art. Someone not particularly rich could order an icon, and even more so in the case of city corporations, which were becoming more and more important in Novgorod with the consolidation of the artisan class. Organized by districts, streets, groups of a hundred, according to trades, Novgorodians loved to order icons for the numerous wood and masonry churches which were springing up. This process had already started in the twelfth century, but it reached its full development only in the fourteenth. As we have seen, in the old days, the principal role belonged to the princely and archiepiscopal studios. Now, close to these appeared studios which served a growing circle of Novgorodians including the country people of the vast northern territories. In Novgorod, the production of icons "for export" quickly became a profitable profession and astute Novgorodians did not fail to draw their own conclusions. Having by this time lost their political weight and economic importance, at this stage the princes probably no longer had their own court studios and did not order the more expensive frescoes. They were replaced by the rich and powerful boyars. And if Novgorod's monumental painting remained within the orbit of the prescribed Byzantine canons during all of the fourteenth century, in icons, on the contrary, a new artistic language with clearly expressed local characteristics rapidly crystallized.

The panorama of Novgorodian iconography in the fourteenth century is extremely varied and contradictory. Relatively few icons have been preserved; they are, moreover, a completely random assortment, and so it is very difficult to reconstruct their development in a systematic way. The traditions of the previous century continued to make themselves felt for a long time, especially in the first half of the fourteenth century. This archaic tendency continued even into the second half of the century, and this is explained by the presence of studios serving various social classes in Novgorod. During the 1330s, examples of Palaeologan art reached Novgorod, but they did not have a determining function, although they influenced some icons. The decisive role, unlike for Moscow, did not belong to this Byzantine style but rather to the local current which was reinforced during the last quarter of the fourteenth century and crested at the turn of the century when the specific aspects of the Novgorodian pictorial school clearly emerged.

In the first half of the fourteenth century, artists were certainly still painting icons which were very archaic in their formal structure. Among them are works like the *Descent into Hell* (Novgorod Museum of History and Architecture),[76] *Saint Nicholas* on a red background (Hermitage),[77] *Saints Boris and Gleb* (Moscow Historical Museum),[78] and also two hagiographical icons in the Russian Museum, *Saint George* and *Saint Nicholas the Wonderworker*.[79] These icons do not display similar stylistic details, but they belong to a single trend which represents the oldest phase in the development of Novgorodian panel painting in the fourteenth century, still deeply rooted in the artistic culture of the previous period.

The appearance of hagiographical icons, brought from Byzantium to Rus, is of particular interest. The central part generally presented the full- or half-length figure of a saint, while the border scenes on the cornice showed episodes from the saint's life. The subjects of these scenes were often taken from apocryphal sources, which gave the artist a greater freedom of interpretation. Moreover, with the ongoing development of art in the fourteenth and fifteenth centuries, realistic elements began to enter these scenes (for example, architectural features and details of daily life). But a scene from a saint's life never became a mere genre scene. It always preserved the distance between the incorporeal and sensible worlds and the speculative principle was always present. The facts pictured for the person praying

before the icon unfolded in slow-motion, as if they were outside time and space. Furthermore, the scenes from the life are comparable to a kind of ideogram in that they allude to the pictured episodes rather than communicate in the circumstantial manner typical of mature realism.

The Russian Museum icons, painted at the beginning of the fourteenth century, belong precisely to the category of hagiographical icons. Their artistic language is extremely laconic; the architectural forms are reduced to a minimum with a predominance of clear colors and the juxtaposition of red and white which the Novgorodians were so fond of. The icon of *Saint Nicholas the Wonderworker* is painted in a very sweet style whereas the icon of *Saint George with Scenes from His Life* is executed in PL. 30 a much harsher, almost "show-bill" style. Several episodes of Saint George's martyrdom are depicted in the border scenes. The central part shows an elaborate variation of the miracle of Saint George with the dragon and princess Elisava (instead of Elizabeth!), her royal parents and a bishop watching from the tower. All the fundamental elements of this composition were already present in the famous twelfth-century fresco in the Church of Saint George in Staraya Ladoga. But that fantastic coloring, characteristic of the fresco, is even more accentuated in the icon with its contrasting proportions, figures which seem to hover in the air, and ingenuous narrative style. The princess seems like a puppet, and so does the dragon crawling tamely behind Elisava.[80] There is nothing martial about George: although he holds a lance in his left hand, he does not threaten anyone with it but carries it at lance-rest and gallops on his white steed toward the field to defend the sowing of the peasants.

The border scenes, which mostly represent various episodes of his martyrdom, are extremely expressive. George is quartered, beaten; they cover him with stones, make him get into a cauldron full of boiling water, saw his head off, and inflict countless tortures on him. The saint emerges from every adversity unscathed, and his face remains impassive as if he felt and experienced nothing. In this way, the Novgorod master represented the account of the martyr's heroism and did so in such a vivid and convincing manner that in spite of the ingenuousness of the painter's artistic language, each episode takes on a surprising concreteness.

The archaic current represented in the icons we have mentioned above was not the only one existing in Novgorod. Beside this there appeared in the 1330s a more advanced trend connected with the influx of examples of Palaeologan art. Already in the figures decorating the doors of Saint Basil, executed for the Cathedral of Saint Sophia in 1336 (preserved today in Alexandrov), we find new stylistic traits (more elongated and lighter figures, a greater dynamism, flowing garments).[81] Two years later, "the Greek Isaiah and his companions," who in 1338 painted the Church of the Entry into Jerusalem, came to Novgorod, as did another Greek painter forty years later, the talented Theophanes. All of this naturally inspired the Novgorodian artists to turn their creativity toward new experimentation.

It is quite probable that the three long panels from the iconostasis of the Cathedral of Saint Sophia, representing the *Twelve Feasts* (beginning with the *Annunciation* and concluding with the *Descent of the Holy Spirit* and the *Dormition*), are related to the studio referred to in the chronicle as that of "the Greek Isaiah."[82] This same chronicle states that in 1340 in Saint Sophia, some of the icons were burned in a fire and Archbishop Vasilii commissioned the painting of new icons for the following year.[83] According to V.V. Filatov's hypothesis, these icons would be the three panels with the *Feasts* which we just mentioned. These works are not first-rate; their composition is not very rhythmical, but to make up for this, they are chromatically rich, with an abundant use of gold and lapis lazuli blue. They are Greek-made, not Russian-made icons, as the coloring, the inscriptions, and the iconography demonstrate.[84] The *Feasts* of the Cathedral of Saint Sophia were probably the main source of the new "Palaeologan" motifs on which local artists could easily draw, something they certainly did. Theophanes the Greek's contribution must have been even richer and his art had a great impact on the Novgorodians. However, Palaeologan Byzantine art did not leave a profound mark on Novgorodian iconography, as it did on monumental painting.

We can attribute only the three Novgorodian icons painted between the middle and end of the fourteenth century to the Byzantinizing tendency: the *Apostle Thomas* on a red background, because PL. 31

the delicate features of the face and the draping of the garment present a similarity, not only to the frescoes of the Skovorodka Monastery near Novgorod (circa 1360), but also to the best Greek icons. Knowledge of these icons is also apparent in the great *Annunciation* (Novgorod Museum of History and Architecture) with its rather coarse and poor artisanship, even from the point of view of composition.[85] The small figure of Saint Theodore of Tiro is placed between the Archangel and the Virgin, undoubtedly introduced at the request of the person commissioning the icon because he was that person's patron saint. The design of the archangel's movement is inspired by the Greek icon in the Cathedral of Saint Sophia, but the Novgorodian master made the entire figure perfectly flat because he obviously did not understand the modeling of the body by means of the draping and thus moved definitely further away from the Greek prototype. The same flattened aspect is also found in the figure of Mary and especially in the throne which has lost any possible hint of volume. In a certain sense, we PL. 34 can also refer to the Byzantinizing trend in the icon of the *Virgin of Mercy* preserved in the Novgorod Museum. Even though its iconography, the stocky proportions of the figures, the intense coloring, and the spare composition are typically Russian, in the execution of the face, with its well-considered formation and audacious illumination, one can perceive a great familiarity either with Greek icons, or more likely with the strongly Byzantine influenced frescoes in the Church of the Nativity of the Virgin above the Graveyard. Since, judging by its size, the icon of the *Virgin of Mercy* must have been intended for a church, there are valid reasons for dating it 1339, the year the masonry church of the *Virgin of Mercy* was built in the Zverin Monastery, from which the icon came.

It would be more important to know which icons Theophanes the Greek painted during the ten years he spent in Novgorod. In fact, he certainly did not limit himself to producing monumental frescoes but also worked as an iconographer. Considering the powerful influence he had on local fresco painters (the frescoes of the church of Saint Theodore Stratilates and of the Dormition on the Volotovo battlefield), we can certainly infer that Novgorodian iconographers were trained in his studio. It PL. 32 is to them we owe the famous icon of the *Virgin of the Don* with the *Dormition* on its back. This *Dormition*, with its lean composition, similar to the Volotovo frescoes in its bold pictorial style, reveals a Novgorodian master's hand beyond any doubt. But we still do not know the author of this image: the same artist who painted the *Virgin and Child* on the front of the icon or another master. There are even questions concerning the icon's place of origin: Kolomna, Moscow, or Novgorod. If it came from Kolomna or Moscow, then the icon dates from the nineties; if from Novgorod, it dates from the eighties. Some also disagree about the name of its author. Some people, like I.E. Grabar, P.P. Muratov, and V.I. Antonova, attribute it to the brush of Theophanes the Greek. Others, like D.V. Ainalov and the author of this study, attribute it to a Russian artist. The opinion of L.I. Lifshits, who sees in the Virgin's image the hand of a Serbian master from a Moravian school and in the *Dormition* that of a Novgorodian painter, remains an isolated view. Such contradictory judgments are explained in part by the excellent artistic quality of the icon, which is far superior to the general level of fourteenth-century Novgorodian iconographic production. This is due to the fact that the icon came directly from Theophanes' studio and was executed by his closest and surely most gifted Novgorodian disciples. Theophanes brought it to Moscow, where the greatest number of copies of this icon are found.

The traditional *Virgin of Tenderness* is portrayed on the front. Mary's face looks very sad. The Mother of God seems to have a foreboding of her Son's tragic destiny. Yet, her face is not only sad but also reflects an inner serenity which gives a nuance of unusual sweetness, foreign to Byzantine icons on the same theme. This sweet and human expression is obtained through vibrant color with intense strokes of precious lapis lazuli and a wise use of light, rounded lines which are not at all harsh or impetuous. We need to observe attentively Mary's rhythmic profile, the outlines of the Child's and Mother's heads, which are almost perfect circles, the softly draped pleats of Christ's chiton and softly wavy edge of the *maphorion,* in order to understand the fine linear orchestration present here. In this icon, the daring asymmetry characterizing the Virgin's face is also typically Russian: her right cheek is much narrower than her left; her mouth is slightly turned to the right; her eyes and mouth are placed

on divergent instead of parallel axes. All of this intensifies the expression and vividness of the image. Byzantine masters, bound by classical canons, would never have taken the liberty of constructing the form with such freedom. As a rule, their designs show greater precision but less emotional expressiveness. The icon's general chromatic range, bright, dense, and saturated, stands out from the line of development of Novgorodian coloring, more luminous and brighter; but at the same time, it does not look like the typical range of the purely Byzantine icons of the fourteenth century, with their refined semitones. We are in the presence of a very original coloristic scheme which occupies an independent place in the history of painting from this period. The icon of the *Virgin of the Don* is a work as unique as the *Virgin of Vladimir* and the mosaic *Deesis* in Constantinople's Santa Sophia. It is an extraordinary work because of its artistic merit, apart from the fact it may be personally attributed to Theophanes or to his school.

The image on the back of the icon was executed by another master, more fiery and impetuous. In this interpretation, the presentation of the Dormition is completely different from other artists' versions, more intimate and spontaneous. The apostles are ordinary people; deeply moved and afflicted, they have come to render a final homage to their Master's Mother. A unique feeling of infinite sadness unites them, and it is so powerful that it blurs individual expressions, making each one share in a common, "universal" gesture. Attentively watching Mary's face, the apostles seem to be trying to imprint her features in their minds, conscious that they are looking upon the Mother of God for the last time. This spiritual sentiment is captured in a very truthful manner by the artist who, in depicting this episode, was probably inspired by some country funeral he had attended. It is significant that all the apostles are typical country people, not the aristocratic figures proper to the Byzantine style. The apostles' heads are magnificent pictorial details which are powerfully expressive, another testimony to the acute sense of observation and faithful memory with which this early Russian artist was endowed.

If there is something artificial in the picture on the front, with the fluid style of the flesh tone, the golden tonality of Christ's chiton, the intense lapis lazuli blue of the coif, sleeve, and scroll, and the golden clavus [band adorning the whole length of the cloak], the *Dormition* has a completely different chromatic range, darker and more dramatic. There is a predominance of deep azures, strong greens, hues of chocolate brown, boldly contrasted with shades of white, bright red, golden yellow, marine blue, and pale pink. The color is evenly applied with precise boundaries; the olive brown shadows on the faces are heavy, the lightening and highlighting very pronounced. The composition, in which all the marginal episodes, so valued by Serbian masters, are left out, is extremely spare, typical of that design technique so dear to Novgorodians. The distinctive simplification of the lines of the profiles and the figures in pure popular style, quite reminiscent of the frescoes of Volotovo, also bring Novgorod to mind. The artist of the *Dormition* was a faithful disciple of Theophanes the Greek, but interpreted the latter's language in an individual manner, giving rise to an unusual symbiosis in its originality.

In spite of the arrival of Theophanes the Greek in Novgorod, Novgorodians obstinately continued to follow their own tradition with unusual tenacity in the area of iconography, where Theophanes' style rapidly died out. This is why even at the end of the fourteenth century, there were still archaic works like the icon of *Saint Nicholas the Wonderworker with Scenes from His Life*, which take up the traditions PL. 33 of the first part of the century, or the small icon of *Boris and Gleb*,[86] or again the icon of *Saint George,* a very primitive handiwork.[87] It would seem that the crystallization of specifically Novgorodian traits in iconography started in the 1370s and 1380s, when a few recently discovered icons were painted: the *Descent into Hell* (Russian Museum), well designed with the groups of saints and mountains coun- PL. 35 terbalancing one another, and at the same time full of lively movement, and *Saints Boris and Gleb* from PL. 37 the Novgorod Museum (painted around 1377). Iconographically, this last is very similar to the Muscovite icon of the 1340s from the Cathedral of the Dormition (preserved today in the Tretyakov Gallery). But everything that bears the mark of the aristocratic style in the Muscovite icon is very simplified in the Novgorodian. The figures have lost their elegance, they have become stocky, their heads

are bigger; the large horses no longer prance but walk with a heavy step. Because of the less elongated shape of the panel, the mountains do not rise up but merely fill the lower part of the icon. Boris and Gleb ride as if they had just emerged from a coat of arms, such is their precision and almost heraldic finishing touches. The saints' faces are elaborated with great pictorial ease, inspired in part by the models of monumental art.

The happiest period in the history of Novgorodian iconography was probably the one bridging the fourteenth and early fifteenth centuries. In the icons of that period, colors take on a purity and resonance not known before. The palette becomes lighter and more luminous and the last traces of the dark tone of an earlier time disappear. The best traditions of thirteenth-century Novgorodian iconography flourish again. Fiery cinnabar becomes the favorite color, determining the joyful, bright aspect of the palette. This cinnabar is used in daring closeness to the gold background and with white, green, olive, soft pink, sky blue, deep cherry, and yellow pigments. Forms become simpler and more geometrical; their volume is reduced almost to zero; the main emphasis is placed on the profile. Preferred compositional patterns are worked out, easily understandable, brief and thin. There is an increase in icons representing a group of saints in a row, and at the same time the favorite model of the saint appears: strong, robust, rather sturdy figures with bent shoulders, almost round heads with fine features and typical small sloping noses. In the execution of faces, garments, and mountains, we find that studied methodology which will later become a canonized pictorial system. In icons from the late fourteenth and first half of the fifteenth century, there are no traces of aridity: they are painted in a light and free style, without effort, and herein lies their particular fascination. By this time, we no longer find that multiplicity of trends which characterized the iconography of the thirteenth and fourteenth centuries, that range of execution, of monumentality. All this is reflected especially in the sudden reduction in the size of icons (except those intended for iconostases). The pictorial style, having become more miniaturistic, with a more organic system of lightening and highlighting, confirms the victory of the iconographic principle. Echoes of Palaeologan painting, still felt in some icons of the previous century, are now almost gone, dissolved in a purely Novgorodian concept of forms, lines, and colors.

There is, among others, a significant monumental icon not only because it is an important work of art which helps to shed light on the style of Novgorodian iconography in the late fourteenth century, but also because it is a strong response to the heresy of the *strigolniki*, which came to Novgorod from Pskov in the last quarter of the century and of which the high ecclesiastical hierarchy was quite fearful. This icon, kept in the Tretyakov Gallery, represents the so-called *Paternitas*. The God of tradition is shown in an iconographic type known in Byzantium and Southern Serbia but not seen in Russian circles in previous periods. God the Father, seated on a curved throne, is wrapped in a white garment, a halo with a cross around his head. Seated on his knees is Christ Emmanuel, who is holding the disc with the dove, symbol of the Holy Spirit, with both hands. Christ also has a halo with a cross. The footstool of the throne is surrounded by the "Thrones" (fiery wheels with eyes and wings). The seraphim are above the throne, and at the sides are two stylites, perhaps inspired by the fresco of Theophanes the Greek in the Church of the Savior of Transfiguration, where stylites are also depicted near the Trinity of the Old Testament.[88] In the lower right corner, we see a young apostle (Thomas or Philip) whose figure breaks the rigid symmetry of the composition. This individual can only be interpreted as the saint-protector of the person who commissioned the painting and wanted to have the saint depicted on his icon. The names of Thomas and Philip are often found in Novgorodian chronicles among names of governors, superintendents, and boyars. In view of the notable dimensions of the icon, it might be inferred that it was executed at the request of a rich and experienced purchaser. The icon's inscriptions irrefutably demonstrate that this person wanted to give a clear lesson to heretics who denied the equality and unity of the three Persons of the Trinity.

It is significant that among the icon's inscriptions, the term "Ancient of Days," normally used by the Greeks and Southern Slavs, is missing (with "Ancient of Days" referring to Christ since, in the view of Byzantine theologians, it was impossible to represent God the Father.) Near God the Father's head,

we read: *O(te)ts i Syn i s(vya)ty(i) Duch* (Father and Son and Holy Spirit). Therefore, the Ancient of Days already appears here as God the Father *representable,* a circumstance unacceptable to a strict Byzantine theologian. However, the artist introduced a small but substantial correction. Above the back of the throne is placed another inscription, *IC XC* [Greek abbreviation for "Jesus Christ"], by which the artist underlined the unity of the Persons of the Blessed Trinity, that is, the one and identical essence of God the Father and Son. But he did not stop there. Above the dove symbolizing the Holy Spirit, the painter once again put the name of the second Person of the Trinity (*IC XC*) to underscore one more time the one and identical essence of the second and third Persons. There is no doubt that with the help of the inscriptions, either the person commissioning the icon or the artist intended to defend the Trinity against the false doctrine spread by the heretical sect of the *strigolniki.* Thus, this work of Novgorodian iconography is an organic part of its living historical context which totally determined its complex intellectual content.

Since the footstool of the throne does not rest firmly on the ground but barely touches it, the throne and the seated figure seem to hover in the air, appearing to viewers like a miraculous vision. The figures of the stylites, whose columns are without any point of support, also contribute to the creation of this impression. Only the apostle with the same name as the person commissioning the icon is firmly placed on the ground. With these devices, the Novgorodian artist made the figure of God the Father, enveloped in white clothing, appear to be rising to heaven. With masterly ability, the iconographer controlled the contrast between this garment, white as snow, and the golden yellow colors of the background and borders. The reserved, reduced palette is entirely justified since it brings about the desired effect: an impression of solemn monumentality.

It is difficult to say what influence the heresy of the *strigolniki* exercised on the Novgorodians' religious feelings. Like the heresies of the twelfth and thirteenth centuries in Western Europe, the effect could have been a freer approach to religion. In any case, it was only from the second half of the fourteenth century on that Novgorodian religiosity took on individual characteristics so precise that they left a profound imprint on all iconographic works on panels, without a single exception. This religiosity was characterized by an ardent faith and a more personal approach to the controversies about religious dogmas. But at the same time, it was distinguished by its rational, not very metaphysical spirit. From here, it was easy to cross over to practical life. It systematically assimilated popular thoughts and feelings and was enlivened by a captivating sincerity and spontaneity. This is why Novgorod's religious art is so moving in its candid immediacy. Its bright and simple images are so concrete they seem to be the fruit of the lively imagination of the people themselves.

Popular taste is already clearly reflected in the choice of saints depicted in Novgorod icons. The most venerated saints were the Prophet Elijah, Saints George, Blaise, Florus and Laurus, Nicholas, Paraskeva Pyatnitsa, and Anastasia, considered as protectors of the peasants and ready to intercede to help them in their afflictions and needs. Elijah is the lord of thunder, providing rain for the peasants and preserving their homes from fire; Saint George, victorious over the dragon, is the lord of fields and keeper of flocks; white-haired Saint Blaise is the protector of animals, whereas Florus and Laurus are the saints of herds, protectors of horses, so valuable to farmers. The wise Nicholas the Wonderworker is the patron of carpenters, the favorite saint of travelers and the suffering, the protector from fires, which were a dreadful scourge in rural Rus. As protectresses of trade and of merchants, Paraskeva Pyatnitsa and Anastasia are well-loved saints in Novgorod.

The popular current insistently gained ground in icons painted between the end of the fourteenth and beginning of the fifteenth centuries, which are characterized by a profound stylistic unity. Perhaps in no other case does the direct link between the iconographic subject and real-life interests emerge as distinctly as in a Novgorod icon kept in the Historical Museum of Moscow. In the upper part, against PL. 38 the background of a rocky landscape, the icon shows Saints Blaise and Spyridon seated, and beneath them are the animals they protect: cows, bulls, goats, sheep, calves, and wild boars, in bright colors, red, orange, white, violet, sky blue, and green.

Blaise was a very popular saint in Novgorod. His veneration took shape under the influence of the cult of a local Slavic deity called Veles (or Volos) and of a legend from Byzantium.[89] John Geometres, a Greek writer of the tenth century, had already called Blaise the "great protector of bulls." In the Greek *Minei,* he is also called a shepherd. In Rus, the peasants' devotion to Saint Blaise was probably rooted especially where there were still echoes of the pagan worship of Veles, god of cattle, and in the icon, Blaise is also accompanied by a whole herd. Opposite him is seated Spyridon, bishop of Tremitonte (Cyprus). He was a saint highly venerated in Byzantium and, according to legend, originally a shepherd. After becoming bishop, he continued to go around with his shepherd's staff and to wear a cap of woven osier. In Greek, the word *spiridion* itself denotes a round woven basket. The saint is represented with this cap in Theophanes' icon and fresco in the Church of the Savior of the Transfiguration. Spyridon was deemed the protector of the earth's fertility. To link the Christian feast with the pagan one, the Church assigned December 12 to his memorial (old calendar). As is well known, on December 12, the days begin to lengthen, and in pre-Christian times, this date was of great importance, emphasized by a special feast called *kolyada* [Latin *calendae*], which recalled the "sun's summer turning point" [summer solstice]. The Church called December 12 the "turning point of Spyridon." Therefore, we understand why in Novgorod the veneration of Spyridon was closely associated with the worship of the sun and of the forces of nature which awakened in the spring. This is probably the reason why the Novgorodian artist portrayed Blaise along with Spyridon, represented as the patrons of stock-rearing and agriculture.

Saint George[90] was one of Novgorod's favorite saints. In the North, in the provinces of Novgorod, Dvina, and Vyatka, there were many churches dedicated to him. Hymns were composed to honor him, proclaiming him lord of the country and indefatigable helper of the colonizers of the northeastern periphery of Rus, while in local legends, he was glorified as the defender of Novgorodians in their struggles against foreigners from the territories of Zavoloche. The religious feast of Saint George was established on April 23, and according to popular tradition, on that day, the saint would come out on his white horse to protect the livestock in the pastures.[91] Little by little, the image of "Egorii the Valiant" became one of the most widespread themes in Novgorodian iconography and several marvelous Novgorodian icons representing Saint George have survived until today. The icon in the Russian Museum, executed in the years bridging the fourteenth and fifteenth centuries, is especially beautiful. George is galloping on his white charger, a luminous point which stands out on a flamboyant red background. His figure is magistrally inscribed on the rectangular panel of the icon. The artist did not hesitate to encroach upon the borders of the icon with the edge of the flowing cloak, George's right hand, the tail and front legs of the horse. The artist had mastered all the details of the art of composition with such assurance that he had no difficulty in reestablishing the balance of the various parts with the help of the mountains: higher to the left, lower to the right where the dragon's body and head are placed. Saint George's fluttering cloak on the left is counterbalanced on the right by the right hand of God. In this way the artist has achieved an extraordinary compositional "structure." The white horse is galloping in a whirling motion, obeying the rider. George is driving his lance into the serpent's jaws, as if fulfilling with his gesture what was already written in the book of fate. He is the bearer of good and light. In his dazzling brilliance there is something stormy, something that makes him like a flash of lightning, and it seems as if there is no power in the world able to stop the impetuous course of this victorious warrior.

The prophet Elijah also enjoyed great popularity in Novgorod. His image is endowed with great expressiveness in the Tretyakov Gallery icon, where he is portrayed on a bright red background. His determined face is very resolute, and he is prepared to assist only those who pray to him with fervor, with their whole heart, to ask for his help. Elijah does not like to jest and Novgorodians were afraid of him. It is no accident that the artist gave his face a strong, penetrating expression: his pitch black eyes seem to transfix the observer; his mustache, beard, and loose hair fall in dishevelled strands; "vivid strokes" are applied over the flesh tone with a daring and vigorous hand, augmenting the pathos of the image.

From the end of the fourteenth century on, we see more icons depicting more than one saint. In their very practical approach, Novgorodians preferred to commission the sort of icon which portrayed several patrons together, and thus expected more concrete help from the icon in their daily affairs. Normally, these saints are arranged in a row and the favorite emblem of the city, the Virgin of the Sign, is placed above them. These icons, with their static, understandable, basic designs, are particularly beautiful because of their very fine chromatic range. Artists masterfully used the multicolored garments of the saints to obtain an unusual intensity of clear color which would honor Matisse himself. In the icon from the Russian Museum, we see Saints Varlaam of Khutynsk, John the Almsgiver, Paraskeva Pyatnitsa, and Anastasia; in that from the Tretyakov Gallery, we find the Prophet Elijah, Saints Nicholas the Wonderworker and Anastasia.[92] Their faces are wise, energetic, strong; all appear as patrons, ready to assist their proteges. PL. 41 PL. 42

The figures of Paraskeva Pyatnitsa and Anastasia[93] are especially interesting. According to some scholars, the veneration of Paraskeva is based on the ancient pagan worship of Mokosh, the goddess of marriage and of spinners. In Bulgaria and Macedonia, the veneration of Paraskeva coincided with the cult proper to a day of the week, Friday *(Pyatnitsa)*. We still have to explain why Paraskeva also came to be seen as protectress of commerce. The worship of the divinity, to whom this day of the week was dedicated, may come into play. And the ancient reckoning of a five-day week, the last day being a holiday which could facilitate commercial exchanges, may also have had its influence. In any case, in Russian land (central Russia and Novgorod), Friday was market day and places of business were open. It is not by chance that in 1156, merchants trading with the West erected a church dedicated to Pyatnitsa on the market square in Novgorod; it surely had a special significance for the merchants. The veneration of another saint, Anastasia, was associated with the resurrection. This is why the images of Paraskeva Pyatnitsa and Anastasia are found so frequently in Novgorodian icons.

The iconography of Novgorodian saints clearly shows how Novgorod's religious art was closely intertwined with real life and its problems. None of these images embodied abstract, metaphysical concepts; they were not thin, dogmatic allegories born of speculative scholarly thinking. Rather, they were living symbols of the most essential interests of country people who thought of their only colt when they looked at the icon of Saint Blaise; when they prayed to Paraskeva Pyatnitsa, they thought about the next market day; when they contemplated Elijah's threatening face, the arid earth thirsting for rain came to their minds; when they paused before Saint Nicholas, they were seeking his help to preserve them from fire. All these saints' images were close and familiar to them. In spite of their abstractness, in the people's eyes, they were filled with a real, vital content which allowed them to draw near to the icons in a very emotional way, to such a degree that to them, icons seemed like the poetic account of the experiences they lived, they endured. PL. 47

In Novgorod, during the late fourteenth and early fifteenth centuries, artists also painted very small icons (like the *Saint George* and *Saint Demetrius of Thessalonica* in the Tretyakov Gallery, for example),[94] processional crosses, medallions for decorating the half-length figures of the *Deesis* and of saints, and some unusual icons in twenty-five sections depicting Christ's life on earth.[95] They painted icons for altar partitions as well, though not as many as later on in the fifteenth century. In Novgorod, the sanctuary partitions were made of wood and consisted of an epistyle *(tyabla)* supported by small columns between which the low royal doors and wooden plutei [balusters or panels] were located.[96] We still do not know if large images of the Virgin and of Christ were placed on the pillars flanking the sanctuary partition in stone churches, as was the case in Byzantine churches;[97] neither do we know when these icons were transferred from the stone pillars to the spaces between the small columns of the partition. In small wooden churches, this transfer probably occurred during the first stages of development. In the row of local icons, where the images of the Virgin and Christ had to be shown, there may also have been the icons of the saint or feast to which the church was dedicated. Moreover, in a few cases, these icons were placed on special corbels or in front of the pillars of the sanctuary (in masonry churches) or on both sides of the sanctuary partition or along the walls. Only a few of the PL. 43

PL. 44 Novgorod icons of the fourteenth century can be connected to the sanctuary partition for certain. From this, we infer that the decoration had to be extremely modest at the time. Among these icons, we mention the bust figures of a series for a *Deesis*[98] and the icon of the *Apostle Peter* in the Russian Museum, which were probably on the epistyle. At that time, the space above the epistyle in the Cathedral of Saint Sophia in Novgorod was occupied by three long panels representing the *Twelve Feasts*, which closed the arched space of the apse. In the fourteenth century, the sanctuary partitions did not have the *Deesis* in full length, nor the register of patriarchs and prophets, which appeared in higher iconostases later on. At this time, icons of saints venerated locally were grouped in a lower tier, with a few panels and a half-length *Deesis* on the epistyle. At times (probably not always), there was also the tier of the *Feasts*. In Novgorod, the development of the sanctuary partition did not progress further. The iconostasis with a full-length *Deesis* appeared only in the fifteenth century in Novgorod, and probably because of the influence of Moscow.

PL. 45 The quadripartite icon in the Russian Museum is an authentic jewel of early-fifteenth-century Novgorodian iconography. We still have not understood why its author combined in a single panel four episodes which have no common link: the Raising of Lazarus, the Trinity of the Old Testament, the Presentation in the Temple, and Saint John the Evangelist dictating his Gospel to Prochorus. It might have been done at the request of the person commissioning the icon. The four scenes are masterfully combined on the icon's rectangular panel. In their clear, uncluttered composition, there is no trace of crowding. The artist skillfully used intervals of space, which acquired an extraordinary expressiveness under his brush. The main accent is placed on the intense splashes of color (predominantly cinnabar) which clearly stand out on the gold background. A kind of dynamic interaction is established between the figures and the architectural and landscape settings. Thus, in the scene of the *Raising of Lazarus*, the movement of Christ's right hand reproduces the parabolic line of the mountain, and the opposite movement of Lazarus bending down and of Martha and Mary prostrated at Christ's feet is accentuated by the fissures of the rocky, highly stylized mountains whose diagonal lines converge toward Christ's hand. In the *Presentation in the Temple*, corresponding to the figures of Joseph to the left and Joachim and Ann to the right, are two tall buildings, turned so as to direct the viewer's eyes toward the center, and the domed top of the baldachin with its marked curve is prolonged in the bowed figures of Mary and Simeon. Placed near the strictly vertical lines of the baldachin's columns and the dark openings of the buildings in the background, the sweet and rounded profiles of the slightly bent figures acquire even more gentleness and litheness. The extraordinary compositional skills of the Novgorodian master are expressed with special evidence in the lower right scene. Sketched within a daring parabolic line, John's figure is enclosed, like a walnut in its shell, in the clear outline of the mountain framing him. The contour of the mountain repeats that of the figure, and the spike of rock at its right, bent to the right, betokens the direction of John's movement, who is represented in three-quarter profile. In its turn, the dark hollow of the grotto delineates the outline of the figure of Prochorus leaning over to write, and the cracks in the two rocky mountains seen above his head bring the observer's glance back to John. In this way, an uninterrupted compositional link is established between the two figures. And even though this link is threatened by the seat, the small cubical table, and the footrest, all shown from different angles, these do not disturb the general balance because they are completely neutralized by being presented in flat projection. Novgorodian artists always took the flat surface of the panel into consideration. Not only did they preserve it, but used it in planning their compositions and calculating all their proportions.

Beginning in the fourteenth century, a new theme became very popular in Novgorodian iconography: the Virgin of Mercy.[99] The feast of "Mercy" *(Pokrov)*, unknown to the Greek Church, was already instituted in the Rus of Vladimir-Suzdal by the twelfth century in remembrance of the miraculous apparition of the Virgin to blessed Andrew Yurodivyi (died about 936), "fool for Christ," and to his disciple Epifanii. In Andrew's *Life*, it is said that the Virgin appeared to him near the main doors of the Blachernae church, then approached the altar, in front of which she started to pray for humankind.

At the end of the prayer, the Virgin took off her cloak or *maphorion* and, holding it with both hands, extended it over all those present.[100] The main relic of the Blachernae church was the Virgin's *maphorion,* still kept there. According to G. Durand de Mende, author of the famous *Rationale Divinorum Officiorum* (Lyons, 1565),[101] the office of the Blessed Virgin, recited at the seventh hour, has its origin in this miracle of the *maphorion.* "In a church in Constantinople," the author says, "an image of the Immaculate Virgin, completely covered with a veil, was venerated, and on Friday, at the sixth hour [about noon], the veil would miraculously rise until evening, disclosing the entire image, and then, at the end of the evening, on Saturday, the veil would fall back over the image and remain there until the following Friday." The Byzantine clergy obviously arranged this event or something similar and gave it an appropriately spectacular character. But until now, no image of the Virgin of Mercy has been found in Greek painting. The iconography of this theme began to develop no later than the thirteenth century (west doors of the Suzdal Cathedral, 1230–1233)[102] and by the fourteenth century was completely developed in its two variations (the veil is extended over the Virgin or Mary is holding it in her hands).[103] The fundamental idea of the miraculous event and of the feast of Mercy linked with it is perfectly clear: it is the theme of intercession and of mercy, in other words, the same idea which is unmistakably clear in the compositions of the *Deesis,* so widespread throughout Rus. It is no surprise that in one of the *Sbornik* (miscellanea) of the mid-fourteenth century in the Historical Museum (Sin. 235), which also contains liturgical offices, we find in particular this unusual invocation to the Mother of God: "Pray to God for us sinners who are celebrating the feast of your mercy in the land of Rus."[104] The institution of the feast of Mercy indicates not only the awakening of national consciousness but also the vitality of ancient popular beliefs systematically blended into the cult of the Virgin. As E.S. Medvedeva[105] keenly observed, the folkloric-ritual concept of the beneficent female divinity, the virgin Aurora *(Zarya),* and of her marvelously immaculate veil and the veneration of the Virgin Mary with the cloak-veil converge in an original manner. In the icon of the Tretyakov Gallery, Mary is shown in PL. 46 the pose of the Orant. She is praying for humanity, interceding for everyone near Christ, who rises above the Virgin's cloak. From both sides, groups of angels and saints lean toward her, their looks and gestures expressing the exultation of their minds. In the central register, two tables are shown and behind them figures of bishops and angels are seen; and below, on each side of the royal doors, we see Andrew Yurodivyi (with the hair shirt), Epifanii, George, Demetrius of Thessalonica (to the right) and John the Baptist with apostles (to the left). The artist placed all the figures within the cornice of the great arches symbolizing the three naves of the church, while a shining white church crowned with five domes is depicted above. With these conventional elements, the onlooker is led to understand that the action unfolds in the sanctuary of a church with three naves, externally characterized by five domes. The Virgin's protective veil, which illumines everything and everyone as if it were embracing the entire world, gives a profound inner significance to this composition.[106] The Mother of God is glorified as a merciful advocate, as "mercy," in whose shadow all those who are suffering and seeking her find safety. In this icon, as E.N. Trubetskoy correctly observed, we have symmetry not only in the disposition of the individual figures but — much more importantly — in their spiritual motion which shows through their apparent immobility. The symmetrical movements of the angels' wings gravitate from both sides toward the Virgin, the motionless center of the universe. All looks are turned toward her, and the main architectural lines are also oriented in her direction. This compositional technique of construction, rigorously centered, can only express a centripetal motion toward common joy. An invisible light, seemingly coming from the Virgin, crosses the space of angels and people and breaks into a multitude of colors.[107]

Novgorodian iconography of the fifteenth century does not like difficult subjects with complex symbolism, so widespread in later iconography. Its themes are simple and metaphorical and do not require complicated explanations. The artists transmitted their message to observers effortlessly, and their works always have a fascinating simplicity. Traditional iconographic types are simplified; all superfluous figures are left out: the authors were satisfied with very little. Their compositions are clear

and easy to understand, and we do not find in them the repetitiveness so harmful to fourteenth-century icons. The main narrative line is not overshadowed by marginal episodes of secondary importance. This special conciseness in the narrative and compositional elaboration of the image constitutes the distinctive trait of Novgorodian iconography of the fifteenth century. Novgorodians preferred the simpler iconographic versions of the traditional *Feasts*. They continued to show their predilection for saints lined up in a row[108] and were really fond of images with bust-length figures[109] and hagiographical icons in which episodes of a saint's life are clearly shown (like the famous icon of *Saint Theodore Stratilates with Scenes from His Life* in the Novgorod Museum).

If we compare the fifteenth-century Novgorod icon with the Moscow icon from the same period, it is easy to see how the first is less aristocratic, how earlier traits persistently emerge in it, and how as a whole it is marked by a strongly "popular" style. Novgorodians preferred sturdy figures, faces of a distinctively national type, with rough features, sometimes even a little coarse, and their saints' eyes often have a penetrating expression. In the fifteenth century their favorite method of composition was still alignment with deliberately wide intervals; they avoided introducing a dynamic movement into icons in favor of static, attenuating compositions. Mountains are more bulky and simpler than in Moscow icons, the frequently imposing architecture is less elegant and more differentiated; lines are more standardized and colors, more flamboyant and spontaneous. The Novgorod icon is recognized first of all by its bright coloring with the predominance of flaming cinnabar. The palette of the Novgorodian master is made of pure, not mixed, especially bright colors creating audacious contrasts. It is less harmonious than the Moscow palette, less rich in delicate nuances, but to make up for this, it has a bold and strong character. Novgorodian tastes are perhaps best reflected in these colors, which are unforgettable because of their vividness and chromatic tension.

In the first half of the fifteenth century, many beautiful icons were painted in Novgorod. They are fascinating because of their freshness and what we might call *vision directe*. Among them, we have to mention works like the two icons of *Saint George* from the I.S. Ostrouchov collection,[110] *Nativity of Christ, Saints Boris and Gleb*,[111] *Annunciation*,[112] and *Virgin and Child Enthroned*[113] (all in the Tretyakov Gallery). In the last icon, we find a motif from the West: at the back of the throne are two angels, shown holding a veil, who seem to emerge from a painting by Duccio. If we consider the strong relations between Novgorod and the West, a borrowing of this kind does not seem strange. But what is significant is that this is the only case; in fact, Novgorodian artists staunchly defended their own art from all "Latin" innovations.

PL. 49 The most beautiful of the icons mentioned above is the *Nativity of Christ with Saints*. The figures of the angels, the Magi, the shepherd, Joseph, the old man in front, on the one hand, and the midwives bathing the newborn, on the other, are arranged on the panel's surface in accordance with the principle of the rigorous correspondence of parts. The composition also has its central axis intersected by the reclining figure of the Virgin. But all these symmetrical elements are treated with great freedom and without any premeditation. This explains why the composition is enlivened by a buoyant and nimble rhythm. The artist skillfully used the mountains to unify episodes that are not simultaneous, arranging the figures in three superimposed areas which, as is often the case in Novgorodian painting, do not disrupt the panel's flat surface but are, on the contrary, completely subject to it. The fissures of the rocks unfailingly direct the spectators' eyes toward the figures placed nearby or in the background. In this way, each person is given prominence and set off from the lines of the landscape in the background. In the upper part of the icon, three very popular saints in Novgorod are shown in half-length, Eudocia, John Climacus, and Juliana, probably the names of the donor's relatives. The coloring reaches a particular refinement in the gray azure mountains, with shadings of a soft lilac color. Against the background of these mountains, the showy splashes of the garments stand out, cinnabar, gray azure, green, and lilac cherry. The shades are chosen with a subtle discernment which makes this icon an exceptional work, among the best Novgorodian paintings from the fifteenth century.

Until the end of the fifteenth century, Novgorodian masters were not very fond of icons of a complicated composition with many figures. Only the theme of the Last Judgment drove them into creating works of this type. One of these, executed shortly after the middle of the fifteenth century PL. 48 (Tretyakov Gallery), is unique not only because of the many figures but also because of the well-knit presence of marginal episodes derived from the most diverse literary sources. This quite unusual composition is built upon different registers in arched curves, in parabolas which with their linear rhythm recall the circles and the bizarre contortions of the serpent. Despite the abundance of episodes immortalized in the icon, they are still easily distinguishable since not one of them leaves the limits of its own plane. Thus, as a whole, the composition is easy to understand even though it lacks the terseness which characterizes the best Novgorodian icons.

The fifteenth century was the classical period in the development of the Russian iconostasis. It was during this time that it became higher, with the emergence of new registers of icons, and acquired an extraordinary architectural systematization. Moscow was undoubtedly of fundamental importance to this development, where the iconostasis of the Annunciation (?) in the Kremlin, executed in 1405 by Theophanes the Greek, Prochor of Gorodets, and Andrei Rublev, showed a full-length *Deesis* for the first time. This novelty was probably imported from Moscow to Novgorod, where full-length *Deeses* started to be used in the first half of the fifteenth century,[114] even though they never attained the dimensions and monumentality which they had in Moscow. In height, they did not go beyond 1.6 meters, whereas Theophanes' *Deesis* was 2 meters taller, and Rublev's *Deesis* in the Vladimir Cathedral of the Dormition measured 3.14 meters. The icons of the *Feasts* were not very different from those of Moscow in terms of dimensions but they were slightly higher and narrower (for example, the icons of the Volotovo church are 89 centimeters tall and their width varies from 58 to 56 centimeters). This was probably due less to light coming from the triumphal arches in the Novgorod church than to the need to incorporate a specific number of *Feasts* in that space. Another register of icons appeared in Novgorod churches from the second (?) half of the fifteenth century on, that of the *Prophets*. We have a magnificent example of them in the Tretyakov Gallery in a series of panels going back to the last decades of the fifteenth century.[115] Thus, the high iconostasis spread throughout Novgorod, although with some delay in comparison to Moscow.

The fact that the full-length *Deesis* is the nucleus of the composition of the iconostasis of the fifteenth century is clearly demonstrated by a very interesting icon in the Novgorod Museum showing *The Praying Novgorodians*. According to the inscription, it was executed in 1467 at the request of PL. 50 boyar Antipa Kuzmin. His entire family is shown praying before the *Deesis,* placed on the upper register of the icon, which represents a portion of space farther away from the observer. Yet, instead of developing the composition in depth, the artist built it up in height, vertically. Antipa Kuzmin and the members of his large family are standing next to one another in a praying attitude. Their figures are in the same scale as the figures of the saints, something Byzantine artists would never have allowed themselves to do. They wear multicolored clothes and cloaks with red collars and red leather boots. The woman at the extreme right is wearing a veil and the children are wearing white tunics. The men have their hair in braids. The faces are not portraits and are differentiated only by the shape of their beards. The nimble pictorial style and the concept of coloring still maintain a strong and direct connection with the traditions of the first half of the fifteenth century but there is something new in the proportions of the figures: there is an elongation unknown before. The figures have become elegant and slender and they appear unsteady on their legs, barely resting on the ground, as if hesitant. This is noticeable especially in the angels, and one already senses Dionysii's time approaching. Toward the end of the century, these new traits became even more prominent in Novgorodian painting.

Works of a more archaic style in which new trends were totally absent were still being painted in Novgorod during the second half of the fifteenth century. Among them, we might mention the quadripartite icon of the *Presentation in the Temple, Entombment, Miracle of the Archangel Michael in Chonae, Apparition of the Angel to the Women Mironositsa,*[116] dating from 1488; *The Entombment,*[117]

PL.53 signed (Yakov Iel); the icon of the *Queen of Heaven Standing at Your Right Hand,* a rather rare subject at the time, inspired by Serbian models (all in the Tretyakov Gallery); the central part of the triptych with the Virgin of the Sign and the busts of Saints Elijah, Nicholas, and John the Baptist, in the Russian Museum.[118] The list of these old-fashioned icons could easily continue, but they were not to determine the main line of development; rather, they already heralded the new style. Among these, we certainly have the *Feasts* from the Dormition Church in the village of Volotovo, which were not executed before the 1470s.

PL. 52 The Volotovo *Feasts* have figures with elongated proportions and complex landscape and architectural backgrounds. In the background of the *Presentation in the Temple,* we see a curved wall with a baldachin rising above it, a church with an apse, and behind Simeon's shoulders a very elongated baldachin accessible by four steps. Simeon's head stands out against the light background of the building whose strongly pronounced vertical accentuates the space between Simeon and Mary, with Anne and Joseph behind Mary. The mass of architectural forms is not very harmonious, and the compositional connection between the figures in the foreground and the scenery in the background is quite weak except for the curved wall which recaptures the movements of the figures approaching Simeon. The rather unusual, somewhat elongated format of the *Feasts* icon from the Volotovo church created some problems for the artist, preventing him from creating a more spare composition (this is especially discernible in other icons from the register of the Feasts, like the *Raising of Lazarus* and *Dormition,* in which there is some overcrowding). The *Transfiguration* is much better. Here the iconographic structure is more easily included in an elongated panel. As usual, the dynamic figures of the apostles, blinded by the light emanating from Christ and prostrated on the ground, are much more expressive.

From the 1470s to the 1490s, excellent icons were still being painted in Novgorod, but it cannot be denied that they already exhibit some stylistic changes which would lead first to a crisis and then to the decline of Novgorodian painting. The freshness, the immediacy of perception, and that unique nuance of ingenuous simplicity, making the icons of the early fifteenth century so fascinating, are vanishing. Everything is becoming more elegant, perfected, and thoroughly formal. Interpretation becomes more terse and stylized; forms are more fractured (especially the shapes of mountains); architectural backgrounds, complicated. The once very simple clothes start to be frequently enriched with ornaments. There appears a tendency toward soft, graceful lines and a more standardized interpretation of faces with the ensuing softening of the severity and power of the images and, as a result, a decrease in their psychological expressiveness. The last twenty-five years of the fifteenth century can be considered the starting point of this process which will come to a conclusion only around the middle of the sixteenth century.

One of the most important Novgorodian iconostases of the late fifteenth century was that of the Church of Saint Nicholas in the Gostinopole Monastery. It is quite accurately dated around 1475, based on the dedicatory inscription on the bell tower. The iconostasis was made up of the local tier, a PL. 55, 56 full-length *Deesis,* the tier of the prophets in busts, and the royal doors. Icons from this group are distinguished by an uncommon refinement of execution replacing the old lively style. But flamboyant and intense colors still remain and also the subtle perception of the outline, especially in the elegant figures of the Archangels Michael and Gabriel.

PL. 57 The wonderful icon of the prophets *Daniel, David, and Solomon* in half-length, now in the Tretyakov Gallery, also belonged in its time to an even more important iconostasis, executed around 1497 for the Cathedral of the Dormition in Saint Cyril of Belozersk Monastery. The silhouettes of the elegant, meticulously drawn figures are especially beautiful with their graceful curves, soft hair flowing to the sides, crowns on their heads, and prophetic sashes. The cloaks fastened with fibulae, the shoulders of the chitons encrusted with precious stones, the edges of the cloaks embroidered with pearls: all this gives the icon a precious appearance, enhanced by the luminosity of bright, pure colors of an extraordinary brillance. But the aridity and standardization of iconographic methods which will characterize sixteenth-century icons can already be seen in the execution of the faces and hands.

Three icons, *The Miracle of Florus and Laurus*, the hagiographical representation of *Theodore Stratilates*, and the *Battle between the Novgorodians and the Suzdalians*, can also be dated to the late fifteenth century.

The cult of Florus and Laurus, as holy protectors of horses and their breeders, was imported into Rus from the Balkans.[119] N.V. Malitskii formulated an ingenious hypothesis according to which the Christian cult of these saints, whose relics were discovered in Thrace and Illyria, replaced the cult of the Dioscuri widespread in that region. And as a matter of fact, we often find in Thrace and Illyria ancient representations of horsemen elevated to the rank of heroes. Malitskii also notes an interesting point: the Dioscuri, as well as Florus and Laurus and the Cappadocian riders, were twins. If this hypothesis is confirmed, then the icons of Florus and Laurus, especially widespread in Novgorod, can be considered the bearers of very ancient traditions springing from the people's lively creativity.

In the Tretyakov Gallery's icon, the composition, strictly centered, which was not the case at one time,[120] has been transformed into a clearly classical form. In the center, the Archangel Michael is holding the reins of a white and a bay horse, in the act of handing them over to Florus and Laurus, standing next to him. The horses are so elaborate and their outlines so precise that they seem to have emerged from a coat of arms. Below are three riders, Spevsipp, Elevsipp, and Melevsipp, whose names in Greek mean "the one who speeds up the horse's gait," "the one who makes the horse run," and "the one who looks after the horse." The iconographer garbled the names, which became Speusip, Gelasip, and Masip. Gelasip is not shown in the center, but a little lower to the left, and his figure is balanced on the right by the two trees and by the outstretched forelegs of the herd of horses being led to the drinking trough; thus, a very difficult compositional problem is skillfully resolved in keeping with the principle of symmetry. The artist filled the surface of the panel evenly by boldly using mountains and plants to fill up the blank spaces and to balance the various parts of the composition. The passion for affectation, typical of the end of the century, is recognizable in the particularly accurate rendering of the horses with their slender and elegant legs and also in the tapered proportions of their figures. PL. 54

The icon of *Saint Theodore Stratilates with Scenes from His Life* offers a series of stylistic traits which are a sign of the approaching sixteenth century: an accentuated vigor is visible in the saint's elegant figure; the architectural backgrounds of the scenes in the margins become more complex, the movement of the figures more complicated, the composition more stratified and, as a result, more elaborate. But even at this stage, there is no loss of the precious quality of Novgorodian panel painting: a very fine sense of the outline and the splendor of the flamboyant and pure hues. PL. 58

Of all the icons representing the *Battle between the Novgorodians and the Suzdalians* that we know, the Tretyakov Gallery copy is the most recent. This theme had become very popular in Novgorod during the period of its violent political conflicts with Moscow. At that time the Suzdalians symbolized the Muscovites, and according to legend, it was against the Suzdalians that celestial powers rose in defense of Novgorod. As we know, Moscow was victorious in this unequal encounter, and in the end, Novgorod was deprived of its independence (1478). Yet, the legend did not lose its fascination; on the contrary, it aroused a great deal of interest. The memory of the northern might of Novgorod, the "free city," was linked to the legend. The famous icon in the Novgorod Museum (around 1460) is rightfully considered the earliest icon on this theme. From the iconographic point of view, it substantially coincides with that of the Tretyakov Gallery, which lacks only the representation of the bridge over the Volchov River in the upper level; but stylistically, the two works are very different and it is most helpful to compare them since the direction in which Novgorodian iconography developed clearly stands out. PL. 51

In the upper register, we see the icon of the *Virgin of the Sign* being carried from the Church of the Savior on Saint Elijah Street to the Novgorod Kremlin *(Detinets)*. To the left, the clergy are bowing to the icon as it leaves the church; to the right, the procession nears the Kremlin's doors where the gathered people are awaiting it. In the central register, the artist has depicted the Novgorodians

barricaded behind fortified walls, messengers sent to negotiate, and the Suzdal army which initiates the hostilities: "like abundant rain," arrows fly across the icon, which looks like a military banner. Below, Novgorodian warriors come out of the gates of the fortress, led by Saints Boris, Gleb, and George, who, according to the legend, were invited by the Virgin to come to the help of the Novgorodian soldiers over whom she extended her divine protection. The Suzdalians hesitate, some of them take flight. Although all the forms are extremely stylized and heterogeneous elements are combined on the same surface, the events are so effectively described and with such expressive clarity that they are easily understood. Developing the composition on the surface, the artist skillfully coordinated all the fundamental components and thus, by excessively elongating the fortified walls in height, succeeded in using them on two registers. The painter knew how to distribute with great art the space between the messengers moving toward one another and, by arranging the formations of the soldiers one over the other and almost surrounding them by an uninterrupted line, achieved the effect of countless hordes facing one another in a deadly encounter. Compared to the Novgorod icon, the artistic language of the Moscow icon is forcefully broken. Everything has become more miniaturized, more delicate, more shapely. The meticulous style, reminiscent of Persian miniatures, is established, and the freshness and ingenuous intuitive immediacy of the earlier time is mostly lost. Despite the excellent quality of the execution, the predominance of the iconographic model is clearly perceptible.

PL. 59 The swan song of fifteenth-century Novgorodian iconography is represented by the famous bilateral panel from the Cathedral of Saint Sophia, now in the Novgorod Museum and also in Museums in Moscow, Saint Petersburg, and London. These small icons, painted on a cloth covered by a thick layer of *levkas*, were intended for display on the lectern during liturgical festivities. Their themes are the usual ones: the main gospel episodes, scenes from the Passion, and figures of saints. The small panels are generally two-sided and the images — predominantly saints — follow one another according to the liturgical calendar. Although heterogeneous and partly replaced by later icons, the Saint Sophia panels are unequaled in terms of the richness of their variety. Only the small panels of a later time from the Cathedral of the Nativity in Suzdal, now kept in the city museum, come close. Various artists, probably belonging to the archiepiscopal studio, worked on the execution of these bilateral panels from Novgorod. As a whole, the series of small panels gives us a clear idea of the artistic pursuits of Novgorodian iconographers on the threshold between the fifteenth and sixteenth centuries.

In the bilateral Saint Sophia panels, we want to show first of all how the basic themes become more complicated. Next to the individual representations of the patriarchs, hermits, Fathers of the Church, the blessed, and other saints, we find a series of compositions with more figures, some of which can be numbered among great iconographic rarities. We note in particular the *Exaltation of the Cross* (this feast had a special meaning for Novgorodians because the Cathedral of Saint Sophia was dedicated on that day), *Synaxis of the Archangels, Synaxis of the Apostles,* to which were added the *Virgin of Mercy* and *In You Everything Rejoices* as well as scenes from the lives of Mary and Christ. In the Christological cycle, the center of gravity is found in the scenes from the Passion. The icons of the *Three Children in the Furnace* and the *Holy Face* occupy a place by themselves. All these subjects do not constitute an organized iconographic program but are simply grouped according to the liturgical calendar.

The tendency to create elaborate subjects was not very common in fifteenth-century iconography, but it is characteristic of the Saint Sophia panels. Fifteenth-century iconography had a special preference for individual images or uncomplicated scenes with a relatively small number of figures in keeping with the Novgorodians' simple and vigorous tastes. With the sixteenth century approaching, interest in small icons with many figures arose in Novgorod. These overcrowded scenes made the conciseness of a previous time gradually disappear; compositions became more and more overloaded and divided, and at the same time there was a change in forms, which became more slender. However beautiful the individual panels may be, which are directly reminiscent of Duccio's works because of the softness of their hues and the particular sweetness of their style, one still perceives in them an impov-

erishment of creative energy. Here, admiration of an artistic style characterized by certain stereotypes was gaining ground. Under its formal appearance, this polished art was intended for the boyars' refined tastes. In breaking away from popular roots, it signaled the coming of the crisis in Novgorodian painting which came quickly with the sixteenth century.

It is interesting to compare the icon of the *Virgin of Mercy* from the Saint Sophia cycle with the Tretyakov Gallery icon from the early fifteenth century on the same theme. The composition is not as refined as it once was; architectural backgrounds have become more complex and they link everything around the figure of the Virgin. The number of people in the scene has increased notably so that the background is not glimpsed anywhere; the clothing is adorned with fine and light ornamental motifs; and the figures are more elongated and elegant. In conclusion, the composition as a whole has lost that extraordinary clarity and structure which makes the Tretyakov Gallery icon so fascinating.

The same overcrowding can be observed in the panel depicting the Passion. Although here four different events are shown, the number of figures included by the artist is clearly disproportionate to such a restricted space. This same tendency also appears in the treatment of the traditional composition of the *Synaxis of the Archangels*. In place of the two archangels holding a shield with the image of Christ, here the whole array of angels and seraphim is shown. As a result, the scene, which was originally simple and spare, becomes a complex composition of more figures with the dense ranks of angels placed above one another and the wings of the seraphim giving a great sense of dynamism.

Much more successful are the panels with individual images or with a limited number of figures, like *John the Baptist in the Desert* or the *Three Children in the Furnace*. The first icon, mantled in an elegant and uniform silvery olive green shade, continues the tradition of the early fifteenth century. The style is exact but not excessively dry; the composition is spare and remarkably constructed. Without rigid symmetry, it does have inner logic, intuitively acquired, in which each element finds its proper place, even though everything is relative and imaginary here. There is an extraordinary harmony of the parts, which complement and balance one another. Here we have a reflection of the age-old iconographic tradition which taught artists to value the rhythm of the surface. The arch of the mountain picks up the curvature of the figure of John; the bowl with the Baptist's head and the mountains to the right are balanced on the left by a tree and two low mountains. The extremities of the flowing mantle and scroll, one of which intersects the tree trunk and the other, the outline of the mountains, serve to connect the individual parts of the composition, preventing it from being splintered into its various elements.

The second icon, whose style suggests the hand of a younger master, shows the three children in the fiery furnace. Behind their backs, one distinguishes a column with the pagan idol the youths refused to adore, an act for which the king condemned them to an agonizing death. An angel unexpectedly appears, saving the three children, and the tongues of fire cannot burn them. In the foreground, the executors of the king's order prostrate themselves on the ground, covering their eyes with their hands to protect themselves from the heavenly light radiating from the angel, a light more intense than the glare of the fire. In the figures of the children, who seem to be performing a round dance with the angel, there is such a lightness, such a joie de vivre that it makes them spontaneously believe in the miraculous victory won in their struggle against the power of the fire. The arrangement of the figures and the position of the rectangular furnace clearly show the artist's interest in seeking a solution to a complex space problem, a fact which testifies in favor of his belonging to a younger generation.

The most festive of these little panels is perhaps the icon *In You Everything Rejoices*,[121] in which the image of the Mother of God — as is clear from the name itself — is acknowledged in her cosmic significance as the "joy of all creation." The central part of the icon is inscribed within a circle. Almost spanning the entire breadth of the background is a white church with many onion domes standing out against the heavenly vault, paradisiacal vegetation twines round the church. In the center, seated on a throne, is the Virgin, the "joy of all creation," with the Child. The exultation of celestial creatures is

symbolized by the Mother of God's angelic halo. At the bottom, already beyond the boundaries of the circle, apostles, prophets, bishops, hermits, saints, and virgins converge toward her from all directions. Here the idea of the universal Church emerges with great plastic expressiveness. Spectators do not have cold and indifferent walls before them but rather a joyful, animated Church which takes an active part in the exultation because of the Virgin.[122]

The small Saint Sophia panels, done for the most part by first-rate masters (it is no accident they were made for the Saint Sophia Cathedral), clearly show the artistic level which Novgorodian painting had attained between the end of the fifteenth and beginning of the sixteenth centuries. But its decline began very quickly. Having lost its independence in 1478, Novgorod also started to lose its traditions at the same time, opening itself more and more to influences from Moscow. For the city, proud of its great past, this was a harsh and tormenting process. As already in Muscovite painting, complex allegorical subjects prevail. More and more elements from daily life appear in the icons; the former epic simplicity vanishes; the compositions become less and less rhythmical; colors grow pale; and an unpleasant aridity seeps into the pictorial style. Although many beautiful icons were still painted in Novgorod and its surroundings in the sixteenth century, they were no longer comparable in quality with the works of the twelfth to fifteenth centuries.

Icons were painted not only in Novgorod but also in the vast northern regions. In the most remote lake and forest lands of the North, iconography was often practiced as a second craft by white (priests) and black (monks) clergy, residents of villages, and even peasants.[123] Working in solitude, artisans deprived of training and a professional milieu, these artists could not, of course, compete with Novgorodian iconographers, and even less could they form a school with precise stylistic characteristics. This is why their works can be classified under the more appropriate term of "Northern Manners." Most of these icons were inspired by Novgorodian models, and scholars frequently face the arduous task of determining if a particular icon was painted in Novgorod itself, in one of the city studios producing for export, or in the surrounding areas where models imported from the administrative center were readily imitated.

Tracing the dates of the "Northern Manners" meets with serious difficulties because artistic development in these regions, far away from Novgorod, proceeded very slowly. Various iconographic types which had already been abandoned long ago in Novgorod and Moscow were preserved here almost unchanged for centuries and faithfulness to tradition was considered the utmost virtue. In the North, simpler iconographic methods were preferred, and the more understandable they were, the more appreciated they were. Here, the connection between iconography and life with its exigencies was even more pressing than in Novgorod, and the old popular beliefs, together with the survival of pagan cults, were especially alive. Thus, Saint Nicholas was venerated not only as the patron of carpenters but also as the protector of the poor and helper of the oppressed. Saints Florus and Laurus, particularly venerated in these areas, were often included in the tier of the Deesis since in Karelia, horses were considered sacred animals and were even sacrificed as offerings. In Karelia, pagan feasts in honor of Saint Blaise, protector of bovine herds, survived until the end of the nineteenth century. Near chapels dedicated to Blaise, people would suspend small cans filled with milk or bring their herds into church to sprinkle them with holy water. Elijah was invoked because he protected the flocks from wolves; Peter protected fishermen; Eustachius and Trifone protected fields from pests.[124] All these saints were considered indefatigable helpers in daily chores and for this reason were very readily depicted. The *Deesis* was also a favorite theme because it embodied the idea of intercession and in the peasants' minds was the most efficacious way of obtaining forgiveness of sins and of securing the help of heavenly powers.

In the enormous territories of the Russian North, there were varied artistic forms with individual nuances in each region. The art of the Vologda region already asserted itself in the fourteenth century as an autonomous, although rather primitive phenomenon. Painting in the territories around the Onega was closer to the artistic culture of the Dvina regions than to Vologda. In addition to the five rural holdings *(pyatiny),* the new lands beyond the Dvina acquired by Novgorod were brought into

the city's orbit of influence. Founded by Novgorodians in the fourteenth and the fifteenth centuries, the monasteries of the Archangel Michael and of Saint Nicholas were the bearers of that influence. In addition, it is well known that Novgorod sent its artistic production to the territories of the Dvina on a regular basis.[125] The works of that region do not constitute a unified group stylistically, but they do have some similarities and so represent a sort of northern variant of the art of Novgorod.[126] The works from the region of the Onega (Karelia and the northern territories of the province of Saint Petersburg) are older and more primitive but also more spontaneous. The rural territory *(pyatina)* of the Onega became part of the Novgorodian domains at a very early date. In these lands, iconography emerged a little later in comparison with the territories beyond the Dvina (only in the second half of the fourteenth century) and drew predominantly from Novgorodian traditions.

The "Northern Manners" are distinguishable by a series of common traits. First of all, there is the popular character of the figurative style, the primitive realism, the ingenuousness of a project and its realization. It would be pointless here to look for a particular refinement of feeling, but profound sincerity, naive and pure candor are always fascinating. The inscriptions frequently reflect the local way of speaking; in ornaments, there is a direct relation with objects of daily use, of applied arts; and the physical traits of local peasants are reflected in the faces of the saints. The flattened figures are often shown in rigid poses, folds are fashioned with straight and fixed lines, the mountains in the background assume simpler and wider forms. The coloring loses the vividness and splendor of the Novgorodian palette; now, there is a predominance of softened, somewhat dark tones which are in perfect harmony with the interior of wooden churches and with the soft hues of the northern landscape. In terms of the technique of execution, the icons of the "Northern Manners" are rather backward in comparison to Novgorod icons. Here, we do not find the impasto style, carefully shaded, nor the fine "expressive strokes," which have been replaced by extensive highlightings; coarsely mixed colors are spread in a liquid and transparent layer, so much so that at times the grain of the pigment is visible; the primer is uneven, the linen or hemp cloth is not indispensable, and the panel is roughly prepared. In this rustic painting, everything — as a sixteenth-century writer observed[127] — is "extremely simple," but at the same time it brims with a special charm which is characteristic of the lively creativity of the people.

Among the icons of the "Northern Manners," many are hackwork, manufactured in a shoddy, coarse way, but there are also pearls of great value: we need to know how to choose from the mass, and only then will it be possible to appreciate adequately the originality of the artistic language developed by the native people of these remote northern regions.

Iconographic workshops existed in Vologda and its surroundings from early times, as verified in a particular work, unique among its kind, like the *Virgin of Tenderness* from the village of Kubenskoe, kept in the Ethnographic Museum of Vologda (first half of the fourteenth century).[128] Among the many quite spontaneous works which may be connected with Vologda,[129] two in particular stand out because of their artistic quality. One of them is *Saint John the Baptist in the Desert,* which, even though PL. 60 it follows the traditional model (compare the Saint Sophia panel), is completely expressed in the language of flat and linear forms. The Baptist's figure is so rhythmic in its silhouette and so well inscribed in the space between the tree and the curved rocks that it could honor Rublev himself. The colors are pale, almost monochromatic, with white, chestnut, and aqua green tones predominating, spread in a very fine coat which allows the underlying linear structure to be seen. The latter is striking in its terseness and graphic expressiveness, one more proof that at times exceptionally skilled masters did work in those distant and isolated lands.

The second icon is a portrait, an extremely rare genre in early Russian iconography, representing the renowned founder of the Monastery of Saint Cyril of Belozersk. According to a reliable inscrip- PL. 61 tion, of a later date, the portrait of Cyril (1337–1427) was executed in 1424 by the well-known local artist Dionysii of Glushchitskii (1362–1437). A contemporary of the saint, the iconographer undoubtedly had the opportunity to see Cyril and impress the saint's face in his mind, and indeed he succeeded in creating an image of extraordinary vitality. We have before our eyes a little old man, short

and robust, with a fan-shaped beard and a good, wise, kind face. His sturdy figure seems to emerge from the ground like a mushroom. It was people of this type who went to conquer the North with its vast, virgin territories; they built roads, cut down forests, cleared the land to transform it into arable fields; and they founded and erected monasteries. They embodied the ideal of not only moral people but people of action as well. The facial features of Cyril of Belozersk show characteristics so individual they suggest the possibility that Dionysii of Glushchitskii may have resorted to a copy from life. This drawing is mentioned in the *Life of Evfrosin of Pskov*, written before 1510, in which he relates how a contemporary of Evfrosin, the iconographer Ignatii, had sketched on parchment the image of the saint from life or based it on personal impressions, adapting it later to his iconographic models.[130] Obviously, early Russian artists executed "resemblances" (that is, portraits of contemporary people) or took their inspiration from oral traditions and from the accounts of eye witnesses or based them on their prophetic visions.[131] But in individual cases, as correctly noted by Yu.N. Dmitriev,[132] sketches made from life or reproduced from memory may have been used. This is precisely the case with the icon of Dionysii of Glushchitskii. As a rule, portraits were poorly esteemed by early Russian artists, more interested in the "spiritual face" than in the image of the flesh-and-bone person. And until the seventeenth century, when artists were necessarily compelled to depict the human face, they adapted it to iconographic canons. The best confirmation of this is found in the faces of the praying Novgorodians in the famous 1467 icon.

In the territories on the Dvina, iconography started a little earlier than in the region of the Onega (*Presentation of the Virgin in the Temple* in the Russian Museum, *Descent into Hell* in the Moscow Historical Museum).[133] This province had close relations with Novgorod, but by the fourteenth century, PL. 62 articles of Muscovite art[134] had already begun to be imported. The *Presentation in the Temple* was painted according to Novgorodian traditions; the types of faces are reminiscent of the frescoes in the church on the Nereditsa. The colors are flamboyant, but among them pale green and deep blue hues predominate, rare in the Novgorodian palette. In this icon, we notice a series of details taken directly from daily life: the architecture is undoubtedly inspired by wooden buildings; the women are wearing earrings; light fixtures with candles hang from the ceiling. The whole composition is adapted to the flat surface and even the stairs on which Mary is seated have lost every trace of volume. In other fourteenth-century icons (*Nicholas of Zaraysk with Scenes from His Life* in the Tretyakov Gallery,[135] the *Deesis* from the Vazentsy cemetery, today in the Hermitage[136]), one senses the kinship with the icons from central Russia, characterized by a certain roughness and primitivism.

Until the sixteenth century, painting from the region of the Onega remained strictly dependent on Novgorodian art and acquired its own style only in the sixteenth and seventeenth centuries. However, even in the earliest stages of development, the icons from this region had an inimitable nuance related to their own patriarchal concept of life. Among these, we might mention the icon of *Saint Nicholas* PL. 63 *and Saint Philip* in the Tretyakov Gallery[137] and the processional icon of *Saint Nicholas the Wonderworker* in the Russian Museum, painted in the middle of the fifteenth century. This second icon is full of that "ardent faith" which only the peasants from the remote lands of the North could have. In all his features, this peasant-like Saint Nicholas, simple and unaffected, recalls a humble village priest, wearing the episcopal *omophorion* as if by chance. Such expressive immediacy also marks the famous PL. 64 icon of the *Prophet Elijah in the Desert*. An extraordinarily designed composition, with the skillfully fashioned mountains serving as the background and, at the same time, the border for the figure of the seated Elijah, this icon was painted in keeping with Novgorodian traditions. Here, however, everything becomes simpler and more spare, from the simple oval outline of the figure, to the "cubist" terraced rocks, to the pale ocher color scheme intended to create the feeling of a "wild" desert.

PL. 65 In the wonderful icon of *Saint Blaise*, with its more elongated proportions, one already perceives the sixteenth century approaching. This work clearly shows that even the remote region of Olonets was not immune to these new tendencies which appeared in the art of Novgorod and Moscow during the late fifteenth century. Still, the northern master remained true to himself. He gave the outline of

the almost flat head a triangular shape; the beard is exceedingly pointed, the crosses extremely elongated, the folds of the cloak straight, and the vividness of the colors muted. The result is an image which is totally different from Novgorodian icons. It is severe and luminous at the same time and characterized by an impression of rare nobility.

In the surrounding regions, there is no doubt that in a few cases, works of excellent quality were painted. This is also demonstrated by the Gorodets icons which belonged to the register of the feasts PL. 66 in the iconostasis (three icons are in the Tretyakov Gallery and the other two in the Kiev Museum of Russian Art). These works cannot be simply listed in the group of icons of the "Northern Manners." In fact, they are much more refined and accomplished from a coloristic point of view. The tradition of Novgorod is clearly present in them but there are also strong echoes of the art of Moscow. In recent times, a shrewd attempt has been made to attribute them to the school of Nizhnii Novgorod. But all the examples from this school preserved in the Museum of Nizhnii Novgorod (Gorkii) are markedly inferior in quality to the icons of the feasts of which we are speaking.[138] On the other hand, the latter are infinitely superior to all the products of the North as well and are thus unique, mysterious pieces in which it has not yet been possible to identify any suitable and convincing parallel. In the terseness and sobriety of their artistic language, as well as in the conception of their coloring, the continuity with the Novgorodian tradition is immediately evident, but to this day, no icon painted in this manner has been found in Novgorod. In the *Descent from the Cross,* all the lines stretch toward the head of Christ and everything is built on the refined effect of nuanced curves. In the *Entombment,* the scene of the great weeping finds an expression without precedent in the emotional force it generates. The three figures bending toward Christ's form, Mary Magdalene with her arms raised to heaven, the rocks threateningly looming over the spectator with their lines converging above Christ's dead body, all of these elements are blended into a unique and powerful melody of epic solemnity devoid of any false glitter. The contrast between Christ's white bands and Mary Magdalene's red mantle produces an unforgettable effect. This economy of color was a prerogative of the Novgorodian masters alone, but they had much to learn from the author of the Gorodets icons in terms of the communication of these gentle spiritual nuances which the efficient and flashy Novgorodians must not have found very interesting.

The art of Novgorod and its vast northern territories will always be one of the most brilliant pages in the history of Russian art. With the fall of the city in 1478, not only did its political importance decrease, but so did its artistic authority. After having established a centralized Russian state, Moscow set out to suppress systematically all local traditions by doing its best to make them flow into the art shaped near the court of the grand prince. Muscovite influences started to penetrate Novgorod with great frequency at the end of the fifteenth century, and this marked the beginning of the end for Novgorodian artistic culture as a profoundly indigenous and original phenomenon. The borders between the iconography from Moscow and that of Novgorod were slowly disappearing and, starting with the second half of the sixteenth century, it becomes more difficult to trace boundary lines between the two schools.

The Pskov School

The iconographic school of Pskov was discovered during recent decades when the icons from Pskov and its surroundings began to be systematically cleaned. Even though nineteenth-century collectors already liked to speak of the "Pskov manner," this term did not yet have a specific meaning. The artist A.V. Grishchenko[139] was the first to speak persistently about a "Pskov School." However, his theory still lacked the support of sufficient facts and, as a result, all his argumentation remained a bit abstract. I.E. Grabar[140] raised the question in a more precise fashion on the basis of new material: the cleaned icons from Pskov. In reality, there were still few of these icons, but it did not prevent Grabar from writing words which were to become prophetic. "From now on, the Pskov School is delineated not less but in fact more than that of Suzdal, and the time is coming when the Pskov school will perhaps present itself to us with as many distinct nuances as those we distinguish in the Novgorod School as things stand now."[141] In fact, after the discoveries following the recent restorations, the specific aspects of Pskov iconography have emerged with such clarity that they allow us to speak with good reason of Pskovian painting as an autonomous iconographic school.

Pskov was an old city, the capital of the Krivichi region in the North. Like Novgorod, it escaped the Tartar yoke and succeeded in preserving its own culture, which flourished in the thirteenth and fourteenth centuries. Until 1348, Pskov was one of the dependent cities of Novgorod; then, based on the Bolotovo agreement, it obtained full independence and became a political center juridically equal to Novgorod the Great. This free city had its own *veche* which promulgated laws, accepted or rejected the prince, heard the reports of its own ambassadors, judged the most important issues, and authorized the allocation of funds for the construction of fortified walls. But, as with Novgorod, the real power belonged to the boyar class: to the governors and the council formed by representatives from the six "districts" into which the city was divided. These "districts" were in turn divided into "quarters," which elected their own representatives, and the "quarters" into "streets," which had their own "elder responsible for the street." Not only did the aristocracy participate in the meetings of the *veche*, but also the *"chyornye lyudi,"* the bulk of the population made up of artisans and merchants. In Pskov, the role of the prince was even more modest than in Novgorod, and given the small size of his territories, there was no great expansion of large landed estates. The land belonged mostly to small owners who formed the majority of the *veche* in Pskov. The predominantly white clergy [married priests without monastic vows] were not hermetically isolated from the rest of the population and did not have their own political weight. Most of the Pskov clergy were of humble origin, and priests took an active part in the economic and administrative life of the city, gathering into numerous "cathedrals." Secular tendencies penetrated into the ecclesiastical milieux, which is reflected in the content and style of the Pskov chronicle, where the religious component is practically insignificant. This chronicle is an absolute stranger to an affected literary style; its language is very popular and closely related to the

local speech. It is not surprising that the heresy of the *strigolniki* emerged precisely in Pskov before it spread to Novgorod later on. This heresy, with its own brand of free thinking, attracted a large circle of artisans, and if there is no direct reflection of it in Pskovian painting, it nevertheless encouraged a less canonical and more individual approach to the traditional iconographic types, which are interpreted in an unusually free manner in Pskovian icons.

The iconography of Pskov has its own well-defined nature. The layout of the icons is predominantly asymmetric and changeable; the design is imprecise but expressive in its original way; the coloring is strong and rather dark with a predominance of emerald green and dark, almost black, green, intense cherry, red with typical shades of orange or pink, dense azure, gray green. The backgrounds are often yellow, but at times gold. Clothes are very often finished by the finest of golden lines which make the colored surfaces shimmer. In its chromatic contrasts, there is something overwhelming, almost dramatic in the coloring. This effect is obtained by a special treatment of the flesh tone, dark brown with abrupt lightening and equally sudden highlighting. The style is ample and energetic with pigments applied unevenly. The artistic language of Pskovian icons is exceedingly expressive and, in that, differs from the harmonious and calm language of Muscovite icons. Analogously, these differences are reminiscent of the fourteenth-century pictorial schools of Sienna and Bologna, which presented equally marked contrasts. Perhaps of all the early Russian iconographic schools, that of Pskov was the most popular in its spirit and the most spontaneous and immediate in its modes of expression.

Not a single twelfth-century icon from Pskov has survived or, at any rate, not one has been discovered up to now, even though it is certain that toward the middle of the twelfth century, masters from Greece, with the help of local artists, were already frescoing the Cathedral of the Savior of the

PL. 67 Transfiguration. The earliest known Pskovian icons (the *Dormition* from the Church "of the Landing Place," named for its location, and the *Virgin Hodegetria*[142] from the Church of Saint Nicholas "of the Pelts," both in the Tretyakov Gallery) go back to the thirteenth century. They are large icons (1.35 x 1 and 1.30 x 1.02 meters) painted according to twelfth-century traditions. The heavy, strong forms are characterized by an obvious primitivism which makes one think of Cappadocian frescoes (for example the fresco in the ancient Church of Tokali Kilise in Göreme from the beginning of the tenth century).[143] The identical faces with their wide-set eyes and large curved noses do not yet have anything typically Pskovian. Comparing this *Dormition* with the similar Novgorodian icon from the Dessiatina Monastery, it is easy to see that Pskov was more backward in its artistic development than Novgorod, and there was a strong archaic current in the first phase of its painting.

PL. 69 A more refined execution characterizes the *Deesis* from the Church of Saint Nicholas of the Pelts, now in the Russian Museum, dating back to the thirteenth century. Unfortunately, the original painting of the faces is almost completely lost, and these faces appear in a remake from a later period, but the contours of the figures, the form of the richly adorned throne, and the shape of the folds have remained intact. In the execution of the clothing, golden *assiste*, greatly loved by Pskovian artists, are so abundantly used that they shatter the surface to an uncommon degree and echo the rhythm of the folds at the level of the purely decorative arabesque. Thus, the work on Christ's cloak and chiton is particularly significant, where we find a totally irrational combination of lines straight as the strings on instruments, which abruptly break at an angle, and gently curved lines, which almost seem to imitate the backbone of a fish. Undoubtedly, the author of this icon had an excellent Byzantine model in front of him, but he transformed it in his own way, neutralizing the principle of volume to the extreme. The artist also asserted his autonomy in the coloring by using green and orange red, colors much appreciated in Pskov.

PL. 68 The most important of early Pskovian icons is definitely the *Prophet Elijah with Scenes from his Life* (Tretyakov Gallery), where local traits emerge with special clarity. Here we find an expedient often employed in the work of Pskovian artists, the daring association on one panel of several totally unrelated themes. At the top, we find a half-length *Deesis* with angels and apostles, clearly inspired by icons placed on the epistyle of the altar partition. In the center and at the bottom, the prophet Elijah in the

desert and twelve (?) scenes from his life are shown; in other words, we are dealing with a hagiographical icon.

Elijah, listening to the voice of God, is not caught at the moment the crow brings him food but when, after a strong wind, the earthquake, and the fire, "a whisper of a little breeze" reaches him and in this the Lord comes (1 K 19:11-12). The monumental and serene figure of the prophet has that expression of patriarchal good-naturedness which Pskovian artists so willingly conferred on their saints. Elijah is shown against a background of mountains, still without the typical stylization of icons from the second half of the fourteenth century. These mountains are striking in the refinement of their chromatic range composed of pink red, pearl gray, violet, and orange red tones. Elijah is wearing a garment of a deep lilac color, over which is draped a silver green cloak, recalling the background, silver at one time but now deprived of its original splendor by oxidation, and the gray-white hair. In addition to these colors, the border scenes also use bright red, brown, dark blue, ocher, and white. In spite of the rather abrupt contrasts, the chromatic system of the icon keeps in general such an unusual silvery tone that it persuades us to attribute this work to a master colorist.

The rectangles with scenes from the prophet's life present calm and spare compositions with simple architectural or uncomplicated landscape backgrounds. The contours of the mountains are skillfully used to frame the figures, emphasizing their movements and creating necessary spaces. In the buildings, totally flat, there is no hint of volume at all. The whole account maintains a great delicacy in its hues and is imbued with great humanity. Especially beautiful is the scene of the *Healing of the Son of the Widow of Zarephath* where Elijah is bending over the little boy lying on his bed and holding him in a loving embrace. Here we perceive that great sense of intimacy found in the Pskovian chronicle where the term "children" is generally quoted in its endearing form (for example, "the women and little ones were exterminated.")

There is no question, of course, that the hagiographical icon of Elijah could have been painted at the beginning of the fourteenth century, even though it is still strongly linked to thirteenth century traditions. Also dating from the beginning of the fourteenth century is the monumental icon of *Saint Nicholas the Wonderworker,* painted with great exactness. The figure of the saint, with two minuscule half-length images of Christ and the Virgin at the sides, stands out against a gold background. The deep cherry color of the garment, painstakingly finished with gold *assiste,* vividly contrasts with the massive white *omophorion,* adorned with black crosses, and the azure collar; the dark flesh tone with greenish shading accentuates a certain austerity, even though the character of the face is clearly softened in comparison to twelfth century icons. If the graphic rendering of the flesh tone, with the help of the strongly stylized lines, goes back to the traditions of former times, the slightly elongated shape of the head already announces, on the contrary, the coming of a new age.

PL. 70

The development of painting in Pskov during the fourteenth century proceeded more slowly than in Novgorod. Many archaic trends were deeply rooted in Pskov, which makes the dating of Pskovian icons more difficult. Works like the *Hodegetria*[144] icon, not yet completely cleaned, *Saint Nicholas* (both in the Pskov Museum of History and Architecture),[145] *Saints Boris and Gleb* (Tretyakov Gallery),[146] and the hagiographical icon of *Saint Nicholas* from 1337(?) (Russian Museum)[147] obviously fall in line with the traditions of past times, whereas others, like *Saint Nicholas* (Tretyakov Gallery),[148] *Saint Demetrius of Thessalonica* (Russian Museum),[149] and *Saint Juliana* (Pskov Museum of History and Architecture),[150] straddle two periods and offer quite contradictory stylistic traits. Only in the last twenty-five years of the fourteenth century did Pskovian iconography reach full maturity. It was precisely during this period and in the first half of the fifteenth century that the best icons were produced, and their inimitable and individual characteristics make it impossible to attribute them to any other iconographic school.

New influences came to Pskov from Novgorod, where the inspired Theophanes the Greek worked in 1378. The activity of this eminent master could not go unnoticed by Pskovian artists, who probably would go to Novgorod to admire the work of the famous painter; and some of them, building on

local traditions and the unforgettable impressions brought back from Theophanes' art, succeeded in creating works of such brilliance and originality that they determined in many ways the future development of Pskovian iconography.

Among Pskovian icons, three in particular present such pronounced stylistic affinity that one can attribute them to a single painter: at any rate, the icons definitely come from the same studio. They are the *Deesis* in the Novgorod Museum, the *Saints Paraskeva, Barbara, and Juliana* and the *Synaxis of the Virgin* in the Tretyakov Gallery. At first sight, these icons strike us because of their pictorial quality, their unusual freedom of style, and a special passionate nature. Barbara and Paraskeva, two very popular saints in Pskov, are introduced into the static composition of the *Deesis,* thereby making the images more familiar and more akin to the faithful contemplating them in prayer. Still preserving the symmetry and traditional immobility of the figures, everything here is permeated by a spirit which moves away from traditional canons. The usual gold background is simulated by a yellow with light and transparent shading; instead of the neutral color on the ground, we find a flamboyant emerald green; instead of the intense cinnabar of the stool, a soft rose; instead of the clear and very distinct splashes of color for the garments, muted lilac, dark green and blue; instead of meticulously delineated faces, a vigorous chromatic plasticity based on the juxtaposition of dark brown shades and areas on the forehead, nose, cheeks, chin, and neck strongly brightened with bold highlights. This original pictorial style enlivens a well-established facial type, with the bone structure clearly outlined and a profound gaze in the deep-set eyes. Whether in the icon's coloring, with its sharp juxtaposition of light and dark, or in its rendition of the faces, over which the light seems to wage a desperate struggle with darkness, we find that completely individual inner tension which will become a distinctive quality of Pskovian iconography and which is rendered even more effectively in the *Deesis* by its contrast with the figures' outer immobility.

An even freer style marks the icon of *Saints Paraskeva, Barbara, and Juliana*. The saints are shown in different poses, thus overcoming the rigid frontal positions in Novgorodian icons with "selected saints." Paraskeva, Barbara, and Juliana seem to be immersed in a heated discussion, each one ready to defend her own interpretation of the dogmas of faith. There is something uncompromising, impetuous, and indomitable about them. The deliberately asymmetrical outlines are full of dynamism, and in them, the soft parabolic lines collide with sharp angles. The background, once light yellow, confers further prominence on the flamboyant colors, the emerald green, cherry, ocher, dark blue, and orange red of the clothes; and with their dark flesh tones, painted in the "Theophanes" tradition, these faces are very alive and passionate. Colors are applied in layers, now thick, now thin; in some places, the pigment is coarsely ground; in others, it forms dense highlights; in still others, it leaves a trace in the shape of a broad stripe; and finally in yet others, it is spread in a very thin layer over a barely perceptible white background (for example, on the cheeks of Paraskeva and Juliana). The preliminary sketch, drawn on the *levkas,* does not always coincide with the final one, another proof of the freedom which distinguished the creative process.

The third icon, which we can certainly regard as the masterpiece of Pskovian painting, portrays the *Synaxis of the Virgin.* It may be the earliest Russian icon on this theme, which explains in part the freedom of the iconographic interpretation since many details were not yet codified, allowing artists greater autonomy in working with the traditional elements of the composition. This theme, already known in Byzantium and Serbia and imported from there to Rus,[151] goes back to a verse from the Christmas liturgy sung on December 25: "We will offer you something, O Christ, you who have appeared on earth. . . ." According to these lines, all creatures offer gifts to the Child as a sign of gratitude: angels offer their singing, the heavens the stars, the magi their presents, the shepherds their guileless amazement, the earth a cave, the desert a cradle, and humankind a Virgin Mother, the Mother of God. The centripetal principle is strongly accentuated in this composition since the image of the Virgin is alone in the center and converging toward her from all sides are the angels, shepherds, magi, and allegorical figures of Earth and Desert. It is the expression of universal joy, of the whole

creation's exultation over the coming of the Savior into the world, the expression of a profound veneration in the presence of the Mother of God who has given birth to the Savior. The Pskovian artist has offered a remarkably personal interpretation of the theme of the *Synaxis*, animating the entire work with a restless, breathless rhythm. The mountains lift themselves up; the throne, with its strange bowed shape, is filled with dynamism; the magi hasten impatiently toward Mary; Desert and Earth impetuously offer her the cradle and cave; the angels, shepherds, reader with the open book, and choir of three deacons glorify her with loud voices. Like a torrent in full spate, all the lines of the rocks flow toward Mary, underscoring her paramount importance. The movements of the figures are brusk and awkward, some convolutions (as with the figure of Earth) are so unexpectedly audacious that they seem almost like echoes of ancient Hellenistic motifs. Intense tones dominate the colors: dark emerald green, light yellow (the background being lost), orange red, cherry, white, black. These hues are juxtaposed without any spaces between, thus giving a special tension to the chromatic range. The dark flesh tones with their abrupt brightening and highlighting, white, clear, luminous like flashes of lightning, also contribute to the creation of this effect. The clothes are finished with pale orange and white lightening applied with a firm hand. All of this together confers on the icon that passionate nature which makes it an extraordinary work of art.

The author of these three icons was a superb artist who, in the impetuous spirit of his art, is markedly reminiscent of Theophanes the Greek and the masters of the Volotovo frescoes. More than from iconographic works, the artist took inspiration from the monumental fresco, drawing from it several benefits, before all else, the ample and energetic pictorial style which he effectively applied to panel painting. As we contemplate this daring art, we instinctively think of a tie to the heretical movements in Pskov at the time, but we do not have reliable data to support this hypothesis. In any case, we are in the presence of that "independent thinking" from which sprang the heresies of the fourteenth and fifteenth centuries in Rus. And if we wish to discover any close relationship for this icon in the history of Pskovian art, it is undoubtedly drawn from the 1313 frescoes in the Snetogory Monastery, in which "the doubts and instability" of the time were so strongly reflected.

Also dating from the last quarter of the fourteenth century is the *Descent into Hell* (Russian Museum). Stylistically, it is close to the three icons just discussed but a bit more reserved in its execution. PL. 74 Here too there are clear echoes from the art of Theophanes; we again detect them in the uncommon impetuousness of the movement, in the unusual dynamic of sudden lightening, in the highlights like blazing fire. Nevertheless, the local tendency emerges decisively in this icon: the crowded composition, scarcely rhythmical, the dense and strong chromatic range, the dark brown flesh tone. It is interesting to notice how in the most forceful poses, there is a certain rigidity which stems from the geometrical standardization of the outlines. In the upper part, despite all the rules, there is an asymmetrical half-length *Deesis* of several figures with Saint Nicholas in place of Christ. This incongruous association leads to a very free design in which not only the central axes of the images in the lower and upper registers lack correspondence but even the symmetry of the groups appearing at the sides of the mandorla, in which Christ is inscribed, proves to be boldly violated. What was important to the Pskovian master was not harmony but rather immediacy and expressive spontaneity.

The subsequent development of Pskovian painting proceeded slowly. The most innovative phase was during the fourteenth century, whereas the fifteenth produced nothing fundamentally original. The patriarchal view of life in Pskov was so potent that even fresco painters and masters of panel painting strictly adhered to their ancestors' legacy. Also, imposing, monumental iconostases were never adopted in Pskov because of the relatively small number of churches. The iconostases with the half-length *Deesis* and the register of the *Feasts* obviously predominate (no fifteenth-century Pskovian icon with the register of the *Prophets* has yet been discovered). In the fifteenth century, we observe a certain brightening in the iconography even if the inner tension which characterizes their images does not completely vanish. The penetrating gazes remain, as well as the uneven and heavy shadows, the daring asymmetry of the composition, the dense chromatic range with its favorite colors: green, cherry,

orange red, and yellow. However, by this time, it would be futile to look for that passionate nature and expressive immediacy which made the icons of the last part of the fourteenth century so fascinating. The purely iconographic methods are back in use: the style is calmer and softer; the improvised and unconventional transitions from light to shadow of the earlier time give way to a technique in which the surface of the illumined areas increases, now delimited with precision, and the thick brush stroke is replaced by linear hatching. These changes have many similarities with the verifiable transmutations in other iconographic schools of the fifteenth century.

PL. 75 The 1409 Evangeliary, produced by the deacon Luka at the Zaveliche Monastery and kept now in the Moscow Historical Museum (*Sin.* 71),[152] helps us date an entire group of Pskovian icons which are stylistically close to miniatures. First of all, we consider the *Nativity of the Virgin* in the P.D. Korin collection (Tretyakov Gallery), with its free compositional scheme in which we find the principle of space accentuated, uncommon in Pskovian iconography. The cubical shapes of the architectural background, skillfully organized along the diagonal of the bed and arranged within the various spatial sections of the picture, remind us of Greek icons in the mature Palaeologan style. The Pskovian master probably had the opportunity to view these works, but did not succeed in grasping the logic intrinsic to their method of composition; as a result, in this icon the solid forms bump into one another, rendering the space narrow and barely rhythmical. Byzantine aesthetics proved foreign and the artist focused all his attention on the very real and simple story, with the tiny figure of Mary in swaddling clothes placed close to Anne, the midwives approaching to wash her, and friends bringing gifts to the new mother. Everything is shown with unsophisticated amiableness and moving candor. Even here, the artist presents a singular *Deesis* in which Saints Nicholas and Anastasia are pictured behind the angels flanking the half-figure of Christ.

PL. 76 The icon of the *Virgin of Tenderness* (Tretyakov Gallery) also dates back to the beginning of the fifteenth century. Christ is pressing against his mother's cheek, his right hand brushing her chin. This charming genre treatment gives a mood of particular sweetness to the icon, whose colors (yellow background, red halos with arabesques, and cherry, dark blue, and rosy red clothing) are kept in a dense range, typically Pskovian. Also quite characteristic of Pskovian icons is the shape of Mary's nose with its slightly prominent tip. The same kind of nose is found in the wonderful icon in the

PL. 77 Tretyakov Gallery showing *Saints Paraskeva Pyatnitsa, Gregory the Theologian, John Chrysostom, and Basil the Great.* A fact indicative of the free interpretation of traditional iconographic models on the part of Pskovian masters is the placing of Paraskeva, the saint most revered in commerce-centered Pskov, the protectress of Friday markets, next to the most illustrious Fathers of the Church. The more brilliant tone of the icon, with white, black, and cinnabar predominating, the gold background — rare in Pskovian iconography — and the more meticulous pictorial style suggest a direct influence from Novgorodian painting; but the slightly darker faces, the dark flesh tone, and the use of deep green clearly reveal the hand of a local master. Especially expressive is the severe face of John Chrysostom, with its exceedingly high forehead and its pattern of highlights carefully planned to form small triangles under the eyes, which enhance the hypnotic power of his gaze.

PL. 78 The icon of *Saint Demetrius of Thessalonica,* already painted around the middle of the fifteenth century, is stylistically quite close to the one just mentioned. His green and red clothing harmonizes perfectly with the gold background and splendidly arabesqued halo which seems to echo the rich decoration on the round shield.

PL. 79 The half-length *Deesis* (Tretyakov Gallery; the icon of the *Archangel Gabriel* ended up in the Russian Museum instead) is also from the first half of the fifteenth century. In it, we can observe a greater austerity in the execution. The lightening is often delimited by shadows, a hint of standardization appears in the faces, and the former psychological tension is clearly reduced. The halo in relief preserved in the icon of the *Archangel Michael* leads one to infer that the other icons of the *Deesis* certainly bore this kind of halo.

The small icon *In You Everything Rejoices,* which occupies a somewhat isolated position because of its miniaturistic style, dates from the beginning of the fifteenth century. The composition is ordered according to the principle of symmetry, but lacks any hieratic rigidity. The rippling lines which outline the halos of the lower group of saints; the unrolled scroll in the hands of John of Damascus, standing near the footstool of the Virgin's throne; the *zakomary* [architectural motif recalling the woman's headgear of the same name] which stand out against the sky and the dome of the church; the trees which seem to sway in the wind, all this brings to the traditional composition, rigidly centered, a dynamic element which emphasizes through contrast the hieratic nature of the central group. The abundance of gold *assiste* on the clothing imparts to the pictorial surface an almost "shimmering" appearance, an effect Pskovian iconographers dearly loved.

As it has been demonstrated by the discovery of several hagiographical icons (the heavily damaged *Cosmas and Damian* in the Ethnographic Museum of Vologda,[153] *Paraskeva Pyatnitsa, Barbara, and Juliana* in the Novgorod Museum,[154] *Saint Nicholas* in the Tretyakov Gallery,[155] *Paraskeva Pyatnitsa* in the Historical Museum of Moscow[156]), icons of this kind were very common in Pskov, all the more so since artists frequently painted saints whose help was expected in daily problems. In these fifteenth century icons, especially in the panels with scenes from a saint's life, early traditions were stubbornly maintained, and this makes it very difficult to establish their exact dates. Here, all the basic stylistic traits of Pskovian painting are present. But at the same time, in hagiographical icons, we occasionally come across such a lively and picturesque interpretation of individual episodes that it makes the hereditary tie to fourteenth-century traditions immediately evident.

Pskovian masters persistently pursued their own course of interpretation until the end of the fifteenth century. And if any echoes of Dionysii's aesthetics filtered into their art, reflected in the elegance of the angels' tapered proportions in the icon of the *Nativity of Christ* (Russian Museum) and of the *Virgin Great Panagia, Saint Nicholas, and Saint George* (Tretyakov Gallery), this does not, however, signify substantial changes. All the old stylistic methods, the dark flesh tone, the very individual, distinctively Pskovian chromatic structure are preserved. In this respect, the icon of the *Nativity of Christ* is particularly indicative. Here, with characteristically Pskovian spontaneity, the adoration of the Magi, Joseph in the desert, Joseph's dream, the shepherds who stare in amazement at the star of Bethlehem, and the saints are repeated twice. The clefts in the mountains are submitted to a fantastic stylization which makes them look like a decorated tapestry over whose background are scattered individual episodes and various figures. At the beginning of the sixteenth century, no one either in Novgorod or in Moscow would have arranged the composition in this fashion because an art so original and imaginative would have seemed provincial and old-fashioned to everyone.

Two icons, today in the Russian Museum and Tretyakov Gallery, testify to how strongly the people of Pskov were attached to the legacy of their ancestors, even at the beginning of the sixteenth century. The first is the *Descent into Hell with Saints.* The exceptionally elongated proportions of the figures are clearly inspired by Muscovite models, but all the saints have purely indigenous features with dark flesh tones. The *Descent into Hell,* also like the recently cleaned[157] icon on the same subject in the Pskov Museum of History and Architecture, continues the fourteenth-century traditions displayed in the icon from the Russian Museum. But here, everything is more essential and more carefully accomplished; the wealth of golden *assiste* mutes the coloring, depriving the paints of the emotional expressiveness of an earlier time. The interpretation of Hades, framed by undulating lines, is quite illustrative of the concreteness of Pskovian artistic tenets. Hades is pictured as a turreted city which fully justifies the doors of the underworld being trampled: Could these doors have been, in fact, a simple cave? Against the black background are depicted angels, who in a solid phalanx defeat Satan, as well as the prisoners of Hell, led by an old man gesticulating spiritedly. Only a Pskovian artist could allow himself to represent such a scene.

Just as interesting an example of Pskovian painting from the turn of the fifteenth to the sixteenth century is the second of these icons, the *Trinity.* Even though it was painted almost one hundred years

PL. 81
PL. 80
PL. 82
PL. 83

after Rublev's *Trinity*, there is nothing in the Pskov icon even remotely reminiscent of it. The whole composition, rigid and hieratic, resembles a coat of arms, so great is its balance. The three angels, perfectly identical, sit in a strictly frontal position; the table in front of them forms a strictly horizontal plane; Abraham and Sarah stand facing each other, repeating the same movement (placing jugs on the table). In the center, against the background of a luminous arch, the servant who kills the calf is shown; his curved figure recalls a heraldic symbol. This heraldic principle emerges strongly in the icon's entire compositional structure. The profusion of decoration and golden *assiste*, added to the more painstaking work on the faces, suggests dating this icon toward the end of the fifteenth or the beginning of the sixteenth century. But without these characteristics we could have easily attributed it to the fourteenth century because the logic of the development of Pskovian art was so unpredictable.

Pskov lost its independence after Novgorod. It was annexed by Moscow only in 1510, which probably explains the obstinate resistance of their traditions, which the people of Pskov always cited with extraordinary esteem. With the loss of its independence, Pskov, like Novgorod, slowly started to lose its artistic importance as well, and even though Pskovian artists were still being invited to Moscow in the sixteenth century, they were no longer in a position to produce anything similar to what their distant predecessors, the citizens of a free Pskov, had created.

The Moscow School

The iconographic school of Moscow was established much later compared to that of Novgorod, and the dawn of its flourishing almost coincides with the period of the greatest brilliance for the school of Pskov. For a long time, Moscow was a small, unimportant city and no one foresaw its future splendor. The first reference to the city in the chronicles goes back to 1147, when it was a princely *votchina* where Yurii Dolgorukii prepared a "great banquet" for his neighbor, Prince Svyatoslav Olgovich of Novgorod Severskii. In 1156, Yurii Dolgorukii "founded the city of Moscow." Surrounding his court with mighty wooden walls, he transformed the small town into a fortified city intended, along with Dmitrovo, to defend the roads of access to the Klyazma River from the vicinity of Yachroma and the Moscow River. It marked the beginning of the gradual rise of Moscow, which already had its own prince by the first half of the thirteenth century. However, in the thirteenth century, Moscow was not yet particularly important but only one among many towns subject to the Tartars in fragmented Rus. Its political ascent started much later, in the fourteenth century, when its princes set out to gather the forces of the nation and led the war against the Tartars.

Muscovite princes always conducted themselves with the utmost prudence and shrewdness. In their harsh conflicts against the powerful princes of Tver and Suzdal-Nizhnii Novgorod, Lithuania, the Golden Horde, they always avoided useless bloodshed. In addition, they proved to be extraordinarily tenacious and enviably self-controlled, seizing every possible opportunity to make "conquests" and "acquisitions" and to expand their own land holdings. Especially skillful in this type of conquest was Ivan Kalita (1328–1340), who designated himself great prince of "all Rus." Under him, after the terrible fire of 1337, a new Kremlin was built of wood, surrounded by an oak wall; also during his reign, the first masonry churches and monasteries appeared in Moscow; and finally, under his rule, the new metropolitan, Teognoste, was decisively installed in Moscow, a circumstance which contributed substantially toward consolidating the position of the Muscovite prince because, from that time on, the "metropolitan of all Rus" resided in his capital. This fact could only add prestige to the authority of the princes, who year after year increased their own influence over the political life of the country.

Unfortunately, the Muscovite frescoes and icons of the twelfth and thirteenth centuries have not survived and, as a result, we can have no idea of the painting of the time. In all probability, Moscow followed the old traditions of Vladimir, but it is hard to say to what extent these traditions endured during the period of Tartar domination. Since Metropolitan Peter, the first to settle in Moscow, came from Vladimir, he may have brought the "painters of the metropolitan" to Moscow; but this is only a hypothesis based on the fact that, in old Rus, iconographers' studios were frequently associated with the courts of the princes, metropolitans, or bishops and, because Muscovite princes were neither rich nor powerful before Ivan Kalita, it is thus probable that the first cradle of art could have been the metropolitan's court.

PL. 84 In Muscovite painting from the first half of the fourteenth century, no doubt there were, as in the following centuries, diverse trends, local and imported (from Byzantium and southern Serbia). The local current probably had its source in the traditions of the thirteenth century and prevailed until Muscovite art came into contact with the innovations of the "Palaeologan Renaissance." A few of the earliest works of Muscovite iconography are connected with these artistic currents. Among them, the first place belongs to the icon of *Saints Boris and Gleb* in the Russian Museum, perhaps painted in the second decade of the fourteenth century.

A well-founded doubt exists concerning this icon: whether it was painted in Moscow or brought there from another artistic center. Many are inclined to attribute it to Suzdal, assuming that the traditions of Suzdal could indeed have determined the development of Muscovite painting in its first phase (this hypothesis has been developed in a particularly exhaustive way by I.E. Grabar).[158] But none of the Suzdal icons from the earliest period have survived; in addition, the very concept of a Rostov-Suzdal school is still so confused and unclear that it should be used only with the utmost caution.

Boris and Gleb, sons of the great prince Vladimir and treacherously killed by their brother Svyatopolk, had already been declared saints by the Church in 1071. Their images were very widespread in Kievan Rus, and from there, they were even taken to Constantinople, where in 1200, Dobrynya Yadreykovich, the future archbishop of Novgorod, saw a large icon of them in the Church of Santa Sophia.[159] As he himself relates, one could buy copies of this picture from local iconographers, and they were probably sold near the church itself. The icon in the Russian Museum is but one link, preserved by chance, in a long chain of works on the same subject,[160] which makes it even more significant, not just as an outstanding work of art, but also as a valuable iconographic document.

Boris and Gleb do not touch the ground. Instead, they seem to hover in the air, like a miraculous vision. Their faces are absorbed and melancholy, and in their features, the iconographer has preserved that individuality which may have characterized the earliest representations of these saints. In addition to the crosses, which allude to the martyrdom of the two brothers, they each hold a sword, the attribute of princely power. The figures are portrayed without motion and almost without any depth; the simple and restrained line performs the principal task. Serene vertical lines predominate (the outline of the nose, the edges of the cloaks, the swords, the slim legs) and emphasize the slenderness of the figures. Despite the icon's dazzling chromatic richness, its coloring is characterized by an extraordinary spareness and amazing coherence since each color unfailingly derives from another, completing and accentuating it. In this exceptional work, colors attain such vibrant purity and the surface of the forms acquires such graphic expressiveness that they lead us to consider the icon of *Saints Boris and Gleb* a kind of prologue to all subsequent Russian iconography.

The preceding icon of *Saints Boris and Gleb* is still stylistically akin to thirteenth-century works. Only the execution of the features, which is fuller and more attentive to volume, points to the four-

PL. 85 teenth century. In the hagiographical icon of *Saints Boris and Gleb* (Tretyakov Gallery), painted around the middle of the fourteenth century, there is much that is still archaic. Here, we do not find a strongly expressed dynamism, complex architectural forms, spatial constructions, elegant and graceful proportions. The faces of the two saints are rendered in fluid colors with a gradual transition from light to shadow. This method, dubbed "shading" by iconographers, goes back to the painting of the pre-Mongol era. All of this shows the persistence of early traditions, still quite strong in Muscovite painting from the first half of the fourteenth century.

The icon's most successful part is the faces of Boris and Gleb, which are suffused by a warm goodness and gentleness. The artist made an effort to stress the idea of sacrifice, the red thread running through all of the *Story of Boris and Gleb*, that remarkable literary monument from Kiev, written at the juncture of the eleventh and twelfth centuries.

In the quadrangles framing the central figures, the sad story of the treacherous assassination of the two brothers is narrated in extremely clear and concise terms. In one of the upper scenes to the right, the artist has shown Boris asleep in his tent while a prophetic dream announces to him that the end is

now approaching. There appears to him a black wild beast resembling a wolf, an image associated in ancient Rus with the idea of the nearness of death;[161] and, as the *Story* states, the soul of the prince is filled with "deep, heavy, and terrible sorrow." But a solicitous little boy bends over Boris to protect his sleep (a little later in the *Story*, he consoles his "beloved lord" seized by distress). Limiting himself to the indispensable alone, the artist set the main focus on the figure of the black beast, whose dark silhouette looms oppressively against the white background of the tent. Seeing this beast, the spectator understands with instant clarity that an overwhelming calamity threatens the prince. Such is the laconic language of the Russian icon that in its best examples, with but a single word, a slight hint, it makes everything comprehensible.

The next episode depicts the murder of Boris and George Ubrin. Here, too, we have the tent and a mountain as the background. One of the assassins thrusts the lance, the other runs his sword through the boy, George Ubrin, the prince's servant, who attempts to shield the stricken prince with his own body while saying these moving words: "I will not abandon you, my beloved lord. Where the beauty of your body fades, there I will lay down my life." The author has arranged the figures in such a way that everyone is turned toward Boris lying on the ground. Their inclined heads are set along a diagonal as if to direct the eyes of the observer to the face of the dying prince, and the same diagonal is depicted in the line of the tent. By these simple means, the artist achieved a great expressiveness and narrative lucidity. The story is related in epic tones, presenting an action which unfolds in time as an event outside of time, symbolizing the principle of evil in human life.

In the cycle of the scenes from Gleb's life, the episode with the body of the slain prince cast into the desert, lying between two logs (tree trunks hollowed out like a boat in which the early Slavs buried their dead) is unusually expressive. A column of fire suddenly appears; a burning candle and the song of angels attract the attention of hunters and passing shepherds who pick up the body and carry it to Yaroslav. The artist limited himself to representing the first phase of the story, painting the solitary body of the murdered prince, who lies between two motionless horizontal shapes, and placing above him the figures of the grieving angels and the miraculous column of fire descending from heaven. The spare, asymmetrical composition is striking because of that inner concentration which is a special characteristic of fourteenth-century icons.

If the icon of Boris and Gleb maintains a lyrical mood, the atmosphere in *Saint Nicholas the Wonderworker with Scenes from His Life* is quite different. In its free and decisive pictorial style and in the uncommon tension of its psychological structure, we sense the hand of a master not very accustomed to examining models. With its characteristic style, this icon occupies a singular place in the panorama of early Russian painting and even now remains a unique work within its genre. In its spirit of rebellion, it forcefully recalls Pskovian icons from the end of the fourteenth century: its style is "primitive," but the face is well delineated, something rarely found in this kind of icon. The border compositions, somewhat rigid and lacking rhythm, are characterized by a great freedom in the placement of figures and architectural backgrounds: now very crowded, now intentionally sparse, with a refined effect created by the intervening spaces. There is something discontinuous, abrupt in the rhythm of the narrative. The two scenes representing three men locked up in prison and Saint Nicholas driving the devils out of the well, are particularly beautiful. The helpless figures of the three men, with their feet in chains and their faces burning with anger, are so convincingly painted that they transform this composition into a scene from life where very little of the iconographic canon is left. No less lively, and even with a touch of irony, is the rendition of the episode of the expulsion of the devils, who jump out of the well in terror as Nicholas waves his stick at them.

PL. 86

How strong the influence of thirteenth-century art might have remained in Muscovite painting is attested, not only by the miniatures of the Evangeliary executed in 1339–1340 for Ivan Kalita (Library of the Academy of Sciences of the USSR of Leningrad [St. Petersburg], Arch. kom 189),[162] but by an entire series of Muscovite icons, for example, the *Savior* in the Cathedral of the Annunciation in the Moscow Kremlin,[163] the hagiographical icon of *Saint Nicholas* (whose restoration has barely begun) in

the Cathedral of the Dormition in the Kremlin,[164] *Saint Nicholas* in the Monastery of the Trinity of Saint Sergius, which may have been for a while in the cell of Saint Sergius of Radonezh himself.[165] All these works, never equaled since in style, are characterized by strong primitivism which leaves us especially surprised because they were painted in the first half of the fourteenth century when the Palaeologan style was already quite widespread in the countries of Southern Slavia. The turning point in Muscovite painting occurred only during the 1340s with the arrival of masters from Constantinople, invited to Moscow by the Greek metropolitan Teognoste.

The relations between Moscow and Constantinople were quite active in the fifteenth century, and the first to bring Greek influences and to make the language known were metropolitans and bishops of Greek origin. In Moscow, there was a Greek colony which had its own monastery with the Church of Saint Nicholas. A center for the transmission of Byzantine culture was the Muscovite Monastery of the Theophany, from which came several learned men, one, the future Metropolitan Alexius, and another, Stefan, the brother of Saint Sergius of Radonezh and confessor to Prince Simeon the Superb. Fyodor, the hegumen [head] of the Simonov Monastery repeatedly went to Constantinople, a city which always exercised a great attraction for Russians. It is no accident that they would go so willingly to "Tsargrad," where they not only visited the sacred places but sometimes even settled. As, for example, Afanasii, hegumen of the Monastery of Serpuchov of the Heights (Vysockii), who bought a cell in Constantinople and spent the rest of his life far from his homeland.

In light of these facts, it is easy to understand the decision of Metropolitan Teognoste, a native of Constantinople, to invite Greek painters. The new masonry churches built in Moscow required frescoes, and the metropolitan availed himself of this great opportunity to summon Greek masters from Tsargrad so that they might demonstrate for the Muscovites all the refinements of Byzantine painting.

The Moscow chronicles relate the arrival of the Greek painters in great detail. In 1344, Teognoste entrusted them with frescoing his metropolitan church, dedicated to the Immaculate Mother of God,[166] a task which was to be completed within a year. It is difficult not to recognize here the hand of the masters from Constantinople who introduced the new "Palaeologan" style, whose influence is not yet detected in the series of Muscovite icons from the first period. However, at the same time Greek artists were working, "Russian iconographers" were also frescoing the Palatine Cathedral of the Archangel.[167] The "brigade" of Russian painters was led by Zacharii, Dionysii, Iosif, and Nikolai. Later on, in 1345, the chronicles make no mention of the brigade of Zacharii and his companions,[168] but mention instead a new studio of artists, headed by Goitan, Semyon, and Ivan. The chronicler describes them with great precision: "Russian by birth but Greek by training." They painted the frescoes of the monastic Church of the Savior in the Wood, completed in 1346. All these historical details trace an interesting panorama of the artistic life of Moscow in the 1340s, from which it is clear that the churches were decorated with frescoes painted either by masters from Greece and their pupils or by Russian artists. It is interesting to note how the chronicler takes care to identify these three groups of painters with exactness. The same sweep of creative energy was probably also at work within the sphere of panel painting, which easily explains the presence of diverse iconographic trends, some conservative, distinguished by an open archaism, and others more progressive, taking their inspiration from forms evolved from the more mature Palaeologan art.

Some works of Muscovite panel painting which still survive allow us to shed light on the activity of Goitan and his companions, in other words, on the work of those artists "Russian by birth but Greek by training."[169] These are the *Savior of the Fiery Eye, Saints Boris and Gleb,* and a *Trinity* not yet completely restored. These three pictures come from the Cathedral of the Dormition in the Moscow Kremlin, and they give us an idea of the direction in which Muscovite painting developed during the 1340s, a direction which was undoubtedly supported by the court of the grand prince, whose economic and political position strengthened year after year. These circles were avidly attracted to Byzantine culture, anxious to crown their own power with the aureole of "pilgrim" splendor, emphasizing at the same time their own superiority over other independent princes.

The icon of the *Savior of the Fiery Eye,* with its dark and dramatic chromatic range, takes its inspiration from the Byzantine palette. In the boldly asymmetrical outline of the head, in the pictorial rendition of the face with the help of heavy highlights and *otmetki,* in the light azure color of the chiton, new influences have already materialized. On the other hand, however, the figure is still somewhat heavy and the expression of the face is as severe as in twelfth-century icons. The deep wrinkles of the forehead and the strongly accentuated furrows on the neck are elements rare in thoroughly Byzantine icons executed in a more polished fashion. But here, these dynamic lines confer a great inner tension to the image. It is no wonder that the icon has been named the *Savior of the Fiery Eye.*

PL. 87

The icon of *Saints Boris and Gleb,* now in the Tretyakov Gallery, inherited a great deal from the Byzantine palette. This wonderful masterpiece is the work of a first-rate master who has drawn a broad idea from his knowledge of fourteenth-century Byzantine painting, but without surrendering anything of his personal style. The icon has an unusually elongated shape (it was probably intended for a pillar). The saints, clothed as warriors, are shown holding lances and seem to be departing for a military campaign, ready to bring help to the prince of Moscow in his battles. The words which the author of the *Life* of Boris and Gleb addresses to the two saints confirms this interpretation of the icon: "You . . . are our army, our defense and support, the steadfastness of the Russian land, two-edged swords."[170] Boris and Gleb ride a black horse and a bay, rhythmically pacing in step. The horses do not seem to stride over the clefts in the rocks so much as glide above them. It appears that the artist wanted to depict the prodigious flight of the two riders over earth, or better, over the chasm dividing the two mountains. The slender figures, perfectly drawn within the rectangular panel, are flanked by the mountains, which fill the lateral spaces and thus give great stability to the entire composition. The half-length Christ in the top right corner is masterfully balanced by the lances slightly inclined to the left. The artist chose the colors of the riders' garments with exquisite taste: the steel-colored reflections on Boris' tunic and rose red cloak as well as Gleb's cherry red tunic and emerald green cloak.

PL. 88

Echoes of the presence of the Greek masters in Moscow are also sensed in the large icon of the *Trinity.* Despite the immobility and rigidity of the composition, reminiscent of the Old Testament variant, this monumental work is an achievement of high artistic value, which is particularly evidenced in the restored head of the angel to the right, with fine, elegant features and thick hair. In this icon, one already senses clearly that the period of Rublev approaches.

PL. 89

Unfortunately, we know practically nothing about Muscovite painting from the last thirty years of the fourteenth century, and as a result, we are reduced to mere suppositions. Several styles were probably still in existence. Muscovite icons like *Saint Nicholas with Scenes from His Life* in the Tretyakov Gallery[171] and the *Virgin of Tichvin* in the Trinity Monastery of Saint Sergius[172] are marked by a strong archaism and exhibit no trace at all of the new "Palaeologan" influences. The icon of *Saint Nicholas* in the Cathedral of the Dormition in Moscow is halfway between: already, in its pictorial interpretation of the face and hands, the mature stylistic hallmarks of the fourteenth century are unquestionably emerging, but the figure itself, stocky and heavy, has a stiff and static quality.

But neither did the Byzantinizing current disappear, as the embroidered veil made in 1389 for Princess Mariya Aleksandrovna Tverskaya, the widow of the Prince of Moscow, Ivan the Proud, certifies with distinctive evidence.[173] The slender and refined figures of the Virgin, John the Baptist, the angels, and the four bishops of Moscow, who are at each side of the *Holy Face,* form a strange *Deesis.* The supple rhythm of the figures, with their gracefully inclined heads and precise proportions, clearly demonstrate how Muscovite artists had already systematically assimilated the principles of Palaeologan aesthetics by around 1380. This Byzantinizing current undoubtedly has its source in the projects carried out by the Greek painters employed by Teognoste and by their pupils mentioned in the chronicles. Goitan, Semyon, and Ivan definitely worked during the 1350s and 1360s, and it is entirely possible that "the starets Prochor of Gorodets" might also have been formed exactly like them; together with Andrei Rublev, he helped Theophanes the Greek paint the iconostasis of the Cathedral of the Annunciation (?) in the Kremlin in 1405. If the starets Prochor was about fifty-five at the time,

this line of succession is not at all improbable. The 1390s saw a sudden surge in the Byzantinizing current due to the importation of a large number of Greek icons and to the work of Theophanes the Greek, who came to Moscow no later than 1395, when, together with Semyon Chernii and his disciples, he began to fresco the Church of the Nativity of the Virgin.

The arrival of Theophanes the Greek in Moscow was great good fortune for Muscovite artists,[174] who found in him an extraordinarily gifted master through whom the finest tradition from Constantinople entered Rus. In his famous letter, Epifanii the Wise, listing the cities in which Theophanes had worked prior to his arriving in Rus, specifies Constantinople, Chalcedon, the Genoese colony of Galatia (a suburb of Constantinople), and the Genoese colony of Caffa on the Black Sea.[175] There is no reason, then, to doubt the Constantinopolitan origins of Theophanes' art, further confirmed by the closeness of his artistic style to that of the frescoes of Kariye Giami. His formation as an artist goes back to the time when the Hesychast disputes had reached their climax and even he could not remain indifferent to the never-ending debates on the nature of the light of Tabor and on the Hesychast ascesis, which led to the attainment of inner peace. Theophanes arrived in Rus no later than 1378 when his talent was already mature. He knew to perfection all the refinements of Palaeologan aesthetics and undoubtedly brought with him a rich assortment of the most recent models even if, as Epifanii claims, he did not like to look at them while he was working. He was a man of great spiritual cultivation, and Epifanii himself called him a "wise and most discerning philosopher." But, we should not forget that the Byzantine Theophanes spent close to thirty years in Rus, in an alien land, among totally foreign people, and under conditions utterly strange to him. In this new environment, he had to feel freer than under the jealous control of the Byzantine clergy, and so it is quite natural that it was precisely in Rus he could fully express his tremendous talent. Here, he also had the chance to execute monumental works, an opportunity which his homeland would certainly not have been able to offer him because of its progressive decline. In Moscow, Theophanes the Greek worked not so much as a fresco or icon painter, but as a miniaturist, decorating valuable manuscripts with illuminated initial letters and small or large scenes.[176] He undoubtedly had a spacious studio where local masters collaborated with him, and his art, powerful and expressive, exercised an irresistible fascination for the Muscovites. In addition, Theophanes had disciples and followers, and his presence contributed substantially to elevating the quality of Moscow's iconography. But his influence was short-lived because Andrei Rublev broke away from him fairly soon to become the advocate of artistic ideals opposed for the most part to those of Theophanes the Greek.

Today we know that Theophanes was not the only Greek master working in Moscow. In an annotation to a manuscript by Simferopol, recording the inscription on a lost icon, there is a mention of the Greek hieromonk Ignatii, who painted the icon of the *Virgin of Tichvin*[177] for Yurii Dmitrievich, the son of Dmitrii Donskoy, in 1383. This Ignatii was a monk of the Monastery of the Archangel in Smolensk, and in 1389, he went on pilgrimage to Constantinople with the retinue of Metropolitan Pimen. He may be the author of the beautiful late-fourteenth-century Greek icon now preserved in the Monastery of the Trinity of Saint Sergius *(The "Peribleptos" Virgin)*.[178] Other Greek masters also worked in Moscow; they painted the *Hodegetria,* not completely cleaned yet, on the back of a twelfth-century icon of Saint George[179] and the splendid large icon of the *Apostles Peter and Paul* in the Cathedral of the Dormition in the Kremlin.[180] From all of this, we can infer that Greek artists were not really a rarity in Moscow during the years bridging the fourteenth and fifteenth centuries. And this explains in part why, of all the artistic schools in early Rus, Moscow really assimilated the principles of Palaeologan painting in the most complete and systematic way.

Besides Byzantine masters arriving in Moscow, Greek icons imported from the East were also significantly important as vehicles of Byzantine artistic culture. Thus, for example, between 1387 and 1395, Afanasii Vysotskii (from the Monastery of the Heights) dispatched from Constantinople to the Monastery of Serpuchov a *Deesis* with bust figures which became an excellent school of painting for the Muscovites.[181] During the 1380s, an icon from Constantinople, of a surpassing artistic caliber, ar-

rived in Moscow, the so-called *Virgin Pimenovskaya*.[182] In 1387, the grand prince of Moscow received as a gift from Constantinople the icon of the *Savior in White Clothing*.[183]

Moscow was not just interested in Byzantine art. At the end of the fourteenth century, there was also widespread interest in the works of masters from Southern Slavia. As we know, with the gradual advance of the Turks into Bulgaria and Serbia, countless emigrants sought refuge in Rus, where they were generously welcomed. It was probably one of these, the Serb Lazar, recorded in the chronicles, who in 1404 placed the "prodigious" clock in the Moscow Kremlin,[184] and emigrants must also have been the authors of the large icon *The Queen of Heaven Standing at Your Right Hand* in the Cathedral of the Dormition and of the *Deesis* in the Tretyakov Gallery.[185]

The last quarter of the fourteenth century was an especially propitious time for Muscovite artistic life, and an important event which took place in 1380 proved to be a major influence: the victory of the Russian army over the Tartars in the battle of Kulikovo. Even though it did not eliminate the relationship of vassalage for Russian territories in their confrontations with the Horde or definitively end the bloody incursions of the Tartars into Rus, this event signaled a decisive turning point in the consciousness of the people. Slowly, the conviction gained strength that the key to future victory over the Mongols, to the liberation of the country from their yoke, consisted in the reunification of scattered forces. The battle of Kulikovo had unequivocally established what Russians were capable of when they united as one in the struggle against the common enemy; it had brought a position of predominance to Muscovite princes, who became the major artisans of the unification of the country; and it had contributed to the growth of a national consciousness. Following the battle, faith in the radiant future of Russia began to spread among the people in spite of the harsh conditions they were living under. The leading interpreter of this mood in art was Andrei Rublev, who was closely associated with those circles in Russian society which took a more active part in the movement of national liberation.

Along with the flourishing of Muscovite painting, literature also blossomed and produced a series of memorable works at the end of the fourteenth century — *Zadonshchina, Narration of the Massacre of Mamay, Life of the Grand Prince Dmitrii Ivanovich, Chronicle of the Raid of Tochamysh* — in which there emerges with insistence the preoccupation with the Russian land; and even in the narrative style, emotional resonances, betraying the growing interest in human feelings and passions, come to the surface. At the same time, language also became more complex, flexible, and multifaceted. In the manuscripts from the end of the fourteenth and beginning of the fifteenth centuries, in addition to the new handwriting (Russian semiuncial), there arose the attempt to simplify the old archaic linguistic forms in order to bring the language closer to readers and make it more accessible. We can trace in the chronicles the passage from local isolation to the development of a pan-Russian culture, and at the same time, the Muscovite chroniclers did not hesitate at that stage to assert their own personal points of view, emphasizing in every possible way the role played by the citizens in the defense of Rus against the nomadic tribes.

In the 1390s and at the beginning of the fifteenth century, the central figure among Moscow artists was Theophanes the Greek, who attracted everyone's attention because of his great mastery and the breadth of his horizons. It is not strange, therefore, that Grand Prince Vasilii Dmitrievich turned to him when he wanted to have frescoes painted in the Church of the Annunciation, which he had built "in the court of the Grand Prince." The frescoes were finished — as the chronicle states — in one year, and besides Theophanes himself, "the starets Prochor of Gorodets and the monk Andrei Rublev"[186] also worked on them. They probably also painted the icons of the iconostasis *(Deesis* and *Feasts)*, later transferred to the new Cathedral of the Annunciation, built between 1484 and 1489 in place of the former church which had been destroyed. It is a monument of capital importance in the history of Russian iconography and also in the history of the iconostasis because the latter developed into its classical form precisely in Moscow. From there, it spread to all the territories of Rus and greatly contributed to the evolution of the high iconostases in which the busts were replaced by full-length figures.

In early Russian as well as in Byzantine churches,[187] the partitions separating the sanctuary from the nave were relatively low and did not completely block the light from the sanctuary arch. In wooden churches, these partitions were also made of wood, whereas in masonry churches, they were made of marble or white stone. As a rule, they were in the shape of a portico formed by small columns which supported the epistyle and by balusters on both sides of the opening for the central door (the royal doors), or else like solid stone walls with the door opening in the center.[188] The first type of sanctuary partitions were decorated with icons placed on the epistyle and sometimes in the spaces between the columns, while partitions of the second type were adorned with frescoes. Because the oldest (before the fourteenth century) sanctuary partitions did not survive in Rus, there is no certainty about the positioning of icons or their number. We do know that there were not many and that they did not form more than three registers (the lowest one, the so-called local tier, the *Deesis* on the epistyle, and the *Feasts* above the tier of the *Deesis*). In addition, the *Deesis* did not have full-length figures but busts. The traditional icons of Christ and the Mother of God, which in Byzantium were placed on the pillars of the sanctuary and not transferred to the spaces between the columns before the fourteenth century, could have occupied for a long time the latter position in the wooden churches of Rus, where there were no sanctuary pillars for the local tier. But it is certain that icons which were in special shrines set on their supports (tripods) in front of the partition and the sanctuary pillars, were already part of this first register. The evolution of the iconostasis was probably faster in wooden churches, where there were no frescoes and the sacred images could be concentrated in just one place, the sanctuary partition.

This was the state of affairs in Rus when Theophanes the Greek was commissioned to paint a very large iconostasis. We must take into account the circumstances under which the artist received such an assignment: it was the period of national ascent, of the rapid consolidation of the principality of Moscow; and it was natural for Vasilii Dmitrievich to want to see in one of his churches an iconostasis far surpassing those of all the other churches, not just in its size but also in the significance of its conception.

During the past years, the problem of the origin of the *Deesis* "of the Annunciation" has become much more complicated.[189] As stated in the chronicles, the Church of the Annunciation was frescoed in 1405. Here, the reference is to the church built in the 1390s and later expanded (or rebuilt) in 1416, as a chronicle of a later time reports. Still later, during the 1480s, the Cathedral of the Annunciation, which still stands, was erected. Recent and unfinished excavations have uncovered the foundations of a small single-apse church without pillars under the Annunciation Cathedral in the Moscow Kremlin. These are probably vestiges of the church built in the 1390s. But, its small size (7.05 x 6.95 meters) exclude the possibility that the iconostasis of Theophanes was made for this church and was installed there (without the figures of Saint George and Saint Demetrius, it is already around 10.17 meters). The chronicler seems to have made a mistake (even though he recorded the exact date, nevertheless, there is no question that he was alluding to a different church from the one for which the iconostasis was created). In all probability, the images were painted for some other church and from there later transferred to the Church of the Annunciation of 1416 (?). The whole significance of Theophanes' *Deesis* with full-length figures (individual panels are from 210 to 211 cm tall) lies in the fact that it was intended for a very large church with the arch of the sanctuary providing a great amount of light, rather than for a church without pillars. This is why L.V. Betin proposed the hypothesis that Theophanes' *Deesis* comes from the Church of the Archangel Michael, where Theophanes worked with his assistants in 1395 and where, later on, he may have painted the icons for the iconostasis with other assistants. However, this hypothesis remains mere conjecture since we have no reliable data about the original dimensions of the Church of the Archangel Michael: this problem will remain an open question until new archeological evidence materializes. As we have already said, in all likelihood the chronicler made a mistake in citing the exact date and author of the iconostasis, but not its place of origin.

In recent years, many poorly reasoned hypotheses have been devised concerning the composition of Theophanes' iconostasis. From some information in a chronicle of 1508, remarking on the existence of a tier of *Prophets* in the new Church of the Annunciation, it has been inferred that such a tier of icons must have already existed in Theophanes' iconostasis; and the description of the cathedral in the seventeenth century, which speaks of the icons of *Simeon the Stylite* and *Daniel the Stylite,* gave grounds for surmising that the prototypes of these icons belonged to Theophanes' iconostasis (an expert in the cleaning of icons has demonstrated that, at most, these date back to the mid-sixteenth century).[190] Betin has gone even further and contrived a daring hypothesis requiring an extremely rich assortment of icons in the iconostasis "of the Annunciation," which, besides a *Deesis* with thirteen figures and fourteen *Feasts,* would have also included the tier of the *Prophets* and the tier of the *Patriarchs.* Ignoring the fact that in the course of time in Rus, the custom of increasing the height of the iconostasis was constantly spreading and also the essential point that not a single Russian icon from the fifteenth century showing patriarchs has come down to us, Betin attributes to Theophanes and his collaborator Rublev an innovation for which they surely do not deserve credit. The high Russian iconostasis developed gradually, through a lengthy evolution, and we have no reason to believe that its design, difficult to realize, was the fruit of an intuition in the mind of a single master.

Even less convincing are Betin's reflections on the choice of saints found in the *Deesis.*[191] According to him, Saints Basil the Great, John Chrysostom, George, Demetrius, and the two legendary stylites were introduced into the *Deesis* as patrons of the princes of Moscow, the framers of the "organization of the Russian land." Apart from the fact that the connection between the saints shown on the icons and the names of the Muscovite princes remains highly debatable in most instances, there is, in any case, no evidence of any other tier of the *Deesis* with a similar genealogical content where the holy patrons follow one another in a chronological order according to the sequence of the princes. The appearance of Saints John Chrysostom and Basil the Great in the iconostasis is explained in another way. As the scope of the *Deesis* was expanded, it was natural to introduce first of all the most venerated Fathers of the Church in keeping with hierarchical Byzantine thought.[192] But the figures of Saints George and Demetrius, which end the tier of the *Deesis,* are there for other reasons: the first as protector of the Russian princes and the army and also as patron of Moscow, the second in memory of Vasilii Dmitrievich's father, Dmitrii Donskoy, who commissioned the iconostasis and was the glorious hero of the battle of Kulikovo.[193]

In its original configuration, the iconostasis included eleven figures in the *Deesis* and fourteen *Feasts.* There may also have been a tier of busts of prophets; but we have no reliable proof of that, and this register was probably added later. Theophanes' innovation did not consist in his giving the iconostasis a fundamentally new significance (this had already been sufficiently developed by Byzantine theologians) but rather in having expanded the iconostasis itself, giving it a completely new and monumental aspect. By replacing the traditional busts in the *Deesis* with full-length figures, bringing the height of the icons to 210 centimeters, and also augmenting the composition with the addition of the Fathers of the Church and martyrs, Theophanes notably elevated the iconostasis which finally covered the arch of the sanctuary almost completely.

In Orthodox churches, the iconostasis, which separated the sanctuary from the nave, represented the boundary between two worlds: the world beyond time and the world of time. Its basic themes were rigorously consistent both in the whole and in the individual parts. Ultimately, all the registers of the iconostasis are nothing other than the revelation of the significance of the primordial and fundamental icon of the ancient sanctuary partition: the image of Christ. If the church is a liturgical space which accommodates the assembly of the faithful and symbolically contains within itself the whole universe, the iconostasis represents the becoming of the Church in time and its life until the glory of the parousia.[194] The upper tier, that of the patriarchs, which was not yet in the Cathedral of the Annunciation,[195] embodies the primitive Church of the Old Testament from Adam to the Law of Moses. In the center of this register, there was generally the image of the Trinity ("the appearance of the three angels to

Abraham near the oak of Mamre"), which symbolized the first manifestation of the Triune God (from the second half of the sixteenth century, the second version of the icon of the Trinity, the *Paternitas,* was portrayed more frequently). In the tier beneath is the register of the *Prophets,* also missing from the Cathedral of the Annunciation, which represents the Church of the Old Testament from Moses to Christ. The words on the prophets' scrolls are texts prophesying the divine incarnation. In the center of this tier, we have the icon of the *Virgin of the Sign,* the pictorial interpretation of Isaiah's prophecy (7:14): "Therefore the Lord himself will give you a sign. See, the virgin will conceive and bear a son, whom she will name Emmanuel." Both these registers prefigure the Church of the New Testament, its preparation through Christ's ancestors. The next register, that of the *Feasts,* was already related to the period of the New Testament, the time of grace. Here, we have the representation of Christ's earthly life, and the choice of gospel scenes and their number in this tier could depend upon the wealth of the person commissioning the icon and upon the amount of light from the arch overlooking the sanctuary. Under the tier of the *Feasts* is the row of the *Deesis,* the fundamental nucleus of the iconostasis' very essence. Here, Christ appears as the judge of the universe; next to him and interceding for the sins of humanity are the Mother of God, who symbolizes the Church of the New Testament, and John the Forerunner (the Baptist), symbol of the Church of the Old Testament. The angels, apostles, bishops, and martyrs also take part in this gesture of entreaty. In the *Deesis,* as in the registers of the feasts, there could be changes in the selection of the saints, depending on the desire of the donor; for example, the pictures of the martyrs Demetrius and George were introduced into the *Deesis* of the Cathedral of the Annunciation for that very reason. However, the *Deesis* and its tier have always remained the central nucleus of the entire composition of the iconostasis. Believers trustingly contemplated Christ's image and expected help and forgiveness for their faults from the figures who, near Christ, intercede for the sins of human beings. Finally, in the lowest register, the local tier, are the icons of Christ and the Virgin, on both sides of the royal doors. Icons representing the feast to which the church is dedicated may also be here. The icons of the local tier are arranged either between the columns of the partition or placed, as we have already said, on special supports in front of the partition or on the pillars of the sanctuary.

Because the Communion of the faithful takes place on the solea, the platform in front of the iconostasis, in general, the Eucharist is pictured in the upper part of the royal doors. The theme of the Communion of the apostles emphasizes and witnesses to Christ's role as first priest, and here he appears precisely in that function. Now and then, the Annunciation is presented over the royal doors, next to the Eucharist, but most of the time, it is by itself, near the symbols of the evangelists. This choice of subjects arose from the fact that the royal doors symbolize the doorway into the reign of God, into Paradise. The Annunciation denotes "the beginning of our salvation," revealing to human beings the door to God's realm; it embodies the good news announced by the evangelists.

Therefore, the iconostasis, in its entirety, unveils for believers the ways of divine revelation and of the progressive fulfillment of salvation through the preparation of the Old Testament, through the tier of the *Feasts,* "completion of all that had been prepared," to the future fulfillment of the divine economy, in other words, to the *Deesis,* where everything converges toward the person of Christ, "one Person of the Blessed Trinity." The trend to enlarge the iconostasis extended not only to all of the fifteenth and sixteenth centuries but even to the seventeenth, when the tier of the *Cherubim* and *Seraphim* appeared above that of the *Patriarchs* and the icon of the *Holy Face* or of the *Lord of Hosts* started to take the place of the cross at the top of the iconostasis. Even new registers were added: the *Passion,* the *Apostles,* and one illustrating the martyrdom of the apostles. But all this was not to the advantage of the Russian iconostasis, which began to lose little by little its organic unity and dogmatic clarity along with its figurative expressiveness and monumentality. The spare style of the fifteenth century yielded to a disorganized excess of details deriving from the typical narrative penchant of the seventeenth century; and the iconostasis, weighed down by a rich intaglio in gilded wood, now takes on a different aesthetic tone.

We have deliberately dwelt on the iconostasis because it represents the central artistic issue of all early Russian iconography. Beginning with the fifteenth century, most icons were done for iconostases which, to a large extent, dictated to artists the style and nature of the images. The iconostases taught artists how to appreciate the beauty of laconic forms, the standardized shape, and the splashes of vivid and pure color. These kept painting free from the prolixity of the narrative pattern and from the intrusion of the genre's minute details. Finally, the iconostases contributed to the growth of a taste for architecture among painters. However, there was also another side to the iconostasis, as its subsequent development demonstrates. After the classical form had been achieved in the works of Theophanes and Rublev and, with the appearance of the tier of *Patriarchs*, the programmatic evolution of the iconostasis had attained its logical fulfillment, the icons belonging to iconostases attained canonical status and began to be reproduced with insignificant variations. This process was already under way in the fifteenth century when Rublev and Dionysii after him repeated the designs on which Theophanes' based his figures.[196] Even in Novgorod, the figure of John the Baptist in the *Deesis* "of the Annunciation" became well-nigh canonical.[197] After Novgorod and Pskov lost their independence, Moscow started to introduce high iconostases into those cities by force and at the same time compelled local artists to follow its tradition, excluding any innovation. Thus, the high iconostasis was very quickly transformed into a barrier on the road to its future development.

In the iconostasis for the Cathedral of the Annunciation (?), Theophanes painted only the main icons in the register of the *Deesis* and in the *Feasts*, painted by Andrei Rublev and Prochor of Gorodets, PL. 90 probably limited himself just to corrections. The icons attributed to Theophanes in the *Deesis* are those of *Christ in Glory*, the *Virgin, Saint John the Baptist*, the *Archangel Gabriel*, the *Apostle Paul, Saint Basil the Great*, and *Saint John Chrysostom*, in which one easily recognizes the strong personality of the impetuous master, author of the frescoes in the Church of the Savior of the Transfiguration in Novgorod (1378). They are painted with dexterity and decisiveness and, at the same time, with an impeccable sense of form. The icons of the Apostle Peter and the Archangel Michael reveal the touch of another hand, less skilled, less forceful.[198] These two icons have a gentler expression and their color range is brighter and clearer. One of Theophanes' close disciples and assistants, perhaps of Russian origin, worked on these icons, whereas we owe the figures of the martyrs George and Demetrius to iconographers who were undoubtedly Russian. The author of the icon of Saint Demetrius was probably the starets Prochor of Gorodets, to whom we also owe a beautiful part of the *Feasts*, but the poor condition of the icon of Saint George prevents us from formulating any hypothesis concerning its creator.

Although at least three masters must have worked on this *Deesis*, it is still considered a unified whole, despite the intrusion of the sanctuary pillars, which separated the five central icons of the *Deesis*, placed in front of the sanctuary arch, from the icons depicting the apostles, the Fathers of the Church, and the martyrs, arranged in the arches of the prothesis [chamber to the left of the sanctuary, where the bread and wine are prepared] and the diaconicon [chamber to the right of the sanctuary, which serves as a sacristy], each probably containing three icons.[199] The center of the principal composition is an image of Christ enveloped in white clothing; from both sides, saints move toward him, hands slightly outstretched before them, heads barely inclined. The movement begins at both ends of the iconostasis and finds its consummation in the serene figure of Christ seated on a throne, who serves as the narrative, but also conceptual center of the whole composition. This figure, from Theophanes' brush, has an extraordinary "composure." The tall, powerful figures are clearly defined, with their dark outlines against the gold background; the vertical and horizontal elements form rhythmical combinations which have been thoroughly considered; all the lines are essential; all the chromatic links are carried to the utmost degree of coherence. The composition is so structured that the spectator can embrace it in a single glance. Still, Theophanes' saints do not lose their own individuality, their own characteristic plastic expressiveness. Each, while taking part in the common action *(adoratio)*, also lives a separate life. In the iconostases of the Cathedrals of the Dormition and the Trinity, Rublev leaned

toward a greater compactness in the figures, and he obtained it not just by neutralizing individual traits, but also by accentuating the "universal" principle, that same principle so evident in the Russian icons *In You Everything Rejoices* and the *Synaxis of the Virgin.*

The icons of Theophanes are painted with amazing ease. In the broad pictorial interpretation of the severe faces, one senses the hand of the expert fresco painter accustomed to working on large surfaces. Over the dark, thick layers of *sankir,* Theophanes often spread heavy highlights *(otmetki);* the outline of the nose is emphasized by a strong stroke in vivid red; all the most prominent points are strongly brightened without fear of the abrupt transitions from light to shadow. With these pictorial practices, the artist achieved that inner psychological tension which is so characteristic even in his Novgorodian frescoes.

In creating his full-length *Deesis,* meant to decorate one of the principal churches of the Kremlin in Moscow, Theophanes responded to a uniquely Russian requirement, but he did so as a true Byzantine. The icons of the Cathedral of the Annunciation (?) share a common spirit which strongly recalls the frescoes in the Church of the Savior of the Transfiguration. These frescoes cannot possibly be attributed to the hand of a Russian master: they are full of a spirit of rejection of the world, in which one cannot miss an echo of Hesychast ideas. Their dense, dramatic coloring is devoid of all joie de vivre. Even in the *Deesis* "of the Annunciation," Theophanes' saints appear strong and mighty, and yet, here too, their thoughts are not focused on earthly things. In his *Deesis,* Theophanes did not stress so much the moment of universal forgiveness as the supplication of the saints for the sins of the human race. Christ is interpreted as the severe judge of the universe, not the kind Savior ready to rush to the aid of fellow human beings. It is precisely here that the radical difference between Theophanes the Greek and Andrei Rublev becomes evident. Rublev always tends to accentuate the humanity of Christ; but for Theophanes, the very idea of the *Deesis* necessitates the dramatic confrontation between Christ, who does not intend to forgive a single sinner, and the saints who implore his mercy. This is why there is so much pathos in the figure of the Virgin, why John the Baptist is so filled with humility, why, finally, the two angels seem so fearful. And even the dauntless Fathers of the Church — Basil the Great and John Chrysostom — seem seized with fear in the presence of the terrible Pantocrator [Ruler of the Universe]. All this is infinitely far from the Russian interpretation of the *Deesis,* in which a mood of distinctive tenderness generally emerges. And if Theophanes the Greek had contributed his own interpretation of the iconostasis, using *Byzantine* tools, it would be up to Andrei Rublev to resolve the same matter in a *Russian* way since he would be the first to infuse a new content into old forms.

A few icons which came directly from Theophanes' workshop have been preserved until now. We have already spoken of one, the *Virgin of the Don,* because it is linked to the traditions of Novgorod and was probably painted by the most talented Novgorodian disciples of Theophanes, who may have brought it with him to Moscow. Two other works from Theophanes' school are the large icon of the *Transfiguration* and a small quadripartite icon (both in the Tretyakov Gallery).[200] In its impetuous movement, the *Transfiguration* has ties with Byzantine models from the Palaeologan period. The figure of Christ, who seems to hover in the air, is cloaked in a white garment and is extraordinarily luminous, surrounded by a halo from which rays of light emanate. Beside Christ are the prophets Elijah and Moses, whose figures recur in half-length at the upper corners of the icon as, carried by angels, they descend from the clouds. The apostles are thrown to the ground. The three apostles guided by Christ are represented in the caves of the background. To the left, the apostles and Christ climb Mount Tabor, while to the right, they descend. The composition is perfectly balanced and rigorously symmetrical. All the figures are masterfully brought together by the mountains, whose fissures the artist has intentionally softened so that the spectator might understand the landscape elements as an accompaniment to the scene he reproduced.

PL. 91

Because of the vigorous disputes about the nature of the light of Tabor between the Hesychasts and their adversaries, the theme of the Transfiguration became extremely popular in the art of the fourteenth century and was interpreted in a more lively and dynamic way than had been done in the art of

the eleventh and twelfth centuries. Among the many icons and miniatures on this subject, the Tretyakov icon is particularly interesting because the idea it expresses clearly follows the doctrine of Saint Gregory Palamas concerning the light of Tabor. Plainly, the artist wanted to portray, first of all, the cold silvery splendor radiating from Christ, which is reflected on the rocks of the mountains as well as on clothing and faces. Like a leitmotif, this silvery gray light suffuses the entire chromatic range of the icon, bringing to mind the description of Christ's appearance on Mount Tabor according to Palamas: "Christ, sun of truth and justice, wanted above all to show himself to the apostles in the most intimate way possible. Then, a great splendor beaming from his extraordinary luminosity, he made himself invisible to them, like the sun when one looks at it, and he was enveloped in a luminous cloud."[201] And Gregory's teaching explains the unique form of the mandorla, composed of two spheres and the resplendent nucleus from which three rays emerge. According to Gregory, the light of Tabor was the symbol of the divine Trinity,[202] and drawing his inspiration from this, the author of the icon fashioned the mandorla in three parts and had three rays coming from the glowing cloud, wanting to indicate in this way how the light of Tabor is intrinsic to the three Persons of the Trinity.

An icon like the *Transfiguration* could come only from an artist close to the Greek master and, moreover, well-versed in all the subtleties of Byzantine theology. This is a further sign of its connection with Theophanes' studio, especially if we bear in mind that Hesychasm did not have a major effect on Russian painting because Gregory of Palamas' works were unknown in early Rus. The author of the icon, which bears inscriptions in Slavonic, may have been one of Theophanes' most faithful disciples, accustomed, like his master, to working on large surfaces. In that case, Theophanes may have introduced him to the fundamentals of the Hesychast doctrine, which the former must have known to perfection but which always remained foreign to Russians in its extreme form.

The icon of the *Transfiguration* unites in itself both Greek and Russian features. The metaphysical concept; the coloring, dark and rather unusual for Russian icons; the severe Christ, a type recalling Theophanes' Savior, all of this would seem to suggest the work of a Greek master. But the faces of the prophets and apostles are already Russian; in them, there is no trace of the Byzantine severity, rather a greater gentleness and detachment. The poses of the deeply moved prophets, bowing before Christ, are not typically Byzantine either; in Greek icons, the prophets are generally presented in a more upright position to underscore the solemnity of the scene. This original blend of Greek and Russian elements allows us to attribute the icon to either a "Russified" Greek, or else — which seems more likely — a Russian pupil of a Greek master.

Someone with a strong personality like Theophanes the Greek must have had a profound impact upon Muscovite painting. Even though his influence did not last very long and, after his death, was quickly reduced to zero with the arrival of Andrei Rublev, it was, nevertheless, very fruitful and even affected artists who did not work in his studio. Three icons may be attributed to them: *The Virgin Orant* in the Tretyakov Gallery, the recently cleaned *Crucifixion* in the Andrei Rublev Museum of Early Russian Art, and the magnificent icon of the *Virgin of the Don* in the Tretyakov Gallery.

The first of these works was donated by Tsar Aleksei Michaylovich to the Monastery of Saint Hy-patius in Kostroma, from which we can infer that it was an icon highly appreciated for its excellent PL. 92 artistic qualities. Its ancient and most refined silver covering has also been preserved. These coverings, already known in Byzantium,[203] became more and more widespread in Rus at the end of the fourteenth century. The glistening of the gold and silver blends splendidly with the vivid colors like precious stones, brilliant and pure. The purpose of the coverings of the early Russian icons was to accentuate at the same time their being both precious and devotional objects. They contributed to separating the icons from the flow of everyday life and at that level they had the same function of abstraction produced by the gold background. But this separation from reality was even more accentuated in the coverings because the image was surrounded by the precious metal often decorated with precious stones. In the course of the fifteenth to the seventeenth centuries, the coverings grew heavier and became more and more massive and magnificent, to the detriment of the painting. However, during the

fourteenth and fifteenth centuries, the balance between the pictorial image and the covering was still preserved, since the fine and delicate ornamentation engraved on the covering harmonized well with the surface of the panel.

This type of covering is exactly what we can see on the Tretyakov icon. It frames and emphasizes at the same time the silhouettes of the two figures: the Virgin bends toward the Child and gently squeezes her Son's hand in hers. These gestures give a particularly affectionate tone to the image. The faces have been worked with fine brush strokes deftly applied over the brightest parts. From this pictorial style, it is easy to perceive that the author of the Russian icon must have been very familiar with Greek models.

PL. 93 The artist who painted the *Crucifixion* must also have strongly felt the Byzantine influence. Unfortunately, this work has lost its frame; and thus the dimensions of the original panel, to which Russian iconographers attached great importance in determining the proportions of their compositions, have been altered. In this icon, emotional accents are emphasized by every possible means: the markedly elongated body of Christ, his head which falls on his shoulder, the solitary figure of Mary, John's bowed frame, the melancholy gesture of his right hand. All these details are already present in Byzantine icons of the thirteenth and fourteenth centuries, but the Moscow icon achieves a special emotional resonance. In the essential, standardized outlines of the figures, it is not hard to recognize the hand of a Russian master who drew his own conclusions from the study of Theophanes' painting. John's face is especially well preserved, painted in such a simple and natural way and with an anguished expression so convincing that it reminds us of the apostles' faces in the *Dormition* on the reverse side of the icon of the *Virgin of the Don*.

Linked to this last icon is the Tretyakov Gallery's small icon, also furnished with its antique covering of embossed silver. While accurately reproducing the famous original, the artist introduced some barely perceptible modifications: the Child's head is not thrown back as much and the feet are straighter. Thus, Christ's figure becomes less spontaneous while retaining completely the mood of infinite tenderness, which is always so moving in the icons which represent the Mother of God caressing her Son.

Because of their dense and thick colors, the group of icons we have just mentioned are very reminiscent of Byzantine panel painting. In these icons, we do not find that clear and pure color which asserts itself in Russian iconography from the thirteenth century and which appeared with such obviousness in many Muscovite icons from the first half of the fourteenth century. Instead, this radi-
PL. 94 ant color is found in the small icon depicting the *Feasts*. The style of this Muscovite icon, with its graceful and elegant figures, its dynamic compositions, its bold chromatic combinations, belongs to the end of the fourteenth century, in other words, to the time Andrei Rublev (about 1370–1430) had already started working.

Rublev's arrival on the scene signaled the beginning of a new and extremely important chapter in the history of Muscovite iconography, which had already started to form an autonomous school even though it acquired its clearly identifiable characteristics only after the first quarter of the fifteenth century. Before then, there was no stylistic standardization in Muscovite icons. These icons attest to the presence in Moscow of various artistic tendencies which were often totally different from one another. Rublev succeeded in blending together local traditions and everything he had derived from the works of Byzantine masters. He owed much to Théophanes the Greek, with whom he worked, even if he placed himself at the opposite pole from his master because his artistic talent was different: severe images, filled with dramatic force, would always be foreign to him. Rublev's vision was distinct, more contemplative and serene, and he deliberately rejected the Byzantine reduction of the form and archaic local traditions, tenaciously rooted and hard to eliminate. In this way, Rublev constructed such a perfect artistic language that his style dictated laws for the entire fifteenth century, and he was held in such renown that for a long time he was considered the unsurpassable ideal of iconographers.

Details concerning Rublev's life are rather scanty. It is not impossible — as M.N. Tichomirov[204] and V.A. Plugin[205] suppose — that Rublev had already started on his own artistic path when he was

still a layman in the workshop of the grand prince. His name is mentioned for the first time in 1405, when he was working along with Theophanes the Greek and the starets Prochor of Gorodets on the frescoes for the church of the grand prince. The chronicles call him "monk," but where and when he received the tonsure still remains a mystery, perhaps in the Monastery of the Trinity of Saint Sergius or the Muscovite Monastery of Andronik. However, one thing is certain, Rublev's close ties to the spiritual movement headed by Sergius of Radonezh (1322–1392), which gave a strong impetus to the growth of cenobitic monasteries in Rus.[206] Like Francis of Assisi, Sergius was also opposed by principle to all ownership, and even more to wealth. He was against any form of forced labor by the peasants on lands belonging to monasteries, maintaining that these lands should be cultivated by the monks themselves. According to Sergius, people had the right to compensation only for the work they had done with their own hands. During his years in a hermitage, Sergius must have learned the Byzantine practice of Hesychasm, which his most faithful follower, Nil of Sora, would later call the "spiritual prayer"; nevertheless, this did not distance him from the world's problems. As an adult, he took an active part in the country's political life, reconciling battling princes; he contributed in every way to the growth of the principality of Moscow and helped Dmitrii Donskoy prepare for the battle of Kulikovo. In the eyes of his contemporaries, Sergius had such great moral authority that his ideas of fellowship, abnegation, and spiritual self-perfection exercised a very potent influence on artists, among them Rublev. At Sergius' initiative, many new churches and monasteries were dedicated to the Trinity: the image of the Trinity was for him the sign of unity and concord. It is no wonder that in his *Life of Saint Sergius*, Epifanii the Wise wrote that Sergius built the Church of the Trinity "so that the odious divisions of this world could be overcome by contemplating the Trinity."[207] And it is precisely in remembrance of Sergius that Rublev created his greatest work: the icon of the *Trinity*.[208]

The chronicles mention Rublev's name for the second time in 1408, when he worked in the Vladimir Cathedral of the Dormition along with the "iconographer Daniil."[209] With this same Daniil, he frescoed between 1425 and 1427 the Cathedral of the Trinity in the Monastery of the Trinity of Saint Sergius, which was built by the hegumen Nikon, a close disciple of Sergius of Radonezh.[210] A seventeenth-century source records that Rublev spent a period of novitiate near Nikon and Nikon himself commissioned him to do the icon of the *Trinity*.[211] According to the account of Epifanii the Wise, Rublev also worked in the Monastery of Andronik, founded by a disciple bearing the same name as Sergius of Radonezh. Here, it seems he had participated not only in decorating the church but also in constructing it.[212] M.N. Tichomirov[213] assumes that at that time, he was not a simple monk but rather a starets of the cathedral, who governed the monastery along with the hegumen and the other startsy. From an eighteenth-century copy of the lost tombstone of Rublev, recovered by P. D. Baranoskii, it appears that the iconographer, buried in the Monastery of Andronik, died on January 29, 1430.

This is all we know of this glorious master's life. Later sources mention Rublev as an excellent iconographer, a man of extraordinary intelligence and with a broad experience of life, also stressing at the same time his profound monastic humility.[214]

Since no work signed by Rublev has survived and considering that in the period we are dealing with, paintings were usually executed by the entire studio (called "brigades" in the chronicles), we can understand the difficulty encountered by scholars who want to identify the works painted by Rublev himself among the anonymous icons of the pupils and followers of the great master.

The origins of Andrei Rublev's art are lost in the unknown. It seems that the artist was born around 1370. In the 1390s, Theophanes the Greek arrived in Moscow and soon drew everyone's attention to himself; and in all probability, Rublev did not remain indifferent to the fascination of this genial master. At any rate, in 1405, he collaborated with Theophanes, who at that time was painting the iconostasis now in the Cathedral of the Annunciation in the Moscow Kremlin. This collaboration may have started even earlier, at the end of the fourteenth century, when Theophanes worked on the decoration of the *Chitrovo Evangeliary*.[215] He himself painted the miniature of John the Evangelist dictating to Prochor and the angel enclosed in the circle, the symbol of the Evangelist Matthew. Another, less

expert hand is responsible for the miniatures representing the Evangelists Matthew, Mark, and Luke. Here, unlike the stern looking John, the faces have a more open and benevolent expression, and Russian physical features (especially in Matthew) clearly emerge. The motifs of Palaeologan architecture, not too successfully employed, prove heavy and uncoordinated among themselves. Everything in these miniatures suggests the hand of a Russian genius not yet fully trained who was attempting to master all the details of Palaeologan painting. There is a most attractive hypothesis that this artist may have been the young Rublev, at that time a pupil in the studio of Theophanes, whose influence is captured in the fresco by Rublev representing Saint Laurus in the Cathedral of the Dormition in Gorodok, near Zvenigorod (around 1400).[216] These works, which we might attribute to the young Rublev only hypothetically, conceal within themselves a great contradiction: while they imply that the origins of Rublev's art go back to the best traditions of Palaeologan painting, especially to Theophanes' Muscovite workshop, at the same time, they witness to the young artist's keen effort not to sacrifice his own concept of the image, much more luminous and limpid than what we find in the works of Byzantine painters.

The next stage in Rublev's work involves the icons of the *Feasts* from the iconostasis "of the Annunciation." Three stylistic groups are quite clearly identifiable in this iconostasis: the first, represented by the *Deesis,* is for the most part the work of Theophanes; the second includes the icons from the tier PL. 96 of the *Feasts* from the *Annunciation* to the *Entry into Jerusalem;* the third is also part of the tier of the PL. 95 *Feasts,* from the *Last Supper* to the *Dormition.* These last seven *Feasts* are executed in a more pictorial style still leaning towards the art of the fourteenth century, whereas the first seven betray the hand of a master belonging to a younger generation. The latter resorted to a nuanced style, with gradual transitions from light to shadow, and he did not like heavy highlights or "expressive strokes." It spontaneously comes to mind that among the three masters of the Cathedral of the Annunciation mentioned in the chronicles, the author of the third group of icons could only have been a representative of an older generation, in other words, "the starets Prochor of Gorodets." The author of the second group, on the other hand, must have been a younger master, in all probability Rublev himself. Not by chance does the chronicler record his name in the third place, respecting the order of seniority and degree of renown of the other artists.

PL. 95 Prochor was a very skilled master, but hardly of an artistic temperament. His colors are beautiful, his style is good; all his compositions are accurately and carefully thought through and his hand is quite flexible. Prochor loved abrupt brightening, thick highlights and quick "characteristic strokes." There is something standardized in the types of his faces with their pointed noses and small, elegant hands. In general, his art presents him as a convinced Grecophile who was well acquainted with the examples of fourteenth-century Byzantine painting. Prochor was likely a direct continuation of the tradition of Goitan, Semyon, and Ivan, who were "disciples of the Greeks," as the chronicles attest.

PL. 96 The author of the second group of icons, which includes the *Feasts* from the *Annunciation* to the *Entry into Jerusalem,* is evidently in a line of stylistic continuity with the author of the third group. Perhaps Prochor, who was probably Rublev's first master, pointed out his extraordinarily gifted pupil to Theophanes. Prochor and Rublev had much in common in their concepts of design, proportion, and composition. But the disciple revealed an artistic personality incomparably more pronounced. I.E. Grabar has justly defined him as "an artist obsessed by the chromatic quest and able not merely to capture the first lively combinations which passed through his head but to blend them into a harmonious effect."[217] In comparison with his coloring, Prochor's chromatic range, although beautiful, seems a bit dull and attenuated. Rublev loved strong, pure colors: pinkish red, malachite green, lilac, silvery green, golden ocher, dark green; and he willingly resorted to azure lightening. He used colors with such impeccable taste that he surpassed by far all his contemporaries.

The *Transfiguration,* held within a cool silvery range, is especially beautiful. From the luminous figure of Christ, light seems to radiate in every direction. Silver green tones dominate the entire icon, from intense malachite green to pale green. These colors are subtly harmonized with Christ's white

clothing and with the lilac rose, pinkish red, and golden ocher garments of the prophets and apostles. The slightly crowded composition is inscribed with great skill within the rectangular panel, and in the contours of the figures, gentle, parabolic curves, which seem to echo the circular luminous cloud, predominate.

The *Annunciation,* with its pinkish red, emerald green, lilac rose, and intense cherry tones, is just as beautiful because of its refined coloring. Here, as in the *Transfiguration,* the exact proportional connections between the central area and the border of the icon have been found. The two buildings, in the form of graceful pavilions, are turned at an angle toward each other in order to accentuate the impetuous arrival of the archangel to Mary and her fright at the appearance of the heavenly messenger. The red drapery, inherited from the ancient *velum* [veil], helps the artist bring the two figures together and, at the same time, reinforce the unity of the composition.

Most of Rublev's icons are permeated by an atmosphere of special sweetness. In the traditional iconographic designs of the Byzantines, the artist would deliberately introduce a series of barely perceptible modifications which enriched the icons with a new emotional resonance. Thus, for example, in the *Transfiguration,* the prophets Elijah and Moses are inclined toward Christ in such a way that the upper part of the work loses its hieratic severity. In the *Nativity of Christ,* the angels bend in front of the crib, and the whole scene consequently takes on a mood of unusual intimacy. In the *Presentation in the Temple,* Simeon, who prepares to receive the Child from Mary's hands, is pictured so bowed that he seems about to kneel before the future Savior of the world. By such means, Rublev softened religious images and brought them closer to human beings; at the same time, he gave the faces such an expression of spiritual purity and sincerity that in comparison with them, the faces of saints in Greek icons seem a bit distant and gloomy (in this regard, Peter's face in the *Transfiguration* is especially indicative).

The icons of the *Feasts* which we are inclined to attribute to Rublev were his first works. If he was already a famous master at the beginning of the 1390s, Theophanes must have certainly called for his help in frescoing the Church of the Nativity of the Virgin (1395) and the Church of the Archangel Michael (1399). However, the chronicler[218] mentions neither the name of Prochor of Gorodets nor that of Andrei Rublev. At this first stage, Theophanes' assistants were Semyon Cernyi and companions. Rublev probably started to be trained as an artist only in the late 1390s, when the activity of Theophanes' Moscow studio expanded and the city was flooded with Greek icons, one of which (the *Annunciation*[219] in the Tretyakov Gallery) is among the masterpieces of Palaeologan painting and, from a stylistic point of view, reveals a particular kinship with Rublev's icons from the tier of the *Feasts.* And certainly, Andrei Rublev also adhered to this Hellenizing tradition in Constantinopolitan painting.

During the fourteenth century, Byzantine art was amply represented in Moscow, thanks to the activity of the Greek masters, the foremost of whom was Theophanes, and also to the large number of Greek icons, from which so much could be learned. It was within this context that Rublev acquired his formation as an artist. He was not the only one to esteem Palaeologan painting in the Moscow of the 1390s. He limited himself to drawing the most logical consequences from their lessons, successfully extracting with his sixth sense the Hellenistic soul from them and developing on this foundation his own personal style, which begins to be delineated quite explicitly in the icons of the *Feasts.*

No later than 1408, when he painted the frescoes of the Cathedral of the Dormition in Vladimir, Rublev started to work with Daniil. This collaboration recurred from 1425 to 1427 for frescoing the Cathedral of the Trinity in the Monastery of the Trinity of Saint Sergius. They seem to have had a bond of close friendship: not by chance do early sources call them "collaborators" and "fasting companions." There are good reasons to think they belonged to the same brigade, which enjoyed a distinguished reputation and received abundant commissions.

In addition to frescoes, as was customary in Rus, Daniil and Rublev also painted icons for the iconostasis of the Vladimir Cathedral of the Dormition. Among all the works of this type which have come down to us, the Vladimir iconostasis is the largest. Still, it would be imprudent to assert that

from the beginning, it included eighty icons:[220] this number is in fact quoted in a 1708 description of the cathedral, but it could be the result of a later enlargement of the iconostasis, the more so in that this practice was exceedingly widespread in Rus. The iconostasis painted by Rublev, Daniil, and their pupils was fashioned with four registers: the local tier, the *Deesis,* the *Feasts,* and the *Prophets.* This last register, which evidently was something new, was made of just half-length images. The tier of the *Patriarchs* did not exist, nor could it have existed since it was still missing in 1481 from the iconostasis in the Cathedral of the Dormition in Moscow. However, even without the tier of the *Patriarchs,* the iconostasis of the Vladimir Cathedral must have had astonishing dimensions. The fifteen icons of the *Deesis,* each more than three meters high (310 centimeters), formed a magnificent composition because of its size: the gigantic figures, turned toward the center, stand out distinctly against the golden background; deprived of volume, they are striking first of all because of their shape, and the masters who painted them were perfectly aware of this and thus simplified the outline to the extreme, conferring on them that spareness and standardization which allowed one to distinguish the images even from a distance.

PL. 99 The figures of the *Deesis* were certainly envisaged by Rublev himself, as the perfection of the attention to line and the rhythmicity of movement attest. Most of these (for example, *Saint John the Baptist* and the *Apostle Paul*) are composed using the lozenge shape so loved by Rublev: the figure is wider in the central part and narrows down toward the top and the bottom, thus achieving an uncommon lightness since it barely brushes against the ground with its feet; its body is completely concealed by the ample and flowing garment and seems to hover in the air.

The close relationship of the *Deesis* with Rublev's work is also attested by the marvelous chromatic range envisioned in an organic and unifying way. Golden yellow and red alternate with green and blue, and white with cherry and black. The fact that the entire pictorial composition was conceived as "images in the distance" determines the essential nature of the coloring, with the predominance of pure shades. But the essentialness of the chromatic combinations does not impoverish them, confirming once again the rule that, the coloring, provided it had acquired the necessary integrity, is not based on the quantity of hues but on their quality, or better still, on the accurate evaluation of their chromatic relation. The color is spread uniformly on large areas, helping one capture the figure at first glance. The palette is extremely light, thus the color brightens the figure and is never gloomy, creating a joyful atmosphere. This is precisely the way the magnificent figure of *Christ in Glory,* occupying the central position in the *Deesis,* is rendered, with its exultant golden ocher and red tones; the figure of John the Baptist, with his emerald green hair shirt and his golden yellow cloak, is similarly produced from this chromatic perspective.

In planning the iconostasis of the Cathedral of the Dormition, Rublev drew on the legacy of Theophanes. Here, the artist, who must have remembered the iconostasis "of the Annunciation," developed the principles it contained. By increasing the size of the figures by almost one meter, vigorously adapting their surfaces to the panels of the icons, standardizing the shapes even more, increasing the intensity of the coloring, Rublev obtained an even greater monumentality than did Theophanes.

In order to paint the fifteen three-meter-tall figures of the iconostasis of Vladimir, Rublev and Daniil must have resorted to the help of pupils; otherwise, the work would have been drawn out for years. Although the icons are not well preserved, even in their present condition, it is not difficult to identify a certain lack of uniformity: assistants would have worked primarily on the register of the *Feasts,* probably made of thirteen icons (not twenty-five as M.A. Ilin claims[221]). Individual signs of Rublev's intervention are noticeable in only one icon, the *Ascension,* which stands out because of its decisively superior quality.

PL. 97 From the compositional point of view, the *Ascension* follows the similar icon of Prochor in the Cathedral of the Annunciation. Rublev emulated Prochor's example, even in his distribution of the main chromatic accents. But what is even more interesting is the way in which he modified his master's chromatic range, giving it a general silvery tone. Rublev's colors are softer, more delicate, and he

unites them in a uniquely harmonious arrangement which acquires a melodiousness unknown to Byzantines. The dramatic tension of color, characteristic of Byzantine icons, gives place in Rublev to an extraordinary lyricism: the artist knew how to draw from colors nuances of great warmth so that his images of saints are enveloped in an absolutely characteristic poetic aura.

In another icon of this register, the *Presentation in the Temple,* painted by a close disciple of Rublev, PL. 98 the clear, soft tones marvelously render that atmosphere of interior illumination which encompasses the characters in the scene. Simeon, standing at the top of the stairs, bows to the little Child and holds him in his arms like a precious treasure. The gesture of veneration before the future Savior of the world is effectively expressed by the great humility in Simeon's posture. The figures of Mary, Joseph, and the prophetess Anna, each corresponding to an architectural structure in the background, are shown in serene and solemn poses. The Russian iconographer's lack of concern with space is explicitly manifested in the interpretation of details like the columns of the baldachin, whose position in space is utterly indefinite and not coordinated with the roof of the baldachin itself. We find here the flat projection of the three-dimensional form, typical of fifteenth-century Russian icons, conditioned in this specific case by the artist's desire to leave the altar "clean," not intersecting with the dark shafts of the columns.

The splendid half-length *Deesis,* called "of Zvenigorod" from the name of the place where it was PL. 100 found, was probably painted during the second decade of the fifteenth century. Only three icons from this *Deesis* have survived, the *Savior,* the *Archangel Michael,* and the *Apostle Paul* (Tretyakov Gallery). It is such a mature work stylistically that it cannot be attributed to Rublev's first creative phase; it could have been painted only after the frescoes of the Cathedral of the Dormition, in other words, after 1408.

At first sight, the icons of the *Deesis* "of Zvenigorod" strike us because of the extraordinary beauty of their cool and luminous colors. The azure gray, rose, blue, pale violet, and cherry tones are used in such inspired combinations against the gold background that they evoke exquisitely musical associations in those contemplating the icon. For Rublev, color was an instrument which helped him reveal the inner world of human beings. His Savior, Paul and the Archangel emanate an irresistible fascination; they are permeated by an extraordinary tenderness with no trace whatsoever of Byzantine severity. In his profound humanity, the *Savior* recalls the famous portrayal of Christ in the tympanum of the "royal doors" at Chartres Cathedral: in Rublev, as in the Gothic master, the image of Christ is made so human that it totally loses its abstract cultic character. But Rublev's *Savior* is, as N.A. Demina aptly defines it, "the incarnation of the beauty that is typically Russian. Not a single element of the face is overly accentuated, everything is well proportioned and harmonious: Christ is blond; his eyes are not too large; his nose is straight and thin, his mouth small; the oval of his face is elongated but not narrow, without a trace of asceticism; his head, with its thick mass of hair, rises with serene dignity over his powerful and well-proportioned neck. In this new countenance, the most important aspect is the look, aimed directly at observers and expressing a eager and potent care for them. Here, one senses the desire to penetrate into the human mind and understand it. The eyebrows are slightly arched, thus removing from the expression every trace of tension or sadness. The gaze is clear, open, and kind. We have a strong and active man before us, a man endowed with sufficient spiritual energy to be lavish with his help for those who need it. The *Savior* of Zvenigorod is larger than life. He is filled with solemnity. There is in him, besides, the severity of an interior purity and simplicity and a total trust in humanity."[222] This brilliant characterization of Rublev's work captures to perfection the newness which the artist introduced into the interpretation of one of the most traditional images in medieval art.

In the full flower of his creative vigor, Rublev painted his most famous work, the icon of the *Trin-* PL. 101 *ity.* Done in remembrance of Saint Sergius of Radonezh, it was the principal icon in the Cathedral of the Trinity, built on the site of an earlier wooden church. As is well known, the Trinity was the object of Saint Sergius of Radonezh's special veneration because, for him, it represented the symbol of peace and harmony, and this is why the monasteries and churches built by his disciples and followers were

frequently dedicated to the Trinity.[223] This also explains the great popularity throughout Rus of this image, which was often the main icon of a church bearing the same name. But there was still another reason which justified the profound interest aroused by this subject: heresies.

It is common knowledge that the *bogomili* and Cathars did not recognize the dogma of the Trinity, and the sect of the *strigolniki,* which established deep roots in Pskov and Novgorod, also denied the equality of the three Persons of the Trinity. The *strigolniki* maintained that in the appearance of the three angels to Abraham, the latter saw just God accompanied by two angels, not the three Persons of the Trinity. Even in Rostov, there proved to be anti-trinitarian movements (in the 1380s), headed by a certain Markian, who excluded Christ from the Trinity and did not accept the veneration of icons.[224]

When Rublev set out to paint the images that he had been commissioned to do, the theme of the Trinity was undoubtedly a burning question for the artist himself as well as for his contemporaries. It was as if he had been entrusted with the task of demonstrating the absolute equality of the three Persons of the Trinity for the edification of the heretics. The superior of the Monastery of the Trinity, Nikon, who requested the icon, probably played a decisive role in this. But like every great work of art, Rublev's *Trinity* involves various emphases; therefore, it would be inadequate to explain its complicated philosophical content solely in terms of the struggle against heretical movements. These movements are helpful in describing the concrete historical context in which the artist painted the icon, and they may have been one of the incentives for his creation; but they are not at all able to explain Rublev's artistic conception in all its depth.

In the icon of the Trinity, some have wished to identify echoes of Gothic and Italian art and have compared it with the works of Duccio and Simone Martini, claiming that the grace of Rublev's angels was inspired by the Sienese painters' figures. This opinion concerning the Russian master's icon was quite widespread in earlier art criticism,[225] but in the light of more recent studies, we can assert with certainty that Rublev did not know the masterpieces of Italian art and as a consequence could not have assimilated any part of them. His only source was Byzantine painting from the Palaeologan period, and furthermore, the painting from the capital, Constantinople: from there he obtained the elegant models for his angels, the pattern for the lowered heads, the rectangular table.[226] However, this artistic continuity did not prevent Rublev from infusing a completely new life into the traditional iconographic type.

Biblical tradition relates how three very handsome youths appeared to the old man Abraham and how he and his wife Sarah had given them hospitality in the shade of the oak of Mamre, feeling in their hearts [as Christians added] that the three youths embodied the three Persons of the Trinity. Byzantine, Eastern Christian, and Russian artists linked with ancient traditions were used to representing this episode with a wealth of details: they would show the table set with food and Abraham and Sarah busy serving the angels; they even introduced an additional episode, the sacrifice of the calf. For them, this scene was first of all a historical event which happened in a specific place and at a specific time. Rublev deliberately distanced himself from this interpretation. He eliminated all secondary and non-essential elements from his icon: missing are the figures of Abraham and Sarah, missing is the sacrifice of the calf and even the abundance of food spread on the table. All that is left are the three angels, the table, the Eucharistic chalice, the oak of Mamre, the house, and the rocks. Every hint of action, every allusion to the historical aspect of the event portrayed in the icon are eliminated in his interpretation. The angels are presented as the symbol of the one and triune God and as the prefiguration of the Eucharist.

In Rublev's icon, created to be contemplated for a long time, there is neither movement nor action. The three angels are seated in deep silence on three low seats. Their heads are slightly bowed, their gazes intent on infinity. Each one is immersed in his own thoughts, but at the same time, all three appear as bearers of a unique experience: humility. The focal point of the icon is the chalice holding the head of the sacrificed calf[227] — which in the Old Testament is the prefiguration of the Lamb of the New Testament; the chalice must be seen as the symbol of the Eucharist. The hands of the angels in

the center and on the left are blessing the cup. These two gestures provide the key to understanding the complex symbolism of the composition. The angel in the center is Christ;[228] absorbed and pensive, his head inclined to the left, he blesses the chalice, thus expressing his will to offer himself in sacrifice to atone for human sins. The inspiration for this act comes from God the Father (the angel on the left), whose face expresses an immeasurable sadness. The Holy Spirit (the angel on the right) is present as the eternally youthful and quickening principle, as the "consoler." And so what is depicted here is, according to the Christian Church's teaching, the act of the supreme sacrifice of love (the Father offers the Son in expiatory sacrifice for the world); but the artist went even further: at the same time, he pictured the act of supreme obedience, the Son's freely choosing to suffer and give himself as a sacrifice for the world. Here, Rublev transformed the traditional iconographic type into a most profound symbol which moves us to reconsider this very ancient theme in an entirely new way.

Russian monastic culture of the fifteenth century was not by any means as primitive as scholars thought at one time. The works of Basil the Great, Isaac the Syrian, John Climacus, Dyonisius the Areopagite were attentively read and thoroughly annotated, in this way bringing to Russian ecclesiastical literature elements of ancient philosophy, of Platonism and Neo-Platonism, and providing the thrust toward a complicated symbolic interpretation of religious images. A monk of the Monastery of the Trinity and of the Andronikov Monastery, Andrei Rublev, surely participated in those speculative conversations taking place in the intimate circle of Sergius, Savva, and Nikon; and he must have known that the icon of the Trinity was viewed by Byzantine theologians, not only as a representation of the one and triune God and a prefiguration of the Eucharist, but also as the symbol of faith, hope, and charity. John Climacus states clearly, "Now, after everything is said, there remain three things which relate and contain everything: faith, hope, and charity, but the greatest of all is charity because its name is God." And again, "From what I can understand, faith is like a ray, hope like the light, and charity like the circle of the sun. And yet these form one single splendor and one single light."[229] This quotation helps us to understand why Rublev used the circle — considered since antiquity as the symbol of heaven, of light, of divinity, and of charity — as the foundation for the design of his icon. In the exposition of the teachings about virtues, charity (that is, God) is equated with the solar circle and its attainment is associated with the mysterious "angelic circular motion."[230]

That the conception is symbolic is typical of the medieval work of art and, in this sense, Rublev's icon is no exception. Here too, the symbolic aspects play an important part; in addition, the symbolic interpretation also extends to the icon's secondary details: the building, the oak of Mamre, and the rock. These three elements of the composition are not intended to illustrate a concrete background; they do not particularize but, on the contrary, contribute to creating the impression that the scene is taking place outside of time and space. The tree is not so much the oak of Mamre as the tree of life, the tree of eternity; the luminous building is not just Abraham's house, but the symbol of Christ the Builder and the symbol of silence, that is, of perfect obedience to the will of the Father; the mountain is the image of the "rapture by the Spirit" (precisely as it is generally understood in the Old Testament and the Gospels). This commentary upon the symbolic content of Rublev's icon could easily go on, but what we have said is sufficient to demonstrate the exceptional complexity of the sources of his ideas.

Rublev's icon produces an equally irresistible impression on contemporary observers, however ignorant they may be about all the subtleties of medieval theology. How can this be accounted for? Naturally, by the fact that in Rublev's *Trinity,* the symbolism of a purely ecclesiastical ilk is broadened into something which touches everyone, the symbol of human love: this is why the icon is filled with such unchanging freshness. Its intention is much more profound and penetrating than a simple assortment of ecclesiastical symbols; in it we have embodied in perfect artistic form the ideals of peace and social harmony, to which the best Russian minds aspired and for which they sought in vain in their daily reality. And because it was pure, noble, and deeply human, this dream found an extraordinary correspondence in the icon.

As with every great work of art, in Rublev's *Trinity*, everything is subordinated to a fundamental idea, the composition, the linear rhythm, and the color. With the help of these elements, Rublev obtained an effect of serene quietude: in his icon, there is something calming, caressing, which invites a sustained and absorbed contemplation. Before the *Trinity*, we desire "to be alone and silent." It compels our imagination to work; it stirs up hundreds of poetic and musical associations which, one after the other, ceaselessly enhance the process of aesthetic perception. Contemplating Rublev's icon leaves us spiritually enriched and this further confirms his exceptional artistic merits.

When we start to observe Rublev's *Trinity*, we are surprised first of all by the extraordinary spiritualization of the angels: there is such tenderness and attentiveness in them that it is impossible to escape their fascination. They are the most poetic images of all early Russian art. Their bodies are slender, light, as if weightless; they wear a simple Greek chiton and over it, the himation which falls in soft drapelike folds. Despite the linear stylization, these garments allow the spectator to sense the beauty of young and graceful bodies which are concealed underneath. The figures of the angels, which are slightly widened in the center and narrowed toward the top and bottom, are drawn according to the lozenge pattern so dear to Rublev, acquiring an amazing lightness. In their poses and gestures, in the way they are sitting, there is no sign of heaviness. Their faces seem especially delicate thanks to the heightened splendor of their hair. Nor is there in the angels any hint whatsoever of strict asceticism. The bodily principle is not sacrificed to the spiritual one, but totally blends with it.

In the icon of the *Trinity*, the circle continually recurs as the leitmotif of the whole composition: it is visible in the curved figure of the angel on the right, in the slope of the mountain, the tree, and the head of the central angel, in the parabolic outline of the angel on the left, and also in the pedestals close to one another. But unlike the Italian circular paintings with their somewhat accentuated techniques, this leitmotif resonates quietly and softly. The artist did not fear to disturb the circular rhythm by the vertical position of the house, knowing full well that this would make his composition more graceful and free, neither was he troubled by the inclination of the central angel's head, which breaks the symmetry in the upper part of the icon, since he effectively reestablished the balance by shifting the pedestal slightly to the right. The Eucharistic cup is also shifted to the right, thus increasing the counterbalance of the central angel's head, inclined to the left. Thanks to the generous use of these asymmetrical placements, the composition gains a rare flexibility: preserving completely its centripetal character and the balance of its masses, while at the same time possessing a purely symphonic wealth of rhythms, diverse echoes of the fundamental circular melody.

By making the circle, that is, a two-dimensional rather than three-dimensional figure, the basis of his composition, Rublev subordinated the composition itself to the surface of the panel. Even though the flanking angels are sitting in front of the table and the central angel is behind it, all three seem arranged within the limits of a single area of space having a minimum of depth and corresponding strictly to the height and width of the panel. The full harmony, which makes Rublev's icon such a perfect work of art, comes from this equilibrium of the three dimensions: if the figures had more volume and the space were deeper, the harmony would suddenly be broken. Precisely by painting his figures as pure shapes and making lines and strokes of color the principal means of artistic expression, Rublev succeeded in keeping that rhythm of the surface, which has always fascinated Russian iconographers and thanks to which his composition acquires that extraordinary lightness.

By constructing his work on the basis of the circle and by subordinating it to the surface of the panel, Rublev deliberately refrained from chiaroscuro modeling, which is replaced by the line, controlled by the artist with great mastery. There is in his lines something so sonorous, so melodic, they are animated by such depth of feeling that one perceives them as a musical theme transposed into graphic language. To be convinced of this, we need only follow with our eyes the flowing movement of the lines defining the figures of the angels, lines which are soft and flexible at the same time and in which the circular melody is repeated in dozens of echoes, always new, unexpected, splendid, and enchanting. But Rublev was not satisfied with rounded lines alone: he knew how to alternate them with

others, straight, diagonal, or acutely angled, introducing great rhythmical variation into his composition. By means of lines, he also knew how to disclose the profound significance of the images and how to delineate precisely the individual gestures of each angel. For example, the cascade of straight lines in the central angel's cloak draws our eyes to the right hand, which points to the Eucharistic chalice (the center of the icon, both in theme and execution); the oblique folds in the himation of the angel on the right emphasize his bending toward the center of the icon; the folded clavus of the central angel repeats the inclination of the head; the parabolic lines of the contours of the angels on the right and in the center, of the mountain and the tree lean to the left, toward the figure of the angel symbolizing God the Father; the legs of the seats, the pillars of the building, and the vertical shepherd's staff of the angel on the left enclose his figure within the compass of straight lines, capturing the attention of the onlooker. Finally, with delicate touch, the artist alternated the lines of the pastoral staffs: the slanted staff of the angel on the right indicates the mountain's starting point; the straighter staff of the central angel draws our attention to the tree; and the vertical staff of the angel on the left recalls the lines of the building. In this fashion, each staff of each angel points to the angel's emblem.[231]

But perhaps the most remarkable aspect of Rublev's icon is his chromatism. This affects us first of all with its wonderful colors in which there is an exceptional harmony; it is exactly the colors, combined with the fluid lines, that determine the artistic nature of the icon, limpid, pure, and harmonious. The chromatic range of the *Trinity* could be defined as "friendly" because it expresses the warm accord of the three angels with amazing clarity.

Rublev obviously did not choose his colors in bright sunlight, but during a glowing summer day with its diffused light, when the most delicate and mysterious hues of objects seem to fade, and begin to emit a more ethereal light with muted harmony.[232] It is interesting to observe that shadows are almost totally absent in Rublev's works: if he used a dark brush or dense color, he did so only to accentuate the luminous nature of the neighboring color. Thanks to this concept of chromatism, Rublev's palette is distinguished not only by its extraordinary luminosity but also by its rare transparency.

The chromatic structure of the icon is characterized by the threefold resonance of its azure. This pure lapis lazuli blue, the most precious and most esteemed by medieval masters, is repeated in the himation of the angel at the center, in the chitons of the angels on each side, and in the joints of the wings. In addition, the artist gave a different timbre to the shadings: from the rather bright strokes of blue in the central figure's himation to the light and very soft tints of azure in the joints. The figure of the angel at the center is placed in relief by the intensity of the azure and also by the dense, rich tone of the dark cherry red chiton. He leans on the snow-white table in which there is no heaviness, which seems as weightless as the figures of the side angels. The color of their clothing is lighter still: the silvery lilac cloak of the angel on the left has azure highlights, the silvery green cloak of the angel on the right has light green accents. This pure and soft color, which recalls the hue of greenish rust, finds distant reflections in the greenish shades of the mountain, house, and oak. The seats and wings of the angels are an intense golden yellow serving as a transition from the bright clothing to the gold of the background, which has almost completely vanished. There is also a golden shading in the faces. The artist attained a most delicate harmony in his colors, which complement and reflect one another; each one resonates with such immaculate purity that after leaving the room where the *Trinity* is exhibited, visitors continue to feel for a long time the re-echoing of these astonishing colors, and the memory of Rublev's azure remains in their consciousness like an unforgettable experience.

There were countless imitations of Rublev's *Trinity*. Of all icons, this was the one most loved by early Russian artists, but in their own work, not one knew how to equal it. Even the oldest copies are unable to evoke the slightest fraction of its fascination. Rublev created it in one of those happy moments of inspiration which only geniuses enjoy, and he succeeded in making a work which we rightfully consider the most beautiful of all Russian icons and one of the most perfect works in all early Russian painting.

The years between the first and second decade of the fifteenth century were the period of Rublev's greatest creative inspiration. A small icon in the Tretyakov Gallery goes back to those years; it is in excellent condition. Usually, the icons from Rublev's time have lost the original gold background and *assiste,* and in some places they have also lost the surface layer of color (many such lacunae are found above all in the icons of the *Feasts* from the Cathedral of the Annunciation). This fact, along with the patina of time, partially modifies their chromatic tonality, particularly if the icons have not been completely cleaned. In this regard, the *Christ in Glory* in the Tretyakov Gallery is a wonderful exception because its colors glow in all their original purity and even the very fine *assiste* on Christ's garment are perfectly preserved. The Savior is shown encircled by seraphim and surrounded by the symbols of the evangelists, as in the central icons from the *Deesis* of the Vladimir Cathedral of the Dormition and in the Cathedral of the Trinity in the Monastery of the Trinity of Saint Sergius. His face has a tragic expression, but at the same time a special inner serenity, while the faces of the seraphim are also highly expressive and full of dramatic force. The author of this icon, executed with the meticulousness of a miniature, was excellent in drawing, with a refined perception of form and the capacity to fix it with impeccably precise lines. All the stylistic characteristics point to Rublev as the painter of this icon.

The later works of Rublev that have survived go back to the late 1430s, when the artist had already reached a venerable age. These works are some icons forming part of the iconostasis in the Trinity Cathedral in the Monastery of the Trinity of Saint Sergius in Sergiev Posad. According to the testimony of Pachomii Logoteta, shortly before his death (November 17, 1427), the hegumen of this monastery, Nikon, proposed that Daniil and his friend Andrei fresco the Cathedral of the Trinity, which he had built. Foreseeing that his death was imminent, the hegumen put pressure on the artists to complete the work very rapidly ("he wanted it to be finished quickly"). Pachomii himself states that Nikon's urgent assignment was completed thanks to the efforts of Daniil and Andrei, but also the "others with them," who decorated the church with "large and varied frescoes."[233]

The iconostasis of the Trinity (almost nothing is left of the cathedral's original frescoes, which have been repeatedly restored) confirms the authenticity of Pachomii's testimony concerning the participation of many masters who, moreover, worked hastily. What immediately leaps to one's attention is the great number of icons belonging to different stylistic currents. It is clear that Daniil and Rublev were surrounded by their pupils and assistants, who were responsible for the main part of the work. What is new in this iconostasis, besides the numerical increase of icons (the fifteen figures of the *Deesis,* nineteen *Feasts,* twelve half-length *Prophets* on six panels with the image of the *Virgin of the Sign* in the center), is the fact that it is the first example of a "closed" iconostasis where the icons do not alternate with the columns of the sanctuary partition, as in the Vladimir Cathedral of the Dormition, but form an uninterrupted wall. This type of "closed" iconostasis probably appeared for the first time in churches without pillars. This permitted the attainment of greater unity in the pictorial composition because it was planned for a single surface. Daniil and Rublev used this possibility brilliantly by accentuating the central axis and discovering the right proportional relationships between the individual registers (the register of the *Patriarchs* came later).

In studying the icons of the iconostasis of the Trinity, it seems evident that not all the painters who worked on it were directly associated with Rublev's studio. Some came from different artistic circles; others belonged to the older generation still strongly tied to traditions of the fourteenth century; yet others were much younger and directed more towards the future than the past. The works of these young masters are especially interesting in that they clearly demonstrate in what direction Muscovite painting developed during the 1420s, when those stylistic transformations, which found their logical fulfillment in the art of Dionysii, were already beginning to be felt.

Among the icons of the *Deesis* executed by various masters, the ones closest to Rublev are the *Archangel Gabriel,* the *Apostle Paul,* and the *Apostle Peter,* which stand out from the others because of their excellent artistic quality. The figure of the apostle Paul is skillfully painted on a rectangular panel: he is planted firmly on his legs, and there is something decisive and strong-willed in his pose. Here

Rublev's art addresses us in its manly aspect, but what is most interesting is the naturalness with which this virility is united to spiritual gentleness. In the artist's interpretation, Paul is both the defender of the Christian Church and the good master always quick to lend a helping hand. His intelligent face speaks of spiritual constancy and strength of character. Also very Rublev-like is the figure of the *Apostle Peter,* unfortunately heavily damaged, but the facial expression, amazingly kind, is preserved without serious lacunae and reveals the hand of the master himself. The figure of the *Archangel Gabriel* is also the work of Rublev. It follows the model of the similar figure in the *Deesis* of the Annunciation. The same closeness is also found in the icons of the *Archangel Michael* and *Basil the Great,* stylistically weaker, and in the icon of the *Apostle Peter* we mentioned above. Evidently, Rublev's workshop had inherited the models from the studios of Theophanes the Greek and Prochor of Gorodets; otherwise, it would be difficult to explain their frequent use during the work on the iconostases of the Vladimir Cathedral of the Dormition and of the Trinity in the Monastery of the Trinity of Saint Sergius. Here, we are dealing with a direct source not only of the artistic tradition but also of the practical methods.

An even greater number of masters collaborated in painting the icons for the register of the *Feasts,* PL. 104 in which Rublev had almost no part (only the *Baptism,* which is heavily damaged, can be attributed to the artist). Therefore, masters of the older generation, immediate disciples of Rublev, and much younger artists worked side by side on this register. The author of the *Last Supper* undoubtedly belonged to the older generation, a very mature painter who observed the traditions of the fourteenth century. As the basis of his composition, he used the iconographic model employed by the starets Prochor of Gorodets for the similar icon in the Annunciation Cathedral, and this brings him near to the artistic culture of the fourteenth century, with which Prochor was also closely connected. The author of the *Last Supper* painted the faces in a free and confident manner, deliberately using thick highlights and small bright strokes. In his concept of form, we sense the pictorial style of the Palaeologan period re-echoing deeply. His chromatic range is built on solid, quite dark, even obscure colors. The shapes of the figures are subjected to a great simplification which did not prevent the master from achieving subtle psychological nuances. The gesture of Judas greedily stretching toward the cup (a movement repeated in the arch resting upon the columns) is extremely expressive; the figure of the disciple sitting next to Judas and leaning on the table with both hands as if to prevent him from acting thoughtlessly, is excellent; the two old apostles sitting nearby and bending their heads to the right in an expression of silent reproach are very eloquent; the lively conversation of the apostles seated in the foreground is presented in a most picturesque way. The author of the *Last Supper* was a master with broad experience and extraordinary courage. If we had more information, it would be very attractive to identify him with Daniil, all the more so because his apostles evoke to some degree Jacob and Isaac in the scene of the *Bosom of Abraham* in the Vladimir Cathedral of the Dormition.

The author of the *Washing of the Feet* also belonged to the older generation. This theme exalts in a symbolic manner the virtue most valued among the monks: humility. Christ, girt with a towel about his waist, is washing the feet of Peter, who, disturbed, raises his hand to his forehead as if he were striving to understand what is taking place. The other apostles, who are preparing themselves for the solemn action of the washing, are pictured in deep absorption: all recognize the importance of the event they are witnessing. The artist succeeded in communicating the richness of the most imperceptible spiritual nuances in a magnificent way: this is the reason his work is so moving. The observer's consciousness is unintentionally penetrated by the profound significance of the episode described by the painter.

In the *Washing of the Feet,* the author blended the old with the new in an original manner. The drawing is not very steady; there are several inaccuracies as in the drawing of fourteenth-century masters, to whom the painter was also close in the rather free treatment of the faces. To make up for this, the coloring of the icon foretells the fifteenth century: it lacks bright chromatic accents and its general tone is silvery. In the architecture, pale pistachio green, silvery gray, and dark cherry red shades combine, and in the clothing, sky blue, green, pink, cherry red and silvery green hues. Especially beautiful

is Peter's pale orange cloak, thrown over his azure chiton. These melodious tones best reveal the various states of mind which have one trait in common: the unusual delicacy of feeling. In such an approach to coloring, the interior kinship of the master with Andrei Rublev is clearly captured.

The author of the *Presentation in the Temple* was also a close disciple of Rublev. On the basis of the model for the similar icon of the Vladimir Cathedral of the Dormition, he played with great astuteness the contrast between the dense, dark colors in the left part of the composition and the light, transparent shades in the right, where magnificent silvery lilac, silvery green, and golden yellow tones dominate. Simeon, the prophetess Anna, and the Christ Child are shown to the right. Obviously, the artist wanted to underline with his soft colors the spiritual purity of the old man and the eighty-four-year-old widow, who had come to glorify the Lord. Such a symbolism of colors was quite customary in medieval painting, but in the icon of the *Presentation in the Temple*, it becomes uncommonly poetic.

The author of the *Women [Mironositsa; Myrrh-bearers] at the Lord's Tomb* (to whom we also owe the seriously damaged *Crucifixion*) was the youngest among the artists of the *Feasts*. The work of this painter is marked by particular elegance; his devout women surprise us because of their grace; his angel is very feminine; his centurion Longinus, exaggeratedly proportioned, reminds us of Dionysii's slender saints; his afflicted John belongs to the group of the most delicate images in fifteenth-century Russian painting. The artist was an authentic virtuoso of the outline, which has a delightful, visible rhythmicity, and he brought the landscape and the figures into perfect harmony. To be convinced, we merely need to follow the lines of the angel's wings and those of the mountains which parallel them: everything guides the onlooker's eyes from the angel to the figures of the women. In turn, the heads of the Myrrh-bearers, turned to the right, the diagonal of the mountain on the left in the foreground, which slants downward to the left, the curved line of the cave, and the sarcophagus placed sideways direct our gaze in the opposite direction, from the women to the angel. This cascade of lines, which meet here, closely connects the figures of the devout women and the angel, and in this way, the artist achieved an amazing unity. He painted his figures without depth by accentuating the lines. In his very refined, somewhat sentimental art, there is no trace of the pictorial traditions of the fourteenth century. Specifically, he replaced the thick, strong highlights with a soft merging of color, and in his choice of colors, he intentionally avoided strong and sharp contrasts, gathering his range of shades into a silvery and transparent tonality. His favorite color was silvery green, which he skillfully blended with pink, golden yellow, cherry red, white, and silvery gray tones (characteristically, he only used red exceptionally, in two secondary parts of the *Crucifixion*). This master undoubtedly knew the art of Rublev, and his artistic formation developed from a precise study of those works, but in many ways, he separated himself from them. Many of his works combine elements which are not Rublevian: the softness bordering on sentimentality, a certain outward infatuation with lines and color, and the preference for elegant form. In all of this, the author of the *Women at the Lord's Tomb* and the *Crucifixion* was a direct precursor of Dionysii. In any case, these are reasons to assert that he himself, or a master close to him, prepared the way for Dionysii and his school.

The iconostasis in the Cathedral of the Trinity leaves no doubt as to the fact that it was the work of a large brigade comprising masters from different generations and different artistic styles. By then, Daniil and Rublev were in the last years of their lives and their artistic activity was beginning to decline. This explains the limited participation of Rublev in the execution of the *Deesis* and the register of the *Feasts*. In fact, he and his friend Daniil only coordinated all the work, and it was probably Rublev himself, with Nikon's intervention, who determined the composition of the iconostasis and chose the icons intended for it. To him, as chief master, we owe the fundamental elements of the composition, its proportional structure, its chromatic accents. However, Rublev did not do violence to the personalities of his collaborators and left them free to work as they were accustomed. This is one of the reasons for the future successes of Rublev's school, which produced several splendid works, among which

PL. 105 we recall the *Virgin of Tenderness* in the Russian Museum, the *Nativity of Christ*, the *Ascension*, the PL. 106, 107 *Christ in Majesty* [Savior Pantocrator] in the Tretyakov Gallery, and *Saint John the Baptist* in the An-

drei Rublev Museum of Early Russian Art. This last icon, suffused with a lofty spirituality, is especially beautiful; the noble and fine face is characterized by a great softness, typical of the icons from the second quarter of the fifteen century in the monastery of the Trinity of Saint Sergius. In Rublev's pupils and followers, we observe the tendency to touch up forms which take on a more artificial nature. Rublev, on the contrary, painted in a softer, more natural manner, without any ostentation; and so, however beautiful they may be, the icons of Rublev's pupils and disciples will always be inferior to the works of the master himself.

Rublev's art marked the summit in the development of the Muscovite school of painting. It coincided with the period of national awakening which saw the rapid consolidation of the principality of Moscow, the period of Saint Sergius of Radonezh, who did everything he could to maintain in his life great moral ideals. Rublev's artistic activity started during the years when cultural ties with Byzantium had become very strong; Moscow was flooded with Greek icons; Greek masters were working in the city, and among them, Theophanes was the central figure. After having systematically assimilated all the refinements of Palaeologan painting, Muscovite artists did not stop there but continued along their own path, giving direction to the gradual process of going beyond the Byzantine legacy. The one to carry out this step with the greatest coherence was Andrei Rublev, the first to break away unequivocally from the severity and asceticism of Byzantine images, extracting their ancient, Hellenistic nucleus.[234] He gave proof of a receptivity — surprising for a someone of his time — to ancient grace, ancient ethos, to clarity of thought, without any frills and captivating because of its noble and modest simplicity. To the vigorous chromatic Byzantine modeling, Rublev opposed the serenity of his smooth application of color; to the almost vibrant Byzantine outline, a clear and essential profile allowing the capture of the figure's shape in one glance; to the complicated system of Byzantine highlights, a precise graphic execution leading to the flattening of the form. He did not take his palette's luminous and brilliant colors from the traditional chromatic canon but from the Russian landscape which surrounded him, and he transposed these colors into the exalted language of art, presenting them in associations so faithful, so impeccable that the absolute purity of sound arises within them as within the creation of a great musician. With the help of these colors and of lines pervaded by an authentic Hellenistic rhythm, Rublev expressed his world of feelings and experiences, the world of an artist wholly absorbed in contemplation who utters a new word, not to run after novelty but to respond to his deep inner demand.

Like Simone Martini, Broederlam, and Master Francke, Rublev also sought to make the traditional canons more flexible and introduce into them a new spirit, more human. But, if for Italians, what really counted most in this world was the human being of will and reason who embodied the idea of *strength;* if for Flemish and German artists, what mattered was nature in its most beautiful and spiritualized guise, where humanity was always an insignificantly small part of the enormous universe, for Rublev what counted most in this world was the *good,* active human being, ready to help the neighbor. Rublev personified this good and active human being in the angel, the saint, and the ascetic. In these images, he was also able to incarnate the pure beauty of youth, the unshakable strength of maturity, and the solemn wisdom of old age, and to all of them he imparted his own most secret human feelings; in his eyes, they were interpreters of the highest moral ideals. For him, God ceased to be a terrible force, magical, blind, and implacable, which was the perception of medieval consciousness: Rublev was very close to human beings and, with them, close to the world. This is why there is nothing frightening, nothing which calls for the mortification of the flesh in his icons. From this viewpoint, Rublev is similar to Nil of Sora, who was spiritually akin, and the extraordinary transparency of his images springs from his own interior illumination.

It would not be right to reduce all the Muscovite painting from the first thirty years of the fifteenth century to the work of Rublev alone. He was certainly the central figure, but other great masters also worked around him, such as Prochor of Gorodets and Daniil. The Moscow school of painting was going through its period of greatest ascent and it probably encouraged many talented artists who belonged to the younger generation. Masters of the previous generation, who carried on the traditions

of the fourteenth century, had by no means left the scene; one can credit them with icons like the *Descent into Hell* in the Tretyakov Gallery,[235] the *Virgin of Tenderness*[236] and the *Virgin of Tichvin* in the Monastery of the Trinity of Saint Sergius,[237] which display much that is archaic and make clear how difficult it was to overcome the legacy of the previous century. These lengthy processes are frequently found in the history of Russian iconography and make it extremely complicated to establish the exact dates of icons and their authentic place in history.

Among the most gifted artists from Rublev's time who, even though they did not belong to his school, worked "in step with the times," we should mention the author of the *Virgin of Tenderness* in the Cathedral of the Dormition in Moscow and the artist who painted the marvelous icon of the *Archangel Michael with Deeds from His Life* in the Cathedral of the Archangel in the Moscow Kremlin. The *Virgin of Tenderness* reproduces the model of the famous Vladimir icon, brought from Vladimir to Moscow in 1395. As is known, this icon traveled several times (?) from Vladimir to Moscow and vice versa and was finally placed in Moscow in 1480,[238] but no source alludes to its leaving Moscow in 1395 or to the fact that under these circumstances, a copy of it was made whose execution was entrusted to young Rublev.[239] The mature style of the icon prevents dating it to the end of the fourteenth century: this work certainly did not appear before the first quarter of the fifteenth century and was painted by a master who must surely have known the icon of the *Virgin of the Don,* which Muscovites admired so much. While preserving the iconographic framework of the highly renowned Byzantine original, the artist imposed a substantial change on the types of the faces, in which lofty spirituality was replaced by an expression of the simplest human feelings.

An eminent master, a contemporary of Rublev, painted the icon in the Cathedral of the Archangel, which is unfortunately badly damaged. A very old tradition associates this masterpiece of Muscovite painting with the name of the Grand Princess Evdokiya, Dmitrii Donskoy's wife (died 1407). Stylistically, the icon announces works of a later period, probably the first decade of the fifteenth century, as is seen especially in the type of the Trinity represented in one of the border scenes, which preserves echoes of Rublev's great art.

The archangel Michael was venerated in all Rus as the most reliable advocate in military matters. Many churches were dedicated to him; before leaving on their military campaigns, princes would always invoke his intercession; his image was engraved on the helmet of Yaroslav Vsevolodovich (beginning of the thirteenth century). A Kievan chronicler already called him the "prince of angels," glorifying him for having fought the devil for the body of Moses, for having intervened, as the protector of the Hebrew people, against the Persian king for the freedom of human beings, for having saved Balaam from a fatal destiny, for having unsheathed the sword before Joshua, forcing him, by example, to march against the enemy, for having annihilated in one night about a hundred thousand Assyrian warriors, for having lifted the prophet Habakkuk up to heaven, and for having fed Daniel in the lions' den.[240] A series of these episodes also appears in the border scenes of the icon, but the choice is very personal and does not correspond exactly to any of the known literary sources. The image of the Trinity in the upper corner, which opens the cycle, provides in a certain sense the key for interpreting the logic of the scenes of the episodes from the life: the archangel Michael appears as the protector of the Blessed Trinity. In the following scene *(Synaxis of the Archangels),* there is an allusion to Satan's fall from the heavenly ranks and to the onset of the reign of darkness which becomes established on earth. These border scenes can be grouped into three categories according to their meaning: the six scenes along the left side illustrate the angels' deeds of protection and punishment; the six scenes along the right, their salvific acts; the three upper and three lower ones, their battle with Satan.[241] In the subjects of the scenes, with their clear-cut contrast between the world of good and the rule of evil, there are possible reflections of the emotions which accompanied the battle of Kulikovo[242] and then found brilliant expression in the literary accounts. Although difficult to prove, it is nevertheless a legitimate hypothesis which in large part explains the bellicose appearance of the archangel in the center of the icon.

Michael is pictured with his sword unsheathed, powerful wings, and a flowing fiery red cloak. The engraved armor accentuates the muscles of the torso; the broad shoulders and well-developed limbs betoken his being accustomed to military labors. There is something menacing, something which commands fear, in the decisive and strong-willed expression on the severe face. The ideal of military courage is embodied in this figure; and in the images which surround it on the cornice, episodes in which Michael appears in the role of a dynamic fighter or avenger predominate. The compositions, the shapes of the impetuous and vehement figures, the strokes of brilliant and intense colors are full of dynamism. The various shades of a soft green tone are boldly next to red and aqua green tints. With great discernment, the artist used the mountains and architectural elements to organize the composition and make it "legible" — an indispensable quality in a hagiographical icon meant to be contemplated from a certain distance.

A peculiarity of this icon is the vegetal ornamentation dotted with engraved points in the *levkas*. This motif may have been inspired by the embossed coverings, more and more widespread in the iconography of the fifteenth century. Since the ornamentation of the icon is not fashioned according to rigidly symmetrical rules but only on following a harmonious correspondence between the parts, it may have a symbolic significance: it may allude to the trees with gold leaves and to the vineyards of Eden, which the archangel Michael guards.[243]

After Rublev's death, the rhythm of development in Muscovite painting slowed a little; and only with Dionysii did another great master appear, but already with a distinct orientation and a totally different temperament.

The 1430s to 1460s represent a somber period for iconography. We lack works with precise dates as well as historical and literary sources. The works of embroidery which have survived from that time are of little use because the specific technique for embroidery was less flexible than the technique for painting. The uncertainty enveloping iconographic works from those decades is explained, in part, by the tragic political events of that period: first, the war with Lithuania and the princes of Galicia, then the civil war between Vasilii Vasilevich the Somber (1425–1462) and Dmitrii Shemyaka weakened the position of the Muscovite princes. In this situation, Moscow almost completely stopped erecting masonry buildings and requests for icons decreased because the new churches which were constructed did not need iconostases. The chief iconographic studio must have still been associated with the metropolitan's palace, whereas artists from the prince's court probably scattered to the various monasteries, which rapidly became richer and intensified their own building activity year after year.

The traditions of Rublev still continued but the forms were becoming slender, more delicate, almost miniature-like. This phase is represented by icons like the *Virgin Hodegetria, the Trinity, and Saints*, the *Virgin of Yaroslav with the Trinity and Figures of Angels and Saints* of 1446 (?), now in the Tretyakov Gallery, and the *Virgin of Tenderness* in the monastery of the Trinity of Saint Sergius.[244] At the same time, artists were also painting more monumental icons in terms of their formal structure, in which they employed the "stumping" method with virtuosity. Among these, we have the fragment of the head of the Virgin included in a sixteenth-century representation of a *Deesis* with bust figures and a splendid work like the *Virgin of Yaroslav* from the I.S. Ostrouchov collection (Tretyakov Gallery). The traditional type of the Virgin of Tenderness is enhanced by a charming gesture: with his right hand, the Child lightly touches Mary's chin and the edge of her garment with his left, accentuating even more the affection which governs the relationship between mother and son. The figures are delineated with a uniquely soft line of rare graphic perfection. The admirable modeling of the faces is accomplished with the help of the softest shades, rendering the chiaroscuro transitions almost imperceptible. The faultless design and exceedingly fine sense of line make this icon a work of the highest quality. Its author was a slightly older contemporary of Dionysii and the exponent of an unusual current still almost unknown in the development of Muscovite iconography around the middle of the century.

A new period in the history of Muscovite art began with the reign of Ivan III (1462–1505), under whom the centralized Russian state began to take shape. Ivan III concluded the annexation, initiated

Pl. 109
Pl. 111
Pl. 114

Pl. 112
Pl. 113

by his father, of several independent principalities to the principality of Moscow. He put an end to the independence of Novgorod Velikii and submitted to his own power the territories beyond the Volga and along the Dvina, as well as Perm and the principality of Tver. Under him, the dependence of the Muscovite state on the Golden Horde ceased, an advantageous peace was concluded with Lithuania, and a series of lethal blows were inflicted on the ranks of the Livonian cavalry. Moscow emerged onto the international scene and initiated diplomatic relations with the Republic of Venice, Germany, Turkey, Hungary, Denmark, and Persia.

With the growing importance of the prince of Moscow, described in 1492 by Metropolitan Zosimus as "sovereign and autocrat of all Rus" and "new tsar of Constantinople,"[245] a new political theory was born. Moscow began to be called the "third Rome," direct heir of the universal empire, as had Byzantium been considered before. Ivan III married Sophia Paleologa, the niece of the last Byzantine emperor and introduced into his court a magnificent system of ceremony very reminiscent of the Byzantine, with solemn exits and sumptuous receptions of ambassadors. He even changed the language of diplomatic acts, making it more rhetorical and studied.

All these changes were also reflected in the arts. Ivan III was no longer satisfied with the modest structures of the Kremlin and invited Italian architects to erect a residence worthy of himself. A period of intense building activity started, and with it, requests for icons also increased. But the spiritual atmosphere in which artists worked between the end of the fifteenth and beginning of the sixteenth centuries was quite different from the one we could observe in Moscow at the time of Dmitrii Donskoy and his immediate successors: it had become colder, more official, less human. The increasing centralization had a profound influence on every sphere of life. The struggle against the heresy of the Judaizers concluded in 1490 with their doctrinal defeat, followed by a bloody repression. Heresies were brought to an end and a solid alliance was forged between Church and secular power, which resulted in an impoverishment of spiritual life. In these circumstances, there was no room for the personal religious search or the upholders of monastic poverty; the monasteries, rapidly enriched, wanted ratified their possession of precious liturgical vessels, sumptuous vestments, in a word, everything against which Nil of Sora had railed and which, instead, Iosif of Volokolamsk, a great lover of earthly things, was introducing very methodically and systematically into monastic life. This provided a context favorable to the rejection of bold innovations, to the reinforcement of conformist tendencies, to the imitation, as sacred traditions, of "models" from the ancient past. However much we may esteem Dionysii and the artists of his time, in their works, we no longer have that depth and immediacy of feeling which characterized the art of Rublev and the masters of his circle.

It would be erroneous to think that Muscovite painting from the last thirty years of the fifteenth century totally depended upon Dionysii. He was definitely the central figure, but there were also other styles besides those of his own school, just as at the time of Rublev. In this context, we recall the small PL. 114 charming icon of the *Virgin of Tenderness* (Monastery of the Trinity of Saint Sergius), whose complete flatness and angularity of form leave no space for the artist to express the tenderness of the mother toward her son, who seems to be playing lightheartedly. Nevertheless, such a purity of emotional resonance is rarely attained in Muscovite iconography.

The large icon of the *Dormition* in the Cathedral of the Dormition in the Moscow Kremlin, painted perhaps on the occasion of the church's consecration in 1479, belongs to a more modern trend, but is also unrelated to Dionysii.[246] This trend, just like the current inspired by Dionysii, is characterized by its emphasis on the festive and representational aspects. The old iconographic practices were reworked, always with a greater solemnity. In the scene of the Dormition, we are immediately struck by the great increase in the number of personages and the great complexity of the compositional fabric. The bed of the Virgin is surrounded not only by the apostles, bishops, and holy women but by angelic hosts as well. The angel standing in front of the apostle Paul has raised his sword over impious Athonius, who unworthily comes near the deathbed of the Virgin (according to the legend, Athonius had both hands cut off). In the upper part, the artist showed the Mother of God as-

cending to heaven and the apostles approaching, soaring on the clouds. According to an ancient apocrypha, the apostles were informed of the impending death of Mary and came, carried on the clouds by angels so that Christ's disciples could take leave of his mother. An auxiliary scene, inspired by the same apocrypha, frequently accompanies this episode: assumed into heaven, Mary hands her belt to the apostle Thomas, who arrived late at her bedside. The composition of the icon in the Cathedral of the Dormition, overpopulated with figures, recalls Serbian frescoes on the same theme. It seems that this variation of the Dormition, overcrowded with people, had become established in Russian iconography only in the last quarter of the fifteenth century, whereas it was still unknown at the time of Rublev. The icon in the Cathedral of the Dormition, which unfortunately presents serious lacunae, may be the first example of this new genre. The magnificent icon of the *Dormition,* kept in the PL. 116 Tretyakov Gallery, is based on a similar iconographic model. Coming from the Monastery of Saint Cyril of Belozersk, where it was the principal icon of the cathedral of the same name, built in 1497, this icon is usually dated back to a previous period, and many simply want to attribute it to the brush of Rublev himself. However, the complex iconographic plan proves that such an early date is wrong. Rublev and his contemporaries preferred simpler and leaner compositions, whereas the author of the *Dormition* from the Monastery of Belozersk clearly favored the version with many figures which came into Russian iconography under the direct influence of Serbian painting. It is evident that this sort of solemn composition with a large number of figures was highly appreciated within the princely milieu; otherwise, it would be difficult to explain exactly why two icons like the *Last Judgment*[247] and the *Apocalypse*[248] come from the Cathedral of the Dormition.

Dionysii, the most famous master from the end of the fifteenth century to the beginning of the sixteenth, started to work in the 1470s. A precise identification of his works turns out to be even more problematic than the study of Rublev's works. A layman, Dionysii never worked alone, but always collaborated with other masters. Most likely, he belonged to a large brigade whose personnel changed according to the commissions. Between 1467 and 1477, together with Mitrofan and his "assistants," he painted the Church of the Nativity of Mary in the Monastery of Pafnutii.[249] Since in the historical data on these frescoes, the first name mentioned is Mitrofan, a monk of the Simonov Monastery in Moscow,[250] we infer that he was the elder, and probably the master of young Dionysii. Some time later, Dionysii painted a *Deesis* for the Monastery of the Savior on the Mountain (Spaso-Kamennii) on Lake Kuben;[251] and about the same time, together with a certain priest, Timofei, together with Yarets and Konya, he executed "a *Deesis...* with *Feasts* and *Prophets*" for the Cathedral of the Dormition, which was built by Fioravanti, in the Kremlin.[252] It is significant that this time Dionysii's name is placed first, from which we can deduce that he must have already been a much admired master. The sum of one hundred rubles, enormous for that time, paid for the icon by Archbishop Vassian of Rostov, the right-hand man of Ivan III, is further proof of Dionysii's renown. Dionysii did not paint the frescoes of the monastic Church of the Savior "in the fires," which rose beyond the Yauza opposite the Kremlin, before 1483. When the church was destroyed in 1547, the chronicler observed with disappointment: "The author of the frescoes of this most beautiful church was the iconographer Dionysii." Around the year 1488, the artist frescoed the Cathedral of the Dormition, built in 1484 in the Monastery of Iosif of Volokolamsk. Here too, he worked with the help of a brigade of masters: his sons Feodosii and Vladimir, the starets Paisii, and two nephews of Iosif of Volokolamsk: the startsy Dosifei and Vassian, future bishops of Krutitskii and Kolomenskoe.[253] The last references to Dionysii cite the year 1502, when, together with his sons, he frescoed the Church of the Nativity of Mary in the Monastery of Ferapont, and a period between 1504 and 1505, when, with the help of his sons and their disciple Pyotr Tuchkov,[254] he executed the icons for the winter Church of the Theophany, built shortly before in the monastery of Volokolamsk. The art of Dionysii flourished, therefore, between the sixties and nineties of the fifteenth century and reached its culmination in the frescoes of the Monastery of Ferapont, which are extremely well preserved. However, considering the master's venerable age, the frescoes must have been painted for the most part by his sons and assistants.

There is no doubt that Dionysii was at the center of the artistic life of Moscow. Associated with the milieux of the court and high clergy, he worked a great deal for monasteries where they staunchly maintained ascetic monastic ideals. It is possible that Iosif of Volokolamsk may have addressed his *Letter to the Iconographer* specifically to him. In it, Iosif was pursuing a merely practical goal, which was to clarify the most current problems which had arisen in the course of the polemics with the iconoclastic heretics and, at the same time, put an end to attempts to create new iconographic types not consecrated by tradition. To this purpose Iosif of Volokolamsk used, with the overscrupulousness which characterized him, an enormous number of patristic texts which handed down the doctrine on the veneration of icons. But his method of approaching these original sources was different from that of Nil of Sora. For the latter, everything the monks possessed had to be of "little value and not decorated," so that the monks were not to use gold or silver vessels or superfluous decorations.[255] To the ecstatic forms of Byzantine ascetic sanctity, Nil of Sora opposed "working from the heart." But Iosif of Volokolamsk, who seemed to agree with Nil of Sora in words, actually took entirely different positions. By every means, he sought to re-establish the severity of the monastic rule, reimpose an iron discipline, and institutionalize the forms of the veneration of sacred images. With Iosif's support and collaboration, the monasteries began to institute worship endowed with ceremonial splendor in which it is impossible not to see penetrating into religious life the typical ostentation developed in the court of Vasilii III.

In Dionysii's art we see the different spiritual currents of his own time intertwined in an original way. And like Rublev, he strove to incarnate the "beauty which is not of this world," tried to portray people whose appearance would foster purification and moral perfection. He was attracted by the state of interior recollection and was fond of conveying in his icons and frescoes the power of wisdom, kindness, and humility. All this he shared in some manner with Rublev, but in his works, new tendencies persistently gained ground, above all, the increasing adherence of artistic thought to the canons, which is manifested in repetitions of the same motifs in the dynamics and artistic methods. There is something monotonous in the faces of the saints which reduces their psychological expressiveness; in the proportions and contours of the figures, a fragility unknown to Rublev emerges, which now and then seems really intentional. All that was strong-willed and powerful in fourteenth-century art gives way in Dionysii to a particular sweetness and harmonious rounding of forms. As a result, the "luminosity" of Rublev is, in Dionysii, imperceptibly transformed into a "festiveness," already a sign in itself that the lofty spirituality of the icon was weakening.

Dionysii's studio was intensely active. An inventory of the icons of the monastery of Iosif of Volokolamsk, prepared in 1545 by the starets Zosimus and the librarian Paisii, lists ninety icons by Dionysii, in addition to other works by his sons Vladimir and Feodosii, the starets Paisii, Daniil of Mozhaysk, Michail Konin, and a certain Novgorodian.[256] In this regard, it is necessary to recall that already at this time Dionysii's style was not confused with that of his sons and disciples, and details were noted, such as the fact that the icon of the *Hodegetria* was Dionysii's work, but the antas [rectangular panels] of the doors were Feodosii's, or that the icon of the *Dormition* was not the work of the master himself, but of his sons and disciples. In general, various artists worked together in painting hagiographical icons. Thus, for example, in the icon by Paisii, the *Nativity of the Virgin*, which is from the local tier, the border scenes on the cornice were painted by Dionysii's son Feodosii. All of this makes it extremely difficult to identify the works done by Dionysii himself, all the more so because we have no icons signed by his companions. The only applicable criterion is that of quality, but this cannot be decisive since we do not know the degree of accomplishment attained by the masters who worked with Dionysii; therefore, it will be more prudent to speak of icons from the stylistic group we are examining as works from the studio of Dionysii or from his school.

Recently, there have been attempts to make the origins of Dionysii's art go back to the school of Rostov-Suzdal,[257] but this theory does not appear convincing at all. Dionysii was strictly a Muscovite master, closely linked to the traditions of the city and especially to those of the young disciples and

successors of Rublev (for example, the author of the *Crucifixion* and the *Women at the Tomb of the Lord* from the register of the *Feasts* of the iconostasis of the Trinity). The extensive use of Muscovite icons from the early fifteenth century as models of inspiration by Dionysii and the masters of his school also constitutes an essential link with Rublev's traditions. From this, we deduce that Dionysii continued the line of evolution carried forward by Rublev in his own day and that he consciously held to it. But the times and general situation were different, and so too was the nature of Dionysii's art.

The oldest icon by this master to have survived until the present goes back to 1482, the *Virgin* PL. 115 *Hodegetria*, now in the Tretyakov Gallery, from the cathedral of the Monastery of the Ascension in the Moscow Kremlin. The chronicler relates that in the 1482 fire, this Greek-made icon lost its layer of color and covering but the panel was preserved. At that time, Dionysii was given the responsibility of painting on that same panel an icon "with the same image."[258] The iconographic type of the Virgin Hodegetria (the one who shows the way) was quite popular in Rus (especially in Moscow). It is known that in 1381, Archbishop Dionysii of Suzdal brought two exact copies of the famous Hodegetria image from Constantinople and placed them in his cathedral at Suzdal and in the cathedral of Nizhnii Novgorod.[259] Later on, one of these copies may have ended up in the Church of the Ascension, but it could also have been another copy, similar to the one in the Tretyakov Gallery.[260] In any case, here Dionysii was constrained by an image which he had to reproduce exactly. He maintained integrally the solemn impressiveness of the image and its iconic inaccessibility. As is typical with Dionysii, the faces are painted with great softness, without abrupt transitions between light and dark areas. The *sankir* is applied in a fine layer; the flesh tone beneath the rose color of the faces is totally absent; and the shades are imperceptibly superposed. All this deprives the face of relief and volume, making it almost immaterial. The elegant half-length figures of the angels wrapped in turquoise blue, green, and yellow garments, inspired by Rublev's saints, are executed with a very fine miniaturist technique which gives an idea of the pictorial style the master used when working with figures on a small scale.

The magnificent icon of the *Deposition of the Virgin's Belt and Robe,* which is held in the Andrei PL. 118 Rublev Museum of Early Russian Art but came from the wooden church, dedicated in 1485, in the village of Borodva, is connected with Dionysii's studio. It is especially important in that it helps date the icon of *Metropolitan Peter with Scenes from His Life,* in the Cathedral of the Dormition in Moscow, since the border scene representing the *Consecration of Patriarch Peter as Metropolitan of All Rus* is stylistically very close to the Borodva icon. The latter is particularly beautiful because of its luminous and festive colors among which red predominates together with Dionysii's favorite pinkish tones.

As of the last quarter of the fifteenth century, hagiographical icons were more and more widespread in Moscow, probably following on the struggle against the heresy of the Judaizers, many of whom denied the veneration of images. Hagiographical icons, brought from Byzantium to Rus, combined a devotional image, generally in the central part of the panel, with scenes from the life of the saint depicted in the center arranged along the border. This sort of composition overcame, in some way, the atemporal setting of the icon, allowing the artist to narrate the saint's life, deeds, and miracles in the sequence of episodes depicted in the rectangles on the cornice. Thus, icons became easier to understand and more didactic, something which was especially important during the years of relentless battle against iconoclastic ideas. From this also came a broadening of themes, thanks to which painting was enriched with new subjects allowing for the introduction into the icon of a series of details frequently drawn from everyday life. In this regard, Muscovite artists of the fifteenth century were quite reserved; they limited themselves to just the indispensable elements, always maintaining some distance between the material world and the world of thought. The scene often became an ideogram in which a building with a dome symbolized the Church; a group of buildings, the city; a rock, the desert; and a small pool of water, a lake or the sea. Because they were arranged in succession, each of the episodes narrating the life of the saint represented an event by itself; consequently, in these hagiographical icons, which seemed to illustrate the flow of single events in time, everything unfolded independently of temporal categories.

Dating hagiographical icons is extremely difficult because, as a rule, artists followed a literary text and on this basis elaborated their own plans; hence, it often happens that similar scenes (for example, prayer or conversation scenes) in icons depicting different saints turn out to be like two peas in a pod. Yet, even hagiographical icons have their variants: the number of characters increases; the architectural backgrounds become more complicated; and the proportions of the figures become more elegant.

Prior to 1481, when Dionysii and his brigade were given the responsibility of painting the icons for the iconostasis, the Cathedral of the Dormition in the Moscow Kremlin, dedicated in 1479, had a painted partition in front of the sanctuary and a series of icons in the local tier (which probably also included the great icon of the *Dormition,* the feast to which the church was dedicated). We do not know exactly when the hagiographical icons of Metropolitans Peter and Alexius were placed in the Cathedral of the Dormition, but it was probably in the 1480s.

As we know, interest in the lives of the metropolitans increased notably in Russian society after the end of the seventies: in 1479, the body of Metropolitan Peter was solemnly translated from the Church of Saint John Climacus to the new Cathedral of the Dormition, and in 1485, the ashes of Metropolitan Alexius were taken to the church built in his honor by Metropolitan Gennadii. And even though these two episodes do not appear in the icons' border scenes, it is still logical to assume that the icons were ordered from Dionysii in the 1480s, when he and his brigade were working on the iconostasis of the Cathedral of the Dormition.

The icons of Peter and Alexius were evidently wall icons and placed facing one another or on either side of a wide opening. There is no reason at all to consider them part of a diptych. Considering the close bond between the authority of the grand prince and the metropolitan cathedral, great political importance was attributed to the two icons. It is no accident that they were executed for the main cathedral of the Kremlin; besides, they depicted the "wonderworkers" against whom — as the 1490 conciliar judgement states — the heretics "made denigrating speeches."

PL. 117 In the icon of Metropolitan Peter, who actively collaborated with Ivan Kalita's work, the metropolitan is represented as the ideal Russian primate, who not only performed miracles but also participated in the forging of the Russian state. In the border scenes, we see Peter appointed metropolitan by the Patriarch of Constantinople, the transfer of the metropolitan cathedral from Vladimir to Moscow according to his desire, his prediction of the brilliant future of Ivan Kalita and his successors, the construction of the principal church of all Russia, the cathedral of the Dormition, and the arrangement of the tomb inside. Next to this main thematic line, figure scenes from the saint's childhood and youth as well as episodes about various miraculous prophecies, the translation of the deceased metropolitan's body to the Cathedral of the Dormition, and the cure of the sick who approach his open coffin.

PL. 119 In the icon of Metropolitan Alexius, who was very close to Dmitrii Donskoy, his state and religious activity is also given prominence: his election as bishop of the city of Vladimir, the expedition to the Golden Horde at the request of the grand prince and the healing of the khan's wife Taydula, the conversations with Saint Sergius of Radonezh. The narrative cycle concludes with Alexius' death, the return of his relics, and his posthumous miracles.

Hagiographical icons have a very old tradition in Russia, but only with Dionysii do they gain that artistic refinement which makes them outstanding examples of early Russian painting. In the icons of Peter and Alexius, we recognize, first of all, the artist's rare ability to architecturally organize the surface, whether of the entire panel or of each individual border scene on the cornice. There is a profound intrinsic logic in the proportional relationships between the central area and the dimensions of the border scenes, between the height and width of each rectangle, between the figures and the backgroud. All of this was normally done by eye, but the eye of the artist was most accurate and rarely made a mistake: only after long years of tenacious apprenticeship did a Russian iconographer became so adept in solving the problems of composition.

In Dionysii's time, the figures of the metropolitans were silhouetted against well-finished, pale green backgrounds, in imitation of clouds, with a light, airy ornamentation. The figures were thus set

in a space which was not oppressive and lacked precise limits, not a real three-dimensional space but rather a rarefied atmosphere in which the figures, buildings, and landscape backgrounds were without weight or volume. This consistent elimination of the principle of space was a characteristic of all the icons and frescoes of Dionysii and the masters of his school; and even though they made the architectural backgrounds more complex in their works, the images did not become more three-dimensional because of it. In this phase of development in Russian iconography, the subordination of the entire composition to the surface of the panel also remained the prevailing rule.

The icons of Peter and Alexius maintain a unique chromatic range, radiant and festive, with a predominance of snowy colors which determine the entire chromatic structure. White was never used so abundantly in a Russian iconographer's palette and this already represented an innovation in coloring. White is a luminous color; it always contains a silvery shade and usually determines the other colors, as if transferring this shade to them. And this is exactly the phenomenon we observe in our two icons: the white which predominates in both icons lightens all the other colors. Here is the reason red is replaced by pink or a pale crimson, green by pistachio, brown by golden brown, yellow by pale yellow, azure by sky blue, and so on. These airy tints, without weight or thickness, lighten the form remarkably. It is interesting to note how mostly white or soft shades of a pale lilac, pearl gray, or faded green are used for architectural backgrounds or mountains. In the icons by Dionysii and the masters of his school, buildings and landscapes are always so pale that even figures in slightly brighter colors stand out against this background like dark shapes. Thanks to this brightening of the whole palette, these icons gain an unusual luminosity in comparison with earlier ones.

Dionysii and the masters of his school preferred the slow unfolding of events. Each scene is like an action that lasts forever, purified of every casual and marginal element. The figures are light and slender; the movements are not hurried; the gait is noiseless. The standing figures are often shown slightly inclined with their arms somewhat stretched forward. Also very common is the theme of the figure who is seated quietly or sunk in meditation or involved in a calm conversation. In this art, which is fundamentally contemplative, there is nothing abrupt, nothing vehement or noisy. If the artist is describing a dramatic conflict, it loses all its tension since the action is immortalized, like an instant frozen in time. This is why it is so difficult to extricate oneself from the nuances of this art in which, at times, everything in the one is sure to find its replica in the others. But the more we immerse ourselves in the contemplation of these hagiographical icons, the more they attract our attention because of their plastic expressiveness. Even if everything resonates softly, even if violent contrasts of situations and characters are missing, the unfolding of events is represented so eloquently that little by little, we begin to understand all that the artist did not convey openly.

And even though Dionysii did not use perspective, did not resort to chiaroscuro modeling, did not depict movement, yet he succeeded perfectly in communicating his message to the observer. He needed only to juxtapose a light area and a dark one, paint a hand which expressively stands out against the white background, or sketch with a single stroke the necessary pose or gesture; two or three buildings or a simple red cloth were enough to deliver to spectators the exact idea the icon illustrates because they understand where the good people are and where the wicked, what they are saying, where they are located, and what their surroundings are. The conciseness of the figurative language logically leads to one part easily giving the meaning of the whole.

In order to make the main plot of the story evident, artists used landscape and architectural backgrounds very aptly. In the scene of the *Appointing of Patriarch Peter as Metropolitan of All of Rus,* the figure of the patriarch is accentuated by the vertical building to the right, the curve of his body by the parabolic line of the baldachin, the group of priests to the left by a rather unusual building crowned by a conical cupola and two gables. In the scene portraying the dream of Ivan Kalita, who is seen riding in front of a high mountain covered with snow, symbol — as Metropolitan Peter would explain — of the rising importance of the grand prince and of Peter's imminent death, the outline of the mountain repeats that of the horse, and the parabolic line which delineates the two figures recalls the curve

of the mountain to the right. In the scene of the *Birth of Elevferii Alexius,* the dark vertical opening of the building to the right underlines by contrast the bow of the maid-servant, and the veil cast between the buildings helps unite the figures of the two women into a compact group. In the scene of *Alexius Healing the Khan's Wife Taydula,* the white tent is effectively used as the background for Taydula and the maid-servant who supports her and for Alexius' outstretched right hand, which holds the aspergillum; the undulating line of the rocks seems to repeat the contour of the stunned crowd which observes the wonder taking place before their very eyes. By these and other measures, artists obtained that narrative lucidity and comprehensibility which were indispensable in hagiographical icons with their small border scenes.

PL. 120 The hagiographical icon of *Saint Cyril of Belozersk* (Russian Museum) also came from Dionysii's studio. Cyril, whose hagiographer was Pachomii Logoteta, was a faithful follower of Sergius of Radonezh. Born in 1337, he arrived in the region of Belozersk when he was sixty and founded there the famous monastery (later named after him). Cyril, who died at the age of ninety, left three letters, filled with a profound spirit of monastic humility, addressed to the three foremost brothers. The artist placed the figure of Cyril, clothed in the monastic habit, in the center, and in the twenty border scenes, related the main events of his life, starting with the monastic tonsure and ending with his legendary miracles and death. The execution of the scenes is limited to the essentials, as in the icons from the Cathedral of the Dormition. Particularly interesting is the scene showing the arrival of Cyril and Ferapont at White Lake, Belozersk (picture at the top, to the right); to the left we see the monks who are approaching the lake guided by Cyril and Ferapont and to the right the two founders of the monastery who dig out a cave as a refuge, the nucleus of the future monastic buildings. As usual, the landscape is developed along vertical lines and the plants and trees indicate that the location chosen for the monastery was surrounded by thick woods.

PL. 122 Dionysii's studio dedicated yet another wonderful icon (Russian Museum) to the figure of Cyril. It was painted when the artist was already mature, when the tendency to exalt elongated proportions and a certain frailness of the figures began to appear in his works. Cyril's head is a twelfth of the figure's entire length, yet the artist succeeded in expressing the ideal of the Russian ascetic in his face: meekness and strength of character.

At the end of the fifteenth and during the first quarter of the sixteenth century, students and followers of Dionysii painted many hagiographical icons (for example, the icons of *Saint Sergius of Radonezh* in the Monastery of the Trinity of Saint Sergius[261] and in the Rublev Museum,[262] *Saint John* PL. 121 *the Theologian* in the Tretyakov Gallery,[263] *Saint Demetrius of Prilutsk* in the Vologda Museum, *Saint Andrew Yurodivyi* in the Russian Museum, and others). Among all these works, the last two are the best in terms of quality. The former came from the studio of Dionysii himself. Its border scenes are very similar to those in the icon of *Saint Cyril of Belozersk with Scenes from His Life* and also recall that icon in their rather dense coloring, with its predominance of dark violet, dark green, greenish yellow, and cherry shades. The slightly somber tonality of these icons may be due to the fact that monks are pictured in both. Demetrius of Prilutsk (died in 1391), a faithful follower of Saint Sergius of Radonezh, founded a monastery in the dense woods of Vologda. The main events of his life are immortalized in sixteen border scenes, beginning with his monastic tonsure and ending with his legendary miracles. In particular, in the scene at the top right, we have the encounter between Brother Demetrius of Prilutsk and Dmitrii Donskoy, the latter inviting the former to come to Moscow to baptize his children. Demetrius of Prilutsk's stern face with its rather characteristic features is very expressive.

PL. 123 The second of these works is the icon of *Saint Andrew Yurodivyi with Scenes from His Life,* in the Russian Museum, already painted at the beginning of the sixteenth century by an assistant of Dionysii. The life of Andrew Yurodivyi [fool for Christ] was imported to Rus from Byzantium. He was venerated among people like pilgrims and the poor, those whose lips speak words of truth. While he was serving as a slave in the house of a noble Byzantine patrician, Andrew began to show signs of madness and his master locked him up, but when he realized that Andrew was harmless, he set him free. From

that time on, the "miraculous" life of the fool for Christ began. The major event in Andrew's life was the Virgin's appearance to him while he was praying in the Church of the Blachernae in Constantinople (the Russian icon of the *Virgin of Mercy* is based on this legendary episode, depicted in the bottom center scene). Andrew Yurodivyi enjoyed great popularity in Byzantium around the year 1000, when everyone was awaiting the end of the world; and Andrew, who was particularly prone to eschatological visions, was among those prophesying it. A similar situation also occurred in Rus in the year 7000 (1492), considered a critical date in the life of humankind. And although the Judaizers, observing the preoccupation which snaked its way among the people, tried in every possible way to refute the widespread ideas about the imminent end of the world, the expectation of the Last Judgment became a kind of collective psychosis. In this climate, the image of Andrew Yurodivyi was bound to attract attention (and did!) in a powerful way because this saint insistently announced the ultimate fate of the world and humanity.

The author of the icon was undoubtedly familiar with Dionysii's art; otherwise, it would be difficult to explain his light, transparent coloring. However, we do not have sufficient reason to describe him as a direct disciple of Dionysii. In his treatment of figures and architectural backgrounds, the author distanced himself considerably from the master's tradition, and he preferred an unadulterated pictorial style, completely graphic, anticipating one of the artistic tendencies of the sixteenth century.

Several icons for iconostases were painted in Dionysii's studio, most of which have not survived or have been scattered. From one of these iconostases, which at one time decorated the cathedral of the Monastery of Paul of Obnora, come the icons of *Christ in Glory* and the *Crucifixion* in the Tretyakov PL. 124 Gallery (a few icons from the same iconostasis, which are still not restored, are in the Vologda Museum). On the back of the icon of the *Christ,* there is an inscription engraved in the wood which repeats one older and half-erased done in dark gray and placed slightly higher: "In the year 1500, the Deesis, the Feasts, and the Prophets were painted by Dionysii." Most likely echoing the struggle against the heresy of the Judaizers, Dionysii introduced into the *Crucifixion* two figures symbolizing the Church of the New Testament and the Synagogue of the Old Testament. The first figure, accompanied by an angel, flies toward Christ; the second one flies away from him and the angel appears to be driving it along. This interpretation of the icon alludes to the triumph of orthodoxy over Judaism. In the arrangement of the figures beside Christ, Dionysii followed rather closely the *Crucifixion* from the iconostasis of the Trinity, whereas the figure of the centurion Longinus is borrowed from the icon of the *Crucifixion* from the Cathedral of the Annunciation, attributed to Prochor. Thus, Dionysii intentionally drew on the legacy of the masters from Rublev's time, but next to brightening the entire chromatic range, he also substantially modified the proportions of the figures, which are more elongated and slender. By reducing the size of the head, the arms and legs became thinner. The result is a certain instability in a figure's stance; the subjects seem barely to touch the ground with their feet, and at the same time, there is a reinforcement of the linearity of form, which acquires an almost calligraphic precision. Because of all these changes, it is clear that even though the compositional nucleus of the old image was kept, it was subjected to a substantial stylistic reworking. In this way, Dionysii succeeded in creating a work of innovative art and of especially refined artisanship, displaying here for the nth time his ability to combine the canons with bold experiments in form.

At the time Dionysii's studio frescoed the cathedral of the Monastery of Ferapont, its iconostasis was also done, and the icons from the local tier, the *Deesis,* and the tiers of the *Prophets* and *Patriarchs* have been preserved. Many masters must have collaborated in the execution of this large achievement, as the varying degree of quality among the individual icons suggests; but there is one trait they all possess in equal measure, their splendid colors which enrich one another. Dionysii himself probably designed the general chromatic composition of the iconostasis, whereas individual icons were painted by his assistants and disciples, which does not preclude Dionysii's having intervened at points requiring a greater proficiency.

PL. 125 Two recently cleaned icons belonged to the local tier: the *Virgin Hodegetria* and the *Descent into Hell*. Their prominent position in the iconostasis and their extraordinary artistic excellence strongly support their being attributed to Dionysii himself. The icon of the *Hodegetria* strikes us immediately with the richness of its decoration. The golden edges of the Virgin's chiton and *maphorion* are studded with precious stones and trimmed with a fringe of a delicate pattern. The edge of Christ's cloak is also golden and adorned. Here, Dionysii reproduced the model of the Virgin referred to as "decorated with the fringe." And the artist selected his colors in keeping with the solemn and lofty structure of the icon: a magnificent and thoroughly uncommon combination of golden orange, pistachio green, and emerald green shades which are joined with the traditional dark cherry of the *maphorion*. In contrast to the rich clothing, the faces are painted in an extremely modest and restrained manner: the chiaroscuro transitions are almost imperceptible, the red of the flesh tone is barely visible, the characteristic features are extremely contained, and the color is applied in a very fine layer. This pictorial style deprives the face of relief, reminding us of what we have already studied in the *Hodegetria* of 1482. However, in the icon from the Ferapont Monastery, the image is interpreted in a more representational way, at the same time remaining totally incorporeal.

PL. 128 The iconographic version of the *Descent into Hell* which we find for the first time on Russian soil in the icon of Kolomna from the early fifteenth century (Tretyakov Gallery) is quite distinctive.[264] In the center, Christ is shown trampling upon the doors of hell and drawing Adam and Eve from their open tombs. To the left, we see patriarchs and prophets, to the right, patriarchs — men and women — and prophets with John the Baptist in the lead. Christ is surrounded by incorporeal powers in the guise of angels with spheres in their hands, symbolizing the power of the virtues whose written names they bear (happiness, resurrection, charity, truth, joy, sound judgment, humility, meekness, wisdom, life, and purity). With long red lances, these angels pierce the demons below them, which represent the vices listed on the inscriptions accompanying them (death, corruption, sadness, despair, hatred, despondency, malice, irrationality, falsehood, enmity, elation, and anxiety). At the bottom, two angels bind Satan, and to the sides, we see the figures of those rising from the dead. The complicated composition, thick with figures, is crowned by the group of angels glorifying the cross of Golgotha.

If the icon of the *Virgin Hodegetria* is symptomatic of an increase in the representational principle in Muscovite painting, then the icon of the *Descent into Hell* attests to a reinforcement of the didactic principle. The theme gives the artist an opportunity to enumerate the virtues and vices meticulously for the obvious edification of the monastic community. However, it is suggestive that gluttony, lust, greed, and vanity are missing from this list, the most prevalent vices among the *styazhateli* [defenders of monastic goods], vices upon which those who commissioned Dionysii obviously did not want to dwell but which Nil of Sora insistently called to mind. Yet one more time we see how dangerous it is to associate Nil of Sora with Dionysii.[265] The latter belonged to a totally different current of thought. It is not by chance that he was so closely connected to those clerical milieux harshly criticized by Nil, who rejected every kind of ownership as well as celebrations of elaborate liturgical ceremonies.

The icon of the *Descent into Hell*, composed according to the heraldic style, has a strongly emphasized central axis (the cross, Christ, the angels) and lateral portions closely corresponding with each other (the groups of prophets and the just, the groups of the risen). Especially successful is the contrast between the black background of Hades with the dull gray-brown bodies of the demons and the bright festive colors of the garments of Christ and the angels binding Satan. The wide open abyss of Hades is framed by the white-shrouded figures of those who have been raised from the dead, by the mountains and the tombs, as if to form a solid bulwark against the forces of evil. In addition, the lines of this frame are so drawn that, continuing in the figures of Adam and Eve, they impetuously stretch toward Christ. In this carefully balanced composition, skillfully projected onto the surface along vertical lines, as in the refined palette, one senses the touch of an eminent master.

PL. 127 The icons from the *Deesis* differ considerably in quality and present more traditional plans. Many of the figures (for example, *Saint John the Baptist, Saint Gregory the Theologian*, the *Apostle Peter, Saint*

114

John Chrysostom) follow the iconostases of Rublev and Daniil in Vladimir and the Monastery of the Trinity of Saint Sergius; but their coloring is completely different, brighter and more festive. The figures of the Fathers of the Church are particularly beautiful, with a plentiful use of large white surfaces which create a spectacular contrast with the black decorations on the vestments and the bold strokes of red.

Dating back to the beginning of the sixteenth century is a group of icons stylistically akin to the Ferapont frescoes. Besides the *Dormition* in the Rublev Museum,[266] we should mention among them the icon *In You Everything Rejoices* in the Tretyakov Gallery. This extraordinarily solemn composition PL. 126 of many figures clearly demonstrates how complicated traditional subjects had become in Dionysii's school and how by that time they had completely lost the spareness of earlier periods. Ranks of saints, who densely crowd the whole lower half of the icon, take part in the praise of the Mother of God. The extremely elongated proportions implies the beginning of the sixteenth century as the date of this work.

A very close follower of Dionysii is the author of the renowned icon in the Tretyakov Gallery, *The Feast Days of the Week*. Its complex composition was created under the direct influence of the *Hexae-* PL. 129 *meron* of Cyril the Philosopher, who offered edifying lessons on the six weekdays. The scene at the upper left, portraying the *Descent Into Hell*, symbolizes the entire week; the *Synaxis of the Archangels*, immediately next to it, refers to Monday; the scenes which follow are linked in order to Tuesday *(Baptism)*, Wednesday *(Annunciation)*, Thursday *(Washing of the Feet)*, Friday *(Crucifixion)*; and to Saturday belong all the saints (ten partitions with rounded tops in which are depicted the blessed, the apostles, holy men, bishops, prophets, doctors who healed without pay, holy women, male and female martyrs). At the center, we have the figure of Christ Emmanuel in glory, surrounded by the Virgin, John the Baptist, and the choir of archangels. This divided composition, which seemingly nothing could unify, achieves unity thanks to its colors, among which an immaculate white dominates. Combined with coral pink, pale pistachio green and pale yellow tones, white serves as the recurrent theme of the whole light and airy chromatic range.

With the art of Dionysii and his contemporaries, a great period in the history of Muscovite painting came to an end. Dionysii was certainly not a fearless innovator; he did not change or reject anything but, on the contrary, consciously adhered to Rublev's traditions, from which he always drew vital creative stimuli. However, he interpreted these traditions in a unilateral manner: Rublev's works attracted him, above all, by their elegance and grace, the beauty of their colors and lines. Despite all this, Dionysii failed to grasp their depth, their philosophical significance, and their exalted spirituality. He was so fascinated by the marvelous exterior appearance of the phenomenon that he involuntarily began to give preference to it and thus impoverished Rublev's art. By trying to make his icons ever more festive to satisfy the tastes of a rapidly ascending Moscow, Dionysii passed, without realizing it, to a slightly exterior concept of form, which above all had to be beautiful in order to delight the eye. And so it happened that Rublev's most faithful follower also became his antagonist in many aspects.

In the sixteenth century, the traditions associated with Dionysii weakened very rapidly, and the first effect was the darkening of the palette and the decrease in the rhythmicity of the iconic composition. Icons became excessively verbose and began to be weighed down by allegories which reinforced their dogmatic component. Development slowed; the Church exercised ever more jealous control so that bold innovations could not enter into painting.

The defeat of heresies and the eradication of independent thinking had a drastically negative effect on art, where "Byzantinism" started to take the upper hand. And even though sixteenth-century theologians invited artists to paint "from ancient examples, as Greek iconographers and as Rublev and other famous iconographers had painted,"[267] the artistic level of the past was never again equalled. Times had changed: after Rublev and Dionysii, Muscovite painting could no longer produce masters on a par with them.

The Artistic Centers in the
Principalities of Central Russia

Before the rise of Moscow, which began to absorb systematically the once independent principalities, artistic life in Rus was not centralized and each city had its own traditions and its own way of life. This was true for Vladimir, Rostov, Tver, Nizhnii Novgorod, Yaroslav and for smaller cities like Suzdal, Pereslavl-Zalesskii, Uglich, Gorodets, Murom. In the various phases of their development, these cities had a major or minor importance, but they were never able to compete with Novgorod, Pskov, or Moscow nor could they be compared with these three cities in regard to their cultural milieux. After the Tartar invasion, the life of these cities was rekindled with great effort and much that had been accumulated in the previous period was irretrievably lost. For this reason, the tendency on the part of certain contemporary scholars to increase the number of early Russian iconographic schools, as if each city had its own school, is very questionable. To form a school, particular conditions had to be present: a continuity and stability of traditions, a fairly high cultural level, an ongoing flow of commissions, the presence of common cultural characteristics and the existence of a stable group of iconographers. All this was not possible in small urban centers with a predominantly rural population. In these small towns, there were individual iconographic workshops, not important enough to constitute a genuine and proper school, where they obstinately followed the old local pictorial methods from which they distanced themselves only when artistic stimuli came from the outside: from Novgorod or Moscow. As a rule, artists worked in these studios in the old ways, without haste, being guided more by a living religious sentiment than professional experience, following more willingly the directions of their own fathers than the experience of contemporary Novgorodian or Muscovite masters. That, however, did not prevent them from creating now and then works of great value, animated by sincere emotion; but it did hinder their moving beyond the old local traditions, the reason there is nearly always something slightly obsolete, if not altogether provincial in their works. Here, the development of iconography unfolded at a much slower pace, and that makes it extremely difficult to date icons from the cities of Northeastern and Northern Rus. In these regions, one constantly comes across delayed historical phenomena, and this obliges us to be particularly cautious in formulating early dates, which are so attractive to all medieval art scholars.

Rostov,[268] which suffered less than other cities from the destruction by the Mongols, already started to build a few masonry buildings in the thirteenth century. Politically, the city was soon subjugated by Moscow and its cultural life was not under the guidance of the Rostov princes — rather marginal figures — but of the episcopal see, established in the eleventh century, with a jurisdiction extending over the immense territories beyond the Volga River, as far as White Lake (Belozersk) and the remote northern colony of Velikii Ustyug. The activity of iconographers was probably centered mainly around

the episcopal palace, but the Rostov icons discovered in the last few years have no stylistic unity, which implies the existence of other iconographic studios at the service of the churches or monasteries of the vast eparchy of Rostov, often distant from one another.

PL. 131 The *Holy Face* in the Tretyakov Gallery, characterized by evident archaism, goes back to the first half of the fourteenth century. This work continues the pictorial tradition of the pre-Mongol period; the face with large eyes has a dark and deep color which gives it a stern look. The light pink of the cheeks, together with the azure arms of the cross in the halo, the red stones which adorn it, and the golden yellow background create a multicolored chromatic range very reminiscent of the coloring in the icons of Yaroslav from the previous period. It is possible to date the *Trinity*[269] and the icon of *Saint*

PL. 130 *Nicholas of Zaraysk with Scenes from His Life,* from the village of Pavlovo near Rostov (Tretyakov Gallery), to about the same period. The technique of the latter, captivating because of its ingenuous simplicity, is typical of many Rostovian works: the fluid colors are applied in such a fine layer that they allow us to see the underlying design which serves almost as an outline; the faces are painted very freely

PL. 132 with fine brush strokes. The icon of *Christ with the Apostles* may also be associated with Rostov. In its elongated and lightened proportions, we already perceive the new influences of the fourteenth century, influences still emerging very timidly in Rostovian icons from the fifteenth century (*Saint*

PL. 133 *Nicholas the Wonderworker with Scenes from his Life* and *Saints Boris and Gleb*[270] in the Tretyakov Gallery; a half-length *Deesis* in the Rostov Museum).[271]

Muscovite influences penetrated ever more insistently into Rostov during the second half of the fifteenth century, and an icon like the *Christ in Glory* (Tretyakov Gallery)[272] could be directly attributed to the hand of a Muscovite master. All the icons from Rostov are stylistically uneven and the artisanship is rather mediocre, so much so that we do not have sufficient reason to consider Rostov a "separate" iconographic school with a well-defined personality. The Rostov icons present only an imperceptible hint of individuality compared to those of Novgorod or Moscow and cannot in any way qualify as a school. This is why the attempt to regard Rostov as the "academy of the painters of Northeastern Rus"[273] seems so unconvincing: Rostovian iconography was never anything like that since it never yielded one authentic masterpiece.

It would not be fair to assign the artistic production of Yaroslav and Suzdal entirely to that of Rostov.[274] Although these cities were closely associated with Rostov ecclesiastically, they also had their own painters. The general range of painting in Suzdal between the fourteenth and fifteenth centuries[275] is quite contradictory and lacks the stylistic unity of which A.N. Ovchinnikov speaks.[276] The political events in Suzdal were complicated and hardly propitious for the development of art. In fact, the city was compelled to maneuver very prudently in the conflict between Moscow and Nizhnii Novgorod. In 1392, Moscow expelled the prince from Suzdal, and in 1451, Vasilii II traded this city for Gorodets, definitively annexing Suzdal to Moscow. The influence of Muscovite art is very evident in Suzdal, especially from the time of Dionysii on.

The best icons come from the Monastery of the Virgin of Mercy, founded in 1364, although that does not mean they were painted there. On this subject, G.I. Vzdornov[277] spoke correctly about a collection of heterogeneous icons put together by some religious very well versed in matters of art.

PL. 134 Two icons from the Virgin of Mercy Monastery, the *Nativity of the Virgin* and the *Virgin Hodegetria* (both in the Russian Museum),[278] are very beautiful in their coloring, but their dense and dark hues are quite different from that bright and airy chromatic range which the followers of the Suzdal pictorial school liked to consider their most characteristic trait. It is known that in the second half of the sixteenth century, the princes of Suzdal-Nizhnii Novgorod maintained relations with Novgorod in order to find an ally in their struggle against Moscow. The bishop of Suzdal would go to Novgorod fairly often for religious affairs, and on the occasion of these visits, there was certainly an exchange of gifts.[279] In this way Novgorodian icons could have easily traveled to Suzdal and vice versa. The icon of

PL. 135 the *Archangel Michael* with a golden background (Tretyakov Gallery) may also have come from Suzdal. At one time, it was part of a half-length *Deesis* in the Church of the Resurrection on Lake Myachino

in Novgorod. This marvelous work, of a lofty spirituality and an extraordinary beauty in its cool coloring, cannot be attributed to the Novgorod school but may be considered a work executed in Suzdal.

The other icons from the Virgin of Mercy Monastery have no stylistic unity (the *Virgin of Mercy* PL. 137 from the second half of the fourteenth century and the *Virgin Hodegetria,* with the *Savior* on the PL. 136 front, from the 1360s, today in the Tretyakov Gallery; the icon of *Saint Nicholas of Zaraysk with Scenes from His Life,* from the first half of the fifteenth century,[280] the *Virgin of Tenderness with Deesis and Saints* from the first half of the fifteenth century,[281] the large *Virgin of Mercy* and the *Annunciation* from the late fifteenth century,[282] today in the Suzdal Museum). When they portrayed the Virgin of Mercy, Suzdal artists preferred the variant which accentuated not so much the miraculous appearance of the Mother of God to Andrew Yurodivyi (like Novgorodian icons) as her glorification by Romanos Melodos, generally shown in the center. The bright, cheerful colors and the kinds of faces in the large *Virgin of Mercy* icon unequivocally point back to Dionysii's art as the source from which the Suzdal artist took his inspiration, even if he was not a Muscovite. With the annexation of Suzdal to Moscow, the barely noticeable characteristics of local painting disappeared more and more, and eventually were slowly assimilated into Muscovite painting.

There were also some iconographic workshops in Nizhnii Novgorod,[283] conquered by Moscow in 1390, that is, shortly before Suzdal. As in Suzdal, painting in Nizhnii Novgorod was likewise under the double influence of Moscow and Novgorod, especially after Ivan III deported to Nizhnii Novgorod and Gorodets in 1489–1490 several citizens originally from Novgorod. In the 1380s, Theophanes the Greek had worked in Nizhnii Novgorod although we have no way of knowing what churches he frescoed. The icons from Nizhnii Novgorod, gathered in the Museum of Fine Arts of Gorkii [once again called Nizhnii Novgorod], are stylistically very restrained and concise. The icon of the *Prophet Elijah with Scenes from His Life,* painted with great freedom and skill, its figures very ex- PL. 138 pressive and elongated, also dates back to the fourteenth century. Most icons from Nizhnii Novgorod go back to the second half of the fifteenth century (the icon of the *Virgin Hodegetria* with the *Descent from the Cross* on the back, the *Transfiguration,* the *Archangel Michael,* and the *Archangel Gabriel*).[284] As N.E. Mneva[285] has observed, these last two may have been part of the same complex to which the *Deesis* in the Tretyakov Gallery belonged. The figures are slender and light, with the ovals of the faces PL. 139 softly drawn, the colors dark and pale, the hatching yellow instead of the usual gold. It is likely that the icons coming from Gorodets, which we have already dealt with in the chapter on the Novgorod school, may have been painted by artists transferred there from Novgorod. Finding themselves in Nizhnii Novgorod or Gorodets, they may have established close contact with local painting, providing in this way an extraordinarily vital synthesis of the elements of northern and central Russian art.

For at least two centuries, Tver,[286] which long aspired to the role of unifying center of all Rus, had been an implacable enemy of Moscow. During the twelfth and thirteen centuries, Tver belonged to the principality of Suzdal-Pereyaslavl; then, toward the middle of the thirteenth century, Tver broke away to become an independent principality. In 1271, it became an episcopal see. At that time more or less, the history of the principality of Tver begins, which endured until 1485, when troops of the Muscovite sovereign Ivan III conquered the city. Tver was a fairly powerful political and economic center where building in stone had started about half a century before Moscow (from 1285 to 1290), continuing almost throughout the fourteenth century and until the first half of the fifteenth. Also having its source in Tver was the idea of "autocracy," which started with Prince Boris Aleksandrovich, as well as the concept of "Tver the third Rome," which would come to its definitive development in Moscow, but already the case in reference to the new center as the unifier of national forces. The political aspirations of the princes of Tver were not fulfilled and they lost the harsh conflict with the Muscovite princes.

Tver painting, to which an exhibition was dedicated in 1970, presents a varied scene; and even in this case it would be difficult to apply the strict notion of "school." In most of the icons, the archaic style emerges insistently. Early works like *Saints Boris and Gleb* (beginning of the fourteenth century) PL. 140

in the Russian Art Museum, Kiev, and the *Savior* (first half of the fourteenth century)[287] and the royal doors with images of *Saint John Chrysostom* and *Saint Basil the Great* (second half of the fourteenth century), in the Tretyakov Gallery, are still strongly linked to thirteenth-century art. They are characterized by heavy forms, static compositions, abrupt combinations of strokes of light and dense shading. The strokes of light are made of fine and elongated lines which form a pattern distinct from the flesh tone; the colors are heavy and dense, and the coloring has an especially uncommon whitish patina. The expressive faces denote great strength, but they lack gentleness. It is difficult to establish when the new tendencies of the fourteenth century started to be felt in Tver iconography; but we do know that at the beginning of the fourteenth century, foreigners from Constantinople, Jerusalem, and Syria (as attested in *Cod. Vatic. gr. 784*)[288] arrived in Tver, and it is also known that in 1399, an embassy from Tver returned home from Constantinople with the icon of the *Last Judgment*,[289] a gift from the patriarch and the ecumenical council. Yet, unlike Moscow, Tver did not assimilate the principles of Palaeologan painting, demonstrating at best a meager interest in it. The archaic current was so strong that it neutralized almost all outside stimuli. Tver masters were always extremely cautious with regard to these new tendencies, which were coming above all from Moscow, and tried by every possible means to preserve their exquisitely local artistic language in its original purity. We find an obvious testimony of all this in icons from the first half of the fifteenth century, like the left anta of the royal doors in the

Rublev Museum,[290] the *Deesis* with eleven figures[291] and the hagiographical icon of *Saint Hypatius of Gangra* in the Tretyakov Gallery. The most interesting of these works is the last, in which there are strong reminiscences of fourteenth-century art: the spare pictorial style, the simple and broad architectural and landscape backgrounds, the flat projection of all the compositions in the border scenes. In this icon, the apocryphal text of the "seven deaths" of Hypatius, pervaded by a frantic spirit of sacrifice, takes the form of a calm epic narrative even though Hypatius is roasted like a fish, dragged by a horse and smashed against rocks, burned in the statue of an ox cast in copper, has tin poured down his throat, is cooked in a pot, has his hands and feet cut off, is crushed by heavy rocks. But like Saint George in the Novgorod hagiographical icon from the beginning of the fourteenth century, the saint easily overcomes all the torments which befall him, distinguishing himself as a tireless defender of the "Christian faith." In many respects, this icon recalls Novgorodian paintings, but the coloring is completely different: whitish and almost faded with a predominance of brown and grayish tones.

Muscovite influence is very clearly seen in Tver (?) icons like the *Metropolitan Peter* (first half of the fifteenth century)[292] and the *Blue Dormition* (second half of the fifteenth century)[293] in the Tretyakov

Gallery and to a much lesser degree in the *Feasts* from the Cathedral of the Resurrection in Kashin (Tretyakov Gallery and Russian Museum). Only in the *Baptism* and in the architectural background of the *Presentation in the Temple* can we observe some iconographic similarity to the icons on the same theme in the Cathedral of the Annunciation (?) in Moscow. However, as a whole, the Kashin *Feasts* lack the refinement of the Muscovite works. Their compositions are not very rhythmical, the vivid and showy colors are closer to the Novgorodian than Muscovite palette. The authors of these icons, who were especially fond of a light azure, almost turquoise in color, audaciously matched it with cinnabar and shades of cherry red, green, and yellow. The sturdy figures have much in common with the images in Novgorodian iconography. In some icons (for example, the *Presentation in the Temple* and *Ascension*), the figures' position in space is evident since they are separated by rather wide intervals. The figures stand firmly on the ground, thereby losing that airy lightness so valued by the painters of Rublev's school, who loved to give their figures a lozenge shape narrowed toward the bottom. In other icons (like the *Nativity of Christ*), the composition is, instead, drawn very flat and the figures are rendered as mere silhouettes. Yet, all these icons do have some features in common: the singular spiritualization of the composition; the use of fluid color applied in a transparent, almost vibrant layer; the prevalence of the broken, undulating line and of the typical "shimmering" brush stroke. Next to the turquoise color which insistently reverberates in all the icons, these traits constitute a phenomenon peculiar to fifteenth-century iconography.

After its annexation to Moscow, Tver met with the same fate as all the other artistic centers of Central Russia: its art began to be absorbed into that of Moscow and was very rapidly transformed into one of its provincial branches.

From the study of the iconography of Rostov, Suzdal, Nizhnii Novgorod, Tver, and the other cities of Central Russia in the light of the new discoveries, it turns out that many icons were painted in these centers, which comprised the local production. But these icons, often very primitive, were generally devoid of those unifying artistic characteristics which might suggest the existence of local "schools." We must again recall that in the fourteenth and fifteenth centuries, early Rus had but three clearly defined iconographic schools: Novgorod, Pskov, and Moscow. Everything produced in other cities was much inferior in quality to the works originating in these three schools. The small independent centers were not able to put forward artistic achievements which in their effect were comparable to works created in Novgorod and Pskov and later in Moscow because they lacked a cultural milieu strong enough for them to detach themselves decisively from the old local traditions. And so we observe only a partial assimilation of the elements of Novgorodian and Muscovite art, next to which local features continued to co-exist peacefully, features at times giving the icons of Rostov, Suzdal, Nizhnii Novgorod, and Tver an imperceptible characteristic nuance of intrinsic attachment to the "primitive." However, most of the time, the icons were deficient in their execution, which is closely related to the problem of quality, something that cannot be excluded when talking about iconography.

In Orthodox consciousness, every icon is sacred and, in consequence, also beautiful. For scholars of early Russian painting who are interested exclusively in iconography, this approach to icons is wholly acceptable since they are interested first of all in *what* is represented in the icon, not in *how* it is represented. This is also acceptable for dealers in antiques who are flooding the market with second-rate icons, deliberately overlooking their quality. In fact, in iconography, as in every other artistic genre, there are degrees of aesthetic value, and early Russians understood this very well: it is no accident that the works of Theophanes the Greek, Prochor of Gorodets, Daniil Chernyi, Andrei Rublev, and Dionysii were held in special esteem and mentioned even in the chronicles. Of course, the most beautiful icons were produced in studios attached to the courts of the grand princes, to the metropolitan and episcopal cathedrals, which could entrust the work to the most qualified masters. Yet, from time to time, authentic jewels were created in the outskirts as well (we recall the icons of Gorodets). We can no longer ignore the fact that toward the end of the fourteenth and beginning of the fifteenth century, besides beautiful icons, many mediocre ones were also beginning to be painted, which is related to the rapidly broadening circle of people requesting icons. In the pre-Mongol period, icons were painted chiefly for the churches and, moreover, the commissions came mostly from the grand prince or the bishop. Icons were expensive; artists were few; in cities and especially in rural areas, there were still strong remnants of paganism, which very much limited the sphere of influence of Christian worship. Gradually, as the Church consolidated its own positions, the new religion became ever more rooted in the people and, little by little, every rural *izba* started to set up its own "beautiful corner" where they placed their icons. It is hard to say exactly when this happened, but probably during the fourteenth and fifteenth centuries. With the appearance of the "beautiful corner," requests for icons suddenly increased and studios painting icons for the remote periphery quickly multiplied, but this in turn brought about a deterioration in the quality of icons, which became a genuine popular art. Peasants did not have very high requirements and so there emerged more "barbarous" variants of the "Northern Manners," still imbued with pagan reminiscences. Often very colorful because of the zest for life they convey, these icons hold more interest for scholars of folklore than of art history.

It is necessary to keep all of this in mind when we speak of the study of early Russian iconography. Its masters created wonderful masterpieces but also purely ordinary works. This is why the task of art historians consists in identifying icons with real artistic value among the enormous number of icons which have survived. Only then will it be possible to really grasp the singular beauty of early Russian iconography, which preserves its eternal significance even in our own day.

Notes on the Text

* Matisse, H., *Sbornik statey o tvorchestve,* M. 1958, p. 98.

1 About him, see Ainalov, D.V., "Znachenie F.I. Buslaeva v nauke istorii iskusst," in *Izvestiya Obshchestva archeologii, istorii i etnografii pri imp. Kazanskom universitete,* t. XIV, 4, Kazan l898, pp. 393–405; Alpatov, M.V., "Iz istorii russkoy nauki ob iskusstve," in Alpatov, M.V., *Etyudy po istorii russkogo iskusstva,* 1, M. 1967, pp. 9–25.

2 Buslaev, F.I., "Obshchie ponyatiya o russkoy ikonopisi," in Buslaev, F.I., *Soch.,* t. I, Spb. 1908, p. 32.

3 Buslaev, F.I., "O narodnoy poezii v drevnerusskoy literature," in Buslaev, F.I., *Soch.,* t. II, Spb. 1910, p. 31.

4 Ibid., pp. 31–32.

5 Ibid., p. 4.

6 Buslaev, F.I., *Obshchie ponyatiya o russkoy ikonopisi,* p. 41.

7 For a more in-depth approach, see Muratov, P., "Vystavka drevnerusskogo iskusstva v Moskve," in *Starye gody,* 1913, April, pp. 31ff.; Id., "Otkrytiya drevnego russkogo iskusstva," in *Sovremennye zapiski,* XIV, Paris 1923, pp. 197–218; Antonova, V.I. — Mneva, N.E., *Katalog drevnerusskoy zhivopisi [v Gos. Tretyakovskoy galeree],* t. I, M. 1963, pp. 10ff.; [Gordienko, E.A., "Istoriya obrazovaniya i izucheniya novgorodoskogo sobraniya drevnerusskoy zhivopisi," in *Muzey,* 1, M. 1980, pp.161–172]. For the titles of the works of art criticism quoted in the text, readers are referred to the general bibliography, listed in alphabetical order.

8 See Kirpichnikov, A., "Vospominaniya o G.D. Filimonove," in *Archeologicheskie izvestiya i zametki,* 1989, n. 11–12, pp. 360–368.

9 See Antonova, V.I. — Mneva, N.E., *Katalog drevnerusskoy zhivopisi,* t. I, pp. 15–19.

10 Ibid., pp. 19–21; Shchekotov, N.M., "Odin iz 'posvyashchennych,'" in *Sredi kollektsionerov,* 1921, n. 2 (July), pp. 7–9; Grabar Igor, "Glaz" [on I.S. Ostrouchov], ibid., pp. 9–10.

11 Grits, T. — Chardzhiev, N., "Matiss v Moskve," in *Matiss. Sbornik statey o tvorchestve,* M. 1958, pp. 96–119.

12 See Lasareff, V. "La méthode de collaboration des maîtres byzantins et russes," in *Classica et Mediaevalia, Revue danoise de philologie et d'histoire,* XVII, Mélanges C. Høeg, Copenhagen 1956, pp.75–90; [Russian Ed.: Lazarev, V.N., "O metode sotrudnichestva vizantiyskich i russkich masterov," in Lazarev, V.N., *Russkaya srednevekovaya zhivopis. Stati i issledovaniya,* M. 1970, pp. 140–149].

13 This approach to the problem has nothing to do with the theory supported by A.N. Grabar (Grabar, *L'art du Moyen Age en Europe Orientale,* Paris 1968, p. 155) which doubts the possibility of dating icons on the basis of their style. Without using stylistic analysis, a scientific history of early Russian iconography would not exist.

14 See Mneva, N.E., "Drevnerusskaya zhivopis Nizhnego Novgoroda," in *Gos. Tretyakovskaya galereya. Materialy i issledovaniya,* II, M. 1958, pp. 28–36; Vzdornov, G. "O zhivopisi Severo-Vostochnoy Rusi XII–XV vekov," in *Iskusstvo,* 1969, n. 10, p. 62; Rozanova, N.V., *Rostovo-suzdalkaya zhivopis XII–XVI vekov,* album, M. 1970, pls. 76–108.

15 See *Muzej drevnerusskogo iskusstva imeni Andreja Rublyova. Zhivopis drevney Tveri,* catalogue, M. 1970; [Vzdornov, G.I., *"Zhivopis"* in *Ocherki russkoy kultury XIII–XV vekov,* pt. 2, *Duchovnaya kultura,* M. 1970, pp. 268, 272, 274 and 356, 358]; Popov, G.V., "Puti razvitiya tverskogo iskusstva v XIV — nachale XVI vv. (zhivopis, miniatyura)," in *Drevnerusskoe iskusstvo. Chudozhestvennaya kultura Moskvy i prilezhashchich k ney knyazhestv. XIV–XVI vv.,* M. 1970, pp. 310–358; Evseeva, L.M. — Kochetkov, I.A. — Sergeev, V.N., *Zhivopis drevney Tveri,* M. 1974; [Popov, G.V., "Tverskaya ikonopis XIV v. i paleologovskii stil," in *Srednevekovoe iskusstvo. Rus. Gruziya,* M. 1978, pp. 176–192; Popov, G.V. — Ryndina, A.V., *Zhivopis i prikladnoe iskusstvo Tveri. XIV–XVI veka,* M. 1979].

16 See *Rostovo-suzdalskaya shkola zhivopisi* [catalogue of the exhibition at the Tretyakov Gallery], M. 1967, cf. critical observations in my article "O nekotorych problemach v izuchenii drevnerusskogo iskusstva" (Lazarev, V.N., *Russkaya srednevekovaya zhivopis. Stati i issledovaniya,* pp. 308–309); [Baldina, O.D., "Dve ikony rostovskoy shkoly zhivoposi," in *Sovetskaya archeologiya,* 1968, n. 3, pp. 172–179]; Vzdornov, G., *O zhivopisi Severo-Vostochnoy Rusi XII–XV vekov,* pp. 59–60; [Id., *Zhivopis,* pp. 263–268, 354–356]; Goleyzovskii, N. — Ovchinnikov, A. — Yamshchikov, S., *Suzdal. Muzey* [M. 1968]; Rozanova, N.V., *Rostovo-suzdalskaya zhivopis XII–XVI vekov,* album, pls. 15–43; Putsko, V., "Zametki o rostovskoy ikonopisi vtoroy poloviny XV veka," in *Byzantinoslavica,* XXXIV, 2, Prague 1973, pp. 199–210; [*Zhivopis Rostova Velikogo,* catalogue, by S. Yamshchikov, M. 1973].

17 See Durylin, S., "Drevnerusskaya ikonopis i Olonetskii kray," in *Izvestiya Obshchestva izucheniya Olonetskoy gubernii,* n. 5–6, Petrozavodsk 1913, pp. 33–45; [Yamshchikov, S., *Zhivopis drevney Karelii,* Petrozavodsk 1966]; Smirnova, E.S., *Zhivopis Obonezhya XIV–XVI veko,* M. 1967; *Archangelskii muzey izobrazitelniych isskustv. Iskusstvo drevnego Severa. Po zalam muzeya,* introductory article by V. Solomina,

Archangelsk 1967; Reformatskaya, M.A., *Severnye pisma*, M. 1968 [on materials from the exhibition "Northern Manners," which was held between the end of 1964 and the beginning of 1965 in the Tretyakov Gallery]; *Zhivopis drevney Karelii*, catalogue, M. 1968; Yamshchikov, S., *Karelia. Museum*, M. 1970; [Kochetkov, I., "Novye otkrytiya drevney zhivopisi," in *Tvorchestvo*, 1972, no. 9, pp. 17–20 (overview of the exhibition "The Art of Northern Russia from the Sixteenth to the Eighteenth Century," which took place in 1971 in the Andrei Rublev Museum of Early Russian Art); Smirnova, E.S., — Yamshchikov, S.V., *Drevnerusskaya Zhivopis. Novye otkrytiya. Zhivopis Obonezhya XIV–XVI vekov*, L. 1974; Vzdornov, G.I., "O severnych pismach," in *Sovetskoe iskusstvoznanie*, '80/1, 1981, pp. 44–69].

18 Lesyuchevskii, V.I., "Vyshgorodskii Kult Borisa i Gleba v pamyatnikach iskusstva," in *Sovetskaya archeologiya*, 1946, n. 8, pp. 225–249; Smirnova, E.S., "Otrazhenie literaturnych proizvedenii o Borise i Glebe v drevnerusskoy stankovoy zhivopis," in *Trudy Otdela drevnerusskoy literatury Instituta russkoy literatury (Pushkinskii dom) Akademii nauk SSSR*, XIV, M.-L. 1958, pp. 312–327; Porfiridov, N.G., "O putyach razvitiya chudozhestvennych obrazov v drevnerusskom iskusstve," in ibid., XVI, M.-L. 1960, pp. 44–48; Poppe, A.V., "O Roli ikonograficheskich izobrazhenii v izuchenii literaturnych proizvedenii o Borise i Glebe," in ibid., XXII, M.-L. 1966, pp. 24–25; Nikolaeva, T.V., "Ryazanskaya ikona s izobrazheniem Borisa i Gleba," in *Slavyane i Rus. Sbornik statey k 60-letiyu Akademika B.A. Rybakova*, M. 1968, pp. 451–458; [Aleshkovskii, M. Ch., "Russkie gleboborisovskie enkolpiony 1072–1150 godov," in *Drevnerusskoe iskusstvo. Chudozhestvennaya kultura domongolskoy Rusi*, M. 1972, pp. 104–125.

19 See [Pokrovskii, N.V., *Siiskii ikonopisnyi podlinnik*, II ed., Spb. 1896 (in the collection "Pamyatniki drevnerusskoy pismennosti," CXIII), pp. 88–92; Uspenskii, A., "Pokrov Presvyatoy Bogoroditsy" (iconographic note), in *Moskovskie tserkovnye vedomosti*, 1902, n. 39, pp. 449–452; Kondakov, N.P., review of the text of N.P. Lichachev, *Materialy dlya istorii russkogo ikonopisaniya. Atlas*, (pts. I–II, Spb. 1906), in *Zhurnal Ministerstva narodnogo prosveshchniya*, 1907, April, rubric "Kritika i bibliografiya," pp. 421–425]; Kondakov, N.P., *Ikonografiya Bogomateri*, t. II, Pg. 1915, pp. 56–59, 92–103; Id., *Russkaya ikona*, t. III, text, pt. 1, Prague 1931, pp. 152–154, 181, and t. IV, text, pt. 2, Prague 1933, pp. 262–263, 329; Myslivec, J., "Dveikony Pokrova," in *Byzantinoslavica*, VI, Prague 1935–1936, pp. 191–212; Lathoud, R., "Le thème iconographique du 'Pokrov' de la Vierge," in *L'art byzantin chez les slaves*, II, Paris 1933, pp. 302–314; Id., "Le thème iconographique du 'Pokrov' de la Mère de Dieu: Origines, variantes," in *Academia Mariana Internat. Alma Socia Christi*, V, Rome 1952, pp. 54–68; Antonova, V.I. — Mneva, N.E., *Katalog drevnerusskoy zhivopisi*, t. I, n. 38, p. 102, pl. 50; Voronin, N.N., "Iz istorii russko-vizantiyskoy tserkovnoy borby XII v.," in *Vizantiyskii vremennik*, 26, M. 1965, pp. 208–218; [Wortley, J., "Hagia Skepê and Pokrov Bogoroditsi. A Curious Coincidence," in *Analecta Bollandiana*, 89, 1971, pp. 149–154].

20 The first testimonies of this iconographic type are already found in Byzantium and Serbia, but full development was attained only in Russia. See Pokrovskii, N.V., *Evangelie v pamyatnikach ikonografii, preimushchestvenno vizantiyskich i russkich*, Spb. 1892 (= "Trudy VIII archeologicheskogo sezda v Moskve," 1890, t. I) pp. 88–89; Millet, H., *Recherches sur l'iconographie de l'Evangile. . .*, Paris 1916, pp. 163–169; [Stefanescu, I.D., "L'illustration des liturgies dans l'art de Byzance et de l'Orient," II, in *Annuaire de l'Institut de philologie et d'histoire orientales*, III, Brussels, 1935, pp. 504–506; Djuric, V.J.,

"Portrety v rozhdestvenskich stichirach," in *Vizantiya. Yuzhnye slavyane i drevnyaya Rus. Zapadnaya Evropa. Iskusstvo i kultura*, M. 1973, pp. 244ff.].

21 See Filimonov, G., "Ikona 'O Tebe raduetsya,'" in *Vestnik Obshchestva drevnerusskogo iskusstva pri moskovskom Publichnom muzee*, 1874, 4–5, sec. "Smes," pp. 38–39; Kondakov, N.P., *Russkaya ikona*, t. IV, text, pt. 2, pp. 291–293; Myslivec, J., "Liturgické hymny jako námety ruskych ikon," in *Byzantinoslavica*, III, Prague 1931, pp. 491–496; Antonova, V.I. — Mneva, N.E., *Katalog drevnerusskoy zhivopisi*, t. I, n. 149, p. 190, pls. 101–105. All the icons of this group illustrate the hymn, "In You Rejoices, O Full of Grace, every creature, the host of angels and the human race, sanctified temple and spiritual paradise. . ." In Russia, this iconographic type was also called *The Praises of the Mother of God*.

22 See Trubetskoy, E.N., *Umozrenie v kraskach. Vopros o smysle zizni v drevnerusskoj religioznoj zivopisi*, M. 1916, pp. 12, 43.

23 See Malitskii, N.V., *Drevnerusskie kulty selkochozyaystvennych svyatych po pamyatnikam iskusstva*, L. 1932 (= "Izvestiya Gos. Akademii istorii materialnoy kultury," t. XI, 10).

24 See Ostrogorskii, G., "Les décisions du 'Stoglav' concernant la peinture d'images et les principes de l'iconographie byzantine," in *L'art byzantin chez les slaves*, I, Paris 1930, pp. 393–410.

25 See Andreev, N.E., "O 'Dele dyaka Viskovatogo,'" in *Seminarium Kondakovianum*, V, Prague 1932, pp. 191–242.

26 "Spisok s gramoty svyateyshich trech patriarchov. V. Materialy dlya istorii ikonopisaniya v Rossii." Soobshcheno P.P. Pekarskim, in *Izvestiya imp. Archeologicheskogo Obshchestva*, t. v, 5, Spb. 1864, col. 321 [text given in free translation]. Cf. Dmitriev Yu. N., "Teoriya iskusstva i vzglyady na iskusstvo v pismennosti drevney Rusi," in *Trudy Otdela drevnerusskoy literatury Instituta russkoy literatury (Pushkinskii dom) Akademii nauk SSSR*, IX, M.-L. 1953, p. 103.

27 When Iosif of Volokolamsk quarreled with Prince Fyodor Borisovich of Volokolamsk, the latter, in an attempt to placate the former, gave him two icons painted by Rublev and Dionysii. See *Zhitie prepodobnogo Iosifa Volokolamskogo, sostavlennoe Savvoyu, episkopom Krutitskim*, M. 1865, p. 40.

28 Quoted in the version of F.I. Buslaev in Buslaev, F.I., *Soch.*, t. I, pp. 7–8.

29 *Zhitie protopopa Avvakuma, im samim napisannoe, i drugie ego sochineniya*, editing, introduction, article, and commentary by N.K. Gudziy, ed. Akademia, M. 1934, pp. 208, 210, 211, 213. Cf. Andreev N., "Nicon and Avvakum on Icon Painting," in *Revue des études slaves*, t. 38, Paris 1961, pp. 37–44; Robinson, A.N., "Ideologiya i vneshnost" (Vzglyady Avvakuma na izobrazitelnoe iskusstvo), in *Trudy Otdela drevnerusskoy literatury Instituta russkoy literatury (Pushkinskii dom) Akademii nauk SSSR*, XXII, p. 353–381.

30 Onasch, K., *Ikonen*, Berlin 1961, p. 13.

31 See [Florenskii, P.A., "Obratnaya perspektiva," in *Uchenye zapiski Tartuskogo gos. universiteta*, n. 198 ("Trudy po znakovym sistemam," III), Tartu 1967, pp. 381–416 (Italian ed., *La prospettiva rovesciata e altri scritti*, Rome 1983)]; Zhegin, L.F., *Nekotorye prostranstvennye formy v drevnerusskoy zhivopisi*, in *Drevnerusskoe iskusstvo. XVII vek.*, M. 1964, pp. 175–214; [Id., "'Ikonnye gorki,' Prostranstvenno-vremennoe edinstvo zhivopisnogo proizvedeniya," in *Uchenye zapiski Tartuskogo gos. universiteta*, n. 181 ("Trudy po znakovym sistemam" II), Tartu

1965, pp. 231–247; Uspenskii, B.A., "K sisteme peredachi izobrazheniya v russkoy ikonopisi," in ibid., pp. 248–257; Zhegin, L.F., *Yasyk zhivopisnogo proizvedeniya* (Uslovnost drevnego iskusstva), M. 1970; Saltykov, A.A., "O prostranstvennych otnosheniyach v vizantiiskoy i drevnerusskoy zhivopisi," in *Drevnerusskoe iskusstvo. Zarubezhnye svyazy*, M. 1975, pp. 398–413; Raushenbach, B.V., "O perspektive v drevnerusskoy zhivopisi," in ibid., pp. 414–440; Id., *prostranstvennych postroeniya v drevnerusskoy zhivopisi*, M. 1975].

32 See Ostashenko, E.Ya., "Arkhitekturnye fony v nekotorych proizvedeniyach drevnerusskoy zhivopisi XIV veka," in *drevnerusskoe iskusstvo. Chudozhestvennaya kultura Moskvy i prilezhashchich k ney knyazhestv. XIV–XVI vv.*, pp. 275–309.

33 *Izhe vo svyatych ottsa nashego avvy Isaaka Siriyanina Slova podvizhnicheskie*, M. 1858, p. 299.

34 Cf. Onasch, K., *Die Ikonenmalerei*, Leipzig 1968, pp. 46–50.

35 This aspect is accurately pointed out by Roger Fry. See Fry, R., "Russian Icon-Painting Western-European Point of View," in *Masterpieces of Russian Painting*, ed. by M. Farbman, London 1930, pp. 36–38, 48.

36 Schekotov, N.M., "Nekotorye cherty stilya russkich ikon XV veka," in *Starye gody*, April 1913, p. 41.

37 Information on the technique of early Russian iconography can be found in all general works dedicated to Russian icons. This question is treated in an excellent manner by V.V. Filatov, who takes into account all the recent discoveries still being restored. (Filatov, V.V., *Russkaya stankovaya tempernaya zhivopis. Technika i restavratsiya*, M. 1961, pp. 5–29). We follow his conclusions in our own presentation. Cf. Simoni, P., *K istorii obichoda knigopistsa, perepletchika i ikonnogo pistsa pri knizhnom i ikonnom stroenii*, I ed. [Spb.] 1906 (in the series "Pamyatniki drevney pismennosti i iskusstva," CLXI); Shchavinskii, V.A., *Ocherki po istorii techniki zhivopisi i technologii krasok v drevney Rusi*, L. 1935 (="Izvestiya Gos. Akademii istorii materialnoy kultury," n. 115); [Kuznetsova, L.V., "O pigmentach drevnerusskoy tempernoy zhivopisi," in *Chudozhestvennoe nasledie. Chranenie, issledovanie, restavratsiya*, n. 3 (33), M. 1977, pp. 63–82. See also Pertsev, N.V., "O nekotorych priemach izobrazheniya litsa v drevnerusskoy stankovoy zhivopisi XII–XIII vv.," in *Soobshechniya Gos. Russkogo muzeya*, VIII, L. 1964, pp. 89–92; Saltykov, A.A., "'Dobroe masterstvo' drevnerusskoy zhivopisi," in *"Slovo o polku Igoreve." Pamyatniki literatury i iskusstva XI–XVII vekov*, M. 1978, pp. 238–250; Yakovleva, A.I., "Priemy lichnogo pisma v russkoy zhivopisi kontsa XII — nachala XIII v.," in *Drevnerusskoe iskusstvo. Monumentalnaya zhivopis XI–XVII vv.*, M. 1980, pp.34–44].

38 Antonova, V.I., *Zametki o rostovo-suzdalskoy shkole zhivopisi*, in *Rostovo-suzdalskaya shkola zhivopisi* [catalogue of the exhibition at the Tretyakov Gallery], p. 12; [see also: Vzdornov, G.I., "Zametki o sofiyskich svyatsach," in *Byzantinoslavica*, XL., 2, Prague 1979, pp. 218–219].

39 See Lazarev, V.N., "O metode raboty v rubluovskoy masterskoy," in *Doklady i soobshechniya filologicheskogo fakulteta Moskovskogo universiteta*, 1, M. 1946, pp. 60–64 [the same text is also quoted in: Lazarev, V.N., *Vizantiyskoe i drevnerusskoe iskusstvo. Stati i materialy*, M. 1978, pp. 205–210].

40 See Tits, A.A., "Nekotorye zakonomernosti kompozitsii ikon Rublyova i ego shkoly," in *Drevnerusskogo iskusstvo XV — nachala XVI vekov*, M. 1963, pp. 22–53; Vagner, G.K., "O proportsiyach v moskovskom zodchestve epochi Andreya Rublyova," in ibid., pp. 54–74; Gusev, N.V., "Nekotorye priemy postroeniya kompozitsii v drevenerusskoy zhivopisi XI–XVII vekov," in *Drevnerusskoe iskusstvo. Chudozhestvennaya kultura Novgoroda,*

M. 1968, pp. 126–139; Onasch, K., *Die Ikonenmalerei*, pp. 66ff.; [Kishilov, N.B., "O nekotorych printsipach geometricheskogo postroeniya ikony," in *Soobshcheniya Vsesoyuznoy tsentralnoy nauchno-issledovatelskoy laboratorii po konservatsii i restavratcii muzeynych chudozhestvennych tsennostey*, 30, M. 1975, pp. 71–82, pls. 1–21; Zhelochovtseva, E.F., "Geometricheskie struktury v architekture i zhivopisi drevney Rusi," in *Estestvenno nauchnye znaniya v drevney Rusi*, M. 1980, pp. 48–63].

41 Especially scholars of the history of early Russian architecture. See Afanasev, K., *Postroenie architekturnoy formy drevnerusskimi zodchimi*, M. 1961; [see also, Kishilov, N.B., "Teoreticheskie predposylki k vosstanovleniyu i rekonstruktsii ikony i freski," in *Vsesoyuznaya konferentsiya "Teoriticheskie printsipy restavratsii drevnerusskoy stankovoy zhivopisi." Doklady, soobshcheniya, vystypleniya uchastnikov konferentsii i prinyatye resheniya Moskva, 18–20 noyabrya 1968 g.*, M. 1970, pp. 175–185].

42 See Alpatoff, M. — Lasareff, V., "Ein byzantinisches Tafelwerk aus der Komnenenepoche," in *Jahrbuch der preussischen Kunstsammlungen*, vol. XLVI, fasc. II, Berlin 1925, pp. 140–155 [Russian text: "Vizantiyskaya ikona komninovskoy epochi," in Lazarev, V.N., *Vizantiyskoe i drevnerusskoe iskusstvo. Stati i materialy*, pp. 9–29]; Anisimov, A.I., *Vladimirskaya ikona Bozhiey Materi*, Prague 1928; Lazarev, V. *Storia della pittura bizantina*, Turin 1967, pp. 204, 257 (with up-to-date bibliography).

43 See Alshits, D.N., "Chto oznachaet 'Pirogoshchaya' russkich letopisey i Slova o polku Igoreve," in *Issledovaniya po otechestvennomu istochnikovedeniyu. Sbornik statey, posvyashchennych 75-letiyu prof. S.N. Valka*, M.-L. 1964 (="Trudy Leningradskogo otdeleniya Instituta istorii Akademii nauk SSSR," n. 7), pp. 475–482.

44 *Poln. sobr. russkich letopisey*, t. I, Spb. 1846, p. 148.

45 According to a source which has been preserved, the monk Varlaam from the Monastery of the Caves went to Constantinople in the 1060s and brought back some icons. See *Paterik Kievskogo Pecherskogo monastyrya*, ed. D.I. Abramovich, ed. Archeografiicheskaya komissiya, Spb. 1911 (in the series "Pamyatniki slavyano-russkoy pismennosti," II), p. 32.

46 Ibid., pp. 121–123. [On Alimpii, see also: Uspenskie, M.I. and V.I., *Zametki o drevnerusskom ikonopisanii. Izvestnye ikonopistsy i ich proizvedeniya, I. Sv. Alimpii, II. Andrey Rublyov*, Spb. 1901, pp. 3–33; Putsko, V. "Kievskii chudozhnik XI veka Alimpi Pecherskii." (Po skazaniyu Polikarpa i dannym archeologicheskich issledovanii), in *Wiener slavistisches Jahrbuch*, 25, 1979, pp. 63–88].

47 Ibid., p. 123.

48 Lasareff, V., "Trois fragments d'épistyles et le templon byzantin," in "Δελτίου τῆς Χριστιαυικῆς Ἀρχαιολογικῆς Ἑταιρείας," περ. Δ', τόμ Δ', Τινητικός Γ. Σωτηρίου, Ἀθῆυαι 1964, pp. 130, 131, 138, 139; [see also the Russian ed.: Lazarev, V.N., "Tri fragmenta raspinych epistiliev i vizantiyskii templon," in Lazarev, V.N., *Vizantiyskaya zhivopis. Sbornik statey*, M. 1971, pp. 122, 124–125, 127].

49 Golubinskii, E.E., *Istoriya russkoy tserkvi*, t. I, second half of the volume, M. 1904, pp. 215–216.

50 Ibid., p. 215.

51 Ibid., p. 216.

52 Lazarev, V.N., "Dva novych pamyatnika russkoy stankovoy zhivopisi XII–XIII vekov," (K istorii ikonostasa), in Lazarev, V.N., *Russkaya srednevekovaya zhivopis. Stati i issledovaniya*, pp. 128–139. In the *Paterik* of the Monastery of the Caves in Kiev, it is mentioned that a devout man who had built a house chapel ordered from Alimpii five large icons of

the *Deesis* to adorn it. (*Paterik Kievskogo Pecherskogo monastyrya*, ed. Archeograficheskaya komisiya, p. 123). It is obviously referring to this *Deesis*, already divided into five separate icons.

53 *Akty Russkogo na sv. Afone monastyrya sv. velikomuchenika i tselitelya Panteleymona*, Kiev 1873, pp. 50–67.

54 Lazarev, V.N., "O rospisi Sofii Novgorodskoy," in *Drevnerusskoe iskusstvo. Chudozhestvennaya kultura Novgoroda*, p. 58; [see also in: Lazarev, V.N., *Vizantiyskoe i drevnerusskoe iskusstvo. Stati i materialy*, p. 169].

55 *Poln. sobr. russkich letopisey*, t. VI, *Sofisyskie letopisi*, Spb. 1853, pp. 87–89.

56 Smirnova, E.S., review of the text of V.N. Lazarev, *Freski Staroy Ladogi* (M. 1960), in *Vizantiyskii vremennik*, 24, M. 1964, pp. 223–224 (with reference to the 1958 conference by M.K. Karger). In my opinion, this hypothesis is still rather dubious. It would have been difficult for the chronicler to cite an artisan with a patronymic (and artists were considered on a par with artisans!). The patronymic in –*ich* was generally reserved for people belonging to higher social classes. This is the reason I tend to think that the chronicle is referring to the Greek Petrovich who was probably very well-known.

57 Cf. the Constantinopolitan icon of *Saint Nicholas* from the eleventh century, in the collection of the Monastery of Sinai (*Frühe Ikonen*, Vienna-Munich 1965, pl. 15).

58 "Letopis Bogolyubova monastyrya s 1158 po 1770 god, sostavlennaya po monastyrskim aktam i zapisyam nastoyatelem odnoy obiteli igumenom Aristarchom v 1767–1769 godach," in *Chteniya v Obshchtestve istorii i drevnostey rossiyskich*, 1878, vol. 1, p. 3. Here, in a very metaphorical way, we have the narration of how the most holy Mother of God, "who ardently intercedes for the whole world, clearly standing under her canopy, with a scroll in her right hand. . .," appeared in person to Andrew. As he had been ordered by the Virgin, Andrew "summoned the most expert portraitists" and ordered them to paint the icon of the Virgin just as she had appeared to him.

59 See Lazarev. V.N., "Zhivopis Vladimiro-Suzdalkoy Rusi," in *Istoriya russkogo iskusstva*, t. I, M., ed. Academy of Sciences of the USSR, 1953, pp. 444, 446, pls. on pp. 445, 447; [*Zhivopis domongolskoy Rusi*, catalogue, ed. O.A. Korina, M. 1974, n. 5, pp. 37–39; Romanova, M., "Unikalnoe proizvedenie zhivopisi domongolskoy epochi," in *Iskusstvo*, 1978, n. 3, pp. 64–67]. Cf. Der Nersessian, S., "Two images of the Virgin in the Dumbarton Oaks Collection," in *Dumbarton Oaks Papers*, n. 14, Washington 1960, pp. 77–86.

60 Cf. on this image: Grabar, Igor, "Andrey Rublyov. Ocherk tvorchestva chudozhnika po dannym restavratsionnych rabot 1918–1925 gg.," in *Voprosy restavratsii*, I, M. 1926, ill. on p. 48 (at the bottom), text on pp. 55 and 56–57 (note 65) [the same in: Grabar, Igor, *O drevnerusskom iskusstve*, M. 1966, p. 158]; Lazarev, V.N., "Zhivopis Vladimiro-Suzdalskoy Rusi," in *Istoriya russkogo iskusstva*, t. I, pp. 474, 476. [Cf. what is said about the icon first and then about the restoration: *Vsesoyuznaya konferentsiya "Teoriticheskie printsipy restavratsii drevnerusskoy stankovoy zhivopisi,"* illustrated album, pls. 27, 28].

61 Kondakov, N.P., *Ikonografiya Bogomateri*, t. II, pp. 105–123.

62 Grabar, Igor, *Andrey Rublyov. Ocherk tvorchestva chudozhnika po dannym restavratsionnych rabot 1918–1925 gg.*, pp. 58–59 [the same text in Grabar, Igor, *O drevnerusskom iskusstve*, p. 162, ill. on p. 161].

63 Schweinfurth, Ph., *Geschichte der russischen Malerei im Mittelalter*, The Hague 1930, pp. 150–151.

64 See Orlov, D., *Yaroslavskii Tolgskii monastyr*, Yaroslav 1913, p. 158.

65 See Uspenskie, M.I. and V.I., *Zametki o drevnerusskom ikonopisanii. Izvestnye ikonopistsy i ich proizvedeniya*, I., *Sv. Alimpii*, II, *Andrey Rublyov*, pp. 18–23.

66 Sotiriou, G. and M., *Icônes du Mont Sinaï*, vol. I, Athens 1956, pls. 146, 147, 157, 171, 232.

67 Kondakov, N.P., *Ikonografiya Bogomateri*, t. II, pp. 316–356.

68 Karabinov, I.A., "'Namestnaya ikona' drevnego Kievo-Pecherskogo monastyrya," in *Izvestiya Gos. Akademii istorii materialnoy kultury*, t. V., L. 1927, pp. 106–17.

69 Reformatskaya, M.A., *Severnye pisma*, p. 12.

70 Yamshchikov, S.V., *Drevnerusskaya Zhivopis. Novye otkrytiya*, album, M. [1966], pl. 9; [Vzdornov, G.I., "Bogomater Umilenie Podkubenskaya," in *Pamyatniki kultury. Novye otkrytiya. 1977*, M. 1977, pp. 192–201].

71 See Grabar, A., "L'imago clipeata chrétienne," in *Académie des Inscriptions et Belles-Lettres. Comptes rendus des Séances de l'année 1957*, April–June, Paris 1958, pp. 209–213, (same text in Gabar, A., *L'art de la fin de l'antiquité et du Moyen Age*, I, Paris 1968, pp. 607–613).

72 Kondakov, N.P., *Litsevoy ikonopisnyi podlinnik*, t. I, *Ikonografiya Gospoda Boga i Spasa nashego Iisusa Christa*, Spb. 1905, pp. 61, 76–77.

73 Braunfels, W., *Die Welt der Karolinger und ihre Kunst*, Munich 1968, p. 366, pl. III [on the iconography of the Synaxis of the Archangels in particular, see Vzdornov, G.I., "ΣΥΝΑΞΙΣ ΤΩΝ ΑΡΧΑΓΓΕΛΩΝ" in *Vizantiyskii vremennik*, 32, M. 1971, pp. 157–183].

74 I know of only one icon from the Byzantine milieu in which the ground is so covered with ornamentation, but this hagiographical icon of Saint George, which comes from the thirteenth century, belongs to a group of provincial works and, according to G. and M. Sotiriou, denotes a strong Georgian influence. See Sotiriou, G. and M., *Icônes du Mont Sinaï*, vol. I, pl. 167.

75 Among the thirteenth-century icons not mentioned in the text, we need to recall the heavily damaged *Virgin of Tenderness* in the Russian Museum (from the D.S. Boshakov collection, inv. n. 2017) [See *Zhivopis drevnego Novgoroda i ego zemel XII–XVII stoletii*, catalogue, L. 1974, n. 7, pp. 34–35; *Zhivopis domongolskoy Rusi*, catalogue, ed. O.A. Korina, n. 15, pp. 73–74].

76 See Lazarev, V.N., *Iskusstvo Novgoroda*, M.-L. 1947, p. 46, pl. 34a; [Smirnova, E.S., *Zhivopis Velikogo Novgoroda. Seredina XIII — nachalo XV veka*, M. 1976, pp. 74–75, catalogue, n. 8, pp. 181–184, ill. on pp. 77, 280 and 281]. The icon goes back to the early fourteenth century.

77 See Kostsova, A., *Novyi pamyatnik novgorodskoy zhivopisi XIII veka*, in "Soobshcheniya Gos. Ermitazha," XXIII, L. 1962, pp. 18–22; [Smirnova, E.S., *Zhivopis Velikogo Novgoroda. Seredina XIII — nachalo XV veka*, pp. 80–82, catalogue, n. 12, pp. 198–199, ill. on p. 299]. It comes from the village of Peredki near Borovichi. The icon was not painted before the first thirty years of the fourteenth century. The left part of the figure and the background (on the far left of the panel) have been painted over, something which is totally unacceptable in the practice of restoration. A late reminiscence of this iconographic type of Saint Nicholas is also found in the icon of "the Northern Manners" from the village of Vegoruks, preserved today in the Museum of Fine Arts of the Autonomous Republic of Karelia in Petrozavodsk (fifteenth century).

78 See Laurina, V.K., "Dve ikony novgorodskogo Zverina monastyrya" (K voprosu o novgorodskoy ikonopisi pervoy poloviny XIV veka), in

Soobshcheniya Gos. Russkogo muzeya, VIII, pp. 105–112; [Smirnova, E.S., *Zhivopis Velikogo Novgoroda. Seredina XIII — nachalo XV veka*, pp. 70–72, catalogue, n. 7, pp. 179–180, ill. on pp. 277–279]. From the chapel of the Zverin Monastery. It may come from the Church of the Mother of God, founded in 1335, of this monastery.

79 See Pertsev, N.V., "Ikona Nikoly iz Lyuboni," in *Soobshcheniya Gos. Russkogo muzeya*, IX, L. 1968, pp. 84–91; Smirnova, E.S., *Zhivopis drevney Rusi. Nachodki i otkrytiya*, L. 1970, text and pls. 1–3; [Id., *Zhivopis Velikogo Novgoroda. Seredina XIII — nachalo XV veka*, pp. 73–74, catalogue, n. 9, pp. 184–187, ill. on pp. 282–293]. The village of Lyuboni is located in the province of Borovichi, region of Novgorod. It is possible that the icon was not painted in Novgorod itself but in some other center of the province. The icon of the *Nativity of the Virgin* in the Tretyakov Gallery must also be included in the group of early Novgorodian icons (Antonova, V.I., — Mneva, N.E., *Katalog drevnerusskoy zhivopisi*, t. I, n. 16, pp. 86–87; Lazarev, V.N., *Novgorodskaya ikonopis*, M. 1969, pl. 19; [Smirnova, E.S., *Zhivopis Velikogo Novgoroda. Seredina XIII — nachalo XV veka*, pp. 84–86, catalogue, n. 14, pp. 204–206, ill. on pp. 315–317]; cf. Matsulevich, L.A., "Dve ikony Rozhdestva Bogomateri," in *Russkaya ikona*, 3, Pg. 1914, pp. 167–171, with illustrations), attributed without sufficient reason to the Tver school (see Popov, G.V., "Puti razvitiya tverskogo iskusstva v XIV — nachale XVI veka," in *Drevnerusskoe iskusstvo. Chudozhestvennaya kultura Moskvy i prilezhashchich k ney knyazhestv. XIV–XVI vv.*, p. 314). At the 1970 exhibition "Early Painting from Tver" (Andrei Rublev Museum of Early Russian Art), the icon of the *Nativity of the Virgin* looked like something foreign, so different from the coloring of all the other icons were its brilliant, purely Novgorodian colors.

80 In a Russian religious poem this episode is described the following way:

And she went straight to the dragon
as if it were a milk cow.

See Rystenko, A.V., *Legenda o sv. Georgii i drakone v vizantiyskoy i slavyano-russkoy literature*, Odessa 1909, p. 324.

81 See Lazarev, V.N., "Vasilevskie vrata 1336 goda," in Lazarev, V.N., *Russkaya srednevekovaya zhivopis. Stati i issledovaniya*, pp. 179–215; Id. *Old Russian Murals and Mosaics*, London 1966, p. 139 [see also in the Russian ed.: Lazarev, V.N., *Drevnerusskie mozaiki i freski. XI–XV vv.*, M. 1973, pls. 292, 293].

82 See Filatov, V.V., "Ikonostas novgorodskogo Sofiiskogo sobora" (Predvaritelnaya publikatsiya), in *Drevnerusskoe iskusstvo. Chudozhestvennaya kultura Novgoroda*, pp. 63–77; [Id., *Prazdichnyi ryad Sofii Novgorodskoy. Drevneyshaya chast glavnogo ikonostasa Sofiiskogo Sobora*, L. 1974]; *Zhivopis drevnego Novgoroda i ego zemel XII–XVII stoletii*, catalogue, n. 18, p. 41. The second group of *Feasts*, made up of four icons, is dated from 1509. The oldest panels are not well preserved and have many lacunae, especially in the faces. Only a few heads have survived, especially in the *Descent into Hell* and *Dormition*.

83 *Novgorodskaya pervaya letopis starshego i mladshego izvodov*, M.-L. 1950, pp. 351–353.

84 In their slightly unusual style, the icons present a distant resemblance to the works from a southern Slavic milieu, and they were probably painted by a master of Balkan origin. The crown of thorns on the head of the crucified Christ shows Western influences.

85 See Onasch, K., *Ikonen*, pl. 23, pp. 355–356; Laurina, V.K., "Ikony Borisoglebskoy tserkvi v Novgorode" (K voprosu o novgorodskoy ikonopisi vtoroy poloviny XIV v.), in *Soobshcheniya Gos. Russkogo muzeya*, IX, pp. 74–76; [Gordienko, E.A., "Novgorodskoe 'Blagoveshchenie' s Fyodorom Tironom," in *Drevnerusskoe iskusstvo. Zarubezhnye svyazl*, pp. 215–222; Smirnova, E.S., *Zhivopis Velikogo Novgoroda. Seredina XIII — nachalo XV veka*, pp. 98–99, catalogue, n. 19, pp. 215–219, ill. on pp. 101, 326–328]. It comes from the Church of Boris and Gleb, built in 1377, the year corresponding to the approximate date of the icon.

86 See Antonova, V.I. — Mneva, N.E., *Katalog drevnerusskoy zhivopis*, t. I, n. 33, pp. 98–99, pl. 42; Lazarev, V.N., *Novgorodskaya ikonopis*, pl. 20; [*Zhivopis drevnego Novgoroda i ego zemel XII-XVII stoletii*, catalogue, n. 85, p. 65].

87 See Antonova, V.I. — Mneva, N.E., *Katalog drevnerusskoy zhivopisi*, t. I, n. 18, pp. 88–89, pl. 45; Onasch, K., *Ikonen*, pl. 25, p. 357; [Smirnova, E.S., *Zhivopis Velikogo Novgoroda. Seredina XIII — nachalo XV veka*, p. 119, catalogue, n. 27, ill. on p. 346]. Cf. the rendition of the back of the horse in the hagiographical icon of *Saint George* in the Russian Museum. The drawing becomes more energetic and accomplished in the Novgorodian icons of the late fourteenth century.

88 Goleyzovskii, N.K., "Zametki o tvorcheste Feofana Greka," in *Vizantiyskiy vremmenik*, 24, M. 1964, p. 143.

89 Malitskii, N.V., *Drevnerusskie kulty selskochozyaystvennych svyatych po pamyatnikam iskusstva*, pp. 12–14.

90 See Kirpichnikov, A.I., *Sv. Georgii i Egorii Chrabryi. Issledovanie literaturnoy istorii christianskoy legendy*, Spb. 1879; Veselovskii, A.N., *Razyskaniya v oblasti russkich duchovnych stichov*, II, *Sv. Georgii v legende, pesne i obryade*, Spb. 1880 (included in tome XXXVII of "Zapiski imp. Akademii nauk," n. 3), pp. 1–228; Myslivec, J., "Svaty Jirí ve vychodokrest anském umeni," in *Byzantinoslavica*, V, Prague 1933–1934, pp. 304–375; Lazarev, V.N., "Novyi pamyatnik stankovoy zhivopisi XII veka i obraz Georgiya-voina v vizantiyskom i drevenerusskom iskusstve," in Lazarev, V.N., *Russkaya srednevekovaya zhivopis. Stati i issledovaniya*, pp. 55–102; Alpatov, M.V., "Obraz Georgiya-voina v iskusstve Vizantii i Drevney Rusi," in Alpatov, M.V., *Etyudy po istorii russkogo iskusstva*, 1, pp. 154–169; Porfiridov, N.G., "Georgii v drevnerusskoy melkoy kamennoy plastike," in *Soobshechniya Gos. Russkogo muzeya*, VIII, pp. 120–125; [Sapunov, B.V., "Narodnye osnovy ikony 'Chudo Georgiya o zmie' XVI v. iz Olontsa," in *Trudy Otdela drevnerusskoy literatury Instituta russkoy literatury (Pushkinskii dom) Akademii nauk SSSR*, XXIV, L. 1969, pp. 171–174; Propp, V.Ya., "Zmeeborstvo Georgiya v svete folklora," in *Folklor i etnografiya Russkogo Severa*, L. 1973, pp. 190–208].

91 Chicherov, V.I., *Zimnii period russkogo narodnogo zemledelskogo kalendariya XVI–XIX vekov*, M. 1957, p. 226.

92 There is a large group of Novgorodian icons from the years spanning the end and beginning of the fourteenth and fifteenth centuries depicting selected saints. They present certain stylistic affinities even though they did not come from the same studio. Among these, we have: the small triptych in the Tretyakov Gallery (Lazarev, V.N., *Novgorodskaya ikonopis*, pl. 27) and also *Florus, James, the Brother of the Lord, and Laurus, Paraskeva Pyatnitsa and Anastasia*, the *Virgin and Child with Blaise* (from the Gatchina Palace, previously belonging to the A.M. Postnikov collection [see Smirnova, E.S., *Zhivopis Velikogo Novgorada. Seredina XIII — nachalo XV veka*, p. 129, catalogue, n. 38, ill. on p. 374]), the *Virgin, the Savior, Stephen, and Nicholas* as well as *Nicholas, Elijah, Paraskeva Pyatnitsa, and Blasius* in the Russian Museum (Lazarev, V.N., *Iskusstvo Novgoroda*, pl. 89; Id., *Novgorodskaya ikonopis*, pls. 28 and 30). [About these icons of a later date, see also: *Zhivopis drevnego Novgoroda i ego zemel XII–XVII stoletii*, catalogue, n. 41, p. 50, pl. 28,

n. 43, p. 51, n. 52, p. 54, pl. 32, n. 53, pp. 54–55, pl. 33; Smirnova, E.S. — Laurina, V.K. — Gordienko, E.A., *Zhivopis Velikogo Novgoroda. XV vek*, M. 1982, pp. 103, 162–163, catalogue, n. 44, 23, pp. 271–272, 239–241, ill. on pp. 478 and 435].

93 [See on these saints]: Veselovskii, A., "Opyty po istorii razvitiya christianskoy legendy, II. Berta, Anastasiya i Pyatnitsa," in *Zhurnal Ministerstva narodnogo prosveshcheniya*, February 1877, pp. 186–252; Kondakov, N.P., *The Russian Icon*, Oxford 1927, pp. 99–100; Malitskii, N.V., *Drevnerusskie kulty selskochozyaystvennych svyatych po pamyatnikam iskusstva*, pp. 11–12.

94 See Lazarev, V.N., *Iskusstvo Novgoroda*, p. 94, pl. 97; Antonova, V.I. — Mneva, N.E., *Katalog drevnerusskoy zhivopisi*, t. I, n. 27, 28, pp. 95–96, pl. 51 *(Demetrius of Thessalonica)*; [Smirnova, E.S. — Laurina, V.K. — Gordienko, E.A., *Zhivopis Velikogo Novgoroda. XV vek*, p. 83, catalogue, n. 13, pp. 220–222, ill. on pp. 424 and 425], inclusion in new plates.

95 Laurina, V. K, "Ikony Borisoglebskoy tserkvi v Novgorode" (K voprosu o novgorodskoy ikonopisi vtoroy poloviny XIV v.), in *Soobshcheniya Gos. Russkogo muzeya*, IX, pp. 79–82; Yamshchikov, S., *Drevnerusskaya zhivopis. Novye otkrytiya*, album, pls. 10, 11; [*Zhivopis drevnego Novgoroda i ego zemel XII–XVII stoletii*, catalogue, n. 42, pp. 50–51; Smirnova, E.S. — Laurina, V.K. — Gordienko, E.A., *Zhivopis Velikogo Novgoroda. XV vek*, pp. 66–67, catalogue, n. 6, pp. 201–205, ill. on p. 400; Bychkov, V.V., "Nekotorye priemy chudozhestvennoy interpretatsii mifologicheskogo teksta v drevnerusskoy zhivopisi," in *Literatura i zhivopis*, L. 1982, pp. 112–117]. The icon which came from the Church of Saints Boris and Gleb in Novgorod also includes the entire cycle of the Passion. The pictorial style and the whole formal structure point to a great primitivism, betraying the hand of an unskilled master.

96 Betin, L.V., "Ob architekturnoy kompozitsii drevnerusskich vysokich ikonostasov," in *Drevnerusskoe iskusstvo. Chudozhestvennaya kultura Moskvy i prilezhashchich k ney knyazhestv. XIV–XVI vv.*, pp. 55–56. Cf. Smirnova, E.S., *Zhivopis Obonezheya XIV–XVI vekov*, pp. 30, 44–45, 65–69.

97 Lasareff, V., *Trois fragments d'épistyles peintes et le templon byzantin*, pp. 130–131, 138–139 [see also in the Russian ed.: Lazarev, V.N., "Tri fragmenta raspisnych episteliev i vizantiyskii templon," in Lazarev, V.N., *Vizantiyskaya zhivopis. Sbornik statey*, pp. 122–124, 127, 129] (see note 48). [See also: Babic, G., "O zhivopisanom ukrasu oltarskich pregrada," in *Zbornik za likovne umetnosti*, 11, Novi Sad 1975, pp. 1–49].

98 See Mazarev, V.N., *Iskusstvo Novgoroda*, pl. 85 v; Smirnova, E.S., *Zhivopis Velikogo Novgoroda. Seredina XIII — nachalo XV veka*, p. 170, catalogue, n. 31, pp. 246–247, ill. on pp. 351–357]. This *Deesis*, composed of seven icons (including the ones of the apostles Peter and Paul), was probably executed in one of the northern provinces, where it used to decorate a small wooden church. The *Deesis* of the fourteenth (?) century, now in the Hermitage, comes from the cemetery of Vazentsy on the Onega. It has bust figures in frontal positions (the icons of the *Savior, Saints Peter, Elijah,* and *Nicholas* have survived; see Kostsova, A.S., "Belomorskaya i severodvinskaya ekspeditsii," in *Soobshechniya Gos. Ermitazha*, XVII, L. 1960, pp. 74–76). [See also: *Sto ikon iz fondov Ermitazha. Zhivopis russkogo Severa XIV–XVIII vekov*, catalogue, ed. A.S. Kostsova, L., n. 1–4].

99 See note 19.

100 See V. Sergii, archiepiskop Vladimirskii, *Svyatyi Andrei Christa radi yurodivyi i prazdnik Presvyatyia Bogoroditsy*, Spb. 1898.

101 Kondakov, N.P., *Ikonografiya Bogomateri*, t. II, pp. 58–59.

102 See Vagner, G.K., *Skulptura Vladimiro-Suzdalskoy Rusi. Yurev Polskoy*, M. 1964, pp. 63–64, pl. 25.

103 For the second variant see the Suzdal icon from the 1360s in the Tretyakov Gallery (Voronin, N.N. — Lazarev, V.N., "Iskusstvo srednerusskich knyazhestv XIII–XV vekov," in *Istoriya russkogo iskusstva*, t. III, M. 1955, ed. Academy of Sciences of the USSR, ill. on p. 11; Antonova, V.I., — Mneva, N.E., *Katalog drevnerusskoy zhivopisi*, t. I, n. 171, pp. 213–214). The earliest example of the first variant is the fresco, from 1313, in the Monastery of Snetogory near Pskov (Lazarev, V.N., "Snetogorskie rospisi," in Lazarev, V.N., *Russkaya srednevekovaya zhivopis. Stati i issledovaniya*, note 27 on pp. 160–161, ill. on p. 162).

104 Gorskii, A., and Nevostruek, K, *Opisanie slavyanskich rukopisey moskovskoy Sinodalnoy biblioteki*, sec. III, pt. 1, M. 1869, p. 554.

105 Medvedeva, E.S., *Drevnerusskaya ikonografiya Pokrova. Dissertatsiya v archive Instituta archeologii Akamedii nauk SSSR v Moskve*, R-2, n. 1728.

106 Trubetskoy, E.N., *Umozrenie v kraskach. . . ,* pp. 33–34.

107 Ibid., p. 34.

108 *Virgin of the Sign with Nicholas, Simeon the Stylite, and John the Almsgiver* (Antonova, V.I. — Mneva, N.E., *Katalog drevnerusskoy zhivopisi*, t. I, n. 66, p. 125; [Smirnova, E.S. — Laurina, V.K. — Gordienko, E.A., *Zhivopis Velikogo Novgoroda. XV vek*, pp. 126, 165–166, catalogue, n. 72, pp. 334–335, ill. on p. 539]), *Cyril and Athanasius of Alexandria and Leontii of Rostov* in the Novgorod Museum (*Novgorodskii istoriko-architekturnyi muzey-zapovednik*, catalogue, L. 1963, ill. on p. 26; [*Zhivopis drevnego Novgoroda i ego zemel XII–XVII stoletii*, catalogue, n. 56, p. 56; Smirnova, E.S. — Laurina, V.K. — Gordienko, E.A., *Zhivopis Velikogo Novgoroda. XV vek*, pp. 127–128, 164–165, catalogue, n. 62, pp. 299–300, ill. on pp. 504 and 505]), *James, the Brother of the Lord, Nicholas, and Ignatius the God Bearer* in the Russian Museum (Smirnova, E.S., *Zhivopis drevney Rusi. Nachodki i otkrytiya*, pl. 9; [Smirnova, E.S. — Laurina, V.K. — Gordienko, E.A., *Zhivopis Velikogo Novgoroda. XV vek*, pp. 114, 116–117, catalogue, n. 53, pp. 286–287, ill. on p. 488]), the panels from the Cathedral of Saint Sophia in the Novgorod Museum and the Tretyakov Gallery [Lazarev, V.N., *Stranitsy istorii novgorodskoy zhivopisi. Dvustoronnie tabletki iz sobora sv. Sofii v Novgorode*, M. 1977; Smirnova, E.S. — Laurina, V.K. — Gordienko, E.A., *Zhivopis Velikogo Novgoroda. XV vek*, pp. 128, 130–131, catalogue, n. 63, pp. 301–320, ill. on pp. 506–521], and many other icons. [On the subject, see: Smirnova, E.S., "O mestnoy traditsii v novgorodskoy zhivopisi XV v. Ikony s izbrannymi svyatymi i Bogomateriyu Znamenie," in *Srednevekovoe iskusstvo. Rus. Gruziya*, pp. 193–211].

109 A classic example is the icon of *Paraskeva Pyatnitsa* in the A.I. Anisimov collection, now in the Tretyakov Gallery (Lazarev, V.N., *Iskusstvo Novgoroda*, pl. 107; Onasch, K., *Ikonen*, pl. 107; [Smirnova, E.S. — Laurina, V.K. — Gordienko, E.A., *Zhivopis Velikogo Novgoroda. XV vek*, pp. 138, 149, catalogue, n. 68, p. 330, ill. on p. 535]).

110 See Antonova, V.I., — Mneva, N.E., *Katalog drevnerusskoy zhivopisi*, t. I, n. 45 and 46, pp. 108–109; Lazarev, V.N., *Novgorodskaya ikonopis*, pp. 30–31, pls. 41–42.

111 See Antonova, V.I. — Mneva, N.E., *Katalog drevnerusskoy zhivopisi*, t. I, n. 67, pp. 125–127, pls. 84, 85.

112 See *Vystavka drevnerusskogo iskusstva, ustroennaya v 1913 godu. . . ,* M. 1913, p. 7, n. 7 and plates; See Antonova, V.I. — Mneva, N.E., *Katalog drevnerusskoy zhivopisi*, t. I, n. 56, p. 117; [Smirnova, E.S. — Laurina, V.K. — Gordienko, E.A., *Zhivopis Velikogo Novgoroda. XV vek*, p. 123, catalogue, n. 57, p. 292, ill. on p. 499].

113 See Alpatov, M., "Eine abendländische Komposition in altrussischer Umbildung," in *Byzantinische Zeitschrift,* vol. 30, 1929/30, pp. 623–626, pl. XV; see Antonova, V.I. — Mneva, N.E., *Katalog drevnerusskoy zhivopisi,* t. I, n. 49, pp. 111–112, pl. 59.

114 See the fifteenth-century *Deesis* from Novgorod in the Tretyakov Gallery (Antonova, V.I. — Mneva, N.E., *Katalog drevnerusskoy zhivopisi,* t. I, n. 44, p. 107 — with an unlikely date, too early — n. 54, pp. 115–116, pls. 60–66, not before the first half of the fifteenth century, the figure of John the Baptist follows the Theophanes plan, the figure of Demetrius of Thessalonica takes its inspiration from the similar icon from the iconostasis in the Monastery of the Trinity of Saint Sergius; n. 81, p. 136; n. 97, pp. 147–148; n. 132, p. 176; [see also Smirnova, E.S. — Laurina, V.K. — Gordienko, E.A., *Zhivopis Velikogo Novgoroda. XV vek,* pp. 98, 107–108, 168–169, 40–45, catalogue, n. 29, 32, and 4, pp. 248–249, 253–254, 192–198, ill. on pp. 442–443, 452–461, 390–393]), in the Novgorod Museum (*Novgorodskii istoriko-arkhitekturnyi muzey-zapovednik,* catalogue, p. 10, ill. on p. 24 and p. 13, ill. on p. 26); [Smirnova, E.S. — Laurina, V.K. — Gordienko, E.A., *Zhivopis Velikogo Novgoroda. XV vek,* pp. 108, 167, catalogue, n. 33, pp. 255–257, ill. on pp. 462–466]. Perhaps one of the earliest Novgorodian full-length *Deeses* is that executed, as the inscription on the icon of the *Archangel Gabriel* states, by Master Aaron in the service of Bishop Evfimii in 1439. See Filatov, V.V., "Ikonostas novgorodskogo Sofiyskogo sobora," in *Drevnerusskoe iskusstvo. Chudozhestvennaya kultura Novgoroda,* pp. 65–68; [Smirnova, E.S., "Ikony 1438 goda v Sofiyskom sobore v Novgorode," in *Pamyatniki kultury. Novye otkrytiya, 1977,* pp. 215–224; Smirnova, E.S. — Laurina, V.K. — Gordienko, E.A., *Zhivopis Velikogo Novgoroda. XV vek,* pp. 76–78, catalogue, n. 8, pp. 208–209, ill. on pp. 412–413]. Until the end of the sixteenth century, the Novgorodians, unlike the Muscovites, unwillingly introduced the figures of the Fathers of the Church into the *Deesis,* limiting themselves, next to the three central figures, only to the archangels, apostles, and martyrs other than Saint Demetrius of Thessalonica and Saint George. This may have been due to the fact that they preferred to depict the Fathers of the Church on the royal doors. The figure of a bishop (John Chrysostom) appears for the first time in the iconostasis of the Church of Saint Nicholas in the Monastery of Gostinopole (about 1475). See Ilin, M.A., "Nekotorye predpolozheniya ob arkhitekture russkich ikonostasov na rubezhe XIV–XV vv.," in *Kultura drevney Rusi. Sbornik statey k 40-letiyu nauchnoy deyatelnosti N.N. Voronina,* M. 1966, pp. 79–88 (the hypotheses formulated by the author appear rather debatable).

115 [This wonderful icon comes, as has already been stated, from the iconostasis of the Cathedral of the Dormition in the Monastery of Cyril of Belozersk. It was executed around 1497 and, in addition to the local tier, is composed of three other registers: the *Deesis,* the *Feasts,* and the *Prophets.* See Lelekova, O.V., "O sostave ikonostasa Uspenskogo sobora Kirillo-Belozerskogo monastyrya," in *Soobshechniya Vsesoyuznoy tsentralnoy nauchno-issledovatelskoy laboratorii po konservatsii i restavratsii muzeynych chudozhestvennych tsennostey,* 26, M. 1971, pp. 91–114; Id., "Ikonostas 1497 g. iz Kirillo-Belozerskogo monastyrya," in *Pamyatniki kultury. Novye otkrytiya, 1976,* M. 1977, pp. 184–195; especially about the register of the *Prophets* of the iconostasis from the Monastery of Saint Cyril, the same author has prepared another article: Lelekova, O.V., "Prorocheskii ryad ikonostasa Uspenskogo sobora Kirillo-Belozerskogo monastyrya," in *Soobshechniya Vsesoyusnoy tsentralnoy nauchno-issledovatelskoy laboratorii po konservatsii i restavratsii muzeynych chudozhestvennych tsennostey,* 28, M. 1973, pp. 126–173. See also: Smirnova, E.S. — Laurina, V.K. — Gordienko, E.A., *Zhivopis Velikogo Novgoroda. XV vek,* pp. 131–135, catalogue, n. 66, pp. 325–328, ill. on pp. 532–533. Unlike the register of the prophets in the iconostasis from the Cathedral of

the Dormition of the Monastery of Belozersk, in the iconostasis of the Church of Saint Nicholas in the Monastery of Gostinopole (about 1475), the images of the prophets were not painted on long panels, but each one individually. See Antonova, V.I. — Mneva, N.E., *Katalog drevnerusskoy zhivopisi,* t. I, n. 98, p. 148, pl. 80; [Smirnova, E.S. — Laurina, V.K. — Gordienko, E.A., *Zhivopis Velikogo Novgoroda. XV vek,* pp. 138–140, catalogue, n. 78, pp. 342–343, ill. on pp. 554 and 555].

116 Antonova, V.I. — Mneva, N.E., *Katalog drevnerusskoy zhivopisi,* t. I, n. 69, p. 128.

117 Ibid., n. 102, pp. 151–152, pl. 73; [Smirnova, E.S. — Laurina, V.K. — Gordienko, E.A., *Zhivopis Velikogo Novgoroda. XV vek,* p. 126, catalogue, n. 20, pp. 296–297, ill. on p. 502]. Inscription located in the lower part, something very rare in early icons. In the lower part, there is also the restored inscription on the icon of *Simeon the Stylite,* done in 1465, in the Novgorod Museum. In style, the icon, painted for the Monastery of Saint Anthony of Dymsk (in the region of Tichvin), leans toward the works of the "Northern Manners." See Zidkov, G.V., "Iz istorii russkoy zhivopisi XV veka," in *Trudy sektsii archeologii Instituta archeologii i iskusstvoznaniya RANION,* IV, M. 1928, pp. 220–223, pl. XV; [Smirnova, E.S. — Laurina, V.K. — Gordienko, E.A., *Zhivopis Velikogo Novgoroda. XV vek,* pp. 110, 155, catalogue, n. 40, pp. 265–266, ill. on p. 474].

118 See Smirnova, E.S., "Fragment novgorodskoy ikony-skladnya XV v.," in *Kultura drevney Rusi. Sbornik statey k 40-letiyu nauchnoy deyatelnosti N.N. Voronina,* pp. 252–256; Id., *Zhivopis drevney Rusi. Nachodki i otkrytiya,* pl. 8; [Smirnova, E.S. — Laurina, V.K. — Gordienko, E.A., *Zhivopis Velikogo Novgoroda. XV vek,* p. 126, catalogue, n. 59, pp. 295–296, ill. on p. 501].

119 See Gusev, P., "Ikonografiya sv. Flora i Lavra v novgoroskom iskusstve," in *Vestnik archeologii i istorii,* ed. Archeologicheskii institut, n. XXI, Spb. 1911, sec. I, p. 97; Malitskii, V.N., *Drevnerusskie kulty selskochozyaystvennych svyatych po pamyatnikam iskusstva,* pp. 21–26.

120 Cf. the icon in the Russian Museum: Lazarev, V.N., *Novgorodskaya ikonopis,* pl. 44.

121 See note 21.

122 See Trubetskoy, E.N., *Umozrenie v kraskach. . . ,* p. 34.

123 Smirnova, E.S., *Zhivopis Obonezhya XIV–XVI vekov,* pp. 98–103; Reformatskaya, M.A., *Severnye pisma,* p. 16.

124 Smirnova, E.S., *Zhivopis Obonezhya XIV–XVI vekov,* pp. 39–42; Reformatskaya, M.A., *Severnye pisma,* p. 18–24.

125 Smirnova, E.S., *Zhivopis Obonezhya XIV–XVI vekov,* pp. 35–36.

126 Ibid., p.36

127 Ibid., p. 106

128 See note 70.

129 See Bogusevich, V., "Zhivopis kontsa XV stoletiya v privologodskom rayone," in *Severnye pamyatniki drevnerusskoy stankovoy zhivopisi,* Vologda 129, pp. 19–21; Lazarev, V.N., *Iskusstvo Novgoroda,* pp. 124–125, Smirnova, E.S., *Zhivopis Obonezhya XIV–XVI vekov,* p. 35; *Drevnerusskaya zhivopis. Vystavka novych otkrytii,* catalogue, Vologda 1970; [Vzdornov, G. *Vologda,* pp. 45ff; Id., "Vologosdskie ikony XIV–XV vekov," in *Soobshcheniya Vsesoyuznoy tsentralnoy nauchno-issledovatelskoy laboratorii po konservatsii i restavratsii muzeynych chudozhestvennych tsennostey,* 30, pp. 125–153; *Zhivopis vologodskich zemel XIV–XVIII vekov,* catalogue, ed. I. Pyatnitskaya, N. Fedyshin, O. Kozoderova, L. Charlampenkova, introductory essay by A. Rybakov, M. 1976; Rybakov, A.A., *Chudozestvennye pamyatniki Vologdy XIII — nachala XX veka,* L. 1980].

130 Serebryanski, N.I., *Zhitie prepodobnogo Evfrosina Pskovskogo*, Spb. 1909 (in the series "Pamyatniki drevney pismennosti i iskusstva," CLXXIII), pp. 65–67. In the *Life* there is an account about how this portrait was compared by the author of the *Life* with the appearance of Evfrosim, who came to him in a dream, and how, on the basis of a sketch by Ignatius kept in the monastery, an icon with the portrait of the saint was painted later by another iconographer. It is interesting to note how a single sketch of a portrait became transformed into an iconographic model, into a canon.

131 This vision is recorded in the *Life* of Aleksandr of Oshevensk (died 1489). There is an account here about the "seer Aleksandr" by a certain Nikifor Filippov, who describes his appearance in the following way: "Aleksandr was a man of medium height, with a lean face, a gentle expression, an intense look, a beard not too long and not very thick, chestnut hair slightly graying." See Buslaev, F.I., "Literatura russkich ikonopisnych podlinnikov," in Buslaev, F.I., *Soch.*, t. II, p. 374.

132 Dmitriev, Yu.N., "O tvorchestve drevnerusskogo chudozhnika," in *Trudy drevnerusskoy literatury Instituta russkoy literatury (Pushkinskii dom) Akademii nauk SSSR*, XIV, pp. 551–556.

133 See [Smirnova, E.S., *Zhivopis Velikogo Novgorada. Seredina XIII — nachalo XV veka*, pp. 86–88, catalogue, n. 17, ill. on pp. 322 and 323, *Presentation in the Temple*]; *IV vystavka "Restavratsiya i konservatsiya proizvedenii iskusstva,"* catalogue, M. 1963, p. 11 (*Descent into Hell* from the Monastery of the Archangel Michael in Archangelsk); [see also: Ovchinnikova, E.S., "Ikona 'Soshestvie vo ad iz sobraniya Gos. Istoricheskogo muzeya v Moskve," in *Drevnerusskoe iskusstvo. Chudozhestvennaya kultura Pskova*, M. 1968, pp. 139–156].

134 Smirnova, E.S., *Zhivopis Obonezhya XIV–XVI vekov*, p. 37.

135 See Antonova, V.I. — Mneva, N.E., *Katalog drevnerusskoy zhivopisi*, t. I, n. 304, p. 359.

136 See Kostsova, A.S., "Belomorskaya i severodvinskaya ekspeditsii," in *Soobshcheniya Gos. Ermitazha*, XVII, p. 74; Smirnova, E.S., *Zhivopis Obonezhya XIV–XVI vekov*, p. 36.

137 See Smirnova, E.S., *Zhivopis Obonezhya XIV–XVI vekov*, p. 32–34, pl. 4; [Id., *Zhivopis Velikogo Novgoroda. Seredina XIII — nachalo XV veka*, p. 79, catalogue, n. 11, ill. on pp. 80, 81 and 298].

138 Cf. Mneva, N.E., "Drevnerusskaya zhivopis Nizhnego Novgoroda," in *Gos. Tretyakovskaya galereya. Materialy i issledovaniya*, II, pp. 28–36.

139 Grishchenko, A., *Voprosy zhivopisi*, n. 3, *Russkaya ikona kak iskusstvo zhivopisi*, M. 1917, pp. 70–86.

140 Grabar, I., "Die Malereschule des alten Pskow," in *Zeitschrift für bildende Kunst*, year 63, 1929–1930, fasc. 1, pp. 3–9 (the article is being reprinted in the collection of essays by I.E. Grabar, *O drevnerusskom iskusstve*, pp. 222–232).

141 Grabar, I., "Die Malereschule des alten Pskow," p. 9 [quoted in the Russian ed.: Grabar, Igor, *O drevnerusskom iskusstve*, p. 232].

142 See Antonova, V.I. — Mneva, N.E., *Katalog drevnerusskoy zhivopisi*, t. I, n. 139, p. 181; Ovchinnikov, A. — Kishilov, N., *Zhivopis drevnego Pskova XIII–XVI vekov*, M. 1971, pl. 1; [Ovchinnikov, A.N., *Opyt opisaniya proizvedenii drevnerusskoy stankovoy zhivopisi. Technika i stil*, 1, *Pskovskaya shkola. XIII–XVI veka*, M. 1971, n. 1, pp. 1–4]. Many lacunae in the faces. Red background. Stylistically close to the *Dormition* in the Tretyakov Gallery.

143 Cf. Budde, L., *Göreme. Hölenkirche in Kappadokien*, Düsseldorf 1958, pl. 45; Restle, M., *Die Byzantinische Wandmalerei in Kleinasien*, II., Recklinghausen 1967, pls. 63, 69, 76, 84.

144 See *Zhivopis drevnego Pskova*, catalogue, ed. S. Yamshchikov, M., 1970, unnumbered; [Id., *Pskov. Museum*, M. 1973, p. 14/15 (plate)]; *VII vystavka proizvedenii izobrazitelnogo iskusstva, restavrirovannych Gos. tsentralnoy nauchno-restavratsionnoy masterskoy imeni akademika I.E. Grabarya*, catalogue, M. 1975, p. 20, unnumbered pl.

145 See *Zhivopis drevnego Pskova*, catalogue, ed. S. Yamshchikov, unnumbered; Ovchinnikov, A. — Kishilov, N., *Zhivopis drevnego Pskova*, pl. 12; [Ovchinnikov, A.N., *Opyt opisaniya proizvedenii drevnerusskoy stankovoy zhivopisi. Technika i stil*, 1, *Pskovskaya shkola. XIII–XVI veka*, n. 7, pp. 17–19].

146 See Antonova, V.I. — Mneva, N.E., *Katalog drevnerusskoy zhivopisi*, t. I, n. 143, p. 185, pl. 94.

147 See Smirnova, E.S., *Zhivopis drevney Rusi. Nachodki i otkrytiya*, text and pls. 4, 5; Ovchinnikov, A. — Kishilov, N., *Zhivopis drevnego Pskova*, pl. 10; [Ovchinnikov, A.N., *Opyt opisaniya proizvedenii drevnerusskoy stankovoy zhivopisi. Technika i stil*, 1, *Pskovskaya shkola. XIII–XVI veka*, n. 5, pp. 12–14]. The icon of the *Baptism* at the Hermitage probably also goes back to the first half of the fourteenth century. See Kostsova, A., "Drevnaya pskovskaya ikona 'Bogoyavlenie' i eyo svyaz s freskami Snetogorskogo monastyrya," in *Soobshcheniya Gos. Ermitazha*, XXIV, L. 1963, pp. 10–14; [Vzdornov, G.I., "Zhivopis," in *Ocherki russkoy kultury XIII–XV vekov*, pt. 2, *Duchovnaya kultura*, p. 277, ill. on p. 278]; Ovchinnikov, A. — Kishilov, N., *Zhivopis drevnego Pskova*, pls. 8, 9; [Ovchinnikov, A.N., *Opyt opisaniya proizvedenii drevnerusskoy stankovoy zhivopisi. Technika i stil*, 1, *Pskovskaya shkola. XIII–XVI veka*, n. 4, pp. 10–12].

148 See *Masterpieces of Russian Painting*, pls. LIII, LIV; Antonova, V.I. — Mneva, N.E., *Katalog drevnerusskoy zhivopisi*, t. I, n. 145, p. 187; [Ovchinnikov, A.N., *Opyt opisaniya proizvedenii drevnerusskoy stankovoy zhivopisi. Technika i stil*, 1, *Pskovskaya shkola. XIII–XVI veka*, n. 9, pp. 22–23].

149 *Russkaya ikona*, 1, ill. on p. 17; Ovchinnikov, A. — Kishilov, N., *Zhivopis drevnego Pskova*, pls. 34, 35; [Ovchinnikov, A.N., *Opyt opisaniya proizvedenii drevnerusskoy stankovoy zhivopisi. Technika i stil*, 1, *Pskovskaya shkola. XIII–XVI veka*, n. 17, pp. 47–48]. Until quite recently the icon was attributed to the Novgorod school.

150 See *Zhivopis drevnego Pskova*, catalogue, ed. S. Yamshchikov, unnumbered (erroneously identified as Paraskeva Pyatnitsa); Ovchinnikov, A. — Kishilov, N., *Zhivopis drevnego Pskova*, pl. 13; [Ovchinnikov, A.N., *Opyt opisaniya proizvedenii drevnerusskoy stankovoy zhivopisi. Technika i stil*, 1, *Pskovskaya shkola. XIII–XVI veka*, n. 8, pp. 19–22].

151 See note 20. The Synaxis of the Most Holy Mother of God is celebrated on December 26 by the Orthodox Church. On this occasion, the Church of the Blachernae celebrated the patriarch.

152 See Lazarev, V.N., "Zhivopis Pskova," in *Istoriya russkogo iskusstva*, t. II, ed. Akademiya Nauk SSSR, M. 1954, pp. 367–368, ill. on p. 366; [Popova, O., *Les miniatures russes du XIe au XVe siècle*, Saint Petersburg 1975, pl. 77].

153 See Yamshchikov, S. *Drevnerusskaya zhivopis. Novye otkrytiya*, album, pl. 5, Ovchinnikov, A. — Kishilov, N., *Zhivopis drevnego Pskova*, pls. 36–38; [Ovchinnikov, A.N., *Opyt opisaniya proizvedenii drevnerusskoy stankovoy zhivopisi. Technika i stil*, 1, *Pskovskaya shkola. XIII–XVI veka*, n. 18, pp. 40–51. Cf. Vzdornov, G.I., *Vologda*, pp. 55, 58, pl. 30; Id., "Vologodskie ikony XIV–XV vekov," in *Soobshecheniya Vsesoyuznoy*

tsentralnoy nauchno-issledovatelskoy laboratorii po konservatsii i restavratsii muzeynyh chudozhestvennych tsennostey, 30, pp. 139–140, pl. 5].

154 See *Zhivopis drevnego Pskova*, catalogue, ed. S. Yamshchikov, un-numbered; [Ovchinnikov, A.N., *Opyt opisaniya proizvedenii drevnerusskoy stankovoy zhivopisi. Technika i stil*, 1, *Pskovskaya shkola. XIII–XVI veka*, n. 24, pp. 63–67.

155 See Antonova, V.I. — Mneva, N.E., *Katalog drevnerusskoy zhivopisi*, t. I, n. 156, pp. 196–197, pls. 109, 110. In the 1460s.

156 See Pavlova-Silvanskaya, M.P., "Zhitiinaya ikona Paraskevy Pyatnitsy s vosemnadtsatyu kleymami," in *Drevnerusskoe iskusstvo. Chudozhestvennaya kultura Pskova*, pp. 127–136.

157 See *Zhivopis drenego Pskova*, catalogue, ed. S. Yamshchikov, un-numbered; Ovchinnikov, A. — Kishilov, N., *Zhivopis drevnego Pskova*, pl. 40; [Ovchinnikov, A.N., *Opyt opisaniya proizvedenii drevnerusskoy stankovoy zhivopisi. Technika i stil*, 1, *Pskovskaya shkola. XIII–XVI veka*, n. 20, pp. 53–56.

158 Grabar, Igor, "Andrey Rublyov. Ocherk tvorchestva chudozhnika po dannym restavratsionnych rabot 1918–1925 ff.," in *Voprosy restavratsii*, I, pp. 46–66 (reprinted in the collection of essays by N.E. Grabar, *O drevnerusskom isskustve*, pp. 153–167).

159 "'Kniga palomnik.' Skazanie mest svyatych vo Tsaregrade Antoniya, archiepiskopa Novgorodskogo, v 1200 godu, ed. Ch.M. Loparev," in *Pravoslavnyi Palestinskii sbornik*, t. XVII, 3, Spb. 1899, p. 16.

160 See note 18.

161 Smirnova, E.S., "Otrazhenie literaturnych proizvedenii o Borise i Glebe v drevnerusskoy stankovoy zhivopisi," *in Trudy Otdela drevnerusskoy literatury Instituta russkoy literatury (Pushkinskii dom) Akademii nauk SSSR*, XV, p. 316.

162 See Lazarev, V.N., "Zhivopis i skulptura velikoknyazheskoy Moskvy," in *Istoriya russkogo iskusstva*, t. III, p. 72, ill. on p. 73; [Id., *Moskovskaya shkola ikonopisi*, M. 1971, pl. 2; Popova, O.S., *Les miniatures russes du XIe au XVe siècle*, pp. 66, 68, 70, pl. 37; Vzdornov, G.I., *Iskusstvo knigi v Drevney Rusi. Rukopisnaya kniga Severo-Vostochnoy Rusi XII — nachala XV vekov*, M. 1980, pp. 67–74, description of the manuscripts, n. 29, ill.].

163 See Lazarev, V.N., *Moskovskaya shkola ikonopisi*, p. 9, pl. 12; [cf. Popova, O.S., "Ikona Spasa iz Uspenskogo sobora Moskovskogo Kremlya," in *Drevnerusskoe iskusstvo. Zarubezhnye svyazi*, pp. 125–146; Id., *Iskusstvo Novgoroda i Moskvy pervoy poloviny chetyrnadtsatoga veka. Ego svyazi s Vizantiey*, M. 1980, pp. 91–123].

164 For the time being, only two scenes from the cornice have been cleaned.

165 See *Troice-Sergieva lavra. Chudozhestvennye pamyatniki*, M. 1968, p. 73, pl. 58; Ilin, M.A., "Mirovidenie XIV veka i ego svyazi s iskusstvom Moskovskoy Rusi," in *Vestnik Moskovskogo universiteta*, ser. XII, History, n. XXIII, pp. 50–52. [Cf. Florenskii, P., "Molennye ikony prepodobnogo Sergiya," in *Zhurnal Moskovskoy patriarchii*, 1969, n. 9, pp. 88–90; Vzdornov, G.I., "Zhivopis," in *Ocherki russkoy kultury XIII–XV vekov*, pt. 2, *Duchovnaya kultura*, p. 354, ill. on p. 355].

166 *Nikon's Chronicle, year 6852 (1344)*, in [*Poln. sobr. russkich letopisey*, t. X, Spb. 1885, p. 216].

167 Ibid.

168 *Nikon's Chronicle, year 6853 (1345)*, in [ibid.].

169 See Zhidkov, G.V., *Moskovskaya zhivopis serediny XIV veka*, M. 1928.

170 *Pamyatniki drevnerusskoy literatury*, 2, *Zhitiya svyatych muchenikov Borisa i Gleba i sluzhby im.*, ed. D.I. Abramovich, Pg. 1916, p. 49.

171 See Antonova, V.I. — Mneva, N.E., *Katalog drevnerusskoy zhivopisi*, t. I, n. 214, pp. 252–253, pl. 169.

172 See *Troitse-Sergieva lavra. Chudozhestvennye pamyatniki*, pls. 59, 60. Here, the icon is erroneously attributed to the Pskov school. [See also: Nikolaeva, T.V., *Drevnerusskaya zhivopis Zagorskogo muzeya*, M. 1977, p. 32, catalogue, n. 102, ill.].

173 Historical Museum, Moscow. Embroidery with seven colors, 123x220 cm. One of the best examples of Muscovite embroidery. The seraphim are arranged above the *Holy Face;* under the *Deesis,* are the half-length saints (among whom it is possible to recognize Vladimir, Boris and Gleb) with the bishops of Moscow; in the corners, the evangelists in medalions; and on the cornice, the figures of half-length angels. See Schekotov, N.M., "Drevnerusskoe shite," in *Sofiya*, 1914, n. 1, pp. 10–11; Lazarev, V.N., "Zhivopis i skulptura velikoknyazheskoy Moskvy," in *Istoriya russkogo iskusstva*, t. III, p. 194, ill. on pp. 198 and 199; [Svirin, A.N., *Drevnerusskoe shite*, M. 1963, pp. 41–42, ill. on p. 43; Mayasova, N.A., *Drevnerusskoe shite*, M. 1971, pp. 10–11, pls. 5, 6; Badyaeva, T.A., "Pelena Marii Tverskoy," in *Voprosy istorii SSSR*, 1, M. 1972, pp. 499–514].

174 Lazarev, V.N., *Theophanes der Grieche und seine Schule*, Vienna-Munich 1968 [see Russian ed.: Lazarev, V.N. *Feofan Grek i ego shokla*, M. 1961].

175 Ibid., p. 8 [Russian ed., p. 9].

176 Ibid., pp. 69–95, pls. 80–129 [Russian ed., pp. 69–85, pls. 61-87].

177 Ainalov, D., *Geschichte der russischen Monumentalkunst zur Zeit des Grossfürstentums Moskau*, Berlin-Leipzig 1933, p. 92. Cf. Antonova, V.I., "Neizvestnyi chudozhnik Moskovskoy Rusi Ignatii Grek po pismennym istochnikam, in *Trudy Otdela drevnerusskoy literatury Instituta russkoy literatury (Pushkinskii dom) Akademii nauk SSSR*, XIV, pp. 569–572.

178 Antonova, V.I., "Ikonograficheskii tip Perivlepty i russkie ikony Bogomateri v XIV veke," in *Iz istorii russkogo i zapadnoevropeyskogo iskusstva*, M. 1960, pp. 105–110; [Nikolaeva, T.V., *Drevnerusskaya zhivopis Zagorskogo muzeya*, p. 29, catalogue, n. 98, ill.].

179 Until now, only the face of the Child has been cleaned [see Popova, O.S., "Ikona Bogomateri Odigitrii serediny XIV v. iz Uspenskogo sobora Moskovskogo Kremliya," in *Pamyatniki kultury. Novye otkrytiya, 1974*, M. 1975, pp. 238–251; Id., *Iskusstvo Novgoroda i Moskvy pervoy poloviny chetyrnadtsatogo veka. . .*, pp. 148–171].

180 See Ilin, M.A., "K moskovskomu periodu tvorchestva Feofana Greka," in *Vestnik Moskovskogo universiteta*, ser. IX, History, 1966, n. 4, pp. 70–75, [*Iskusstvo Moskovskoy Rusi epochi Feofana Greka i Andreya Rublyova. Problemy, gipotezy, issledovaniya*, M. 1976, pp. 54–58, pl. 41]. Here the icon is attributed to Theophanes the Greek with insufficient reason.

181 See Lazarev, V.N., "Novye pamyatniki vizantiiskoy zhivopisi XIV veka. Vysockii chin," in Lazarev, V.N., *Vizantiiskaya zhivopis. Sbornik statey*, pp. 357–372.

182 Rice, D. Talbot, *Arte di Bisanzio*, Florence 1959, p. 106, pl. 193, XLIV; Lazarev, V.N., *Storia della pittura bizantina*, pp. 376, 418 (note 90).

183 *Sophia Chronicle, Year 6905 (1397)*, in [*Poln. sobr. russkich letopisey*, t. IV, Spb. 1853, p. 130: "the Savior in White Clothing"].

184 *Chronicle of the Resurrection, Year 6912 (1404)*, in [*Poln. sobr. russkich letopisey*, t. VII, Spb. 1859, p. 77].

185 See Lazarev, V.N., "Kovalevskaya rospis i problema yuzhno-slavyanskich svyazey v russkoy zhivopisi XIV veka," in Lazarev, V.N., *Russkaya srevdnevekovaya zhivopis. Stati i issledovaniya*, p. 260, ill. on pp. 271–273 and pp. 277–278, ill. on pp. 274–275; Antonova, V.I. — Mneva, N.E., *Katalog drevnerusskoy zhivopisi*, t. I, n. 338, pp. 381–383, pls. 250–254; Putsko, V., "Ikona 'Predsta tsaritsa' v Moskovskom Kremle," in *Zbornik za likovne umetnosti*, 5, Novi Sad 1969, pp. 57–74, pls. 1–8; Popov, G.V., "Tri pamyatnika yuzhno-slavyanskoy zhivopisi XIV veka i ich russkie kopii serediny XVI veka," in *Vizantiya. Yuzhnye slavyane i drevnyaya Rus. Zapadnaya Evropa. Iskusstvo i kultura*, pp. 353, 358–359; [Ostashenko, E.Ya., "Ob ikonograficheskom tipe ikony 'Predsta tsaritsa' Uspenskogo sobora Moskovskogo Kremlya," in *Drevnerusskoe iskusstvo. Problemy i atributsii*, M. 1977, pp. 157–187].

186 Priselkov, M.D., *Troitskaya letopis. Rekonstruktsiya teksta*, M.-L. 1950, p. 459.

187 See Lasareff, V. *Trois fragments d'épistyles peintes et le templon byzantin*, pp. 117–143 [Russian ed.: Lazarev, V.N., "Tri fragmenta raspisnych epistiliev i vizantiiskii templon," in Lazarev, V.N., *Vizantiiskaya zhivopis. Sbornik statey*, pp. 110–136].

188 Lazarev, V.N., "Zhivopis i skulptura velikoknyazheskoy Moskvy," in *Istoriya russkogo iskusstva*, t. III, pp. 120, 122; Ilin, M.A., "Nekotorye predpolozheniya ob architekture russkich ikonostasov na rubezhe XIV–XV vv.," in *Kultura drevney Rusi. Sborknik statey k 40-letiyu deyatelnosti N.N. Voronina*, pp. 82, 86–87.

189 Betin, L.V., "O proischozhdenii ikonostasa Blagoveshchenskogo sobora Moskovskogo Kremlyia," in *Restavratsiya i issledovaniya pamyatnikov kultury*, 1, M. 1975, pp. 37–44 [Cf. Schennikova, L.A., "O proischozhdenii drevnego ikonostasa Blagoveshchenskogo sobora Moskovskogo Kremlya," in *Sovetskoe iskusstvoznanie*, '81, 2 (15), M. 1982, pp. 81–129]. For the history of the infrastructure of the Church of the Annunciation, see Vzdornov, G.I., "Blagoveshchenskii sobor ili pridel Vasiliya Kesariiskogo?" in *Sovetskaya archeologiya*, 1966, n. 1, pp. 317–322; Aleshkovskii, M.Ch. — Altshuller, B.L., "Blagoveshchenskii sobor, a ne pridel Vasiliya Kesariiskogo," in ibid., 1973, n. 2, pp. 88–89; Fedorov, V.I. — Shelyapina, N.S., "Drevneyshaya istoriya Blagoveshchenskogo sobora Moskovskogo Kremlya (Po materialam architekturno-archeologicheskich issledovanii)," in ibid., 1972, n. 4, pp. 223–234; [Fedorov, V.I., "Blagoveshchenskii sobor Moskovskogo Kremlya v svete issledovanii 1960–1972 gg.," in ibid., 1974, n. 2, pp. 112–129; Kuchkin, V.A., "K istorii kamennogo stroitelstva v Moskovskom Kremle v XV v.," in *Srednevekovaya Rus. Sbornik statey pamyati N.N. Voronima*, M. 1976, pp. 293–297; Sorokatyi, V.M., "Nekotorye nadgrobnye ikonostasy Archangelskogo sobora Moskovskogo Kremlya," in *Drevnerusskoe iskusstvo. Problemy i atributsii*, pp. 417–420; Altshuller, B, L., "Eshchyo raz k voprosu o drevneyshei istorii Blagoveshchenskogo sobora Moskovskogo Kremlya," in *Restavratsiya i issledovaniya pamyatnikov kultury*, II, M. 1982, pp. 28–30.

190 Mayasova, N.A., "K istorii ikonostasa Blagoveshchenskogo sobora Moskovskogo Kremlya," in *Kultura drevney Rusi. Sbornik statey k 40-letiyu nauchnoy deyatelnosti N.N. Voronina*, pp. 152–157.

191 Betin, L.V., "Istoricheskie osnovy drevnerusskogo vysokogo ikonostasa," in *Drevnerusskoe iskusstvo. Chudozhestvennaya kultura Moskvy i prilezhashchich k ney knyazhestv, XIV–XVI vv.*, pp. 57–72.

192 These were Basil the Great and John Chrysostom, not by chance often shown in the composition of the *Adoration of the Liturgical Sacrifice* (Melismoi). They also appear in the Serbian Church of Chilandari on Mount Athos, where they flank Christ the High Priest (Millet, G., *Broderies religieuses de style byzantin*, Paris 1947, pp. 76–78, pl. CLIX). Also indicative is the fact they appear in many Novgorodian royal doors.

193 Lazarev, V.N., *Andrey Rublyov i ego shkola*, M. 1966, p. 117. In Byzantium, there were *Deeses* with bust-length images of martyrs (George and Procopius on a long panel with a *Deesis* which formed part of the thirteenth-century church; see Sotiriou, G. and M., *Icônes du Mont Sinaï*, vol. I, pl. 117).

194 Uspenskii, L., "Vopros ikonostasa," in *Vestnik russkogo zapadno-evropeyskogo patriarshego ekzarchata*, n. 44, October-December 1963, p. 247. In this present study, we will often use this significant article, written by one of the foremost experts on Orthodox liturgy and iconography and also including bibliographical information. Concerning the latter, see also Lazarev, V.N., *Theophanes der Grieche und seine Schule*, p. 262 [Russian ed.: Lazarev. V.N., *Feofan Grek i ego shkola*, p. 93, note 1]. For the philosophical-conceptual foundations of the iconostasis, see Florenskii, P., "Ikonostas," in *Bogoslovskie trudy*, 9, M. 1972, pp. 83–148 [Italian ed.: *Le porte regali. Saggio sull'icona*, Milan 1977].

195 This probably appeared for the first time in Rublev's iconostasis for the Cathedral of the Dormition in Vladimir.

196 See Lazarev, V.N., "O metode raboty v rublyoskoy masterkoy," in *Doklady i soobshcheniya filologicheskogo fakulteta Moskovskogo universiteta*, 1, pp. 60–64 [new ed.: Lazarev, V.N., *Vizantiiskoe y drevnerusskoe iskusstvo. Stati i materialy*, pp. 205–210]. Lazarev, V.N., "Dionysii i ego shkola," in *Istoriya russkogo iskusstva*, t. III, p. 526.

197 Cf. the fifteenth-century *Deesis* from Novgorod in the Tretyakov Gallery: Antonova, V.I., — Mneva, N.E., *Katalog drevnerusskoy zhivopisi*, t. I, pls. 60–66, 78–79.

198 See Lazarev, V.N., *Theophanes der Grieche und seine Schule*, p. 98 [Russian ed.: Lazarev, V.N., *Feofan Grek i ego shkola*, p. 90, pls. 100, 101 and 96, 97]. Cf. Nikiforaki, N.A., "Opyt atributsii ikonostasa Blagoveshchenskogo sobora pri pomoshchi fizicheskich metodov issledovaniya," in *Kultura drevney Rusi. Sbornik statey k 40-letiyu nauchnoy deyatelnosti N.N. Voronina*, pp. 173–176. The study of the icons through the electronic-optic commutator of infrared rays has demonstrated that in a series of icons there is a change in the original design. These "amends" are especially evident in the head of the archangel Michael, where they may be the result of corrections by Theophanes himself.

199 Betin, L.V., "Ob architekturnoy kompositsii drevnerusskich vysokich ikonostasov," in *Drevnerusskoe iskusstvo. Chudozhestvennaya kultura Moskvy i prilezhashchich k ney knyazhestv. XIV–XVI vv.*, pp. 51–52; N.A. Mayasova supposes that the icons of Saint George and Saint Demetrius, in which the level of the ground is slightly higher, were located on lateral walls, "at an angle" (Mayasova, N.A., "K istorii ikonostasa Blagoveshchenskogo sobora Moskovskogo Kremlya," in *Kultura drevney Rusi. Sbornik statey k 40-letiyu nauchnoy deyatelnosti N.N. Voronina*, pp. 154–156). However, this is a sheer hypothesis, since we do not know the exact dimensions of the church for which the iconostasis was intended.

200 See Antonova, V.I. — Mneva, N.E., *Katalog drevnerusskoy zhivopisi*, t. I, n. 218, pp. 258–259, pls. 164–168; Lazarev, V.N., *Theophanes der Grieche und seine Schule*, pp. 110–111, pls. 162–166 [in the Russian ed.: Lazarev. V.N., *Feofan Grek i ego shkola*, pp. 103–111, pls. 120, 121; see also Goleyzovskii, N. — Yamshchikov, S., *Feofan Grek i ego shkola*, album,

M. 1970, pls. 13, 14; Salko, N.B., "Raskrytie 'Chetyredesyatnitsy'" in *Soobshcheniya Vsesoyuznoy tsentralnoy nauchno-issledovatelskoy laboratorii po konservatsii i restavratsii muzeynych chudozhestvennych tsennostey*, 30, pp. 116–125, sketches 1–8].

201 Migne, J., *Patrologia graeca*, t. 151, col. 444 B.

202 Ibid., col. 425 C.

203 Radojcic, S., "Zur Geschichte des silbergetriebenen Reliefs in der byzantinishchen Kunst," in *Tortulae. Studien zu altchristlichen und byzantinishchen Monumenten*, Rome-Fribourg-Vienna 1966 (="Römische Quartalschrift für christliche Alterumskunde und Kirchengeschichte," vol. 30, supplement, pp. 229–242) [see also the new Serbian ed. of this work: Radojcic, S., *Uzori i dela starih srpskih umetnika*, Belgrade 1975, pp. 53–72].

204 Tichomirov, M.N., "Andrey Rublyov i ego epocha," in *Voprosy istorii*, 1961, n. 1, pp. 7–8 [the same text in Tichomirov, M.N., *Russkaya kultura X–XVIII vv.*, M. 1968, pp. 211–212].

205 Plugin, V.A., "Nekotorye problemy izucheniya biografii i tvorchestva Andreya Rublyova," in *Drevnerusskoe iskusstvo. Chudozhestvennaya kultura Moskvy i prilezhashchich k ney knyazhestv. XIV–XVI vv.*, pp. 73–86 [same text in: Plugin, V.A., *Mirovozzrenie Andreya Rublyova (Nekotorye problemy). Drevnerusskaya zhivopis kak istoricheskii istochnik*, M. 1974, pp. 10–27].

206 Golubinskii, E., *Prepodobnyi Sergii Radonezhskii i sozdannaya im Troitskaya lavra*, 2nd ed., M. 1909, pp. 96–106; Klyuchevskii, V.O., "Znachenie prepodobnogo Sergiya dlya russkogo naroda i gosudarstva," in Klyuchevskii, V.O., *Ocherki i rechi*, 2, Pg. 1913, pp. 194–209.

207 *Zhitie prepodobnogo i bogonosnogo ottsa nashego Sergiya chudotvortsa i pochvalnoe slovo emu, napisannye uchenikom ego Epifaniem Premudrym v XV veke. Soobshchil archim. Leonid*, Spb. 1885 (in the series 'Pamyatniki drevney pismennosti," LVIII), pp. 17, 28.

208 Sacharov, I., *Issledovaniya o russkom ikonopisanii*, vol. 2, Spb. 1849, appendix, p. 14. In the source of the seventeenth-century *Skazanie o svyatych ikonopistsach*, it is said that Rublev painted the icon of the Trinity at the request of Nikon "in honor of his saintly father Sergius Thaumaturgos."

209 Priselkov, M.D., *Troitskaya letopis. Rekonstruktsiya teksta*, p. 466.

210 *Poln. sobr. russkich letopisey*, t. VI, p. 138.

211 See note 208.

212 Lazarev, V.N., *Andrey Rublyov i ego shkola*, p. 76.

213 Tichomirov, M.N., "Andrey Rublyov i ego shkola," in *Voprosy istorii*, 1961, n. 1, p. 16 [the same text in Tichomirov, M.N., *Russkaya kultura X–XVIII vv.*, p. 224].

214 Lazarev, V.N., *Andrey Rublyov i ego shkola*, p. 69.

215 Lazarev, V.N., *Theophanes der Grieche und seine Schule*, pp. 75–93 (with bibliographical information [in the Russian ed.: Lazarev, V.N. *Feofan Grek i ego shokla*, pp. 75–82; see also: Popova, O., *Les miniatures russes du XIe au XVe siècle*, pp. 138–152]. Cf. Alpatov, M.V., *Andrey Rublyov*, M. 1959, pp. 13–14; Id., *Andrey Rublyov*, M. 1972, pp. 38–42; [Vzdornov, G.I., *Iskusstvo knigi v Drevney Rusi. Rukopisnaya kniga Severo-Vostochnoy Rusi XII — nachala XV vekov*, pp.105–109. Description of the manuscript, n. 58 (with bibliographical information)]. There is no reason to attribute the entire manuscript to Rublev, as M.V. Alpatov, who does not distinguish the hand of individual miniature painters, has done.

216 See Lazarev, V.N., *Old Russian Murals and Mosaics*, pp. 182–183, pl. 151 [the same text in the Russian ed.: Lazarev, V.N., *Drevnerusskie mozaiki i freski, XI–XV vv.*, pp. 71–72, pls. 393, 394].

217 Grabar, Igor, "Andrey Rublyov, Ocherk tvorchestva chudoznika po dannym restavratsionnych rabot 1918–1925 gg.," in *Voprosy restavratsii*, I, p. 83 [the same text in: Grabar, Igor, *O drevnerusskom iskusstve*, p. 180].

218 Priselkov, M.D., *Troitskaya letopis. Rekonstruktsiya teksta*, pp. 445, 450.

219 Wood, egg tempera, 45x35 cm. From the Monastery of the Trinity of Saint Sergius. In good condition. Partial lacunae in the *levkas* of the cornice. There are many traces of a nailed covering on the gold background and the border scenes. The icon was probably imported from Constantinople, as suggested by its elegant design, extraordinarily rhythmical composition, and refined coloring. As a matter of fact, it is quite unlikely that even the most gifted Muscovite master could have assimilated the Greek iconographic language so systematically. But there was much to learn from icons of this type, which must have been frequently found in the Moscow of the fourteenth century. And Rublev understood this better than anyone else. Cf. the Greek icons from the fourteenth century in the National Museum of Ochrid and the Art Gallery of Skopje (Radojcic, S., *Icônes de Serbie et de Macédoine*, Belgrade 1961, ill. on pp. 18, 19, 21, 23, 64). Belonging to this group of icons, we also have the icon of the *Annunciation* from the register of the *Feasts* from the Cathedral of the Annunciation. See Alpatov, M. "Eine Verkündigungsikone aus der Paläologenepoche in Moskau," in *Bizantinische Zeitschrift*, vol. XXV, 1925, pp. 347–357; Ainalov, D., *Geschichte der russischen Monumentalkunst zur Zeit des Grossfürstentums Moskau*, pp. 92–93; SSSR. *Drevnye russkie ikony*, New York-Milan 1958 (in the UNESCO series "Universal Art") p. 26, pl. XX; Onasch, K., *Ikonen*, pl. 81, p. 383; Lazarev, V., *Storia della pittura bizantina*, pp. 375, 418; [Alpatov, M.V., *Drevnerusskaya ikonopis*, M. 1974, pl. 9, p. 293].

220 Cf. Ilin, M.A., "Ikonostas Uspenskogo sobora vo Vladimire Andreya Rublyova," in *Drevnerusskoe iskusstvo. Chudozhestvennaya kultura Moskvy i prilezhashchich k ney knyazhestv. XIV–XVI vv.*, pp. 29–33.

221 Ibid., p. 32. The oldest iconostases did not have such a large number of *Feasts*.

222 See Demina, N.A., "Cherty geroicheskoy deystvitelnosti XIV–XV vekov v obrazach lyudey Andreya Rublyova i chudozhnikov ego kruga," in *Trudy otdela drevnerusskoy literatury Instituta russkoy literatury (Pushkinskii dom) Akademii nauk SSSR*, XII, M.-L. 1956, p. 319 [see also Demina, N.A., "Istoricheskaya deystvitelnost XIV–XV vv. v iskusstve Andreya Rublyova i chudozhnikov ego kruga," in Demina, N.A., *Andreya Rublyova i chudozhnikov ego kruga*, M. 1972, pp. 37–38].

223 Vzdornov, G.I., "Novootkrytaya ikona Troitsy iz Troitse-Sergievoy lavry i 'Troitsa' Andreya Rublyova," in *Drevnerusskoe iskusstvo. Chudozhestvennaya kultura Moskvy i prilezhashchich k ney knyazhestv. XIV–XVI vv.*, pp. 153–154.

224 Klibanov, A.I., *Reformatsionnye dvizheniya v Rossii v XIV — pervoy polovine XVI vv.*, M. 1960, pp. 160–166, 173–176; Onasch, K., "Andrey Rublyov. Bizantinisches Erbe in russischer Gestalt," in *Akten des XI. internationalen Byzantinistenkongresses, München 1958*, Munich 1960, pp. 427–429; Lazarev, V.N., *Andrey Rublyov i ego shkola*, pp. 34–35; Vzdornov, G.I., "Novootkrytaya ikona Troitsy iz Troitse-Sergievoy lavry i 'Troitsa' Andreya Rublyova," in *Drevnerusskoe iskusstvo. Chudozhestvennaya kultura Moskvy i prilezhashchich k ney knyazhestv. XIV–XVI vv.*, pp. 151–152.

225 Cf. Ainalov, D.V., *Istoriya russkoy zhivopisi s XVI po XIX stoletie*, 1st ed., Spb. 1913, pp. 16–18; Sychev, N., "Ikona sv. Troitsy v Troitse-Sergievoy lavre," in *Zapiski otdeleniya russkoy i slavyanskoy archeologii imp. Russkogo Archeologicheskogo obshchestva*, t. X., Pg. 1915, pp. 58–76; Punin, N., "Andrey Rublyov," in *Apollon*, 1915, n. 2, pp. 18, 22, 23; Millet, G. *Recherches sur l'iconographie de l'Evangile. . .*, p. 681; Marle, R. van, *The Development of the Italian Schools of Painting*, II, The Hague 1924, p. 67. A.N. Grabar (Grabar, A., *L'art du Moyen Age en Europe Orientale*, pp. 203–204) is the only contemporary author who maintains this rather obsolete point of view.

226 Cf. the icons of the *Trinity* in the Benaki Museum of Athens (*Frühe Ikonen*, pls. 78, 79), in the Hermitage (Lazarev, V.N., *Storia della pittura bizantina*, pl. 351), the miniature in the *cod. Paris gr. 1242*, f. 123 v. (ibid., pl. 541), the *panagia* in the Carrand collection of the National Museum of the Bargello of Florence (*The Burlington Magazine*, LXXI, 1937, p. 256, pl. IVD).

227 In the interpretation of the overall concept of the *Trinity* and in its artistic analysis, I have based my remarks mostly on N.A. Demina's study which is dedicated to Rublev's icon (Demina, N.A., *"Troitsa" Andreya Rublyova*, M. 1963). However, in the interpretation of the individual Persons of the Trinity, my viewpoint is substantially different from the one presented by Demina, who identifies the central figure with God the Father.

228 Concerning the interpretation of this figure and the discordant opinions formed about this problem, see Lazarev, V.N., *Andrey Rublyov i ego shkola*, note 78 on pp. 61–62; Vzdornov, G.I., "Novootkrytaya ikona Troitsy iz Troitse-Sergievoy lavry i 'Troitsa' Andreya Rublyova," in *Drevnerusskoe iskusstvo. Chudozhestvennaya kultura Moskvy i prilezhashchich k ney knyazhestv. XIV–XVI vv.*, pp. 147–148; [Uspenskii, L., "Bolshoy Moskovskii sobor i obraz Boga-ottsa," in *Vestnik russkogo zapadnoevropeyskogo patriarshego ekzarchata*, n. 78–79, April-September 1972, note 73 on pp. 167–168. The various interpretations of this figure are exhaustively presented in the essays and bibliography compiled in the volume: *Troitsa Andreya Rublyova. Antologiya*, ed. G.I. Vzdornov, M. 1981]. Christ is identified by the clavus on the right sleeve of the chiton. It is not clear if originally there was a halo with a cross.

229 *Ioanna, igumena Sinayskoy gory, Lestvitsa*, Monastery of the Trinity of Saint Sergius 1898, discourse 30, p. 246.

230 Losskii, V., "Otritsatelnoe bogoslovie v uchenni Dionisiya Areopagita," in *Seminarium Kondakovianum*, III, Prague 1929, p. 142.

231 Demina, N., *'Troitsa' Andreya Rublyova*, pp. 71–72.

232 Ibid., p. 73.

233 See note 210.

234 Cf. Alpatov, M., "La valeur classique de Roublëv." in *Commentari*, 1958, n. 1, pp. 25–37 [see Russian ed.: Alpatov, M.V., "Klassicheskaya osnova iskusstva Rublyova," in Alpatov, M.V., *Etyudy po istorii russkogo iskusstva*, 1, pp. 112–118, pls. 75–89]. In this article, the author presents analogies with ancient art interpreted in such a subjective manner that they do not provide any useful features for explaining the problem touched upon by the author.

235 See Antonova, V.I. — Mneva, N.E., *Katalog drevnerusskoy zhivopisi*, t. I, n. 212, pp. 248–249, pls. 160, 161. The icon, from Kolomna, was not painted before the fifteenth century.

236 See *Troitse-Sergieva lavra. Chudozhestvennye pamyatniki*, p. 76, pl. 66; Nikolaeva, T.V., *Sobranie drevnerusskogo iskusstva v Zagorskom muzee*, L. 1968, p. 32, pl. 5; [Id., *Drevnerusskaya zhivopis Zagorskogo muzeya*,

p. 32, catalogue, n. 100, ill.]. Very early copy of the *Virgin of the Don* from the juncture spanning the fourteenth and fifteenth centuries.

237 See *Troitse-Sergieva lavra. Chudozhestvennye pamyatniki*, p. 60, pls. 59, 60 (with an erroneous attribution of this icon to the Pskov school). Late fourteenth — early fifteenth century (cf. note 172].

238 Anisimov, A.I., *Vladimirskaya ikona Bozhiey Materi*, pp. 18–24.

239 Antonova, V.I., "Ranne proizvedenie Andreya Rublyova v Moskovskom Kremle," in *Kultura drevney Rusi. Sbornik statey k 40-letiyu nauchnoy deyatelnosti N.N. Voronina*, pp. 21–25.

240 *Hypatius Chronicle, Year 6619 (1111)*, in [*Poln. sobr. russkich letopisey.*, t. 11, Spb. 1845, pp. 375, 377].

241 Tichomirova, K.G., "Geroicheskoe skazanie v drevnerusskoy zhivopisi," in *Drevnerusskoe iskusstvo. Chudozhestvennaya kultura Moskvy i prilezhashchich k ney knyazhestv. XIV–XVI vv.*, pp. 8–17.

242 Ibid., pp. 24–28.

243 Ibid., p. 10.

244 See *Troitse-Sergieva lavra. Chudozhestvennye pamyatniki*, p. 93, pl. 106; Nikolaeva, T.V., *Sobranie drevnerusskogo iskusstva v Zagorskom muzee*, p. 58, pl. 26; [Id., *Drevnerusskaya zhivopis Zagorskogo muzeya*, p. 34, catalogue, n. 106, ill.].

245 *Russkaya istoricheskaya biblioteka*, t. IV, *Pamyatniki drevnerusskogo kanonicheskogo prava*, pt. 1 (pamyatniki XI–XV vv.), Spb. 1880, n. 118 (1492 declaration by Metropolitan Zosimus on the *Festive Letter* for the eighth millenium), col. 799.

246 See *Chudozhestvennye pamyatniki Moskovskogo Kremlya*, M. 1956, pl. 53; Popov, G.V., *Zhivopis i miniatura Moskvy serediny XV — nachala XVI veka*, M. 1975, pp. 54–56, pls. 58–61.

247 See Popov, G.V., *Zhivopis i miniatura Moskvy serediny XV — nachala XVI veka*, p. 57, pls. 62–67.

248 See Alpatov, M.V., *Pamyatnik drevnerusskaya zhivopisi kontsa XV veka. Ikona "Apokalipsis" Uspenskogo sobora Moskovskogo Kremlya*, M. 1964; Popov, G.V., *Zhivopis i miniatura Moskvy serediny XV — nachala XVI veka*, pp. 64–66, pls. 94–97; [Christe, Y., "Quelques remarques sur l'icône de l'Apocalypse du maître du Kremlin à Moscou," in *Zograf*, 6, Belgrade 1976, pp. 59–67].

249 Kadlubovskii, A.P., "Zhitie Pafnutiya Borovskogo, pisannoe Vassianom Saninym," in *Sbornik Istoriko-filologicheskogo obshchestva pri Institute knyazya Bezborodko v Nezhine*, II, Nezhin 1899, p. 125.

250 Antonova, V.I., "U Medvezhya ozera i v Vesi Egonskoy," in *Trudy otdela drevnerusskoy literatury Instituta russkoy literatury (Pushkinskii dom) Akademii nauk SSSR*, XXII, pp. 189–194; Florya, B.N., "Moskovskii ikonopisets serediny XV v. Mitrofan po dannym pismennych istochnikov," in *Kultura drevney Rusi. Sbornik statey k 40-letiyu nauchnoy deyatelnosti N.N. Voronina*, pp. 278–280.

251 "Pamyatniki drevnerusskoy duchovnoy pismennosti. Skazaniya Paisiya Yaroslavova (XV sec.)" in *Pravoslavnyi sobesednik*, February 1861, p. 212.

252 *Lvov Chronicle, Year 6989 (1481)*, in [*Poln. sobr. russkich letopisey*, t. XX, first half, Spb. 1910, p. 347].

253 Zimin, A.A., "Kratkie letopistsy XV–XVI vv.," in *Istoricheskii archiv*, t. V, M.-L. 1950, pp. 15–16.

254 The date of the inscription in the church, deciphered at the time by K.K. Romanov as August 6, 1500 — September 8, 1502, is now read

as August 6, 1502 — September 8, 1503, after the study of N.K. Goleyzovskii [Goleyzovskii, N.K., "Zametki o Dionysii," in *Vizantiiskii vremennik*, 31, M. 1971, pp. 176–177]. On the icons from the Church of the Theophany, see: Popov, G.V., *Zhivopis i miniatura Moskvy serediny XV — nachala XVI veka*, p. 76 and note 119, p. 131.

255 *Nila Sorskogo Predanie i Ustav*, introductory essay by M.S. Borovkova-Maykova, Spb. 1912 (in the series "Pamyatniki drevney pismennosti i iskusstva," CLXXIX), pp. 8, 9, 47.

256 Georgievskii, V.T., *Freski Ferapontanova monastyrya*, Spb. 1911, appendix, pp. 1–8.

257 Yamshchikov, S.V., *Drevnerusskaya zhivopis. Novye otkrytiya*, album, pls. 18–21; [Goleyzovskii, N.K. — Ovchinnikov, A.N. - Yamshchikov, S.V., *Sokrovishcha Suzdalya*, pp. 154–172]; Yamshchikov, S.V., *Suzdal. Muzey*, unnumbered (the icon of the *Virgin of Mercy* from the Monastery of Mercy, text by A.N. Ovchinnikov); Antonova, V.I., "Zametki o rostovo-suzdalskoy shkole zhivopisi," in *Rostovo-suzdalskaya shkola zhivopisi*, [catalogue], p. 12. Cf. the reliable interpretation of the problem by G.V. Popov (*Zhivopis i miniatura Moskvy serediny XV — nachala XVI veka*, pp. 87–88).

258 *Lvov Chronicle, Year 6990 (1482)*, in [*Poln. sobr. russkich letopisey*, t. XX, first half, p. 348].

259 *Nikon Chronicle, Year 6889 (1381)*, in [*Poln. sobr. russkich letopisey*, t. XI, first half, Spb. 1898, p. 70]. Cf. Golubinskii, E.E., *Istoriya russkoy tserkvi*, t. II, second half of the volume, M. 1911 (on the cover: 1917), p. 606.

260 See Antonova, V.I. — Mneva, N.E., *Katalog drevnerusskoy zhivopisi*, t. I, n. 221, pp. 262–263, pl. 172; Bank, V.A., *Vizantiiskoe iskusstvo v sobraniyach Sovetskogo Soyuza*, L. 1967, pl. 244, annotation on p. 321.

261 See *Troitse-Sergieva lavra. Chudozhestvennye pamyatniki*, p. 94, pl. 107; [Nikolaeva, T.V., *Drevnerusskaya zhivopis Zagorskogo muzeya*, pp. 26, 30, catalogue, n. 69, ill.].

262 See Ivanova, I.A., *Muzey drevnerusskogo iskusstva imeni Andreya Rublyova*, album, M. 1968, pls. 53–56.

263 See Antonova, V.I. — Mneva, N.E., *Katalog drevnerusskoy zhivopisi*, t. I, n. 284, pp. 346–347, pls. 230–231.

264 See ibid., n. 212, pp. 248–249, pls. 160, 161.

265 Laurina, V.K., "Vnov raskrytaya ikona 'Soshestvie vo ad' iz Ferapontova monastyrya i moskovskaya literatura kontsa XV v.," in *Trudy otdela drevnerusskoy literatury Instituta russkoy literatury (Pushkinskii dom) Akademii nauk SSSR*, XXII, pp. 174–176.

266 See Ivanova, I.A., *Muzey drevnerusskogo iskusstva imeni Andreya Rublyova*, album, pls. 19–27; Popov, G.V., *Zhivopis i miniatura Moskvy serediny XV — nachala XVI veka*, pp. 92–96, pls. 131–136 (with a date which is too early in the 1480s [1490]).

267 *Stoglav*, Spb. 1863, p. 12.

268 See bibliography given in note 16.

269 See Antonova, V.I., "O pervonachalnom meste 'Troitsy' Andreya Rublyova," in *Gos. Tretyakovskaya galereya. Materialy i issledovaniya*, I, M. 1956, pp. 25–27 and pls.; Antonova, V.I. — Mneva, N.E., *Katalog drevnerusskoy zhivopisi*, t. I, n. 166, pp. 207–208; Rozanova, N.V., *Rostovo-suzdalskaya zhivopis XII–XVI vekov*, album, pls. 28, 29. From the Church of Saints Cosmas and Damian in Rostov, built on the site where originally rose a church dedicated to the life-giving Trinity (known by 1207).

270 See Antonova, V.I. — Mneva, N.E., *Katalog drevnerusskoy zhivopisi*, t. I, n. 180, pp. 221–222, pl. 131.

271 See ibid., n. 188, pp. 226–227; [*Zhivopis Rostova Velikogo*, catalogue, ed. S. Yamshchikov, unnumbered, pls. 7–13].

272 Antonova, V.I. — Mneva, N.E., *Katalog drevnerusskoy zhivopisi*, t. I, n. 193, pp. 229–230, pl. 134.

273 "Zametki o rostovo-suzdalskoy shkole zhivopisi," in *Rostovo-suzdalskaya zhivopisi*, [catalogue], p. 12.

274 Cf. Vzdornov, G.I., "O zhivopisi Severo-Vostochnoy Rusi XII–XVI vekov," in *Iskusstvo*, 1969, n. 10, p. 60.

275 See bibliography given in note 16.

276 Goleyzovskii, N. — Ovchinnikov, A. — Yamshchikov, S., *Sokrovishcha Suzadlya*, pp. 155–175.

277 Vzdornov, G.I., "O zhivopisi Severo-Vostochnoy Rusi XII–XVI vekov," in *Iskusstvo*, 1969, n. 10, p. 60.

278 See Rozanova, N.V., *Rostovo-suzdalskaya zhivopis XII–XVI vekov*, album, pl. 46.

279 Goleyzovskii, N. — Ovchinnikov, A. — Yamshchikov, S., *Sokrovishcha Suzadlya*, p. 107.

280 See ibid., ill. on pp. 42, 43, 46, and 47.

281 See ibid., ill. on pp. 30, 31, and 33.

282 See ibid., ill. on pp. 37–39.

283 See bibliography given in note 14.

284 See Mneva, N.E., "Drevnerusskaya zhivopis Nizhnego Novgoroda," in *Gos. Tretyakovskaya galereya. Materialy i issledovaniya*, II, pp. 32–34, pls. III–VII; Rozanova, N.V., *Rostovo-suzdalskaya zhivopis XII–XVI vekov*, album, pls. 86, 87, 89, 90.

285 Mneva, N.E., *Drevnerusskaya zhivopis Nizhnego Novgoroda*, p. 34.

286 See bibliography given in note 15.

287 See Antonova, V.I. — Mneva, N.E., *Katalog drevnerusskoy zhivopisi*, t. I, n. 197, p. 232, pls. 135, 136; Evseeva, L.M. — Kochetkov, I.A. — Sergeev, V.N., *Zhivopis drevney Tveri*, pls. 6, 7; [Popov, G.V. — Ryndina, A.V., *Zhivopis i prikladnoe iskusstvo Tveri. XIV–XVI veka*, M. 1979, pp. 41–48, catalogue, n. 1, ill. on p. 376].

288 Turyn, A., *Codices graeci Vaticani saeculis XIII et XIV scripti annorumque notis instructi*, Vatican City 1964, pp. 113–114, pl. 188. In this manuscript, which includes the Jerusalem Rule and was written by the hieromonk Nil in Tver in the years 1317–1318, Theodorus of Jerusalem, John of Constantinople, and Thomas of Syria are mentioned (the last was the person commissioning the manuscript). As is known, John was the confessor of Prince Michail Yaroslavich of Tver. Cf. Popov, G.V., "Puti razvitiya tverskogo iskusstva v XIV — nachale XVI veka (zhivopis, miniatyura)," in *Drevnerusskoe iskusstvo. Chudozhestvennaya kultura Moskvy i prilezhashchich k ney knyazhestv. XIV–XVI vv.*, note 22 on p. 316.

289 *Poln. sobr. russkich letopisey*, t. XV, 1, *Rogozhskii letopisets*, Pg. 1922, col. 168–172. The processional icon painted on both sides (*Virgin Hodegetria* and *Saint Nicholas the Wonderworker*), preserved in the Andrei Rublev Museum of Early Russian Art, is probably a Greek (or Serbian) work from the late fourteenth century. The icon was rediscovered in the Vasilevskii village church in the region of Staritsa. Without sufficient grounds, G.V. Popov considers it to be the work of a Russian master. See Popov, G.V., "O chudozhestvennych svyazach Tveri s Afonom (vynosnaya ikona pervoy chetverti XV veka tverskogo proischozhdeniya),"

in *Starinar*, XX, (1969), Belgrade 1970, pp. 315–322; [cf. also: Evseeva, L.M. — Kochetkov, I.A. — Sergeev, V.N., *Zhivopis drevney Tveri*, pp. 20–21, pls. 13, 14; Popov, G.V. — Ryndina, A.V., *Zhivopis i prikladnoe iskusstvo Tveri. XIV–XVI veka*, pp. 113–120, catalogue, n. 5, ill. on pp. 380–382].

290 See Popov, G.I., "Puti razvitiya tverskogo iskusstva v XIV — nachale XVI veka (zhivopis, miniatyura)," in *Drevnerusskoe iskusstvo. Chudozhestvennaya kultura Moskvy i prilezhashchich k ney knyazhestv. XIV–XVI vv.*, pp. 326–328, ill. on p. 318; [Evseeva, L.M. — Kochetkov, I.A. — Sergeev, V.N., *Zhivopis drevney Tveri*, pp. 37–38, pls. 51–52; Popov, G.V. — Ryndina, A.V., *Zhivopis i prikladnoe iskusstvo Tveri. XIV–XVI veka*, pp. 177–186, catalogue, n. 19, ill. on pp. 436–437]. The archangel Gabriel is shown in the upper part in a gesture of blessing; in the lower part, the evangelists John, with Prochor, and Luke, with the divine Sophia, (a rather unusual motif for the royal doors).

291 See Antonova, V.I. — Mneva, N.E., *Katalog drevnerusskoy zhivopisi*, t. I, n. 203, pp. 237–238, pls. 142–146; Popov, G.V., "Puti razvitiya tverskogo iskusstva v XIV — nachale XVI veka (zhivopis, miniatyura)," in *Drevnerusskoe iskusstvo. Chudozhestvennaya kultura Moskvy i prilezhashchich k ney knyazhestv. XIV–XVI vv.*, p. 324, ill. on p. 319; [Evseeva, L.M. — Kochetkov, I.A. — Sergeev, V.N., *Zhivopis drevney Tveri*, pp. 29–31, pls. 30–41; Popov, G.V. — Ryndina, A.V., *Zhivopis i prikladnoe iskusstvo Tveri. XIV–XVI veka*, pp. 135–141, catalogue, n. 10, ill. on pp.

389–395]. The figure of Alexander of Thessalonica, part of the *Deesis*, must have recalled one of the most popular princes of Tver, Alexander Michailovich, killed in the territories by the Golden Horde in 1338.

292 See Popov, G.V., "Puti razvitiya tverskogo iskusstva v XIV — nachale XVI veka (zhivopis, miniatyura)," pp. 336, 338, ill. on p. 337; [Evseeva, L.M. — Kochetkov, I.A. — Sergeev, V.N., *Zhivopis drevney Tveri*, pp. 26–27, pls. 24, 25; Popov, G.V. — Ryndina, A.V., *Zhivopis i prikladnoe iskusstvo Tveri. XIV–XVI veka*, pp. 141–145, ill. on p. 142].

293 See *SSSR. Drevnye russkie ikony*, pl. XVI; Antonova, V.I. — Mneva, N.E., *Katalog drevnerusskoy zhivopisi*, t. I, n. 201, pp. 235–236, pls. 140, 141; Popov, G.V., "Puti razvitiya tverskogo iskusstva v XIV — nachale XVI veka (zhivopis, miniatyura)," pp. 340, 342, ill. on p. 343; [Evseeva, L.M. — Kochetkov, I.A. — Sergeev, V.N., *Zhivopis drevney Tveri*, pp. 28–29, pls. 26–29; Popov, G.V. — Ryndina, A.V., *Zhivopis i prikladnoe iskusstvo Tveri. XIV–XVI veka*, pp. 189–194, catalogue, n. 22, ill. on pp. 440 and 441]. The *Dormition* was attributed to the school of Tver for the first time by N.E. Mneva. In my opinion, this attribution, like the early dating of the icon (first quarter of the fifteenth century), appears very dubious after the change of the date of the *Dormition* from the Monastery of Saint Cyril of Belozersk (Tretyakov Gallery) [see Lelekova, O.V., *O sostave ikonostasa Uskpenskogo sobora Kirillo-Belozerskogo monastyrya*, pp. 96–97]. It is easier to consider it a Muscovite work from the second half of the fifteenth century.

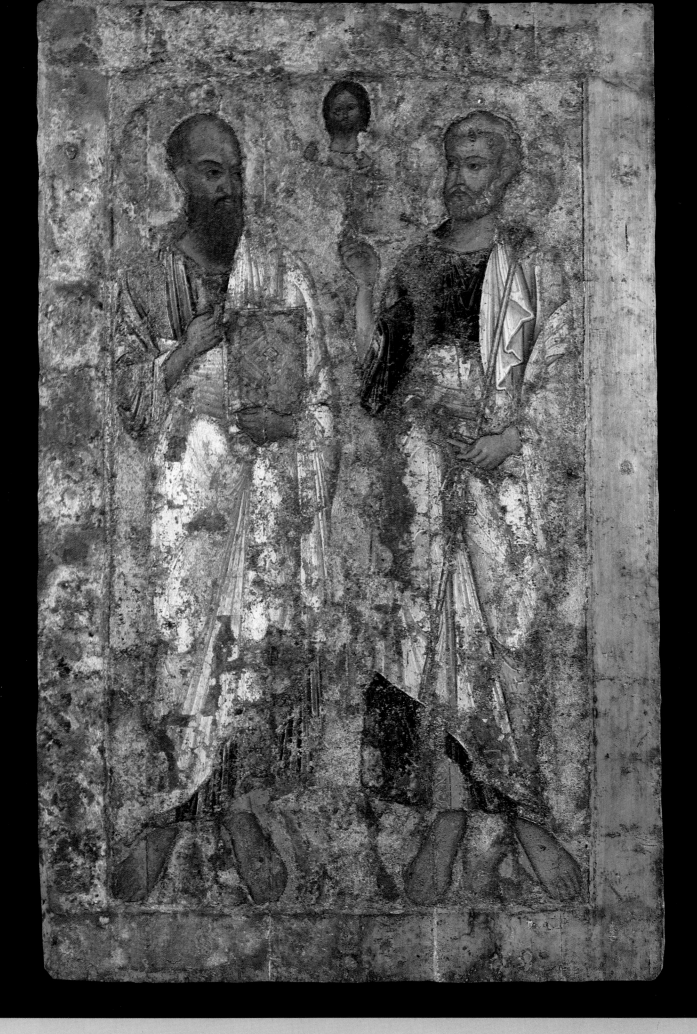

THE APOSTLES PETER AND PAUL
MUSEUM OF HISTORY AND ARCHITECTURE, NOVGOROD

MID
11TH CENTURY

1

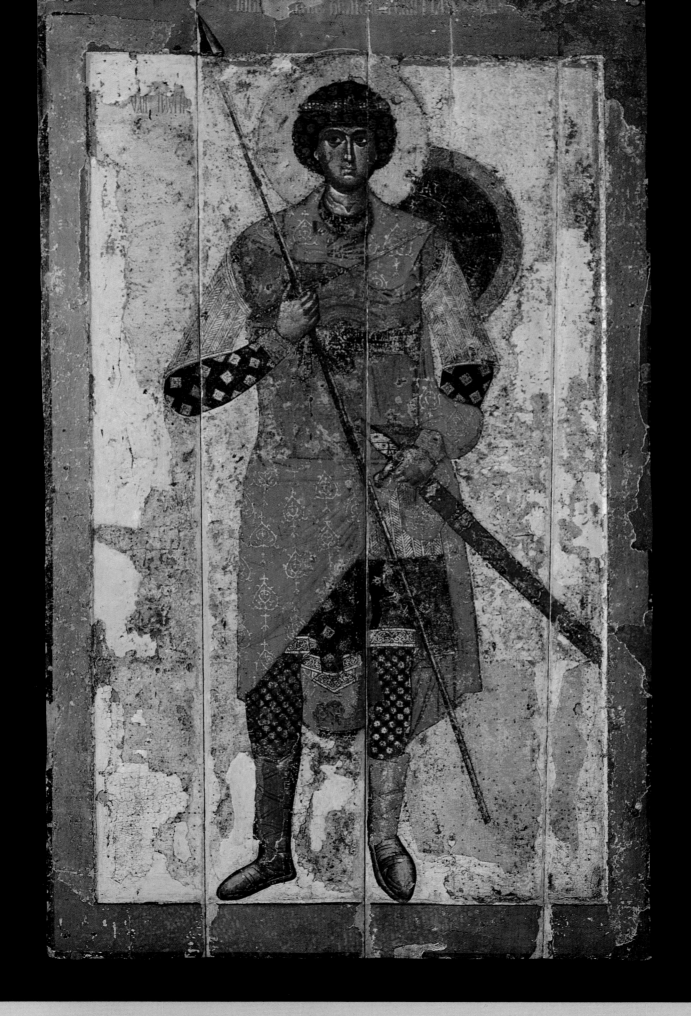

SAINT GEORGE
TRETYAKOV GALLERY, MOSCOW

1130s–1140s 2

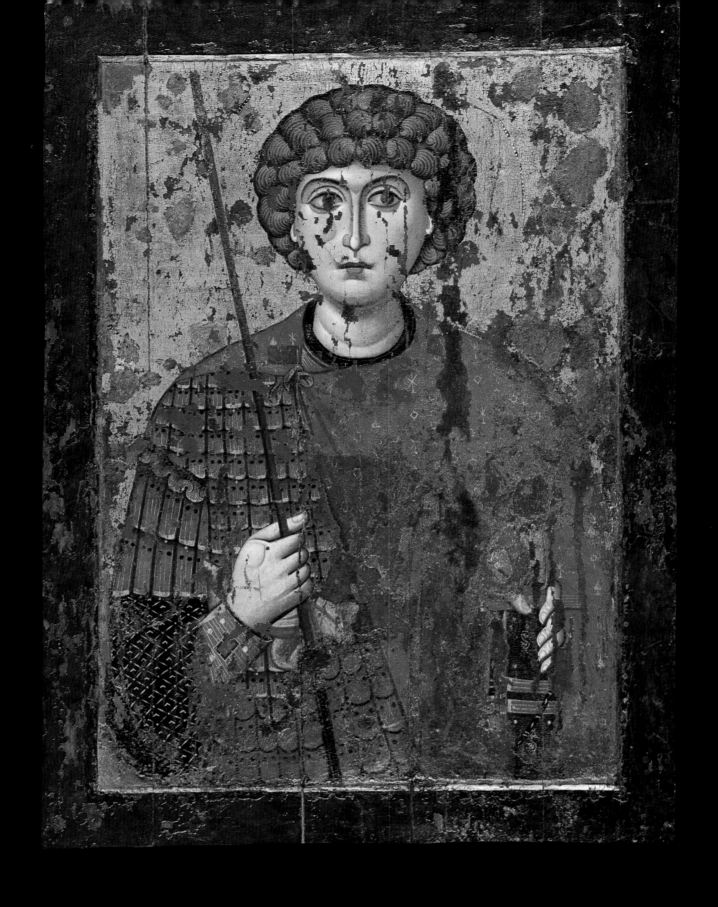

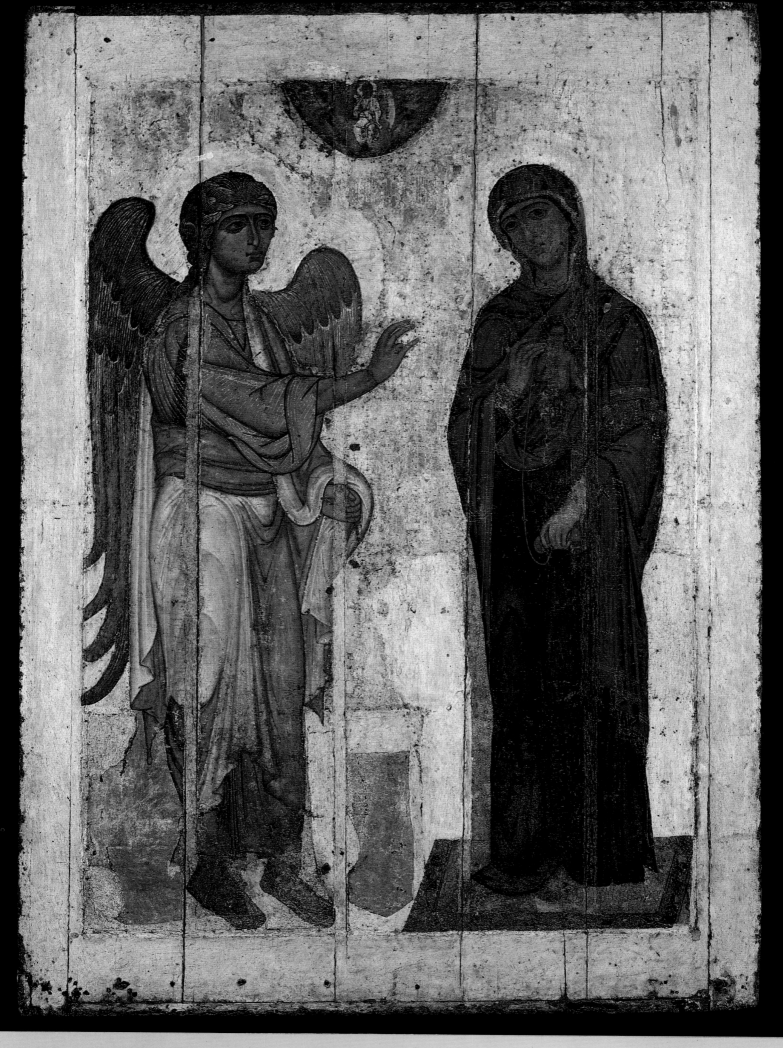

THE USTYUG ANNUNCIATION
TRETYAKOV GALLERY, MOSCOW

SECOND HALF
OF 12TH CENTURY 4

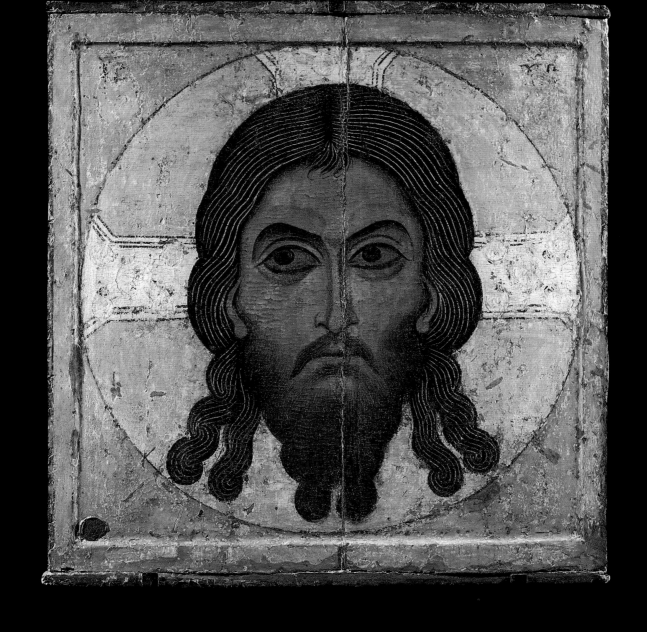

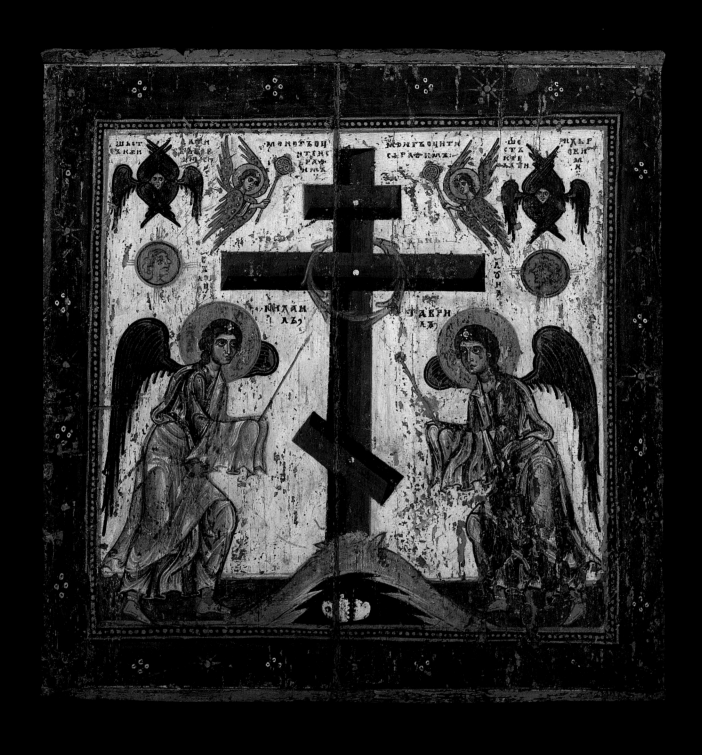

VERSO: ADORATION OF THE CROSS
TRETYAKOV GALLERY, MOSCOW

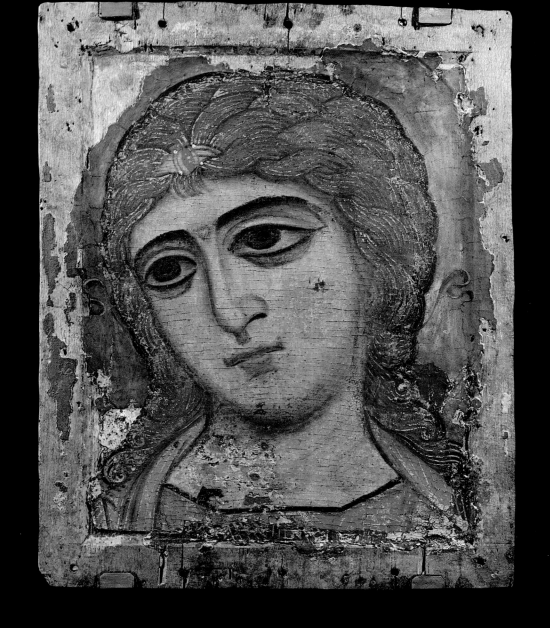

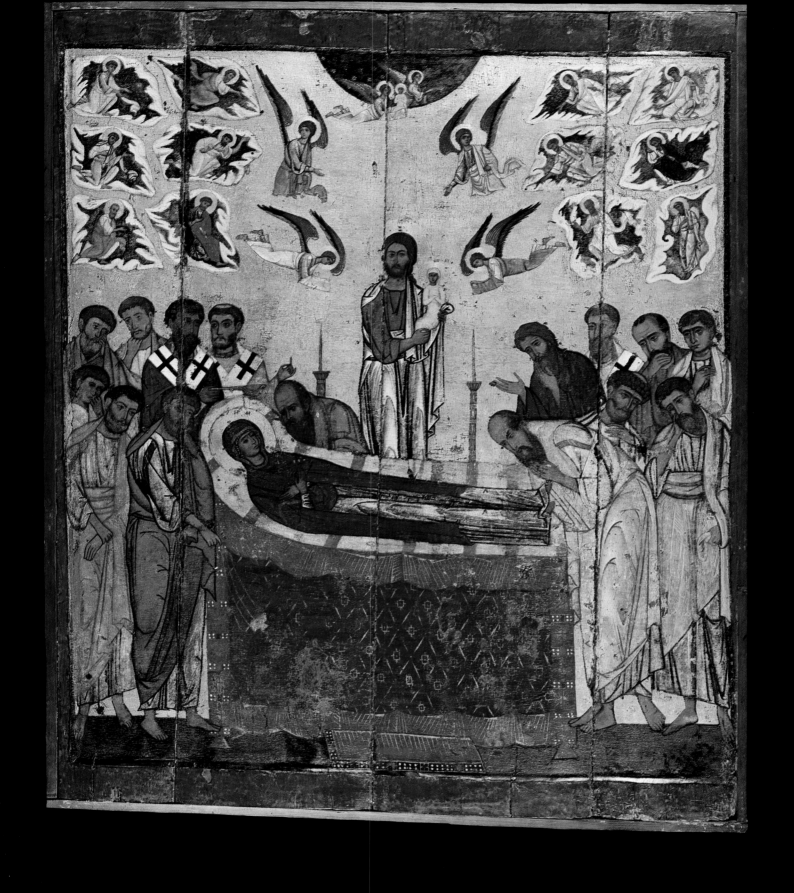

THE DORMITION
TRETYAKOV GALLERY, MOSCOW

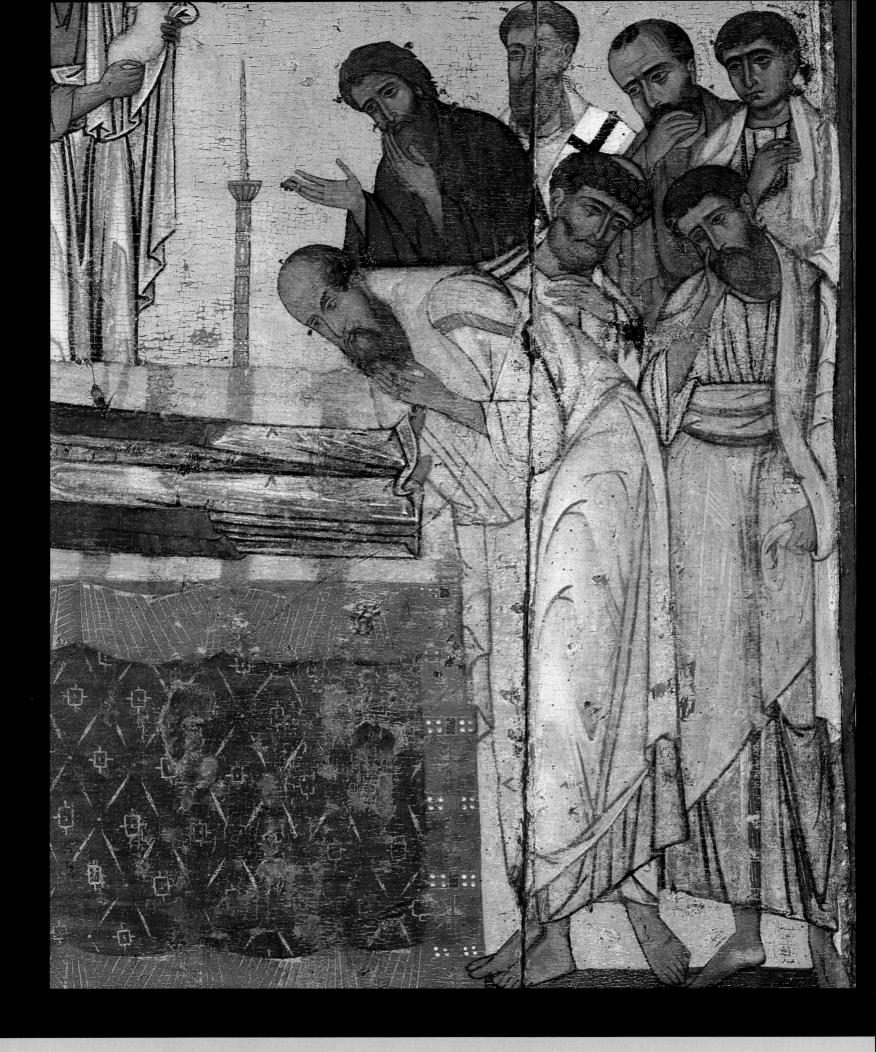

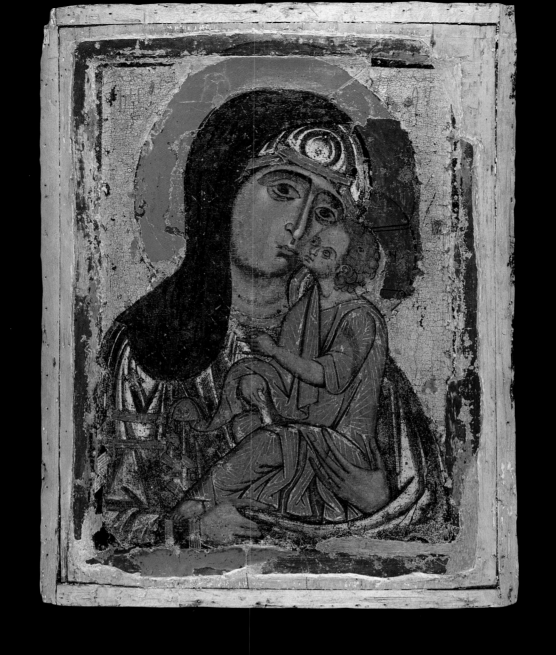

THE VIRGIN OF TENDERNESS
CATHEDRAL OF THE DORMITION, KREMLIN, MOSCOW

EARLY
13TH CENTURY 8

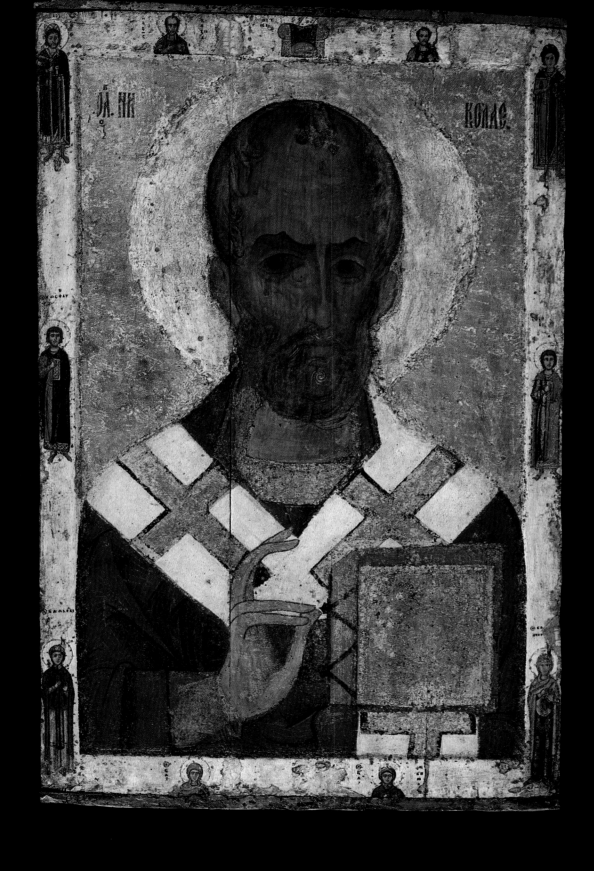

SAINT NICHOLAS THE WONDERWORKER
TRETYAKOV GALLERY, MOSCOW

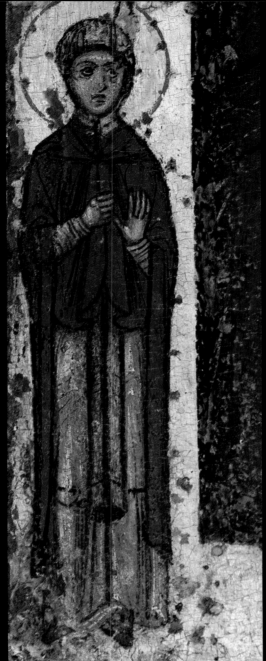
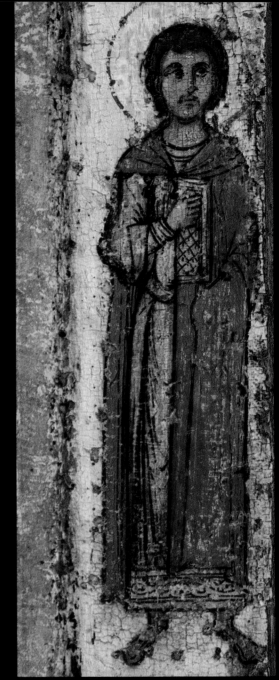
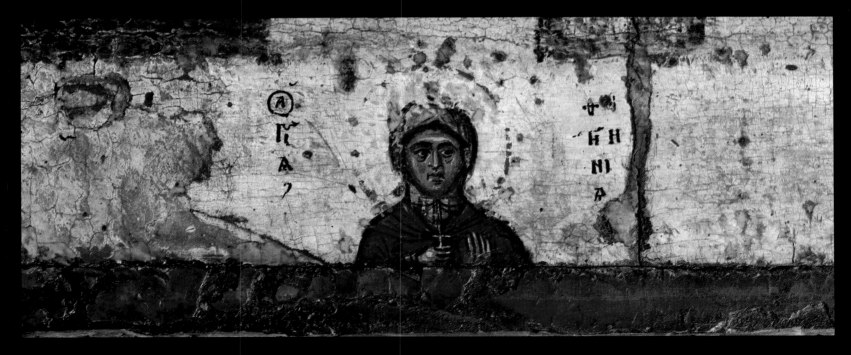

SAINT NICHOLAS THE WONDERWORKER (DETAILS)
TRETYAKOV GALLERY, MOSCOW

EARLY
13TH CENTURY 9

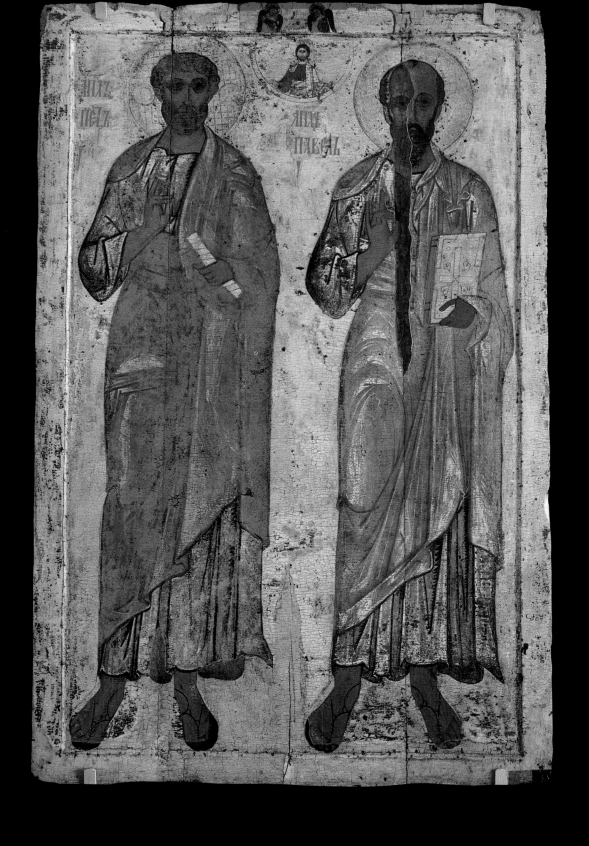

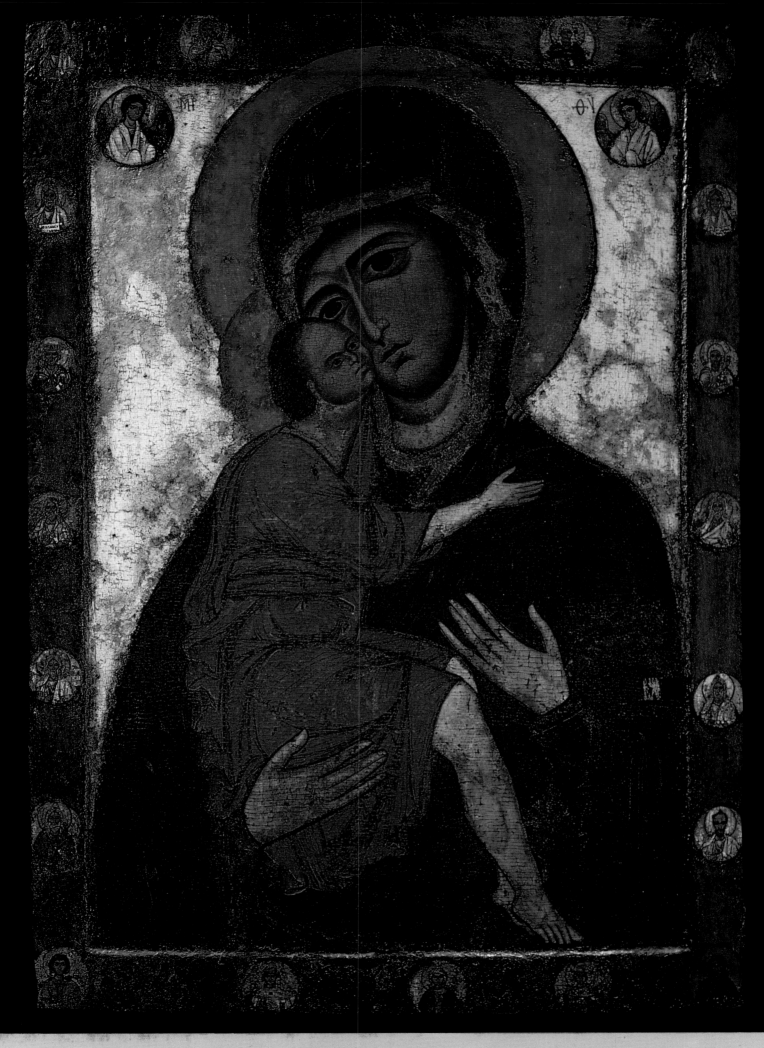

THE VIRGIN OF BELOZERSK
RUSSIAN MUSEUM, SAINT PETERSBURG

FIRST THIRD
OF 13TH CENTURY

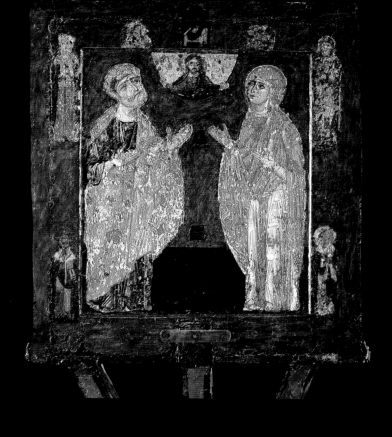

12 BEFORE 1169

RECTO: THE VIRGIN OF THE SIGN
VERSO: THE APOSTLE PETER AND MARTYR NATALYA
MUSEUM OF HISTORY AND ARCHITECTURE, NOVGOROD

152

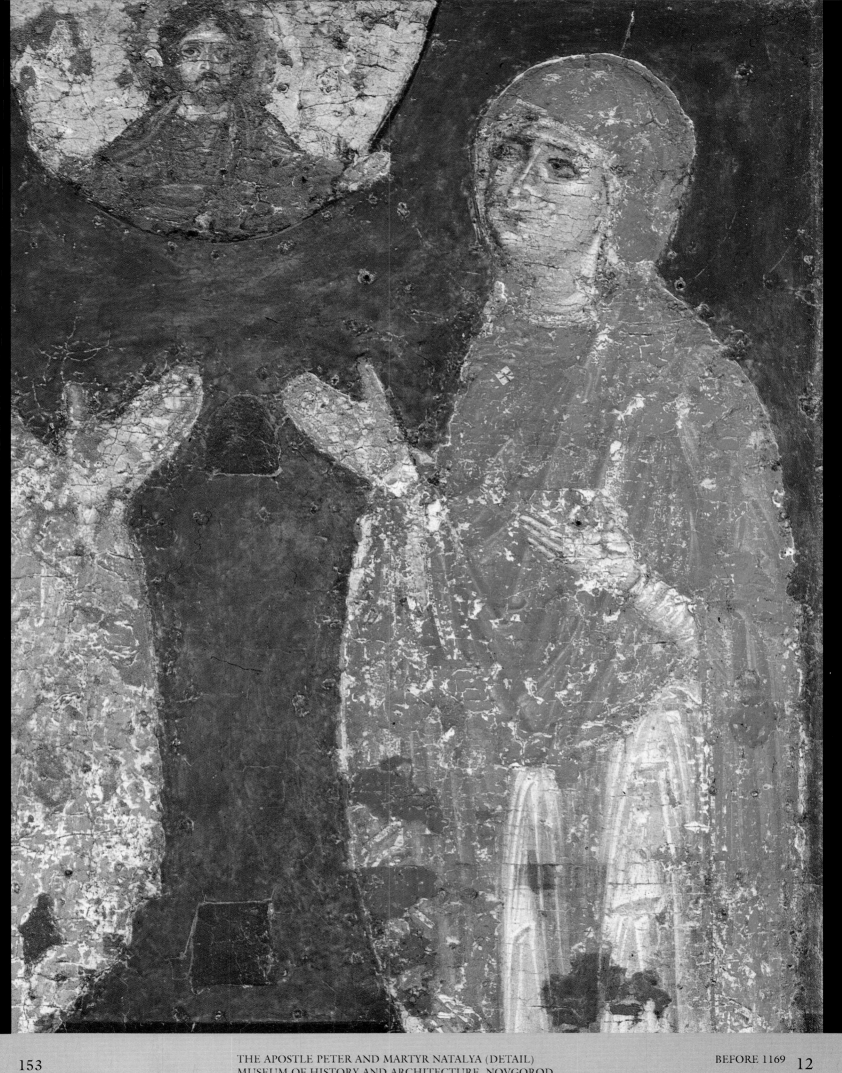

THE APOSTLE PETER AND MARTYR NATALYA (DETAIL)
MUSEUM OF HISTORY AND ARCHITECTURE, NOVGOROD

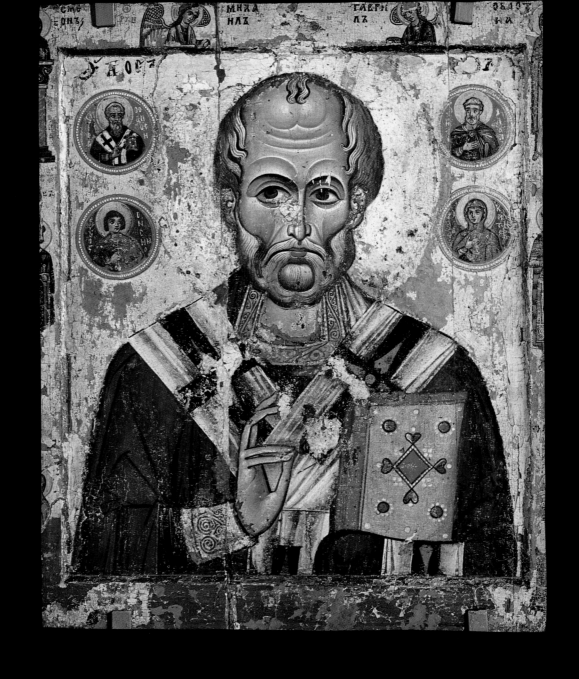

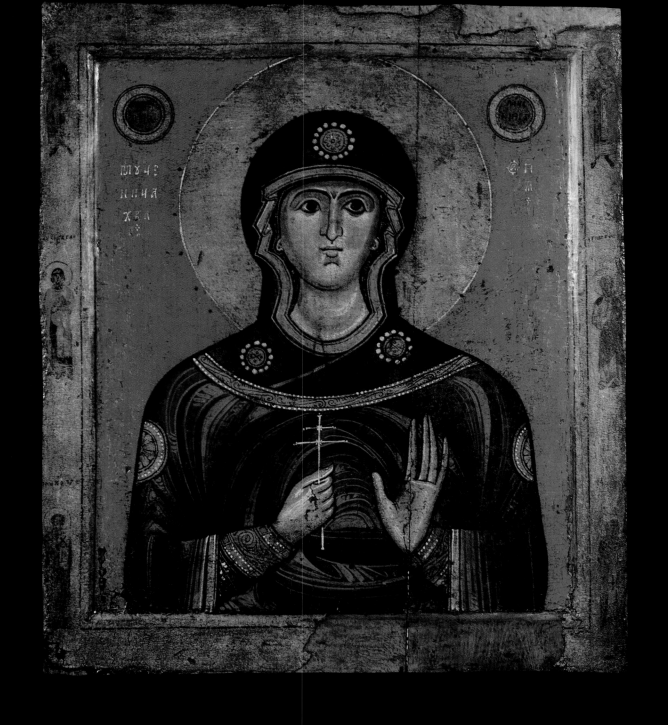

THE MARTYR JULIANA (VERSO OF THE VIRGIN OF THE SIGN)
P. D. KORIN MUSEUM (BRANCH OF THE TRETYAKOV GALLERY)

13TH CENTURY 14

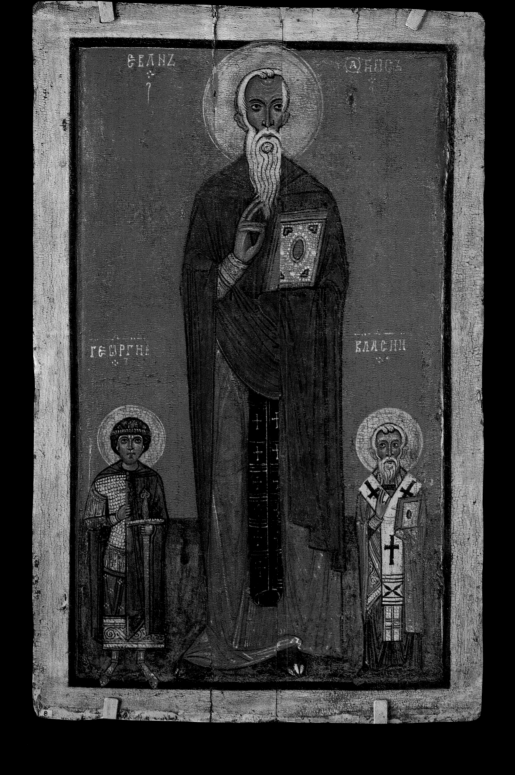

ΘΕΛΝΖ (Α)ΓΙΟСЬ

ГЕѠРГИ БЛАСНИ

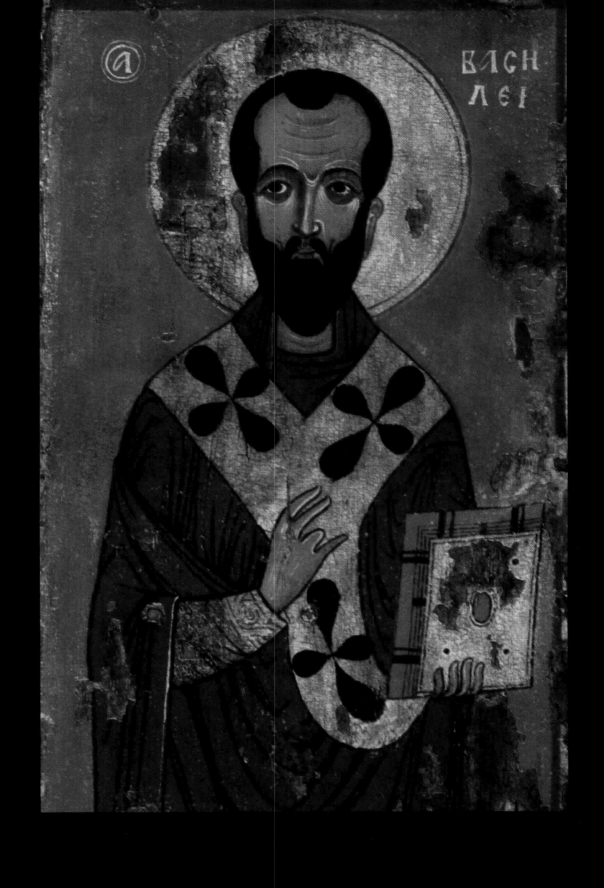

ΒΑCΗΛΕΙ

A BISHOP (DETAIL OF THE ROYAL DOORS)
TRETYAKOV GALLERY, MOSCOW

LAST THIRD
OF 13TH CENTURY 16

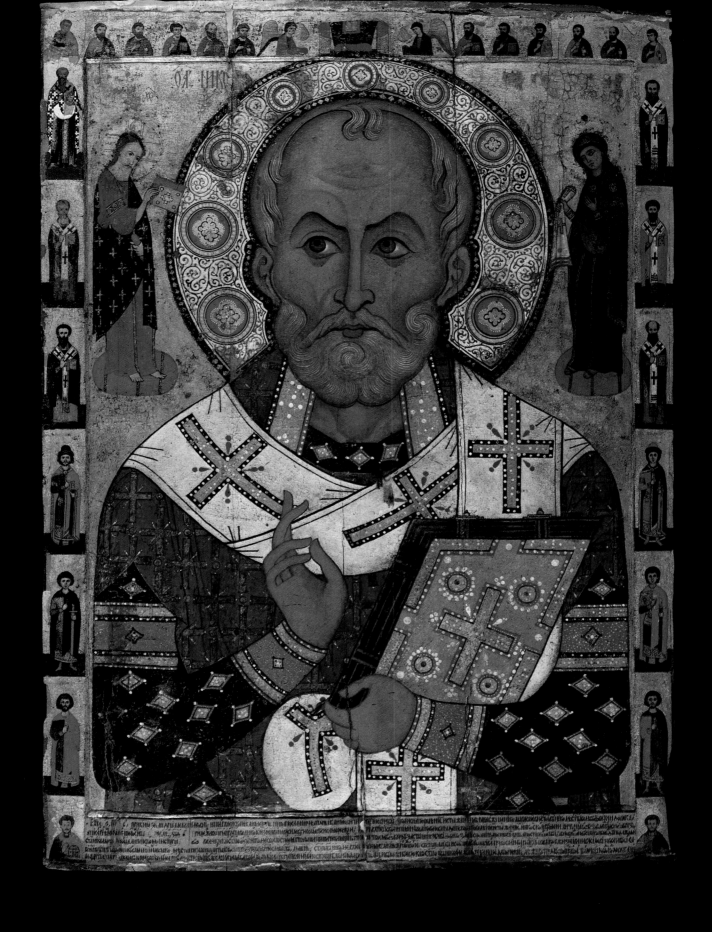

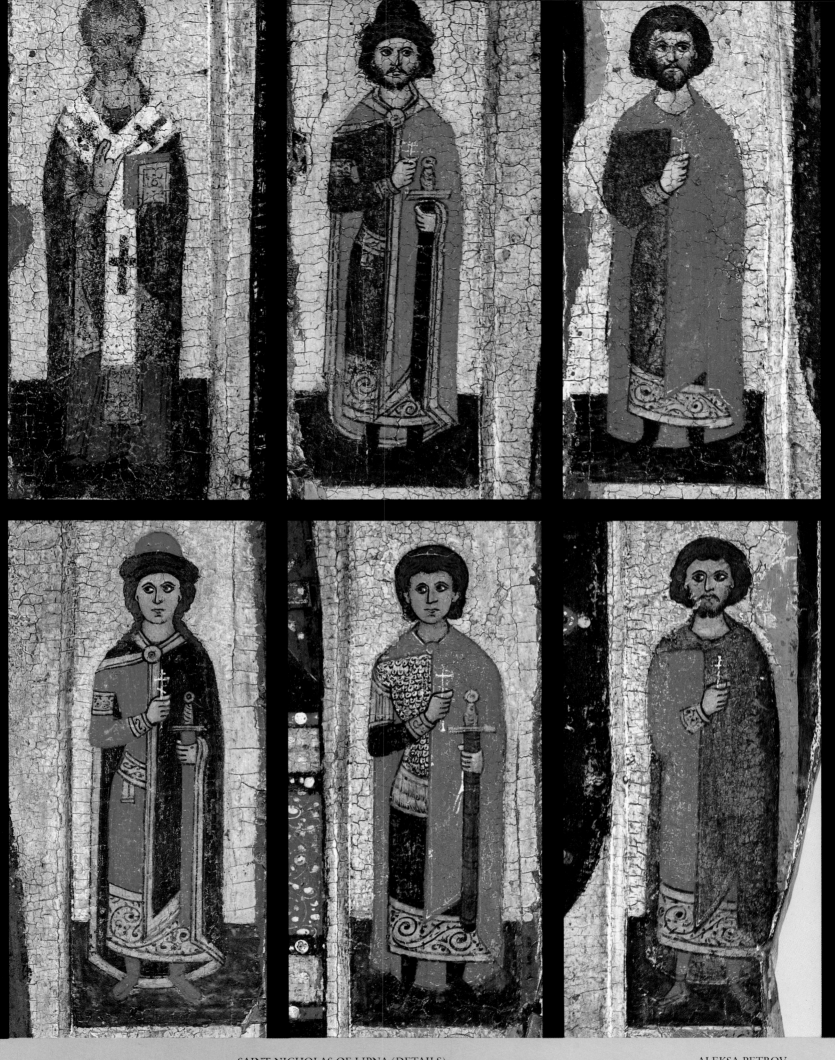

SAINT NICHOLAS OF LIPNA (DETAILS)
MUSEUM OF HISTORY AND ARCHITECTURE, NOVGOROD

ALEKSA PETROV
1294

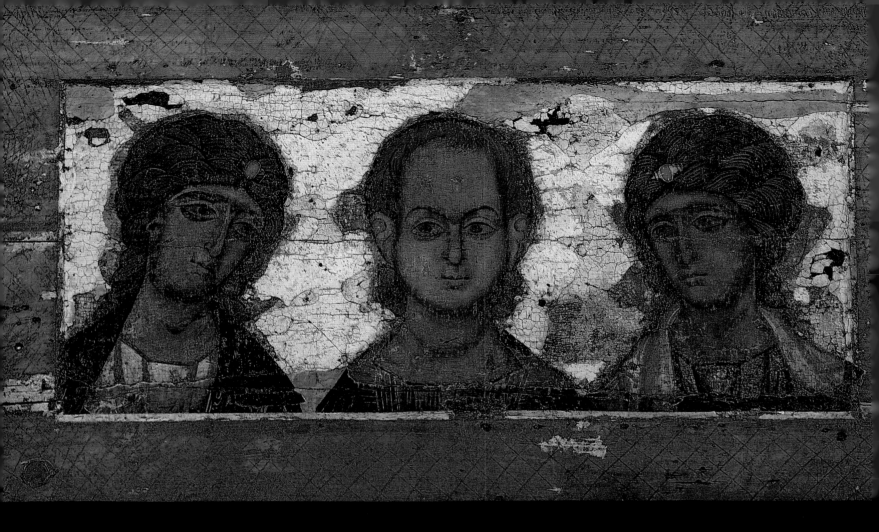

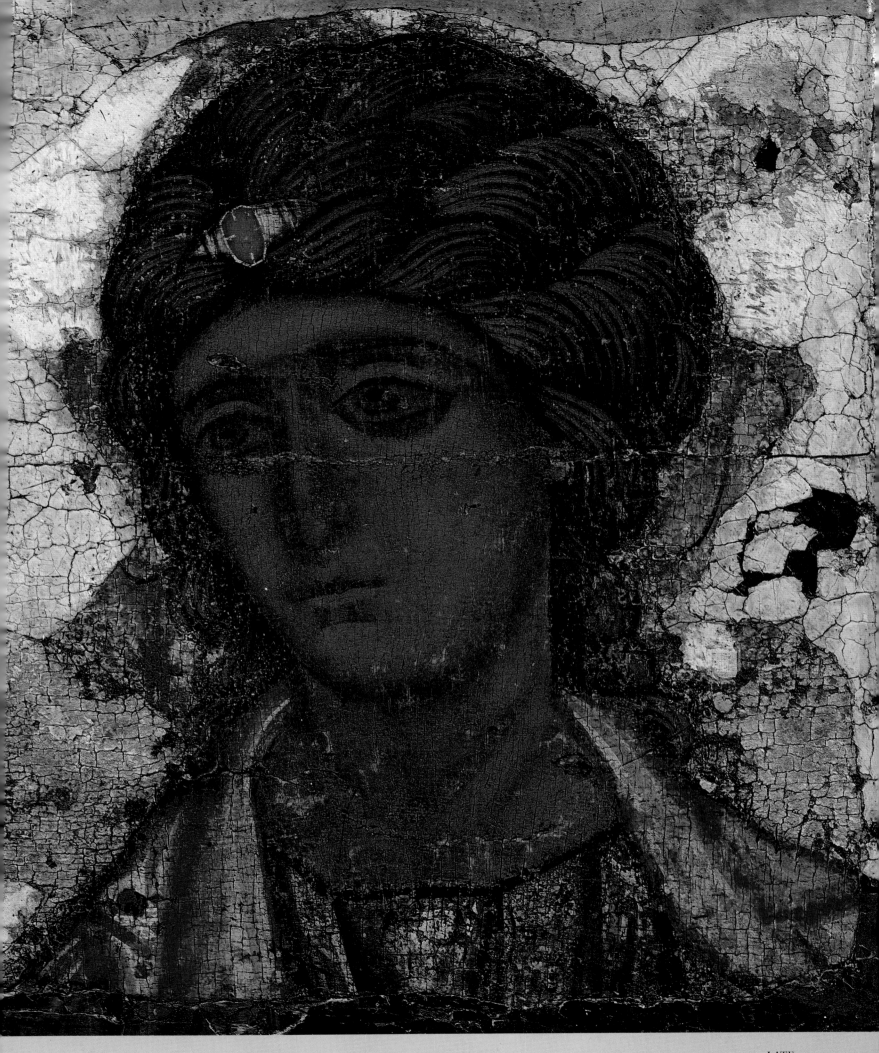

CHRIST EMMANUEL WITH ANGELS (DETAIL)
TRETYAKOV GALLERY, MOSCOW

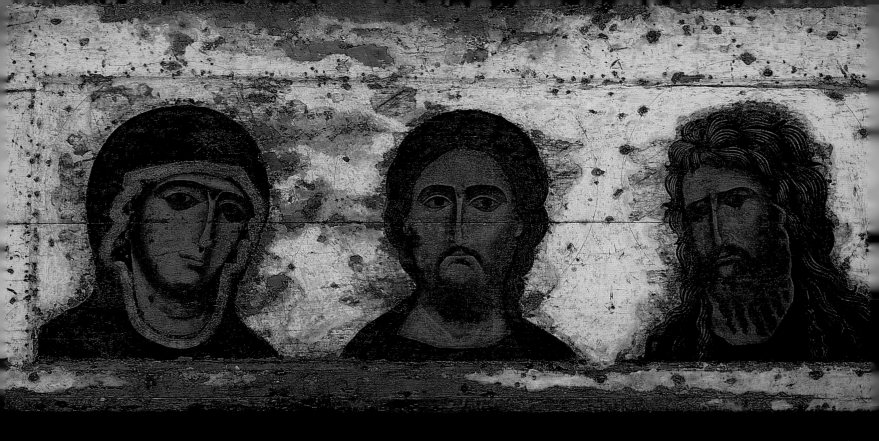

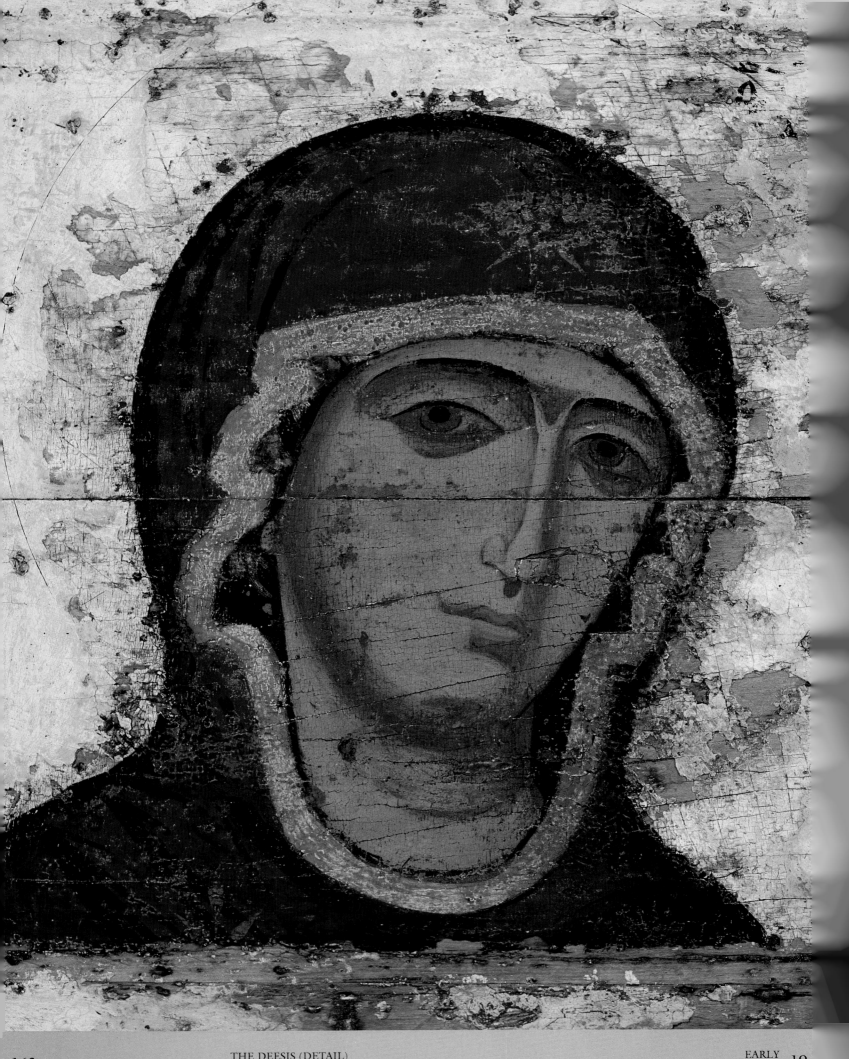

THE DEESIS (DETAIL)
TRETYAKOV GALLERY, MOSCOW

EARLY
13TH CENTURY

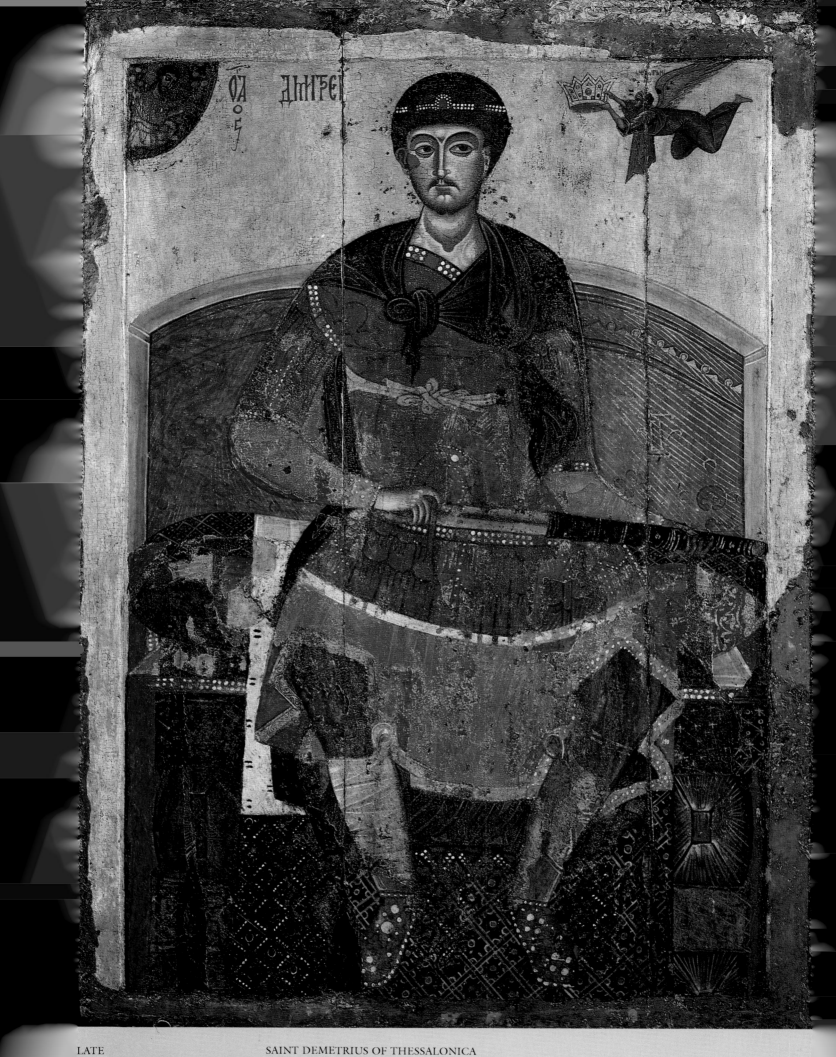

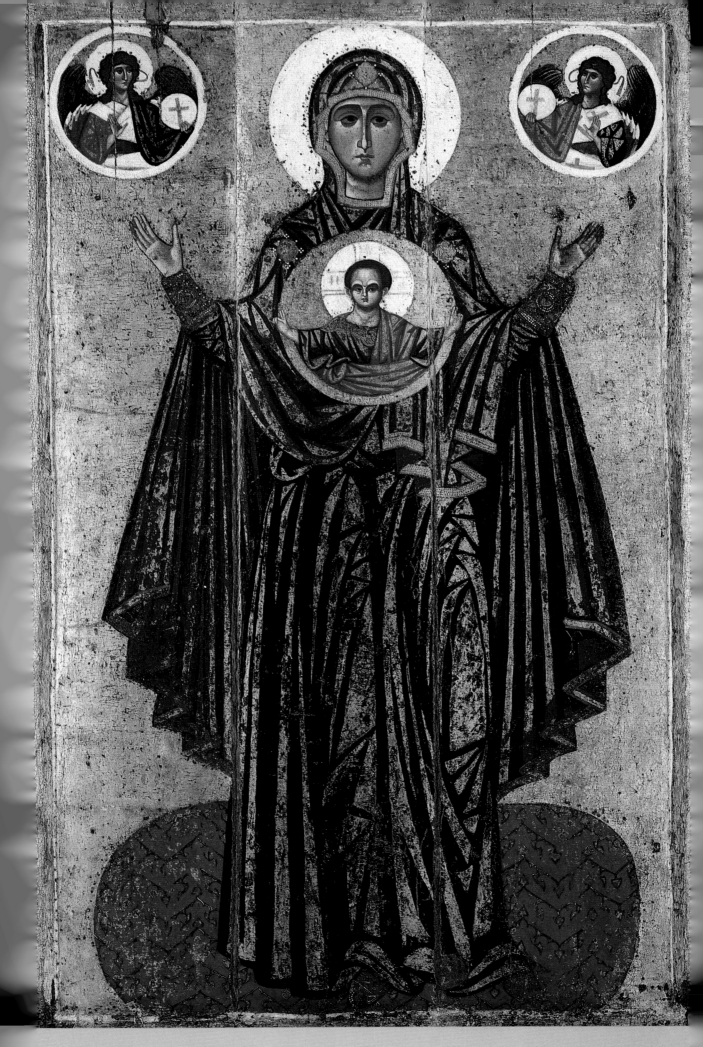

THE VIRGIN GREAT PANAGIA
TRETYAKOV GALLERY, MOSCOW

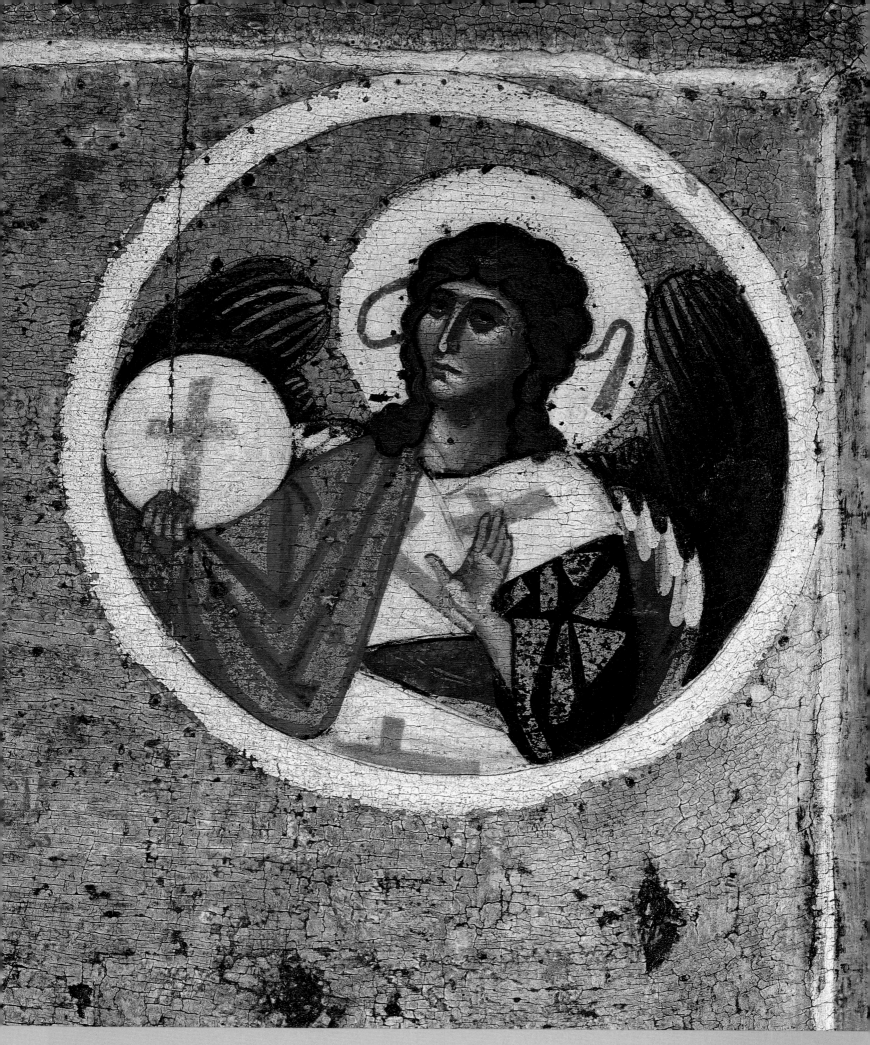

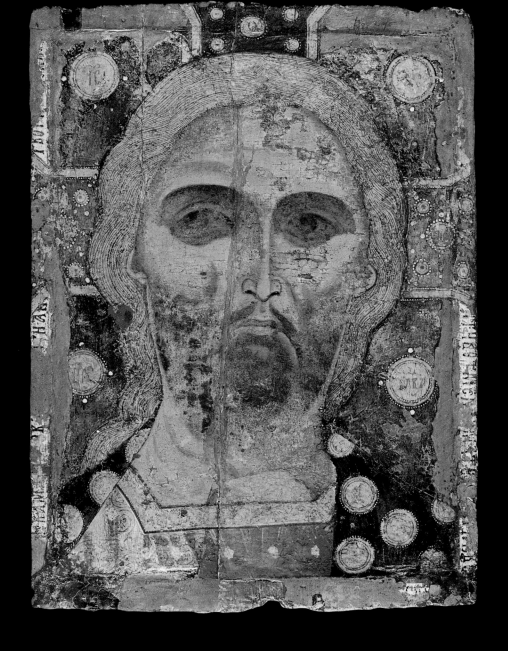

THE SAVIOR WITH GOLDEN HAIR
CATHEDRAL OF THE DORMITION, KREMLIN, MOSCOW

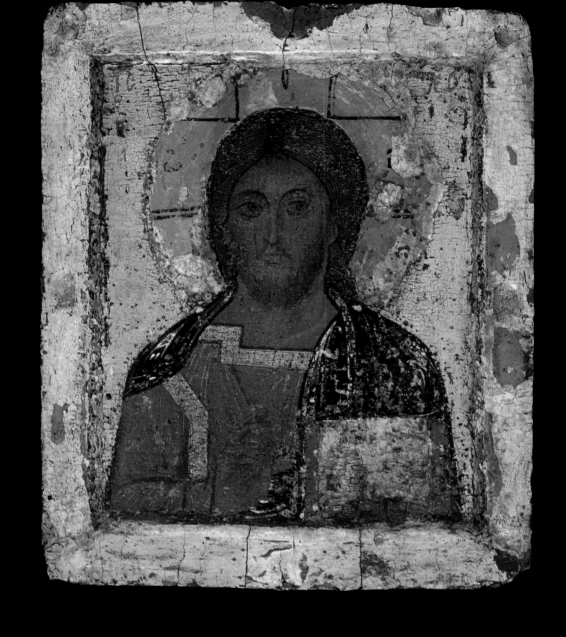

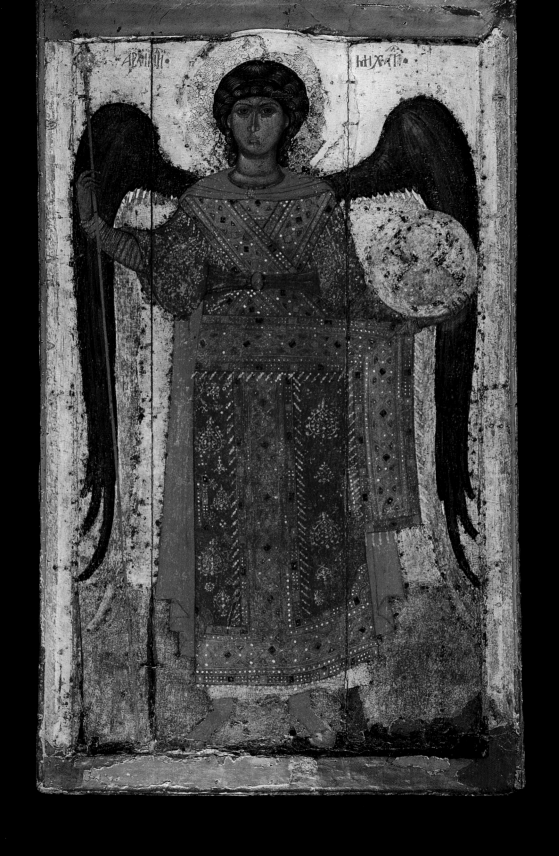

THE ARCHANGEL MICHAEL
TRETYAKOV GALLERY, MOSCOW
LATE
13TH CENTURY 24

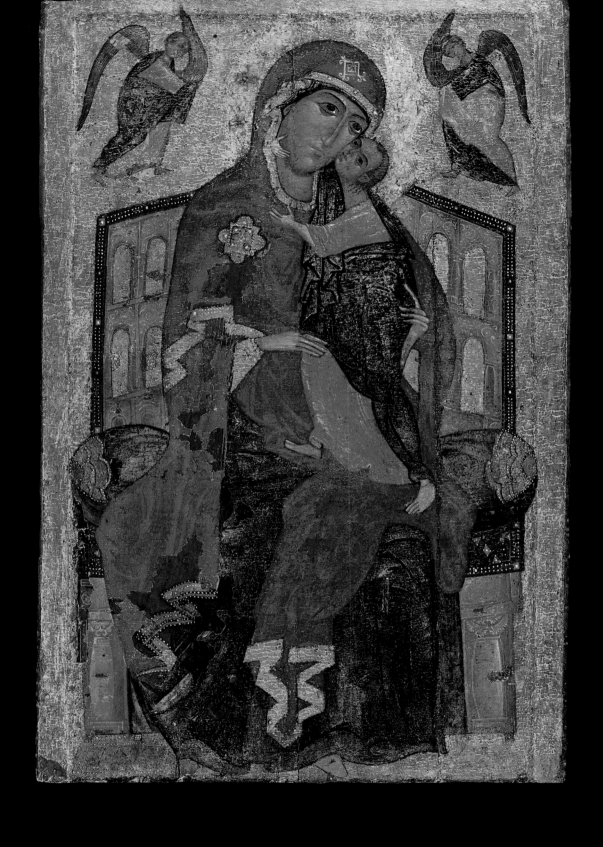

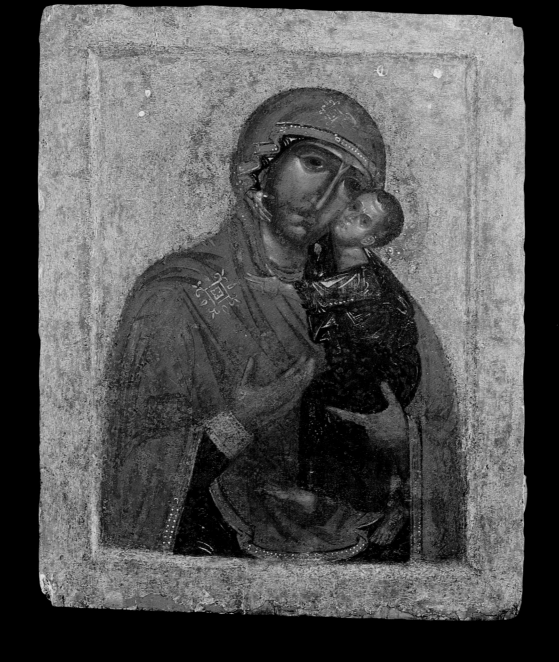

THE SMALL ICON OF THE VIRGIN OF TOLGA (TOLGSKAYA II) ABOUT 1314
FINE ARTS MUSEUM, YAROSLAV

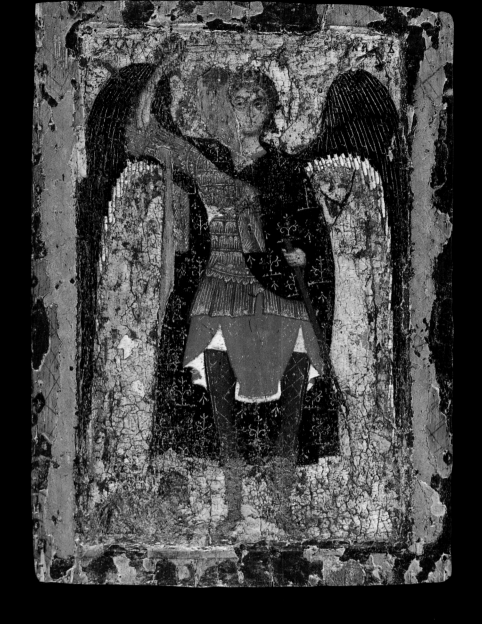

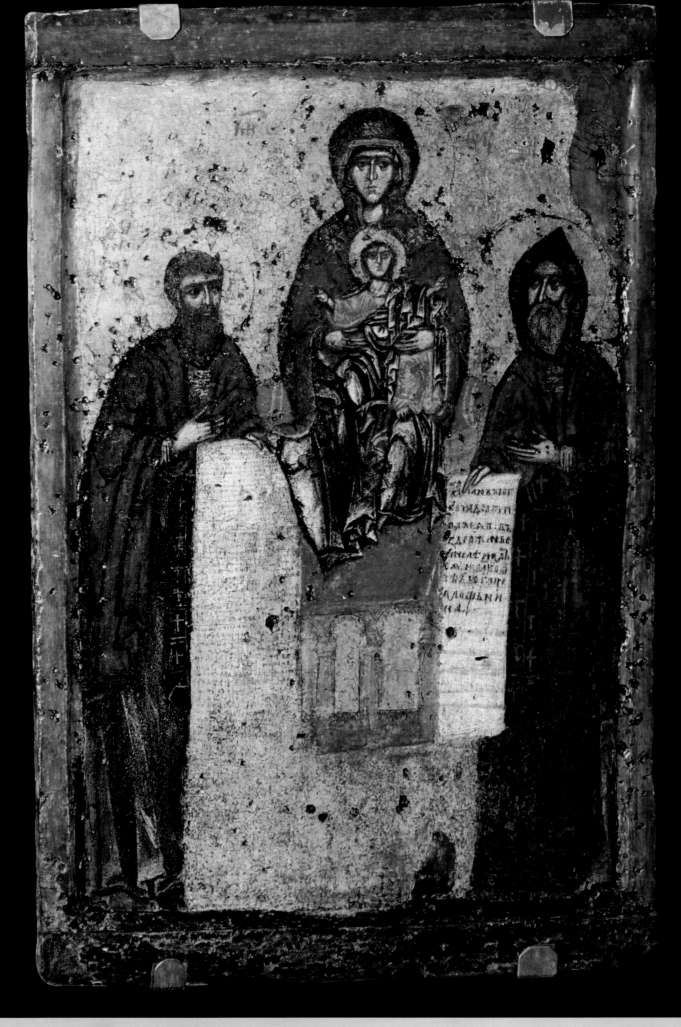

THE VIRGIN OF SVEN WITH
SAINTS ANTHONY AND THEODOSIUS PECHERSKY
TRETYAKOV GALLERY, MOSCOW

ABOUT 1288 28

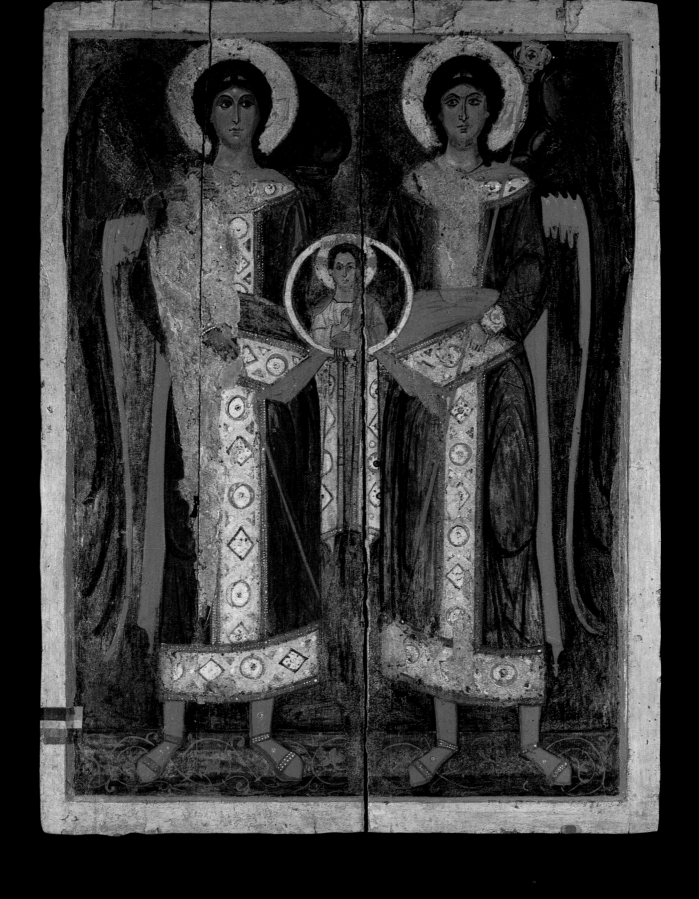

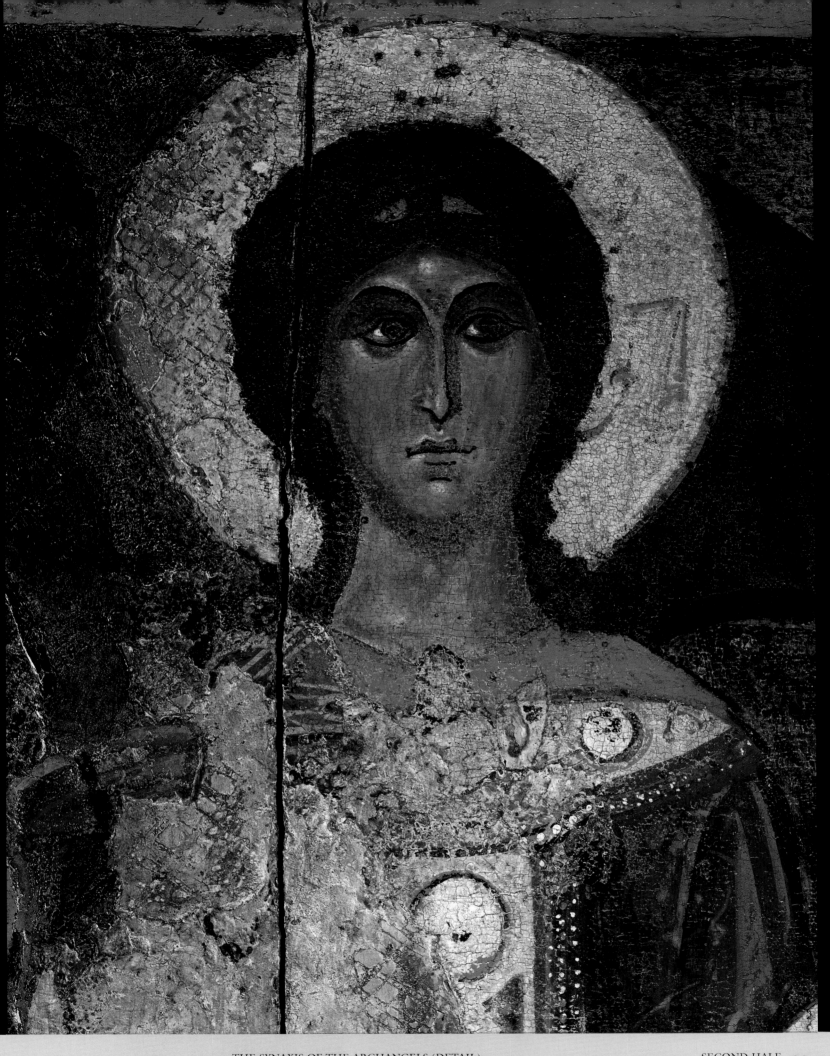

THE SYNAXIS OF THE ARCHANGELS (DETAIL)
RUSSIAN MUSEUM, SAINT PETERSBURG

SECOND HALF
OF 13TH CENTURY 29

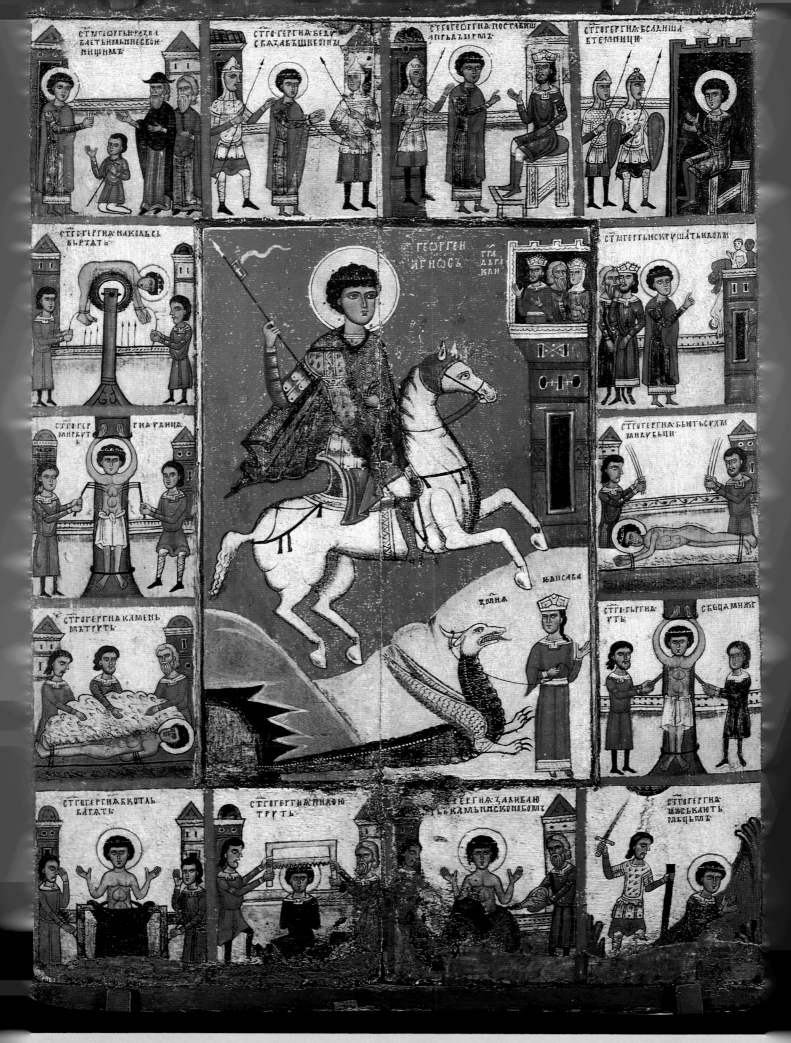

OVGOROD SCHOOL
ARLY
TH CENTURY

SAINT GEORGE WITH SCENES FROM HIS LIFE
RUSSIAN MUSEUM, SAINT PETERSBURG

1

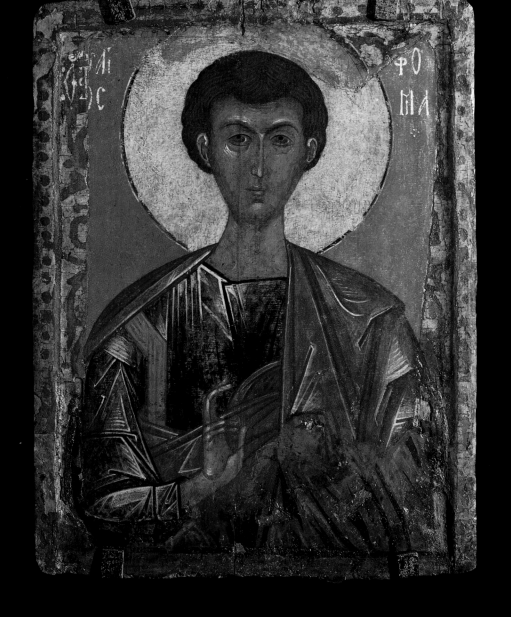

THE APOSTLE THOMAS
RUSSIAN MUSEUM, SAINT PETERSBURG

NOVGOROD SCHOOL
1360s 31

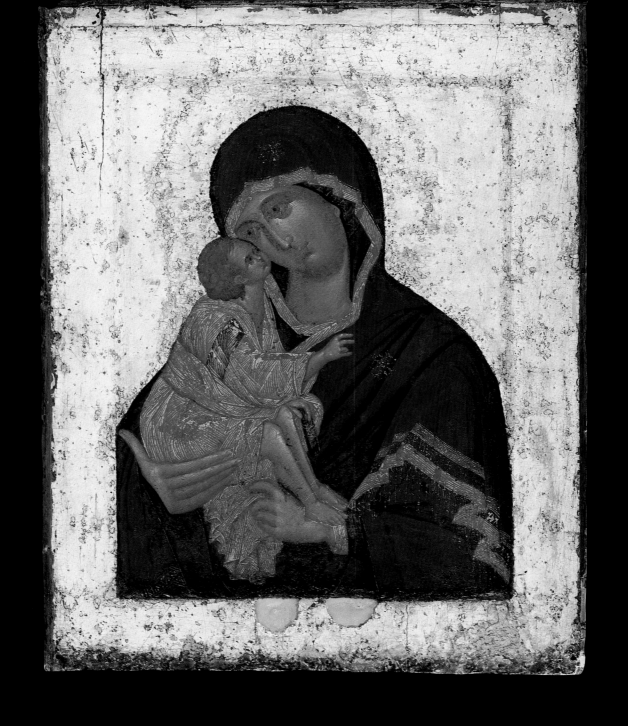

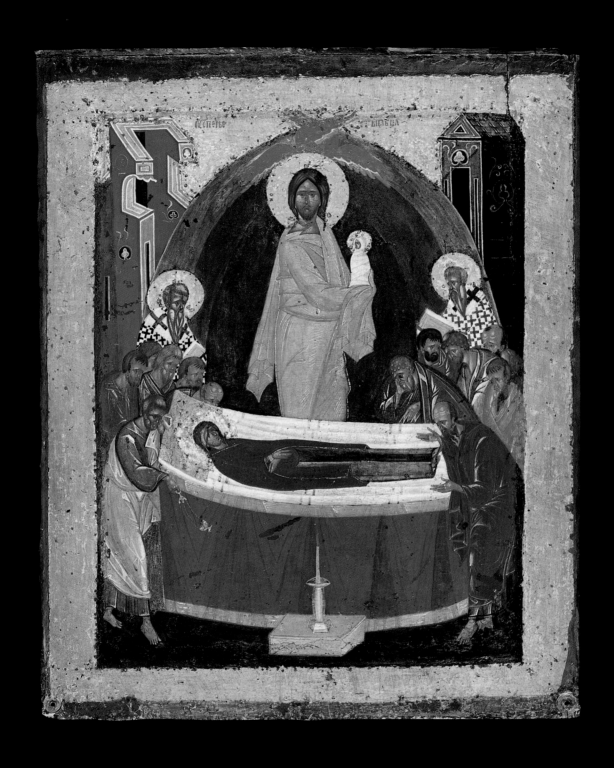

VERSO: THE DORMITION
TRETYAKOV GALLERY, MOSCOW

THE DORMITION (DETAIL)
TRETYAKOV GALLERY, MOSCOW

NOVGOROD SCHOOL
1390s

32

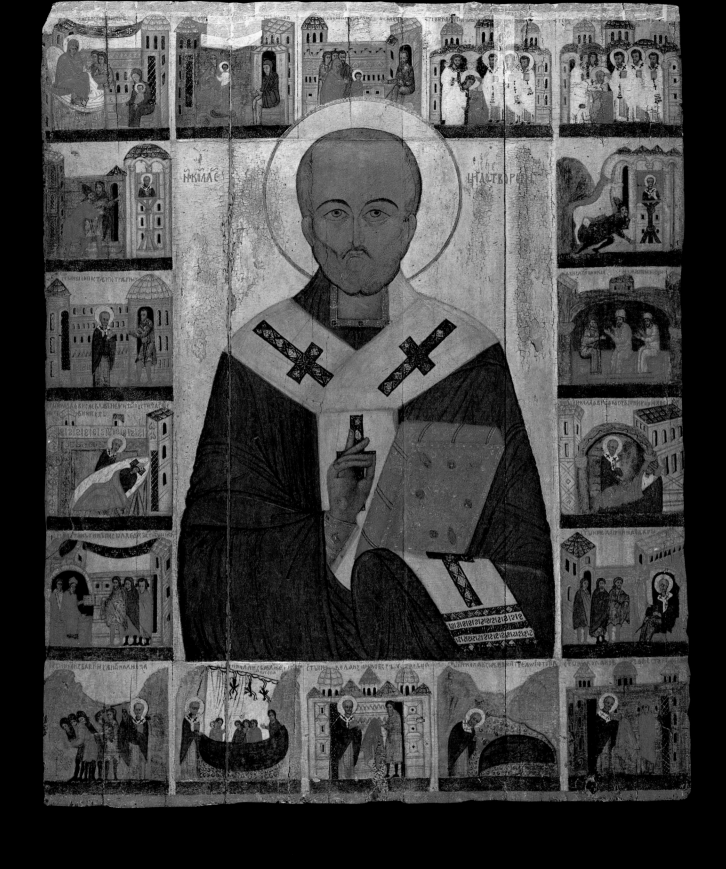

SAINT NICHOLAS THE WONDERWORKER
WITH SCENES FROM HIS LIFE (DETAILS)
MUSEUM OF HISTORY AND ARCHITECTURE, NOVGOROD

NOVGOROD SCHOOL
1370s–1380s 33

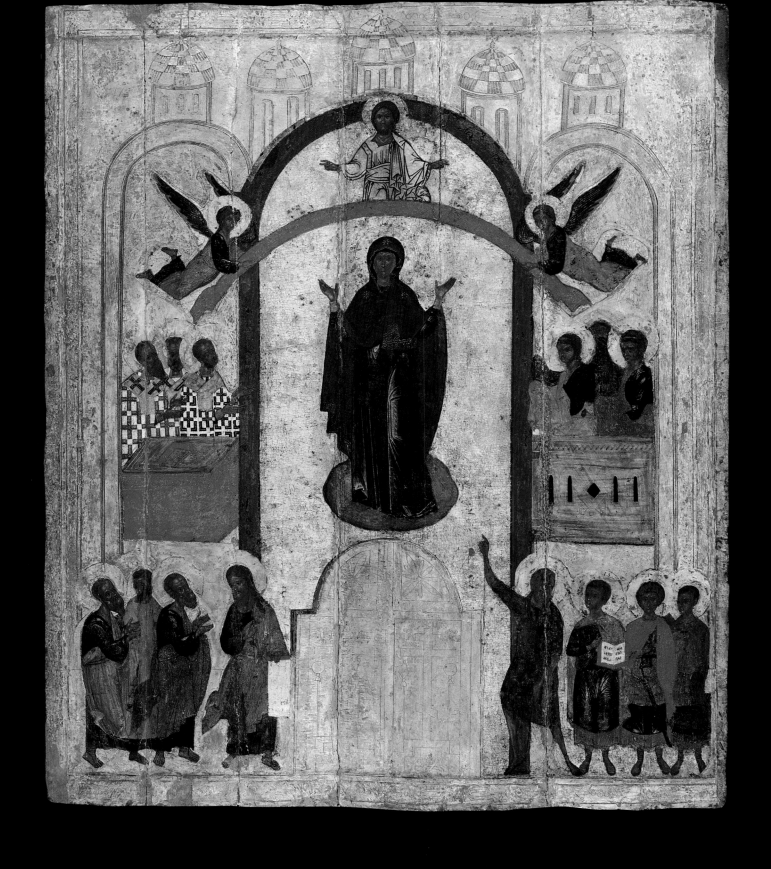

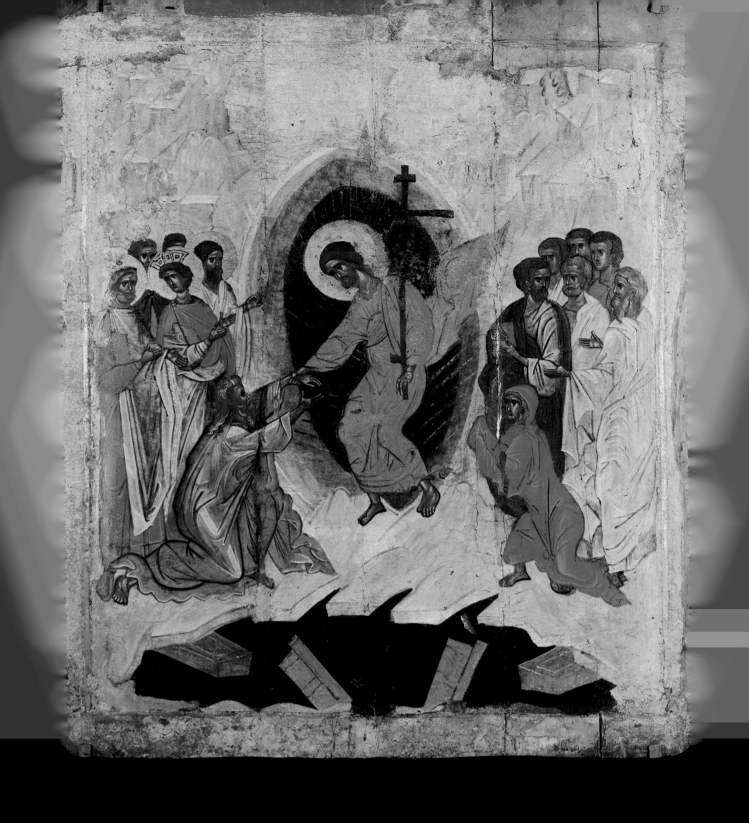

THE DESCENT INTO HELL
RUSSIAN MUSEUM, SAINT PETERSBURG

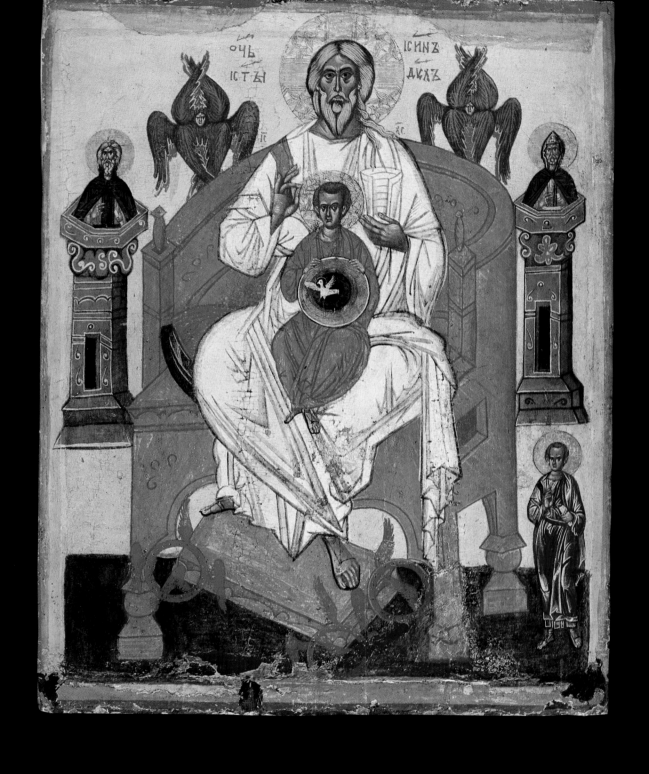

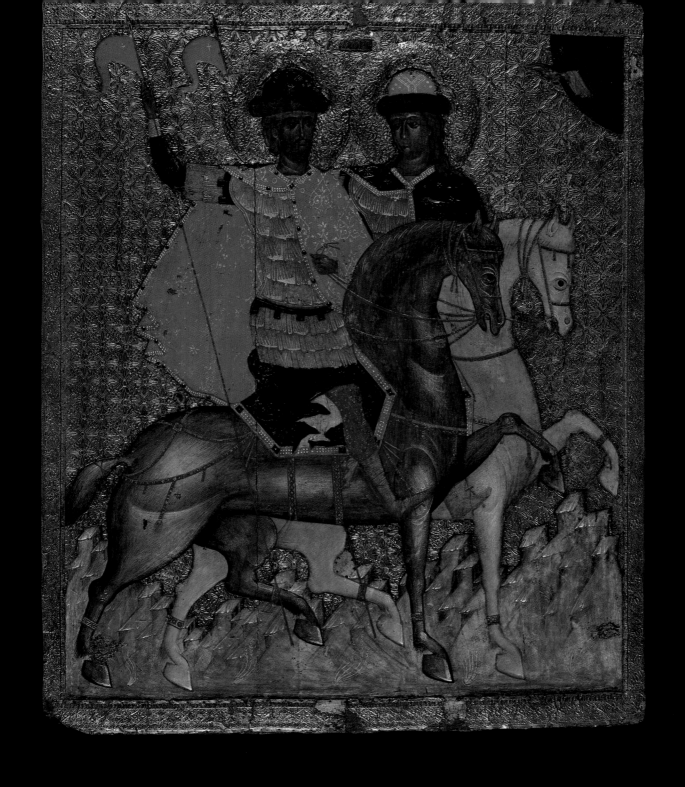

SAINTS BORIS AND GLEB
MUSEUM OF HISTORY AND ARCHITECTURE, NOVGOROD

NOVGOROD
ABOUT 1377 37

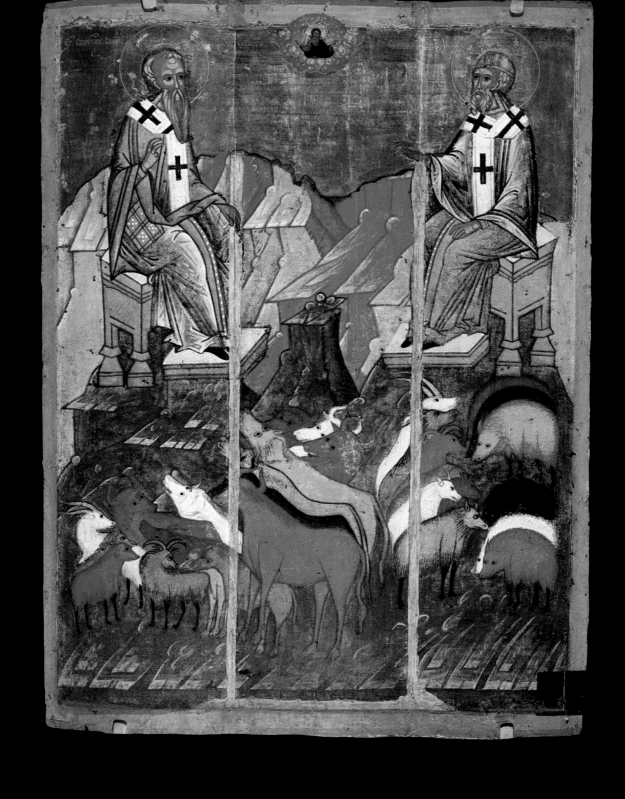

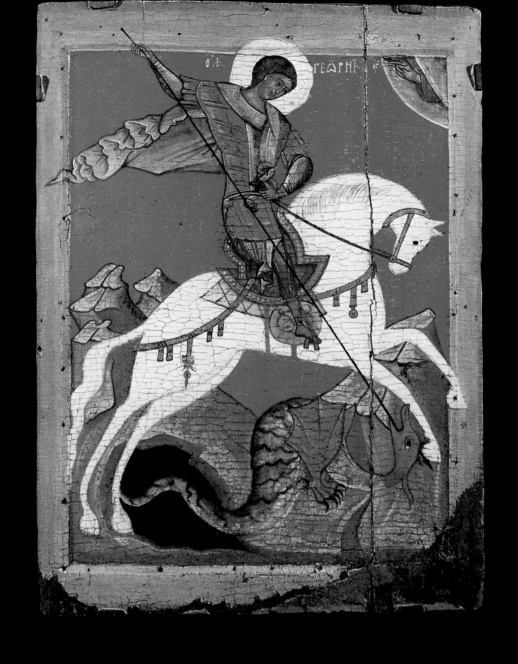

ОΓ ΓΕΩΡΓΗ

189 THE MIRACLE OF SAINT GEORGE AND THE DRAGON NOVGOROD SCHOOL
 RUSSIAN MUSEUM, SAINT PETERSBURG LATE 14TH– 39
 EARLY 15TH CENTURY

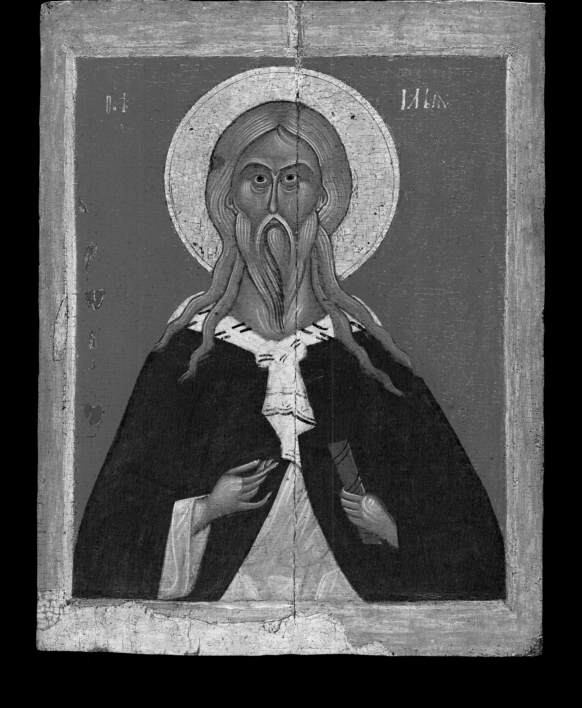

40 NOVGOROD SCHOOL THE PROPHET ELIJAH 190
 LATE 14TH– TRETYAKOV GALLERY, MOSCOW
 EARLY 15TH CENTURY

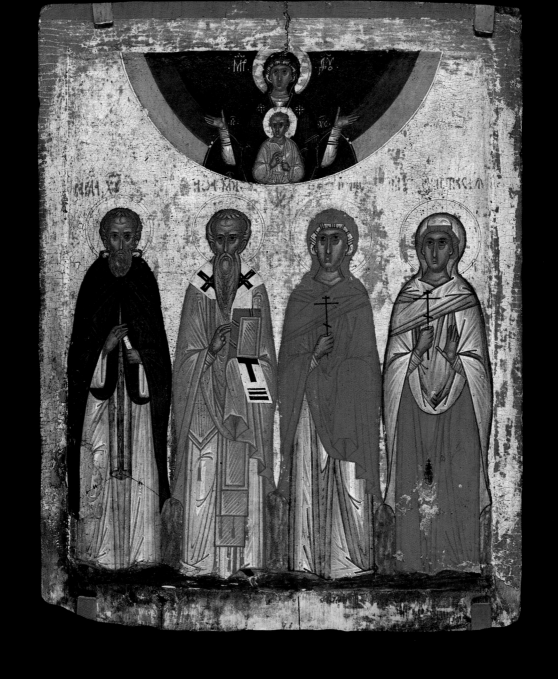

191 THE VIRGIN OF THE SIGN WITH SAINTS (BARLAAM OF KHUTYNSK, JOHN THE ALMSGIVER, PARASKEVA PYATNITSA, AND ANASTASIA) RUSSIAN MUSEUM, SAINT PETERSBURG

NOVGOROD SCHOOL
EARLY 41
15TH CENTURY

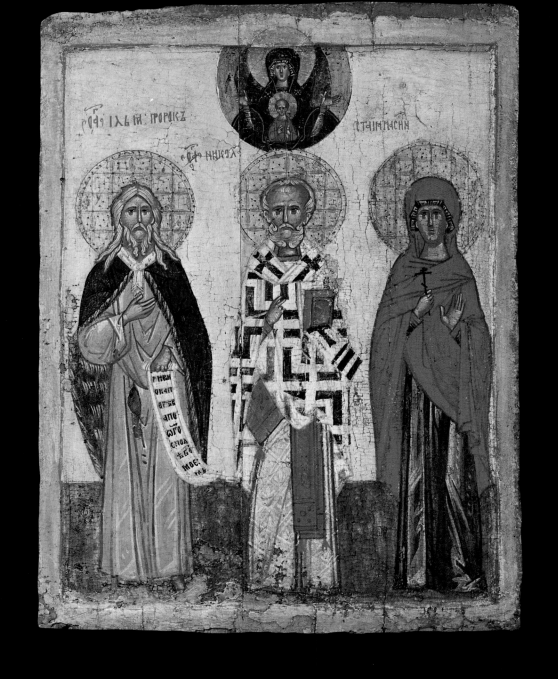

NOVGOROD SCHOOL
EARLY
15TH CENTURY

THE VIRGIN OF THE SIGN WITH SAINTS
(THE PROPHET ELIJAH, NICHOLAS THE WONDERWORKER, AND ANASTASIA)
TRETYAKOV GALLERY, MOSCOW

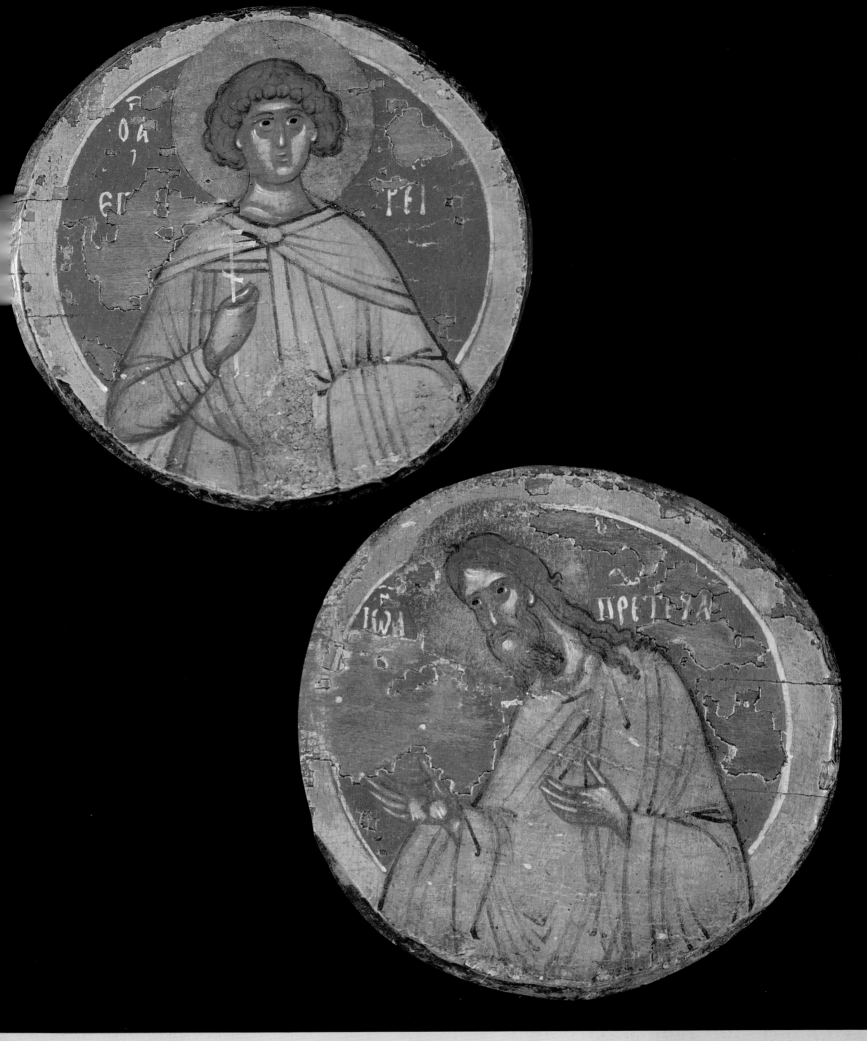

SAINTS GEORGE AND JOHN THE BAPTIST,
FRAGMENTS FROM A PROCESSIONAL ICON
RUSSIAN MUSEUM, SAINT PETERSBURG

NOVGOROD SCHOOL
EARLY **43**
15TH CENTURY

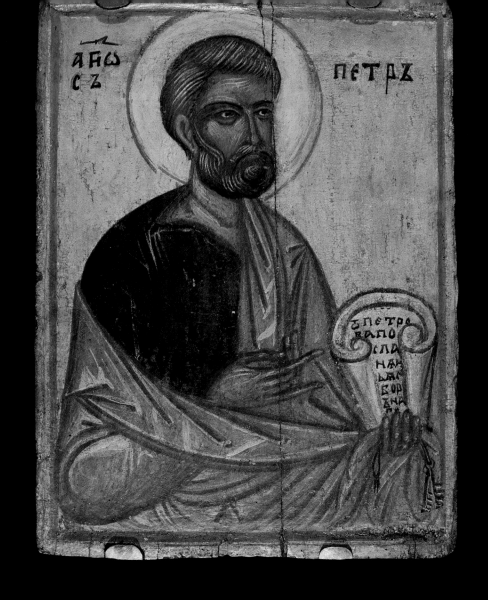

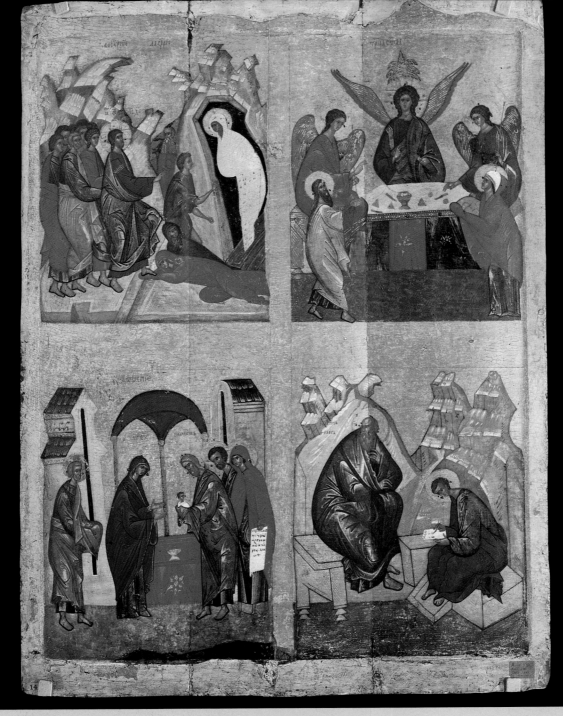

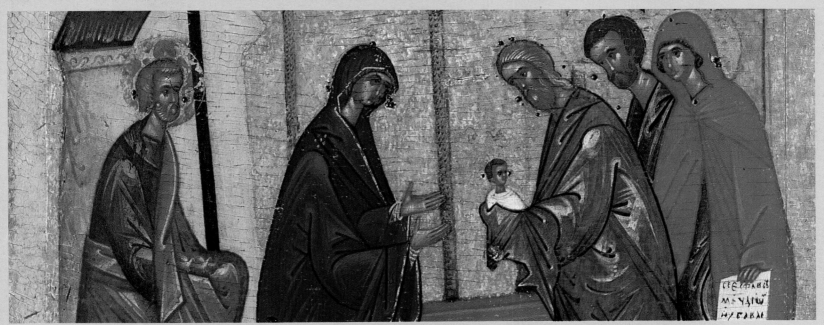

QUADRIPARTITE ICON: THE RAISING OF LAZARUS; THE TRINITY;
THE PRESENTATION IN THE TEMPLE;
SAINTS JOHN THE EVANGELIST AND PROCHORUS
RUSSIAN MUSEUM, SAINT PETERSBURG

NOVGOROD SCHOOL
EARLY
15TH CENTURY

195

45

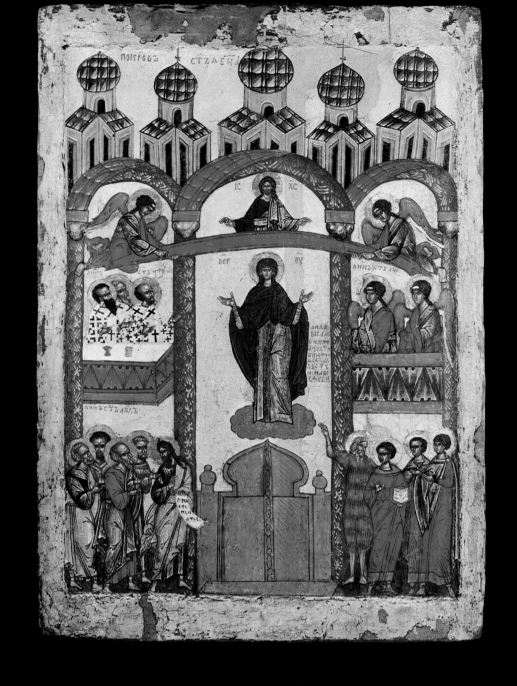

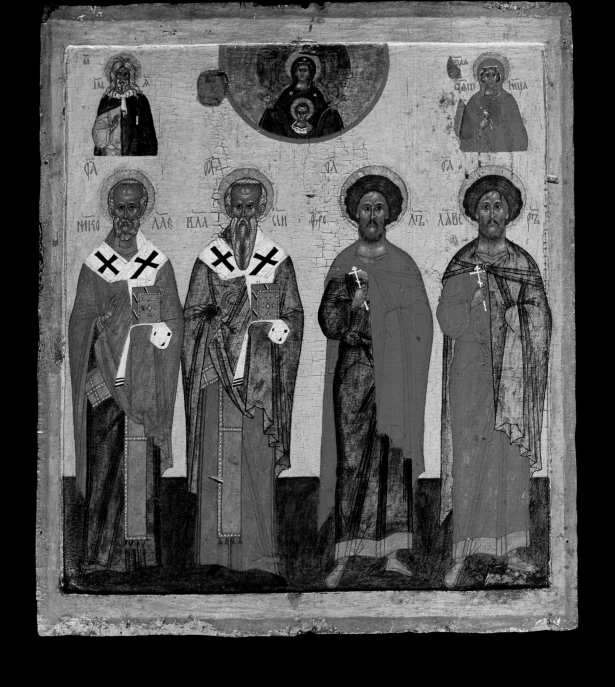

THE VIRGIN OF THE SIGN WITH SAINTS (THE PROPHET ELIJAH,
PARASKEVA PYATNITSA, NICHOLAS, BLAISE, FLORUS, AND LAURUS)
TRETYAKOV GALLERY, MOSCOW

NOVGOROD SCHOOL
SECOND QUARTER 47
OF 15TH CENTURY

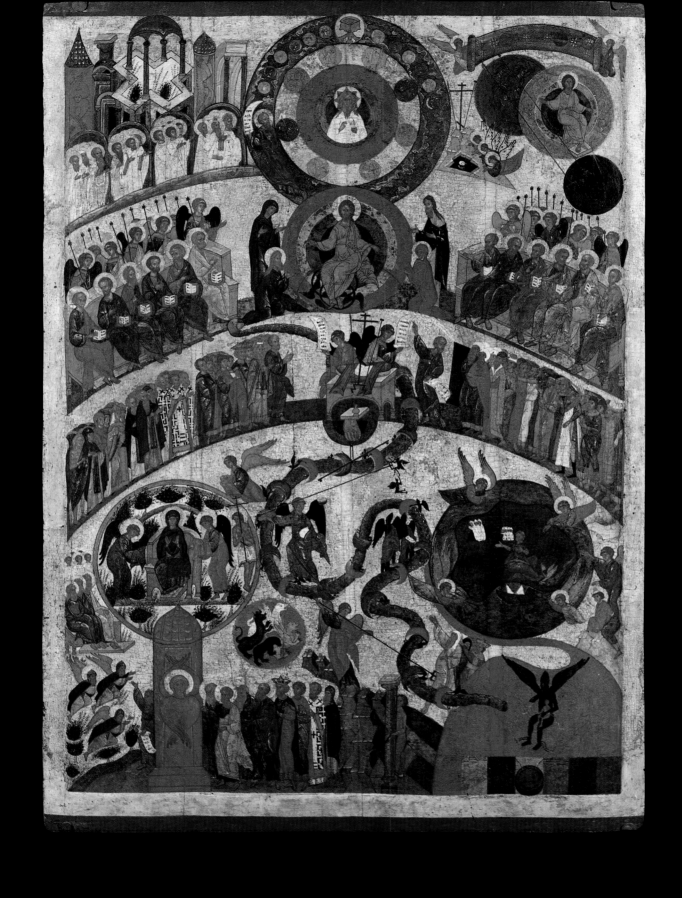

NOVGOROD SCHOOL
THIRD QUARTER
OF 15TH CENTURY

THE LAST JUDGMENT
TRETYAKOV GALLERY, MOSCOW

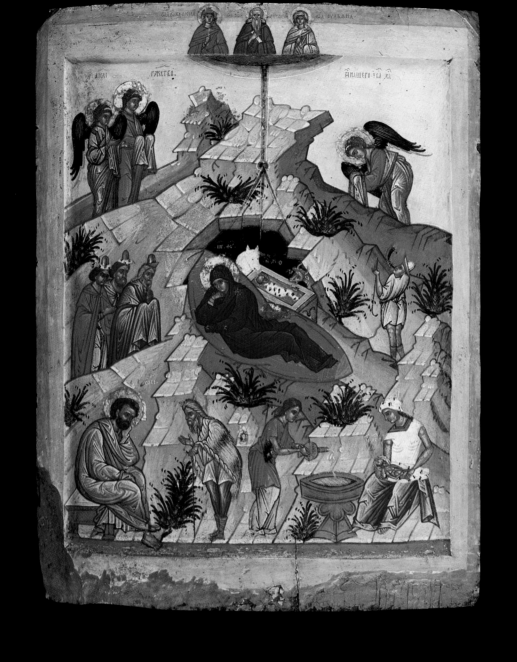

199 THE NATIVITY OF CHRIST WITH SAINTS
(EUDOCIA, JOHN CLIMACUS, AND JULIANA)
TRETYAKOV GALLERY, MOSCOW

NOVGOROD SCHOOL
FIRST HALF 49
OF 12TH CENTURY

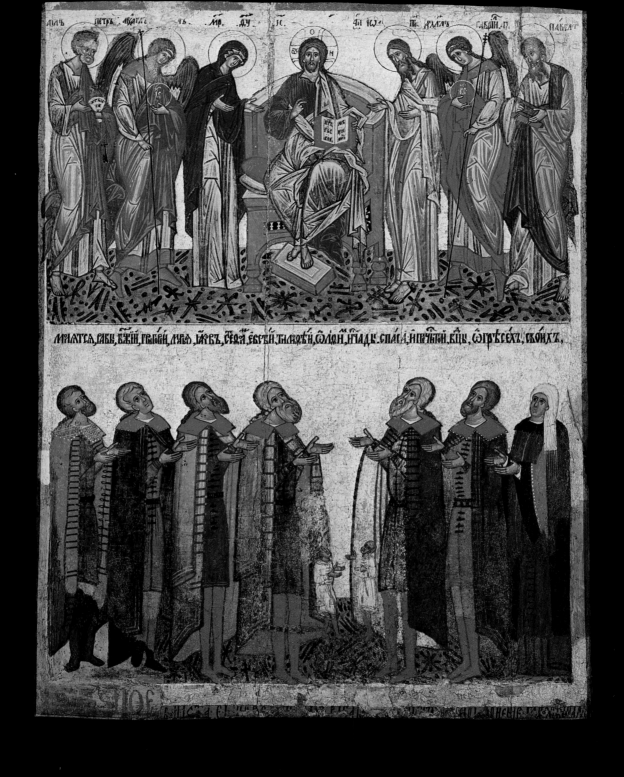

NOVGOROD SCHOOL
1467

THE PRAYING NOVGORODIANS
MUSEUM OF HISTORY AND ARCHITECTURE, NOVGOROD

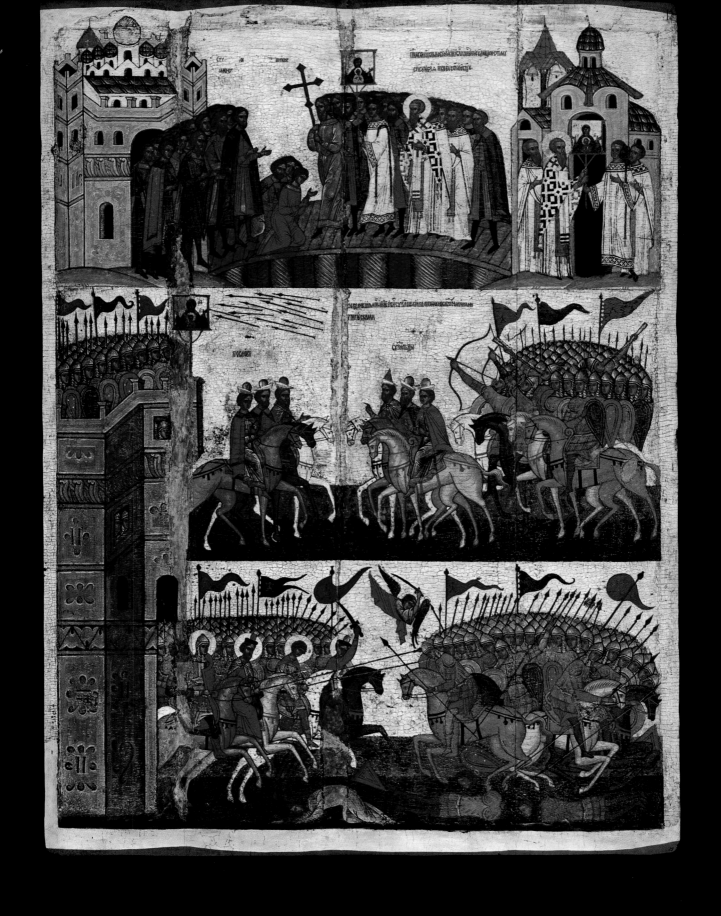

THE BATTLE BETWEEN THE NOVGORODIANS AND SUZDALIANS
MUSEUM OF HISTORY AND ARCHITECTURE, NOVGOROD

NOVGOROD SCHOOL
1460s
51

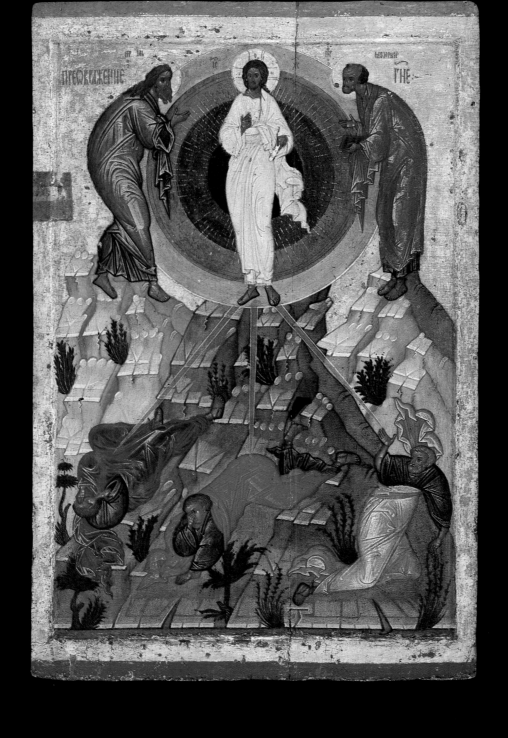

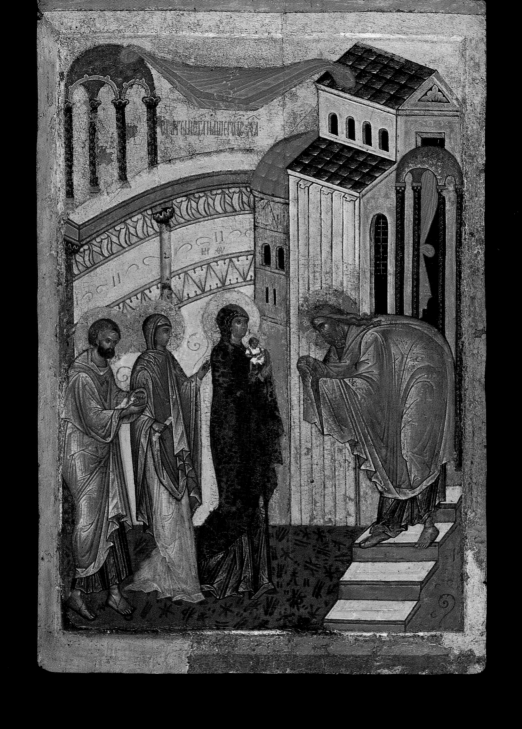

THE PRESENTATION IN THE TEMPLE
MUSEUM OF HISTORY AND ARCHITECTURE, NOVGOROD

NOVGOROD SCHOOL
1470s–1480s 52

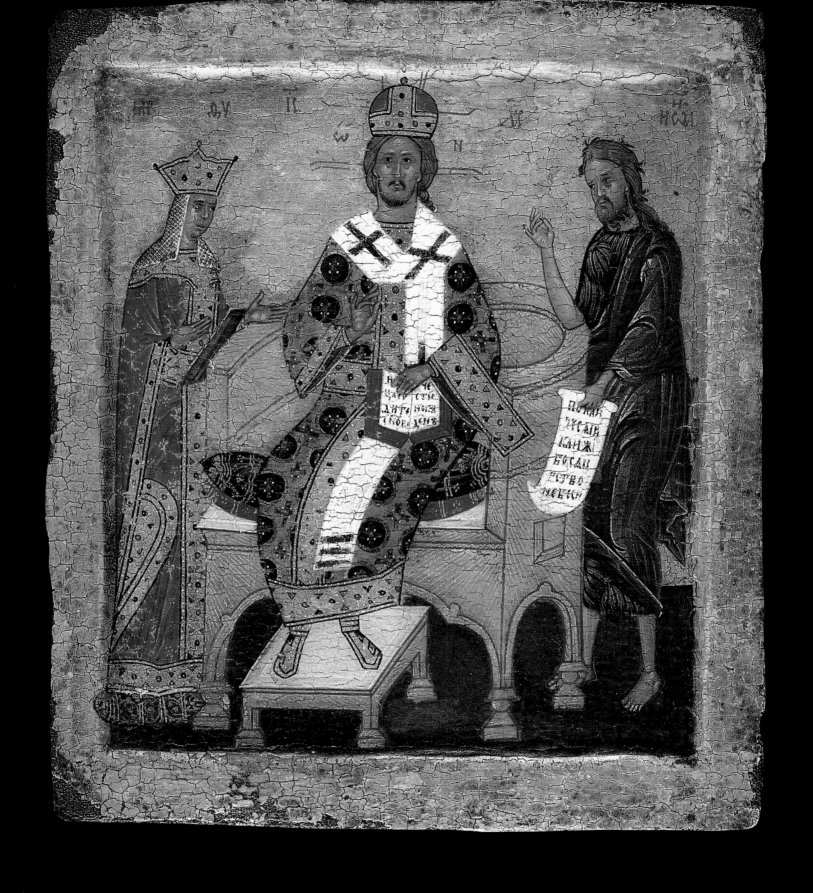

53 NOVGOROD SCHOOL THE QUEEN OF HEAVEN STANDING AT YOUR RIGHT HAND
 SECOND HALF TRETYAKOV GALLERY, MOSCOW 204
 OF 15TH CENTURY

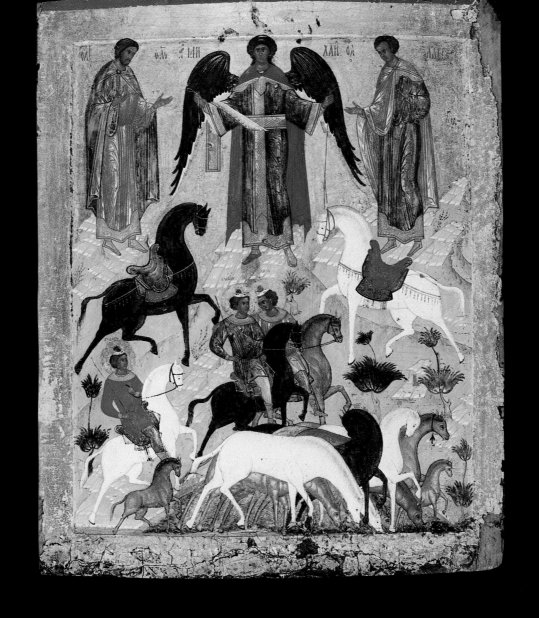

THE MIRACLE OF SAINTS FLORUS AND LAURUS
TRETYAKOV GALLERY, MOSCOW

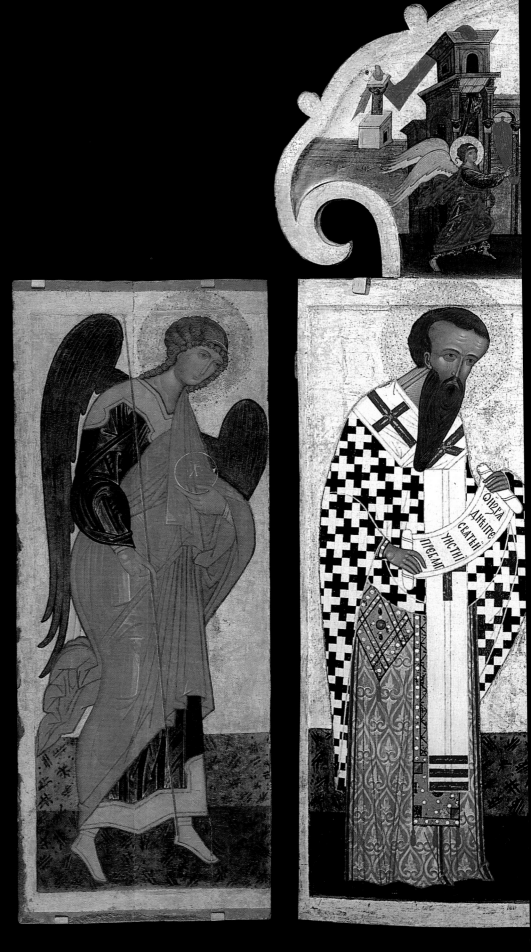

NOVGOROD SCHOOL
ABOUT 1475

THE ROYAL DOORS WITH REPRESENTATIONS
OF THE ANNUNCIATION AND TWO BISHOPS;
THE ARCHANGELS MICHAEL AND GABRIEL
RUSSIAN MUSEUM, SAINT PETERSBURG

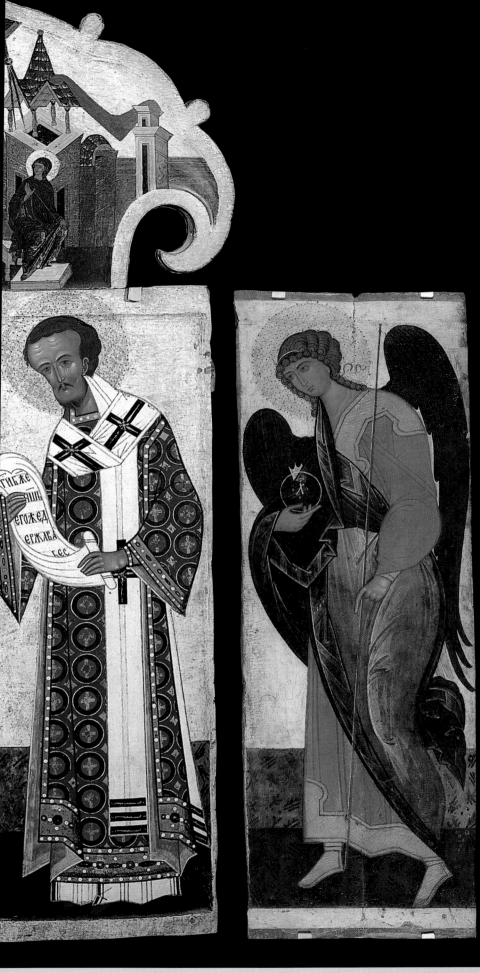

THE ROYAL DOORS WITH REPRESENTATIONS
OF THE ANNUNCIATION AND TWO BISHOPS;
THE ARCHANGELS MICHAEL AND GABRIEL
TRETYAKOV GALLERY. MOSCOW

NOVGOROD SCHOOL
ABOUT 1475 56

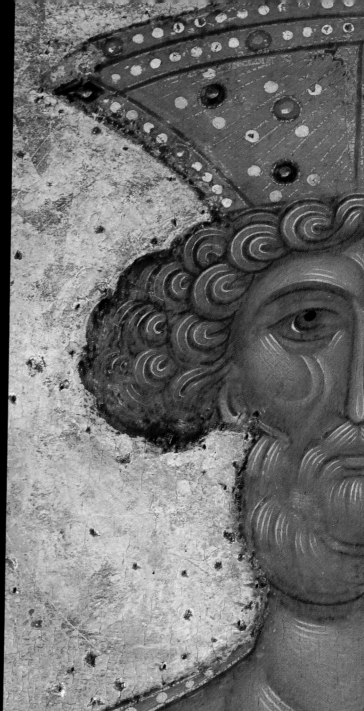

DANIEL, DAVID, AND SOLOMON
TRETYAKOV GALLERY, MOSCOW

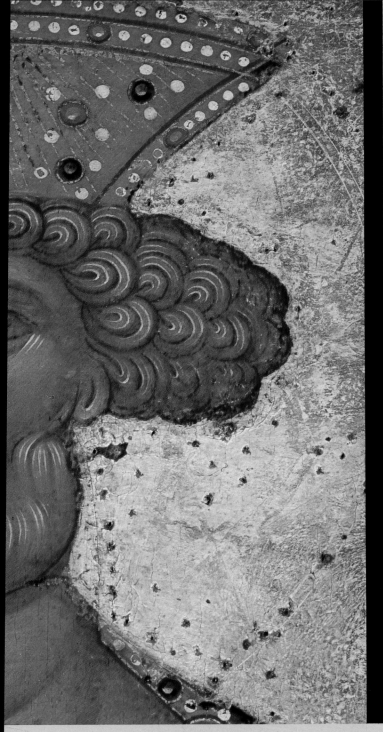

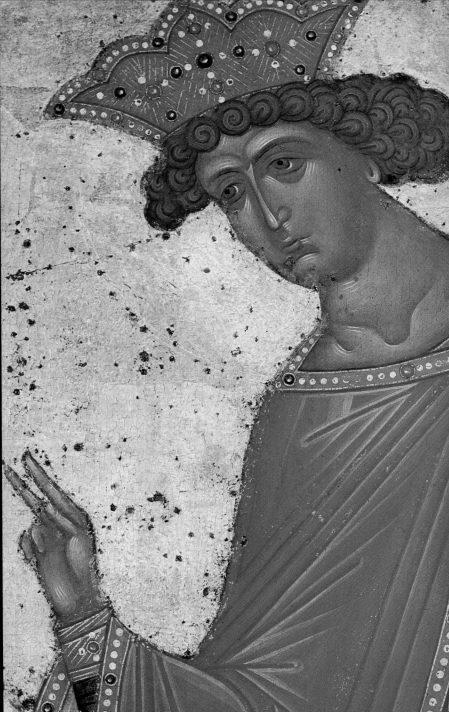

DANIEL, DAVID, AND SOLOMON
TRETYAKOV GALLERY, MOSCOW

NOVGOROD SCHOOL
ABOUT 1497 57

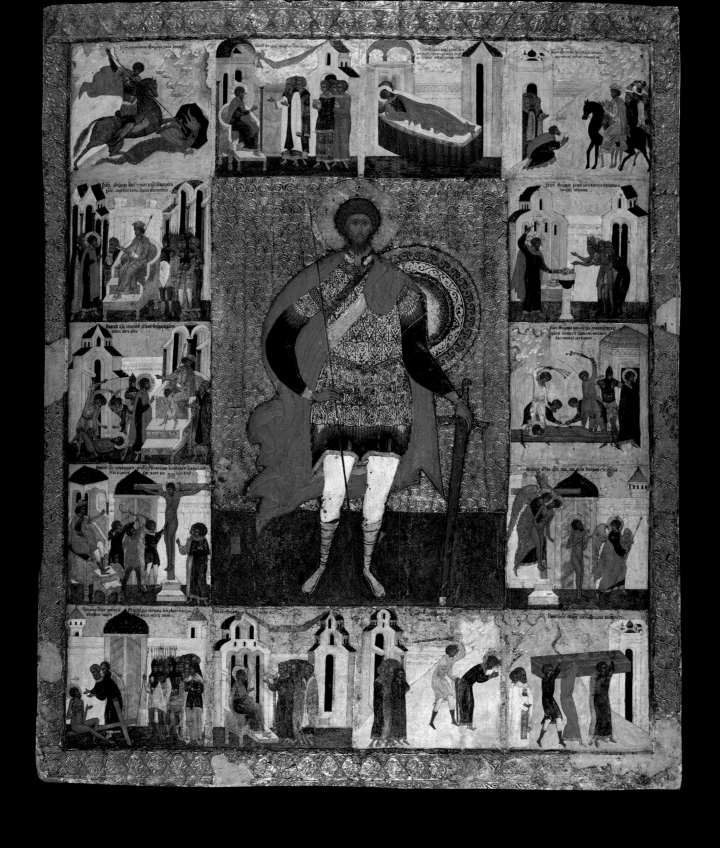

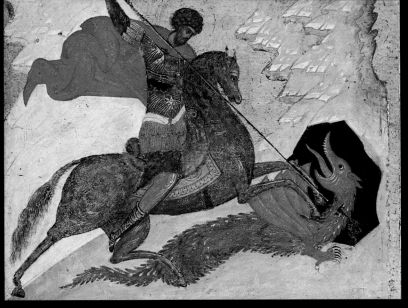
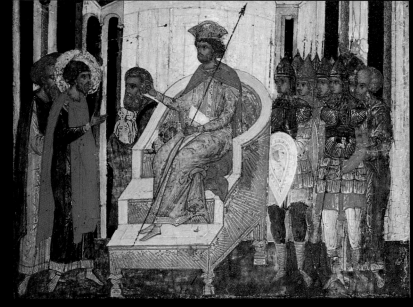
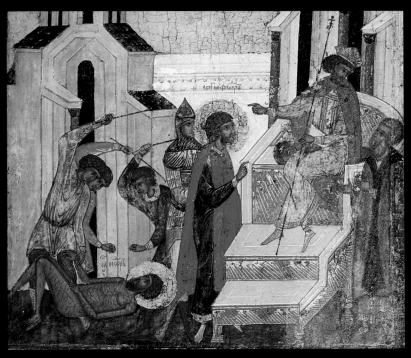
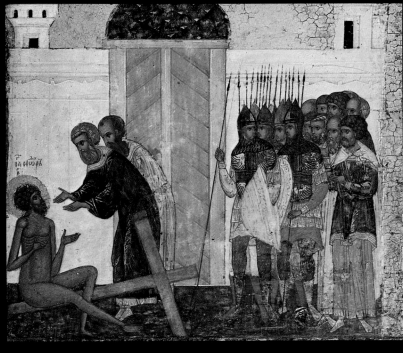
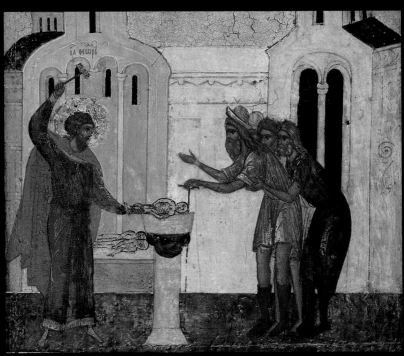
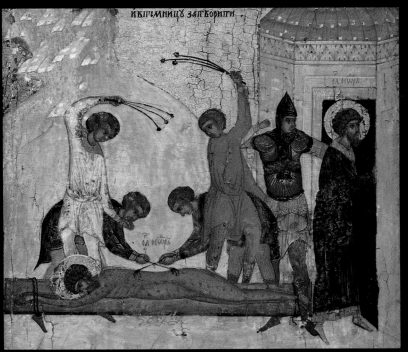

SAINT THEODORE STRATILATES WITH SCENES
FROM HIS LIFE (DETAILS)
MUSEUM OF HISTORY AND ARCHITECTURE, NOVGOROD

NOVGOROD SCHOOL
LATE 15TH CENTURY 58

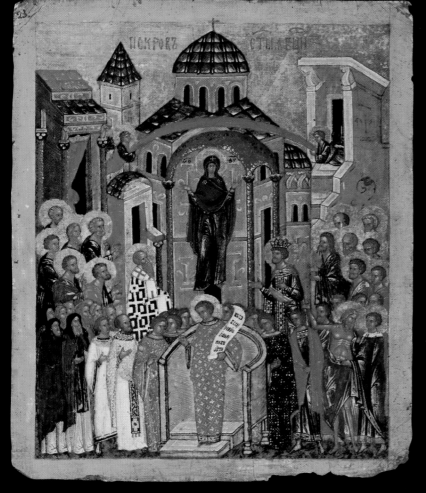

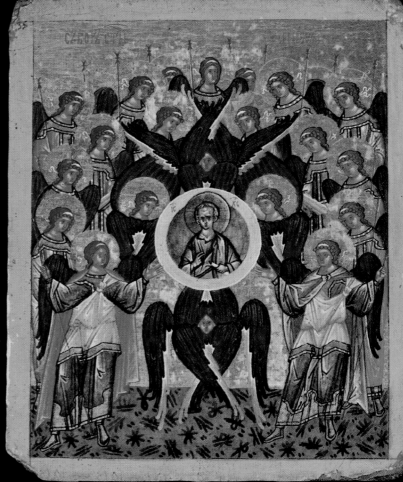

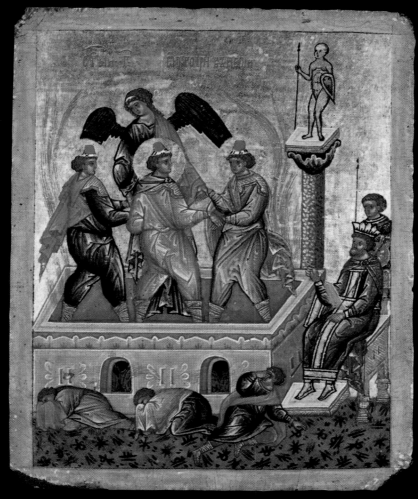

NOVGOROD SCHOOL
LATE 15TH–
EARLY 16TH CENTURY

THE VIRGIN OF MERCY; RECTO: THE SYNAXIS OF THE ARCHANGELS;
VERSO: THE THREE CHILDREN IN THE FIERY FURNACE
MUSEUM OF HISTORY AND ARCHITECTURE, NOVGOROD;
RUSSIAN MUSEUM, SAINT PETERSBURG

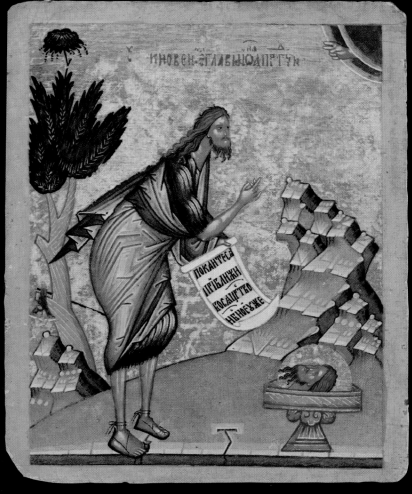

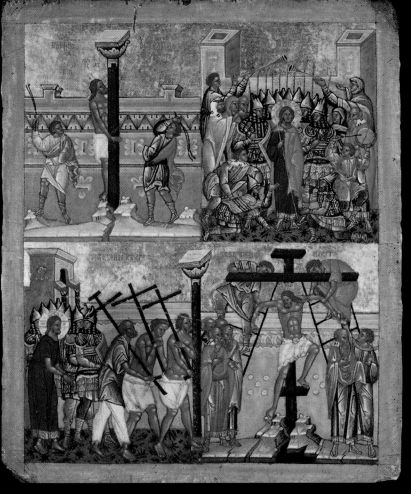

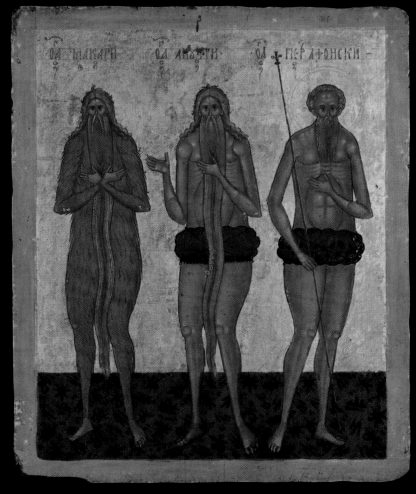

SAINT JOHN THE BAPTIST IN THE DESERT; SCENES OF THE PASSION; SAINTS
MACARIUS OF EGYPT, ONUPHRIUS THE GREAT, AND PETER OF ATHOS
MUSEUM OF HISTORY AND ARCHITECTURE, NOVGOROD;
RUSSIAN MUSEUM, SAINT PETERSBURG

NOVGOROD SCHOOL
LATE 15TH–
EARLY 16TH CENTURY

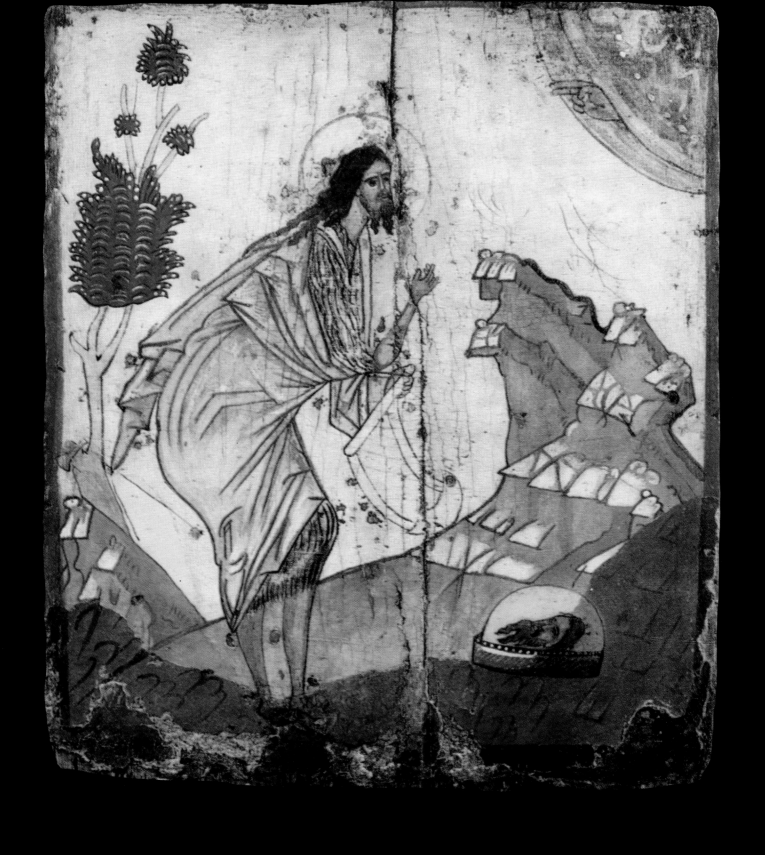

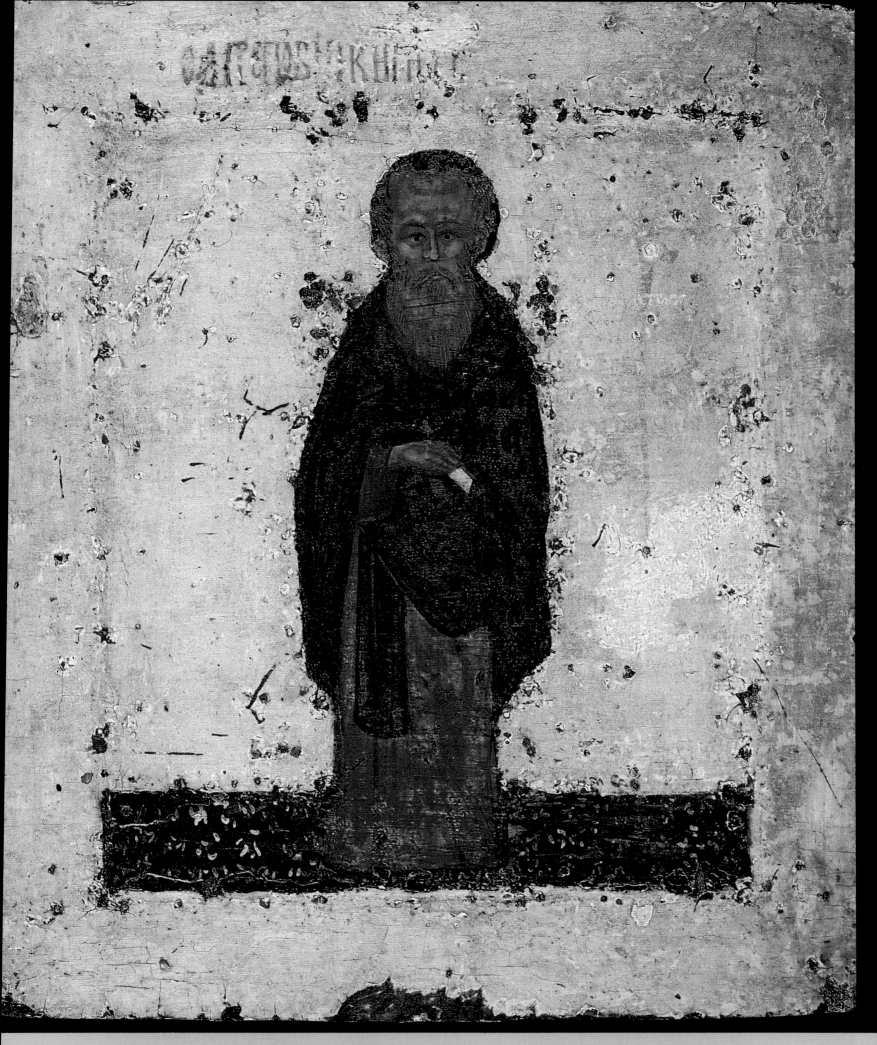

SAINT CYRIL OF BELOZERSK
TRETYAKOV GALLERY, MOSCOW

NORTHERN SCHOOL
DIONYSII OF GLUSHCHITSKII **61**
1424

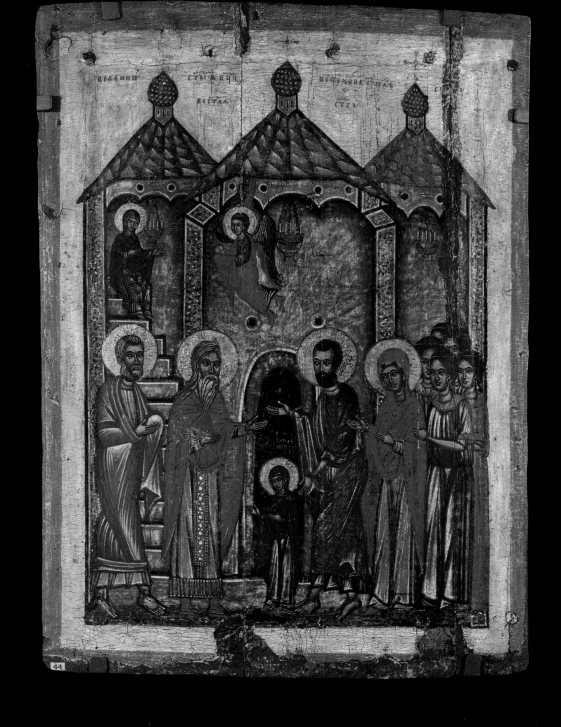

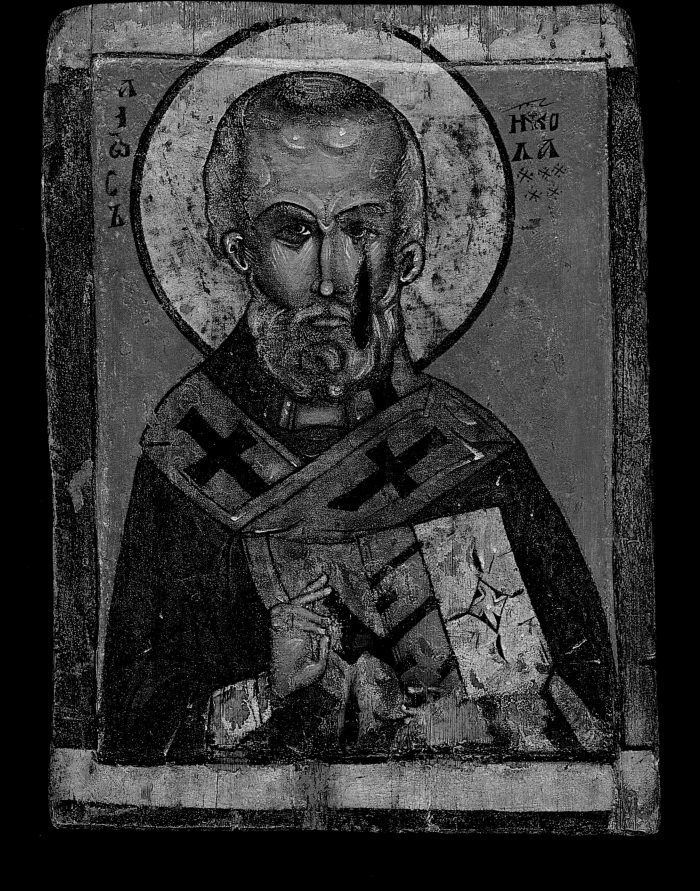

ΑΓΙΟС ΝΙΚΟΛΑ

SAINT NICHOLAS THE WONDERWORKER
RUSSIAN MUSEUM, SAINT PETERSBURG

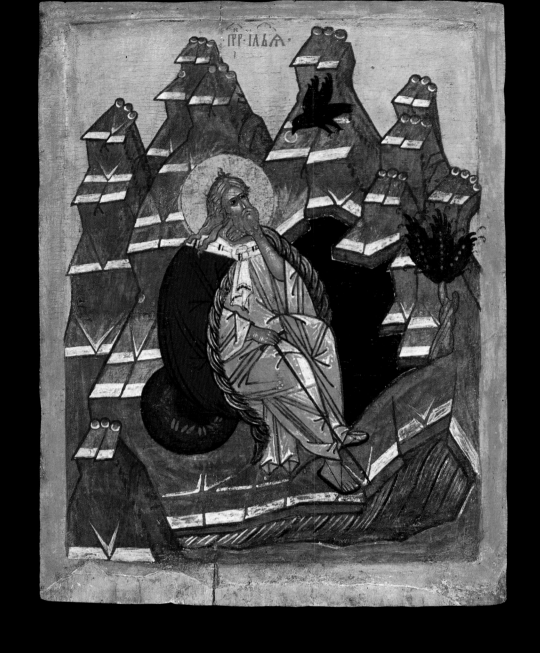

64 NORTHERN SCHOOL THE PROPHET ELIJAH IN THE DESERT 218
FIRST HALF KARELIAN FINE ARTS MUSEUM, PETROZAVODSK
OF 15TH CENTURY

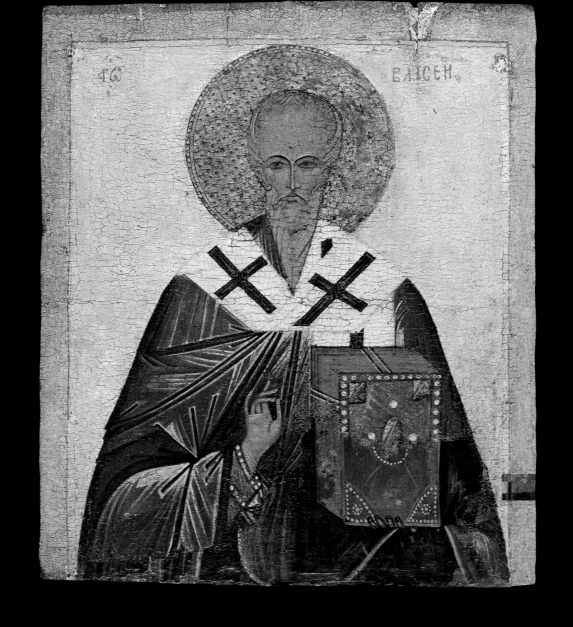

SAINT BLAISE
KARELIAN FINE ARTS MUSEUM, PETROZAVODSK

NORTHERN SCHOOL
SECOND HALF 65
OF 15TH CENTURY

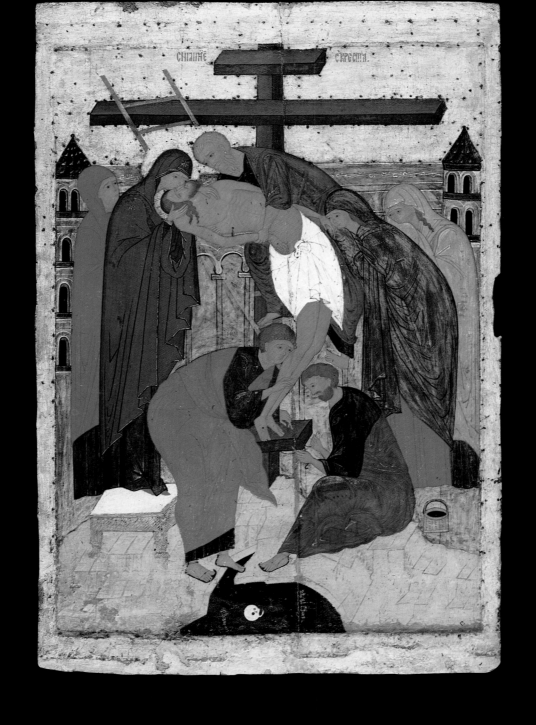

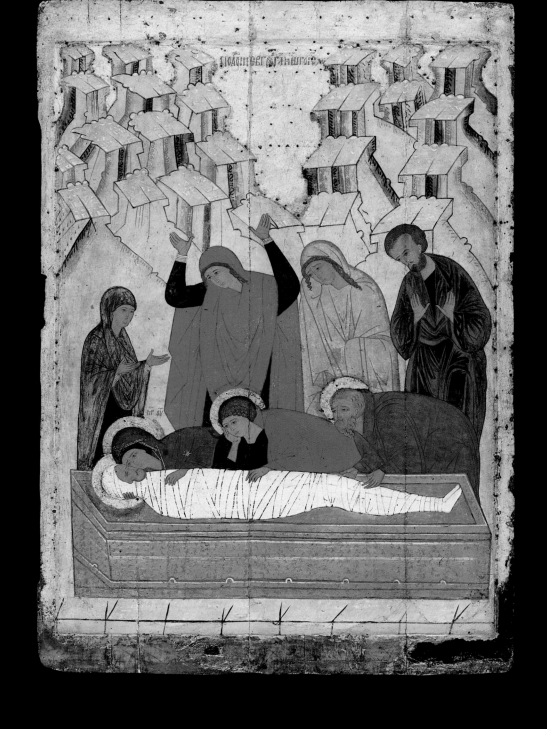

THE ENTOMBMENT
TRETYAKOV GALLERY, MOSCOW

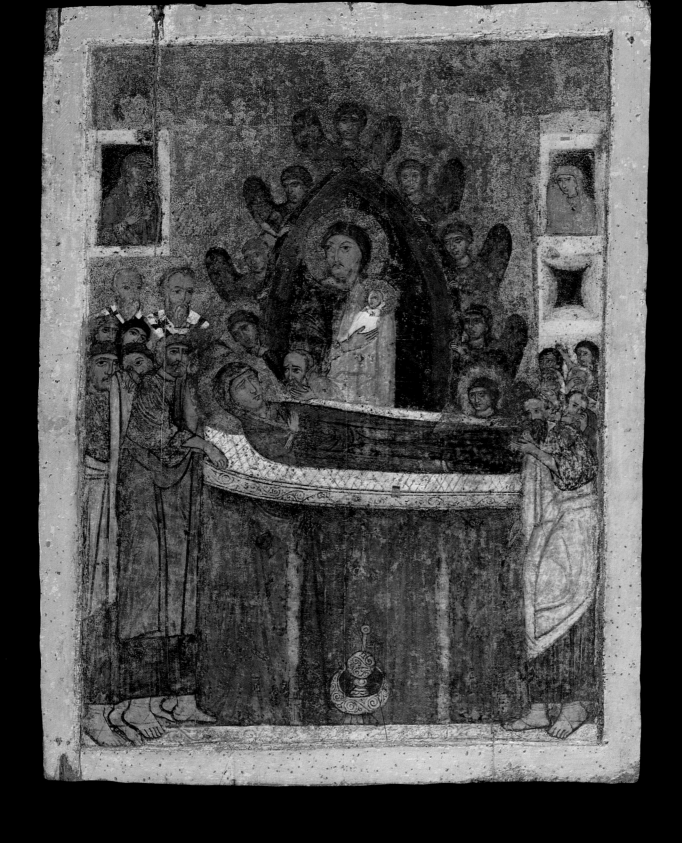

THE DORMITION (DETAIL)
TRETYAKOV GALLERY, MOSCOW

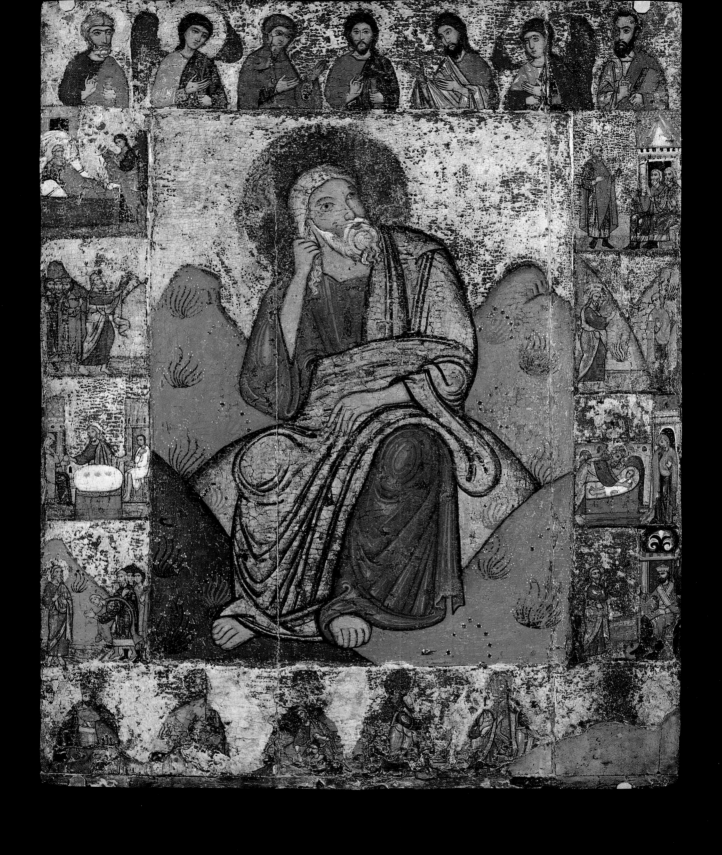

PSKOV SCHOOL
LATE 13TH–
EARLY 14TH CENTURY

THE PROPHET ELIJAH WITH SCENES FROM HIS LIFE
RUSSIAN MUSEUM, SAINT PETERSBURG

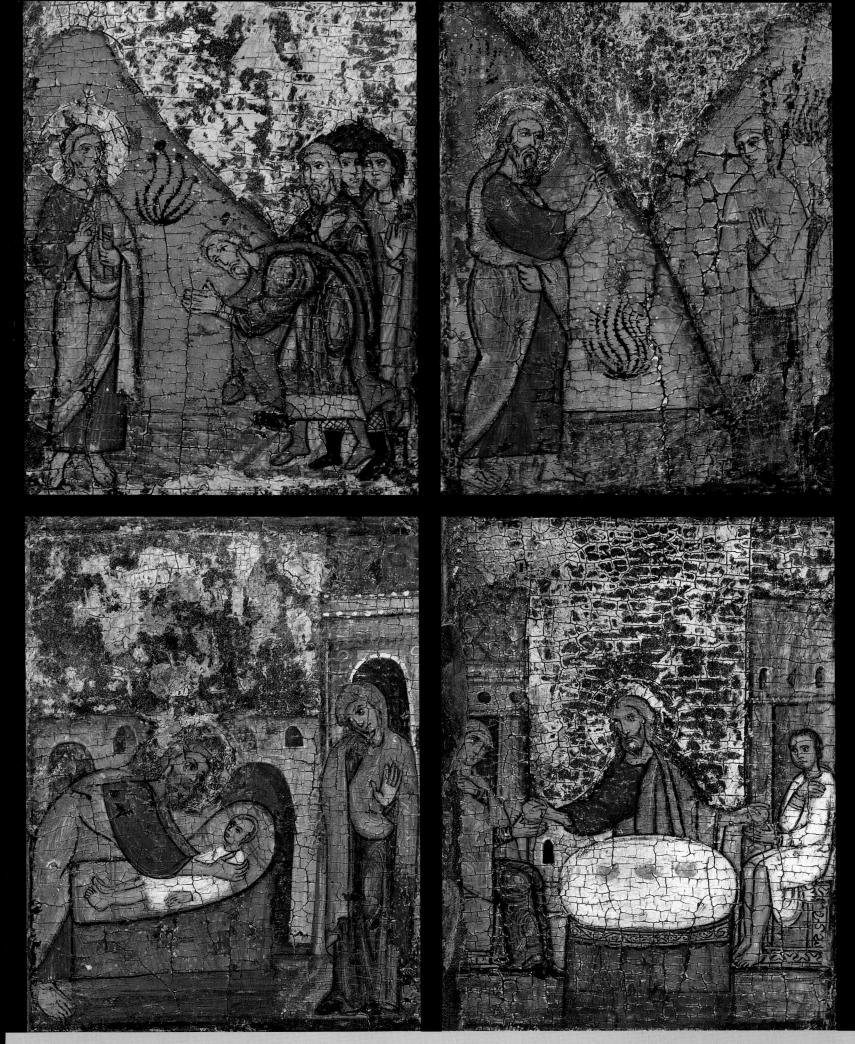

THE PROPHET ELIJAH WITH SCENES FROM HIS LIFE (DETAILS)
RUSSIAN MUSEUM, SAINT PETERSBURG

PSKOV SCHOOL
LATE 13TH–
EARLY 14TH CENTURY

68

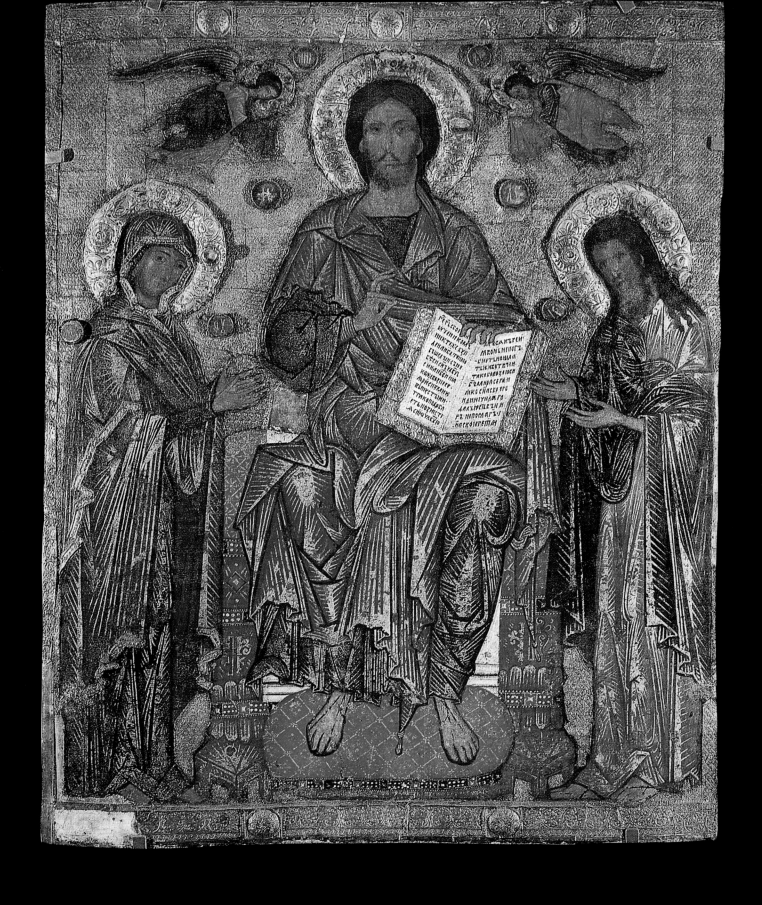

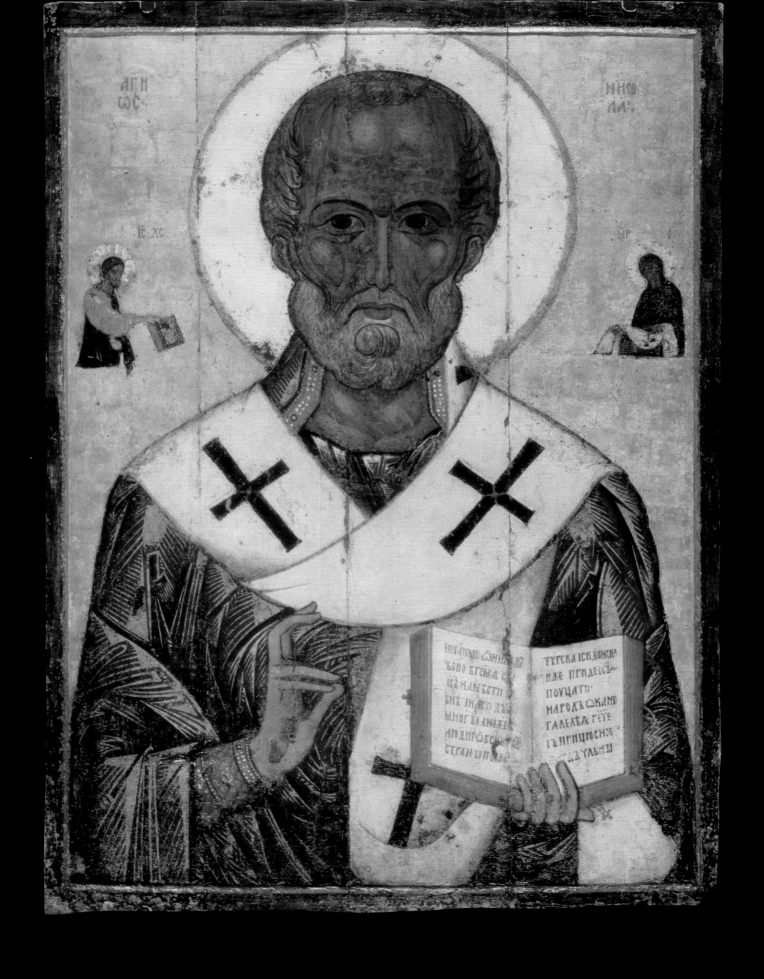

SAINT NICHOLAS THE WONDERWORKER
TRETYAKOV GALLERY, MOSCOW

PSKOV SCHOOL
EARLY 70
14TH CENTURY

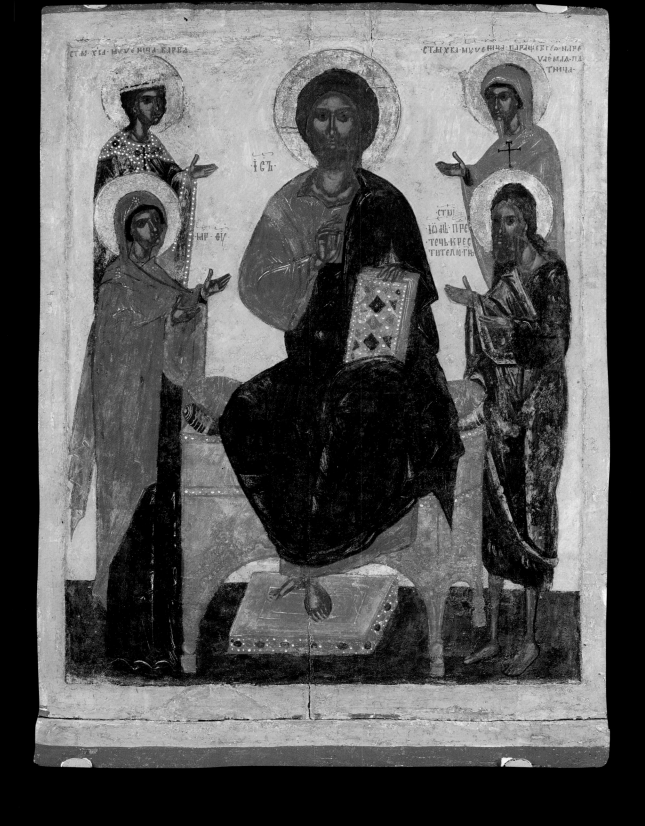

СТЫ ХВ МУЧЕНИЦА БАРБА

ІСЪ

СТЫ ХВ МУЧЕНИЦА ПАРАСКЕВА НАРЕ
УАЕМА ПА
ТНЦА

МР ѲУ

СТЫ
ІОАНЬ ПРЕ
ТЕЧЬ КРЕС
ТИТЕЛЮ ГЬ

PSKOV SCHOOL
LAST QUARTER
OF 14TH CENTURY

DEESIS WITH SAINTS BARBARA AND PARASKEVA
MUSEUM OF HISTORY AND ARCHITECTURE, NOVGOROD

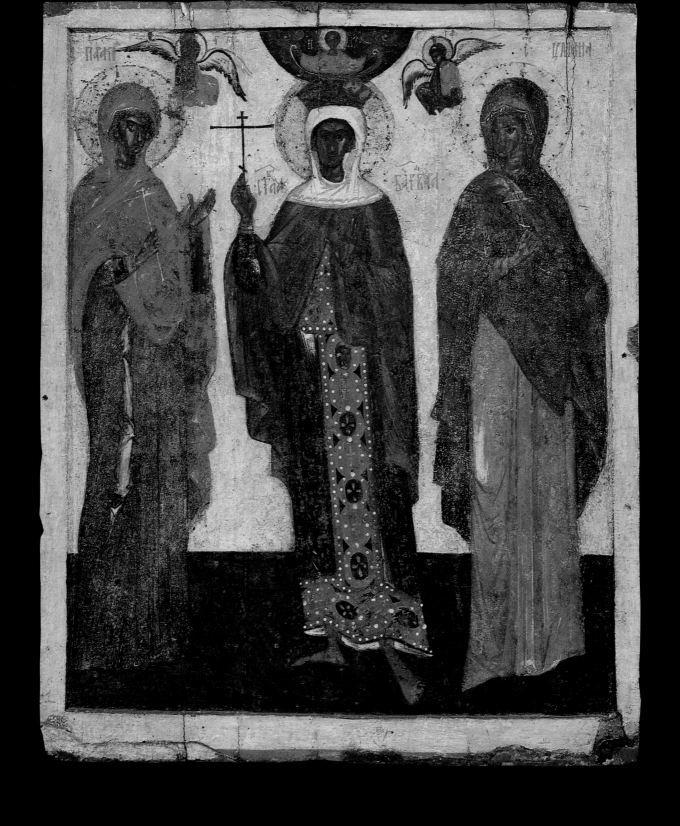

SAINTS PARASKEVA, BARBARA, AND JULIANA
TRETYAKOV GALLERY, MOSCOW

PSKOV SCHOOL
LAST QUARTER 72
OF 14TH CENTURY

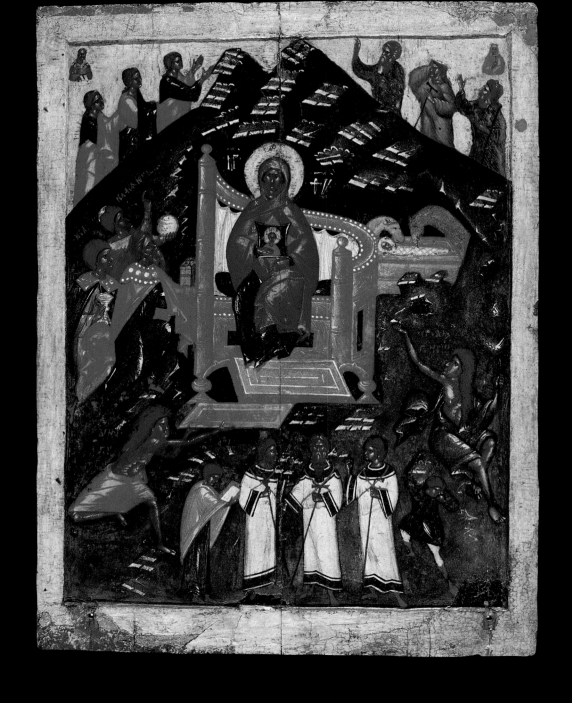

THE SYNAXIS OF THE VIRGIN (DETAIL)
TRETYAKOV GALLERY, MOSCOW

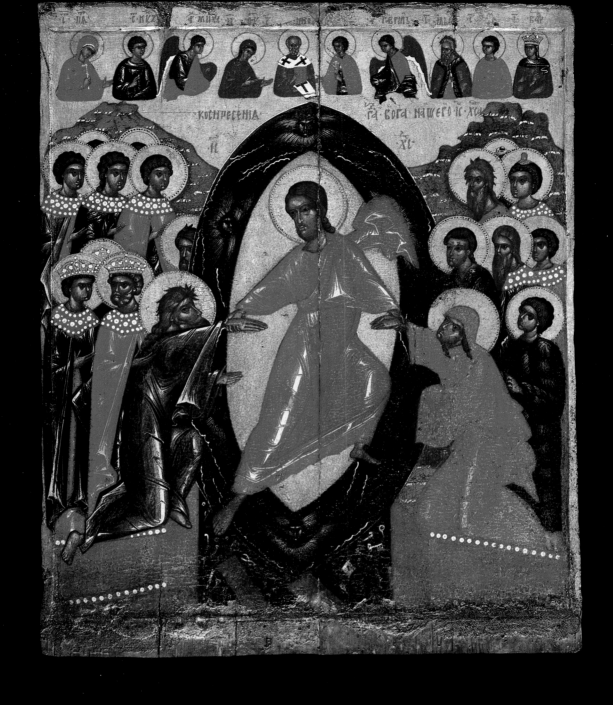

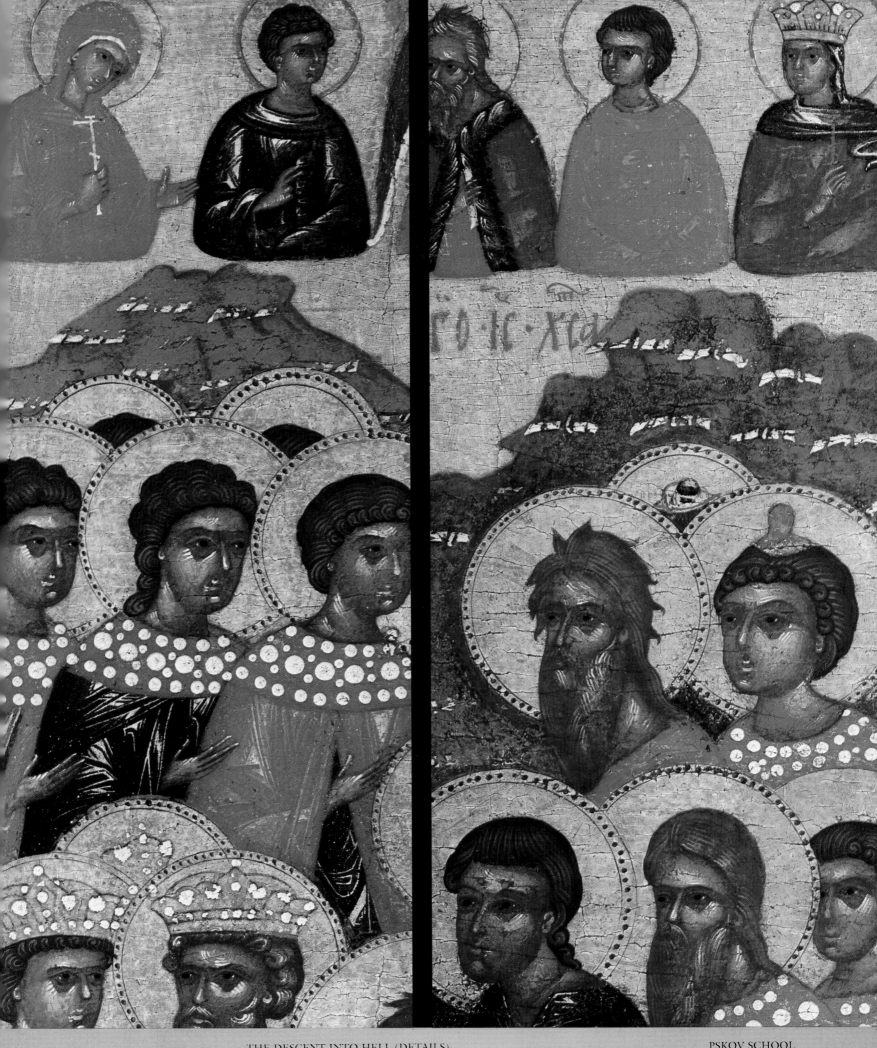

ΓΟ · ΙΣ · ΧϹ

THE DESCENT INTO HELL (DETAILS)
RUSSIAN MUSEUM, SAINT PETERSBURG

PSKOV SCHOOL
LAST QUARTER 74
OF 14TH CENTURY

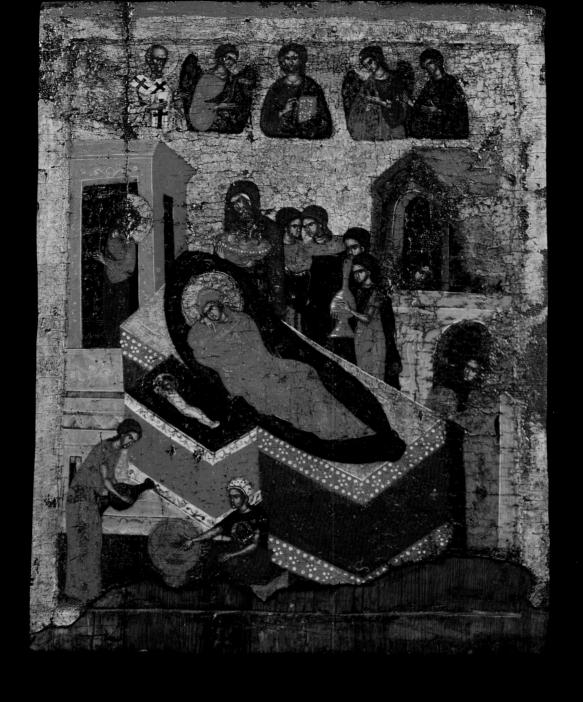

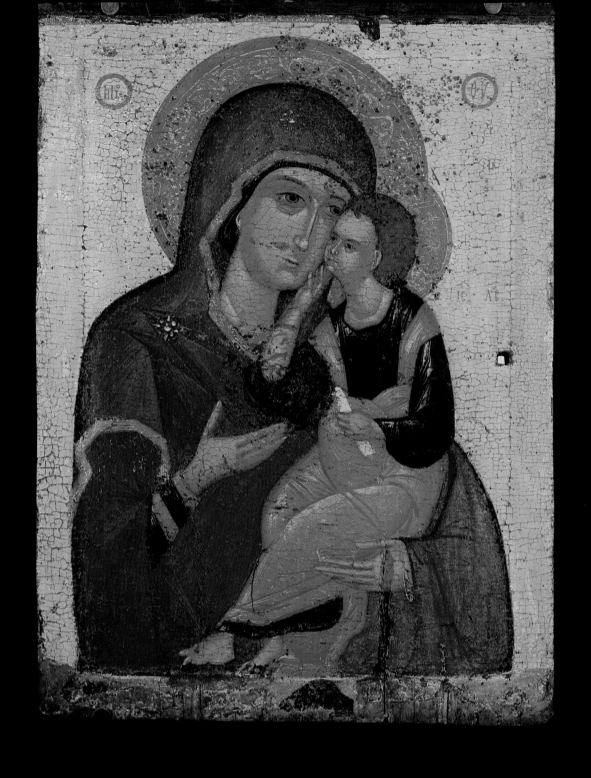

THE VIRGIN OF TENDERNESS
TRETYAKOV GALLERY, MOSCOW

PSKOV SCHOOL
EARLY 76
15TH CENTURY

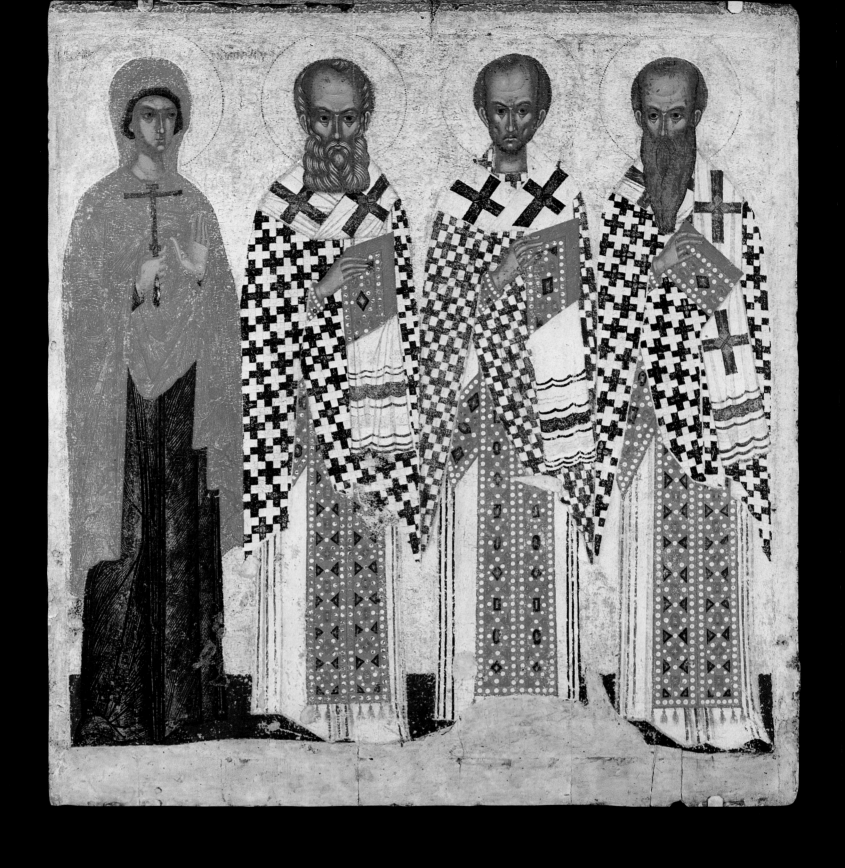

PSKOV SCHOOL
EARLY
15TH CENTURY

SAINTS PARASKEVA PYATNITSA, GREGORY THE THEOLOGIAN,
JOHN CHRYSOSTOM, AND BASIL THE GREAT
TRETYAKOV GALLERY, MOSCOW

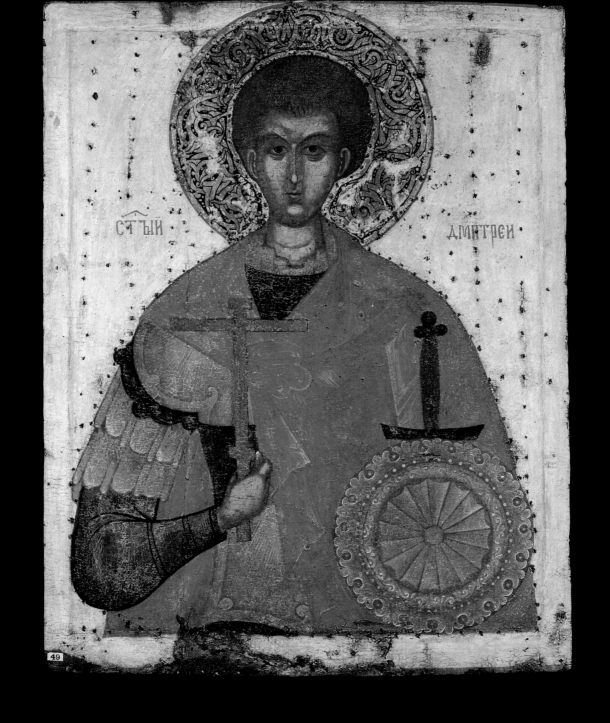

СТЫИ ДМИТРЕИ

237 SAINT DEMETRIUS OF THESSALONICA PSKOV SCHOOL
 RUSSIAN MUSEUM, SAINT PETERSBURG SECOND QUARTER 78
 OF 15TH CENTURY

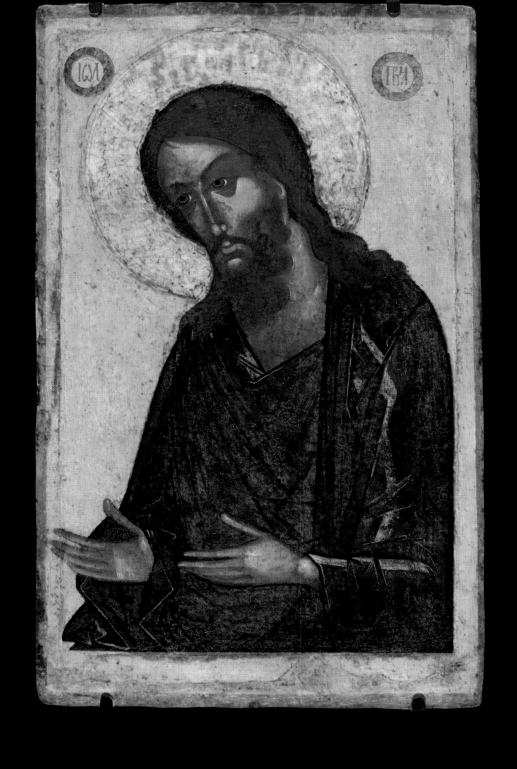

PSKOV SCHOOL
FIRST HALF
OF 15TH CENTURY

SAINT JOHN THE BAPTIST
TRETYAKOV GALLERY, MOSCOW

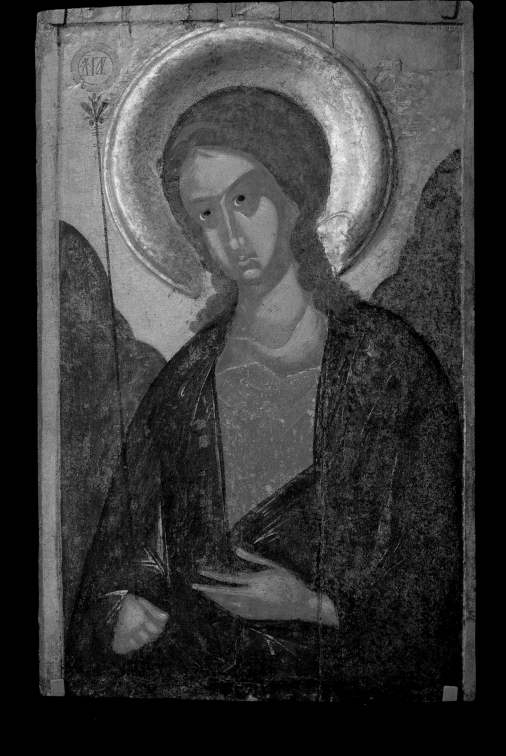

THE ARCHANGEL GABRIEL
RUSSIAN MUSEUM, SAINT PETERSBURG

PSKOV SCHOOL
FIRST HALF 79
OF 15TH CENTURY

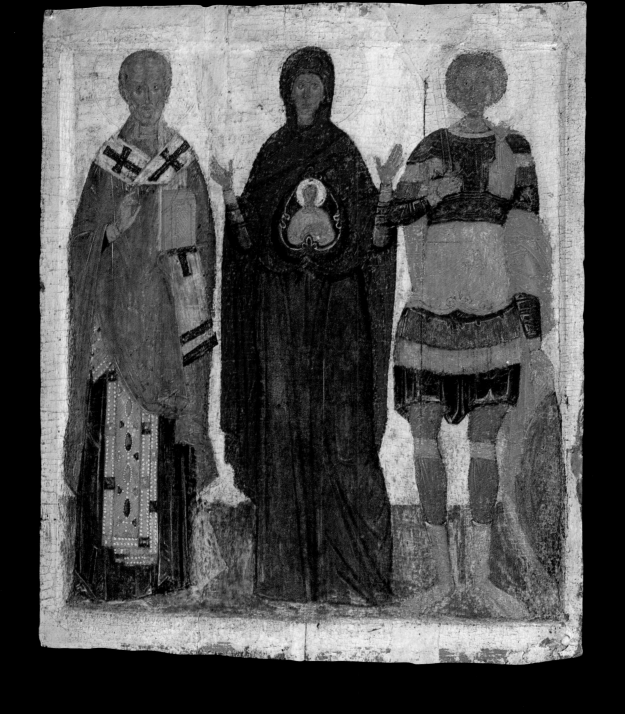

PSKOV SCHOOL
LATE
15TH CENTURY

THE VIRGIN GREAT PANAGIA, SAINTS NICHOLAS AND GEORGE
TRETYAKOV GALLERY, MOSCOW

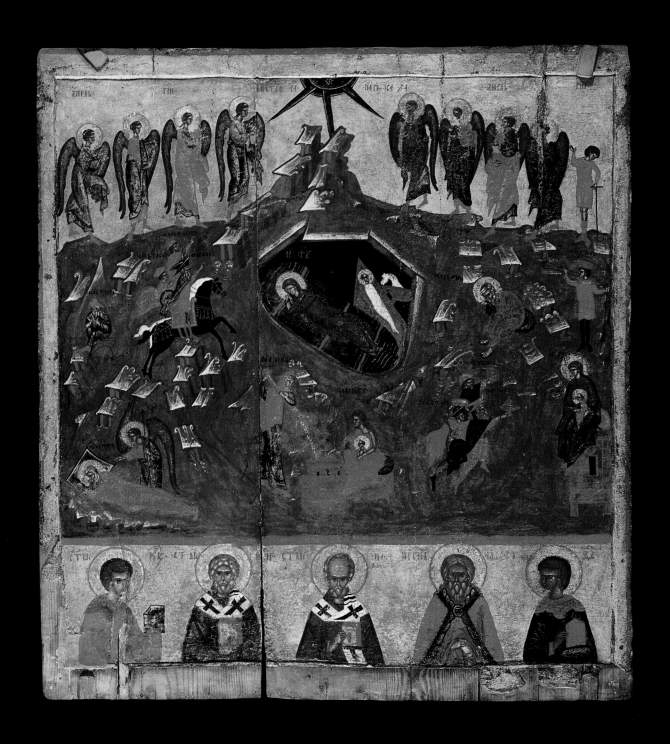

THE NATIVITY OF CHRIST WITH SAINTS
TRETYAKOV GALLERY, MOSCOW

PSKOV SCHOOL
LATE 81
15TH CENTURY

PSKOV SCHOOL
LATE
15TH CENTURY

THE NATIVITY OF CHRIST WITH SAINTS (DETAILS)
TRETYAKOV GALLERY, MOSCOW

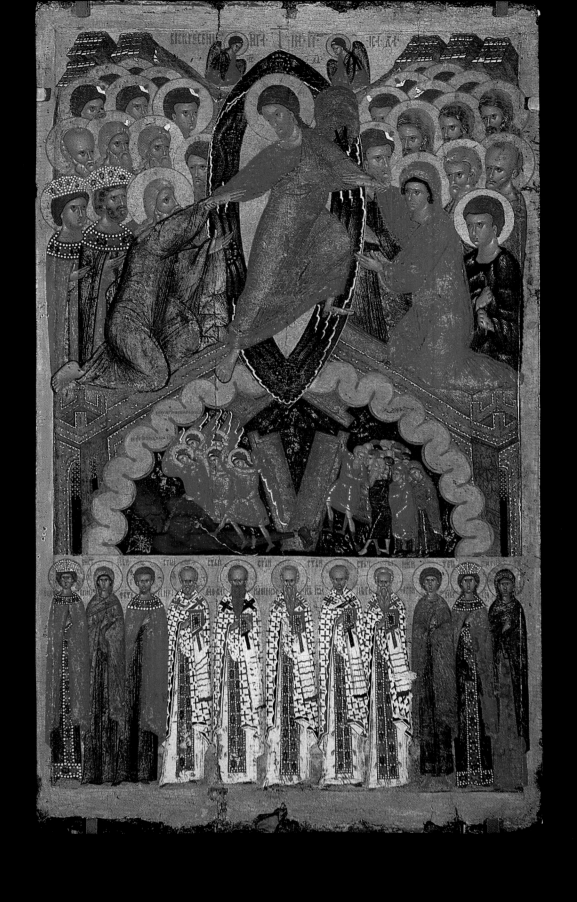

THE DESCENT INTO HELL WITH SAINTS
RUSSIAN MUSEUM, SAINT PETERSBURG

PSKOV SCHOOL
LATE 15TH– 82
EARLY 16TH CENTURY

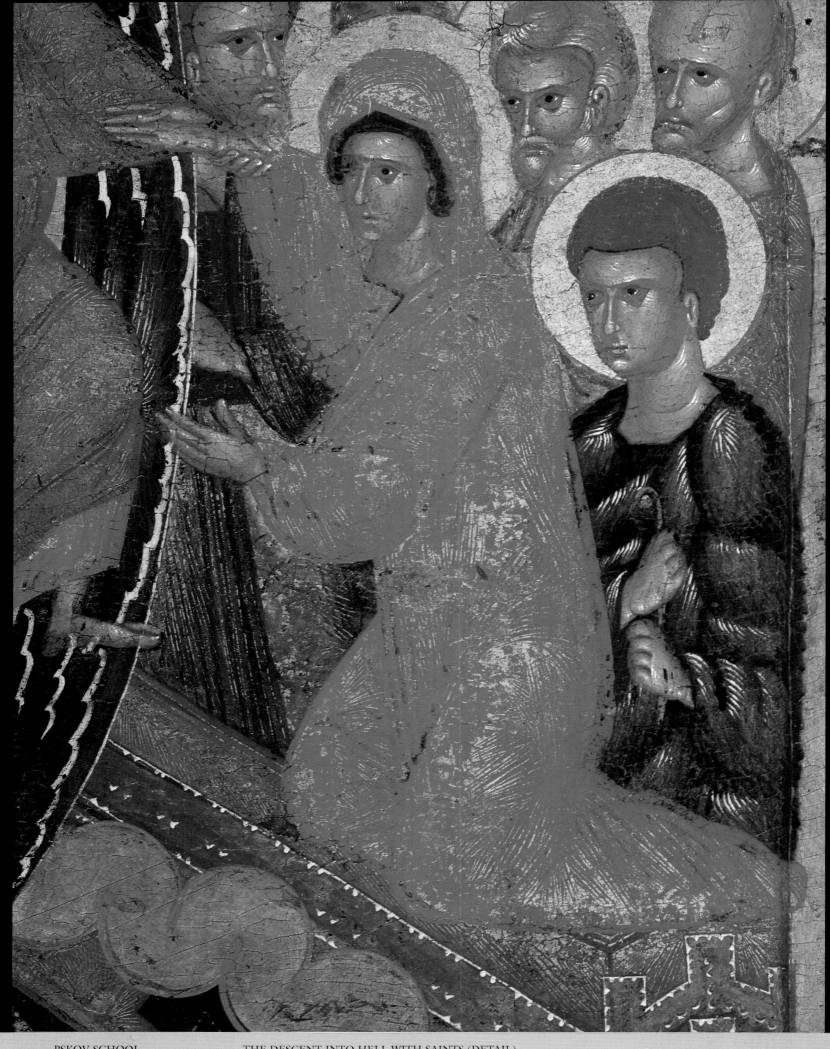

PSKOV SCHOOL
LATE 15th–
EARLY 16TH CENTURY

THE DESCENT INTO HELL WITH SAINTS (DETAIL)
RUSSIAN MUSEUM, SAINT PETERSBURG

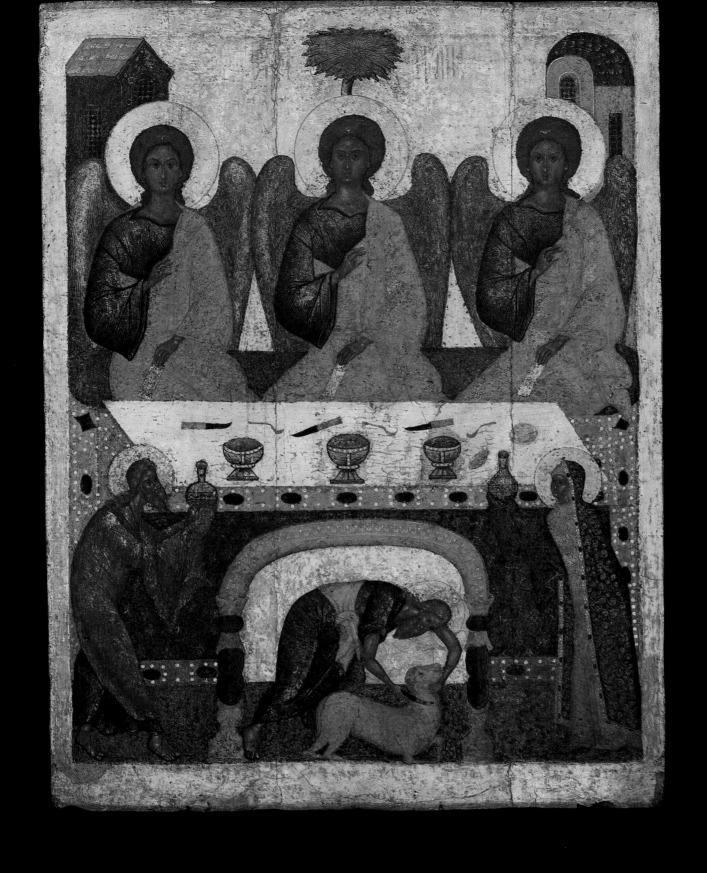

THE TRINITY
RUSSIAN MUSEUM, SAINT PETERSBURG

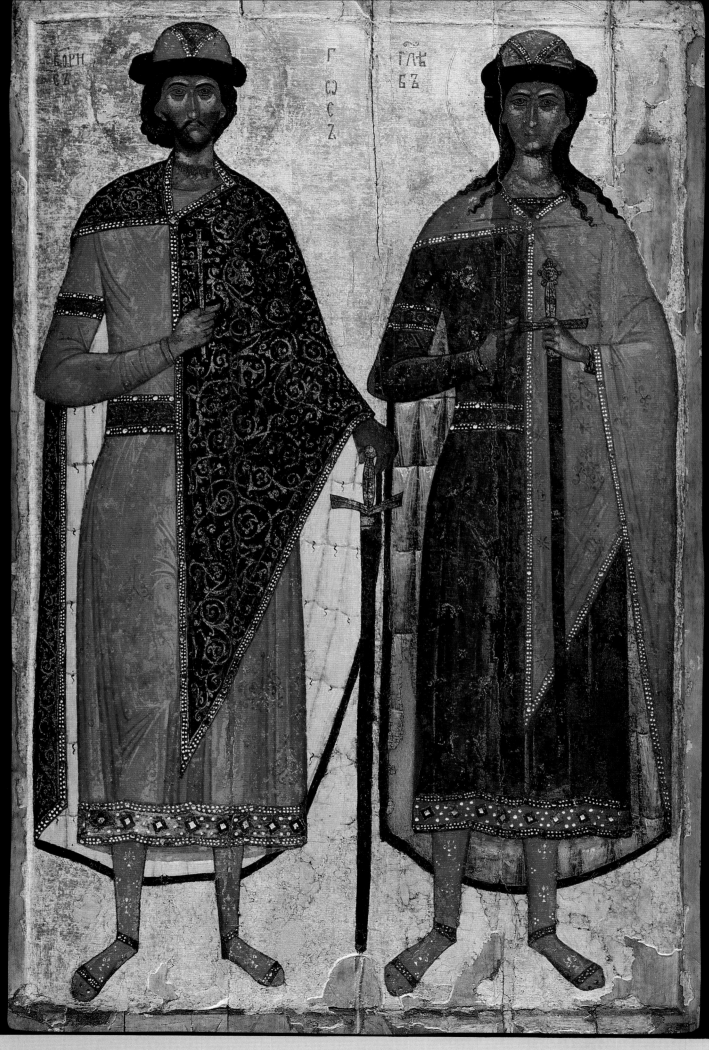

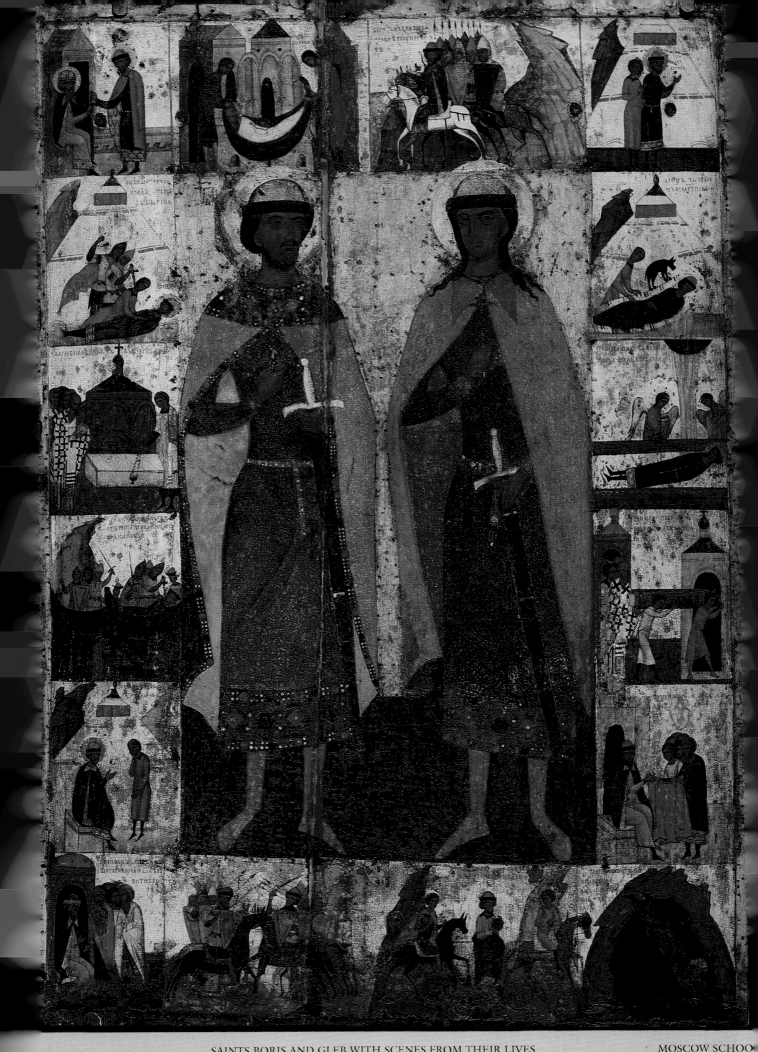

SAINTS BORIS AND GLEB WITH SCENES FROM THEIR LIVES
TRETYAKOV GALLERY, MOSCOW

MOSCOW SCHOO
SECOND QUARTE
OF 14TH CENTUR

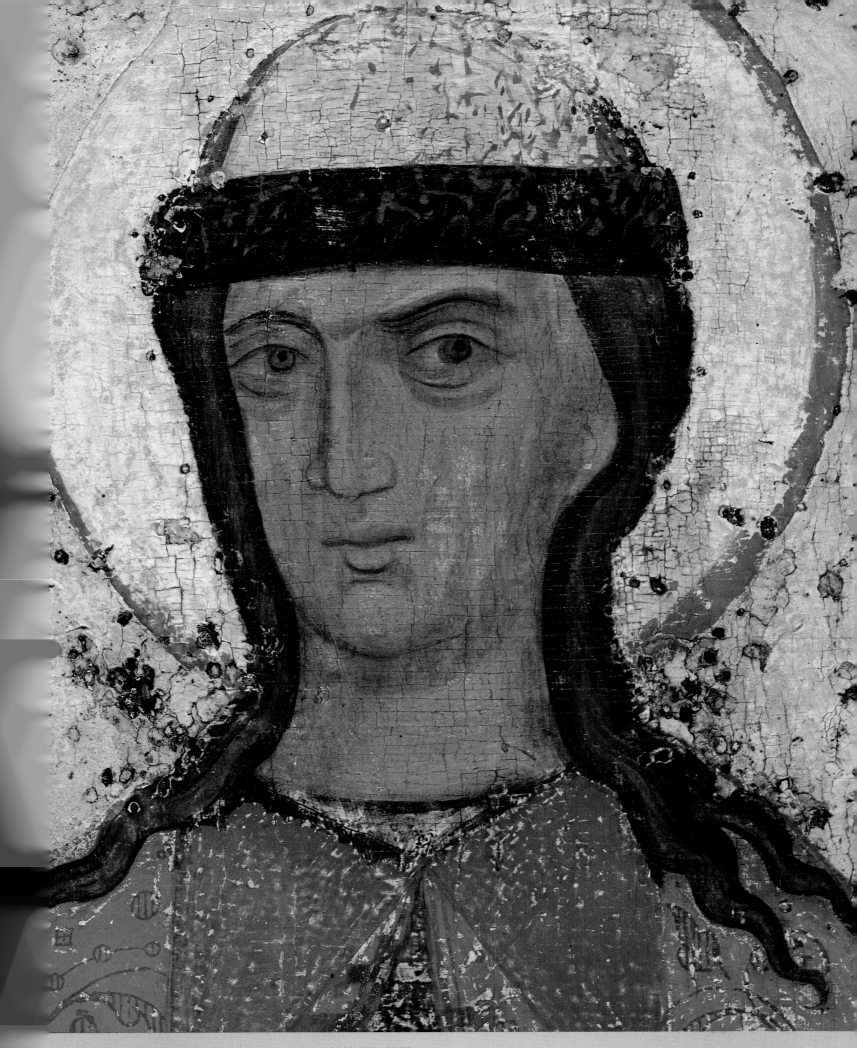

85 MOSCOW SCHOOL
SECOND QUARTER
OF 14TH CENTURY

SAINTS BORIS AND GLEB
WITH SCENES FROM THEIR LIVES (DETAIL)
TRETYAKOV GALLERY, MOSCOW

248

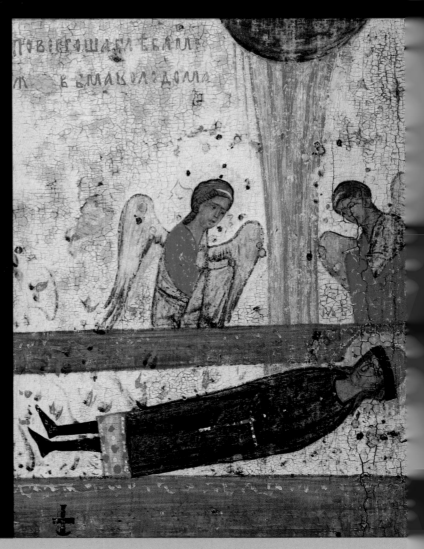

SAINTS BORIS AND GLEB
WITH SCENES FROM THEIR LIVES (DETAILS)
TRETYAKOV GALLERY, MOSCOW

MOSCOW SCHOOL
SECOND QUARTER
OF 14TH CENTURY

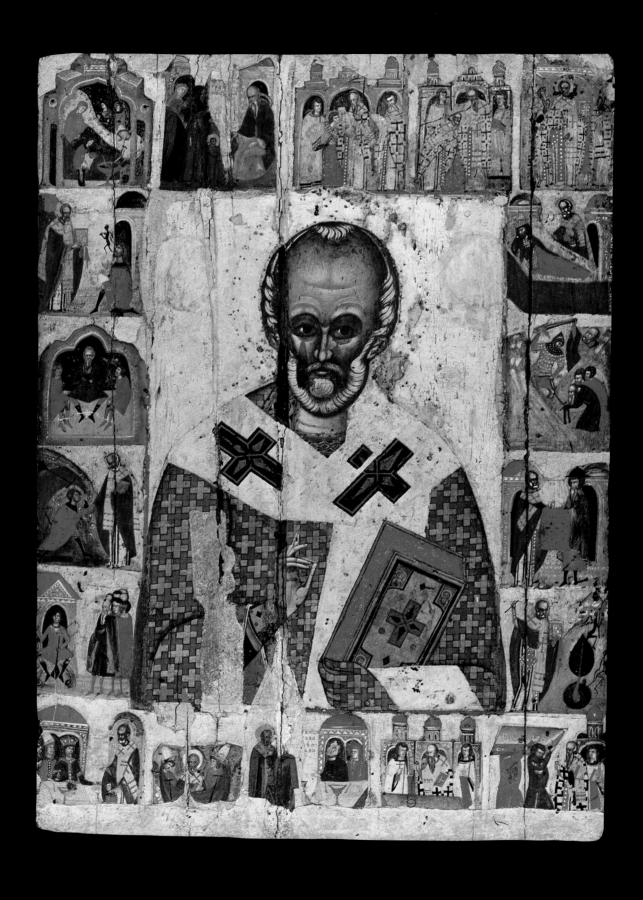

MOSCOW SCHOOL
SECOND HALF
OF 14TH CENTURY

SAINT NICHOLAS THE WONDERWORKER
WITH SCENES FROM HIS LIFE
TRETYAKOV GALLERY, MOSCOW

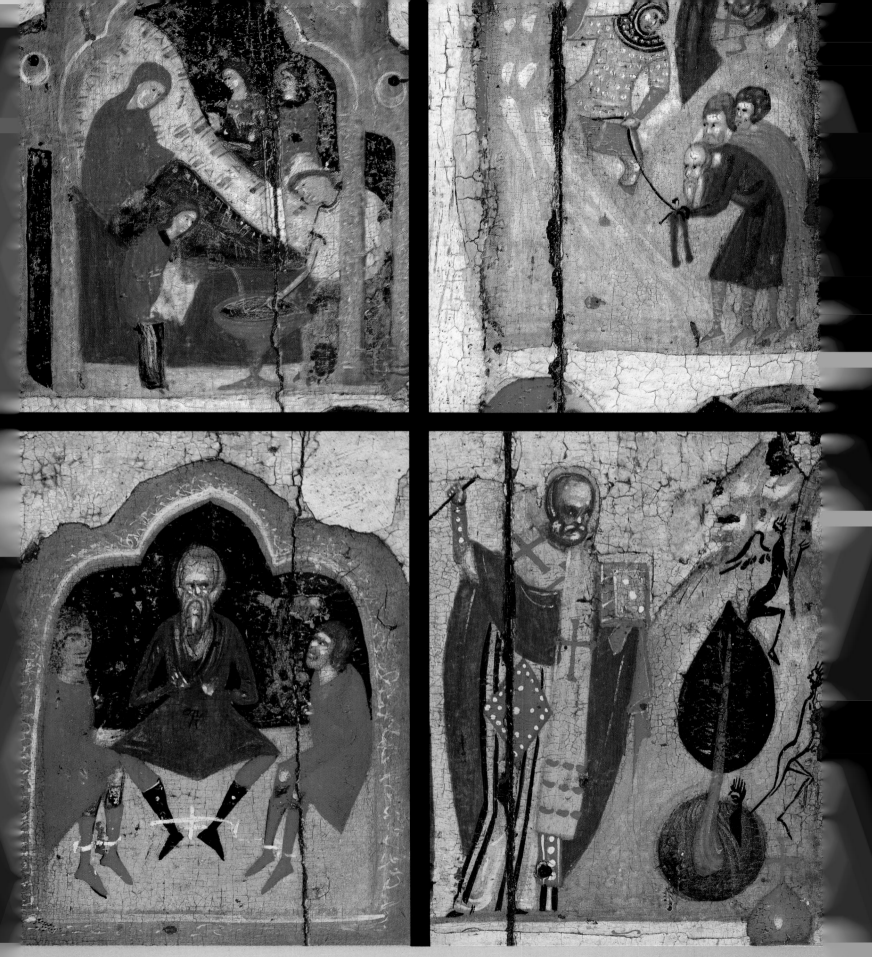

SAINT NICHOLAS THE WONDERWORKER
WITH SCENES FROM HIS LIFE (DETAILS)
TRETYAKOV GALLERY, MOSCOW

MOSCOW SCHOOL
SECOND HALF **86**
OF 14TH CENTURY

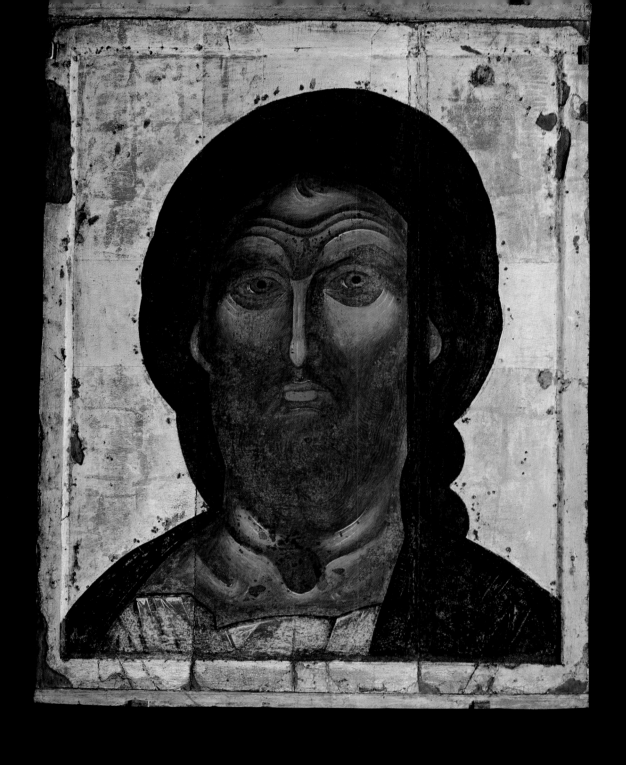

87 MOSCOW SCHOOL
 MID 14TH CENTURY THE SAVIOR OF THE FIERY EYE
 CATHEDRAL OF THE DORMITION, KREMLIN, MOSCOW 252

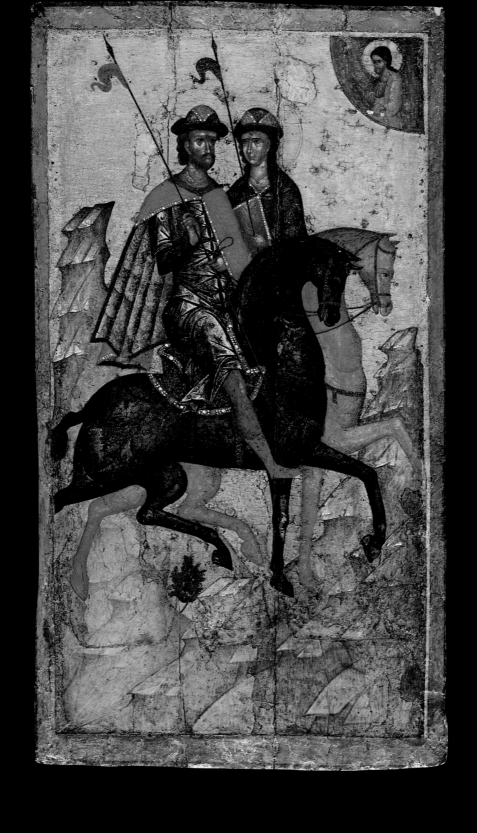

SAINTS BORIS AND GLEB
TRETYAKOV GALLERY, MOSCOW

MOSCOW SCHOOL
MID 14TH CENTURY

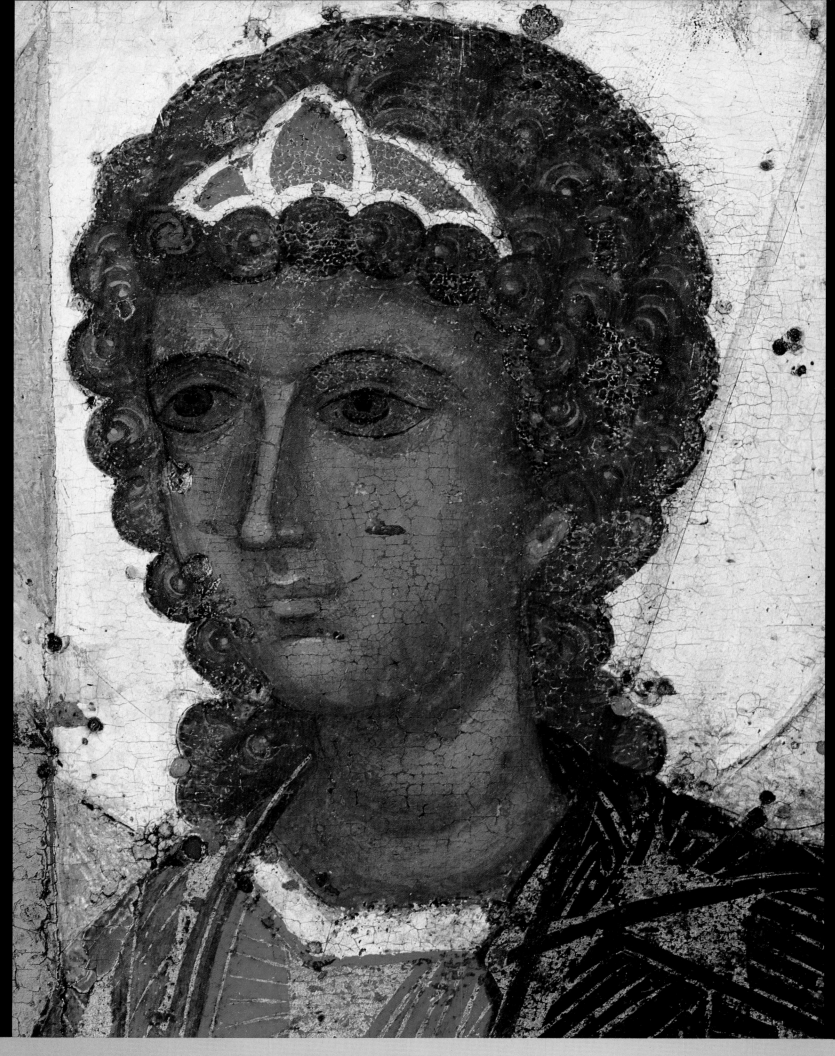

MOSCOW SCHOOL
MID 14TH CENTURY

HEAD OF AN ANGEL FROM AN ICON OF THE TRINITY
CATHEDRAL OF THE DORMITION, KREMLIN, MOSCOW

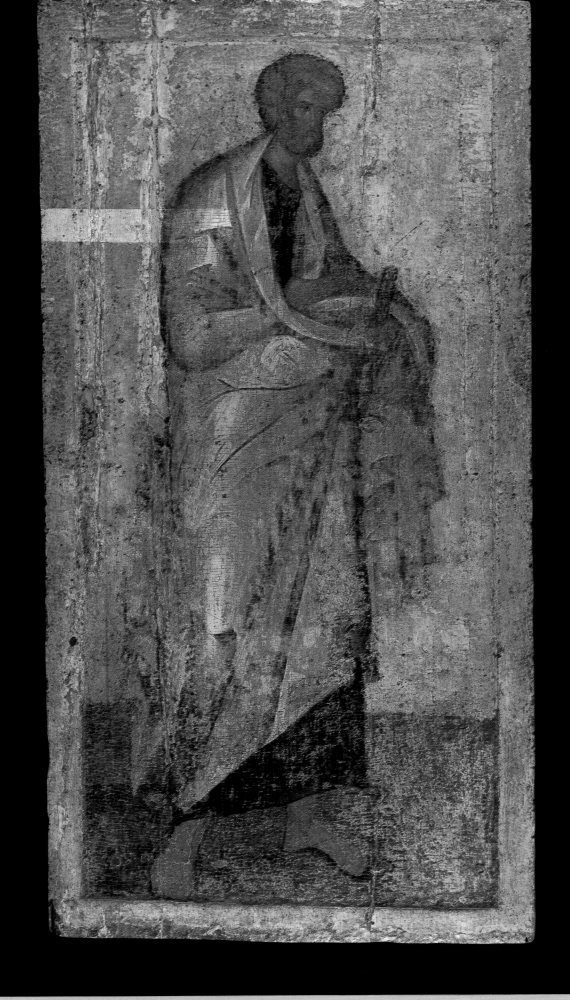

DEESIS: THE APOSTLE PETER
CATHEDRAL OF THE ANNUNCIATION, KREMLIN, MOSCOW

MOSCOW SCHOOL
THEOPHANES THE GREEK
AND HELPERS
LATE 14TH–EARLY 15TH CENTURY

90

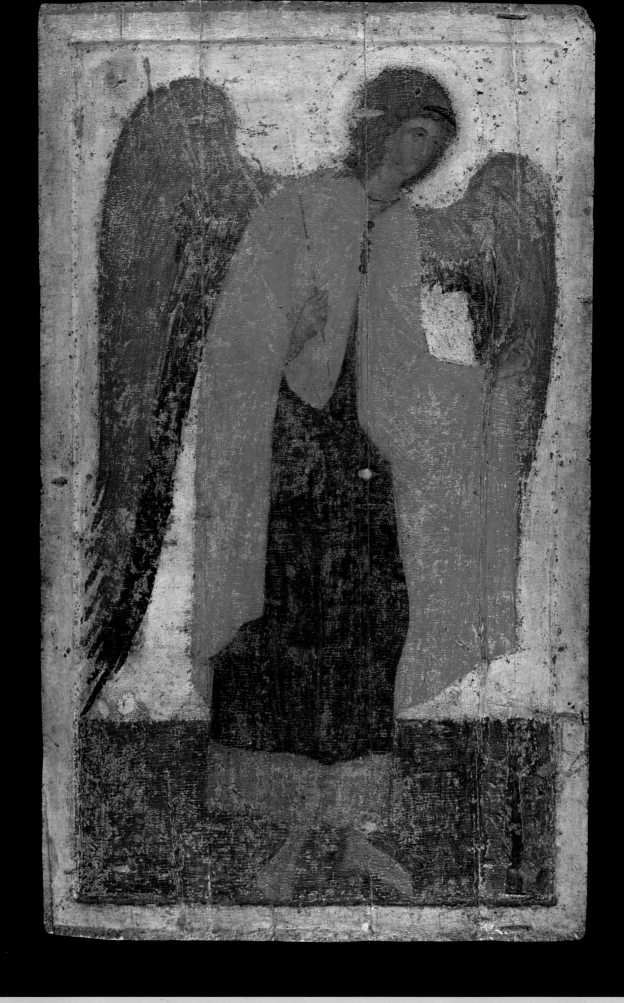

MOSCOW SCHOOL
THEOPHANES THE GREEK
AND HELPERS
LATE 14TH–EARLY 15TH-CENTURY

DEESIS: THE ARCHANGEL MICHAEL
CATHEDRAL OF THE ANNUNCIATION, KREMLIN, MOSCOW

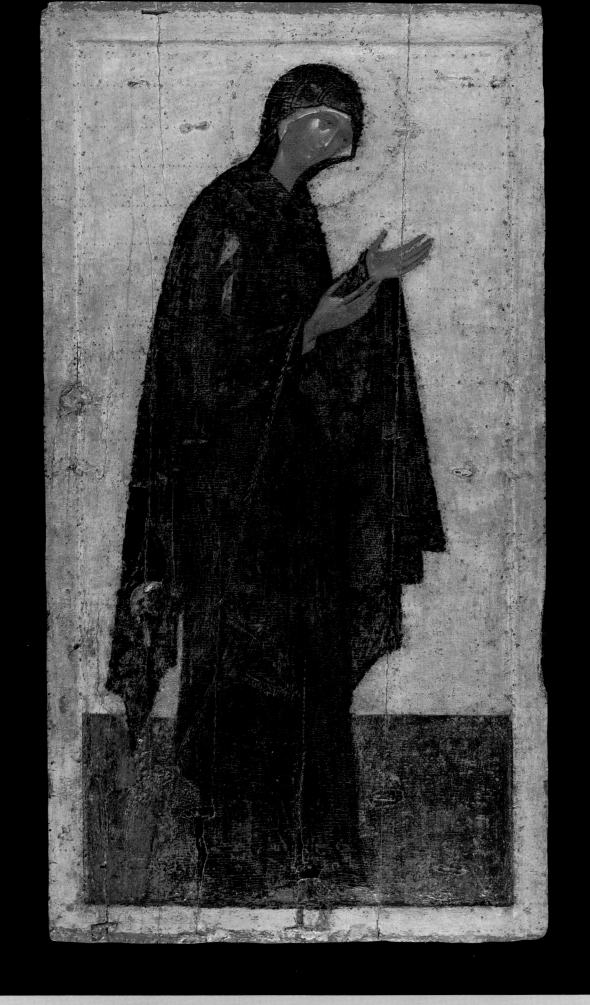

DEESIS: THE VIRGIN
CATHEDRAL OF THE ANNUNCIATION, KREMLIN, MOSCOW

MOSCOW SCHOOL
THEOPHANES THE GREEK 90
AND HELPERS
LATE 14TH–EARLY 15TH CENTURY

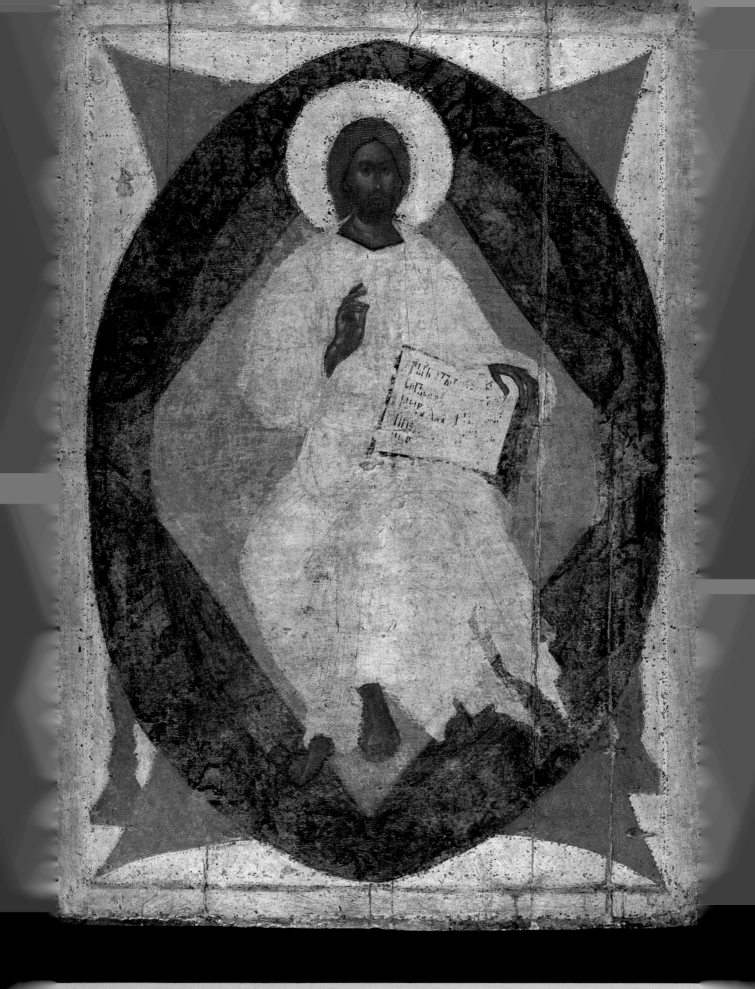

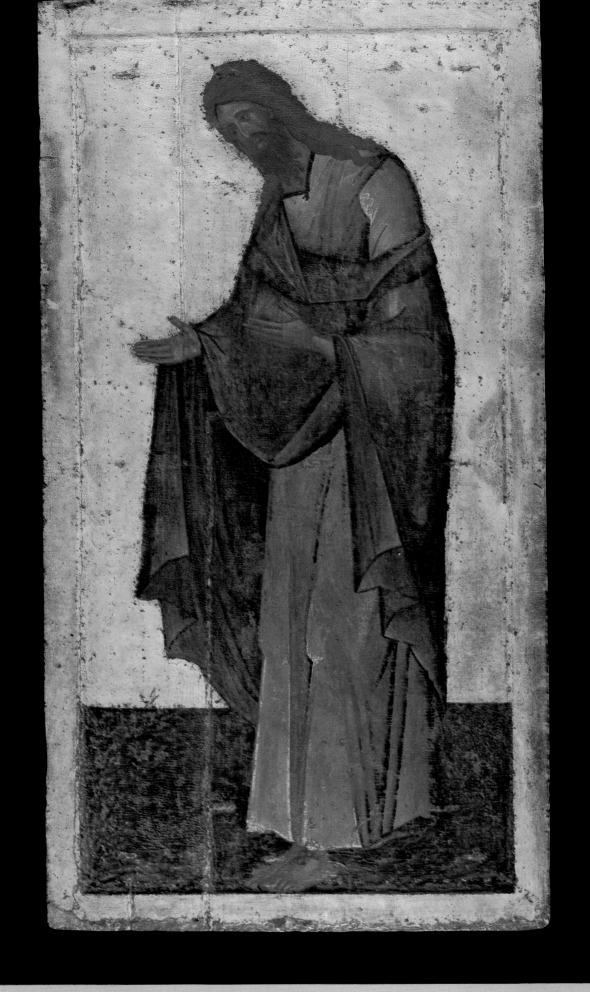

DEESIS: SAINT JOHN THE BAPTIST
CATHEDRAL OF THE ANNUNCIATION, KREMLIN, MOSCOW

MOSCOW SCHOOL
THEOPHANES THE GREEK
AND HELPERS
LATE 14TH–EARLY 15TH CENTURY

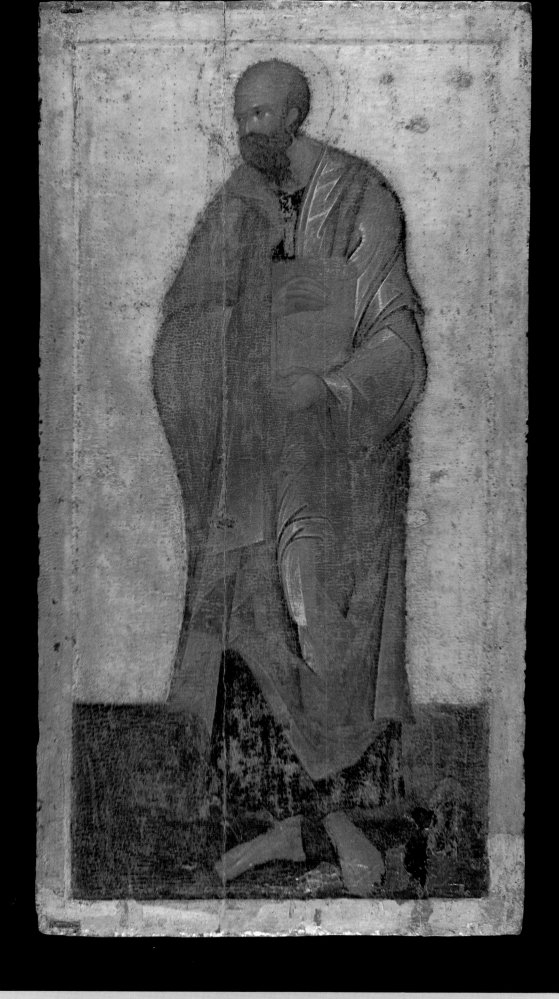

MOSCOW SCHOOL
THEOPHANES THE GREEK
AND HELPERS
LATE 14TH–EARLY 15TH CENTURY

DEESIS: THE APOSTLE PAUL
CATHEDRAL OF THE ANNUNCIATION, KREMLIN, MOSCOW

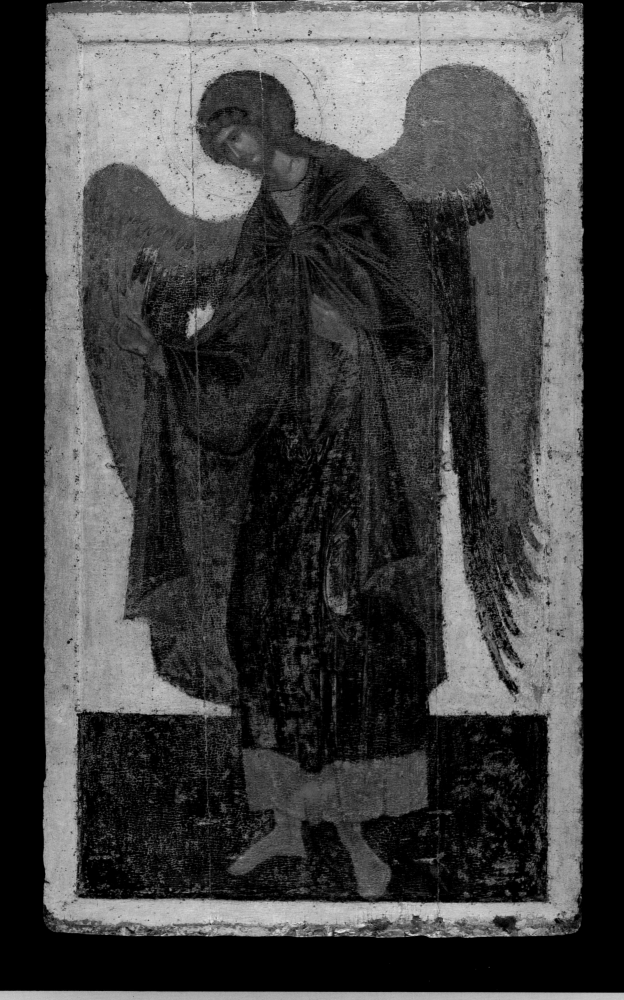

DEESIS: THE ARCHANGEL GABRIEL
CATHEDRAL OF THE ANNUNCIATION, KREMLIN, MOSCOW

MOSCOW SCHOOL
THEOPHANES THE GREEK
AND HELPERS
LATE 14TH–EARLY 15TH CENTURY

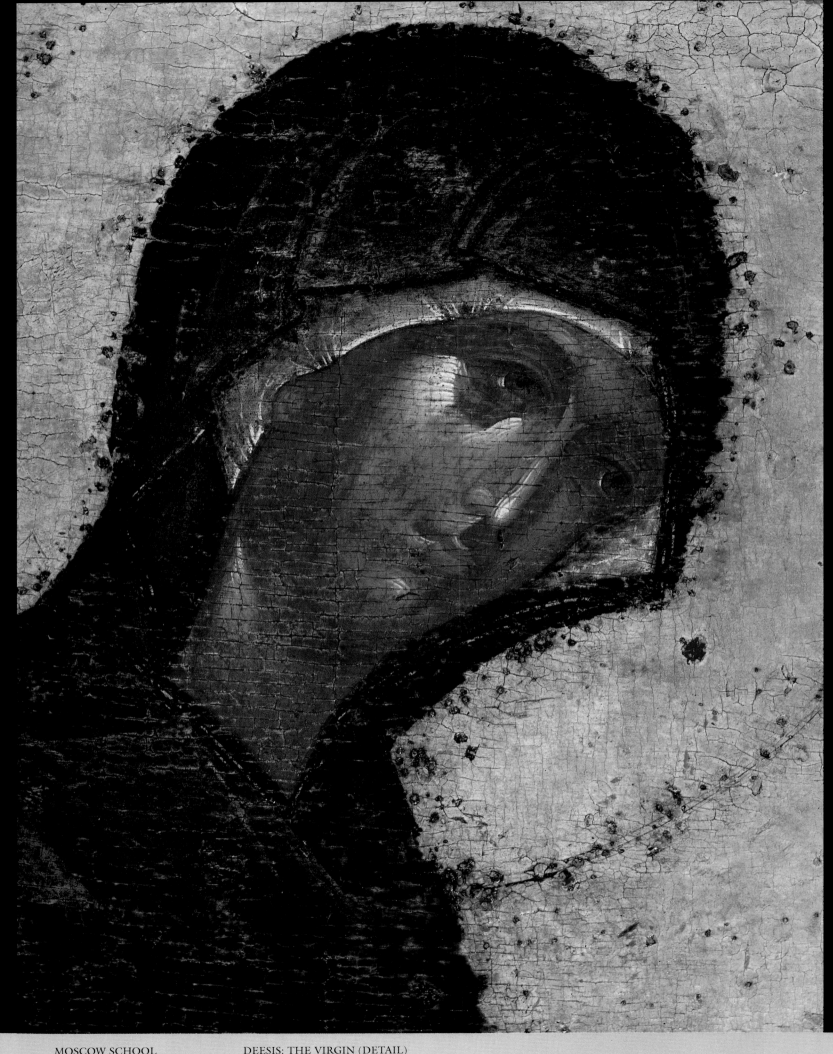

MOSCOW SCHOOL
THEOPHANES THE GREEK
AND HELPERS
LATE 14TH–EARLY 15TH CENTURY

DEESIS: THE VIRGIN (DETAIL)
CATHEDRAL OF THE ANNUNCIATION, KREMLIN, MOSCOW

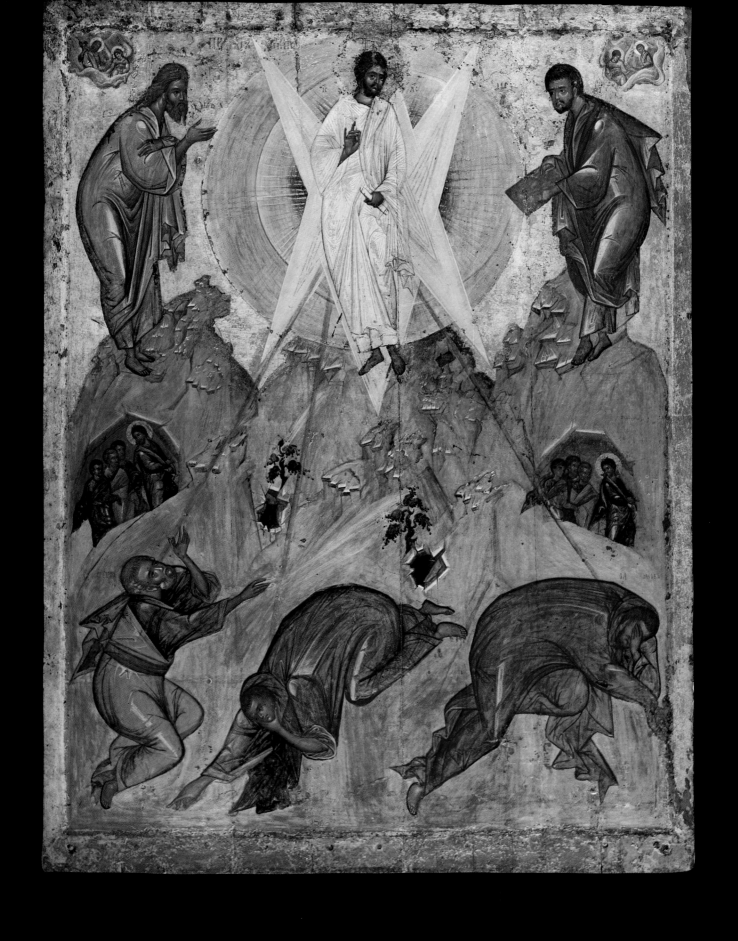

THE TRANSFIGURATION
TRETYAKOV GALLERY, MOSCOW

MOSCOW SCHOOL
SCHOOL OF THEOPHANES
THE GREEK
ABOUT 1403

91

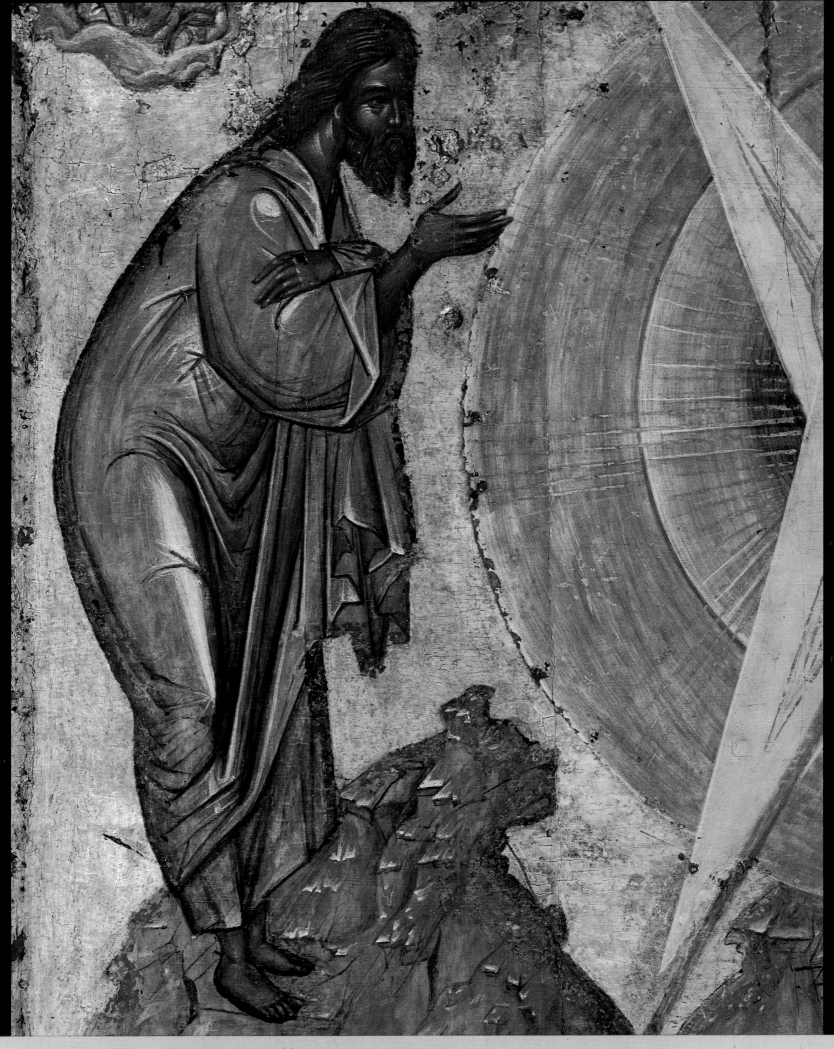

MOSCOW SCHOOL
SCHOOL OF THEOPHANES
THE GREEK
ABOUT 1403

THE TRANSFIGURATION (DETAIL)
TRETYAKOV GALLERY, MOSCOW

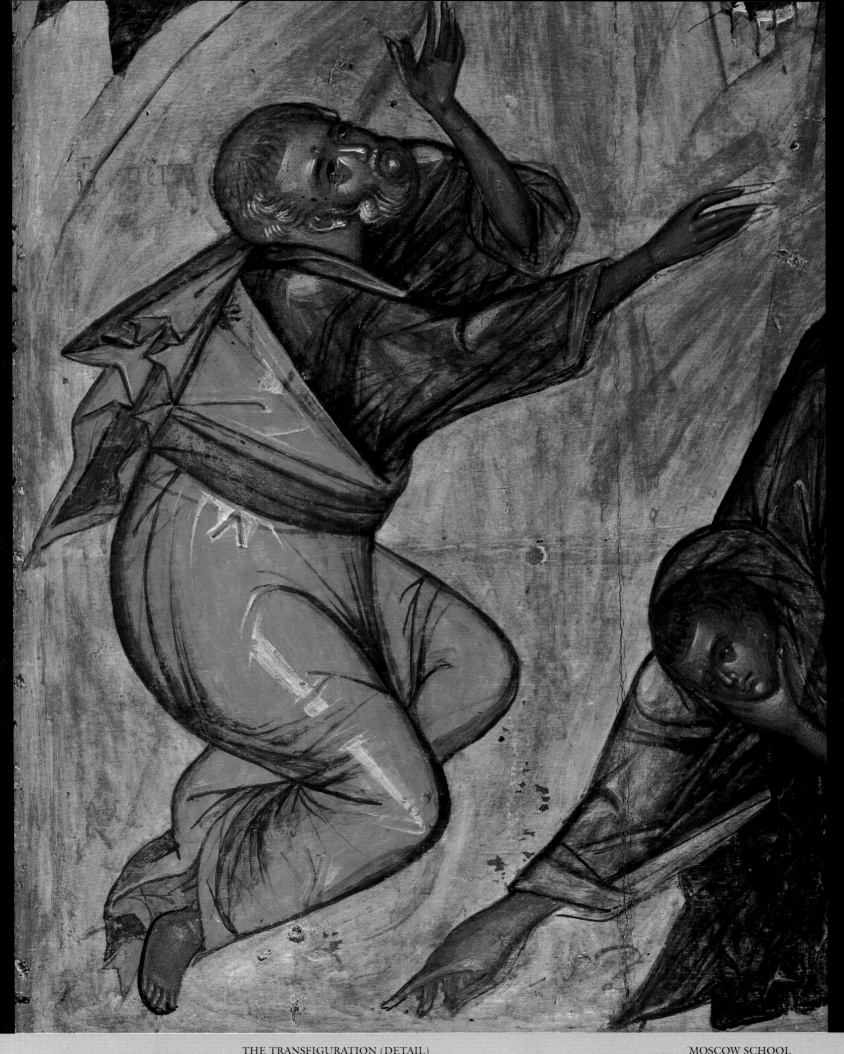

THE TRANSFIGURATION (DETAIL)
TRETYAKOV GALLERY, MOSCOW

MOSCOW SCHOOL
SCHOOL OF THEOPHANES
THE GREEK
ABOUT 1403

91

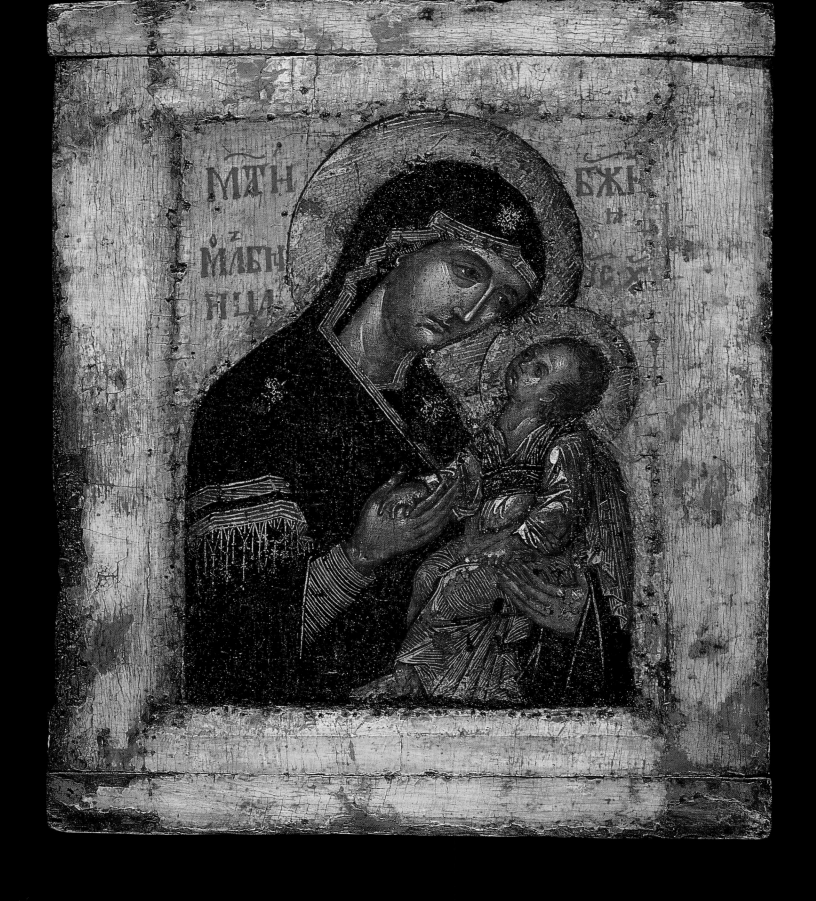

The following text appears within the icon image:

МТН ОҀ МЛ҃ЕН ЦΔ БЖ҃Ι ΙС ХС

MOSCOW SCHOOL
LATE
14TH CENTURY

THE VIRGIN ORANT
TRETYAKOV GALLERY, MOSCOW

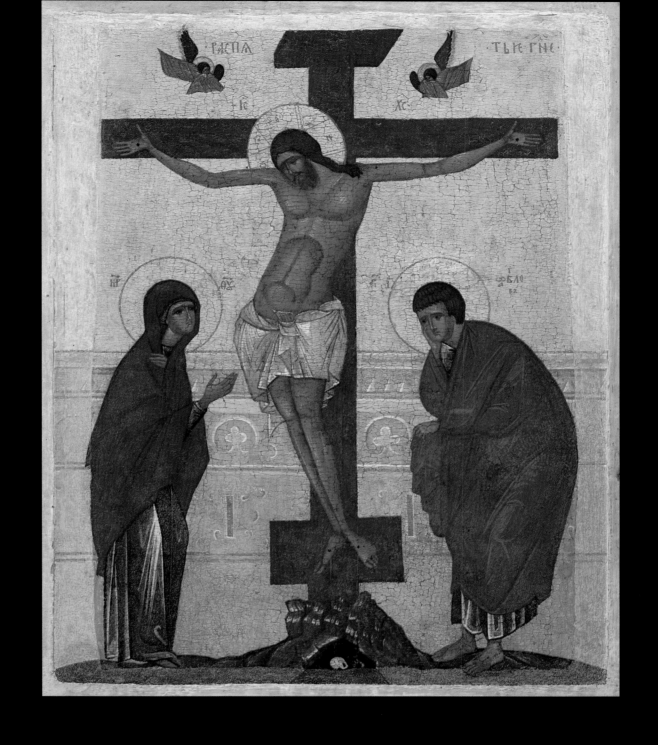

THE CRUCIFIXION
ANDREI RUBLEV MUSEUM OF EARLY RUSSIAN ART, MOSCOW

MOSCOW SCHOOL
LATE 93
14TH CENTURY

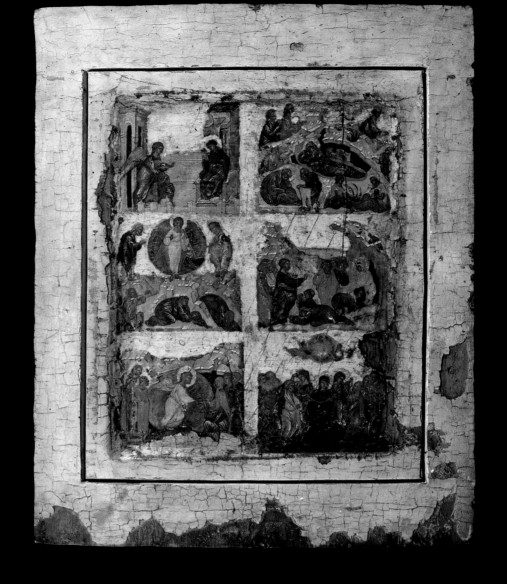

94 MOSCOW SCHOOL
LATE 14TH CENTURY

FEASTS: THE ANNUNCIATION, NATIVITY OF CHRIST, TRANSFIGURATION
RAISING OF LAZARUS, DESCENT INTO HELL, AND ASCENSION
TRETYAKOV GALLERY, MOSCOW

268

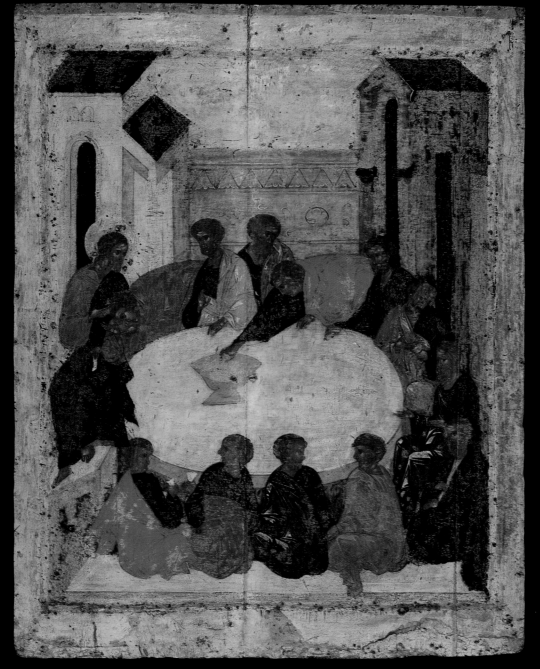

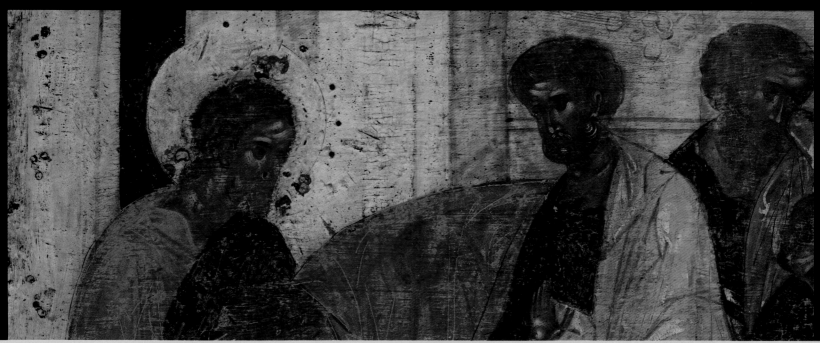

269 THE LAST SUPPER; AT BOTTOM: DETAIL
CATHEDRAL OF THE ANNUNCIATION, KREMLIN, MOSCOW

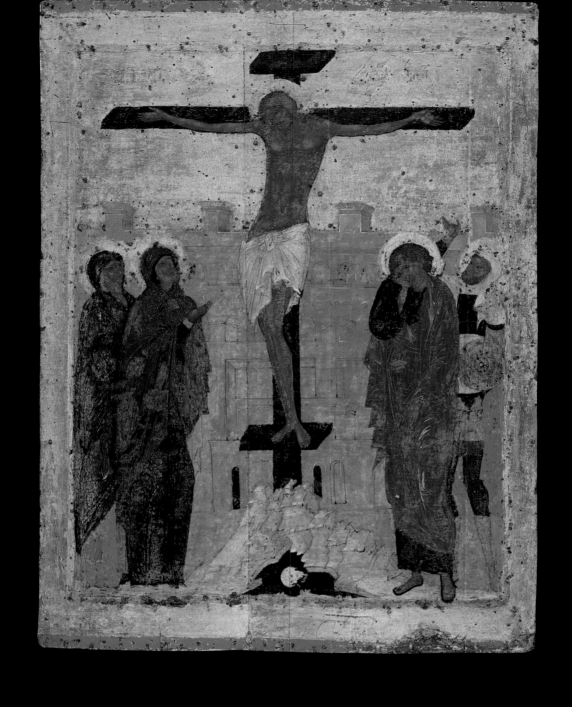

MOSCOW SCHOOL
PROCHOR OF
GORODETS
1405

THE CRUCIFIXION
CATHEDRAL OF THE ANNUNCIATION, KREMLIN, MOSCOW

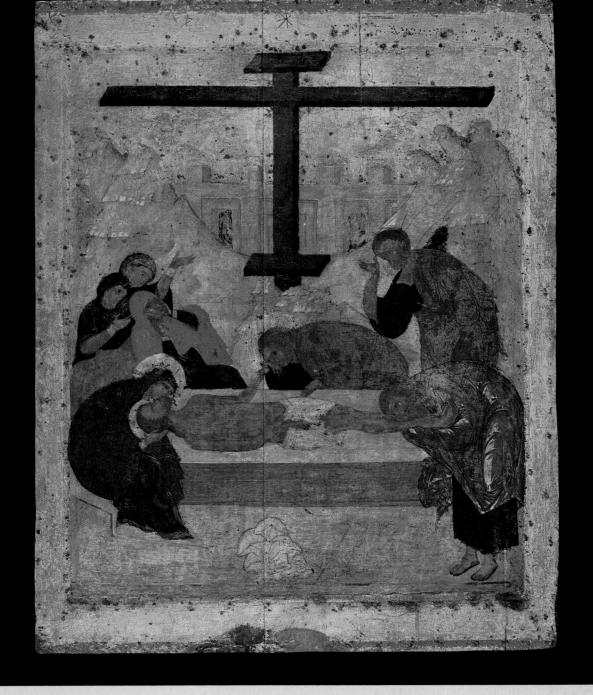

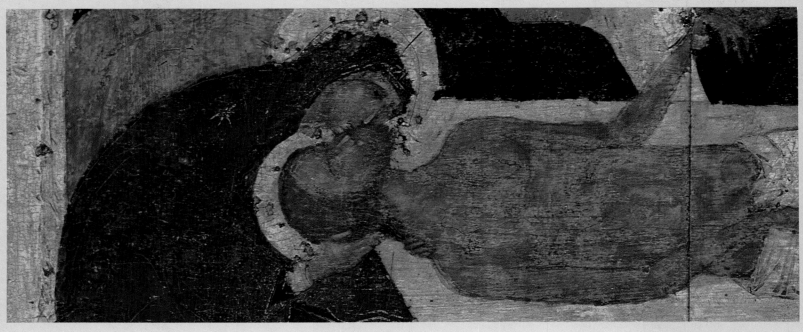

THE ENTOMBMENT; AT BOTTOM: DETAIL
CATHEDRAL OF THE ANNUNCIATION, KREMLIN, MOSCOW

MOSCOW SCHOOL
PROCHOR OF GORODETS 95
1405

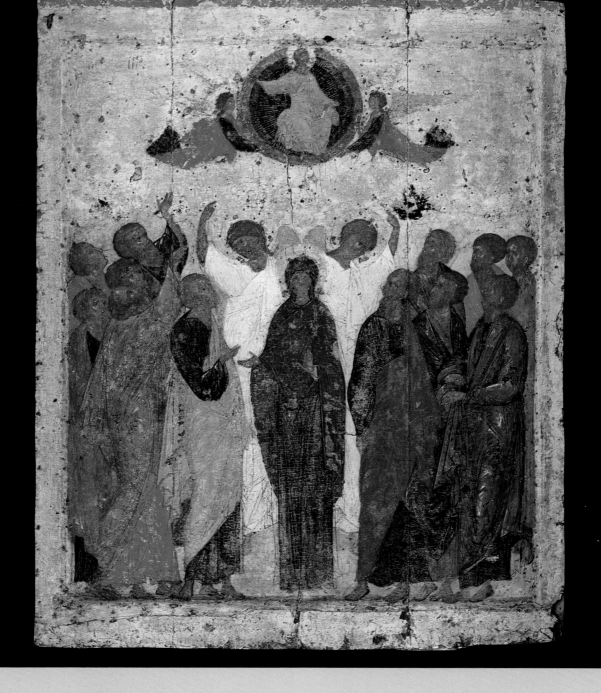

MOSCOW SCHOOL
PROCHOR OF
GORODETS
1405

THE ASCENSION; AT BOTTOM: DETAIL
CATHEDRAL OF THE ANNUNCIATION, KREMLIN, MOSCOW

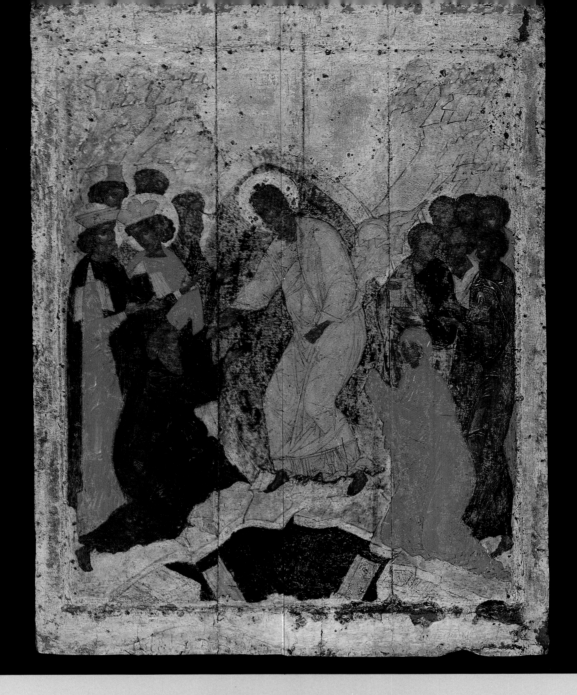

THE DESCENT INTO HELL; AT BOTTOM: DETAIL
CATHEDRAL OF THE ANNUNCIATION, KREMLIN, MOSCOW

MOSCOW SCHOOL
PROCHOR OF GORODETS 95
1405

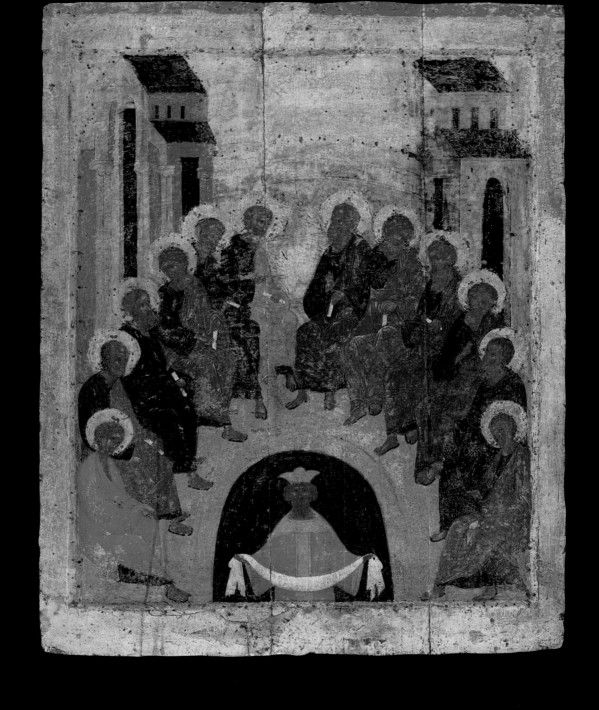

MOSCOW SCHOOL
PROCHOR OF
GORODETS
1405

PENTECOST
CATHEDRAL OF THE ANNUNCIATION, KREMLIN, MOSCOW

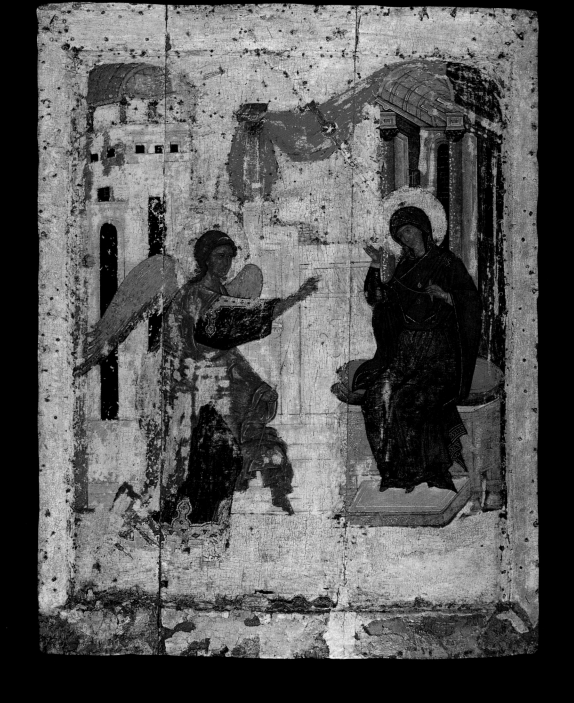

THE ANNUNCIATION
CATHEDRAL OF THE ANNUNCIATION, KREMLIN, MOSCOW

MOSCOW SCHOOL
ANDREI RUBLEV **96**
1405

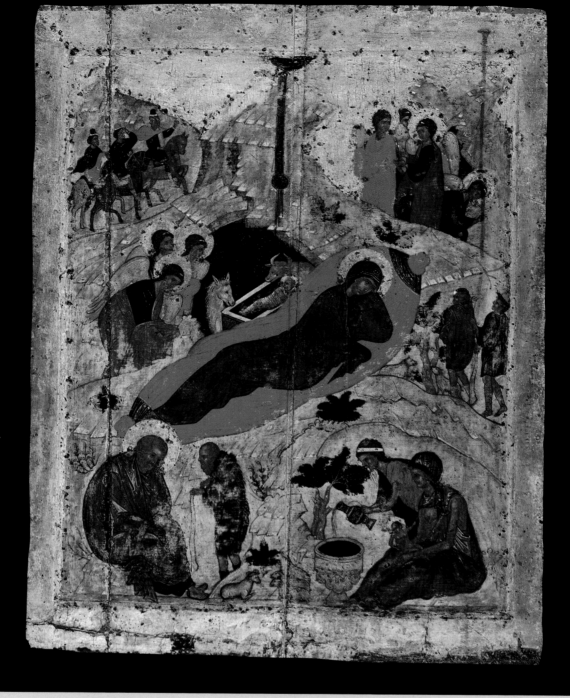

MOSCOW SCHOOL
ANDREI RUBLEV
1405

THE NATIVITY OF CHRIST; AT BOTTOM: DETAILS
CATHEDRAL OF THE ANNUNCIATION, KREMLIN, MOSCOW

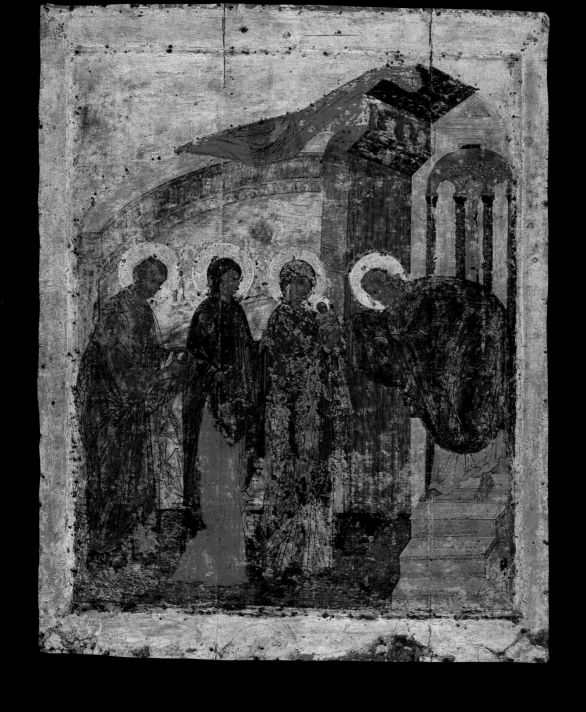

THE PRESENTATION IN THE TEMPLE
CATHEDRAL OF THE ANNUNCIATION, KREMLIN, MOSCOW

MOSCOW SCHOOL
ANDREI RUBLEV **96**
1405

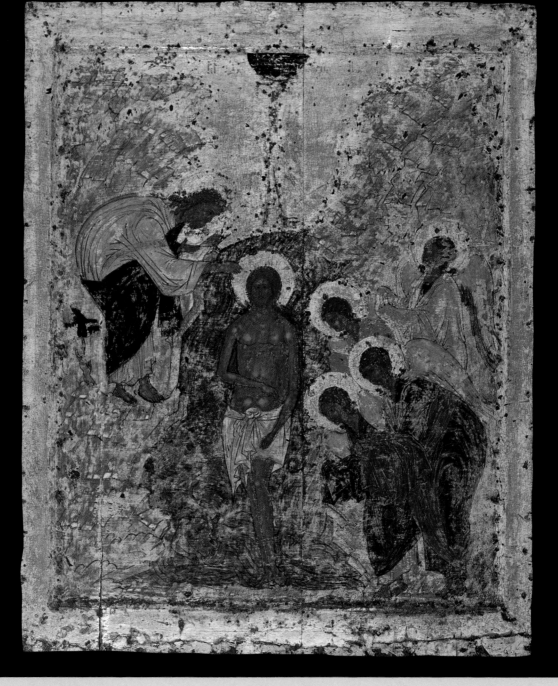

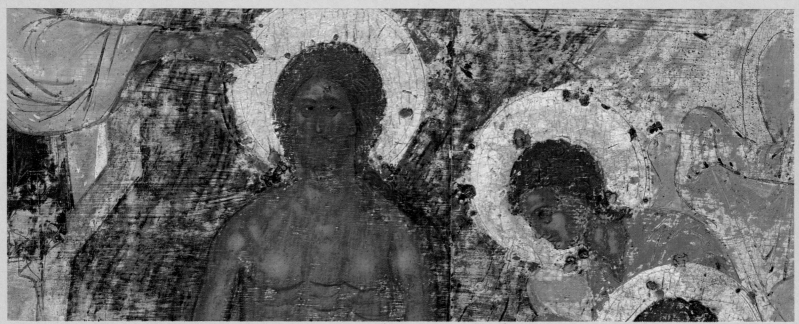

MOSCOW SCHOOL
ANDREI RUBLEV
1405

THE BAPTISM; AT BOTTOM: DETAIL
CATHEDRAL OF THE ANNUNCIATION, KREMLIN, MOSCOW

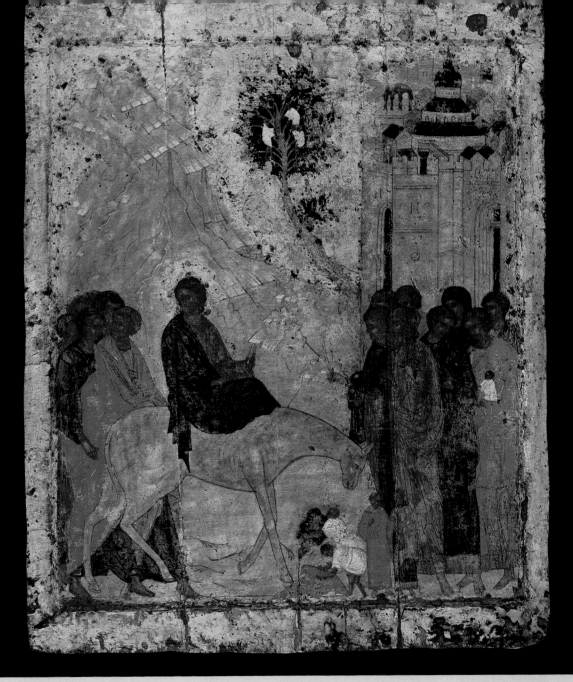

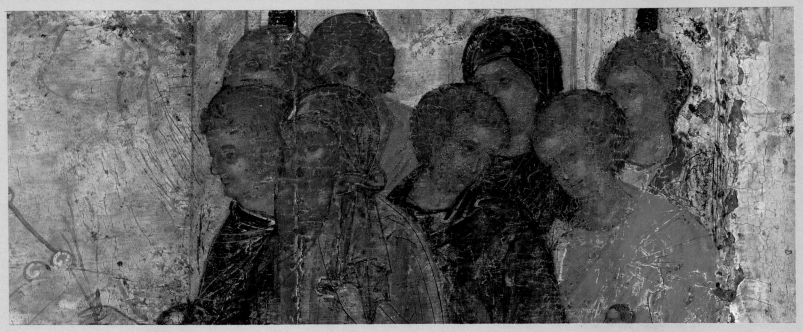

THE ENTRY INTO JERUSALEM; AT BOTTOM: DETAIL
CATHEDRAL OF THE ANNUNCIATION, KREMLIN, MOSCOW

MOSCOW SCHOOL
ANDREI RUBLEV **96**
1405

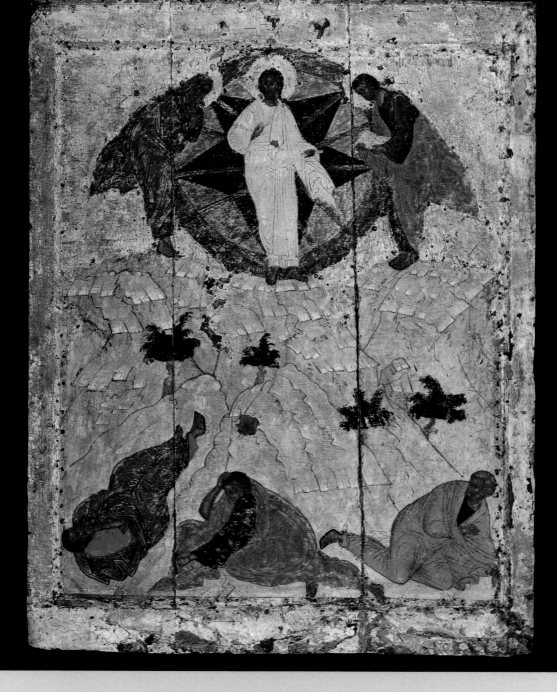

MOSCOW SCHOOL
ANDREI RUBLEV
1405

THE TRANSFIGURATION; AT BOTTOM: DETAILS
CATHEDRAL OF THE ANNUNCIATION, KREMLIN, MOSCOW

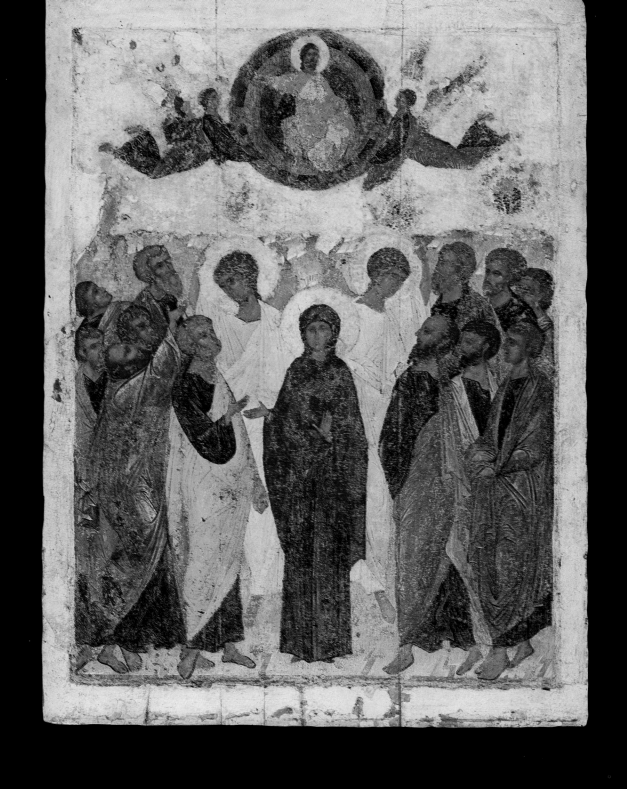

THE ASCENSION
TRETYAKOV GALLERY, MOSCOW

MOSCOW SCHOOL
ANDREI RUBLEV 97
1408

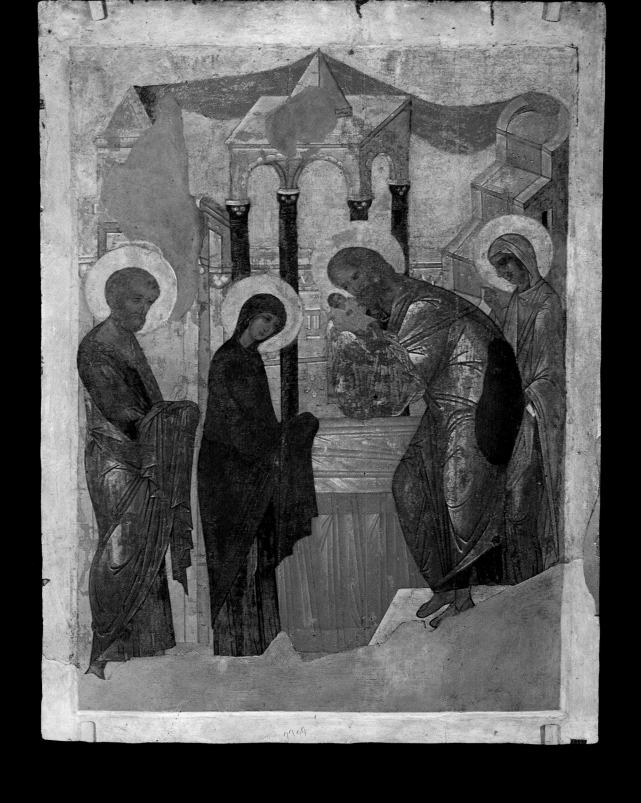

MOSCOW SCHOOL
STUDIO OF ANDREI RUBLEV
1408

THE PRESENTATION IN THE TEMPLE
RUSSIAN MUSEUM, SAINT PETERSBURG

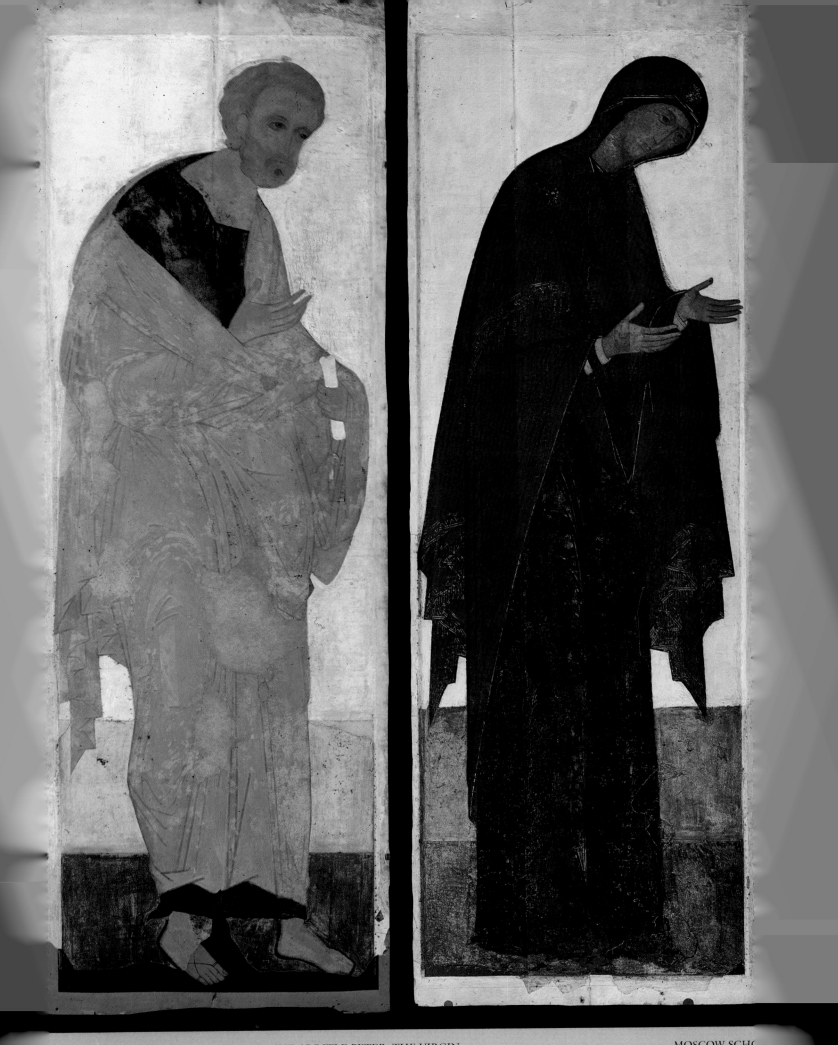

DEESIS: THE APOSTLE PETER; THE VIRGIN
RUSSIAN MUSEUM, SAINT PETERSBURG;
TRETYAKOV GALLERY, MOSCOW

MOSCOW SCHO
ANDREI RUBLEV AND HELF

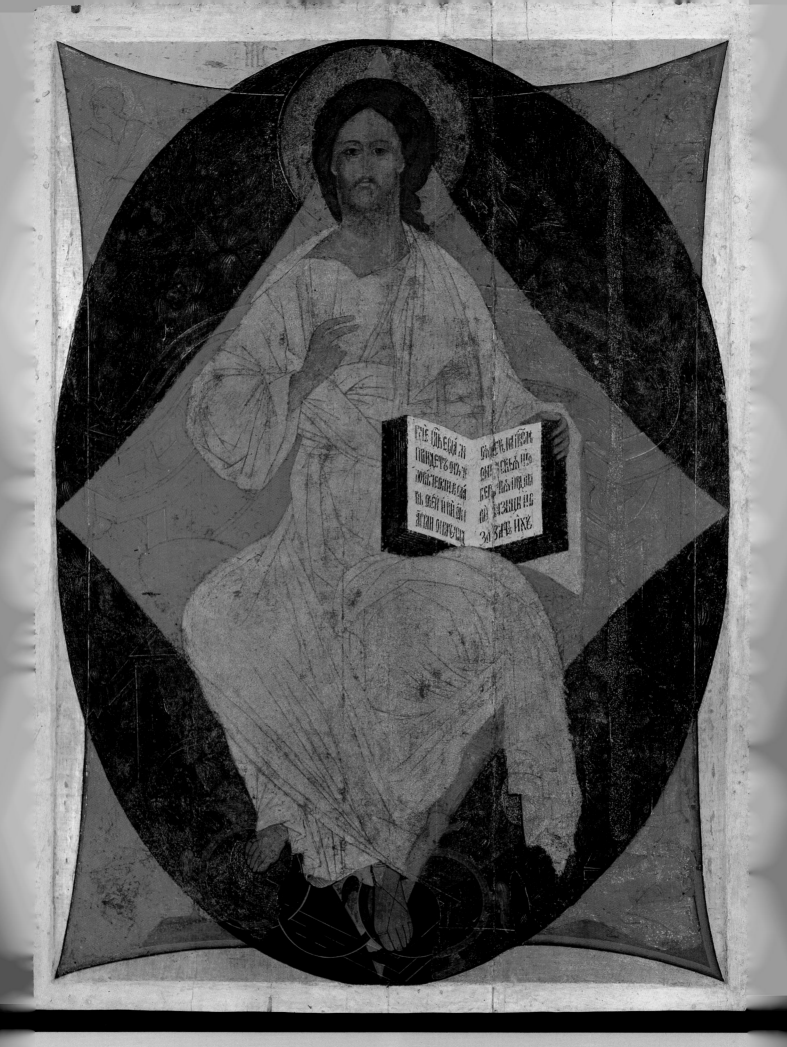

ГДЕ Ѡ Ж ЄСА И
ПРИИДЄТ ОН
ЛОБСЛАВНАГ ОБ
ВО ЄЙ И НА ѠИ
ҐЛИ ОНСЕ

СА ДЄ Ц НАПРЄСТѠ
ОВИ СЛАВЫ ЇѠ
ВСЕ НАРОДЫ
Ѡ ѠЗНЦИ НА
ЗА ЗАЦ ИХЄ

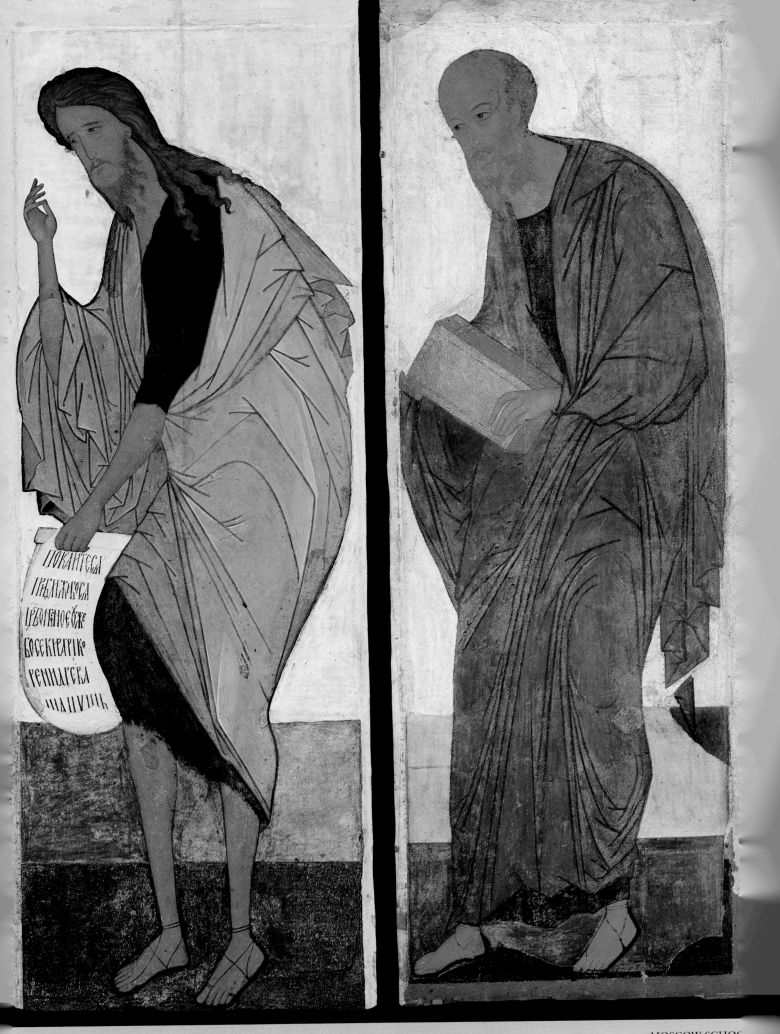

DEESIS: SAINT JOHN THE BAPTIST; THE APOSTLE PAUL
TRETYAKOV GALLERY, MOSCOW;
RUSSIAN MUSEUM, SAINT PETERSBURG

MOSCOW SCHOOL
ANDREI RUBLEV AND HELPERS

14

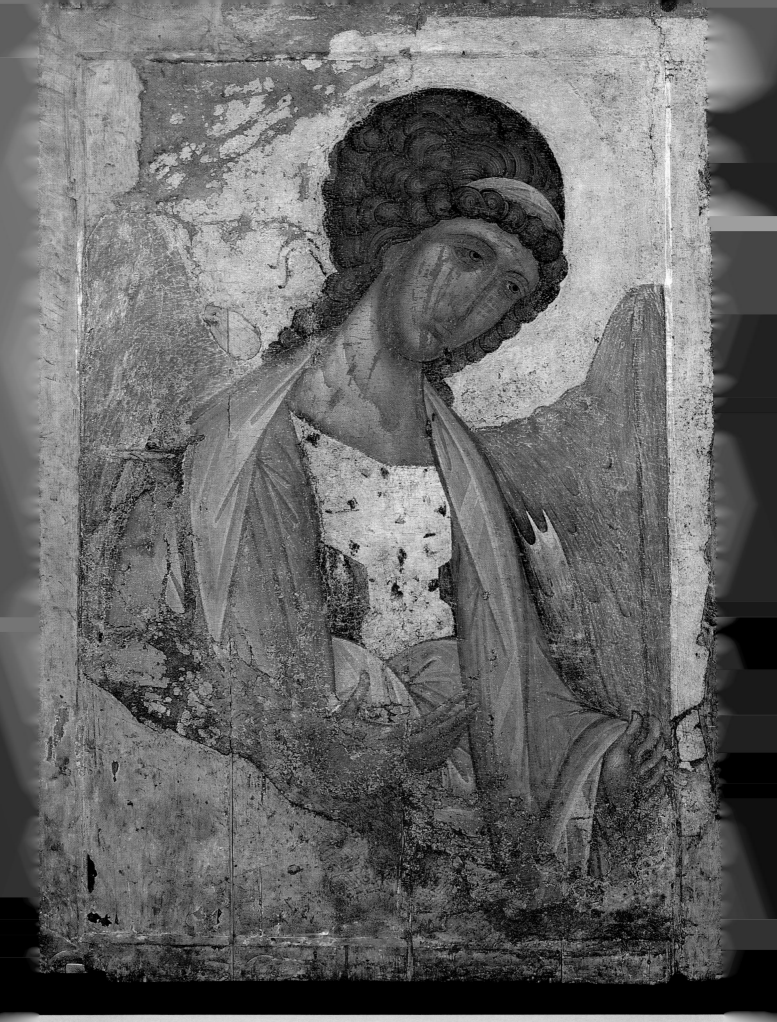

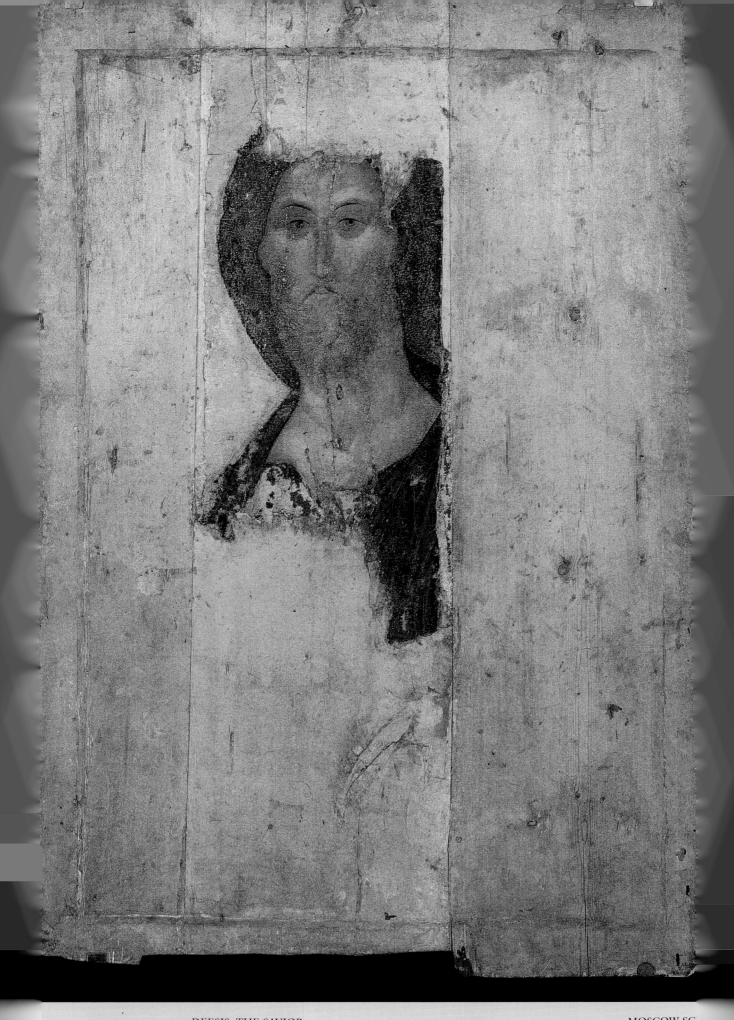

DEESIS: THE SAVIOR
TRETYAKOV GALLERY, MOSCOW

MOSCOW SC
ANDREI RU
140(

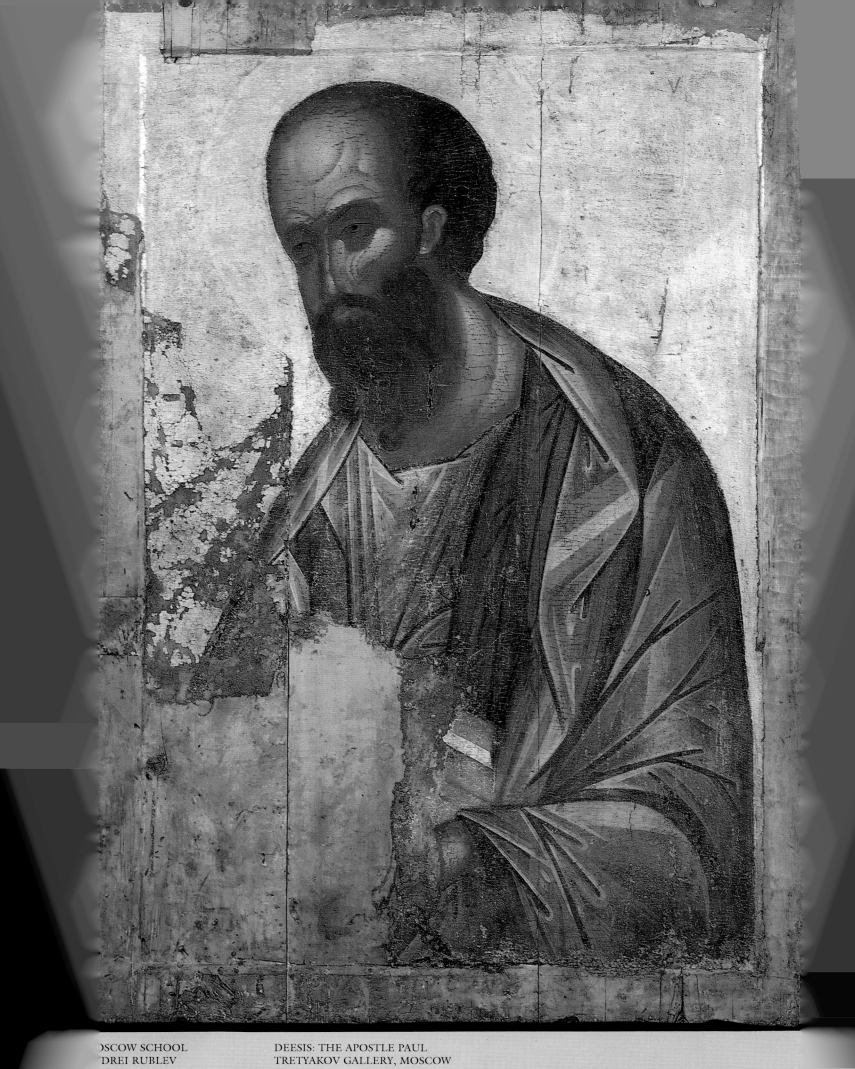

MOSCOW SCHOOL
ANDREI RUBLEV

DEESIS: THE APOSTLE PAUL

TRETYAKOV GALLERY, MOSCOW

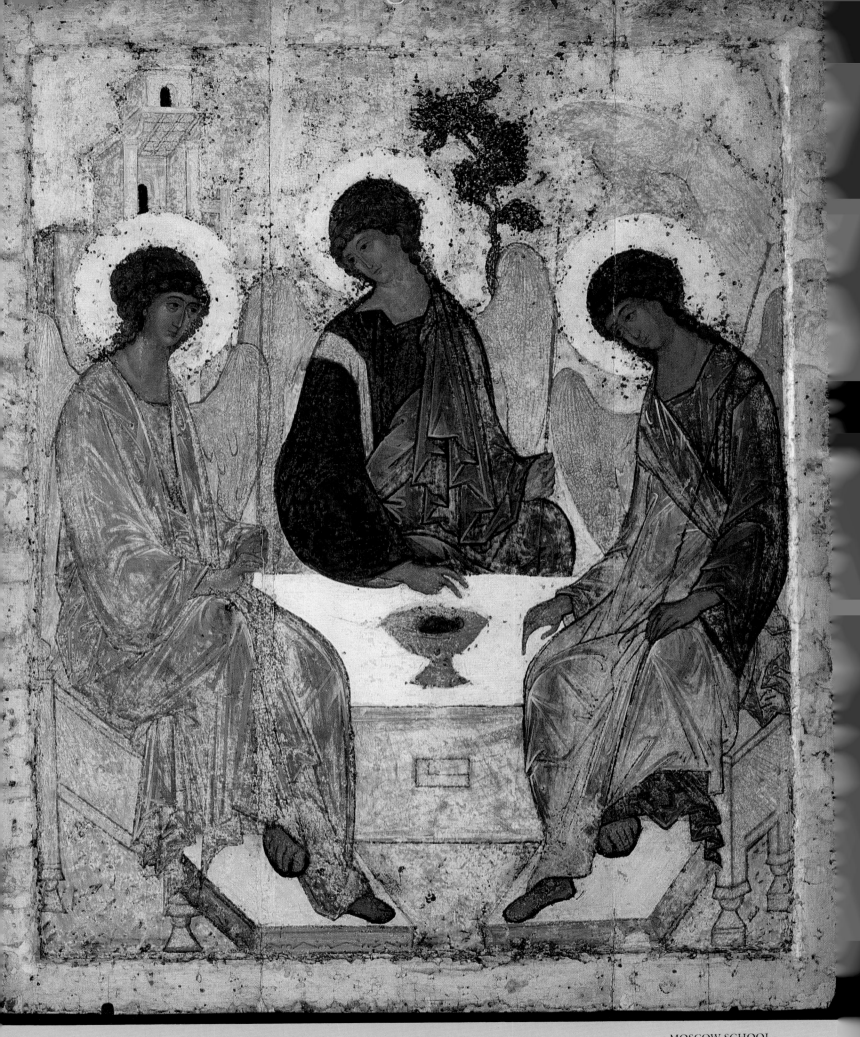

THE TRINITY
TRETYAKOV GALLERY, MOSCOW

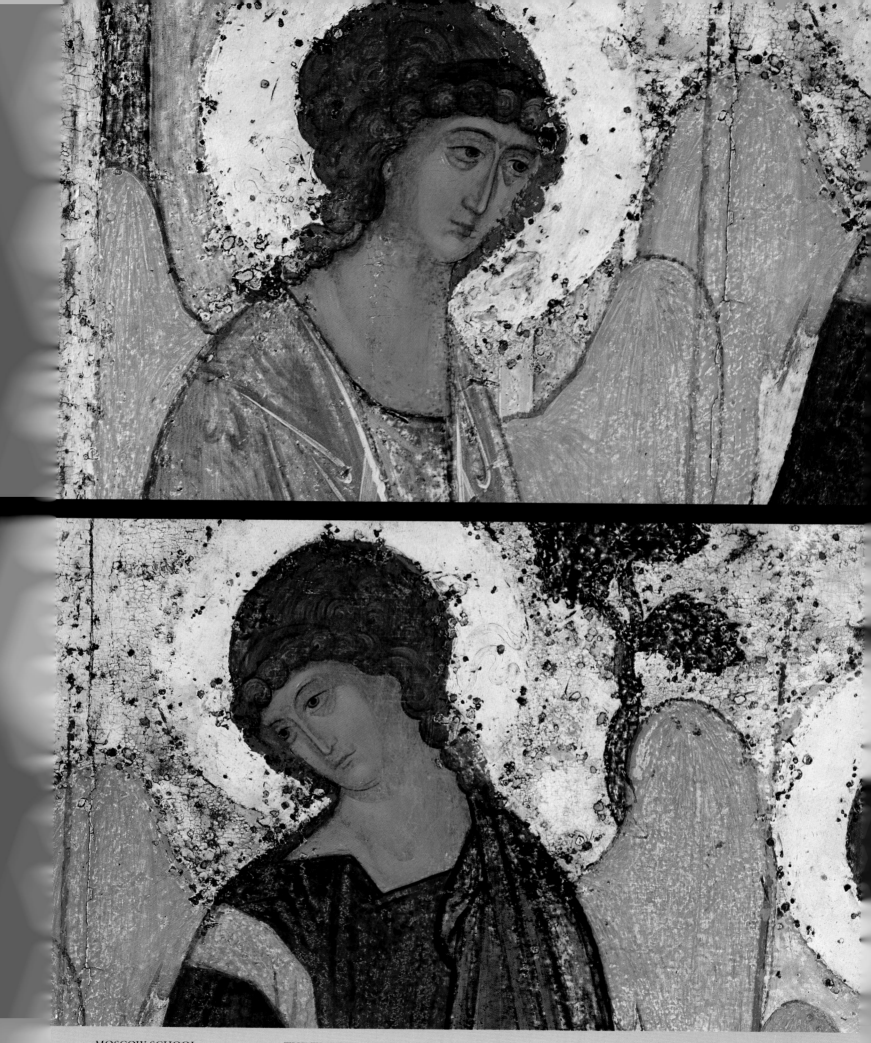

MOSCOW SCHOOL
ANDREI RUBLEV
ABOUT 1411

THE TRINITY (DETAILS)
TRETYAKOV GALLERY, MOSCOW

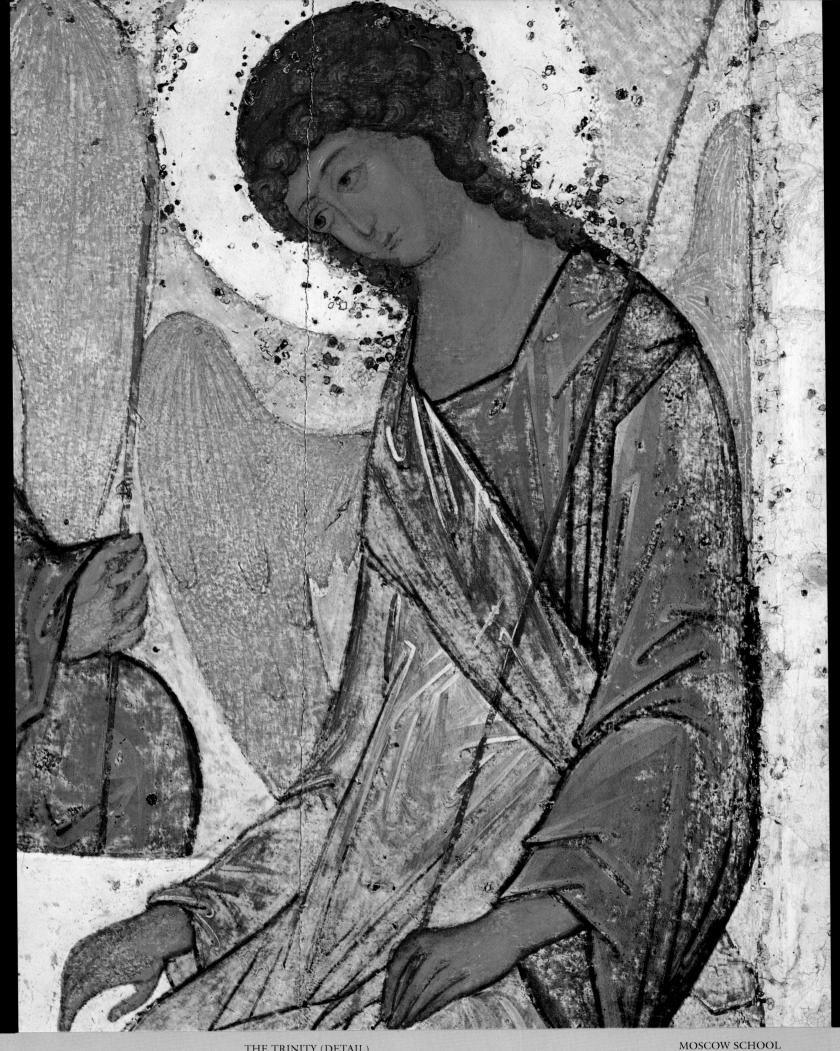

THE TRINITY (DETAIL)
TRETYAKOV GALLERY, MOSCOW

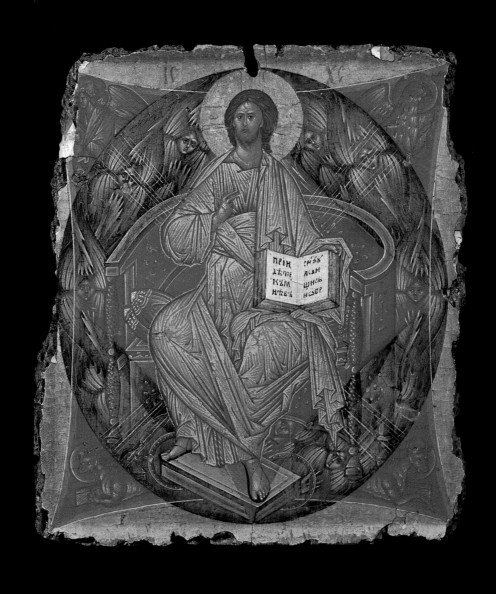

102 MOSCOW SCHOOL CHRIST IN GLORY
 ANDREI RUBLEV TRETYAKOV GALLERY, MOSCOW
 1500–1510 292

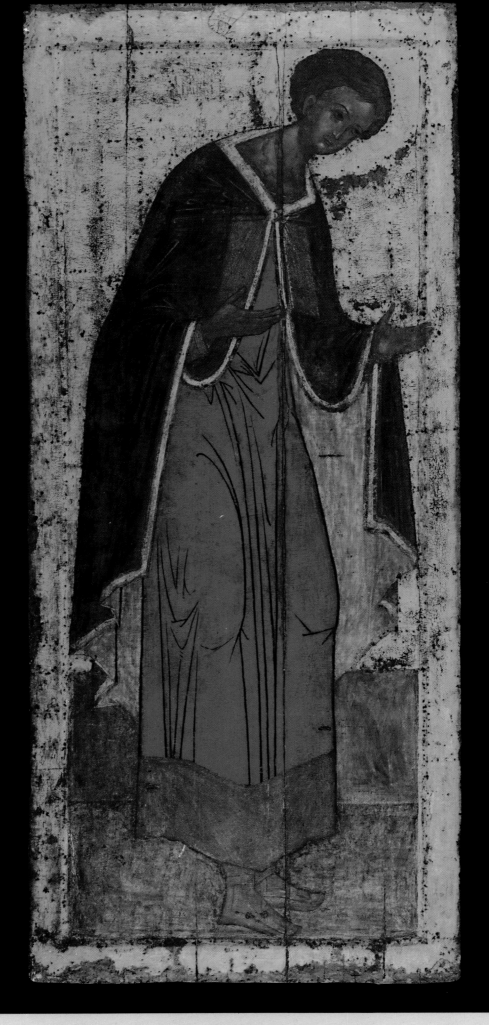

DEESIS: SAINT DEMETRIUS OF THESSALONICA
CATHEDRAL OF THE TRINITY IN THE MONASTERY
OF THE TRINITY OF SAINT SERGIUS
SERGIEV POSAD (ZAGORSK)

MOSCOW SCHOOL
ANDREI RUBLEV
AND FOLLOWERS
1425–1427

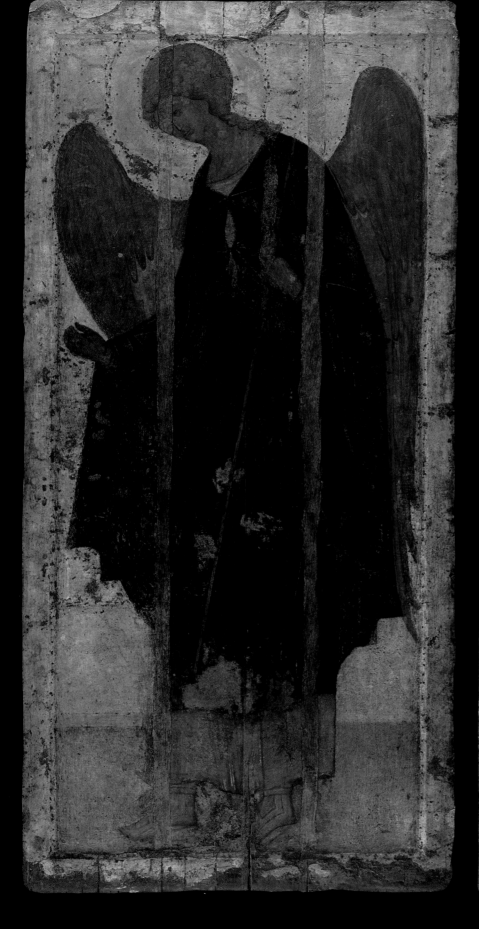
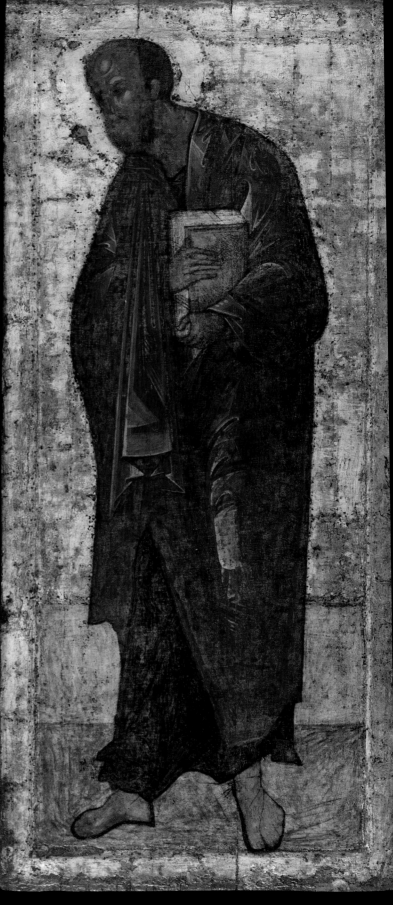

103

MOSCOW SCHOOL
ANDREI RUBLEV
AND FOLLOWERS
1425–1427

DEESIS: THE ARCHANGEL GABRIEL; THE APOSTLE PAUL
CATHEDRAL OF THE TRINITY IN THE MONASTERY
OF THE TRINITY OF SAINT SERGIUS
SERGIEV POSAD (ZAGORSK)

294

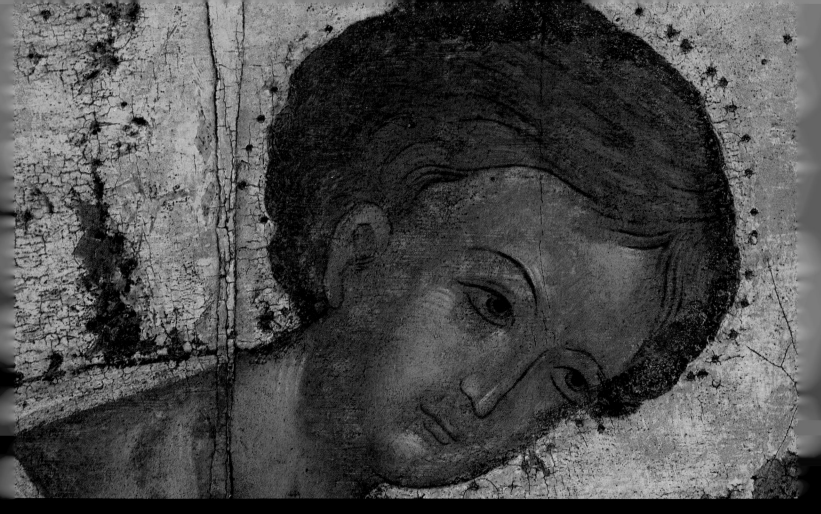

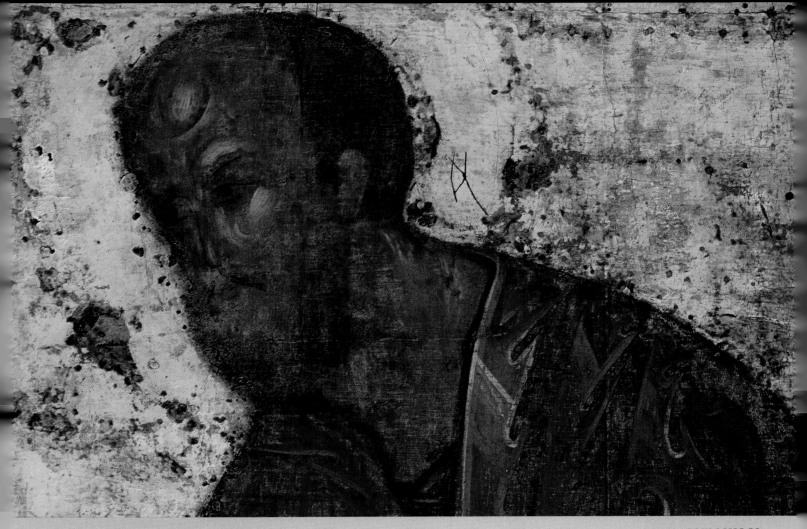

DEESIS: SAINT DEMETRIUS OF THESSALONICA; THE APOSTLE PAUL (DETAILS)
CATHEDRAL OF THE TRINITY IN THE MONASTERY
OF THE TRINITY OF SAINT SERGIUS
SERGIEV POSAD (ZAGORSK)

MOSCOW SCHOOL
ANDREI RUBLEV
AND FOLLOWERS
1425–1427

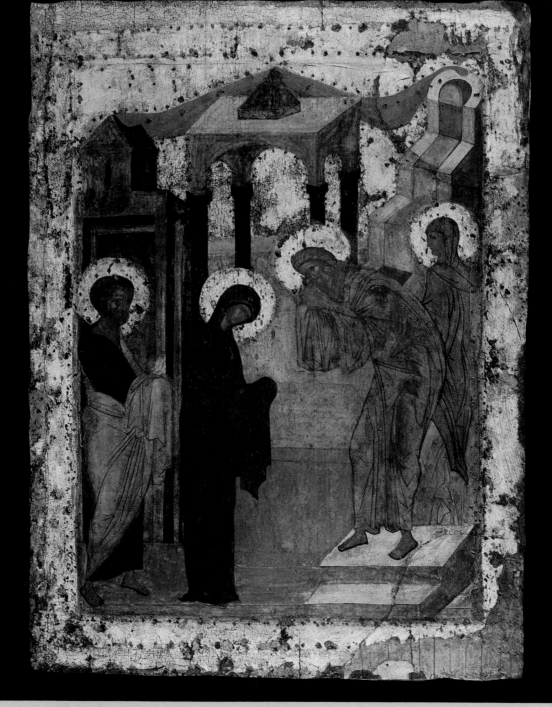

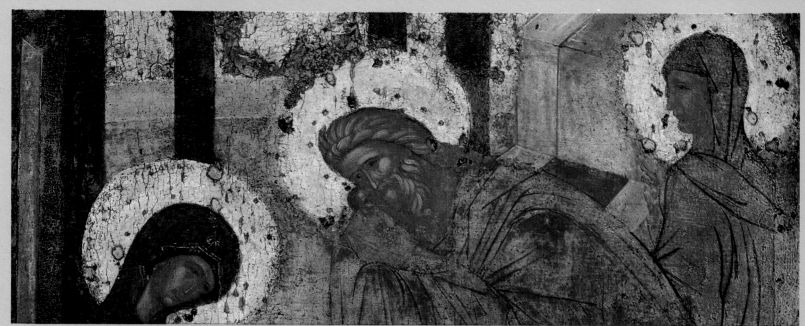

MOSCOW SCHOOL
SCHOOL OF
ANDREI RUBLEV
1425–1427

THE PRESENTATION IN THE TEMPLE; AT BOTTOM: DETAIL
CATHEDRAL OF THE TRINITY IN THE MONASTERY
OF THE TRINITY OF SAINT SERGIUS
SERGIEV POSAD (ZAGORSK)

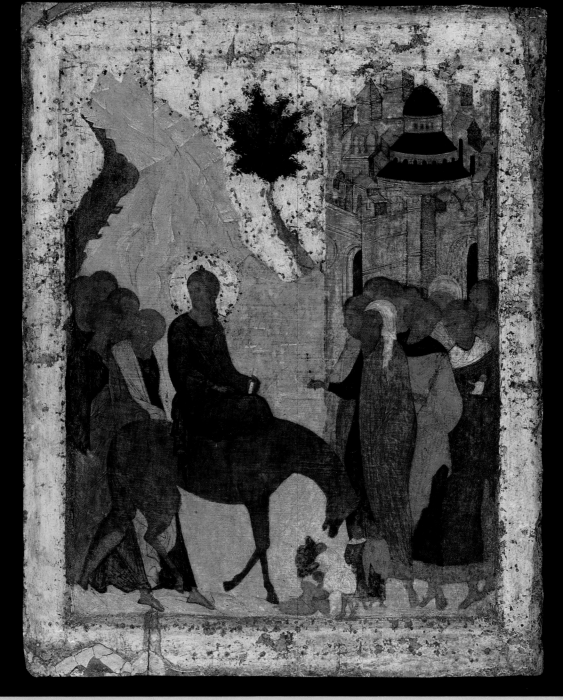

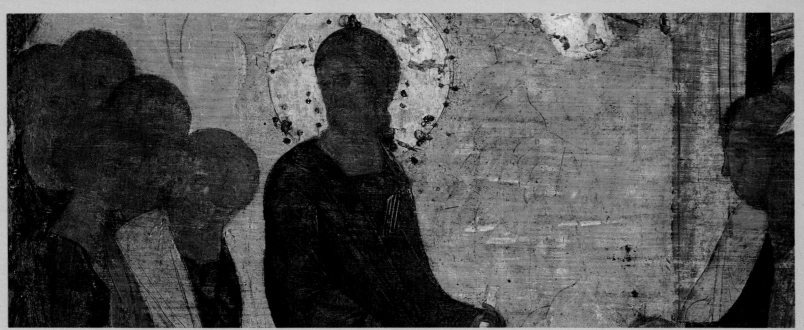

THE ENTRY INTO JERUSALEM; AT BOTTOM: DETAIL
CATHEDRAL IN THE TRINITY OF THE MONASTERY
OF THE TRINITY OF SAINT SERGIUS
SERGIEV POSAD (ZAGORSK)

MOSCOW SCHOOL
SCHOOL OF
ANDREI RUBLEV
1425–1427

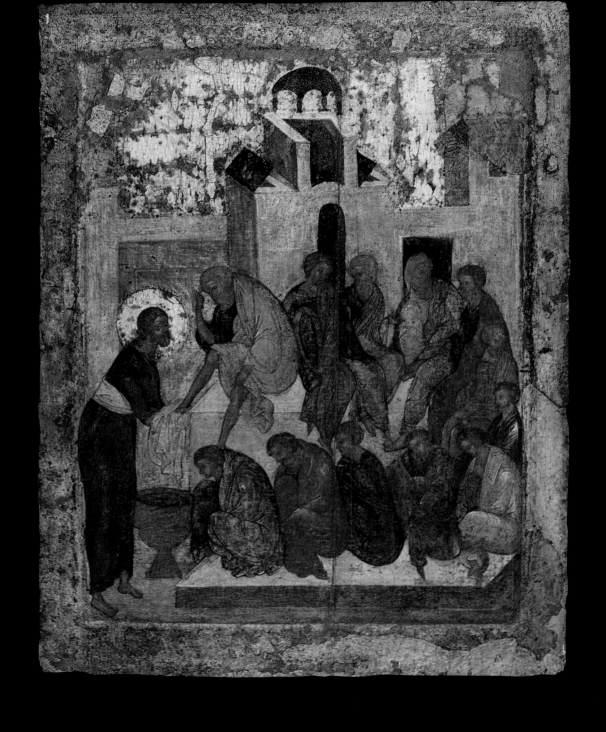

MOSCOW SCHOOL
SCHOOL OF
ANDREI RUBLEV
1425–1427

THE WASHING OF THE FEET
CATHEDRAL OF THE TRINITY IN THE MONASTERY
OF THE TRINITY OF SAINT SERGIUS
SERGIEV POSAD (ZAGORSK)

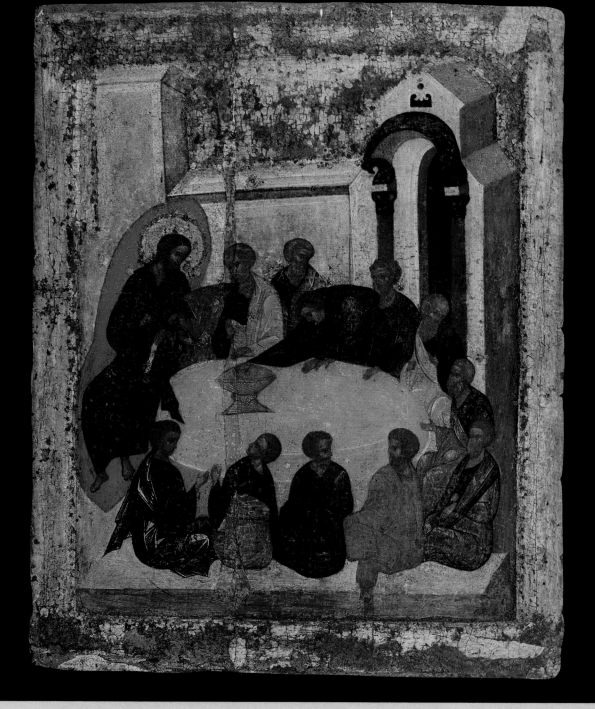

THE LAST SUPPER; AT BOTTOM: DETAIL
CATHEDRAL OF THE TRINITY IN THE MONASTERY
OF THE TRINITY OF SAINT SERGIUS
SERGIEV POSAD (ZAGORSK)

MOSCOW SCHOOL
SCHOOL OF
ANDREI RUBLEV
1425–1427

104

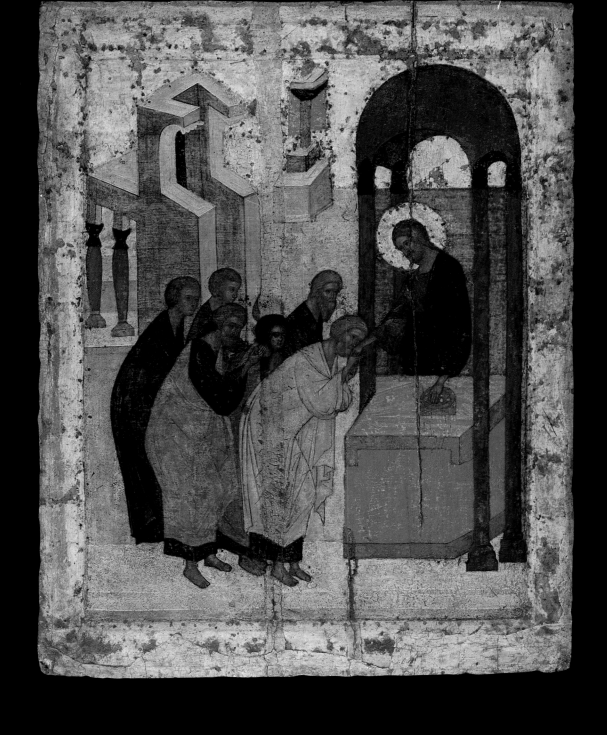

MOSCOW SCHOOL
SCHOOL OF
ANDREI RUBLEV
1425–1427

THE COMMUNION WITH BREAD
CATHEDRAL OF THE TRINITY IN THE MONASTERY
OF THE TRINITY OF SAINT SERGIUS
SERGIEV POSAD (ZAGORSK)

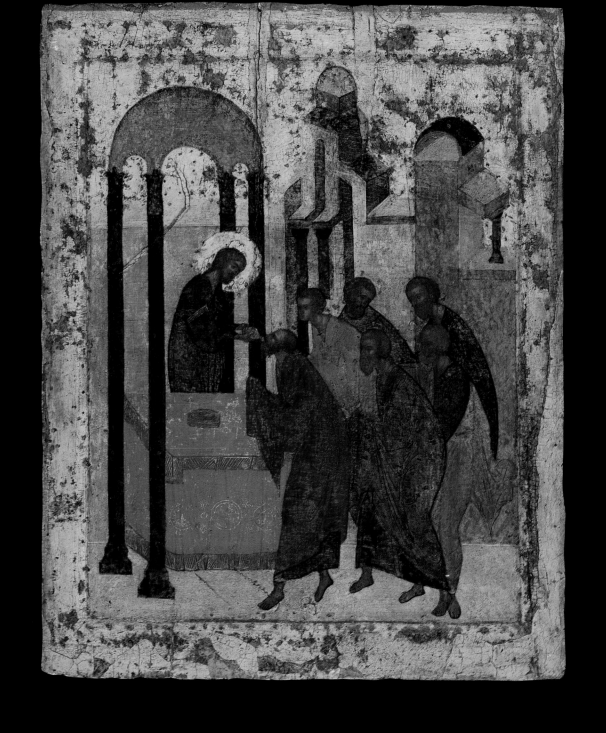

301

THE COMMUNION WITH WINE
CATHEDRAL OF THE TRINITY IN THE MONASTERY
OF THE TRINITY OF SAINT SERGIUS
SERGIEV POSAD (ZAGORSK)

MOSCOW SCHOOL
SCHOOL OF
ANDREI RUBLEV
1425–1427

104

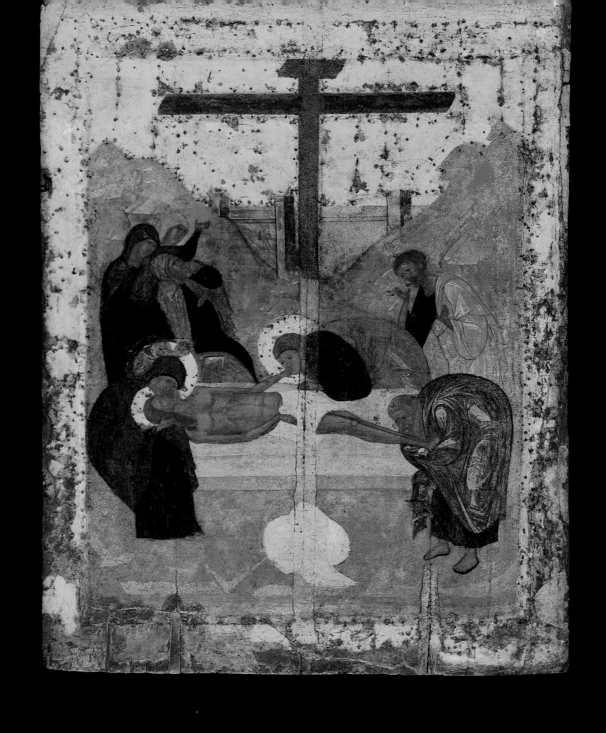

MOSCOW SCHOOL
SCHOOL OF
ANDREI RUBLEV
1425–1427

THE ENTOMBMENT
CATHEDRAL OF THE TRINITY IN THE MONASTERY
OF THE TRINITY OF SAINT SERGIUS
SERGIEV POSAD (ZAGORSK)

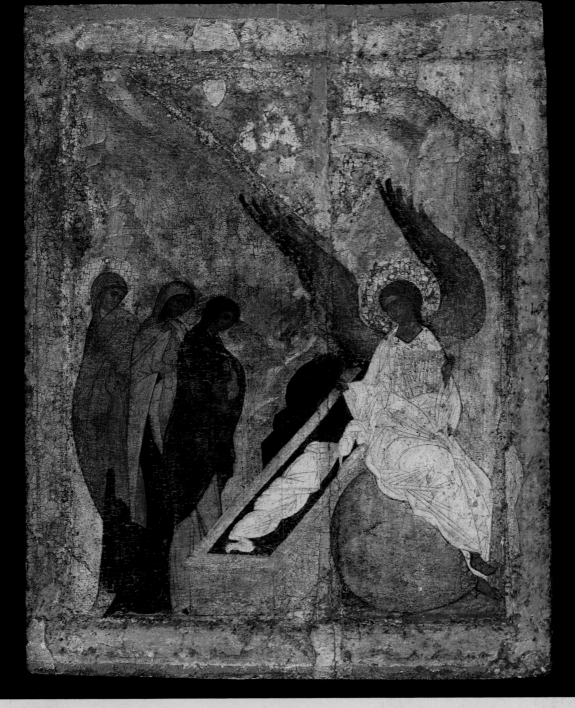

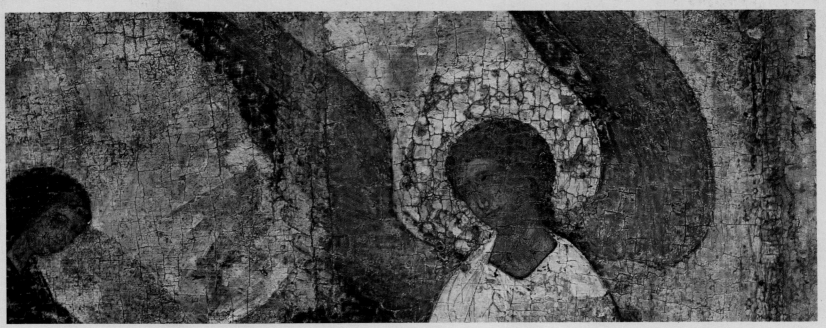

THE WOMEN AT THE LORD'S TOMB; AT BOTTOM: DETAIL
CATHEDRAL OF THE TRINITY IN THE MONASTERY
OF THE TRINITY OF SAINT SERGIUS
SERGIEV POSAD (ZAGORSK)

MOSCOW SCHOOL
SCHOOL OF
ANDREI RUBLEV
1425–1427

104

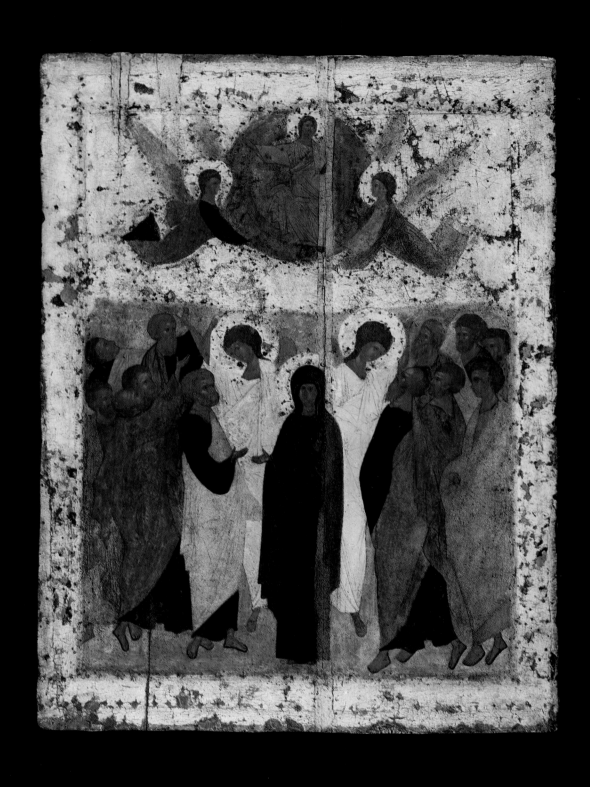

MOSCOW SCHOOL
SCHOOL OF
ANDREI RUBLEV
1425–1427

THE ASCENSION
CATHEDRAL OF THE TRINITY IN THE MONASTERY
OF THE TRINITY OF SAINT SERGIUS
SERGIEV POSAD (ZAGORSK)

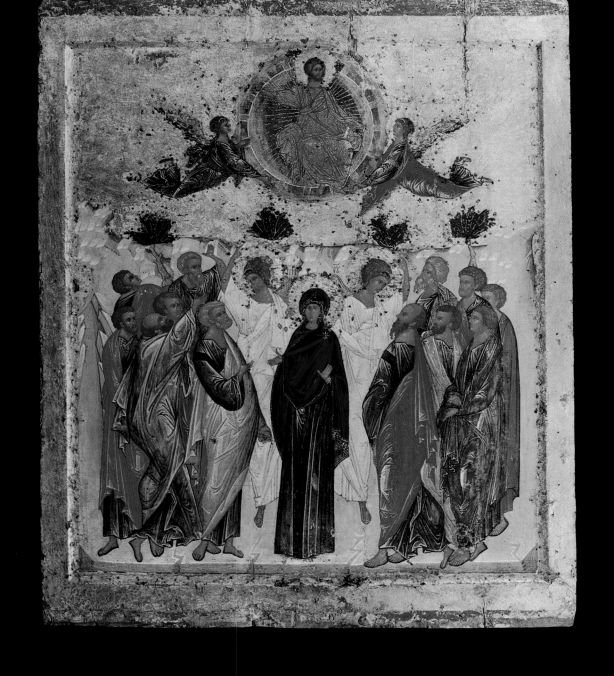

THE ASCENSION
TRETYAKOV GALLERY, MOSCOW

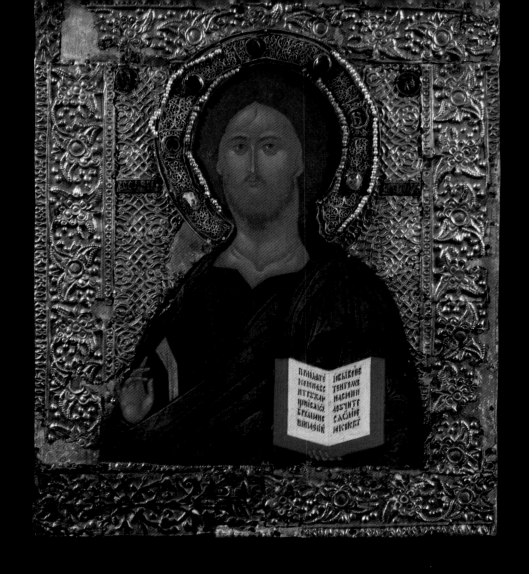

MOSCOW SCHOOL
SECOND QUARTER
OF 15TH CENTURY

CHRIST IN MAJESTY
TRETYAKOV GALLERY, MOSCOW

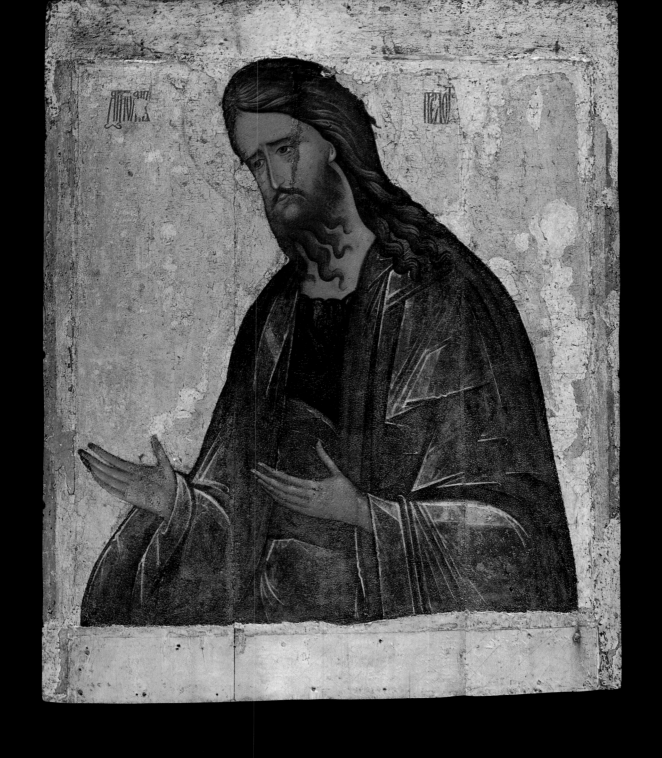

АГИ ІШАН ПРДТ

SAINT JOHN THE BAPTIST
ANDREI RUBLEV MUSEUM OF EARLY RUSSIAN ART, MOSCOW

MOSCOW SCHOOL
SECOND QUARTER 107
OF 15TH CENTURY

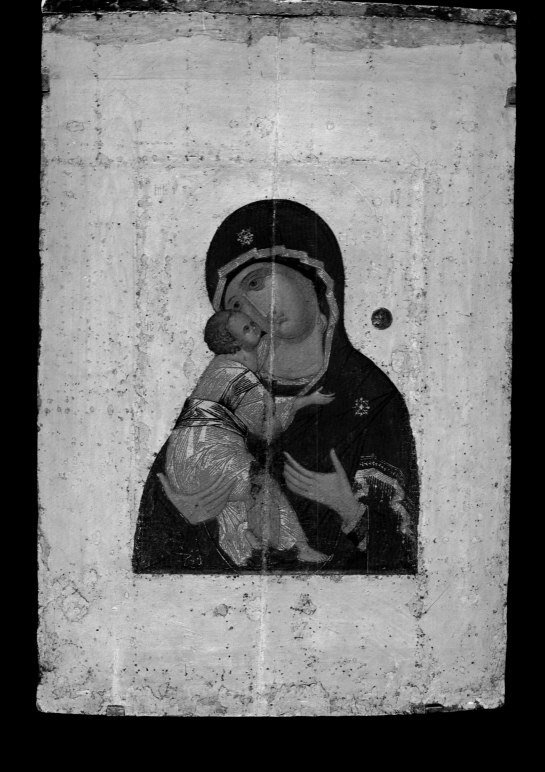

MOSCOW SCHOOL
FIRST QUARTER
OF 15TH CENTURY

THE VIRGIN OF VLADIMIR
CATHEDRAL OF THE DORMITION, KREMLIN, MOSCOW

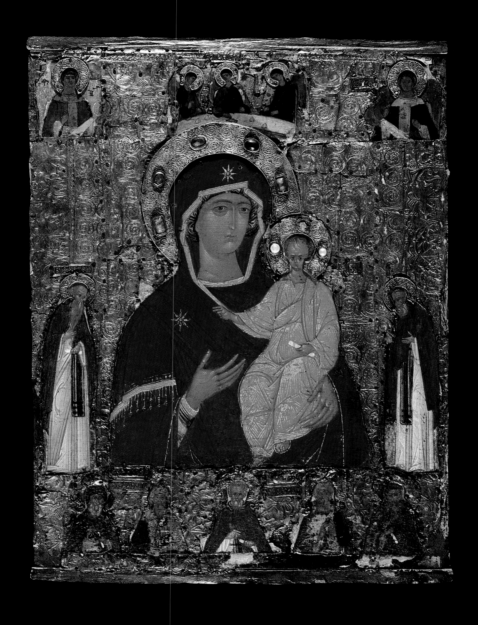

THE VIRGIN HODEGETRIA, THE TRINITY, AND SAINTS
TRETYAKOV GALLERY, MOSCOW

MOSCOW SCHOOL
MID 15TH CENTURY

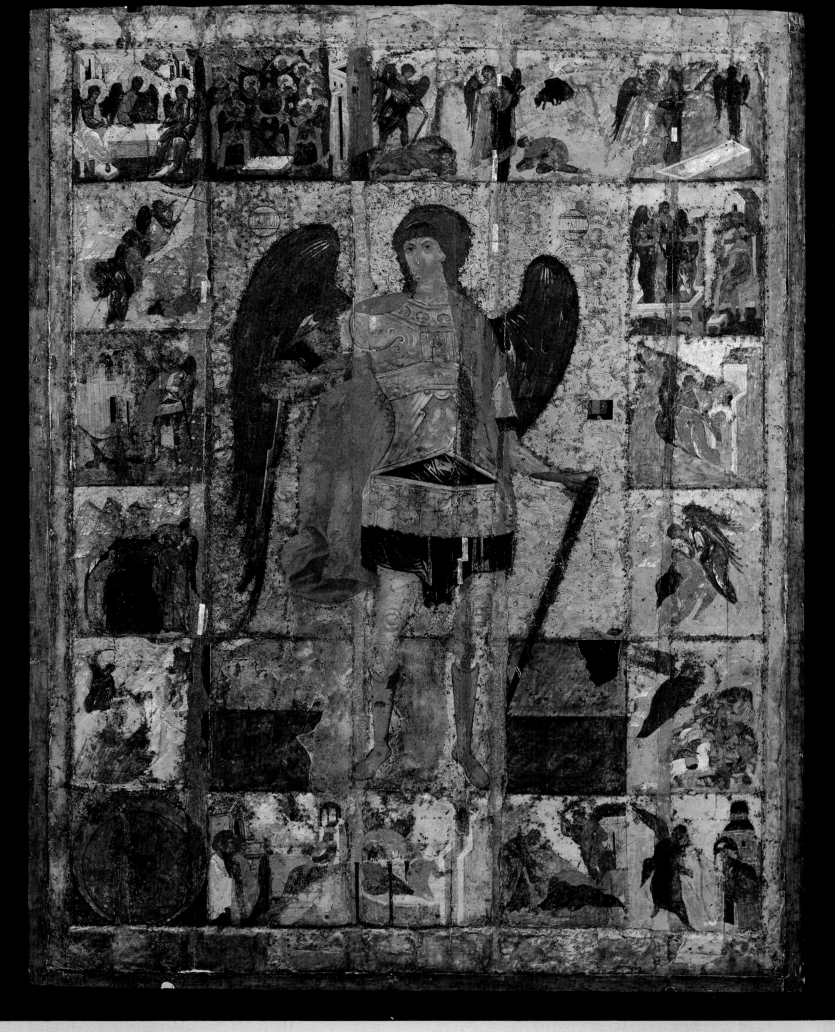

MOSCOW SCHOOL
1400–1410

THE ARCHANGEL MICHAEL
WITH SCENES FROM HIS DEEDS
CATHEDRAL OF THE ARCHANGEL, KREMLIN, MOSCOW

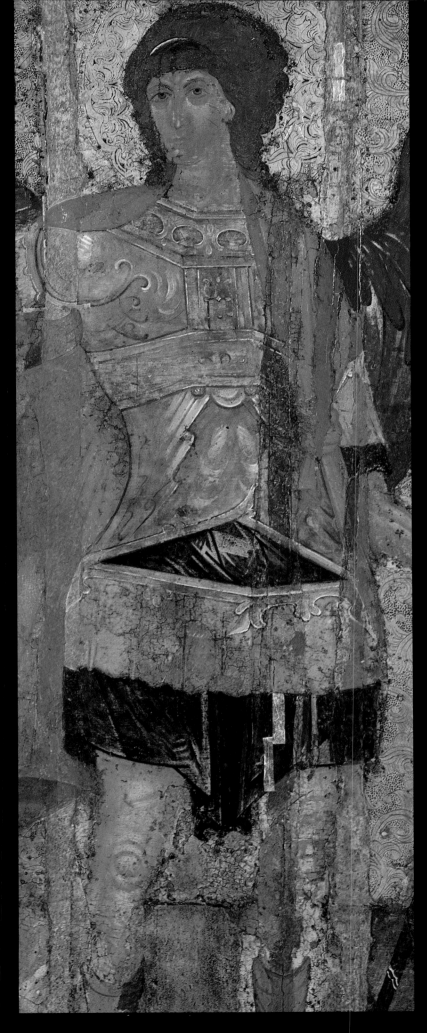

THE ARCHANGEL MICHAEL
WITH SCENES FROM HIS DEEDS (DETAILS)
CATHEDRAL OF THE ARCHANGEL, KREMLIN, MOSCOW

MOSCOW SCHOOL
1400–1410 110

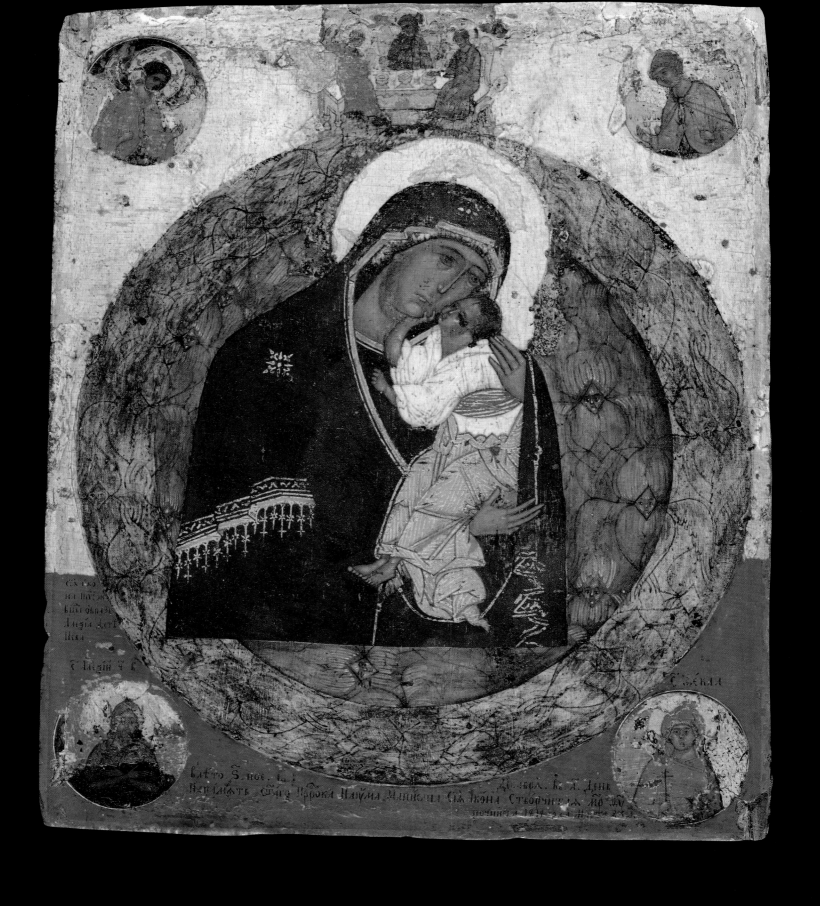

MOSCOW SCHOOL
1466

THE VIRGIN OF YAROSLAV WITH THE TRINITY
AND HALF-LENGTH FIGURES OF ANGELS AND SAINTS
TRETYAKOV GALLERY, MOSCOW

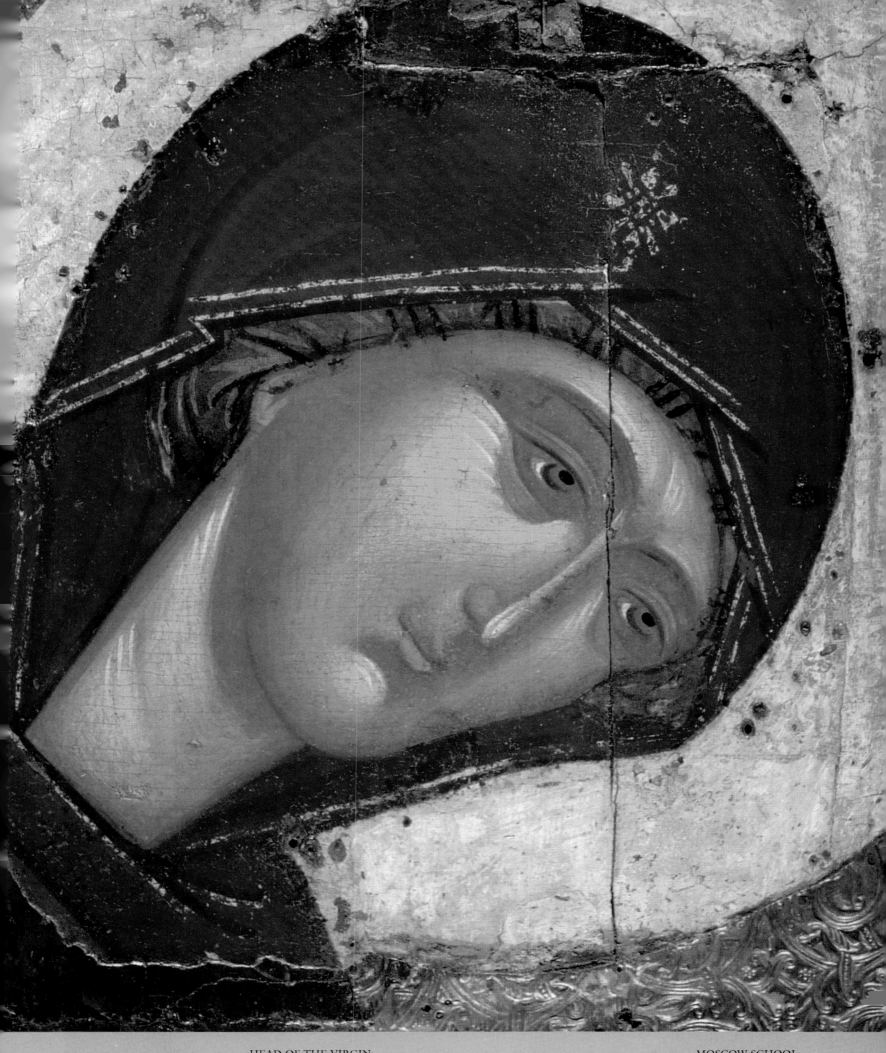

HEAD OF THE VIRGIN
TRETYAKOV GALLERY, MOSCOW

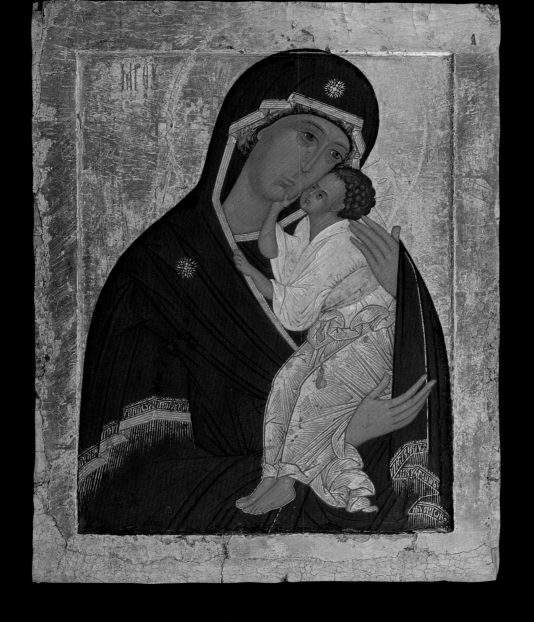

MOSCOW SCHOOL
SECOND HALF
OF 15TH CENTURY

THE VIRGIN OF YAROSLAV
TRETYAKOV GALLERY, MOSCOW

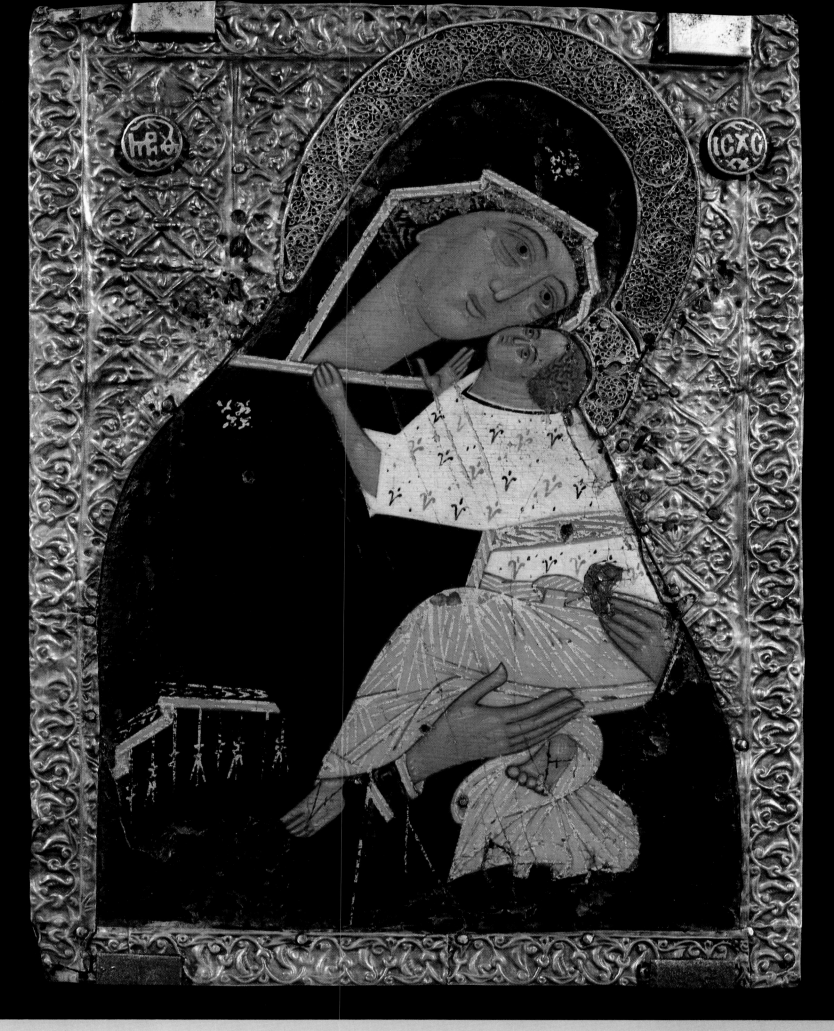

THE VIRGIN OF TENDERNESS
MONASTERY OF THE TRINITY OF SAINT SERGIUS
SERGIEV POSAD (ZAGORSK)

MOSCOW SCHOOL
LAST THIRD
OF 15TH CENTURY

114

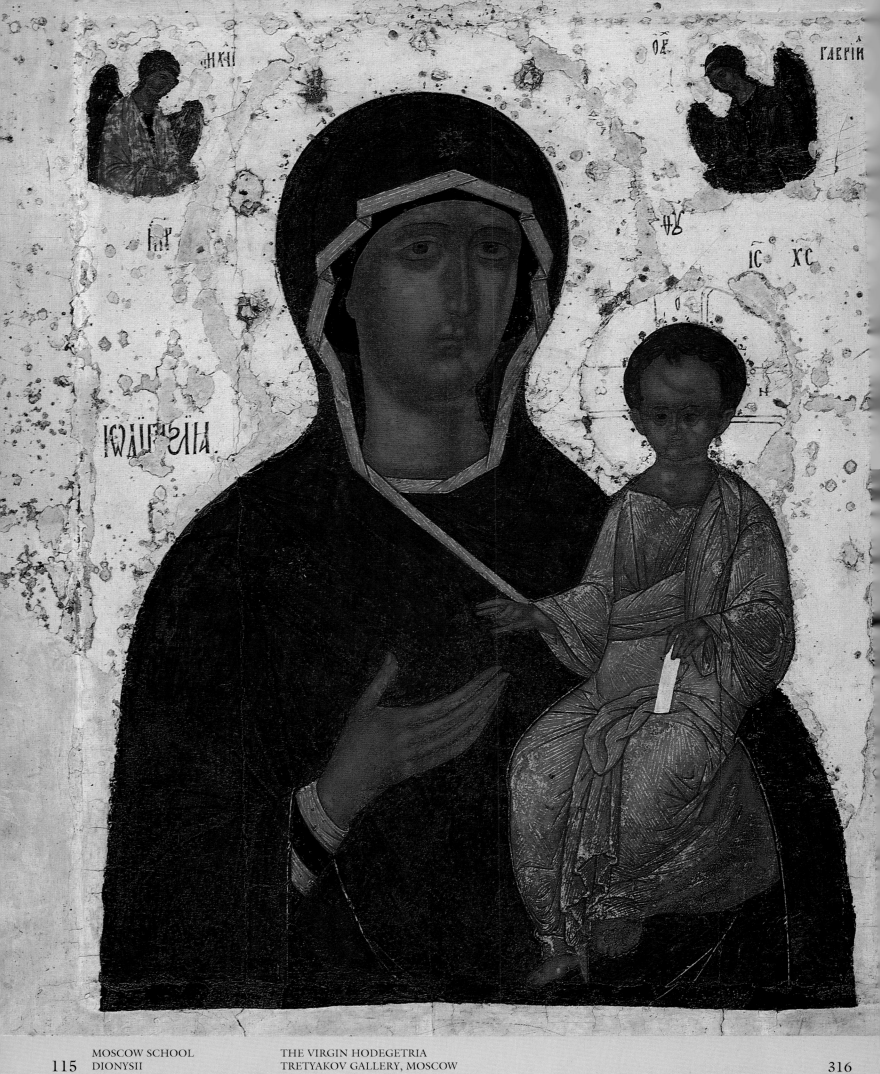

MOSCOW SCHOOL
DIONYSII
1482

THE VIRGIN HODEGETRIA
TRETYAKOV GALLERY, MOSCOW

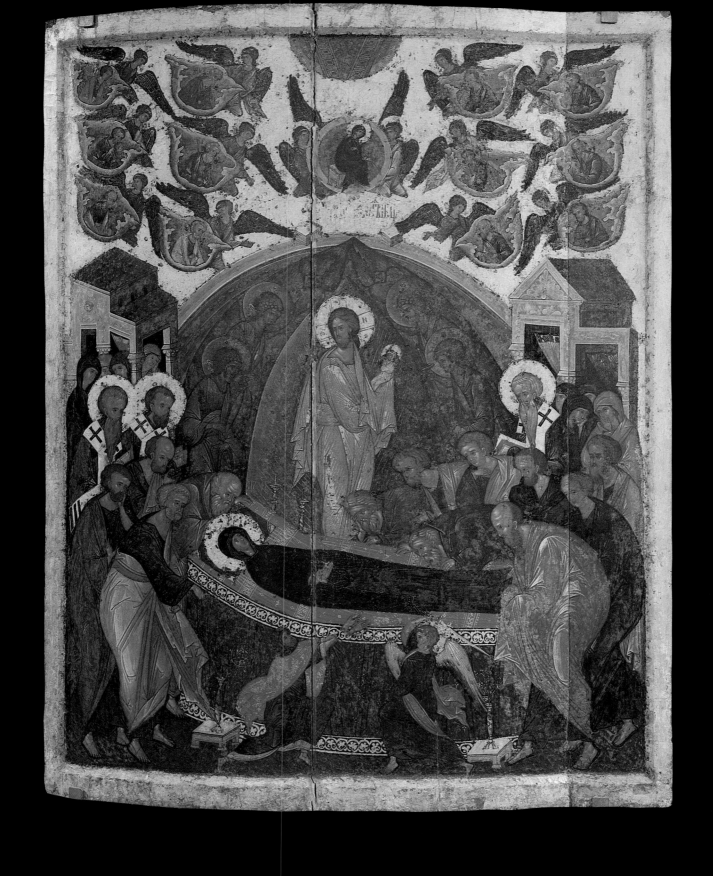

THE DORMITION
TRETYAKOV GALLERY, MOSCOW

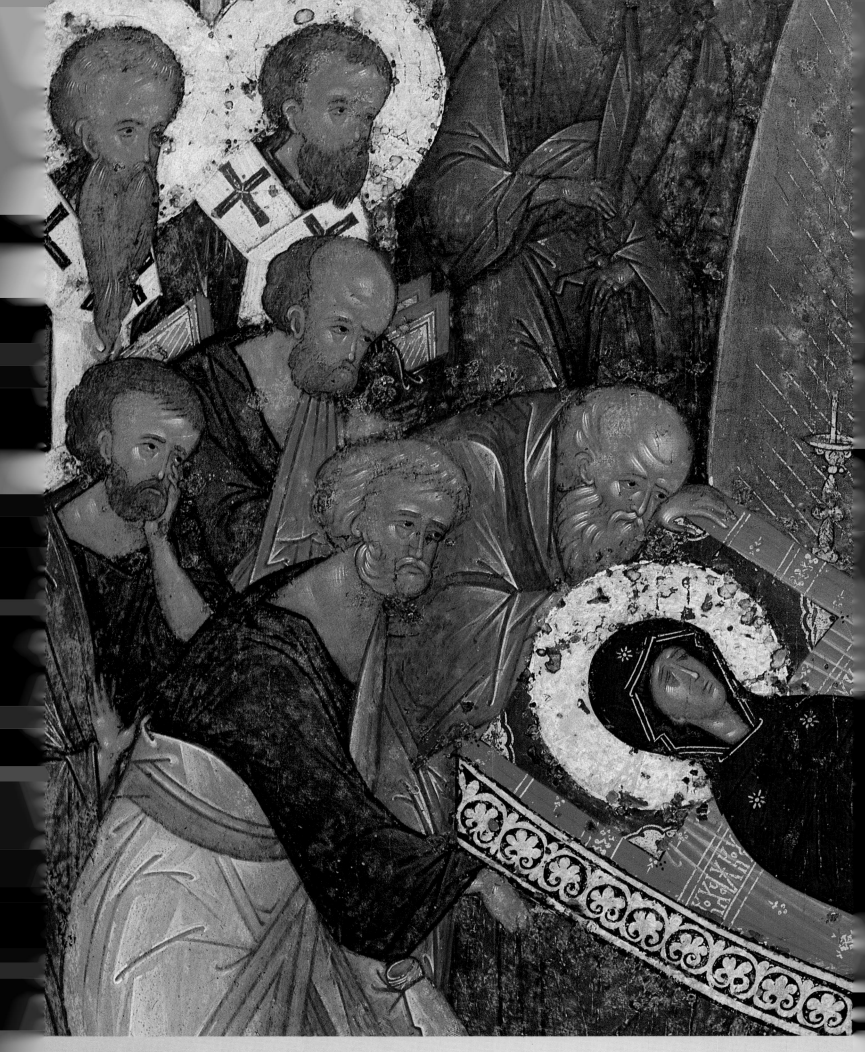

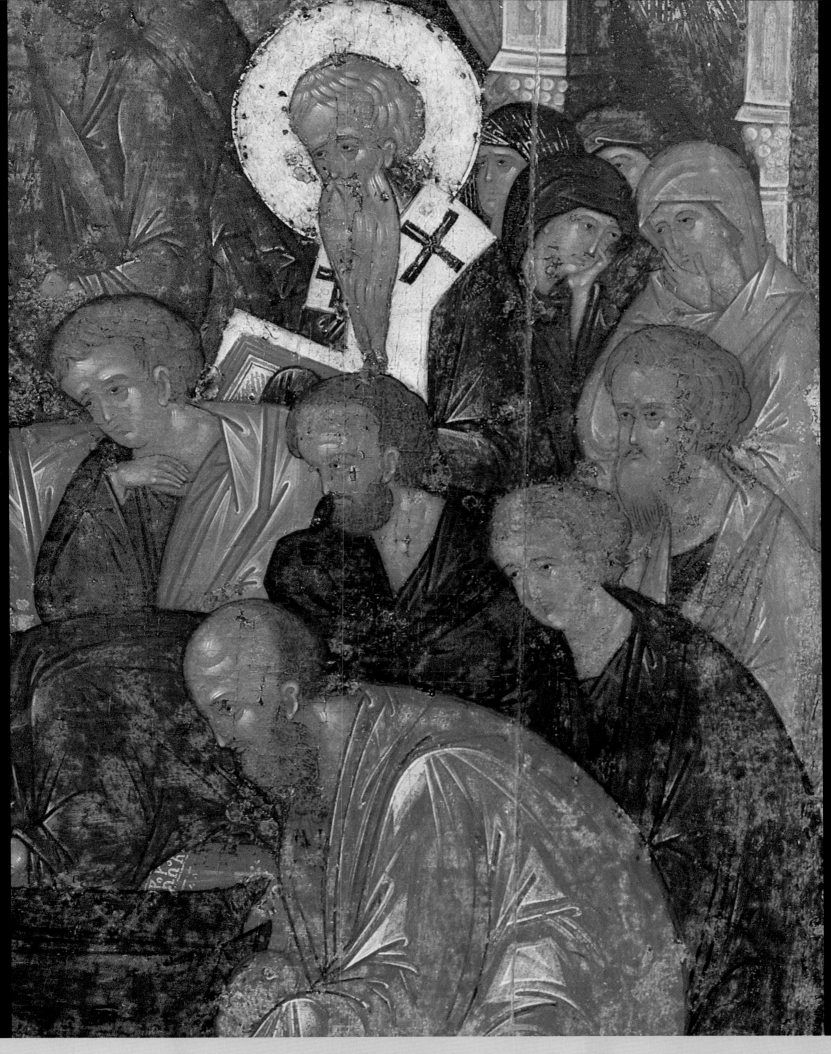

THE DORMITION (DETAIL)
TRETYAKOV GALLERY, MOSCOW

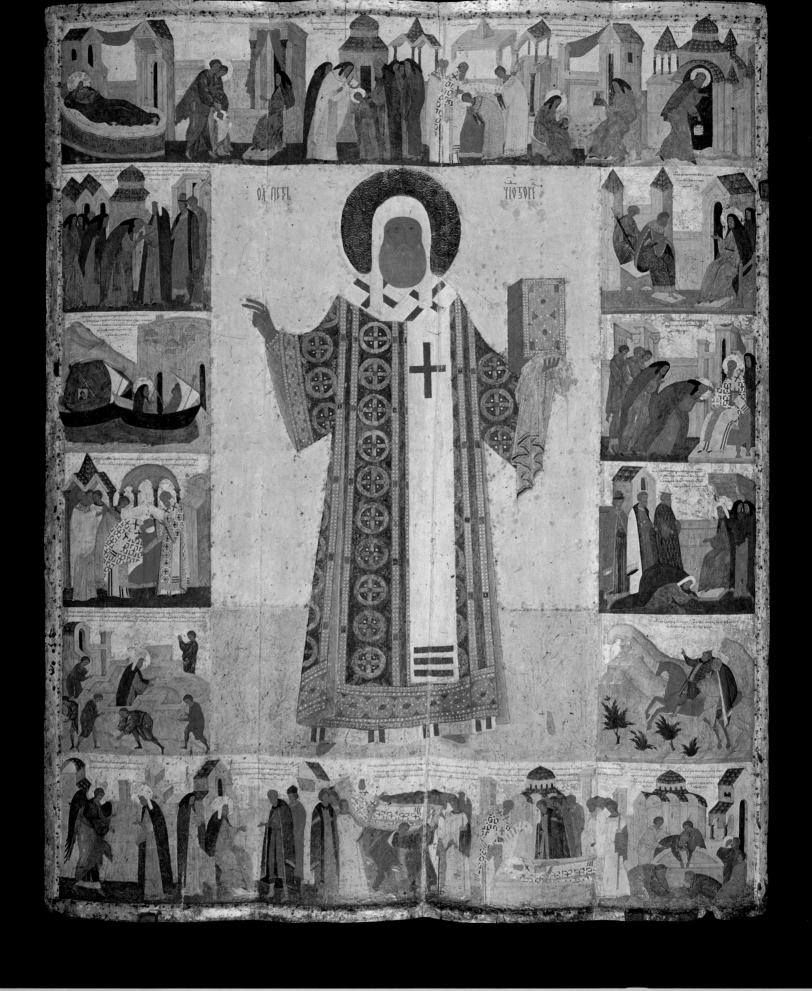

ОЙ ПЕРЬ ЧЮДОРЕ

117 MOSCOW SCHOOL THE METROPOLITAN PETER
 STUDIO OF DIONYSII WITH SCENES FROM HIS LIFE 320
 1480s CATHEDRAL OF THE DORMITION, KREMLIN, MOSCOW

THE METROPOLITAN PETER
WITH SCENES FROM HIS LIFE (DETAILS)
CATHEDRAL OF THE DORMITION, KREMLIN, MOSCOW

MOSCOW SCHOOL
STUDIO OF DIONYSII
1480s

MOSCOW SCHOOL
STUDIO OF DIONYSII
ABOUT 1485

THE DEPOSITION OF THE VIRGIN'S BELT AND ROBE
ANDREI RUBLEV MUSEUM OF EARLY RUSSIAN ART, MOSCOW

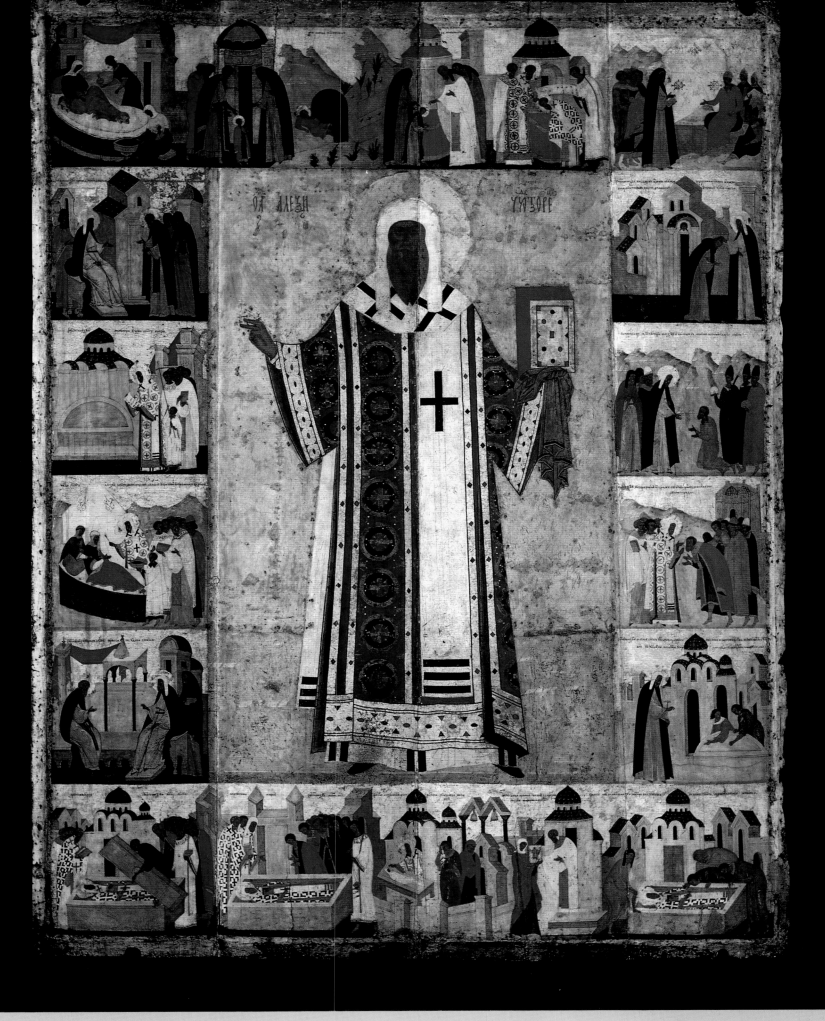

ОА АЛЕѮÏ ҮꙊꙀꙊРЕ

THE METROPOLITAN ALEXIUS WITH SCENES FROM HIS LIFE
TRETYAKOV GALLERY, MOSCOW

MOSCOW SCHOOL
STUDIO OF DIONYSII 119
1480s

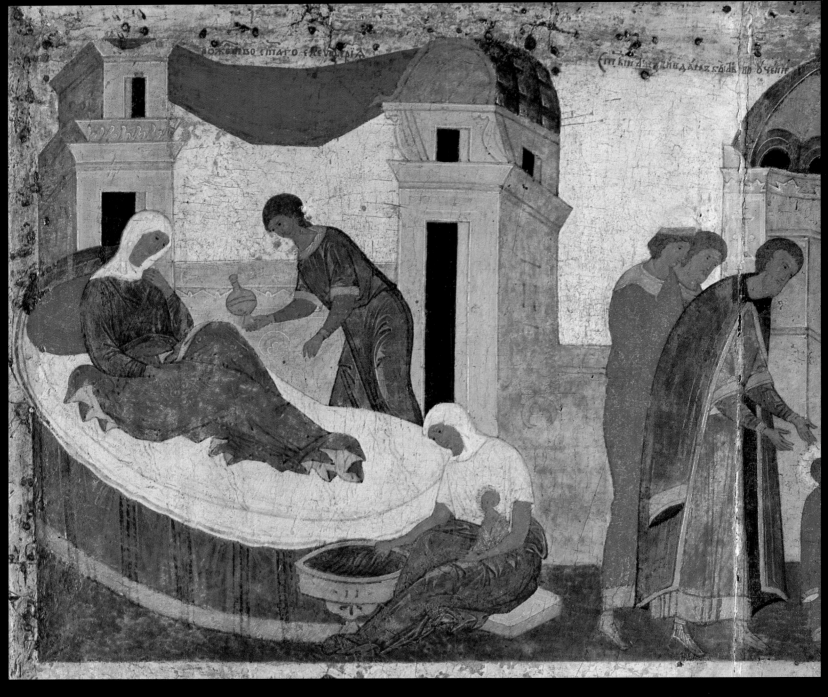
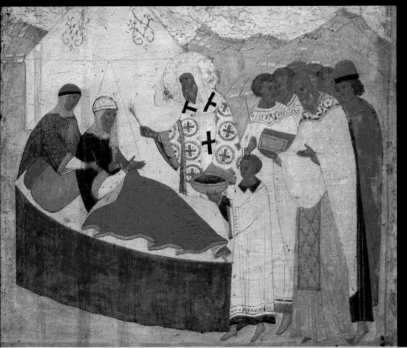
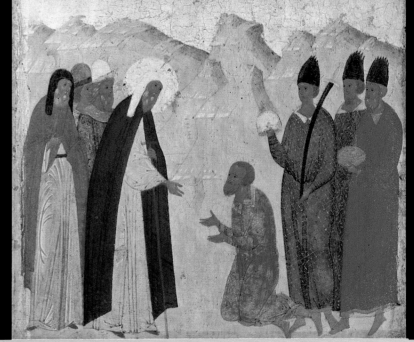

MOSCOW SCHOOL
STUDIO OF DIONYSII
1480s

THE METROPOLITAN ALEXIUS WITH SCENES FROM HIS LIFE (DETAILS)
TRETYAKOV GALLERY, MOSCOW

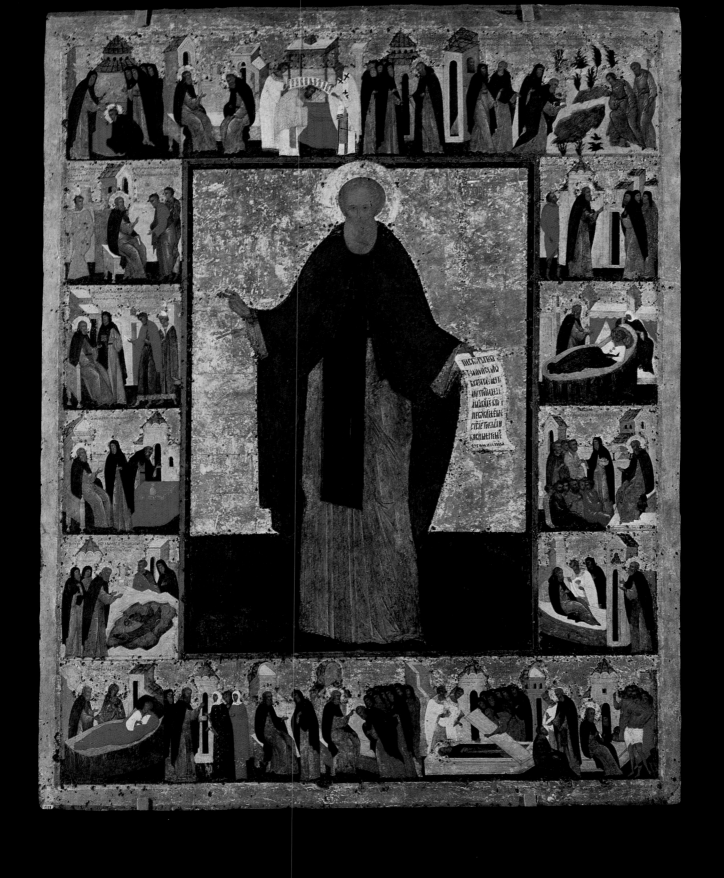

SAINT CYRIL OF BELOZERSK WITH SCENES FROM HIS LIFE
RUSSIAN MUSEUM, SAINT PETERSBURG

MOSCOW SCHOOL
STUDIO OF DIONYSII 120
LATE 15TH CENTURY

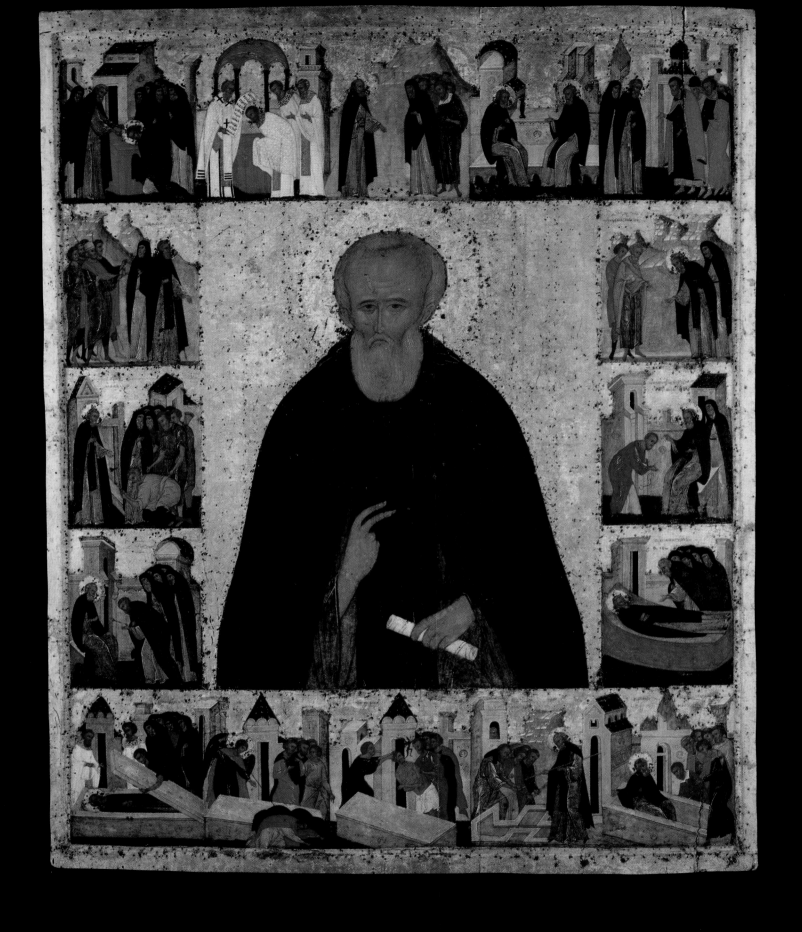

MOSCOW SCHOOL
STUDIO OF DIONYSII
LATE 15TH CENTURY

SAINT DEMETRIUS OF PRILUTSK WITH SCENES FROM HIS LIFE
REGIONAL ETHNOGRAPHIC MUSEUM, VOLOGDA

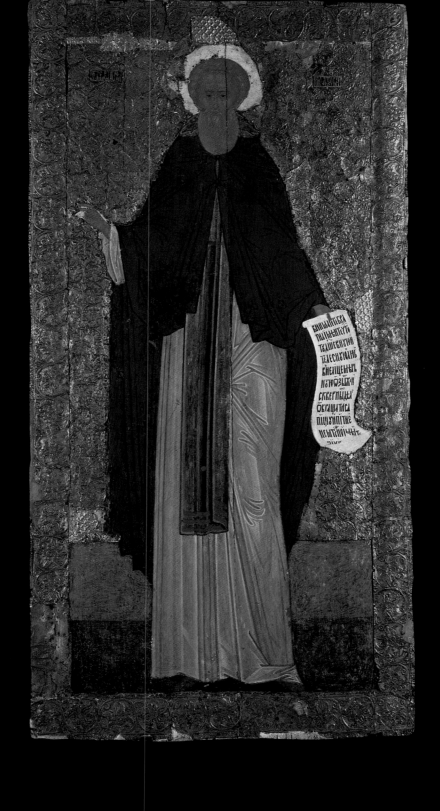

SAINT CYRIL OF BELOZERSK
RUSSIAN MUSEUM, SAINT PETERSBURG

MOSCOW SCHOOL
STUDIO OF DIONYSII 122
EARLY 16TH CENTURY

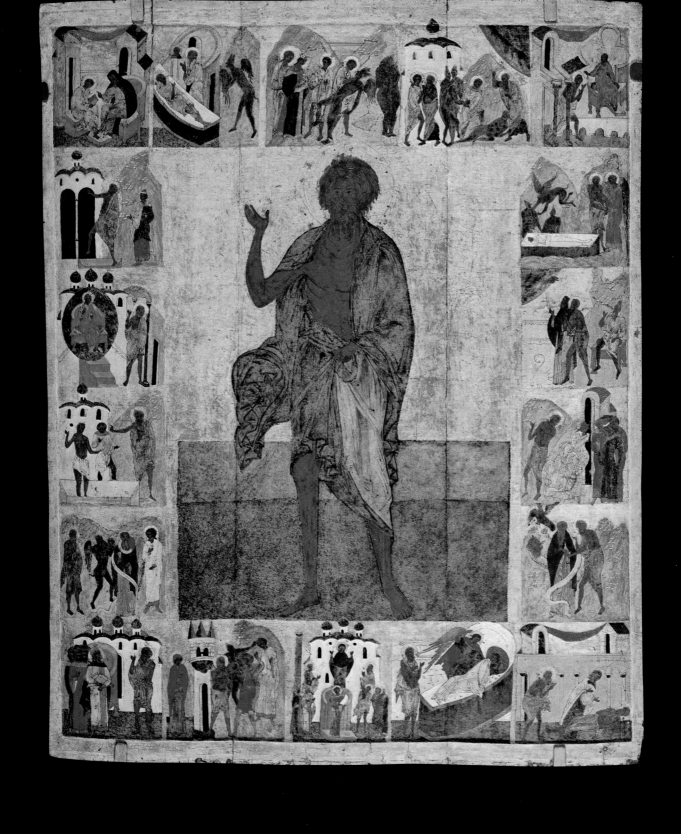

MOSCOW SCHOOL
DIONYSII'S FOLLOWERS
EARLY 16TH CENTURY

SAINT ANDREW YURODIVYI (GOD'S FOOL)
WITH SCENES FROM HIS LIFE
RUSSIAN MUSEUM, SAINT PETERSBURG

328

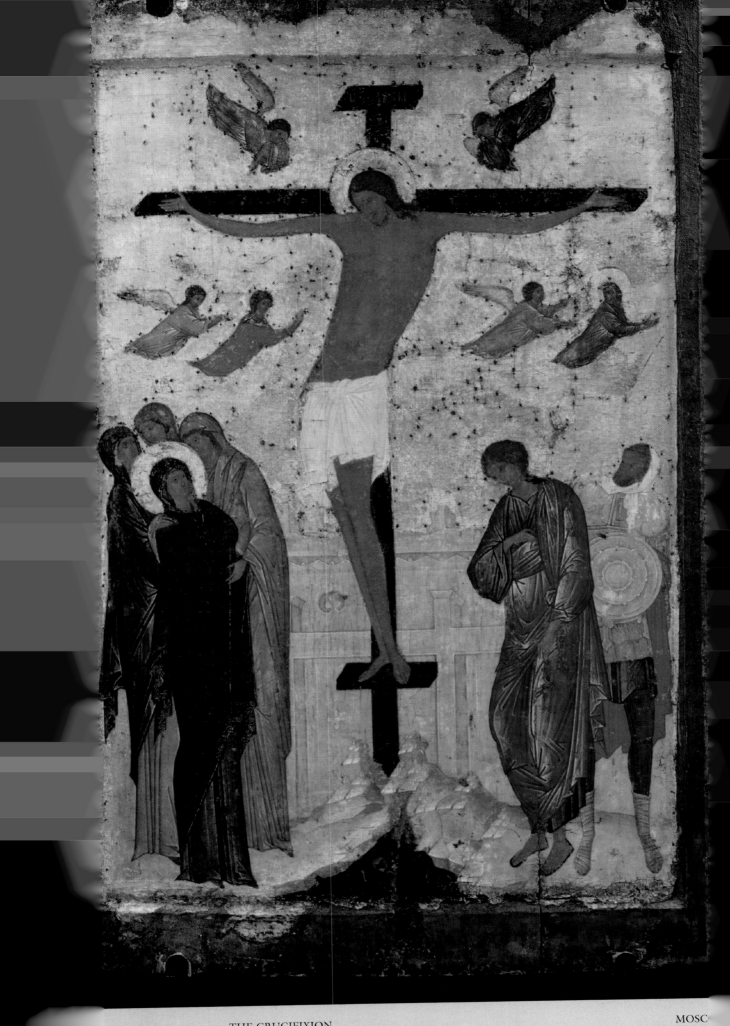

THE CRUCIFIXION
TRETYAKOV GALLERY, MOSCOW

MOSCOW SCHOOL
DIONYSII
1500

THE CRUCIFIXION (DETAIL)
TRETYAKOV GALLERY, MOSCOW

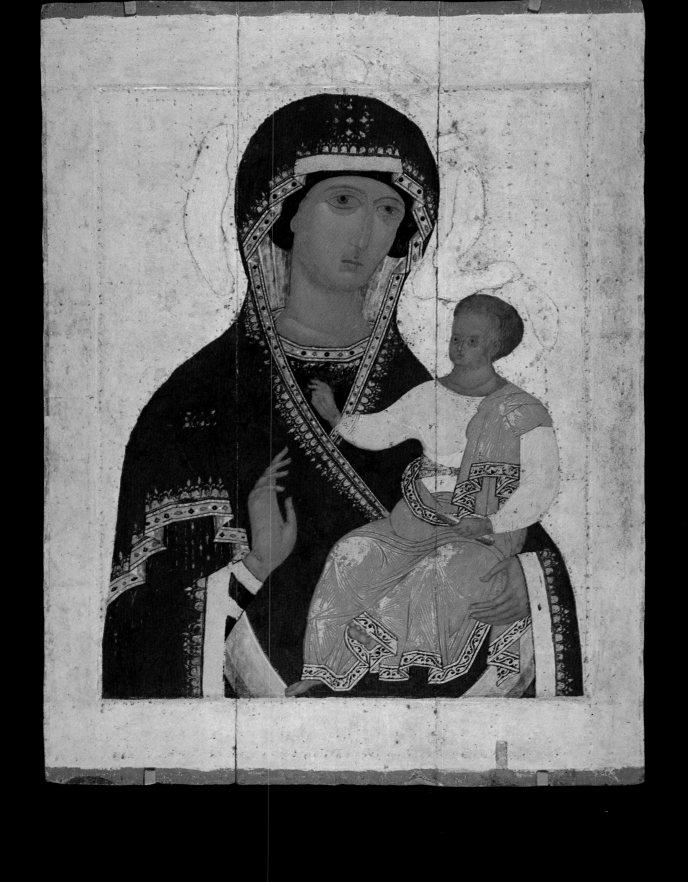

THE VIRGIN HODEGETRIA
RUSSIAN MUSEUM, SAINT PETERSBURG

MOSCOW SCHOOL
DIONYSII 125
1502

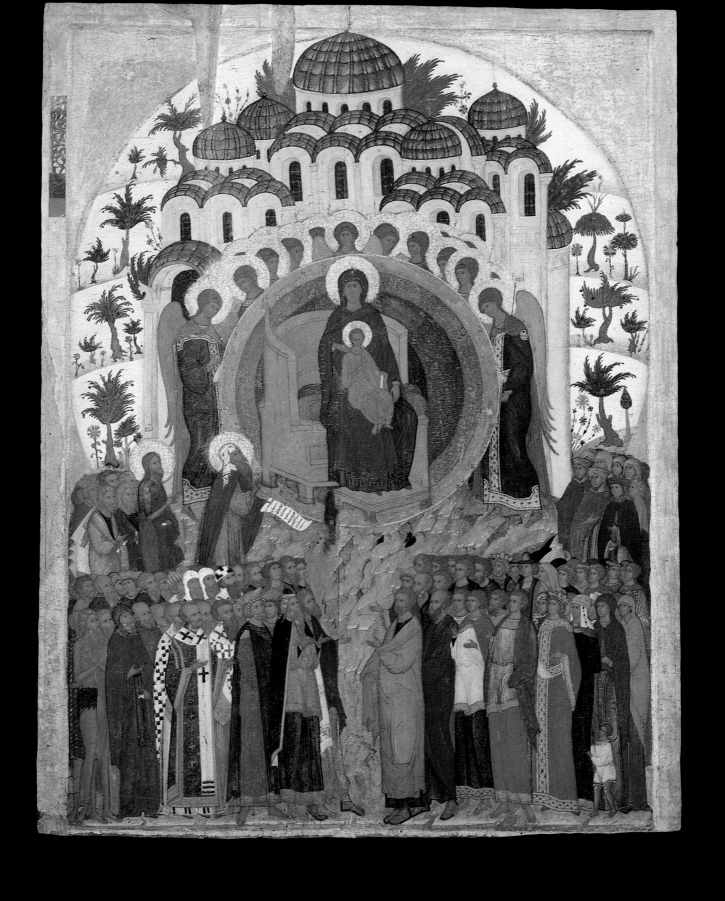

MOSCOW SCHOOL
STUDIO OF DIONYSII
EARLY 16TH CENTURY

IN YOU EVERYTHING REJOICES
TRETYAKOV GALLERY, MOSCOW

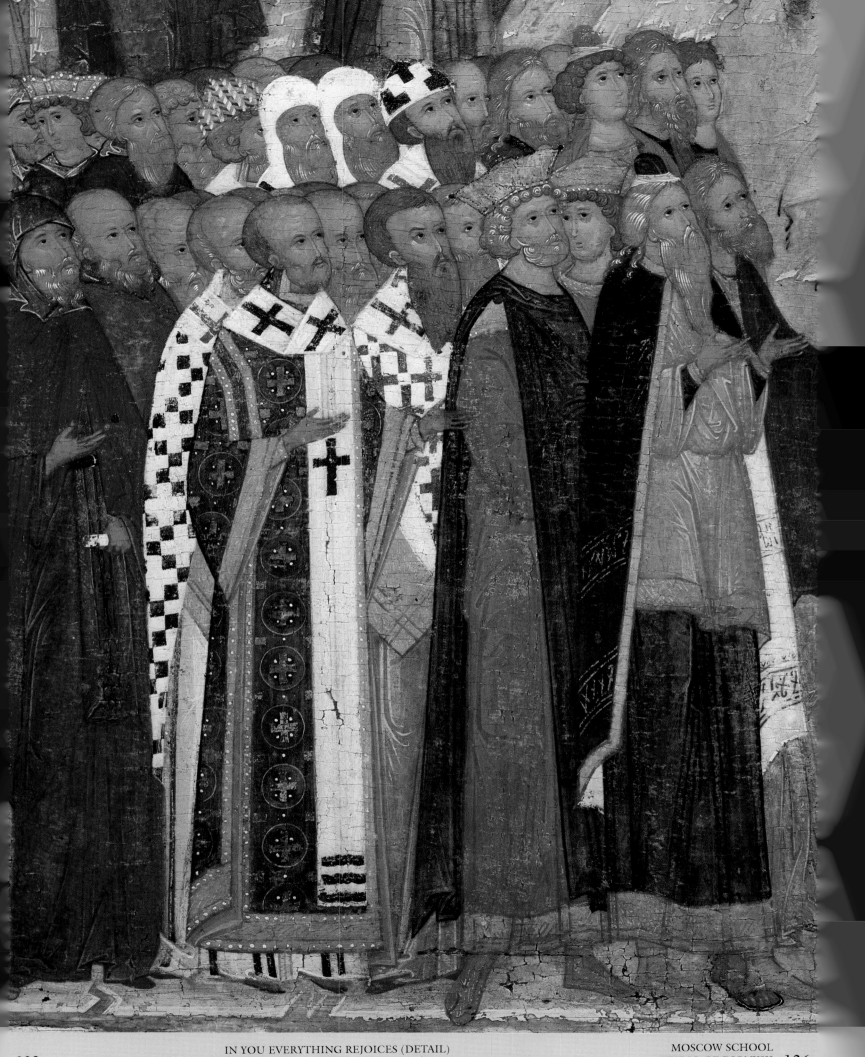

IN YOU EVERYTHING REJOICES (DETAIL)
TRETYAKOV GALLERY, MOSCOW

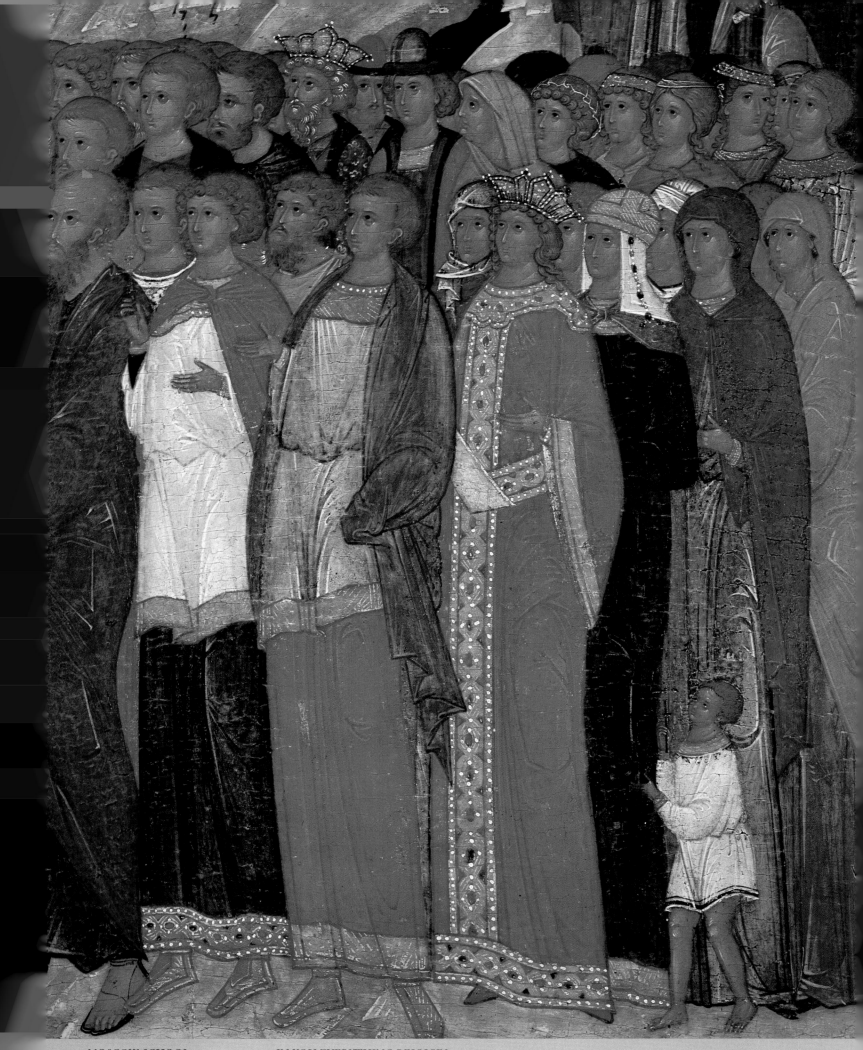

MOSCOW SCHOOL
STUDIO OF DIONYSII
EARLY 16TH CENTURY

IN YOU EVERYTHING REJOICES
TRETYAKOV GALLERY, MOSCOW

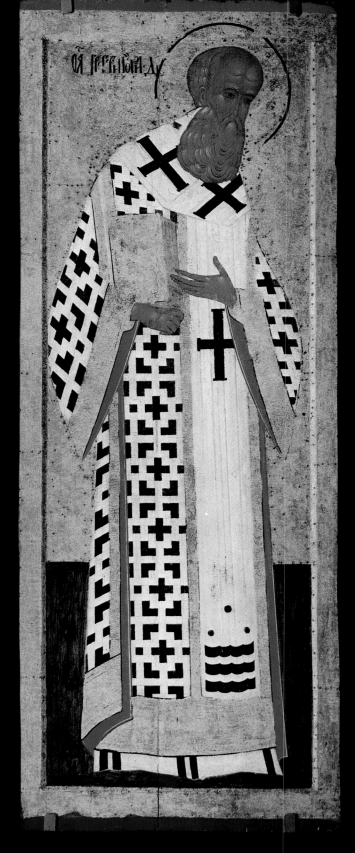

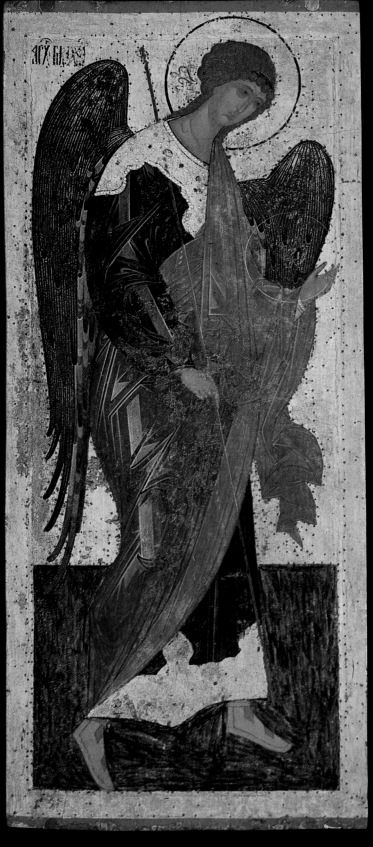

335

DEESIS: SAINT GREGORY THE THEOLOGIAN; THE ARCHANGEL MICHAEL
RUSSIAN MUSEUM, SAINT PETERSBURG;
TRETYAKOV GALLERY, MOSCOW

MOSCOW SCHOOL
STUDIO OF DIONYSII 127
1502

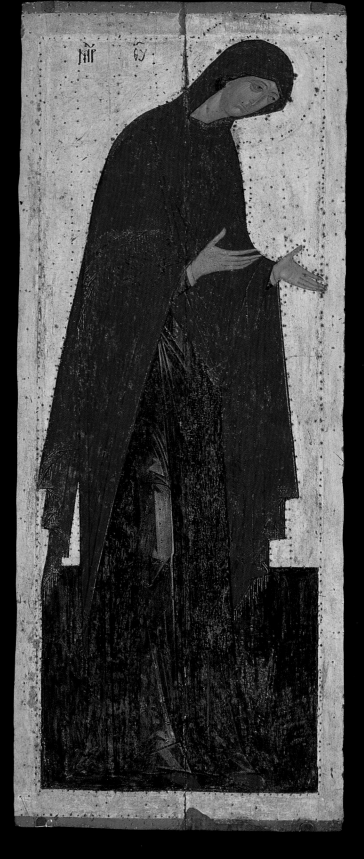
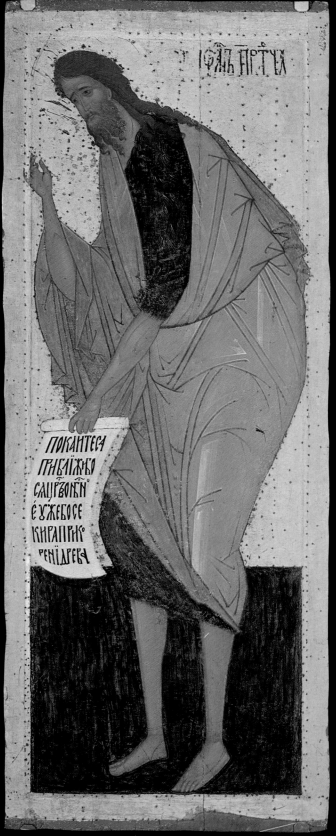

MOSCOW SCHOOL DEESIS: THE VIRGIN; SAINT JOHN THE BAPTIST
STUDIO OF DIONYSII TRETYAKOV GALLERY, MOSCOW
1502

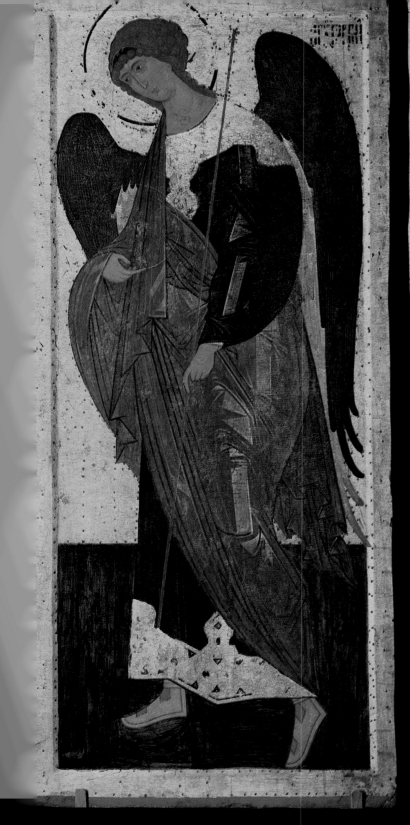
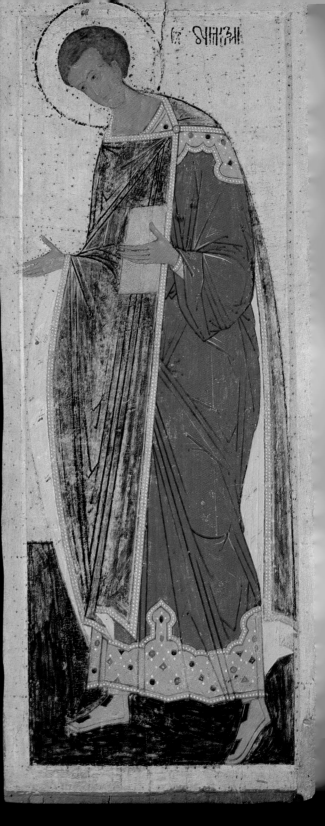

DEESIS: THE ARCHANGEL GABRIEL; SAINT DEMETRIUS OF THESSALONICA
RUSSIAN MUSEUM, SAINT PETERSBURG;
TRETYAKOV GALLERY, MOSCOW

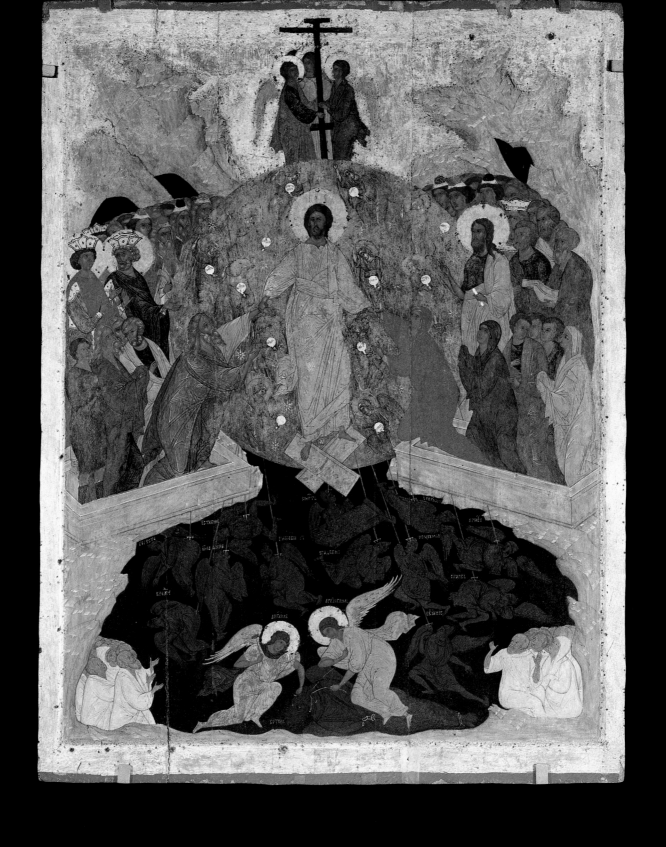

MOSCOW SCHOOL
DIONYSII AND PUPILS
1502

THE DESCENT INTO HELL
RUSSIAN MUSEUM, SAINT PETERSBURG

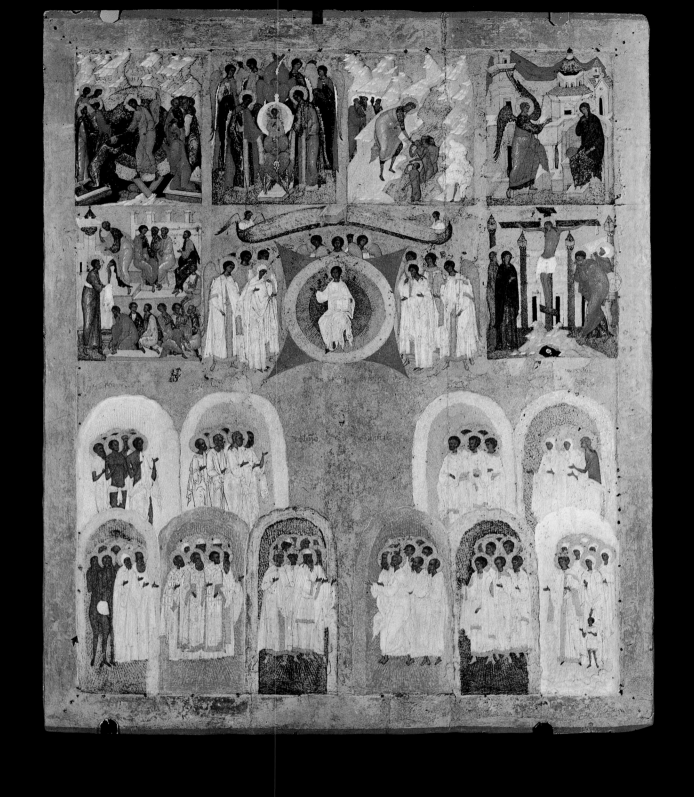

THE FEAST DAYS OF THE WEEK
TRETYAKOV GALLERY, MOSCOW

MOSCOW SCHOOL
FOLLOWER OF DIONYSII 129
EARLY 16TH CENTURY

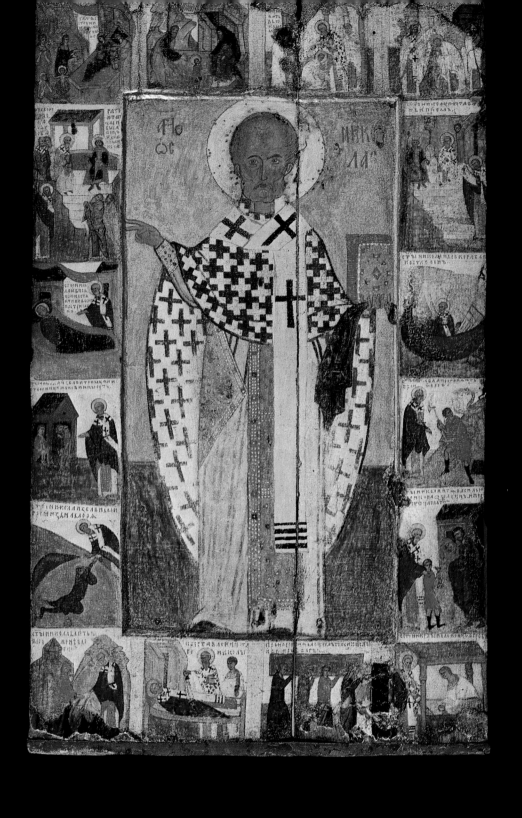

FIRST HALF
OF 14TH CENTURY

SAINT NICHOLAS OF ZARAYSK
WITH SCENES FROM HIS LIFE
TRETYAKOV GALLERY, MOSCOW

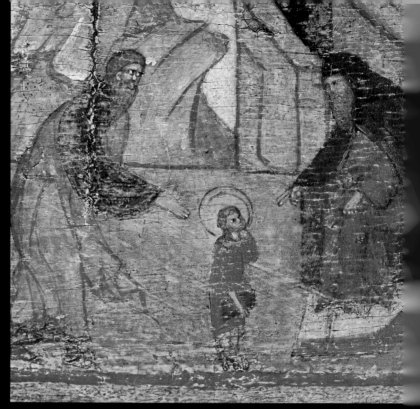
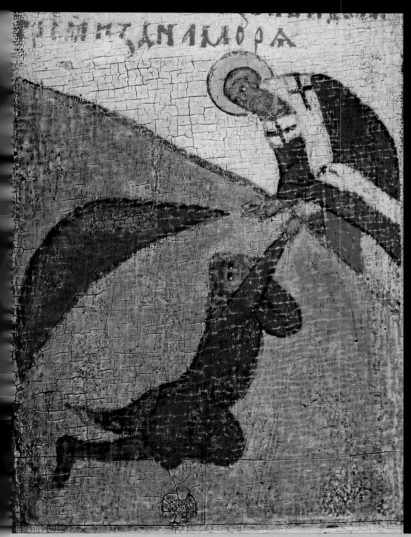
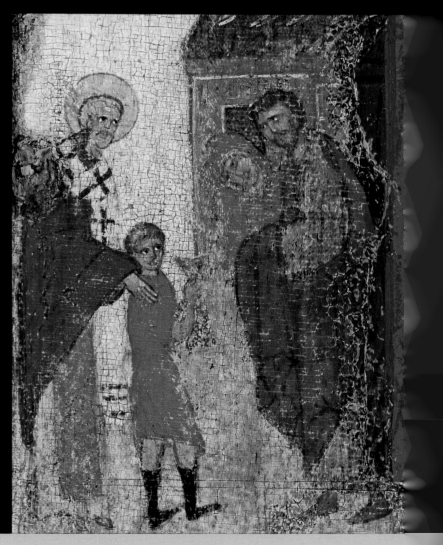

SAINT NICHOLAS OF ZARAYSK
WITH SCENES FROM HIS LIFE (DETAILS)
TRETYAKOV GALLERY, MOSCOW

FIRST HALF
OF 14TH CENTURY

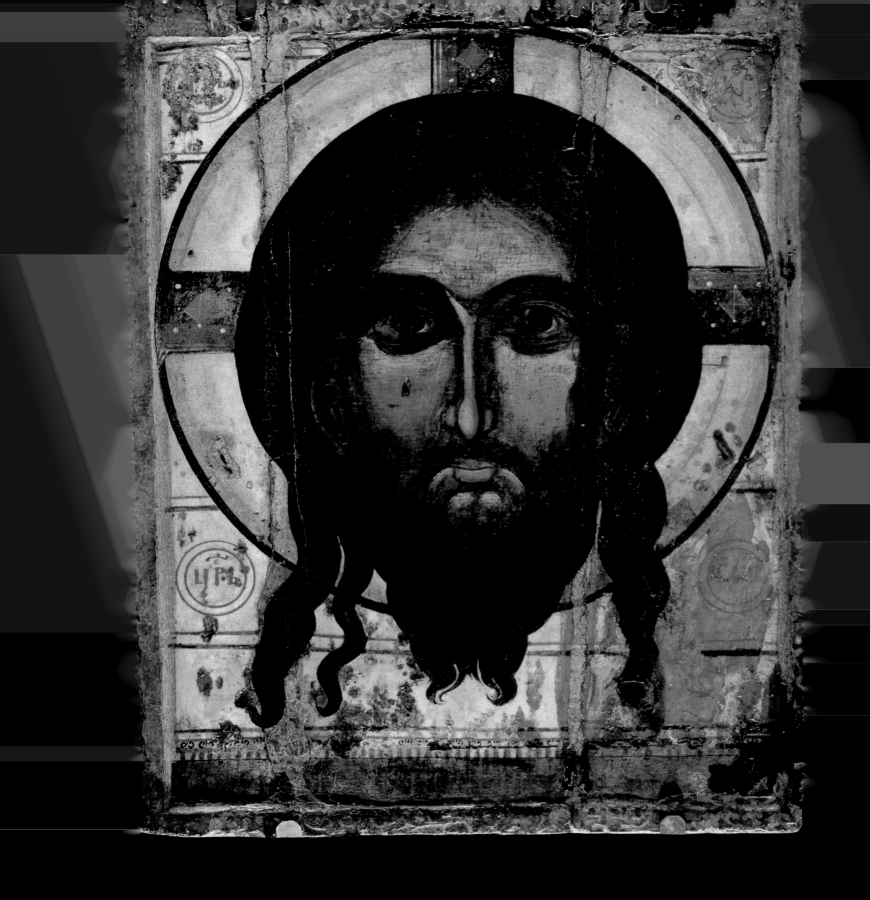

THE HOLY FACE
TRETYAKOV GALLERY, MOSCOW

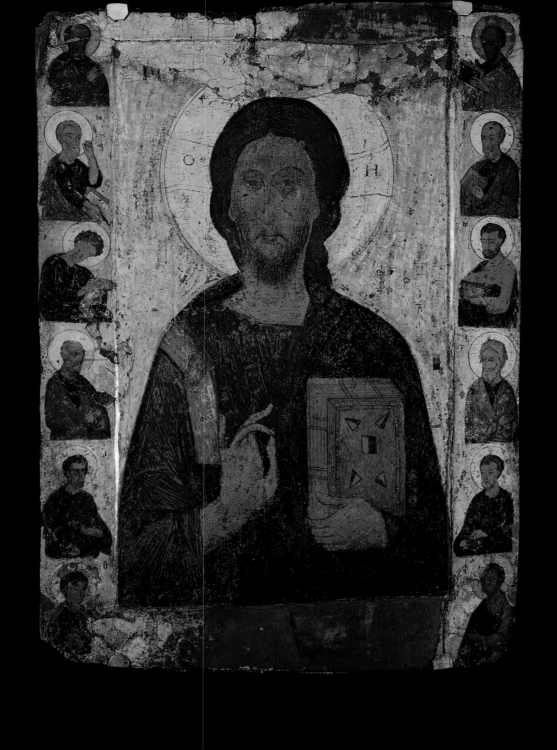

CHRIST WITH THE APOSTLES
TRETYAKOV GALLERY, MOSCOW

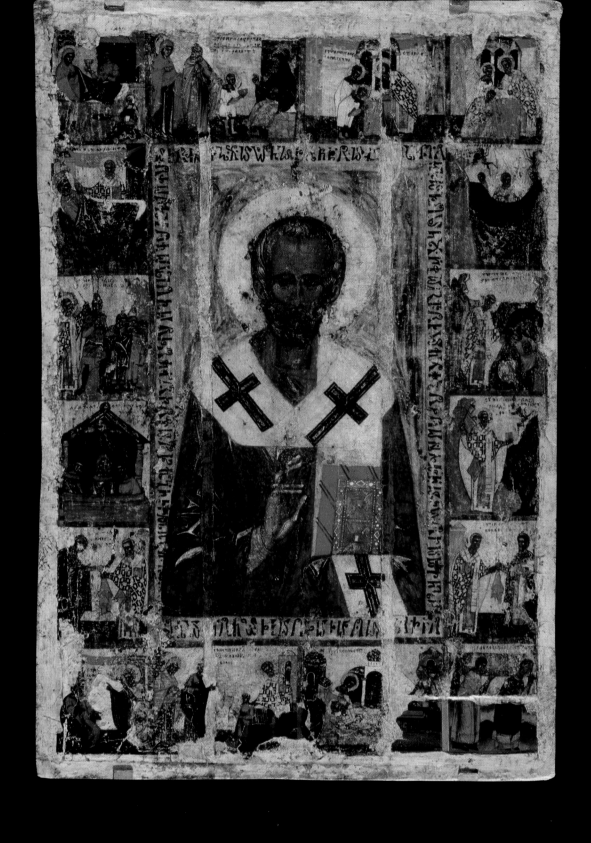

SAINT NICHOLAS THE WONDERWORKER
WITH SCENES FROM HIS LIFE
TRETYAKOV GALLERY, MOSCOW

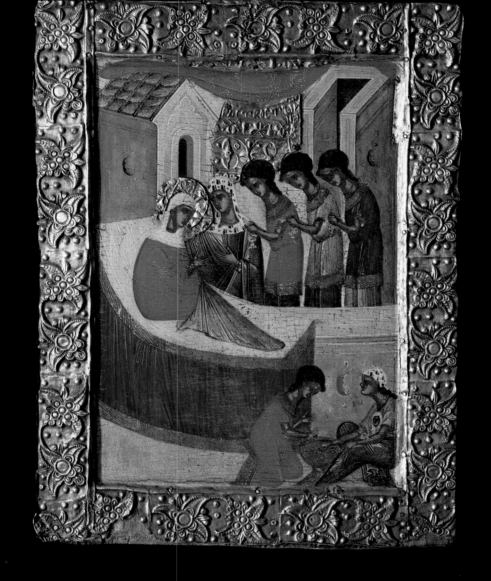

THE NATIVITY OF THE VIRGIN
RUSSIAN MUSEUM, SAINT PETERSBURG

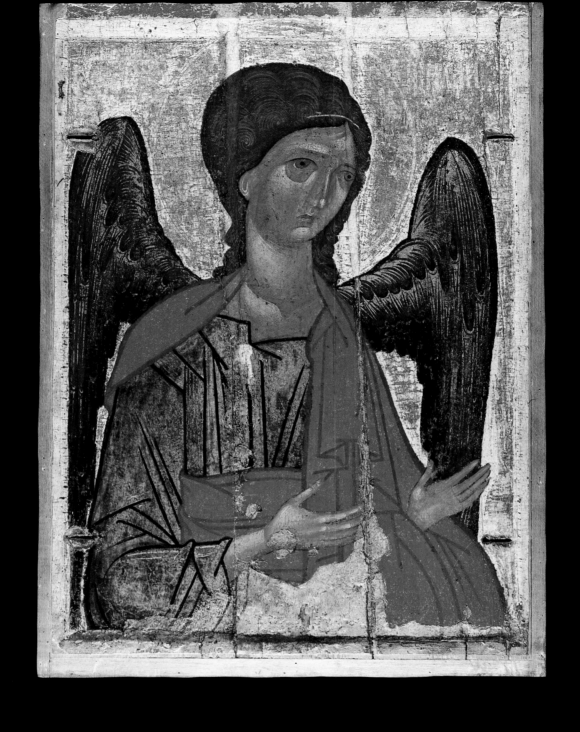

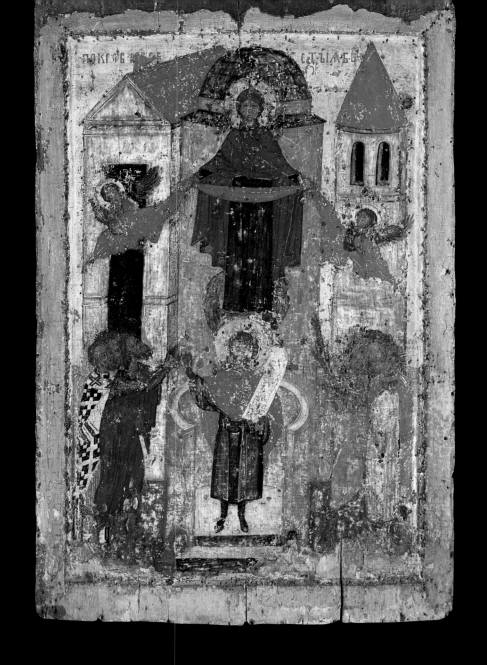

THE VIRGIN OF MERCY
TRETYAKOV GALLERY, MOSCOW

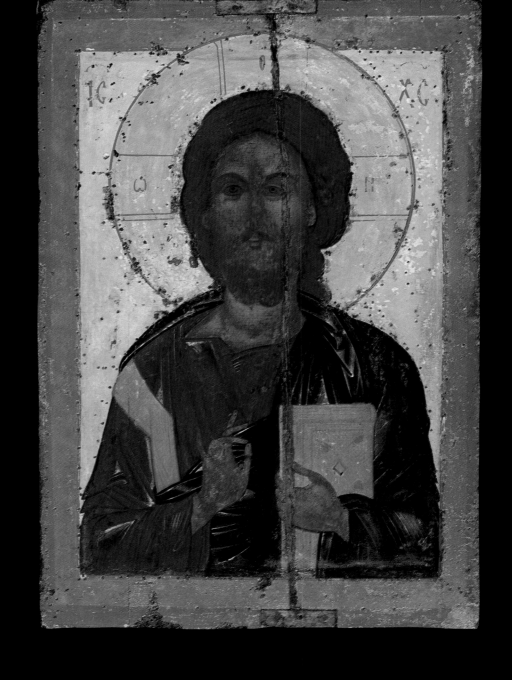

RECTO: THE SAVIOR
TRETYAKOV GALLERY, MOSCOW

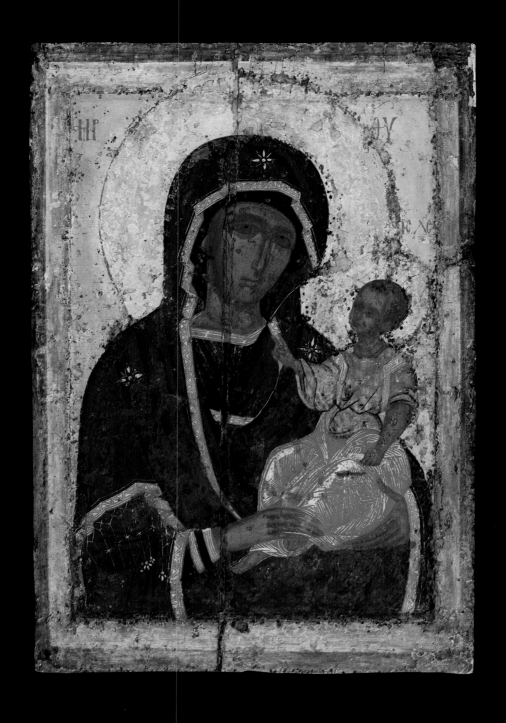

VERSO: THE VIRGIN HODEGETRIA
TRETYAKOV GALLERY, MOSCOW

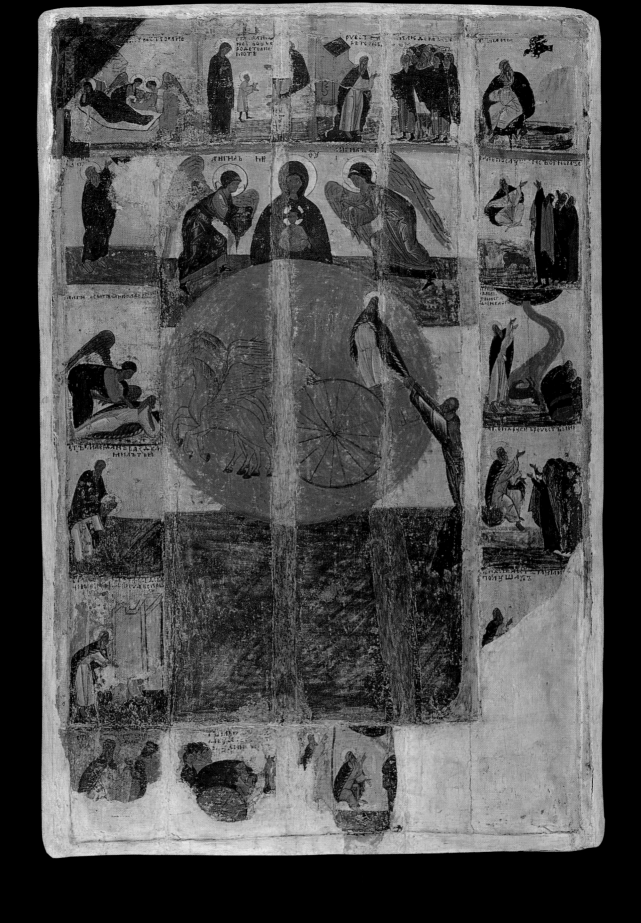

LATE
14TH CENTURY
THE PROPHET ELIJAH WITH SCENES FROM HIS LIFE
MUSEUM OF FINE ARTS, NIZHNII NOVGOROD (GORKII)

THE PROPHET ELIJAH WITH SCENES FROM HIS LIFE (DETAILS)
MUSEUM OF FINE ARTS, NIZHNII NOVGOROD (GORKII)

LATE
14TH CENTURY

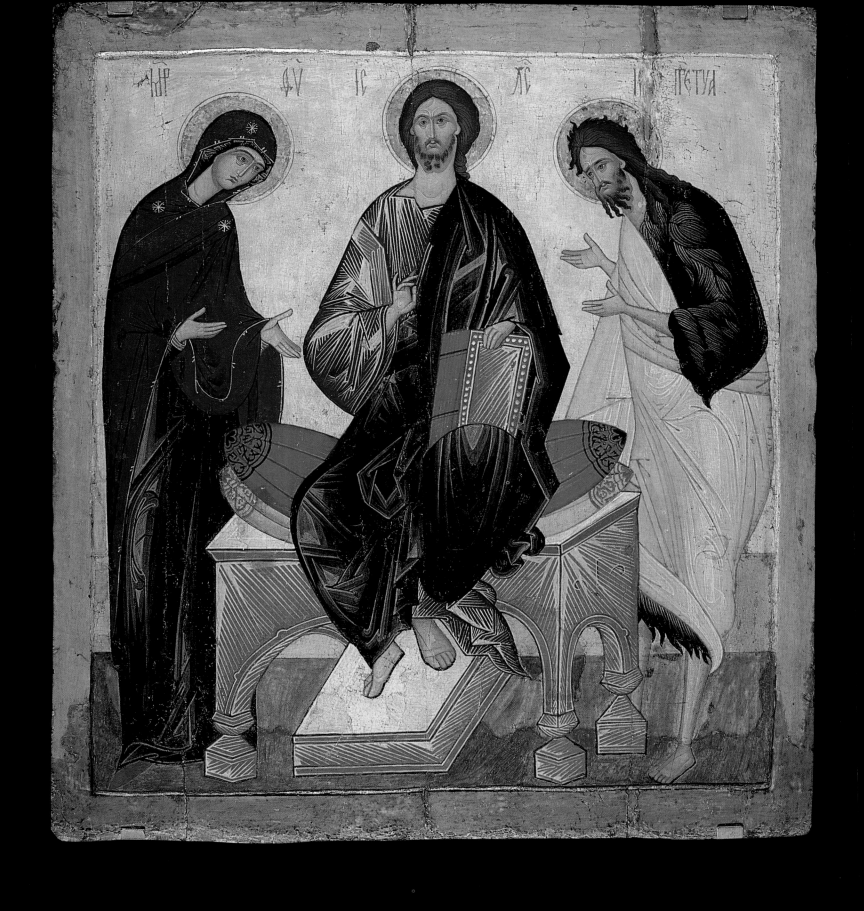

SECOND HALF
OF 15TH CENTURY

THE DEESIS
TRETYAKOV GALLERY, MOSCOW

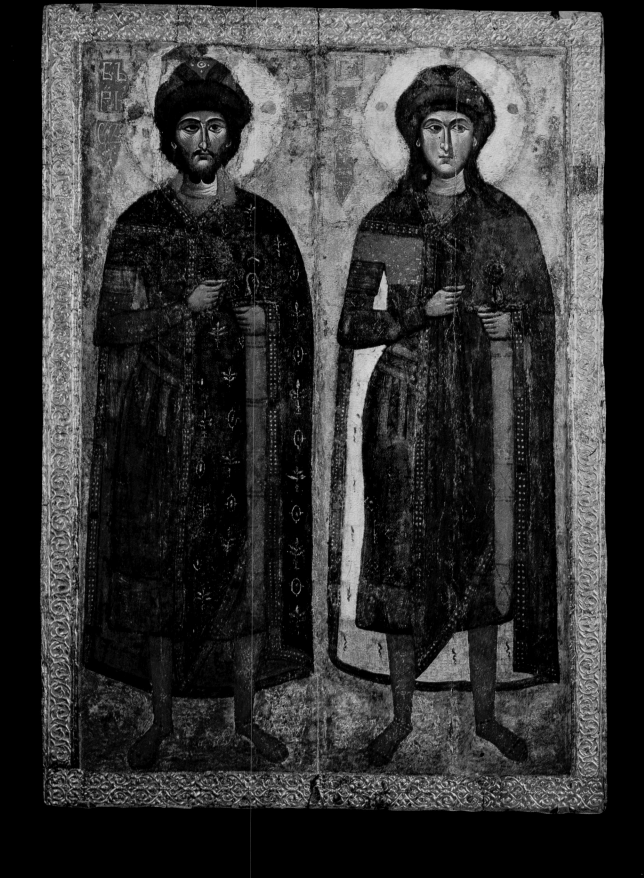

SAINTS BORIS AND GLEB
RUSSIAN ART MUSEUM, KIEV

EARLY
14TH CENTURY

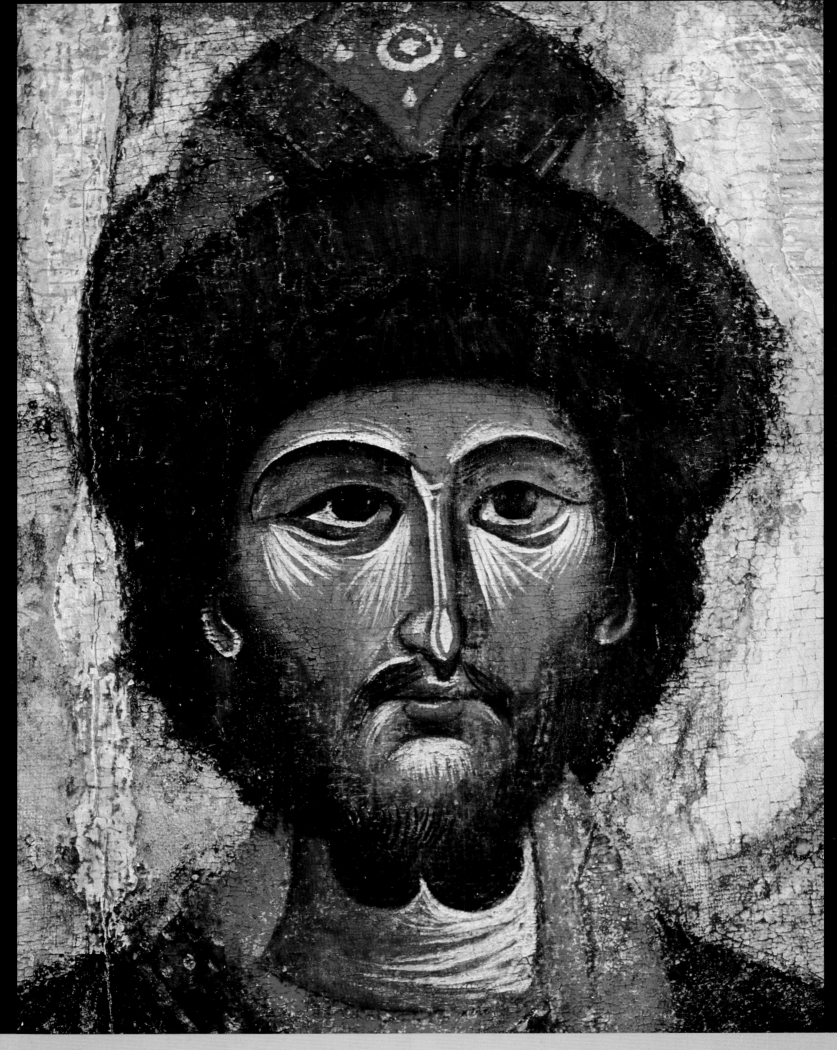

EARLY
14TH CENTURY
SAINTS BORIS AND GLEB (DETAIL)
RUSSIAN ART MUSEUM, KIEV

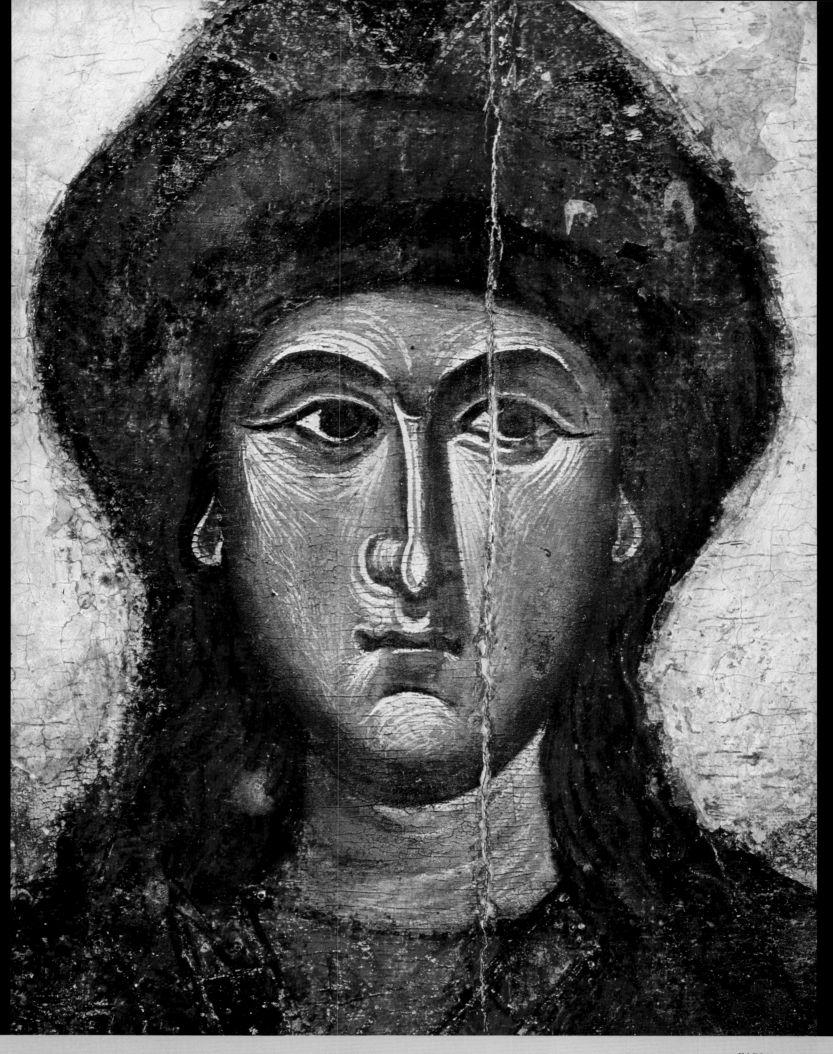

SAINTS BORIS AND GLEB (DETAIL)
RUSSIAN ART MUSEUM, KIEV

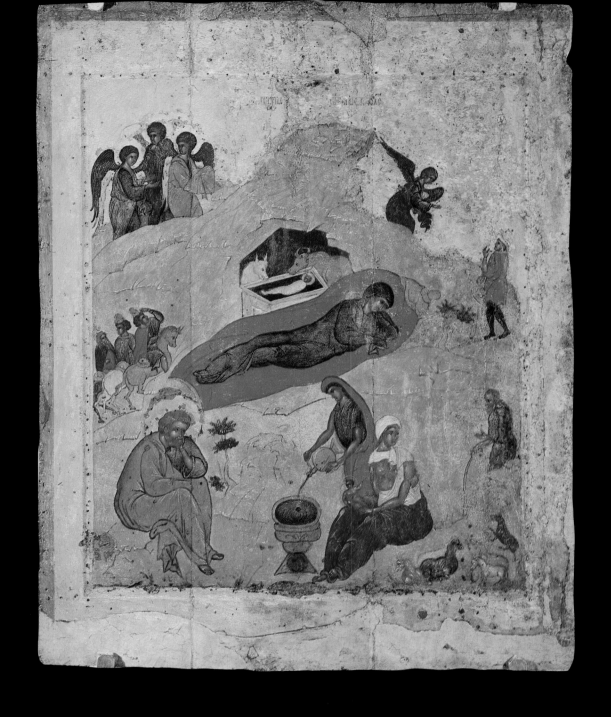

THE NATIVITY OF CHRIST
TRETYAKOV GALLERY, MOSCOW

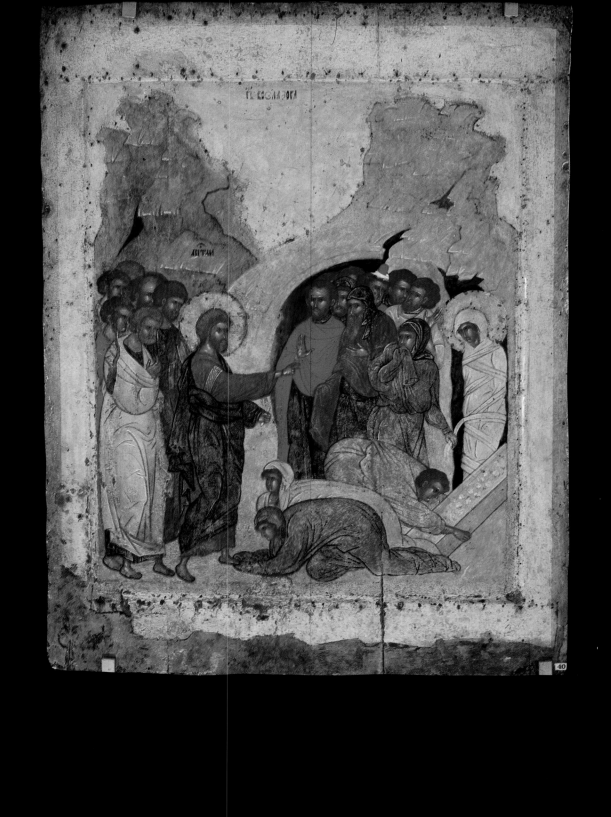

THE RAISING OF LAZARUS
RUSSIAN MUSEUM, SAINT PETERSBURG

MID
15TH CENTURY

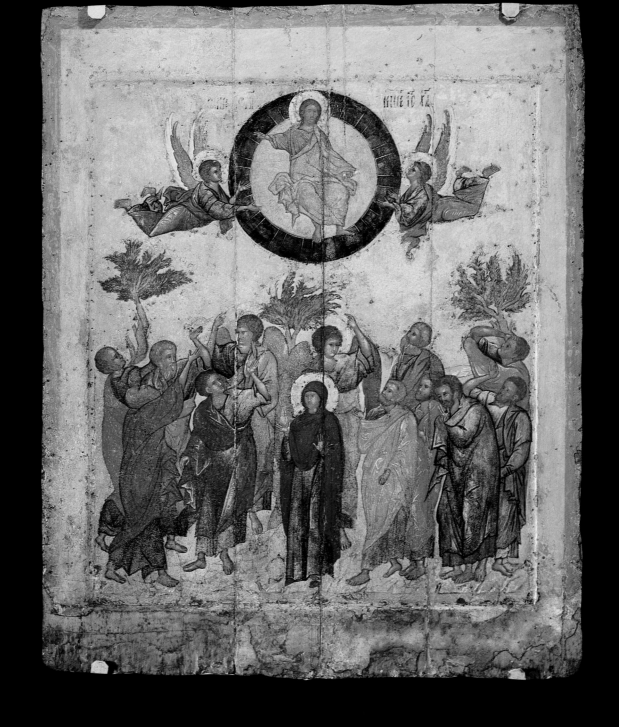

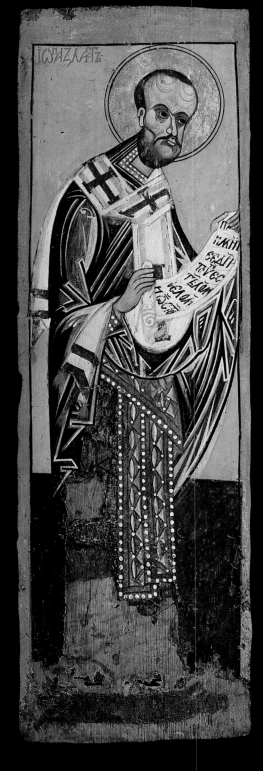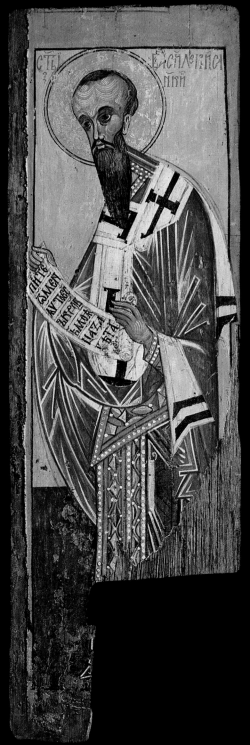

THE ROYAL DOORS WITH IMAGES OF SAINTS JOHN CHRYSOSTOM
AND BASIL THE GREAT
TRETYAKOV GALLERY, MOSCOW

SECOND HALF
OF 14TH CENTURY

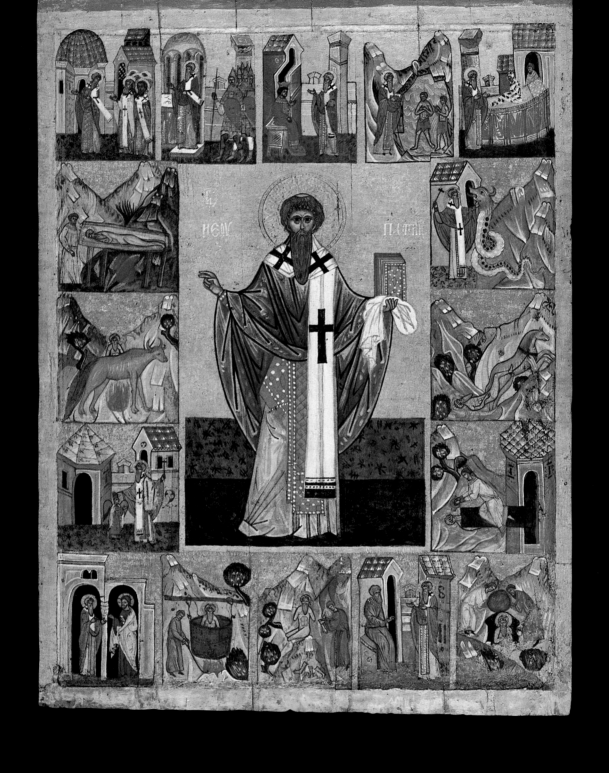

Notes on the Plates

In these notes on the individual plates, we record the specific bibliography referring to individual works, and we deliberately omit works of a more general type in order not to make the bibliography too weighty. Information on these latter texts can be found in the description of the icons in the Tretyakov Gallery included in the two-volume catalogue of V.I. Antonova and N.E. Mneva. Digressions of an iconographic nature are introduced only when they deal with a rather unusual type.

In our edition, there are a few more illustrations than those originally planned by Lazarev, who had to adapt to the characteristics of Phaidon Press's series, as he had already done for his monograph *Old Russian Murals and Mosaics*. However, the illustrations introduced in this second phase do not reproduce new works, but rather details or entire icons with multiple compositions, such as the registers of the *Deesis*, the *Feast*, and the *Prophets* of the large Russian iconostases. In these cases, we selected only the images mentioned in the *Notes on the Plates*.

It was the intention of the author to have the illustrations divided into "sketches" (in his listings there are 54) and "plates" (254). The term "sketches" signified the reproductions of individual icons and of details intended for the body of the text, whereas the term "plates" was used for the reproductions of the works included in the iconographic section. Included among the sketches were a few miniatures and masterpieces of embroidery such as, for example, the illustration of *Lobkovskii Prolog* from 1262, which reproduces the Novgorodian icon of the *Holy Face*, and the large veil of Mary Tverskaya, executed in Moscow in 1389. Two icons which are not Russian appear among the sketches: a Greco-Slavic icon from 1341 (?) from the Saint Sophia Cathedral of Novgorod and the Greek *Annunciation* from the end of the fourteenth century preserved in the Tretyakov Gallery. In the course of editing Lazarev's manuscript, it was decided to eliminate four of the mentioned works from the illustrations because they differed from most of the Russian icons in type and style, but the references to these works have been preserved in the notes. For technical reasons, we have not been able to reproduce some other works. However, by making these minor changes, we have not in any way altered the general characteristics of Lazarev's new book.

Since all the icons from the eleventh to sixteenth centuries, with the exception of the so-called little panels, were painted on panels with the technique employing egg tempera, we do not include remarks of a technical nature in the notes on the plates. Nor do we mention the presence of the canvas, which is frequently invisible to the untrained eye. Following the name of the museum, we specify the corresponding catalogue number of the icon in brackets.

1. THE APOSTLES PETER AND PAUL

Mid 11th century. 236x147 cm. Museum of History and Architecture, Novgorod [11776].

From Saint Sophia Cathedral in Novgorod, built by Yaroslav's son, Prince Vladimir, between 1045 and 1050. It was probably a "wall" image, as suggested by the large dimensions of the icon. It was preserved under a silver covering from the first half of the twelfth century. The garments are all that is left of the original painting (with a combination of intense azure, white, soft pink, and golden yellow shades) except for a few fragments of greenish brown ocher on the neck of the Apostle Paul. The faces, hands, and feet are completely lost (no layers of color prior to the fifteenth century have been recovered). The outlines of the heads have preserved their original shape. Icons of this type were very popular in Byzantium, where the Apostles Peter and Paul were depicted either separately (twelfth-century icon in the Protaton Monastery on Mount Athos: *Frühe Ikonen*, Vienna-Munich 1965, pl. 41) or together (fourteenth-century icon in Saint Catherine Monastery on Mt. Sinai: Sotiriou, G. and M., *Icônes du Mont Sinaï*, vol. I, pls. 217, 224; a Greek icon between the end of the fourteenth and beginning of the fifteenth century in the Cathedral of the Dormition, Kremlin, Moscow; a late icon from the seventeenth century in the Church of Saint George in Struga: *Icônes de Yougoslavie*, texte et catalogue V.J. Djuric, Belgrade 1960, n. 90, pl. CXVII).

Bibliography: Mneva, N.E. — Filatov, V.V., "Ikona Petra i Pavla novgorodskogo Sofiiskogo sobora," in *Iz istorii russkogo i zapadnoevropeyskogo iskusstva*, M. 1960, pp. 81–102; [Rybakov, B.A., *Russkie datirovannye nadpisi XI–XIV vekom*, M. 1964, pp. 25–26, n. 18]; Lazarev, V.N., *Novgorodskaya ikonopis*, M. 1969, p. 6, pls. 1, 2; *Zhivopis domongolskoy Rusi*, catalogue, ed. O.A. Korina, M. 1974, n. 1, pp. 23–26.

2. SAINT GEORGE

1130s–1140s. 230x142 cm. Tretyakov Gallery, Moscow [28711].

From the princely Cathedral of Saint George in the Saint George Monastery near Novgorod, founded in 1119 and dedicated, according to the not too reliable testimony of the *Third Novgorod Chronicle*, on June 29, 1140 (Yu.N. Dmitriev suggests this date should read 1130). The icon, placed on a pillar, was the principal image in the church of the same name. (The distance between the extremities of the cruciform pillar was 150 cm, and the icon was no more than 8 cm narrower). On the back

of the icon an unreliable date from the nineteenth century is engraved: 1130. Extant from the twelfth century are the outline of the figure, the hair, the halo, the breastplate, the collar, the shoulder strap and the shield, fragments of the cloak and of the shoe on the right foot, the lance and part of the fingers of the left hand. All the rest (including the face) has been added or repainted, mostly in the fourteenth century. In the places where the layer of the original color has been lost are also the remaining additions of the sixteenth century (ornamented trouser legs), seventeenth and nineteenth centuries (footwear). Iconographically, the representation of Saint George follows the Byzantine warrior type, widespread in the tenth century, rather than the martyr type.

Bibliography: Antonova, V.I. — Mneva, N.E., *Katalog drevnerusskoy zhivopisi* [Tretyakov Gallery], t. 1, M. 1963, n. 1, pp. 47–49, pl. 17; Lazarev, V.N., *Russkaya srednevekovaya zhivopis. Stati i issledovaniya*, M. 1970, pp. 87–88 (in the essay "Novyi pamyatnik stankovoy zhivopisi XII veka i obraz Georgiya-voina v vizantiiskom i drevnerusskom iskusstve"), ill. on pp. 84–85; Id., *Novgorodskaya ikonopis*, pp. 7–8, pl. 3; [Popova, O.S., "Novgorodskaya zhivopis rannego XIV veka i paleologovskoe iskusstvo," in *Vizantiya. Yuzhnye slavyane i drevnyaya Rus. Zapadnaya Evropa. Iskusstvo i kultura. Sbornik statey v chest V.N. Lazareva*, M. 1973, pp. 256–266]; *Zhivopis domongolskoy Rusi*, catalogue, n. 16, pp. 75–76; [Smirnova, E.S., *Zhivopis Velikogo Novgoroda. Seredina XIII — nachalo XV veka*, M. 1976, p. 70, catalogue, n. 6, ill. on p. 276; Popova, O.S., *Iskusstvo Novgoroda i Moskvy pervoy poloviny chetyrnadtsatogo veka. Ego svyazi s Visantiey*, M. 1980, pp. 65–88].

3. SAINT GEORGE

About 1170. 174x122 cm. Cathedral of the Dormition, Kremlin, Moscow [966 sob/zh-135].

In good condition (except for small lacunae on the face, in the background, and more consistent damage in the lower part of the garment). The icon is probably from the Cathedral of Saint George in the monastery of the same name near Novgorod, in which the main icon of the church was a full-length figure of Saint George. The person commissioning the icon may have been Andrei Bogolyubskii's younger son, Prince Georgii Andreevich. In 1174, he was expelled by the Novgorodians and lived the rest of his life in Georgia, where he was the first husband of the Georgian Queen Tamara. The icon is dated from the beginning of the 1170s. Except for the gesture of the left hand, the iconographic type of the warrior and the type of face have close analogies in Byzantine works of the twelfth century (cf. the icon of Saint Panteleemon in the *lavra* of Mount Athos: *Frühe Ikonen*, pl. 42). But in the icon in the Cathedral of the Dormition, the figure appears more massive and corporeal.

Bibliography: Gordeev, N., "O pamyatnike drevnerusskogo iskusstva," in *Iskusstvo*, January-February 1947, pp. 73–75; Lazarev, V.N., *Russkaya srednevekovaya zhivopis. Stati i issledovaniya*, pp. 55–102 (in the essay "Novyi pamyatnik stankovoy zhivopisi XII veka i obraz Georgiya-voina v vizantiiskom i drevnerusskom iskusstve"); Pertsev, N.V., "O nekotorych priemach izobrazheniya litsa v drevnerusskoy stankovoy zhivopisi XII–XIII, vv.," in *Soobshcheniya Gos. russkogo muzeya*, VIII, L. 1964, pp. 89–92; [Lazarev, V.N., *Novgorodskaya ikonopis*, pp. 8–9, pls. 4, 5; Demina, N.A., "Otrazhenie poeticheskoy obraznosti v drevnerusskoy zhivopisi (na primere ikony 'Georgiivoin' XI–XII vekov")," in *Drevnerusskoe iskusstvo. Chudozhestvennaya kultura domongolskoy Rusi*, M. 1972, pp. 7–24]; *Zhivopis domongolskoy Rusi*, catalogue, n. 10, pp. 58–60; [Alpatov, M.V., *Drevnerusskaya ikonopis*, M. 1974, pl. 33, p. 298; Maslenitsyn, S.I., "K atributsii izobrazheniya Georgiya na dvustoronney ikone iz Uspenskogo sobora Moskovskogo Kremlya," in *Srednevekovaya Rus. Sbornik statey

pamyati N.N. Voronina, M. 1976, pp. 231–239; Tolstaya, T.V., *Uspenskii sobor Moskovskogo Kremlya*, M. 1979, p. 44, pls. 66–68; Muzeus, L.A. — Lukyanov, B.B. — Yakovleva, A.I., "Drevneyshaya domongolskaya ikona iz Muzeev Moskovskogo Kremlya," in *Chudozhestvennoe nasledie. Chranenie, issledovanie, restavratsiya*, 7 (37), M. 1981, pp. 90–106].

4. THE USTYUG ANNUNCIATION

Second half of 12th century. 29x144 cm. Tretyakov Gallery, Moscow [25539].

The icon does not come from Velikii Ustyug (as oral tradition claims) but rather from the Cathedral of Saint George in the monastery of the same name near Novgorod, from where it was taken to Moscow by the order of Ivan the Terrible (as in the testimony of "Rozyska o bogochulnych strokach i o somnenii svyatych chestnych ikon diaka Ivana Michaylova syna Viskovatogo," in *Chteniya v Obshchestve istorii i drevnostey rossiiskich pri Moskovskom universitete*, 1858, vol. 2, p. 13). The figures are well preserved. In the sixteenth century, the original golden background was replaced by a new *levkas*. During that phase, the outlines of the heads and bodies were slightly damaged and the angel's wings were repainted. The icon lacked any ground. It may also have been painted after the dedication of the cathedral (1130 or 1140) because it is not the main image, which was instead a full-length figure of *Saint George*. The so-called *fetus type*, that is, Christ in Mary's womb, was found for the first time in the now lost mosaic of the Cathedral of the Dormition in Nicaea, representing the Virgin and Child (Lazarev, V.N., *Storia della pittura bizantina*, Turin 1967, pls. 77–79). Christ's head was touched by the ray emanating from the right hand of the Father, at the apex of the half-dome of the apse. Although the archangel Gabriel is missing in the Nicaea mosaic, Schmit (Schmit, Th., *Die Koimesis-Kirche von Nikaia*, Berlin-Leipzig 1927, p. 42) still correctly interpreted that figure as an illustration of the dogma of the virgin birth. About the *fetus type*, see Pokrovskii, N.V., *Evangelie v pamyatnikach ikonografii, preimushchestvenno vizantiiskich i russkich*, Spb., 1892 ("Trudy VIII archeologicheskogo sezda v Moskve, 1890 g.," t. I), pp. 29–30; Grabar, A. "Etudes critiques, 2, Iconographie de la Sagesse Divine et de la Vierge," in *Cahiers archéologiques*, VIII, Paris 1956, p. 259; Verheyen, E., "An Iconographic Note on Altdorfer's Visitation in the Cleveland Museum of Art," in *The Art Bulletin*, XLVI, 1964, pp. 536–539; Guldan, E., "Die Darstellung der Inkarnation Christi im Verkündigundsbild," in *Römische Quartalschrift für Christliche Altertumskunde und Kirchengeschichte*, 63, 1968, pp. 145–169.

Bibliography: Anisimov, A., "Domongolskii period drevnerusskoy zhivopisi," in *Voprosy restavratsii*, II, M. 1928, pp. 119–122; Kondakov, N.P., *Russkaya ikona*, t. III, text, pt. 1, Prague 1931, pp. 106–107; Ainalov, D., *Geschichte der russischen Monumentalkunst zur Zeit des Grossfürstentums Moskau*, Berlin-Leipzig 1933, pp. 65–67 (with a rather unlikely sixteenth-century date); Antonova, V.I. — Mneva, N.E., *Katalog drevnerusskoy zhivopisi*, t. I, n. 4, pp. 54–58 (with a rather unlikely 1119–1130 date), pls. 19–22; Onasch, K., *Ikonen*, Berlin 1961, pp. 350–351; Lazarev, V.N., *Novgorodskaya ikonopis*, pp. 9–10, pls. 6–7, *Russkaya srednevekovaya zhivopis. Stati i issledovaniya*, pp. 105, 108, 109 (in the essay "Rannie novgorodskie ikony"); *Zhivopis domongolskoy Rusi*, catalogue, n. 4, pp. 32–36.

5. RECTO: THE HOLY FACE
VERSO: THE ADORATION OF THE CROSS

Second half of 12th century. 77x71 cm. Tretyakov Gallery, Moscow [14245].

From the Cathedral of the Dormition, Kremlin, Moscow. There is no doubt about the Novgorodian origin of the icon. Also supporting this

assertion are the typically Novgorodian expressions in the inscriptions on the back of the icon (the substitution of the *ch* with the letter *ts*), the resemblance of the angels to those in the dome and apse of the church on the Nereditsa (Myasoedov, V.K., *Freski Spasa-Nereditsy*, preface by N.O. Sychev, L. 1925, pls. IV, VI, and XXVIII), and the reproduction of the painting on the front of the icon (and also in part on the back) in the illuminated Novgorodian codex of 1262 (*Lobkovskii Prolog*, Historical Museum, Moscow, *Chlud.*, 187, f. 1). As G.I. Vzdornov has established, the icon comes from the wooden Church of the Holy Face in Novgorod, built by Vnezd Nezdinich in 1191. In good condition. The type of the Holy Face [Savior Not Made by Human Hands] follows the Byzantine tradition exactly (see Grabar, A.N., *Nerukotvorennyi Spas Lanskogo sobora*, Prague 1931). The *Adoration of the Cross* is on the silver paten from the sixth century kept in the Hermitage (Volbach, F. *Frühchristliche Kunst*, Munich 1958, pl. 245, p. 91). In the Muscovite icon, the cross is decorated with a crown of thorns and the angels hold the reed and the lance, symbols of Christ's passion. The cross rises above the dark cave with Adam's skull. The sun and moon are seen at either end of the cross's arms; two cherubim and two seraphim with the *ripidion* in their hands are shown in the upper part. About the iconography, see: Kondakov, N.P., *Archeologicheskoe puteshestvie po Sirii i Palestine*, Spb. 1904, pp. 22, 285–301; Grabar, A., *Martyrium*, II, Paris 1946, pp. 275–290. It is difficult to determine if the icon was originally painted on both sides or if the image on the back was added later on.

Bibliography: Anisimov, A., "Domongolskii period drevnerusskoy zhivopisi," pp. 125–128, 133; Ainalov, D., *Geschichte der russischen Monumentalkunst zur Zeit des Grossfürstentums Moskau*, pp. 64–65; Antonova, V.I. — Mneva, N.E., *Katalog drevnerusskoy zhivopisi*, t. I, n. 7, pp. 66–68 (oddly attributed to the Vladimir-Suzdal school), pls. 26–27; Onasch, K., *Ikonen*, pls. 10, 11, pp. 347–349; Lazarev, V.N., *Novgorodskaya ikonopis*, pp. 10–11, pl. 9; Id., *Russkaya srednevekovaya zhivopis. Stati i issledovaniya*, pp. 103–105 (in the essay "Rannie russkie ikony"); [Vzdornov, G.I., "Lobkovskii Prolog i drugie pamyatniki pismennosti i zhivopisi Velikogo Novgoroda," in *Drevnerusskoe iskusstvo. Chudozhestvennaya kultura domongolskoy Rusi*, pp. 265–269]; *Zhivopis domongolskoy Rusi*, catalogue, n. 23, pp. 101–107; [Alpatov, M.V., *Drevnerusskaya ikonopis*, pl. 38, p. 299; Kolchin, B.A. — Choroshev, A.S. — Yanin, V.L., *Usadba novgorodskogo chudozhnika XII v.*, M. 1981, p. 156, fig. 76].

6. ANGEL

Second half of 12th century. 48.8x39 cm. Russian Museum, Saint Petersburg [2115].

From the Rumyantsev Museum of Moscow, where it formed part of the section of works from the early Christian period. The stylistic affinity with the icons of the *Holy Face* and the *Ustyug Annunciation* leaves no doubt that it belongs to the Novgorod school. In good condition. The original golden background was lost and replaced in the seventeenth century by a green background. In this phase, the outline of the head was slightly damaged. For the type of the angel's face, see the representation of the Archangel Michael in the apse of the Monreale Cathedral (Kitzinger, E., *I mosaici di Monreale*, Palermo 1960, pl. 87).

Bibliography: Anisimov, A., "Domongolskii period drevnerusskoy zhivopisi," pp. 122–125; Ainalov, D., *Geschichte der russischen Monumentalkunst zur Zeit des Grossfürstentums Moskau*, pp. 63–64; Onasch, K. *Ikonen*, pl. 13, p. 349; [Lazarev, V.N., *Novgorodskaya ikonopis*, p. 11, pl. 10]; Id., *Russkaya srednevekovaya zhivopis. Stati i issledovaniya*, pp. 109, 112 (in the essay "Rannie russkie ikony"); *Zhivopis domongolskoy*

Rusi, catalogue, n. 3, pp. 29–31; *Zhivopis drevnego Novgoroda i ego zemel XII–XVII stoletii*, catalogue, authors-editors V.K. Laurina, G.D. Petrova, E.S. Smirnova, L. 1974, n. 1, pp. 31–32; Alpatov, M.V., *Drevnerusskaya ikonopis*, pl. 39 p. 299].

7. THE DORMITION

Early 13th century. 155x128 cm. Tretyakov Gallery, Moscow [30461].

The monastery of the Dessiatina in Novgorod, from which the icon comes, is mentioned in the chronicle of the year 998 (*Poln. sobr. russkich letopisey*, t. XVI, Spb. 1889, p. 40). It is in good condition except for some insignificant damage. Gold background. Side borders cut off. The preserved part of the cornice is without *levkas*, from which it can be inferred that from the beginning it was meant to have an engraved silver covering (similar to the one which we can see in the icon of *Saint George* (full-length), in the *Ustyug Annunciation*, and in the *Deesis* from the Cathedral of the Dormition). In the eleventh and twelfth centuries, in keeping with the Byzantine tradition, the borders of the icon were evidently covered by a cornice of engraved silver as we see in the icon of *Peter and Paul* and in that of the *Virgin of Korsun*. See Radojcic, S., "Zur Geschichte des silbergetriebenen Reliefs in der byzantinischen Kunst," in *Tortulae. Studien zu altchristlichen und byzantinischen Monumente*, Rome-Friburg-Vienna ("Römische Quartalschrift für Christliche Altertumskunde und Kirchengeschichte," vol. 30, supp.), pp. 229–242 [printed in Serbian in Radojcic, Sv., *Uzori i dela starich srpskich umetnika*, Belgrade 1975, pp. 53–72]. The theme of the apostles rushing on clouds, derived from apocryphal sources, appeared for the first time in works of the eleventh century (frescoes in Tokali Kilise in Göreme and in the Church of Saint Sophia in Ochrid, covering of the icon in the Monastery of Kotscheri in Mingrelia [Georgia]; miniature in the liturgical scroll in the library of the Greek patriarchate of Jerusalem, Stauron 109).

Bibliography: Antonova, V.I. — Mneva, N.E., *Katalog drevnerusskoy zhivopisi*, t. I, n. 11, pp. 73–75, pls. 28–30; Onasch, K., *Ikonen*, pl. 14, pp. 349–350; [Lazarev, V.N., *Novgorodskaya ikonopis*, pp. 11–12, pls. 11–12]; Id. *Russkaya srednevekovaya zhivopis. Stati i issledovaniya*, pp. 114–118 (in the essay "Rannie russkie ikony"); *Zhivopis domongolskoy Rusi*, catalogue, n. 26, pp. 113–117; *Zhivopis drevnego Novgoroda i ego zemel XII–XVII stoletii*, catalogue, n. 3, p. 32; [Alpatov, M.V., *Drevnerusskaya ikonopis*, pl. 34, p. 298].

8. THE VIRGIN OF TENDERNESS

Early 13th century. 56x42 cm. Cathedral of the Dormition, Kremlin, Moscow [1075 sob/zh-267].

From the Cathedral of the Dormition in the Kremlin. The icon has lacunae (halo, golden ornaments on the cloak, background on the borders), but the faces and the garments are rather well preserved. To the right, we see a large addition of new *levkas*. The interior dark azure borders with small gold squares are partly preserved. The flesh tone is a dense olive with rosy touches and the dull red line of the nose.

The iconographic type of the Virgin of Tenderness came from Byzantium to Russia quite early (not later than the twelfth century) and became increasingly more widespread: the *Virgin of Belozersk* and the *Virgin of the Blachernai* from the thirteenth century in the Russian Museum [*Zhivopis domongolskoy Rusi*, catalogue, n. 15, pp. 73–74], the twelfth-century metal cross in the Historical Museum of Moscow [Lazarev, V.N., *Vizantiiskaya zhivopis. Sbornik statey*, M. 1971, p. 282, ill. on p. 286 (in the essay "Etyudy po ikonografii Bogomateri")], the small thirteenth-century stone icon representing the Virgin of Tenderness

surrounded by the seven sleeping Ephesian boys [Ibid. (Nikolaeva, T.V., *Drevnerusskaya melkaya plastika XI–XVI vekov,* M. 1968, fig. 15)], the small fourteenth-century slate icon in the Museum of Sergiev Posad (Zagorsk) [Ibid., fig. 22], and others. For the type of Mary, see the icon of the *Virgin Hagiosoritissa of Sinai* (*Frühe Ikonen,* pl. 31), for the folds of the garment, see the mosaic by Hosios Lukas of Phocis (Kondakov, N.P., *Ikonografiya Bogomateri,* t. II, Pg. 1915, fig. 136).

Bibliography: Zonova, O., "Pamyatnik russkoy zhivopisi XII v.," in *Iskusstvo,* 1967, n. 8, pp. 66–69 [the same in *Drevnerusskoe iskusstvo. Chudozhestvennaya kultura domongolskoy Rusi,* pp. 270–282]; *Zhivopis domongolskoy Rusi,* catalogue, n. 14, pp. 71–72; *Zhivopis drevnego Novgoroda i ego zemel XII–XVII stoletii,* catalogue, n. 2, p. 32; [Alpatov, M.V., *Drevnerusskaya ikonopis,* pl. 42, p. 300; Batchel, G.S., "Restavratsionne raskrytie ikony 'Umilenie' XII veka," in *Restavratsiya i issledovaniya pamyatnikov kultury,* 1, M. 1975, pp. 127–135; Tolstaya, T.V., *Uspenskii sobor Moskovskogo Kremlya,* p. 46, pl. 72; Yakovleva, A.I, "Tri ikony domongolskoy epochi iz sobraniya Muzeev Kremlya," in *Chudozhestvennoe nasledie. Chranenie, issledovanie, restavratsiya,* 6 (36), M. 1980, pp. 33–35].

9. SAINT NICHOLAS THE WONDERWORKER

Early 13th century. 145x94 cm. Tretyakov Gallery, Moscow [12862].

The icon comes from the Monastery of Novodevichii, where, according to monastic tradition, it was brought from Novgorod by Ivan the Terrible in 1564, together with the icon of the *Virgin of Yaroslav* (Retkovskaya, L.S., *Novodevichii monastyr. Putevoditel po muzeyu,* M. 1956, p. 38). Very little is left of the silver background; from the original paint of the white *omophorion* only a few small fragments remain, also true of the gold on the collar, of the crosses on the *omophorion,* and of the covering of the evangeliary. The inscription and the *levkas* of the halo go back to the sixteenth century. The face, the body, and the images on the cornice are well preserved. In imitation of the silver coverings, the borders are decorated with small figures painted on a white background. These images, the work of another master, may have been painted after the main figure, although this seems somewhat unlikely. Along the top are represented the Hetoimasia and the busts of Cosmas and Damian; on the lateral borders, Boris and Gleb, Florus and Laurus, Eudocia and Domna (?); along the bottom, Paraskeva Pyatnitsa and Fetiniya. The choice of saints suggests Novgorod as the place where the icon was painted. In support of this thesis, we also have the ornamentation on the throne and the "disheveled" style of the hair, which we find only in Novgorodian works (icon of *Saint Nicholas the Wonderworker* in the Russian Museum, frescoes of Staraya Ladoga).

Bibliography: Anisimov, A., "Domongolskii period drevnerusskoy zhivopisi," pp. 133–135; Antonova, V.I. — Mneva, N.E., *Katalog drevnerusskoy zhivopisi,* t. 1, n. 9, pp. 69–71 (with an erroneous attribution to the school of Kiev), pl. 31; Onasch, K., *Ikonen,* pl. 9, p. 347; Lazarev, V.N., *Russkaya srednevekovaya zhivopis. Stati i issledovaniya,* pp. 113–114 (in the essay "Rannie russkie ikony"); *Zhivopis domongolskoy Rusi,* catalogue, n. 21, pp. 94–97; [Alpatov, M.V., *Drevnerusskaya ikonopis,* pl. 40, p. 299].

10. THE APOSTLES PETER AND PAUL

First third of 13th century. 139x90 cm. Russian Museum, Saint Petersburg [2095].

From Belozersk. In satisfactory condition. Almost nothing is left of the original silver background. The right half of Paul's face is lost (here and

continuing down, we find a new *levkas,* in a dark strip which is clearly noticeable). The icon may have been brought from Novgorod to Belozersk. Its clear coloring, different from the Novgorodian palette, is rather strange.

Bibliography: Pertsev, N.V., "O nekotorych priemach izobrazheniya litsa v drevnerusskoy stankovoy zhivopisi XII–XIII, vv.," p. 91; Lazarev, V.N., *Russkaya srednevekovaya zhivopis. Stati i issledovaniya,* pp. 114–120; *Zhivopis domongolskoy Rusi,* catalogue, n. 2, pp. 27–28; *Zhivopis drevnego Novgoroda i ego zemel XII–XVII stoletii,* catalogue, n. 4, pp. 32–33; [Alpatov, M.V., *Drevnerusskaya ikonopis,* pl. 35, p. 298].

11. THE VIRGIN OF BELOZERSK

First third of 13th century. 155x106 cm. Russian Museum, Saint Petersburg [2116].

From the Cathedral of the Savior of the Transfiguration in Belozersk. Generally in a good state of preservation. Almost nothing remains of the original silver background. The silver *assiste* have faded. The medallions on the lower border are poorly preserved. The azure of the cornice has been slightly altered by time. In type, the icon resembles the renowned *Virgin of Vladimir.* The border medallions are an imitation of the embossed coverings, but here the silver is replaced by the less expensive painting. The icon was most likely executed in Novgorod.

Bibliography: Dmitriev, Yu.N., *Gos. Russkii muzey. Putevoditel. Drevnerusskoe iskusstvo,* L.-M. 1940, p. 17; Lazarev, V.N., "Zhivopis i skulptura Novgoroda," in *Istoriya russkogo iskusstva,* t. II, edition Academy of Sciences of the USSR, M. 1954, p. 134, colored pls.; Antonova, V.I., "K voprosu o pervonachalnoy kompozitsii ikony Vladimirskoy Bogomateri," in *Vizantiiskii vremennik,* 18, M. 1961, pp. 204–205; [Pertsev, V.N., "O nekotorych priemach izobrazheniya litsa v drevnerusskoy stankovoy zhivopisi XII–XIII, vv.," p. 91]; Vzdornov, G.I., "O zhivopisi Severo-Vostochnoy Rusi XII–XV vekov," in *Iskusstvo.,* 1969, n. 10, pp. 58–59; *Zhivopis domongolskoy Rusi,* catalogue, n. 13, pp. 68–70; *Zhivopis drevnego Novgoroda i ego zemel XII–XVII stoletii,* catalogue, n. 5, p. 33; [Alpatov, M.V., *Drevnerusskaya ikonopis,* pl. 43, p. 300].

12. RECTO: THE VIRGIN OF THE SIGN
VERSO: THE APOSTLE PETER AND MARTYR NATALYA

Before 1169. 59x52.7 cm. Museum of History and Architecture, Novgorod [2175].

From the Church of the Savior of the Transfiguration in Saint Elijah Street in Novgorod. The front of the icon with the image of the *Virgin of the Sign* has been almost completely destroyed and repainted. The back has many lacunae and has completely lost some of the layer of color. The part which is best preserved is the Apostle Peter's face. The figure of the *Virgin of the Sign,* which goes back to the image of the *Virgin Blachernitissa,* was especially venerated by the Novgorodians, who considered it the emblem and protector of the city. See: Kondakov, N.P., *Ikonografiya Bogomateri,* t. II, pp. 116–117; Frolow, A. "Le Znamenie de Novgorod, l'évolution de la légende," in *Revue des études slaves,* XXIV, 1948, pp. 67–81; XXV, 1949, pp. 45–72; Grabar, A., *L'iconoclasme byzantin,* Paris 1957, pp. 253–255; [Tatic — Buric, M., "Ikona Bogoroditse Znamenya," in *Zbornik za likovne umetnosti,* 23, Novi Sad 1977, pp. 1–23; Lechner, G.M., "Zur Ikonographie der 'Gottesmutter des Zeichens,'" in *Kunst der Ostkirche. Ikonen, Handschriften, Kultgeräte. Ausstellung des Landes Niederösterreich. Stift Herzogenburg. 7. Mai bis 30. Oktober 1977,* Vienna 1977, pp. 77–90].

Bibliography: Anisimov, A., "Domongolskii period drevnerusskoy zhivopisi," pp. 123, 128, 133; Lazarev, V.N., *Russkaya srednevekovaya*

zhivopis. Stati i issledovaniya, pp.119, ill. on p. 123 (in the essay "Rannie russkie ikony"); [Id., Novgorodskaya ikonopis, p. 13, pl. 13]; Zhivopis domongolskoy Rusi, catalogue, n. 8, pp. 51–54.

13. SAINT NICHOLAS THE WONDERWORKER

Mid 13th century. 67.6x52.5 cm. Russian Museum, Saint Petersburg [2778].

From the Monastery of the Holy Spirit in Novgorod. First mentioned in the chronicle of the year 1162. Side borders cut off. In good condition except for some lacunae in the background, on the clothing, and on the face. The traditional dating of the icon to the twelfth century seems too early. The style as well as the paleographic sources contradict this hypothesis.

Bibliography: Dmitriev, Yu.N., Gos. Russkii muzey. Putevoditel. Drevnerusskoe iskusstvo, p. 13; Lazarev, V.N., Novgorodskaya ikonopis, pp. 13–14, pl. 14; Zhivopis domongolskoy Rusi, catalogue, n. 6, p. 33–44; Zhivopis drevnego Novgoroda i ego zemel XII–XVII stoletii, catalogue, n. 6, p. 33–44; [Alpatov, M.V., Drevnerusskaya ikonopis, pl. 41, p. 300; Smirnova, E.S., Zhivopis Velikogo Novgoroda, Seredina XIII — nachalo XV veka, pp. 23–32, catalogue, n. 1, pp. 150–156, ill. on pp. 265–268].

14. THE MARTYR JULIANA

verso of the Virgin of the Sign
13th century. 78x66 cm. P.D. Korin Museum (branch of the Tretyakov Gallery), Moscow.

From the Zverin Monastery in Novgorod. The icon's originating in a women's monastery explains the predominance of women saints on the cornice. The *Virgin of the Sign* represented on the front has many lacunae. Gold background. Among the figures on the border, it is possible to recognize Saint Natalya. The bust figure of the Martyr Juliana, very popular in Novgorod, is on the back of the icon. The halo and borders are ocher. Portrayed on the borders are the wonderworking Saints Cyril and John, and Saints Barbara, Timothy, Nicholas, and Clement (?). Saint Barbara's cloak, with many decorations, witnesses to the author's passion for the "arabesque," so loved in early Rus. The central figure is well preserved, but the images on the borders are half-obliterated. Because of the archaic configuration of the forms, it is difficult to give an exact date for the icon, but it was probably painted around the middle of the thirteenth century. Belonging to the same style is the Novgorodian icon of *Saint Clement* with a red background, from a private collection in Stockholm (Kjellin, H., Ryska ikoner i svensk och norsk ägo, Stockholm 1956, p. 118, pl. XLI).

Bibliography: Onasch, K., Ikonen, pls. 18, 19, pp. 352–353; Antonova, V.I., Drevnerusskoe iskusstvo v sobranii Pavla Korina, M. 1966, n. 1, pp. 25–28, pls. 1–6 (with an erroneous twelfth-century date); Zhivopis domongolskoy Rusi, catalogue, n. 9, pp. 55–57; [Kolchin, B.A. — Choroshev, A.S. — Yanin, V.L., Usadba novgorodskogo chudozhnika XII v., p. 157, fig. 75].

15. SAINTS JOHN CLIMACUS, GEORGE, AND BLAISE

Last third of 13th century. 109x67 cm. Russian Museum, Saint Petersburg [2774].

According to oral tradition, the icon came from the village of Kresttsy near Novgorod. In good condition. During the restoration, the two panels on which the icon is painted were incorrectly superimposed, and as a result, John Climacus' face lost its symmetry. In style, the icon is very similar to the *Enthroned Savior with Saints* (Tretyakov Gallery; see Antonova, V.I. — Mneva, N.E., Katalog drevnerusskoy zhivopisi, t. I, n. 14, pp. 83–84, pl. 38).

Bibliography: Anisimov, A., "Domongolskii period drevnerusskoy zhivopisi," pp. 148–151; Onasch, K., Ikonen, pl. 27, pp. 358–359; Porfiridov, N.G., "Dva proizvedeniya novgorodskoy stankovoy zhivopisi XIII veka," in Drevnerusskogo iskusstvo. Chudozhestvennaya kultura Novgoroda, M. 1968, pp. 140–144; Lazarev, V.N., Novgorodskaya ikonopis, p. 14, pl. 15; Zhivopis drevnego Novgoroda i ego zemel XII–XVII stoletii, catalogue, n. 9, p. 35–36; [Smirnova, E.S., Zhivopis Velikogo Novgoroda, Seredina XIII — nachalo XV veka, pp. 35–45, catalogue, n. 2, pp. 157–160, ill. on pp. 268, 269].

16. THE ROYAL DOORS
WITH THE ANNUNCIATION AND TWO BISHOPS

Last third of 13th century. Left door, 137x35 cm; right door, 137x36 cm; jamb, 6 cm. Tretyakov Gallery, Moscow [12876 and 12877].

From the Church of the Trinity in the village of Krivoe, region of Archangelsk. The jamb, with a semicircular section, has retained traces of the original painting in imitation of marble (red and black streaks). With the exception of some damage to the panel (the icon is painted without cloth), it is generally well preserved. The abundance of ornamentation to which the author resorts whenever it is possible is very characteristic. On the subject of the royal doors, see Grabar, A., "Deux notes sur l'histoire de l'iconostase d'après les monuments de Yougoslavie," in Zbornik radova Vizantoloshkog instituta, 7, Belgrade 1961, pp. 14–17, pls. 1–4; Lazarev, V.N., Vizantiiskaya zhivopis. Sbornik statey, pp. 125 and 130 (in the essay "Tri fragmenta raspinych epistiliev i vizantiiskii templon").

Bibliography: Anisimov, A., "Domongolskii period drevnerusskoy zhivopisi," pp. 143–151; Ainalov, D., Geschichte der russischen Monumentalkunst zur Zeit des Grossfürstentums Moskau, pp. 55–56 (with an erroneous reference to the Kiev school); Antonova, V.I. — Mneva, N.E., Katalog drevnerusskoy zhivopisi, t. 1, n. 15, pp. 84–85, pl. 40; [Putsko, V., "Tsarskie vrata iz Krivetskogo pogosta. K istorii altarnoy pregrady na Rusi," in Zbornik za likovne umetnosti, 11, Novi Sad 1975, pp. 51–78; Smirnova, E.S., Zhivopis Velikogo Novgoroda, Seredina XIII — nachalo XV veka, pp. 45–46, catalogue, n. 4, pp. 166–170, ill. on pp. 272, 273].

17. ALEKSA PETROV
SAINT NICHOLAS OF LIPNA

1294. 184x129 cm. Museum of History and Architecture, Novgorod [5769].

From the Church of Saint Nicholas in the Lipna Monastery near Novgorod. In good condition (except for some damage in the background). The icon was the principal image of the church and also showed the patron of the donor. In imitation of a silver cornice, numerous figures of saints appear on the borders. Among them, Boris and Gleb, Florus and Laurus, George, Cosmas and Damian are easy to recognize. The faces are not Byzantine in style.

Bibliography: Ainalov, D., Geschichte der russischen Monumentalkunst zur Zeit des Grossfürstentums Moskau, pp. 70–71; Onasch, K., Ikonen, pl. 17, p. 351; Lazarev, V.N., Novgorodskaya ikonopis, pp. 14–15, pl. 16; [Smirnova, E.S., "Ikona Nikoly 1294 goda mastera Aleksy Petrova," in Drevnerusskoe iskusstvo. Zarubezhnye svyazi, M. 1975, pp. 81–105; Id., Zhivopis Velikogo Novgoroda, Seredina XIII — nachalo XV veka, pp. 45–48, catalogue, n. 5, pp. 170–174, ill. on pp. 274, 275].

18. CHRIST EMMANUEL WITH ANGELS

Late 12th century. 72x129 cm. Tretyakov Gallery, Moscow [0158].

From the Cathedral of the Dormition, Kremlin, Moscow. It was probably brought there from Vladimir along with other icons sent to Moscow

to be restored in 1518. In good condition except for some damage in the lower part of the icon, where a new *levkas* was applied in a fine strip which becomes slightly wider toward the left. Almost nothing is left of the gold background and the rosy halos. The incisions on the borders were done to hold the *levkas* better. However, since no trace of it was found in that area, there are good reasons to suppose that the borders were covered from the beginning with an embossed silver cornice. For the aristocratic type of the archangels, see the mosaics of Cefalù (Lasareff, V., "The Mosaics of Cefalù," in *The Art Bulletin*, XVII, 1935, fig. 1, 4. 7 [new edition: "Mozaiki Chefalu," in Lazarev. V.N., *Vizantiiskaya zhivopis. Sbornik statey*, ill. on pp. 206, 208 and 209]) and the frescoes of the large and small cycles in the Cathedral of Saint Demetrius in Vladimir (Grabar, I., *Die Freskomalerei der Dimitrij-Kathedrale in Wladimir*, Berlin 1926, pls. XI, XXXIV, LXIII). The icon was probably painted in the 1190s, during the work of frescoing the Cathedral of Saint Demetrius in Vladimir. Since no early icon from Suzdal has survived, it is better to speak of the "Vladimir school" rather than the "Vladimir-Suzdal" school when referring to the earliest icons.

Bibliography: Antonova, V.I. — Mneva, N.E., *Katalog drevnerusskoy zhivopisi*, t. 1, n. 6, pp. 65–66, pls. 22–25; Lazarev, V.N., *Russkaya srednevekovaya zhivopis. Stati i issledovaniya*, pp. 128–130 (in the essay "Rannie russkie ikony"); *Zhivopis domongolskoy Rusi*, catalogue, n. 17, pp. 77–81.

19. THE DEESIS

Early 13th century. 61x146 cm. Tretyakov Gallery, Moscow [0159].

From the Cathedral of the Dormition, Kremlin, Moscow, where it was placed over the tomb of Metropolitan Filipp II. There is a new layer of *levkas* from the sixteenth century over almost the entire surface of the background and on the borders. The panel is furrowed by a horizontal crack toward the middle. There is a fragment of the original black inscription to the right of the Virgin's head. The Virgin's head is the best preserved. On the heads of Christ and John the Baptist, the upper layers of color (worked with ocher) are lost and are thus duller. There is a small addition of new *levkas* on the nose and left cheek of the Virgin.

Bibliography: Antonova, V.I. — Mneva, N.E., *Katalog drevnerusskoy zhivopisi*, t. 1, n. 8, pp. 68–69, pls. 11–14; Lazarev, V.N., *Russkaya srednevekovaya zhivopis. Stati i issledovanija*, pp. 130–131 (in the essay "Rannie russkie ikony"); *Zhivopis domongolskoy Rusi*, catalogue, n. 18, pp. 82–85.

20. SAINT DEMETRIUS OF THESSALONICA

Late 12th century. 156x108 cm. Tretyakov Gallery, Moscow [28600].

From the Cathedral of the Dormition in Dmitrov. The head, the torso, the right arm with sword, the part of left arm up to the elbow, the tunic, the legs down to the feet, and the bust figure of the Savior in the upper left corner are what is preserved from the original twelfth-century painting. The rest of the figure, the background, the inscriptions, the back of the throne, and even the flying angel with the crown were painted in the sixteenth century. On the lower part of the throne and on the legs, where the lacunae are located, the paint of the fourteenth and sixteenth centuries is preserved. It is assumed that the back of the throne, painted in the sixteenth century, bears on the right side the princely coat of arms of Vsevolod Big Nest, which reproduces the original (Rybakov, B.S., "Znaki sobstvennosti v knyazheskom chozyaystve Kievskoy Rusi X–XII vv.," in *Sovetskaya archeologiya*, 1940, n. 6, pp. 235–236). The icon was probably donated by Vsevolod himself to the city of Dmitrov, founded in 1154, in remembrance of his birth. Demetrius of Thessalonica was very popular, not only in Byzantium, but also among Slavs. Along with Saint George, this "holy warrior" was considered to be the protector of the military class. In the years 1116–1117, the "panel of Saint Demetrius was taken from the city of Thessalonica, from his tomb," to the city of Vladimir; upon its arrival in Vladimir, Vsevolod placed the panel in the Cathedral of Saint Demetrius (*Chronicle of the Resurrection, Year 6720 [1212]*). The paint of this icon is almost completely lost. Typologically, the icon in the Tretyakov Gallery is very close to the Greek relief in Saint Mark's, which was executed between the end of the twelfth and beginning of the thirteenth centuries (see Demus, O., *The Church of San Marco in Venice. History-Architecture-Sculpture*, Washington 1960, pl. 40, pp. 128–129). There is no reason to identify the portrait of Vsevolod in this icon, as V.I. Antonova supposes.

Bibliography: Ainalov, D., *Geschichte der russischen Monumentalkunst zur Zeit des Grossfürstentums Moskau*, pp. 60–61; Antonova, V.I., "Istoricheskoe znachenie izobrazheniya Dmitriya Solunskogo XII veka iz. g. Dmitrova," in *Kratkie soobshcheniya Instituta istorii materialnoy kultury*, XLI, 1951, pp. 85–98; [Antonova, V.I. — Mneva, N.E., *Katalog drevnerusskoy zhivopisi*, t. I, n. 10, pp. 71–73, pls. 15, 16]; Onasch, K., *Ikonen*, pl. 4, pp. 343–344; [Popov, G.V., "Iz istorii drevneyshego pamyatnika goroda Dmitrova," in *Drevnerusskoe iskusstvo. Chudozhestvennaya kultura domongolskoy Rusi*, pp. 198–216]; *Zhivopis domongolskoy Rusi*, catalogue, n. 20, pp. 89–93; [Alpatov, M.V., *Drevnerusskaya ikonopis*, pl. 36, p. 298].

21. THE VIRGIN GREAT PANAGIA

About 1224. 194x120 cm. Tretyakov Gallery, Moscow [12796].

From the Monastery of the Savior of the Transfiguration in Yaroslav, whose church was dedicated on August 6, 1224, the approximate date on which the icon was painted. Generally in good condition. The gold on the background, on the borders, and in the medallion is lost in many areas. The iconographic style of the Great Panagia must not be confused with that of the *Burning Bush* (ή βάτος), as the Sotirious do (Sotiriou, G. and M., *Icônes du Mont Sinaï*, vol. I, pls. 158, 231). They are two different types. In the Church of the Blachernai, besides the *Great Panagia*, there are other famous icons, as verified in particular by the image of the Virgin of Tenderness in a twelfth century Sinaitic icon, next to which the epithet *Blachernitissa* is placed. Attributing our icon to the Kiev school, as D.V. Ainalov and V.I. Antonova suggest, is absolutely unacceptable, just as the strange date of the early twelfth century (about 1114), proposed by V.I. Antonova, cannot be accepted. The type of the face of the Virgin is very similar to that of the Byzantinized miniature in a *Psalter* from Thuringia-Saxony executed around 1235 and preserved in Donaueschingen (Haseloff, A., *Eine thüringisch-sächsische Malershule des 13. Jahrhunderts*, Strasbourg 1897, pp. 18–20, pl. 91). For the angels, see the fresco from the late twelfth century in the Cathedral of Saint Demetrius in Vladimir (Grabar, I., *Die Freskomalerei der Dimitrij Kathedrale in Wladimir*, pls. XI, XXXIV, XXXV).

Bibliography: Anisimov, A., "Domongolskoy period drevnerusskoy zhivopisi" pp. 159–161, 164–165; Ainalov, D., *Geschichte der russischen Monumentalkunst zur Zeit des Grossfürstentums Moskau*, pp. 56–60; Onasch, K., *Ikonen*, pl. 6, pp. 345–346; Antonova, V.I. — Mneva, N.E., *Katalog drevnerusskoy zhivopisi*, t. I, n. 3, pp. 51–54, pls. 3–6; Maslenitsyn, S.I., *Yaroslavskaga ikonopis*, pp. 7–9, pls. 1–5; *Zhivopis domongolskoy Rusi*, catalogue, n. 6, pp. 40–45; [Alpatov, M.V., *Drevnerusskaya ikonopis*, pl. 37, p. 299; Putsko, V., "Bogomater Velikaya Panagiya," *Zbornik radova Vizantoloshkog instituta*, 18, Belgrade 1978, pp. 247–256].

22. THE SAVIOR WITH GOLDEN HAIR

First quarter of 13th century. 58.5x42 cm. Cathedral of the Dormition, Kremlin, Moscow [5136 sob/zh-146].

From the Cathedral of the Dormition, Kremlin, Moscow, where it was probably brought at the time of Ivan the Terrible. In very poor condition. Many lacunae and losses in the background and in the lower part of the face. A new *levkas* has been applied in a series of points (the lower right part of Christ's cloak, the right part of the neck, the cross at the top, and the hair in the upper part along the vertical crack). In its coloring and the kind of decorations, the icon recalls the works of Yaroslav. N.P. Kondakov (*Litsevoy ikonopisnyi podlinnik*, I, *Ikonografiya Gospoda Boga i Spasa nashego Iususa Christa*, Spb. 1905, p. 80, pl. VI) published this icon, placing it in the fifteenth century and attributing it to Moldavia-Walachia (sic!). D.V. Ainalov attributed the icon to the school of Novgorod, which is definitely inconsistent with its style.

Bibliography: Anisimov, A., "Domongolskoy period drevnerusskoy zhivopisi," pp. 141–143; Ainalov, D., *Geschichte der russischen Monumentalkunst zur Zeit des Grossfürstentums Moskau*, pp. 67–68; *Zhivopis domongolskoy Rusi*, catalogue, n. 24, pp. 108–110; [Tolstaya, T.V., *Uspenskii sobor Moskovskogo Kremlya*, p. 46, pl. 74; Yakovleva, A.I., "Tri ikony domongolskoy epochi iz sobraniya Muzeev Kremlya," pp. 31–33].

23. THE SAVIOR

Mid 13th century. 44.5x37 cm. Yaroslav, Fine Arts Museum [I–1205].

From the Cathedral of the Dormition in Yaroslav, dedicated in 1219. In mediocre condition. Many lacunae on the background, the *himation*, and the book. The upper layers of colors on the face and hands are partially effaced, therefore the flesh tone seems duller. The edge of the chiton and clavus are decorated with an ornamental motif especially used in Yaroslav icons.

Bibliography: Grabar, Igor, *O drevnerusskom iskusstve*, M. 1966, p. 162 (in the essay "Andrey Rublyov. Ocherk tvorchestva chudozhnika po dannym restavratsionnykh rabot 1918–1925 gg."); [Vzdornov, G., "O zhivopisi Severo-Vostochnoy Rusi XII–XV vekov," p. 58]; Rozanova, N.V., *Rostovo-Suzdalskaya zhivopis XII–XVI vekov*, M. 1970, pl. 11; Maslenitsyn, S.I., *Yaroslavskaya ikonopis*, pp. 9–10, pl. 6; *Zhivopis domongolskoy Rusi*, catalogue, n. 25, pp. 111–112; [*Yaroslavskaya ikonopis XIII–XVIII vekov*, catalogue, ed. I. Bolottseva, Yaroslav 1981, n. 1].

24. THE ARCHANGEL MICHAEL

Late 13th century. 154x90 cm. Tretyakov Gallery, Moscow [17304].

From the Monastery of the Savior in Yaroslav. It arrived there from the Church of the Archangel Michael on the River Kotorosl. The church was built around 1299 by Princess Anne, the wife of Fyodor Rostislavich the Black. It was probably the main icon of the church. It is in relatively good condition in spite of many losses in the layer of colors. The figure in the medallion is almost totally lost. Application of new *levkas* in the upper and lower parts of the panel which has undergone additions from everywhere. For the iconographic type, see the Byzantine soapstone relief from the twelfth century representing the Archangel Michael in the Bandini Museum of Fiesole (Rice, D. Talbot, *Arte di Bisanzio*, Florence 1959, pl. 162).

Bibliography: Anisimov, A., *Restavratsiya pamyatnikov drevnerusskoy zhivopisi v Yaroslavle. 1919–1926*, M. 1926, p. 8; Grabar, Igor, *O drevnerusskom iskusstve*, p. 162 (in the essay "Andrey Rublyov. Ocherk tvorchestva chudozhnika po dannym restavratsionnykh rabot 1918–1925 gg.");

Antonova, V.I. — Mneva, N.E., *Katalog drevnerusskoy zhivopisi*, t. I, n. 163, pp. 204–205, pls. 126, 127]; Onasch, K., *Ikonen*, pl. 7, p. 346; [Vzdornov, G.I., "Zhivopis," in *Ocherki russkoy kultury XIII–XV vekov*, pt. 2, *Duchovnaya kultura*, M. 1970, pp. 266–267]; Maslenitsyn, S.I., *Yaroslavskaya ikonopis*, p. 12, pl. 8.

25. THE LARGE ICON OF THE VIRGIN OF TOLGA (TOLGSKAYA I)

Last quarter of 13th century. 140x92 cm. Tretyakov Gallery, Moscow [12875].

From the Church of the Exaltation of the Cross in the Monastery of Tolga near Yaroslav. Generally good condition. The major lacunae are found on the halo and background where the silver is oxidized. Additions of new *levkas* are visible on the garment. The upper edge and especially the lower one are cut off. The iconographic type of the Virgin of Tenderness with the Child standing comes from Byzantine sources. It is found in two Sinaitic icons from the twelfth and thirteenth centuries (Sotiriou, G. and M., *Icônes du Mont Sinaï*, vol. I, pls. 148, 201). The representation of the Virgin sitting on a throne was also well known in Byzantium (ibid., pls. 54, 157, 171, 191, 222, 232), but it was most widespread in the painting of the Italian Duecento. However, it would be a mistake to hypothesize an Italian influence on the icon on account of that. The closest iconographic analogies can be established with the miniature on the parchment of an *Exultet* in the National Library in Paris (Nlles Acq. lat., n. 710, about the year 1115: Bertaux, L., *L'art dans l'Italie Méridionale*, Paris 1904, pp. 228–229; cf. with the parchment of the *Exultet*, pl. II, 11S), the Byzantine relief from the thirteenth century in Saint Mark's (Demus, O., *The Church of San Marco in Venice*, p. 121, pl. 35), the small gold icon from the thirteenth century in the Hermitage (Bank, A.V., *Vizantiiskoe iskusstvo v sobraniyach Sovetskogo Soyuza*, L.-M. 1967, pl. 247, p. 374). But in the Tolga icon, the entire composition is flattened. V.I. Antonova's attempt to assign the icon of the *Virgin of Tolga* to the Georgian school has absolutely no foundation. The icon is painted on a panel of linden, not of cypress, which gives evidence against its southern origin.

Bibliography: Anisimov, A., "Domongolskoy period drevnerusskoy zhivopisi," pp. 156–157, 161–164, 171; Ainalov, D., *Geschichte der russischen Monumentalkunst zur Zeit des Grossfürstentums Moskau*, pp. 87–88; Onasch, K., *Ikonen*, pl. 8, pp. 346–347; Antonova, V.I. — Mneva, N.E., *Katalog drevnerusskoy zhivopisi*, t. I, n. 162, pp. 202–204, pls. 115, 116; Maslenitsyn, S. I., *Yaroslavskaya ikonopis*, pp. 15–17, pls. 13, 14.

26. THE SMALL ICON OF THE VIRGIN OF TOLGA (TOLGSKAYA II)

About 1314. 61x48 cm. Fine Arts Museum, Yaroslav [I–1206].

From the Monastery of Tolga near Yaroslav. In mediocre condition. There are lacunae on the garment, and the background color is oxidized. The faces are well preserved. Application of new *levkas* on the lower part of the nose and on the left cheek of the Virgin. In its coloring, the icon is similar to the *Tolgskaya I* (combination of silvery background with dark cherry, dark azure and emerald green tones). It would seem that the Large Icon of the Virgin of Tolga was a highly venerated image since there was yet another replica with a bust-length figure (*Tolgskaya III*, in the Russian Museum, Saint Petersburg, first half of fourteenth century; about this latter, see Rozanova, N.V, *Rostovo-Suzdalskaya zhivopis XII–XVI vekov*, pl. 14; Maslenitsyn, S.I., *Yaroslavskaya ikonopis*, pp. 14–15, pls. 11, 12; *Yaroslavskaya ikonopis XIII–XVIII vekov*, catalogue, n. 2].

27. THE APPEARANCE OF THE ARCHANGEL MICHAEL TO JOSHUA NAVIN

Second quarter of 13th century. 50x35.8 cm. Cathedral of the Dormition, Kremlin, Moscow [3474 sob/zh–257].

The icon may have come from the Church of the Archangel Michael, built by Michail Choroborit on the location where the Cathedral of the Archangel is now. Many lacunae in the lower part of the icon, on the white background, the pink halo, and the olive green of the cornice, on which only small fragments of the original painting are preserved. The face and body of the archangel are fairly well preserved. To the left of the head and near the right elbow, the paint is chipped down to the surface of the panel.

Bibliography: Anisimov, A., "Domongolskoy period drevnerusskoy zhivopisi," pp. 135–137; Ainalov, D., *Geschichte der russischen Monumentalkunst zur Zeit des Grossfürstentums Moskau*, pp. 88–89; *Zhivopis domongolskoy Rusi,* catalogue, n. 27, pp. 118–120; [Alpatov, M.V., *Drevnerusskaya ikonopis*, pl. 44, p. 300; Tolstaya, T.V., *Uspenskii sobor Moskovskogo Kremlya,* p. 46, pl. 75; Yakovleva, A.L., "Tri ikony domongolskoy epochi iz sobraniya Muzeev Kremlya," pp. 36–38].

28. THE VIRGIN OF SVEN WITH SAINTS ANTHONY AND THEODOSIUS PECHERSKY

About 1288. 67x42 cm. Tretyakov Gallery, Moscow [12723].

From the Monastery of the Dormition in Sven near Bryansk. In poor condition. Many lacunae in the surface layer of colors. Addition of new *levkas* in the upper part of the Child's head, in the right half of Anthony's body, in the upper right corner, at the bottom, and on the borders. At top and bottom where the cornice has been cut off, the panel presents some additions. In 1330 (?), a precious covering, enriched by Ivan the Terrible in 1588, was applied to the icon. The mediocre quality of the work and its particular style do not allow us to attribute it with certainty to the Kiev school. It might be a copy of a copy already executed in the Sven monastery. The lost icon of the *Virgin of the Caves* enjoyed great renown in Russia, as evidenced by the many reproductions in later icons.

Bibliography: Ierofey archim., *Bryanskii Svenskii Uspenskii monastyr Orlovskoy eparchii,* M. 1866, pp. 102–113; Anisimov, A., "Domongolskoy period drevnerusskoy zhivopisi," pp. 152, 154–155; Ainalov, D., *Geschichte der russischen Monumentalkunst zur Zeit des Grossfürstentums Moskau,* pp. 61–62; Onasch, K., *Ikonen,* pl. 3, pp. 342–343; Antonova, V.I. — Mneva, N.E., *Katalog drevnerusskoy zhivopisi,* t. I, n. 12, pp. 76–77, pls. 32–35; *Zhivopis domongolskoy Rusi,* catalogue, n. 12, pp. 62–67.

29. THE SYNAXIS OF THE ARCHANGELS

Second half of 13th century. 165x118 cm. Russian Museum, Saint Petersburg [3103].

From the Monastery of the Archangel Michael in Velikii Ustyug, founded in 1212 (the cathedral of the architstrategos [commander-in-chief] Michael was dedicated in 1216). In good condition. Addition of new *levkas* on the figure to the left (from the right shoulder along the garment), on the figure to the right (the upper part of the *loros* and the hem of the garment), on the background (at the top to the right and left including the archangel's wing). A piece of chipped paint remains on the left border. The panel is one of the rare early examples of this iconographic type (fresco from the Church of Tigran Onents in Ani (Armenia), 1215; mo-

saic in Saint Mark's in Venice, thirteenth century; fresco in the Parma Baptistery, around 1270; and others). This iconographic type is also found in Georgia (see Chubinashvili, G., *Gruzinskoe chekannoe iskusstvo VIII–XVIII vekov,* Tbilisi 1957, pl. 89; Id., *Gruzinskoe chekannoe iskusstvo,* Tbilisi 1959, text, pp. 602–604, ill., pls. 377–378). The icon was most likely painted in Ustyug itself in the second half of the thirteenth century, after the dedication of the cathedral.

Bibliography: *IV vystavka "Restavratsiya i konservatsiya proizvedenii iskusstva,"* catalogue, M. 1963, pp. 7–8, 11, two pls.; Yamshchikov, S., "Raskrytie shedevry," in *Tvorchestvo,* 1963, n. 12, p. 9; Id., *Drevnerusskaya zhivopis. Novye otkrytiya,* M. 1966, pl. 1; Reformatskaya, M.A., *Severnye pisma,* M. 1968, p. 13; Goleyzovskii, N. — Yamshchikov, S., *Novye otkrytiya sovetskich restavratorov,* M. 1971, pls. 1, 2; Vzdornov, G.I., "Ikona 'Sobor archangelov Michaila i Gavriila' iz Velikogo Ustyuga," in *Soobshcheniya Vsesoyuznoy tsentralnoy nauchno-issledovatelskoy laboratorii po konservatsii i restavratsii muzeynych chudozhestvennych tsennostey,* 27, M. 1971, pp. 141–162; [*Novye otkrytiya sovetskich restavratorov,* 1, M. 1973, unnumbered (annotation by S.V. Yamshchikov)].

30. SAINT GEORGE WITH SCENES FROM HIS LIFE

Early fourteenth century. 89x63 cm. Russian Museum, Saint Petersburg [2118].

From the M.P. Pogodin collection. In good condition except for some lacunae in the lower part of the panel. The style of the icon is very close to the earliest traditions of the thirteenth century (see the representation of the Martyr Juliana on the bilateral icon of the *Virgin of the Sign* in the P.D. Korin collection and the icon of *Saint Clement* in a private Stockholm collection). The image of Saint George slaying the dragon was imported into Russia from Byzantium, where it is already found in twelfth-century works.

Bibliography: Matsulevich, L.A., "Dve ikony Rozhdestva Bogomateri iz sobraniya S.P. Ryabushinskogo," in *Russkaya ikona,* 3, Spb. 1914, pp. 173–174; Kondakov, N.P., *Russkaya ikona,* t. II, album, pt. 2, Prague 1919, pl. 14; t. III, text, pt. 1, pp. 135–137; Ainalov, D., *Geschichte der russischen Monumentalkunst zur Zeit des Grossfürstentums Moskau,* pp. 68–70; Dmitriev, Yu.N., *Gos. Russkii muzey. Putevoditel. Drevnerusskoe iskusstvo,* p. 14; Lazarev, V.N., *Russkaya srednevekovaya zhivopis. Stati i issledovaniya,* pp. 77–79 [on iconography], p. 88 [on the fresco of Staraya Ladoga], pp. 94, 96; *Zhivopis drevnego Novgoroda i ego zemel XII–XVII stoletii,* catalogue, n. 14, pp. 38–39; [Alpatov, M.V., *Drevnerusskaya ikonopis,* pl. 49, p. 301; Smirnova, E.S., *Zhivopis Velikogo Novgoroda. Seredina XIII — nachalo XV veka,* pp. 75–79, catalogue, n. 10, pp. 188–195, ill. on pp. 294–297].

31. THE APOSTLE THOMAS

1360s. 53x39 cm. Russian Museum, Saint Petersburg [2064].

[In the N.P. Lichachev collection]. The figure is in good condition. The application of new *levkas* is visible on the head, the lower right part of the garment, and the cornice. In style, the icon recalls the frescoes from the Monastery of Skovorodka (see the head of the prophet Zechariah).

Bibliography: Lazarev, V.N., *Iskusstvo Novgoroda,* M.-L. 1947, p. 92, pl. 86; Id., *Novgorodskaya ikonopis,* p. 19, pl. 22; *Zhivopis drevnego Novgoroda i ego zemel XII–XVII stoletii,* catalogue, n. 32, pp. 46–47 (the date, early fifteenth century, is too late); Smirnova, E.S., *Zhivopis Velikogo Novgoroda. Seredina XIII — nachalo XV veka,* pp. 130–133, catalogue, n. 37, pp. 257–258, ill. on p. 373].

32. RECTO: THE VIRGIN OF THE DON
VERSO: THE DORMITION

1390s. 86x68 cm. Tretyakov Gallery, Moscow [14244].

The icon came from the Cathedral of the Annunciation, Kremlin, Moscow, where it was brought in 1591 (?) from the Cathedral of the Dormition of Kolomna. It is well preserved. The gold on the background, the cornice, and the halos is almost completely lost. The left eye of the Virgin is slightly damaged. In the scene of the Dormition, small chips of color can be seen on the faces of Bishop Timothy, Saint James, the brother of the Lord, and the Apostle Philip. The panel is extended on all sides by thin cross bars. According to an unreliable source, the icon was brought by the Cossacks of the Don to Prince Dmitrii Ivanovich before the battle of Kulikovo in 1380 (introduction to the 1692 inventory of the Donskoy Monastery). We do not know for sure when the icon arrived in Kolomna. Ivan the Terrible prayed before this icon on July 3, 1552, before leaving for the Kazan campaign; and in 1598, Patriarch Iov dedicated it to the reign of Boris Godunov. Since there are copies of the icon of the *Virgin of the Don* in Moscow, it is quite probable that it was painted in the 1390s when Theophanes moved with his brigade from Novgorod and Nizhnii Novgorod to Moscow. The well-informed Epifanii does not mention the work of Theophanes the Greek in Kolomna; it would be imprudent therefore to date — as does V.I. Antonova — the icon of the *Virgin of the Don* exactly to 1392, when the "masonry Cathedral Church of the Dormition" in Kolomna (*Stepennaya kniga*, 1392) was "completed." This cathedral, founded in 1379, was finished in 1382. From the time of its dedication, it must have had its main icon and the bilateral icon of the *Virgin of the Don* was precisely that kind of processional icon. There are no reliable grounds for supposing that the icon of the *Virgin of the Don* goes back to this 1382 prototype, of which it would be a sort of replica, since the exact date when the icon arrived in the Cathedral of the Dormition in Kolomna is still unknown today. L.I. Lifshits' hypothesis, according to which the icon was requested by Metropolitan Kiprian in 1395 after the Tartars' retreat from Moscow, appears much more convincing. The icon may have been painted in remembrance of Moscow's miraculous liberation from the Tartar yoke, as a thanksgiving for the protection of the Virgin. In restoring the icon, G.O. Chirikov had already hypothesized that the figures on the front and back might have been executed by different masters. This opinion is highly debated in L.I. Lifshits' work, which has convinced me of his correctness. However, it is still not known if the figures were painted at the same time or different times. In any case, the relation of the icon to Theophanes the Greek's workshop is unquestionable, and there is no reason to attribute the image on the front to a Serbian master. Personally, I am inclined to think that both images were painted by Novgorodian pupils of Theophanes who had followed the master to Moscow, although the possibility that Theophanes himself painted the front is not at all excluded.

Bibliography: Kondakov, N.P., *Russkaya ikona*, t. IV, text, pt. 2, Prague 1933, pp. 221–222; Antonova, V.I., "O Feofane Greke v Kolomne, Pereslavle-Zalesskom i Serpuchove," in *Gos. Tretyakovskaya galereya. Materialy i issledovaniya*, II, M. 1958, pp. 10–22; Lazarev, V.N., *Feofan Grek i ego shkola*, M. 1961, pp. 63–67; Onasch, K., *Ikonen*, pls. 86–90, pp. 384–386; Antonova, V.I. — Mneva, N.E., *Katalog drevnerusskoy zhivopisi*, t. I, n. 215, pp. 255–257, pls. 173–175; Lifshits, L.I., "Ikona Donskoy Bogomateri," in *Drevnerusskoe iskusstvo. Chudozhestvennaya kultura Moskvy i prilezhashchich k ney knyazhestv. XIV–XVI vv.*, M. 1970, pp. 87–114; [Goleyzovski, N. — Yamshchikov, S., *Feofan Grek i ego shkola*, M. 1970, pls. 1–8; Alpatov, M.V., *Drevnerusskaya ikonopis*, pls. 17, 62, 63, pp. 294, 303].

33. SAINT NICHOLAS THE WONDERWORKER WITH SCENES FROM HIS LIFE

1370s–1380s. 147x115 cm. Museum of History and Architecture, Novgorod [2182].

From the Church of Boris and Gleb in Novgorod, consecrated by Bishop Aleksii in 1377 *(First Chronicle of Novgorod)*. Except for a few chips in the layer of color, generally in good condition. The date of the icon is 1370s to 1380s, and it clearly shows how Novgorodian artists remained steadfastly faithful to early traditions. In the scene of the appearance of Nicholas to the eparch Evlalii, we note the accentuated flatness of the composition and the abundance of ornamentation. In the cycle of episodes from his life, developed in eighteen border scenes, the main accent is on miracles which show the mercy of Nicholas and his effective help for humankind.

Bibliography: Laurina, V.K., "Ikony Bogoyavlenskoy tserkvi v Novgorode" (K voprosu o novgorodskoy ikonopisi vtoroy poloviny XIV veka), in *Soobshcheniya Gos. Russkogo muzeya*, IX, L. 1968, pp. 76–79; [Smirnova, E.S., *Zhivopis Velikogo Novgoroda. Seredina XIII — nachalo XV veka*, pp. 124–126, catalogue, n. 34, pp. 251–253, ill. on pp. 360–367].

34. THE VIRGIN OF MERCY

About 1390. 151x126 cm. Museum of History and Architecture, Novgorod [11170].

From the masonry Church of the Virgin of Mercy in the Zverin Monastery, built by Archbishop Ioann in 1399 and solemnly consecrated on October 1 of the same year *(First Chronicle of Novgorod)*. Except for individual figures, in mediocre condition. The original gold background is completely lost. The original *levkas* is preserved only in the central arch (next to the royal doors) and near the figures of the angels and those of the lower right group; in the other areas, a new *levkas* has been applied, and on it the outlines of the domes, the lateral arches and the royal doors have been painted. The faces are well preserved. A new *levkas* has been added on the clothes of the figures in the lower part. The accurately executed faces are reminiscent of the group of Bizantinizing frescoes *(Dormition, Nativity, Saint Simeon)* in the Church of the Nativity of the Virgin above the Cemetery, from the late fourteenth century (see Karger, M.K., *Novgorod Velikii*, L.-M. 1961, pp. 217–223, 225). V.K. Laurina has sought to link the icon of the *Virgin of Mercy* to the masonry church of the same name built in 1335, but there is no mention of a church of the Virgin of Mercy in the chronicles of that year, although a church of the Virgin is mentioned.

Bibliography: Laurina, V.K., "Dve ikony novgorodskogo Zverina monastyrya" (K voprosu o novgorodskoy ikonopisi pervoy poloviny XIV veka), in *Soobshcheniya Gos. Russkogo muzeya*, VIII, pp. 105, 112–119; Lazarev, V.N., "O date odnoy novgorodskoy ikony," in *Novoe v archeologii. Sbornik statey, posvyashchennyi 70-letiyu A.V. Artsichovskogo*, M. 1972, pp. 247–253; [Smirnova, E.S., *Zhivopis Velikogo Novgoroda. Seredina XIII — nachalo XV veka*, pp. 104–114, catalogue, n. 21, pp. 222–227, ill. on pp. 332–334].

35. THE DESCENT INTO HELL

1370s–1380s. 134x180 cm. Russian Museum, Saint Petersburg [2664].

The icon comes from Tichvin and is in good condition. Lacunae are visible on the background, borders, and mountains. Its iconographic arrangement recalls the thirteenth-century icon from Pskov (?) in the Tretyakov Gallery (Antonova, V.I. — Mneva, N.E., *Katalog drevnerusskoy zhivopisi*,

t. I, n. 146, pp. 187–188, pls. 98, 99). The image, in which specifically iconographic methods are clearly emerging, was painted toward the end of the fourteenth century. Although strongly influenced by the experience of Greek masters who were passing through, the facial types and the style of execution are typically Novgorodian.

Bibliography: Porfiridov, N.G., ”Vydayushchiisya pamyatnik drevnerusskoy zhivopisi,” in *Iskusstvo*, 1959, n. 2, pp. 67–71; Smirnova, E.S., “Novye raboty muzeya po restavratsii proizvedenii drevnerusskoy zhivopisi,” in *Soobshcheniya Gos. Russkogo muzeya*, VI, L. 1959, pp. 60–62; *Zhivopis drevnego Novgoroda i ego zemel XII–XVII stoletii*, catalogue, n. 38, p. 45; [Smirnova, E.S., *Zhivopis Velikogo Novgoroda. Seredina XIII — nachalo XV veka*, pp. 117–118, catalogue, n. 26, pp. 236–237, ill. on pp. 344, 345].

36. PATERNITAS

Late 14th century. 113x88 cm. Tretyakov Gallery, Moscow [22211].

We do not know the exact place of origin of this icon belonging to the M.P. Botkin collection. In good condition. An addition of new *levkas* can be seen in the lower part of the icon. Representations of the Trinity already appeared in Byzantium in the eleventh century (*Col. Vat. gr. 394*, f. 7), but were not widespread there. In the West, they appeared in the twelfth century, but there the Christ-Emmanuel is replaced by the Crucified. In Russian iconography, this Western type of *Paternitas*, called *Sedes Gratiae*, arrived toward the middle of the sixteenth century (quadripartite icon in the Cathedral of the Annunciation, Kremlin, Moscow), causing bitter criticism on the part of the *dyak* Viskovatyi. The author of the Novgorodian icon follows the Byzantine-Slavic version, but took some liberty with the inscriptions, transforming the "Ancient of Days" into God the Father.

Bibliography: Gerstinger, H., "Über Herkunft und Entwicklung der anthropomorphen byzantinisch-slawischen Trinitäts-Darstellungen des sogenannten Synthronoi- und Paternitas (-Otéchestwo) Typus," in *Festschrift W. Sas-Zaloziecky zum 60. Geburtstag*, Graz 1956, pp. 79–85 [on iconography]; Onasch, K., *Ikonen*, pl. 24, pp. 237–245; Retkovskaya, L.S., "O poyavlenii i razvitii kompozitsii 'Otechestvo' v russkom iskusstve XIV–XVI vv.," in *Drevnerusskoe iskusstvo XV — nachala XVI vekov*, M. 1963, pp. 237–245; Antonova, V.I. — Mneva, N.E., *Katalog drevnerusskoy zhivopisi*, t. I, n. 25, pp. 94–95, pls. 44–47; Lazarev, V.N., "Ob odnoy novgorodskoy ikone i eresi antitrinitariev," in *Kultura drevney Rusi. Sbornik statey k 40-letiyu nauchnoy deyatelnosti N.N. Voronima*, M. 1966, pp. 101–112 (printed in: Lazarev, V.N., *Russkaya srednevekovaya zhivopis. Stati i issledovaniya*, pp. 289–291); Papadopulos, S., "Essai d'interprétation du thème iconographique de la Paternité dans l'art byzantin," in *Cahiers archéologiques*, XVIII, 1968, pp. 121–136; Grabar, A., in ibid., XX, 1970, pp. 236–237; [Uspenskii, L., "Bolshoy Moskovskii Sobor i obraz Boga-ottsa," in *Vestnik russkogo zapadnoevropeyskogo patriarshego eksarchata*, n. 78–79, April-September 1972, pp. 139–177; Smirnova, E.S., *Zhivopis Velikogo Novgoroda. Seredina XIII — nachalo XV veka*, p. 117, catalogue, n. 25, pp. 234–236, ill. on pp. 340–343].

37. SAINTS BORIS AND GLEB

About 1377. 116x93 cm. Museum of History and Architecture, Novgorod [7574].

From the masonry Church of Boris and Gleb, consecrated by Bishop Aleksii in the summer of 1377 (*First Chronicle of Novgorod*). In good condition. Background and cornice sheathed with an embossed covering.

Bibliography: Zhidkov, G.V., "K istorii novgorodskoy zhivopisi vtoroy poloviny XIV veka," in *Trudy sektsii iskusstvoznaniya Instituta arche-

ologii i iskusstvoznaniya RANION*, III, M. 1928, pp. 66–70; [Smirnova, E.S., *Zhivopis Velikogo Novgoroda. Seredina XIII — nachalo XV veka*, pp. 99–103, catalogue, n. 20, pp. 219–221, ill. on pp. 329–331].

38. SAINTS BLAISE AND SPYRIDON

About 1407. 117.5x85.5 cm. Historical Museum, Moscow [I–VIII–5756].

From the Church of Saint Blaise, built in 1407, near the Cathedral of Saint Sophia (*First Chronicle of Novgorod*). The icon also bears the same date, as correctly pointed out by G.I. Vzdornov. In good condition. A new *levkas* was added along the vertical cracks and near the lower cornice of the icon. The artist skillfully uses the mountains as an element to organize the composition, which unifies all the figures placed on different levels. The composition is developed not in depth but vertically, on the basis of the purely decorative effect of the splashes of showy colors. L.M. Glashchinskaya wanted to link the picture to the construction of the wooden Church of Saint Blaise in 1379, but this date seems too early for our icon.

Bibliography: Glashchinskaya, L.M., "Perezhitki dochristianskich verovanii v novgorodskom iskusstve XIV v.," in *Novgorodskii istoricheskii sbornik*, III–IV, Novgorod 1938, pp. 127–134; Lazarev, V.N., *Novgorodskaya ikonopis*, pp. 21–22, pl. 23; Vzdornov, G.I., "Zhivopis," in *Ocherki russkoy kultury XIII–XV vekom*, pt. 2, *Duchovnaya kultura*, p. 311; *Zhivopis drevnego Novgoroda i ego zemel XII–XVII stoletii*, catalogue, n. 33, p. 47; [Smirnova, E.S. — Laurina, V.K. — Gordienko, E.A., *Zhivopis Velikogo Novgoroda. XV vek*, M. 1982, pp. 111, 117, catalogue, n. 45, pp. 273–274, ill. on p. 479].

39. THE MIRACLE OF SAINT GEORGE AND THE DRAGON

Late 14th–early 15th century. 58x41.5 cm. Russian Museum, Saint Petersburg [2123].

From the church in the village of Manichino on the Pasha River, region of Saint Petersburg. In good condition. Addition of new *levkas* in the lower part of the icon. A provincial replica of the icon is in the Hermitage (from the village of Nyormushi on the Onega River; see *Soobshcheniya Gos. Ermitazha*, XXIII, L. 1962, p. 69); [*Sto ikon iz fondov Ermitazha*, catalogue of the exhibition, n. 12].

Bibliography: Dmitriev, Yu.N., *Gos. Russkii muzey. Putevoditel. Drevnerusskoe iskusstvo*, p. 26; Lazarev, V.N., *Novgorodskaya ikonopis*, p. 25, pl. 24; *Zhivopis drevnego Novgoroda i ego zemel XII–XVII stoletii*, catalogue, n. 60, pp. 57–58 (the date, last quarter of fifteenth century, is too late); [Alpatov, M.V. *Drevnerusskaya ikonopis*, pl. 56, p. 302; Smirnova, E.S. — Laurina, V.K. — Gordienko, E.A., *Zhivopis Velikogo Novgoroda. XV vek*, pp. 86–89, 158–161, catalogue, n. 17, pp. 227–228, ill. on p. 429].

40. THE PROPHET ELIJAH

Late 14th–early 15th century. 75x57 cm. Tretyakov Gallery, Moscow [12007].

In the I.S. Ostrouchov collection. In good condition. Addition of new *levkas* on the lower border, to the left and up. In the treatment of the face, the icon is close to the *Paternitas*. Also dated to the threshold between the fourteenth and fifteenth centuries are two icons of the Prophet Elijah with a red background, in the Tretyakov Gallery (from the village of Rakuly; see Antonova, V.I. — Mneva, N.E., *Katalog drevnerusskoy zhivopisi*, t. I, n. 36, pp. 100–101, pl. 54) and the Russian Museum (from the village of Pyalma in the Autonomous Republic of Karelia; see Smirnova, E.S., *Zhivopis Obonezhya XIV–XVI vekov*, M. 1967, pp. 30–32;

Id., *Zhivopis drevney Rusi. Nachodki i otkrytiya*, pl. 6). But the icon in the I.S. Ostrouchov collection is far superior to the others because of its expressive intensity and the quality of its execution.

Bibliography: Muratov, P.P., *Drevnerusskaya ikonopis v sobranii I.S. Ostrouchova*, M. 1914; Onasch, K., *Ikonen*, pl. 28, p. 359; Antonova, V.I. — Mneva, N.E., *Katalog drevnerusskoy zhivopisi*, t. I, n. 42, pp. 105–106, pl. 53; Lazarev, V.N., *Novgorodskaya ikonopis*, pp. 22–23, pl. 25; *Zhivopis drevnego Novgoroda i ego zemel XII–XVII stoletii*, catalogue, n. 39, p. 49 (the date, second half of fifteenth century, is too late); [Alpatov, M.V., *Drevnerusskaya ikonopis*, pl. 57, p. 302; Smirnova, E.S. — Laurina, V.K. — Gordienko, E.A., *Zhivopis Velikogo Novgoroda. XV vek*, pp. 86–89, 156–157, catalogue, n. 16, pp. 226–227, ill. on p. 428].

41. THE VIRGIN OF THE SIGN WITH SAINTS
(BARLAAM OF KHUTYNSK, JOHN THE ALMSGIVER, PARASKEVA PYATNITSA, AND ANASTASIA)

Early 15th century. 66x50.3 cm. Russian Museum, Saint Petersburg [2064].

In the V.A. Prochorov collection. In good condition. The background is lost. The lower border is stripped down to the board. Small lacunae on Anastasia's garment. Novgorodians were very fond of this type of icon since the selection of the saints was dictated by the person commissioning the icon. The interpretation of the faces is very close to what we find in the icon of *Blaise and Spyridon* from 1407 (?).

Bibliography: Lazarev, V.N., *Novgorodskaya ikonopis*, pp. 23–24, pl. 29; *Zhivopis drevnego Novgoroda i ego zemel XII–XVII stoletii*, catalogue, n. 49, p. 53 (the date, second half of fifteenth century, is too late); [Smirnova, E.S. — Laurina, V.K. — Gordienko, E.A., *Zhivopis Velikogo Novgoroda. XV vek*, pp. 111, 163, catalogue, n. 44, pp. 271–272, ill. on p. 478].

42. THE VIRGIN OF THE SIGN WITH SAINTS
(THE PROPHET ELIJAH, NICHOLAS THE WONDERWORKER, AND ANASTASIA)

Early 15th century. 66x50 cm. Tretyakov Gallery, Moscow [17310].

In the A.I. Anisimov collection. In good condition. Addition of new *levkas* in the lower part of the icon.

Bibliography: Antonova, V.I. — Mneva, N.E., *Katalog drevnerusskoy zhivopisi*, t. I, n. 29, p. 96, pl. 48; Lazarev, V.N., *Novgorodskaya ikonopis*, pl. 26; [Smirnova, E.S. — Laurina, V.K. — Gordienko, E.A., *Zhivopis Velikogo Novgoroda. XV vek*, pp. 103, 162–163, catalogue, n. 23, pp. 239–241, ill. on p. 435].

43. SAINTS GEORGE AND JOHN THE BAPTIST
FRAGMENTS FROM A PROCESSIONAL ICON

Early 15th century. Diameter of the medallion 13.8 cm. Russian Museum, Saint Petersburg [220].

In the N.P. Lichachev collection. In good condition. A few processional crosses from the early fifteenth century are preserved in the Russian Museum (inv. n. 6203) and the Tretyakov Gallery (Antonova, V.I. — Mneva, N.E., *Katalog drevnerusskoy zhivopisi*, t. I, n. 37, p. 101).

Bibliography: Lichachev, N.P., *Manera pisma Andreya Rublyova*, [Spb.] 1907, fig. 26 on p. 53 *(Saint George)*; [Smirnova, E.S. — Laurina, V.K. — Gordienko, E.A., *Zhivopis Velikogo Novgoroda. XV vek*, p. 126, catalogue, n. 73, pp. 335–336, ill. on pp. 540 and 541].

44. THE APOSTLE PETER

Late 14th century. 41x30 cm. Russian Museum, Saint Petersburg [2898].

From the village of Beloruksa in the Zaonezhskaya Peninsula, which formed part of the rural district *(pyatina)* of the Onega in Novgorod territory. In good condition. The slightly dull, muddy colors, the lack of cloth, the roughly worked panel suggest a local, northern origin. In style, the closest relationship can be established with the icon of the *Apostle Peter* from the *Deesis* of the fourteenth century on a red background in the Russian Museum (Lichachev, N.P., *Materialy dlya istorii russkogo ikonopisaniya*, atlas, pt. I, Spb. 1906, pls. CIII, CIV; [Smirnova, E.S., *Zhivopis Velikogo Novgoroda. Seredina XIII — nachalo XV veka*, catalogue, n. 31, ill. on p. 356], where we find the same simplified interpretation of the hair and folds of the garments. It is one of the earliest examples of *Deeses* in which the bust figures are turned toward the center of the composition.

Bibliography: Smirnova, E.S., *Zhivopis Obonezhya XIV–XVI vekov*, pp. 30–32, glued color insert, pl. 1; *Zhivopis drevnego Novgoroda i ego zemel XII–XVII stoletii*, catalogue, n. 22, p. 42; [Smirnova, E.S., *Zhivopis Velikogo Novgoroda. Seredina XIII — nachalo XV veka*, p. 120, catalogue, n. 52, pp. 247–249, ill. on p. 358].

45. QUADRIPARTITE ICON
(THE RAISING OF LAZARUS, THE TRINITY, THE PRESENTATION IN THE TEMPLE, SAINTS JOHN THE EVANGELIST AND PROCHORUS)

Early 15th century. 130x77 cm. Russian Museum, Saint Petersburg [2775].

From the Church of Saint George in Novgorod. In good condition. Addition of new *levkas* in the lower part of the *Presentation in the Temple*. Much damage to the original gold background. It is one of the masterpieces of Novgorodian painting on wood from the fifteenth century.

Bibliography: *Masterpieces of Russian Painting*, London 1930, pl. VII, p. 110; Dmitriev, Yu.N., *Gos. Russkii muzey. Putevoditel. Drevnerusskoe iskusstvo*, pp. 23–25; Lazarev, V.N., *Novgorodskaya ikonopis*, pp. 26–27, pls. 32–36; *Zhivopis drevnego Novgoroda i ego zemel XII–XVII stoletii*, catalogue, n. 37, pp. 48–49; [Smirnova, E.S. — Laurina, V.K. — Gordienko, E.A., *Zhivopis Velikogo Novgoroda. XV vek*, pp. 81–83, 144–148, catalogue, n. 11, pp. 213–217, ill. on pp. 418–422].

46. THE VIRGIN OF MERCY

Early 15th century. 74x50 cm. Tretyakov Gallery, Moscow [12009].

In the I.S. Ostrouchov collection. In good condition. Some addition of new *levkas* on the borders. Background an ivory color. This same iconographic version, typical of Novgorod, is also found in the *Virgin of Mercy* from the Zverin Monastery, in the fragment of icon in the A.I. Anisimov collection (Laurina, V.K., "Dve ikony novgorodskogo Zverina monastyrya," p. 118), in the icon in the A.V. Morozov collection at the Tretyakov Gallery (Wulff, O., and Alpatoff, M., *Denkmäler der Ikonenmalerei*, Hellerau (Dresden) 1925, pl. 63, p. 154), in the icons of the "Northern Manners" in a private Oslo collection (Kjellin, H., *Ryska ikoner i svensk och norsk ägo*, p. 100, pl. 32), in the Museum of Fine Arts of Petrozavodsk (Yamshchikov, S., *Zhivopis drevney Karelii*, Petrozavodsk 1966, n. 1), and in the Russian Museum (Smirnova, E.S., *Zhivopis Obonezhya XIV–XVI vekov*, fig. 24).

Bibliography: Muratov, P.P., *Drevnerusskaya ikonopis v sobranii I.S. Ostrouchova*, p. 14; Onasch, K., *Ikonen*, pl. 21, pp. 344–345 [on iconography], 354; Antonova, V.I. — Mneva, N.E., *Katalog drevnerusskoy*

zhivopisi, t. I, n. 38, pp. 101–102, pls. 49, 50; Laurina, V.K., "Dve ikony novgorodskogo Zverina monastyrya" (K voprosu o novgorodskoy ikonopisi pervoy poloviny XIV veka), p. 114; Lazarev, V.N., *Novgorodskaya ikonopis,* pl. 30, p. 297; [Smirnova, E.S. — Laurina, V.K. — Gordienko, E.A., *Zhivopis Velikogo Novgoroda. XV vek,* pp. 101–102, 148–149, catalogue, n. 19, p. 231, ill. on p. 431].

47. THE VIRGIN OF THE SIGN WITH SAINTS
(THE PROPHET ELIJAH, PARASKEVA PYATNITSA, NICHOLAS, BLAISE, FLORUS, AND LAURUS)

Second quarter of 15th century. 69x57 cm. Tretyakov Gallery, Moscow [14480].

In the S.P. Ryabushinskii collection. In good condition. Slight addition of new *levkas* on the yellow background and on the ground. The icon was painted around the middle of the fifteenth century. The person requesting it probably wanted to be safe from all possible misfortunes and asked the artist to introduce the two figures of Elijah and Paraskeva Pyatnitsa in order that they might protect the house from fire and ensure the market days be profitable.

Bibliography: Antonova, V.I. — Mneva, N.E., *Katalog drevnerusskoy zhivopisi,* t. I, n. 34, p. 99; Lazarev, V.N., *Novgorodskaya ikonopis,* p. 31, pl. 43; [Smirnova, E.S., "O mestnoy traditsii v novgorodskoy zhivopisi XV v. Ikony s izbrannymi svyatymi i Bogomateryu Znamenie," *Srednevekovoe iskusstvo. Rus. Gruziya,* M. 1978, p. 196, ill. on p. 200].

48. THE LAST JUDGMENT

Third quarter of 15th century. 162x115 cm. Tretyakov Gallery, Moscow [12874].

In the A.V. Morozov collection. In good condition. The gold on the background and borders is almost completely gone. When the icon was discovered at the beginning of the twentieth century, the colors were brightened with small additions to the design. Besides the traditional elements, this scene of the Last Judgment also includes many auxiliary episodes. In the center of the upper register, there is a representation of a bust figure of the Lord of Hosts surrounded by seraphim and the symbols of the evangelists. Twelve small circles with crowned heads personifying the heavenly stars are arranged in the outer circle; they correspond to the twelve months of the year (the alternation of light pink and dark green tones in the circles symbolizes the alternation of day and night). This same circle includes the figure of the patriarch Enos, who was taken bodily up to heaven and received from God the revelation of the events preceding the end of the world, and also the chalice with the blood — probably an apocryphal chalice of Solomon, interpreted as the prefiguration of the Eucharist. To the right, under the scroll of heaven unrolled by the angels, we see three other circles, one with Christ seated on a throne, another with the "angels of light," and the third, black darkness, which the angels of light drive away with tridents. Beneath these circles, three angels soar toward Golgotha. The heavenly Jerusalem with the just is shown in the upper left corner. The second register is totally traditional (the *Deesis,* Adam and Eve, the apostles, and the angels). Equally traditional is the third register (the throne prepared for judgment, the angels, the just, and the sinners), although we find here two very unusual details: behind the sinners, we see a black area which symbolizes the darkness sent from heaven, in the form of the black circle (first register), falling over the earth; and under the throne, we see the palm of a hand and a chalice on a tray (probably the chalice in which Joseph of Arimathea gathered Christ's blood, according to the apocryphal Gospel of Nikodim). From Hades' wide open mouth to Adam's feet, the serpent uncoils, and we see small rings encircling it and the tiny figures of devils. The rings symbolize the torments through which the sinners will have to go. To the right, under the sinners, there is a dark circle surrounded by angels, which announces the coming of Judgment Day. In this circle, there are the traditional images of the earth and sea, which give back their dead. At the bottom is the wide open mouth of Hades with Satan restraining Judas' soul. With a trident, an angel thrusts three sinners (the selection of figures, an archbishop, the tsar, and a monk, is characteristic of Novgorodian free thinking) into Hades. At the bottom, there are seven scenes, corresponding to the seven capital sins, depicting the torments of Hades. To the left, heaven is represented by the traditional subjects (the Mother of God with the angels and the good thief, the gates of Paradise, the just). Winged monks fly toward the gates of Paradise. Over the group of the just, we see a small circle with four beasts which symbolize the four "kingdoms doomed to ruin:" Babylon, Macedonia, Persia, and Rome (vision of the prophet Daniel). Finally, at the bottom, between the scenes of Hades and Paradise, we see a naked man tied to a column. This is the "good thief" who "because of his compassion is being freed from eternal torments and because of his sins has been deprived of the reign of heaven." Compared with Byzantine representations of the Last Judgment, the Novgorodian icon is teeming with secondary episodes and is characterized by a more liberal distribution of individual subjects on the surface of the panel.

Bibliography: Kondakov, N.P., *Russkaya ikona,* t. IV, text, pt. 2, p. 249; Antonova, V.I. — Mneva, N.E., *Katalog drevnerusskoy zhivopisi,* t. I, n. 64, pp. 121–124, pl. 72; [Alpatov, M.V., *Drevnerusskaya ikonopis,* pls. 113, 115, p. 309].

49. THE NATIVITY OF CHRIST WITH SAINTS
(EUDOCIA, JOHN CLIMACUS, AND JULIANA)

First half of 15th century. 57x42 cm. Tretyakov Gallery, Moscow [12010].

From the I.S. Ostrouchov collection. In good condition. Some lacunae in the lower part of the panel. Because of its excellent state of preservation, this icon provides a reliable example of the coloring in Novgordian iconography.

Bibliography: Muratov, P.P., *Drevnerusskaya ikonopis v sobranii I.S. Ostrouchova,* plate, pp. 13–14; [Antonova, V.I. — Mneva, N.E., *Katalog drevnerusskoy zhivopisi,* t. I, n. 43, pp. 106–107]; Onasch, K., *Ikonen,* pl. 26, pp. 357–358; Lazarev, V.N., *Novgorodskaya ikonopis,* p. 30, pl. 38; [Alpatov, M.V., *Drevnerusskaya ikonopis,* pl. 109, p. 308; Smirnova, E.S. — Laurina, V.K. — Gordienko, E.A., *Zhivopis Velikogo Novgoroda. XV vek,* p. 102, catalogue, n. 20, pp. 232–234, ill. on p. 432].

50. THE PRAYING NOVGORODIANS

1467. 112x85 cm. Museum of History and Architecture, Novgorod [7580].

From the Monastery of Saint Nicholas of the Baskets in Novgorod. In good condition. Tiny chips in the colors. Addition of new *levkas* in the lower corners of the icon. In the center, we find a semiuncial inscription: *The servants of God, Gregory, Mary, Jacob, Stephen, Evsey, Timothy, Olfim with their sons, pray for their sins to the Savior and the Immaculate Mother of God.* In the lower part, there is a later semiuncial inscription: *In the year 6975 (1467), in the fifteenth indiction, on behalf of God's servant Antipa Kuzmin, for the veneration of the Orthodox.* During the cleaning of the icon, remnants of the original, old inscription re-appeared under this second inscription: *. . . indikta 15 pove[le]n[iem] raba B[ozhiya] Anti[pa] Kuz[mina] poklonenie chrestianam* [in the fifteenth indiction

on behalf of God's servant Antipa Kuzmin for the veneration of Christians]. In 1849, G.D. Filimonov succeeded in reading the inscription on the lower cornice of the icon prior to the additions, when the remnants of the original date, now lost, were still visible. The indiction, which starts the year in September, coincides with the date deciphered by Filimonov (1467), reconstructed quite arbitrarily either as 1487 (Archimandrite Makarii and F.I. Buslaev) or as 1475 or 1493 (N. P. Kondakov). The Novgorodian chronicles mention in the 1470s the boyars Kuzmin: in 1476, Vasilii, Ivan, and Timothy Kuzmin participated in an audience with Ivan III. The person commissioning the icon, Antipa Kuzmin, probably belonged to the same family.

Bibliography: Makarii, archim., *Archeologicheskoe opisanie tserkovnych drevnostey v Novgorode i ego okrestnostyach*, t. II, M. 1980, pp. 79–80; Gusev, P.L., "Dve istoricheskie ikony Novgorodskogo tserkovnogo drevlechranilishcha," in *Trudy Novgorodskogo tserkovno archeologicheskogo obshchestva*, 1, Novgorod 1914, pp. 176–184; Anisimov, A., "Etyudy o novgorodskoy ikonopisi, II, Molyashchiesya novgorodtsy," in *Sofiya*, 1914, n. 3, pp. 15–28; Ainalov, D., *Geschichte der russischen Monumentalkunst zur Zeit des Grossfürstentums Moskau*, pp. 80–81; Onasch, K., *Ikonen*, pl. 44, pp. 366–367; Lazarev, V.N., *Novgorodskaya ikonopis*, pp. 33–34, pls. 49, 50; Yanin, V.L., "Patronalnye syuzhety i atributsiya drevnerusskich chudozhestvennych proizvedenii," in *Vizantiya. Yuzhnye slavyane i drevnyaya Rus. Zapadnaya Evropa. Iskusstvo i kultura*, pp. 267–271; [Alpatov, M.V. *Drevnerusskaya ikonopis*, pl. 107, p. 308; Smirnova, E.S. — Laurina, V.K. — Gordienko, E.A., *Zhivopis Velikogo Novgoroda. XV vek*, pp. 103–105, 154–155, catalogue, n. 28, pp. 246–248, ill. on pp. 440 and 441].

51. THE BATTLE BETWEEN THE NOVGORODIANS AND SUZDALIANS

1460s. 165x120 cm. Museum of History and Architecture, Novgorod [1284].

[The place of origin is unknown. In the middle of the nineteenth century, it was in the Chapel of Varlaam of Chutyn, from where it was transferred to the Church of Saint Nicholas of the Baskets. According to P.L. Gusev's hypothesis, before then it was in the Church of Saint Demetrius, on the street of the Tribute of Glory in Kozhevniki, dismantled in 1847. The old gold background is almost completely lost. During the icon's restoration in 1913–1914, the inscriptions of the sixteenth century were left. They probably go back to those of the previous century. The areas of damage along the joinings of the panels have been covered over by new *levkas* and the design and original painting have been restored according to their general characteristics. The condition as a whole is satisfactory].

The theme of the icon is an episode from Novgorodian military history, when in 1169, the Suzdalians and their allies (the citizens of Ryazan, Murom, Smolensk, and others), under the leadership of Andrei Bogolyubskii Mstislav, besieged the city and, thanks to the miracle of the icon of the *Virgin of the Sign*, especially venerated in the city, were forced to withdraw. The icon blinded the enemies and brought disorder among their ranks, thus giving help to the warriors of "its city."

[On the literary version of the legend, see: Dmitriev, L.A., *Zhitiinye povesti russkogo Severa kak pamyatniki literatury XII–XVII vv. Evolyutsiya zhanra legendarno-biograficheskich skazanii*, L. 1973, pp. 97–143]. The mature and perfected art of the painter of this icon is not only an indication of a highly developed coloristic sensibility, but also of an extraordinary capacity for giving an unusual expressiveness to a pure and simple shape, whether it be the shape of a building, a horseman, a cross, or a banner. Normally the shape consists of an area of showy color which stands out on the lighter background.

Bibliography: Anisimov, A., "Etyudy o novgorodskoy ikonopisi, II, Chudo ot ikony Bogoroditsy," in *Sofiya*, 1914, n. 5, pp. 5–21; Gusev, P.L., "Dve istoricheskie ikony Novgorodskogo tserkovnogo drevlechranilishcha," pp. 170–176; [Porfiridov, N.G., "Dva syuzheta drevnerusskoy zhivopisi v ich otnoshenii k literaturnoy osnove," in *Trudy Otdela drevnerusskoy literatury Instituta russkoy literatury (Pushkinskii Dom) Akademii nauk SSSR*, XXII, M.-L. 1966, pp. 112–115; Lazarev, V.N., *Novgorodskaya ikonopis*, pp. 35–36, pls. 51–53; Polechovskaya, T.B., "O tolkovannii novgorodskich ikon XV v. 'Bitva novgorodtsev s suzdaltsami'" in *Trudy Gos. Ermitazha*, XV, L. 1974, pp. 30–35].

52. THE TRANSFIGURATION; THE PRESENTATION IN THE TEMPLE

1470s–1480s. 88x57; 90x58 cm. Museum of History and Architecture, Novgorod [7580, 7583].

From the church of the Dormition in the village of Volotovo near Novgorod [The *Raising of Lazarus*, the *Descent into Hell*, and the *Dormition* also form part of this series of icons]. In good condition except for some insignificant lacunae on the borders. The ornamental finish on the ground is typical of Novgorodian icons from the late fifteenth century. There is also a more accurate execution of the rocks forming the mountains. Everything is symptomatic of a tendency toward the "decorated" form. In icons from the first half of the fifteenth century, everything is simpler and more essential. There is the possibility that the composition of the *Deesis* in the church of Volotovo, now lost, may have also included the icon of the *Apostle Peter* now in the Stockholm National Museum (Kjellin, H., *Ryska ikoner i svensk och norsk ägo*, pl. 21). It possesses a strong stylistic similarity to the *Feasts*. For the *Transfiguration*, see the panels in the P.D. Korin collection (Antonova, V.I., *Drevnerusskoe iskusstvo v sobranii Pavla Korina*, n. 5, pp. 31–32, pl. 16; [Lazarev, V.N., *Stranitsy istorii novgorodskoy zhivopisi. Dvustoronnie tabletki iz sobora sv. Sofii v Novgorode*, M. 1977, pl. XII].

Bibliography: Onasch, K., *Ikonen*, pls. 37–40, pp. 363–365; Lazarev, V.N., *Novgorodskaya ikonopis*, pp. 34–35, pls. 46, 47; [*Zhivopis drevnego Novgoroda i ego zemel XII–XVII stoletii*, catalogue, n. 59, p. 57; Smirnova, E.S. — Laurina, V.K. — Gordienko, E.A., *Zhivopis Velikogo Novgoroda. XV vek*, pp. 93–98, 170–173, catalogue, n. 30, pp. 249–252, ill. on pp. 444 and 449].

53. THE QUEEN OF HEAVEN STANDING AT YOUR RIGHT HAND

Second half of 15th century. 29x24 cm. Tretyakov Gallery, Moscow [2].

In the P.M. Tretyakov collection. In good condition. It is the oldest example of the subject *The Queen of Heaven Standing at Your Right Hand* (or *The King of Kings*) in panel painting. This theme appeared for the first time in Russia in the frescoes of the Church of the Savior of the Transfiguration in Kovalevo near Novgorod (1380), where it was brought from Serbia. Christ is wearing a miter, which in the eleventh century was already considered to be the equivalent of the imperial crown and was interpreted in a symbolic way: recalling the crown of thorns of the Crucified, this bishop's miter was considered the symbol of the King of Kings, that is, Christ. The Virgin is shown in imperial garb with the crown on her head (Psalm 45 (44): ". . . the queen stands at your right hand in gold of Ophir.") Evidently, the royal garments of Christ were replaced by episcopal vestments for the first time in Serbia and in this way the two types were combined: The King of Kings and the High Priest. See Lazarev, V.N., *Russkaya srednevekovaya zhivopis. Stati i issledovaniya*,

pp. 249–262 (in the article "Kovalevskaya rospis i problema yuzhnoslavyanskich svyazey v russkoy zhivopisi XIV veka"). The author may have seen the great Serbian icon from the late fourteenth century, where the same composition was depicted, in the Cathedral of the Dormition in the Kremlin in Moscow.

Bibliography: Onasch, K., *Ikonen,* pl. 29, pp. 359–360; Antonova, V.I. — Mneva, N.E., *Katalog drevnerusskoy zhivopisi,* t. I, n. 80, pp. 135–136, pl. 74; [Smirnova, E.S. — Laurina, V.K. — Gordienko, E.A., *Zhivopis Velikogo Novgoroda. XV vek,* p.126, catalogue, n. 58, pp. 293–294, ill. on p. 500].

54. THE MIRACLE OF SAINTS FLORUS AND LAURUS

Late 15th century. 47x37 cm. Tretyakov Gallery, Moscow [12064].

In the I.S. Ostrouchov collection. In good condition. The gold of the background and cornice has been restored in many areas. In the icon in the A.V. Morozov collection in the Tretyakov Gallery (Antonova, V.I. — Mneva, N.E., *Katalog drevnerusskoy zhivopisi,* t. I, n. 110, pp. 160–161; Lazarev, V.N., *Novgorodskaya ikonopis,* pl. 64), also painted in the late fifteenth century, the composition appears more spare and presents a central axis and a more definite symmetry in its parts.

Bibliography: Muratov, P.P., *Drevnerusskaya ikonopis v sobranii I.S. Ostrouchova,* pp. 25–27 and plate (with an erroneous attribution to the school of Dionysii); Kondakov, N.P., *Russkaya ikona,* t. IV, text, pt. 2, p. 241; Antonova, V.I. — Mneva, N.E., *Katalog drevnerusskoy zhivopisi,* t. I, n. 124, pp. 170–171, pl. 76; *Zhivopis drevnego Novgoroda i ego zemel XII–XVII stoletii,* catalogue, n. 105, p. 71; [Alpatov, M.V., *Drevnerusskaya ikonopis,* pl. 120, p. 310].

55–56. THE ROYAL DOORS WITH REPRESENTATIONS OF THE ANNUNCIATION AND TWO BISHOPS; *THE ARCHANGELS MICHAEL AND GABRIEL*

About 1475. 166.5x81.5 cm (with decorations from the 16th century in the upper part); 146x53 cm; 146x54 cm. Russian Museum, Saint Petersburg [2661]; Tretyakov Gallery, Moscow [22290, 22288].

From the Church of Saint Nicholas in the Gostinopole Monastery. In good condition. In Novgorod, the royal doors were predominantly decorated with icons of the Annunciation and with the figures of Saints Basil the Great and John Chrysostom. However, especially in the surrounding areas, there were also royal doors with representations of the evangelists and of the Eucharist (Antonova, V.I. — Mneva, N.E., *Katalog drevnerusskoy zhivopisi,* t. I, n. 53, p. 114, pl. 67 and n. 79, p. 135; Laurina, V.K., "Ob odnoy gruppe novgorodskich provintsialnych tsarskish vrat," in *Drevnerusskoe iskusstvo. Chudozhestvennaya kultura Novgoroda,* pp. 145–178). Royal doors of a similar artisanship are preserved in the Novgorod Museum (from the Church of Sopino in the district of Borovichi) and in the Tretyakov Gallery (Antonova, V.I. — Mneva, N.E., *Katalog drevnerusskoy zhivopisi,* t. I, n. 109, pp. 159–160). This iconographic type of Annunciation, characteristic of Novgorod, with the figure of the Virgin shown in the process of a sudden three quarter turn, is already found in the icon from the first half of the fifteenth century in the Recklinghausen Icon Museum (*Kunstsammlungen der Stadt Recklinghausen. Ikonen Museum. Erweitert Katalog,* 1960, n. 159, pl.). The images of the archangels at the sides (with the exception of the left border on the icon of the Archangel Michael) have been trimmed. These were part of the *Deesis* to which the icons of the *Virgin, John the Baptist,* the *Apostle Peter,* and *John Chrysostom* (all in the Tretyakov Gallery) were joined. Also forming part of this complex were the royal doors, the icon

of the *Prophet Daniel* and probably the *Baptism* and *Entry into Jerusalem* in the P.D. Korin collection (Antonova, V.I., *Drevnerusskoe iskusstvo v sobranii Pavla Korina,* n. 8, pp. 34–35, pls. 22, 23; with the upper borders trimmed, 58x45.5 and 54x43 cm). The following icons also come from the Gostinopole Monastery: in the Tretyakov Gallery, the *Women at the Lord's Tomb [Mironositsa]* (Lazarev, V.N., *Novgorodskaya ikonopis,* p. 37, pl. 56, 80x59 cm) and the *Dormition* (Antonova, V.I. — Mneva, N.E., *Katalog drevnerusskoy zhivopisi,* t. I, n. 100, pp. 149–150; 117x92 cm); in the Russian Museum, the *Battle of the Novgorodians and the Suzdalians* (Onasch, K., *Ikonen,* pl. 42). For the types of the archangels, see the icons in the Tretyakov Gallery (Antonova, V.I. — Mneva, N.E., *Katalog drevnerusskoy zhivopisi,* t. I, pls. 61, 64) and the icons from the Murom Monastery on Lake Onega, in the Russian Museum (Smirnova, E.S., *Zhivopis drevney Rusi. Nachodki i otkrytiya,* pl. 7). In Novgorod, the figures of the *Deesis* were characterized by a great stability, from which we infer that the artist used tracing, a method well-known in Moscow.

Bibliography: Repnikov, N., "Pamyatniki ikonografii uprazdnennogo Gostinopolskogo monastyrya," in *Izvestiya Komiteta izucheniya drevnerusskoy zhivopisi,* 1, Pb. 1921, pp. 18–20; Lazarev, V.N., *Iskusstvo Novgoroda,* pp. 117, 120–121; [Antonova, V.I. — Mneva, N.E., *Katalog drevnerusskoy zhivopisi,* t. I, n. 101, pp. 150–151, pls. 77–79]; *Zhivopis drevnego Novgoroda i ego zemel XII–XVII stoletii,* catalogue, n. 58, pp. 56–57; [Alpatov, M.V., *Drevnerusskaya ikonopis,* pls. 94–100, p. 307; Smirnova, E.S. — Laurina, V.K. — Gordienko, E.A., *Zhivopis Velikogo Novgoroda. XV vek,* pp. 118, 121, 168, catalogue, n. 55, pp. 289–290, ill. on pp. 494–497].

57. DANIEL, DAVID, AND SOLOMON

About 1497. 67x179 cm. Tretyakov Gallery, Moscow [19774].

The icon belonged to A.I. Anisimov. It came from the iconostasis of the Cathedral of the Dormition in the Monastery of Cyril of Belozersk, which was built around 1497. In good condition. Noticeable damage of the original gold background. Upper border trimmed. Red inner edges.

Bibliography: Yagodovskaya, A., "Vnov otkrytaya ikona XV veka," in *Iskusstvo,* 1959, n. 1, pp. 72–73; Antonova, V.I. — Mneva, N.E., *Katalog drevnerusskoy zhivopisi,* t. I, n. 91, pp. 142–143, pls. 68–71; Lazarev, V.N., *Novgorodskaya ikonopis,* pp. 37–38, pls. 57–59; [Lelekova, O.V., "Prorocheskii ryad ikonostasa Uspenskogo sobora Kirillo-Belozerskogo monastyrya," in *Soobshcheniya Vsesoyuznoy tsentralnoy nauchno issledovatelskoy laboratorii po konservatsii i restavratsii muzeynych chudozhestvennych tsennostey,* 28, M. 1973, pp. 150, 160, 164, figs. 10, 11, 16, 19, 26]; Popov, G.V., *Zhivopis i miniatyura Moskvy serediny XV — nachala XVI veka,* M. 1975, p. 129, note 92; [Alpatov, M.V., *Drevnerusskaya ikonopis,* pls. 88, 108, 306; Lelekova, O.V., "Ikonostas 1497 g. iz. Kirillo-Belozerskogo monastyrya," in *Pamyatniki kultury. Novye otkrytiya. 1976,* M. 1977, p. 185; Smirnova, E.S. — Laurina, V.K. — Gordienko, E.A., *Zhivopis Velikogo Novgoroda. XV vek,* pp. 131–135, catalogue, n. 66, pp. 325–328, ill. on pp. 532 and 533].

58. SAINT THEODORE STRATILATES WITH SCENES FROM HIS LIFE

Late 15th century. 136.5x109 cm. Museum of History and Architecture, Novgorod [11159].

From the Church of Saint Theodore Stratilates by the Brook in Novgorod. In good condition. Irrelevant additions of new *levkas* on the ground in the central part and lower right corner. Substantial retouching

on the saint's legs below the knees and in the central part of the shield. The gold background of the main image is lost and the pink color of the cornice covered. The narrative in the border scenes on the cornice begins with *Theodore's Fight with the Dragon,* followed by the episodes with Emperor Licinius and scenes of various tortures. The cycle concludes with two scenes: the *Death of Saint Theodore* and the *Transfer of Saint Theodore's Body to Euchaita.* Everything recounted takes place in soft tones and is filled with hope. In describing the scenes of martyrdom, the author accentuates not so much physical pain as the supreme beauty of suffering. It is one of the most beautiful hagiographical icons from Novgorod.

Bibliography: Anisimov, A., *Novgorodskaya ikona sv. Feodora Stratilata,* M. 1916, [on the cover: *Yaroslavkoe chudozhestvennoe obshchestvo, 1918*]; Lazarev, V.N., *Novgorodskaya ikonopis,* p. 39, pls. 65–67; *Zhivopis drevnego Novgoroda i ego zemel XII–XVII stoletii,* catalogue, n. 141, p. 83; [Alpatov, M.V., *Drevnerusskaya ikonopis,* pl. 125, p. 311].

59. THE VIRGIN OF MERCY; RECTO: THE SYNAXIS OF THE ARCHANGELS; VERSO: THE THREE CHILDREN IN THE FIERY FURNACE; SCENES FROM THE PASSION (SCOURGING OF CHRIST, MOCKING OF CHRIST, WAY TO CALVARY, CHRIST ASCENDING THE CROSS); SAINTS MACARIUS OF EGYPT, ONUPHRIUS THE GREAT, AND PETER OF ATHOS; SAINT JOHN THE BAPTIST IN THE DESERT

Late 15th–early 16th century. Canvas, levkas, egg tempera, 24x19.5 cm. Museum of History and Architecture, Novgorod [3104, 3102, 3093, 3096]; Russian Museum, Saint Petersburg [233].

Panels from the Cathedral of Saint Sophia in Novgorod. Twelve bilateral panels are preserved in the Novgorod Museum. Originally there were many more; the remaining ones were separated and replaced, in part, by later icons. One panel ended up in the Russian Museum *(John the Baptist in the Desert,* and on the back *Saints Procopius, Nikita, and Eustachius);* another (the *Trinity,* and on the back the *Virgin Hodegetria)* now belongs to a private English collection; two (the *Nativity of Christ,* on the back *Eutimius the Great, Anthony the Great, and Savva the Blessed;* the *Transfiguration,* on the back *Vladimir, Boris, and Gleb)* are part of the P.D. Korin collection (Antonova, V.I., *Drevnerusskoe iskusstvo v sobranii Pavla Korina,* n. 5, pp. 31–33, pls. 14–17); six panels are in the Tretyakov Gallery (Antonova, V.I. — Mneva, N.E., *Katalog drevnerusskoy zhivopisi,* t. I, nos. 112, 113, 115, 120, 122, 128, pl. 90). The influence of Rublev's famous work is definitely felt in the *Trinity,* and that of Dionysii's well-known icon from the Monastery of Ferapont, in the *Virgin Hodegetria.* From this, it can be inferred that Muscovite influences had already been introduced into the Sophia's panels, although they did not yet represent the determining element. The icon in the V. Verlin collection in Paris *(Jesus among the Doctors),* which repeats almost exactly the analogous composition in one of the Novgorodian icons, also came from the same studio. Three passion scenes from the register of the supplementary feasts in the Sophia iconostasis *(The Way to Calvary, Christ Ascending the Cross, Request to Pilate for Christ's Body),* painted in 1509 by Andrei Lavrenteve and Ivan Derma Yartsev, indicate that the workshop from which the panels came was working closely with the archiepiscopal see (these additions to the oldest *Feasts,* from the fourteenth century, were executed at Archbishop Serapion's order — *Fourth Novgorod Chronicle).* The scenes of the *Way to Calvary* and *Christ Ascending the Cross* (Filatov, V.V., "Ikonostas novgorodskogo Sofiiskogo sobora. Predvaritelnaya publikatsiya," in *Drevnerusskoe iskusstvo. Chudozhestvennaya kultura Novgoroda,* pp. 70–80) coincide almost to the letter with similar subjects on bilateral panels, but they have a more marked "iconographically pictorial" character. The most complete collection of panels from this particular iconographic genre, very close to the miniature, is preserved in the Tretyakov Gallery. (Antonova, V.I. — Mneva, N.E., *Katalog drevnerusskoy zhivopisi,* t. I, nos. 60, 71, 86, 90, 92, 93, 112, 113, 115, 120, 122, 126, 128–131). Cf. Kjellin, H., *Ryska ikoner i svensk och norsk ägo,* pp. 82–88, pls. XXIII–XXIV; (Antonova, V.I., *Drevnerusskoe iskusstvo v sobranii Pavla Korina,* n. 5, pp. 31–33, pls. 14–17; Onasch, K., *Ikonen,* pls. 49–55, p. 369.

Bibliography: Ainalov, D., *Geschichte der russischen Monumentalkunst zur Zeit des Grossfürstentums Moskau,* p. 102; Lazarev, V.N., *Iskusstvo Novgoroda,* pp. 121–122; Id., *Novgorodskaya ikonopis,* pp. 39–42, pls. 68–76; Vzdornov, G.I., "Zhivopis," p. 317; Laurina, V.K., "Novgorodskaya ikonopis kontsa XV — nachala XVI veka i moskovskoe iskusstvo," in *Drevnerusskoe iskusstvo. Chudozhestvennaya kultura Moskvy i prilezhashchich k ney knyazhestv XIV–XVI vv.,* pp. 405, 407, 409, 411, 415, 417; [Alpatov, M.V. *Drevnerusskaya ikonopis,* pl. 117, p. 310]; Lazarev, V.N., "The Bipartite Tablets of Saint Sophia in Novgorod," in *Studies in Memory of D. Talbot Rice,* Edinburgh 1975, pp. 68–82; [Id., *Stranitsy istorii novgorodskoy zhivopisi. Dvustoronnye tabletki iz sobora sv. Sofii v Novgorode;* Vzdornov, G.I., "Zametki o sofiiskich svyattsach," in *Byzantinoslavica,* XL, 2, 1979, pp. 204–220; Smirnova, E.S. — Laurina, V.K. — Gordienko, E.A., *Zhivopis Velikogo Novgoroda. XV vek,* pp. 128, 130–131, catalogue, n. 63, pp. 301–320, ill. on pp. 509, 510, 515, 518 and 521].

60. SAINT JOHN THE BAPTIST IN THE DESERT

Early 15th century. 40x33 cm. Regional Ethnographic Museum, Vologda [7873].

From the hermitage of the Dormition in Semigorodnaya, district of Kadnikovskii. In mediocre condition. Much damage in the surface layer of colors. Substantial addition of new *levkas* in the lower part of the panel. Deep crack in the center. The linear structure of the composition remains intact.

Bibliography: Lazarev, V.N., *Iskusstvo Novgoroda,* p. 124; Reformatskaya, M.A., *Severnye pisma,* p. 35, fig. 11; [Vzdornov, G., *Vologda,* L. 1972, pp. 58–59, pl. 33 on p. 54; Id., "Vologodskie ikony XIV–XV vekov," in *Soobshcheniya Vsesoyuznoy tsentralnoy nauchno-issledovatelskoy laboratorii po konservatsii i restavratsii muzeynych chudozhestvennych tsennostey,* 30, M. 1975, pp. 143–144, fig. 7; *Zhivopis vologodskich zemel XIV–XVIII vekov,* catalogue, M. 1970, n. 8, p. 14, ill. on p. 15; Rybakov, A.A., *Chudozhestvennye pamyatniki Vologdy XIII — nachala XX veka,* L. 1980, p. 12, pl. 8].

61. DIONISII OF GLUSHCHITSKII
SAINT CYRIL OF BELOZERSK

1424. 28x24 cm. Tretyakov Gallery, Moscow [28835].

From the Monastery of Saint Cyril of Belozersk. In good condition with the exception of the gold background, which is almost completely lost. From the original inscription on the cornice at the top, the word "Cyril" has been preserved. The chromatic range is made up of dark tones (dark brown and dark green). The icon was placed in a shrine executed in 1614. On the shrine's antas, four scenes from Cyril's life are depicted. In the upper and lower part of the shrine's central section, there is an inscription with ligatures: *Image of Cyril the Wonderworker painted by blessed Dionysii Glushchitskii in the year 6932 (1414) when Cyril the Wonderworker was still alive. This tabernacle was made in the house of the most*

pure Cyril the Wonderworker in the year 7122 (1614) with the blessing of the hegumen Matfey for the glory of God. Amen. We cannot doubt the reliability of these details since they are based either on an inscription of a previous time, or less likely, on the monastic oral tradition. Later representations of Cyril of Belozersk (in the Tretyakov Gallery and Russian Museum) break away from his only portrait and show an idealized image of him where no individual characteristics are left.

Dionysii Glushchitskii was born near Vologda and is buried in the Sosnovets cemetery. The surname "Glushchitskii" comes from the monastery which he founded on the River Glushchitskii, where he was the hegumen. Dionysii was a painter, wood carver, carpenter, and amanuensis at the same time and he used to weave baskets and take care of smithy work.

Bibliography: Antonova, V.I. — Mneva, N.E., *Katalog drevnerusskoy zhivopisi*, t. I, n. 246, pp. 305–307, pl. 207; Dmitriev, Yu.N., "O tvorchestve drevnerusskogo chudozhnika," *Trudy Otdela drevnerusskoy literatury Instituta russkoy literatury (Pushkinskii Dom) Akademii nauk SSSR*, XIV, M.-L. 1958, pp. 48–49; Reformatskaya, M.A., *Severnye pisma*, p. 29, fig. 10.

62. THE PRESENTATION OF THE VIRGIN IN THE TEMPLE

14th century. 91x66 cm. Russian Museum, Saint Petersburg [2724].

From the Church of the Trinity in the village of Krivoe on the Northern Dvina. The Church of the Presentation of the Virgin in the Temple, where our icon was probably the main panel, was located near Krivoe, on Knyazh Island. In good condition. Addition of new *levkas* in the lower part of the panel.

Bibliography: Lazarev, V.N., *Iskusstvo Novgoroda*, p. 29, pl. 81a; Smirnova, E.S., *Zhivopis Obonezhya XIV–XVI vekov*, p. 36; *Zhivopis drevnego Novgoroda i ego zemel XII–XVII stoletii*, catalogue, n. 16, p. 40; Smirnova, E.S., *Zhivopis Velikogo Novgoroda. Seredina XIII — nachalo XV veka*, pp. 86–88, catalogue, n. 17, pp. 208–213; ill. on p. 323].

63. SAINT NICHOLAS THE WONDERWORKER

First half of 15th century. 61x44 cm (without handles). Russian Museum, Saint Petersburg [2090].

From the village of Priozero, Lodeynopole province, region of Saint Petersburg. In good condition. Some layers of colors have been lost, especially in the lower part of the panel. Addition of new *levkas* on the left cheek. It is a processional icon (on the back there are traces of a figure of the Virgin and Child of the Hodegetria type). It is one of the more folklike representations of Saint Nicholas.

Bibliography: Porfiridov, N.G., "O putyach razvitiya chudozhestvennych obrazov v drevnerusskom iskusstve," in *Trudy Otdela drevnerusskoy literatury Instituta russkoy literatury (Pushkinskii Dom) Akademii nauk SSSR*, XVI, M.-L. 1960, p. 42; Smirnova, E.S., *Zhivopis Obonezhya XIV–XVI vekov*, pp. 45–46, 111–112; *Zhivopis drevnego Novgoroda i ego zemel XII–XVII stoletii*, catalogue, n. 20, pp. 41–42; [Smirnova, E.S., *Zhivopis Velikogo Novgoroda. Seredina XIII — nachalo XV veka*, p. 120, catalogue, n. 30, pp. 242–245; ill. on p. 350].

64. THE PROPHET ELIJAH IN THE DESERT

First half of 15th century. 57x42 cm. Karelian Fine Arts Museum, Petrozavodsk [I–363].

From the Chapel of the Prophet Elijah in the village of Pyalma, Pudozh district, Autonomous Republic of Karelia. In good condition. Lacunae in the background in the lower part of the cornice. It is one of the best examples of the "primitive" North. The figure of Elijah, regarded as the "lord of thunder," the one who rules over the sun and the rain, was very popular in the North. Cf. icons from a later period in the Russian Museum (Smirnova, E.S., *Zhivopis drevney Rusi. Nachodki i otkrytiya*, pl. 45) and in the Bergen Art Gallery (Kjellin, H., *Ryska ikoner i svensk och norsk ägo*, pp. 110–111).

Bibliography: Smirnova, E.S., *Zhivopis Obonezhya XIV–XVI vekov*, p. 111, pls. 18, 19; Id., *Zhivopis drevney Rusi. Nachodki i otkrytiya*, pl. 36; *Zhivopis drevnego Novgoroda i ego zemel XII–XVII stoletii*, catalogue, n. 88, p. 66.

65. SAINT BLAISE

Second half of 15th century. 53.5x44 cm. Karelian Fine Arts Museum, Petrozavodsk [I–464].

From the Church of Florus and Laurus in the village of Megrega, Olonets district, Autonomous Republic of Karelia. In good condition. In the lower right corner, we notice a large addition of paint from a later period (part of the figure and half of the evangeliary). It is one of the most refined icons of the "Northern Manners." Its author certainly knew the best examples of Novgorodian painting, which he interpreted in his own way. Cf. the recently restored Novgorod icon in the Russian Museum (*James, the Brother of the Lord, Nicholas, and Ignatius the God Bearer*, Smirnova, E.S., *Zhivopis drevney Rusi. Nachodki i otkrytiya*, pl. 9).

Bibliography: Smirnova, E.S., *Zhivopis Obonezhya XIV–XVI vekov*, pp. 77–78, 110; Reformatskaya, M.A., *Severnye pisma*, p. 35, pl. 7; *Zhivopis drevnego Novgoroda i ego zemel XII–XVII stoletii*, catalogue, n. 87, p. 66.

66. THE DESCENT FROM THE CROSS; THE ENTOMBMENT

Late 15th century. 91x62; 90x63 cm. Tretyakov Gallery [12040, 12041].

The origin of these icons is still being debated. They were found by I.S. Ostrouchov in Gorodets on the Volga River. According to the not totally reliable testimony of the restorer, P.I. Yukin, the dealer who sold the icons had brought them from Kargopol. Two icons from the same register of *Feasts* (the *Last Supper* and the *Beheading of John the Baptist*) are in the Kiev Museum of Russian Art (*SSSR. Drevnerusskie ikony*, New York-Milan (in the series "Universal Art"), 1958, pls. XIII, XV), another (the *Descent into Hell*) became part of the A.V. Morozov collection, from where it was later transferred to the Tretyakov Gallery (Antonova, V.I. — Mneva, N.E., *Katalog drevnerusskoy zhivopisi*, t. I, n. 105, pp. 154–155). The dimensions of the icons lead us to think that they formed part of a large iconostasis. In good condition. Addition of new *levkas* on the lower borders. On the background and on the borders, there are insignificant remnants of gold and traces of the nails of the cover. In these icons, Muscovite traditions (lightness of the figures defined by soft and graceful lines, slender and refined features) are combined in a very original way with Novgorodian traditions (coloring). But compared to typically Novgorodian icons with their bright and showy colors, the colors of our icons appear slightly darkened. The iconography of the *Descent from the Cross* and *Last Supper* recall Rublev's iconostasis in the Cathedral of the Trinity in the Monastery of the Trinity of Saint Sergius (see Lebedewa, J., *Andrej Rubljow und seine Zeitgenossen*, Dresden 1962, pls. 70, 78). The iconography of the *Entombment* is very similar to the 1488 icon of Yakov Iel, in the Tretyakov Gallery (Antonova, V.I. — Mneva, N.E., *Katalog drevnerusskoy zhivopisi*, t. I, pl. 73) and to the small panel in a private Oslo collection (Kjellin,

H., *Ryska ikoner i svensk och norsk ägo*, p. 89). However, we should not forget that the Muscovite version of the *Descent from the Cross* is also found in the small fourteenth-century Novgorodian panel in a private Oslo collection (Kjellin, H., *Ryska ikoner i svensk och norsk ägo*, p. 89) and in the sixteenth-century icon in the Church of the Presentation in Vologda (*Severnye pamyatniki drevnerusskoy stankovoy zhivopisi*, Vologda 1929, p. 22). As a whole, we get the impression that the authors of these icons of the *Feasts* were very familiar with the Muscovite as well as with the Novgorodian works. They may have come from the Novgorodian artistic circles that Ivan III had forcefully transferred to Nizhnii Novgorod after the annexation of Novgorod to Moscow. Uprooted from their native environment, they could have produced works in which Muscovite traditions blended organically with those of Novgorod. In this regard, N.E. Mneva's theory on the Nizhnii Novgorod origin of these icons can be accepted as a working hypothesis, all the more so since she has rightly noted a certain stylistic similarity with the icons in the Fine Arts Museum of Nizhnii Novgorod (Gorkii) (*Descent from the Cross* and the mountains of the *Transfiguration*). Nevertheless, the attribution proposed by N.E. Mneva cannot be retained as totally convincing.

Bibliography: Mneva, N.E., "Drevnerusskaya zhivopis Nizhnego Novgoroda," in *Gos. Tretyakovskaya galereya. Materialy i issledovaniya*, II, pp. 33–34; *SSSR. Drevnyerusskie ikony*, pls. XI–XIV; Antonova, V.I. — Mneva, N.E., *Katalog drevnerusskoy zhivopisi*, t. I, nos. 105–107, pp. 154–158, pls. 75, 76; [Alpatov, M.V., *Drevnerusskaya ikonopis*, pls. 138, 140, p. 313; cf., Vzdornov, G., *Vologda*, 2nd ed., L. 1978, p. 73].

67. THE DORMITION

13th century. 135x100 cm. Tretyakov Gallery, Moscow [28764].

From the Church of the Dormition at the Landing Place in Pskov. The church was built in 1444 on the site of an earlier church, burned down in a fire or otherwise destroyed. In bad condition. Many lacunae in the upper layer of colors and in the olive green background, meticulously filled in. The parts which are best preserved are Christ's head and the heads of the Virgin and apostles on the left. In the foreground, we see a candlestick with a lighted candle, held in a round container. In style, this is one of most primitive of early Russian icons, testifying to the existence in early Pskovian painting of trends which are very reminiscent of the art of the Christian East. Similar tendencies were also found in Novgorod (Vzdornov, G.I., "Miniatyura iz Evangeliya popa Domki i cherty vostochnochristianskogo iskusstva v novgorodskoy zhivopisi XI–XII vekov," in *Drevnerusskoe iskusstvo. Chudozhestvennaya kultura Novgoroda*, pp. 201–222).

Bibliography: Antonova, V.I. — Mneva, N.E., *Katalog drevnerusskoy zhivopisi*, t. I, n. 141, pp. 138–184, pls. 92, 93; Ovchinnikov, A. — Kishilov, N., *Zhivopis drevnego Pskova*, M. 1970, pls. 5–7 and descriptions; [Ovchinnikov, A.N., *Opyt opisaniya proizvedenii drevnerusskoy stankovoy zhivopisi. Tekhnika i stil.* 1, Pskovskaya shkola. XIII–XVI veka, M. 1971, n. 3, pp. 6–9].

68. THE PROPHET ELIJAH WITH SCENES FROM HIS LIFE

Late 13th–early 14th century. 141x111 cm. Tretyakov Gallery, Moscow [14907].

From the Church of the Prophet Elijah in the village of Vybuty near Pskov. In poor condition. Large lacunae on the tin of the background and on the lower border where in the place of the scenes from his life, bust figures of saints have been successively painted. The first layer of color is chipped in many places. Only insignificant fragments of the scenes from his life have been preserved on the lower border.

Bibliography: Onasch, K., *Ikonen*, pl. 62, p. 374; Antonova, V.I. — Mneva, N.E., *Katalog drevnerusskoy zhivopisi*, t. I, n. 140, pp. 182–183, pl. 91; [Ovchinnikov, A.N. — Kishilov, N., *Zhivopis drevnego Pskova*, p. 7, pls. 2–4 and descriptions; [Ovchinnikov, A.N., *Opyt opisaniya proizvedenii drevnerusskoy stankovoy zhivopisi. Tekhnika i stil.* 1, Pskovskaya shkola. XIII–XVI veka, n. 2, pp. 4–6; Alpatov, M.V., *Drevnerusskaya ikonopis*, pl. 48, p. 301].

69. THE DEESIS

13th century. 140x110 cm. Russian Museum, Saint Petersburg [2779].

From the Church of Saint Nicholas of the Pelts in Pskov, built in the following period, where it came from some other older church. As a whole in good condition, except for the faces, repainted later. The silver crowns go back to the fourteenth century, the engraved covering to the sixteenth.

Bibliography: *Masterpieces of Russian Painting*, p. 110, pl. V; [Vzordov, G., "O ponyatiyach 'shkola' i 'pisma' v zhivopisi Drevney Rusi," in *Iskusstvo*, 1972, n. 6, p. 67, ill. on p. 66].

70. SAINT NICHOLAS THE WONDERWORKER

Early 14th century. 141x102 cm. Tretyakov Gallery, Moscow [28720].

From the Church of Saint Nicholas of the Pelts in Pskov, built in the following period, where it came from some other older church. In good condition. The pigment is crumbling a bit on the right hand and chipped on the left. The gold background and *assiste* have preserved almost all their original splendor. In the execution of the face, the tradition of the twelfth century seems to come alive again (frescoes of Arkazhi and of the Nereditsa), with the characteristic underlining of the cheekbones by oval shapes pointing downwards (cf. Lazarev, V.N., *Old Russian Murals and Mosaics*, London 1966, pl. 92). The author of the icon was clearly going back to very early traditions even though he was working in the fourteenth century.

Bibliography: Onasch, K., *Ikonen*, pl. 63, p. 374; Antonova, V.I. — Mneva, N.E., *Katalog drevnerusskoy zhivopisi*, t. I, n. 142, pp. 184–185, pl. 95; Ovchinnikov, A.N. — Kishilov, N., *Zhivopis drevnego Pskova*, p. 7, pl. 11 and descriptions; [Ovchinnikov, A.N., *Opyt opisaniya proizvedenii drevnerusskoy stankovoy zhivopisi. Tekhnika i stil.* 1, Pskovskaya shkola. XIII–XVI veka, n. 6, pp. 15–17].

71. DEESIS WITH SAINTS BARBARA AND PARASKEVA

Last quarter of 14th century. 126x91 cm. Museum of History and Architecture, Novgorod [2779].

From the wooden Church of Saint Barbara in Pskov, built in 1618. In good condition. The major lacunae are in the halos. There are losses in the upper layer of colors which have been faithfully restored. The yellow background gives us an insight into the way the original backgrounds of the icons *Saints Paraskeva Pyatnitsa, Barbara, and Juliana* and the *Synaxis of the Virgin* looked like. The inscriptions on the background contain characteristic elements of Pskovian speech.

Bibliography: Yamshchikov, A., *Drevnerusskaya zhivopis. Novye otkrytiya*, pls. 2–4; Reformatskaya, M.A., "O gruppe proizvedenii pskovskoy stankovoy zhivopisi vtoroy poloviny XIV veka," in *Drevnerusskoe iskusstvo. Chudozhestvennaya kultura Pskova*, M. 1968, pp. 114–126; Ovchinnikov, A.N. — Kishilov, N., *Zhivopis drevnego Pskova*, pp. 10–12, pls.

23–25 and descriptions; [Ovchinnikov, A.N., *Opyt opisaniya proizvedenii drevnerusskoy stankovoy zhivopisi. Tekhnika i stil.* 1, *Pskovskaya shkola. XIII–XVI veka,* n. 13, pp. 33–37].

72. SAINTS PARASKEVA, BARBARA, AND JULIANA

Last quarter of 14th century. 143x108 cm. Tretyakov Gallery, Moscow [28758].

From the Church of Saint Barbara in Pskov. In poor condition. Many lacunae in the upper layer of colors, accurately restored. Above Barbara there is a bust of the Savior Emmanuel flanked by two angels.

Bibliography: Antonova, V.I. — Mneva, N.E., *Katalog drevnerusskoy zhivopisi,* t. I, n. 147, pp. 188–189, pl. 100; Reformatskaya, M.A., "O gruppe proizvedenii pskovskoy stankovoy zhivopisi vtoroy poloviny XIV veka," pp. 121–122; Ovchinnikov, A.N. — Kishilov, N., *Zhivopis drevnego Pskova,* pls. 20–22 and descriptions; [Ovchinnikov, A.N., *Opyt opisaniya proizvedenii drevnerusskoy stankovoy zhivopisi. Tekhnika i stil.* 1, *Pskovskaya shkola. XIII–XVI veka,* n. 12, pp. 32–34].

73. THE SYNAXIS OF THE VIRGIN

Last quarter of 14th century. 81x61 cm. Tretyakov Gallery, Moscow [14906].

From the Church of Saint Barbara in Pskov. In good condition. Lacunae in the *levkas* on the lower cornice. The original yellow background, over which a new gold one was spread, has been lost, as well as the wings of the angels and the headgear of the center shepherd. K. Onasch's hypothesis is groundless. He claims that the angels' lost wings are the direct result of the doctrine of the *strigolniki.* Saint Nicholas and Saint Barbara are shown in the upper corners, evidently at the request of the icon's donor. On her bosom, Mary has an eight-pointed star with the image of the Savior Emmanuel. To the right, is the manger with the Child in swaddling clothes, warmed by the breath of the ox and donkey. In the sixteenth and seventeenth centuries, the iconography of the Synaxis of the Virgin became more complex (with the appearance of the personifications of the sea and the winds, the continents, and other details). In our icon, the expressive figure of the youth with his raised right hand at the lower right corner remains unexplained. M.A. Reformatskaya claims it is the figure of a young shepherd who marvels at the star of Bethlehem in amazement.

Bibliography: Ainalov, D., *Geschichte der russischen Monumentalkunst zur Zeit des Grossfürstentums Moskau,* pp. 82–84; *Masterpieces of Russian Painting,* pl. XXXVI, p. 118; Onasch, K., *Ikonen,* pl. 64, pp. 374–375; Antonova, V.I. — Mneva, N.E., *Katalog drevnerusskoy zhivopisi,* t. I, n. 149, pp. 190–191, pls. 101–103; Reformatskaya, M.A., "O gruppe proizvedenii pskovskoy stankovoy zhivopisi vtoroy poloviny XIV veka," pp. 122–126; Ovchinnikov, A.N. — Kishilov, N., *Zhivopis drevnego Pskova,* pp. 10–13, pls. 15–19 and descriptions; [Ovchinnikov, A.N., *Opyt opisaniya proizvedenii drevnerusskoy stankovoy zhivopisi. Tekhnika i stil.* 1, *Pskovskaya shkola. XIII–XVI veka,* n. 11, pp. 27–32; Alpatov, M.V., *Drevnerusskaya ikonopis,* pls. 133, 137, p. 313].

74. THE DESCENT INTO HELL

Last quarter of 14th century. 81.5x65 cm. Russian Museum, Saint Petersburg [2120].

In the P.N. Lichachev collection. In good condition. Lateral borders trimmed. Damage in the *levkas* on the upper and lower borders. The Christ in dynamic movement is a characteristic type in Pskov iconography. It is frequently found in the icons of the Descent into Hell, quite popular in that city.

Bibliography: Dmitriev, Yu.N., *Gos. Russkii muzey. Putevoditel. Drevnerusskoe iskusstvo,* pp. 30, 34; Reformatskaya, M.A., "O gruppe proizvedenii pskovskoy stankovoy zhivopisi vtoroy poloviny XIV veka," p. 126; Ovchinnikov, A.N. — Kishilov, N., *Zhivopis drevnego Pskova,* pp. 13–14, pls. 28–30 and descriptions; [Ovchinnikov, A.N., *Opyt opisaniya proizvedenii drevnerusskoy stankovoy zhivopisi. Tekhnika i stil.* 1, *Pskovskaya shkola. XIII–XVI veka,* n. 15, pp. 39–44].

75. THE NATIVITY OF THE VIRGIN

Early 15th century. 80x61.5 cm. Tretyakov Gallery, Moscow [dr 455].

In the collection of the artist V.M. Vaznetsov. The general condition of the central part is satisfactory. Many lacunae at the left and especially at the right of the panel. At the bottom, the primer is totally lost. The garments and objects are richly decorated with golden *assiste* which have disappeared in many places. Remnants of the original gold are visible on the background, borders, and halos. Joachim, moving aside a green curtain, is looking on from the building to the left. At the sides of the *Deesis* there were the figures — which are now lost — of Queen Alexandra and the Martyr Catherine (only fragments of the inscriptions are left). The icon did not form part of the cycle of *Feasts,* but was probably painted for a special occasion, the birth of the donor's daughter.

Bibliography: Onasch, K., *Ikonen,* pl. 65, p. 375; Antonova, V.I., *Drevnerusskoe iskusstvo v sobranii Pavla Korina,* n. 10, pp. 36–37, pls. 24–27; [Alpatov, M.V., *Drevnerusskoe ikonopis,* pl. 131, p. 312].

76. THE VIRGIN OF TENDERNESS

Early 15th century. 109x77 cm. Tretyakov Gallery, Moscow [12725].

From the Church of Saint Nicholas in the cemetery of Lyubyatovo near Pskov. In good condition. Slight damage on lower part of the icon, the Virgin's hands, and Christ's right hand. In due course, a panel of engraved silver, on which was an inscription dated June 3, 1890, was nailed onto the back of the icon: *In the year 1570, on the Saturday of the second week of Lent, Tsar Ivan Vasilevich the Terrible, going to execute justice on the Pskovians, spent the night in this Monastery of Saint Nicholas in Lyubyatovo, and here, while attending the singing of Matins in church, contemplating the miraculous icon of the Virgin of Tenderness, his heart was moved and he said to his soldiers: Break your swords on the rock and stop killing* (see Lebedev, G., *Pogost Lyubyatovo,* Pskov 1887, p. 1). An ancient legend or some document now lost may be at the origin of this account. It is common knowledge that the ire of Ivan the Terrible spared Pskov, where he did go in 1570. In the account, the power of the icon on the people of early Rus finds a forceful expression: this was always one of the governing influences in Russian iconography.

Bibliography: [Nekrasov, A.I., *Drevnerusskoe izobrazitelnoe iskusstvo,* p. 181, fig. 122]; Antonova, V.I. — Mneva, N.E., *Katalog drevnerusskoy zhivopisi,* t. I, n. 150, pp. 191–192.

77. SAINTS PARASKEVA, PYATNITSA, GREGORY THE THEOLOGIAN, JOHN CHRYSOSTOM, AND BASIL THE GREAT

Early 15th century. 147x134 cm. Tretyakov Gallery, Moscow [1].

From a nineteenth-century chapel in the vicinity of the Monastery of Snetogory. In good condition. The original *levkas* is lost in the lower part of the panel. Traces of gold are preserved on the ground and on the

cornices. The dark green fold of Paraskeva's garment is decorated with half-erased golden *assiste*. The left border is trimmed. In general, the icon is given a date (fourteenth century) which is too early.

Bibliography: *Masterpieces of Russian Painting*, pl. VI, p. 100; Onasch, K., *Ikonen*, pl. 66, p. 376; Antonova, V.I. — Mneva, N.E., *Katalog drevnerusskoy zhivopisi*, t. I, n. 144, pp. 185–187, pls. 96, 97; Ovchinnikov, A.N. — Kishilov, N., *Zhivopis drevnego Pskova*, p. 16, pls. 41–42 and descriptions; [Ovchinnikov, A.N., *Opyt opisaniya proizvedenii drevnerusskoy stankovoy zhivopisi. Technika i stil.* 1, *Pskovskaya shkola. XIII–XVI veka*, n. 21, pp. 56–58; Alpatov, M.V., *Drevnerusskaya ikonopis*, pl. 130, p. 312].

78. SAINT DEMETRIUS OF THESSALONICA

Second quarter of 15th century. 87x67 cm. Russian Museum, Saint Petersburg [2096].

From the Church of Saint Barbara in Pskov. In good condition. The gold background is marked by traces of the covering's nails. The crumbling of the *levkas* can be seen on the lower border. Niello-like decoration on the halo. The icon was restored in an especially meticulous manner.

Bibliography: *Masterpieces of Russian Painting*, pl. XXX, p. 116; Dmitriev, Yu.N., *Gos. Russkii muzey. Putevoditel. Drevnerusskoe iskusstvo*, p. 34; Ovchinnikov, A.N. — Kishilov, N., *Zhivopis drevnego Pskova*, pl. 43 and descriptions; [Ovchinnikov, A.N., *Opyt opisaniya proizvedenii drevnerusskoy stankovoy zhivopisi. Technika i stil.* 1, *Pskovskaya shkola. XIII–XVI veka*, n. 22, pp. 58–60; Alpatov, M.V., *Drevnerusskaya ikonopis*, pl. 127, p. 312].

79. SAINT JOHN THE BAPTIST; THE ARCHANGEL GABRIEL

First half of 15th century. 110x68; 104x63 cm. Tretyakov Gallery, Moscow [12855]; Russian Museum, Saint Petersburg [2121].

The Baptist is from the Historical Museum of Moscow, along with other icons of the *Deesis*. The icons with the half-length figures of the archangels, one of which is in the Russian Museum, also formed part of the composition. In good condition. The *levkas* on the halo is new (originally it was in relief, as it is in the Russian Museum's icon). The type of Christ in this *Deesis* can be linked with the Christ of the *Transfiguration* on the back of the icon of the Virgin Hodegetria in the Russian Museum, which I am inclined to date back to the second, rather than to the first half of the fifteenth century (*Masterpieces of Russian painting*, pl. LVI, pp. 123–124).

Bibliography: Antonova, V.I. — Mneva, N.E., *Katalog drevnerusskoy zhivopisi*, t. I, n. 151, pp. 192–193, pl. 106.

80. THE VIRGIN GREAT PANAGIA, SAINTS NICHOLAS AND GEORGE

Late 15th century. 83x68 cm. Tretyakov Gallery, Moscow [15262].

From the Church of the Resurrection in the village of Rakuly, region of Archangelsk. In mediocre condition. A great deal of damage in the layer of surface colors. Traces of gold on the ground and the borders. The figure of the Savior Emmanuel is not included in the mandorla as usual, but in a heart-shaped frame decorated with a trifolium ornament. The Muscovite influence is clearly seen in the elongated proportions of the especially tapered figures.

Bibliography: Antonova, V.I. — Mneva, N.E., *Katalog drevnerusskoy zhivopisi*, t. I, n. 154, p. 195.

81. THE NATIVITY OF CHRIST WITH SAINTS

Late 15th century. 81x71 cm. Russian Museum, Saint Petersburg [vch 72685].

From the Church of the Virgin of Mercy in the city of Opochka, region of Pskov. In good condition. On the borders, especially on the lower one, the background is lost so that the panel is visible. Also visible are losses in the layer of colors in the figures of the angels at the top right and in the bust figures at the ends of the bottom register. The icon continues in a later form the best traditions of the fourteenth century. The wordy and ingenuous inscriptions are done in the spirit of Pskovian iconic epigraphy with its typical freedom in dialectal spelling. Some details are particularly beautiful (for example, Joseph in the desert or the shepherds leaning on their staffs) and filled with fascinating spontaneity.

Bibliography: Smirnova, E.S., *Zhivopis drevney Rusi. Nachodki i otkrytiya*, pls. 19–21; *Zhivopis drevnego Pskova*, catalogue, ed. by S. Yamshchikov, M. 1970, ill. on unnumbered p.; Ovchinnikov, A.N. — Kishilov, N., *Zhivopis drevnego Pskova*, pls. 47, 49; [Ovchinnikov, A.N., *Opyt opisaniya proizvedenii drevnerusskoy stankovoy zhivopisi. Technika i stil.* 1, *Pskovskaya shkola. XIII–XVI veka*, n. 27, pp. 72–75; Alpatov, M.V., *Drevnerusskaya ikonopis*, pls. 134–136, p. 313].

82. THE DESCENT INTO HELL WITH SAINTS

Late 15th–early 16th century. 157x92 cm. Russian Museum, Saint Petersburg [vch 3140].

From the Cathedral of the Trinity in the city of Ostrovo, region of Pskov. In good condition. Loss of the primer on the upper and lower borders. Depicted among the selected saints are Catherine, Anastasia, the Martyr Fotii, Nicholas, Basil the Great, John (in episcopal vestments), John Chrysostom, Gregory the Theologian, the Martyr Nicetas, Barbara, and Paraskeva. As in the fourteenth-century icon of the *Descent into Hell*, parts of the figures intersect with the cornice, indicating a certain liberty in the conception of the composition.

Bibliography: Porfiridov, N.G., "K istorii pskovskoy stankovoy zhivopisi. Ikona 'Soshestvie vo ad' iz g. Ostrova," in *Drevnerusskoe iskusstvo. Chudozhestvennaya kultura Pskova*, pp. 109–113; Smirnova, E.S., *Zhivopis drevney Rusi. Nachodki i otkrytiya*, pls. 17–19; Ovchinnikov, A.N. — Kishilov, N., *Zhivopis drevnego Pskova*, p. 17, pl. 46 and descriptions; [Ovchinnikov, A.N., *Opyt opisaniya proizvedenii drevnerusskoy stankovoy zhivopisi. Technika i stil.* 1, *Pskovskaya shkola. XIII–XVI veka*, n. 23, pp. 60–63; Alpatov, M.V., *Drevnerusskaya ikonopis*, pl. 132 (detail), p. 313].

83. THE TRINITY

Late 15th–early 16th century. 145x108 cm. Tretyakov Gallery, Moscow [28597].

In the S.A. Scherbatov collection. In good condition. The chromatic range is built upon the typical Pskovian palette: emerald green, orange red, dark green, cherry. One notices at once the abundance of gold which covers all the garments like a fine *assiste*.

Bibliography: Zhidkov, G.V., "Zhivopis Novgoroda, Pskova i Moskvy na rubezhe XV i XVI vekov," in *Trudy sektsii iskusstvoznaniya Instituta archeologii i iskusstvoznaniya RANION*, II, M. 1928, pp. 115–118; [Antonova, V.I. — Mneva, N.E., *Katalog drevnerusskoy zhivopisi*, t. I, n. 159, pp. 198–199]; Ovchinnikov, A.N. — Kishilov, N., *Zhivopis drevnego Pskova*, p. 16, pls. 44, 45 and descriptions; [Ovchinnikov, A.N., *Opyt opisaniya proizvedenii drevnerusskoy stankovoy zhivopisi. Technika i stil.* 1, *Pskovskaya shkola. XIII–XVI veka*, n. 25, pp. 67–69].

84. SAINTS BORIS AND GLEB

Early 14th century. 143x95 cm. Russian Museum, Saint Petersburg [2117].

From Mstera, region of Vladimir, where it was purchased from a traveling salesman. The Russian Museum acquired it from the N.P. Lichachev collection. It is difficult to speak of its condition as a whole. Additions of new *levkas* are visible in the lower part of the panel, near Gleb's left shoulder, along the joining, and the cracks. During restoration, Boris' left hand and part of his left leg, Gleb's right hand and boots were repainted. The restoration is visible near the chins and necks of the two figures. P.I. Neradovski was inclined to link the icon to the territory of Vladimir-Suzdal; D.V. Ainalov, to Novgorod, a circumstance which openly contradicts its style. The pictorial style of the faces recalls the *Small Virgin of Tolga*, painted in 1314 (?). In any case, the icon cannot be dated back to the thirteenth century, as most scholars claim. This icon may have been painted in Vladimir before the metropolitan cathedral was transferred to Moscow.

Bibliography: Neradovski, P.I., "Boris i Gleb iz sobraniya N.P. Lichacheva," in *Russkaya ikona*, 1, Spb. 1914, pp. 63–77; Sychev, N., "Drevlechranilishche Russkogo muzeya imperatora Aleksandra III," in *Starye gody*, January–February 1916, pp. 18–19; Ainalov, D., *Geschichte der russischen Monumentalkunst zur Zeit des Grossfürstentums Moskau*, pp. 72–73; Onasch, K., *Ikonen*, pl. 78, pp. 381–382; [Lazarev, V.N., *Moskovskaya shkola ikonopisi*, M. 1971, pp. 6–7, pl. 1; Alpatov, M.V., *Drevnerusskaya ikonopis*, pl. 45, p. 300].

85. SAINTS BORIS AND GLEB WITH SCENES FROM THEIR LIVES

Second quarter of 14th century. 134x89 cm. Tretyakov Gallery, Moscow [28757].

From the Church of Saints Boris and Gleb by the Ponds, in the city of Kolomna, annexed to the principality of Moscow in 1302. In mediocre condition. The upper layer of colors has several lacunae. The tunics and cloaks of the central figures were repainted after a fire in the sixteenth century. The gold background of the central part and the traces of gold on the borders with a red inner outline date back to that time. The original background of the central part was red. The iconography of the border scenes recalls a lost illustrated *Lives of Boris and Gleb*, which may have been done in the twelfth century.

Bibliography: Demina, N.A., *Andrey Rublyov i chudozhniki ego kruga*, M. 1970, p. 27 (in the essay "Istoricheskaya deystvitelnost XIV–XV vv. v iskusstve Andreya Rublyova i chudozhnikov ego kruga"); Smirnova, E.S., "Otrazhenie literaturnych proizvedenii o Borise i Glebe v drevnerusskoy stankovoy zhivopisi," in *Trudy Otdela drevnerusskoy literatury Instituta russkoy literatury (Pushkinskii Dom) Akademii nauk SSSR*, XV, M.-L. 1958, pp. 312–321; Antonova, V.I. — Mneva, N.E., *Katalog drevnerusskoy zhivopisi*, t. I, n. 209, pp. 244–246, pls. 153–157; [Alpatov, M.V., *Etyudy po istorii russkogo iskusstva*, 1, M. 1967, pp. 188–194 (essay "Gibel Svyatopolka v legende i ikonopisi"); Lazarev, V.N., *Moskovskaya shkola ikonopisi*, pp. 7–8, pls. 3–8; Ruzsa, G., "Nézzük meg együtt a kolomnai Borisz és Gleb ikont," in *Müvészet*, 1974, 11, pp. 30–32; Alpatov, M.V., *Drevnerusskaya ikonopis*, pls. 52, 53, p. 302].

86. SAINT NICHOLAS THE WONDERWORKER WITH SCENES FROM HIS LIFE

Second half of 14th century. 135x96 cm. Tretyakov Gallery, Moscow [15274].

From the Cathedral of Saint John the Theologian in Kolomna. In mediocre condition. Many lacunae and damage in the upper layer of colors. The old *levkas* on the background of the central part has almost completely disappeared, whereas on the background of the border scenes it has remained in part. Work of the seventeenth century remains on the vestments, the hand, the evangeliary, and the crosses of the *omophorion* of the central figure, but very little of the original painting survives. On the lower cornice, the *levkas* is crumbling, making the panel visible, while the other borders have been trimmed. N.M. Karpinskii has dated the fragments of the old inscriptions in cinnabar to the end of the fourteenth century, which does not allow us to place the icon back in the first half of the century, despite its evident archaism. V.I. Antonova's supposition that the image was painted by a Greek master has no foundation.

Bibliography: Antonova, V.I. — Mneva, N.E., *Katalog drevnerusskoy zhivopisi*, t. I, n. 211, pp. 247–248, pls. 158, 159; [Lazarev, V.N., *Moskovskaya shkola ikonopisi*, pp. 8–9, pls. 9–11].

87. THE SAVIOR OF THE FIERY EYE

Mid 14th century. 100x77 cm. Cathedral of the Dormition, Kremlin, Moscow [956 sob/zh-128].

In the Cathedral of the Dormition, Kremlin, Moscow. In good condition as a whole. Addition of new *levkas* along the vertical crack and in small areas on the borders. On the background with remnants of gold, traces of a nailed covering are noticeable. At the top and bottom, are cross-bars fastened on the borders. This was a processional icon and had a pole, later eliminated, at the bottom. The somber expression of the face is created by the dark olive brown of the flesh tone with thick olive green shadows and by the deep, strongly emphasized furrows. This example of Christ is so unusual that it is impossible to find any other similar image.

Bibliography: Kondakov, N.P., *Litsevoy ikonopisnyi podlinnik*, I, *Ikonografiya Gospoda Boga i Spasa nashego Iisusa Christa*, 84–85; Zhidkov, G.V., *Moskovskaya zhivopis serediny XIV veka*, M. 1928, pp. 13–39; Id., "L'icône du 'Sauveur à l'oeil courroucé' de la cathédrale de la Dormition à Moscou," in *L'art byzantin chez les Slaves*, t. II, Paris 1932, pp. 174–194; Ainalov, D., *Geschichte der russischen Monumentalkunst zur Zeit des Grossfürstentums Moskau*, p. 92; [Lazarev, V.N., *Moskovskaya shkola ikonopisi*, p. 11, pl. 13; Popova, O.S., "Ikona 'Spas Yarkoe Oko' iz Uspenskogo sobora Moskovskogo Kremlya," in *Drevnerusskaya iskusstvo. Problemy i atributsii*, M. 1977, pp. 126–148 (same thing in Popova, O.S., *Iskusstvo Novgoroda i Moskvy pervoy poloviny chetyarnadtsatogo veka. Ego svyazi s Vizantiey*, pp. 124–147ff.; Tolstaya, T.V., *Uspenskii sobor Moskovskogo Kremlya*, pp. 46–47, pl. 77].

88. SAINTS BORIS AND GLEB

Mid 14th century. 128x75 cm. Tretyakov Gallery, Moscow [dr 1129].

From the Chapel of Saints Peter and Paul in the Cathedral of the Dormition, Kremlin, Moscow. In good condition. During the restoration in 1913, the lower corner with the hind legs of the horses was completed and Boris' beard was touched up. Traces of gold are left on the background. The cornice is brown. On the occasion of the exhibition of Pskovian painting organized in 1970, the icon was attributed to the Pskov school without sufficient proof. The icon seemed foreign in that context, thus demonstrating the groundlessness of the attribution. D.V. Ainalov's thesis, attributing the icon to the Novgorod school, is equally unacceptable.

Bibliography: Skvortsov, A.M., "Ikona sv. knayzey Borisa i Gleba," in *Sofiya*, 1914, n. 6, pp. 25–39; Zhidkov, G.V., *Moskovskaya zhivopis*

serediny XIV veka, pp. 40–63; Ainalov, D., *Geschichte der russischen Monumentalkunst zur Zeit des Grossfürstentums Moskau*, pp. 73–74; Onasch, K., *Ikonen*, pl. 79, pp. 381–382; [Antonova, V.I. — Mneva, N.E., *Katalog drevnerusskoy zhivopisi*, t. I, n. 213, pp. 250–251, pls. 162, 163]; Ovchinnikov, A.N. — Kishilov, N., *Zhivopis drevnego Pskova*, p. 14, pls. 31–32 and descriptions; [Ovchinnikov, A.N., *Opyt opisaniya proizvedenii drevnerusskoy stankovoy zhivopisi. Tehnika i stil. 1, Pskovskaya shkola. XIII–XVI veka*, n. 10, pp. 23–26; Lazarev, V.N., *Moskovskaya shkola ikonopisi*, pp. 11–12, pls. 14, 15].

89. HEAD OF AN ANGEL FROM AN ICON OF THE TRINITY

Mid 14th century. 168x144 cm (dimension of the entire icon). Cathedral of the Dormition, Kremlin, Moscow [5139 sob/zh-149].

In the Cathedral of the Dormition, Kremlin, Moscow. The icon was painted over in the eighteenth century. In 1945, a test restoration was done of the head of the angel to the right. It showed that the original layer of colors was in very bad condition. The angel's green cloak is richly adorned with gold *assiste*. The cleaning of this great masterpiece will signal an important advance in the study of early Muscovite iconography.

Bibliography: *Chudozhestvennye pamyatniki Moskovskogo Kremlya*, M. 1956, p. 37, fig. 13; Lazarev, V.N., *Moskovskaya shkola ikonopisi*, p. 12, pl. 16; [Tolstaya, T.V., *Uspenskii sobor Moskovskogo Kremlya*, p. 47, pls. 78 and 110].

90. THEOPHANES THE GREEK AND HELPERS
DEESIS: CHRIST IN GLORY; THE VIRGIN; SAINT JOHN THE BAPTIST; THE ARCHANGEL MICHAEL; THE ARCHANGEL GABRIEL; THE APOSTLE PETER; THE APOSTLE PAUL; SAINT BASIL THE GREAT; SAINT JOHN CHRYSOSTOM

Late 14th–early 15th century. 210x141, 210x109, 210x109, 210x121, 210x117, 210x107, 210x117, 210x98.5, 210x103 cm. Cathedral of the Annunciation, Kremlin, Moscow [3232 sob/zh-1385, 3233 sob/zh-1386, 3234 sob/zh-1387, 3235 sob/zh-1388, 3236 sob/zh-1389, 3237 sob/zh-1390, 3238 sob/zh-1391, 3240 sob/zh-1393, 3239 sob/zh-1392].

[From an unknown church of the late fourteenth or early fifteenth century in the Kremlin, Moscow. The icons might have been intended for the Cathedral of the Archangel and could have been transferred to the Cathedral of the Annunciation after its resoration in 1416]. See p. 84 and note 189. In good condition as a whole. The gold backgrounds with traces of the coverings' nails are almost totally lost. Flaking of the surface layer of colors on the garments and ground. The faces are the best preserved parts. Since we do not know the exact dimensions of the sanctuary, prothesis, and diaconicon arches of the church for which the iconostasis was painted, any inference concerning the length of the original *Deesis*, which could have also included the figures of the two stylites, still remains doubtful. Nevertheless, it is very possible that the iconostasis of Theophanes, naturally preserved as a treasure, could have come here in its original form, without yet having the tier of *Prophets*.

Bibliography: Grabar, Igor, *O drevnerusskom iskusstve*, pp. 84, 87, 89, 90 (in the essay "Feofan Grek. Ocherk iz istorii drevnerusskoy zhivopisi"); Lazarev, V.N., *Feofan Grek i ego shkola*, M. 1961, pp. 86–94, pls. 88–111; Mayasova, N.A., "K istorii ikonostasa Blagoveshchenskogo sobora Moskovskogo Kremlya," in *Kultura drevney Rusi. Sbornik statey k 40-letiyu nauchnoy deyatelnosti N.N. Voronina*, pp.

152–157; Nikiforaki, N.A., "Opyt atributsii ikonostasa Blagoveshchenskogo sobora pri pomoshchi fizicheskich metodov issledovaniya," in ibid., pp. 173–176; Vzdornov, G.I., *Zhivopis*, pp. 326–328; Betin, L.V., "Istoricheskie osnovy drevnerusskogo vysokogo ikonostasa," in *Drevnerusskoe iskusstvo. Chudozhestvennaya kultura Moskvy i prilezhashchich k ney knyazhestv. XIV–XVI vv.*, pp. 52–72; [Id., O proischozhdenii ikonostasa Blagoveshchenskogo sobora Moskovskogo Kremlya," in *Restavratsiya i issledovaniya pamyatnikov kultury*, 1, M. 1975, pp. 37–44; Lazarev, V.N., *Moskovskaya shkola ikonopisi*, p. 18, pl. 22; Alpatov, M.V., *Drevnerusskaya ikonopis*, pls. 59–61, 66, p. 302; Betin, L.V., "Ikonostas Blagoveshchenskogo sobora i moskovskaya ikonopis nachala XV v.," in *Restavratsiya i issledovaniya pamyatnikov kultury*, 2, pp. 31–44].

91. SCHOOL OF THEOPHANES THE GREEK
THE TRANSFIGURATION

About 1403. 184x134 cm. Tretyakov Gallery, Moscow [12797].

From the Cathedral of the Savior of the Transfiguration in Pereslavl-Zalesskii, which became *votchina* [inherited land] of the Prince of Moscow in 1302. In good condition. Small remnants of gold on the background and borders. Partial loss of the *levkas* on the borders. Close to John, traces of a damaged Greek inscription are visible. V.I. Antonova suggests a convincing date for the icon, about 1403, when the Prince of Moscow, Vasilii Dmitrievich, financed the rebuilding of the Cathedral of the Savior in Pereslavl-Zalesskii. The three apostles twice repeated are found in works of the Byzantine milieu from the thirteenth century on (*cod. Ivir, 5, f. 34v*). The prophets descending from the clouds become a fairly common detail in later works.

Bibliography: Antonova, V., "O Feofane Greke v Kolomne, Pereslavle-Zalesskom i Serpuchove," in *Gos. Tretyakoskaya galereya. Materialy i issledovaniya*, II, pp. 22–25; [Antonova, V.I. — Mneva, N.E., *Katalog drevnerusskoy zhivopisi*, t. I, pp. 257–258, pls. 176, 177]; Onasch, K., *Ikonen*, pls. 91–93, pp. 386–387; Lazarev, V.N., *Feofan Grek i ego shkola*, pp. 101–103; [Chemegi, I., "Sotsialno-istoricheskii fon pereslavl-zalesskoy ikony 'Preobrazhenie,'" in *Acta Historiae Artium*, t. XIV, fasc. 1–2, Budapest 1968, pp. 49–62; Goleyzovskii, N. — Yamshchikov, S., *Feofan Grek i ego shkola*, pls. 9–12; Alpatov, M.V., *Drevnerusskaya ikonopis*, pls. 64, 65, p. 303].

92. THE VIRGIN ORANT

Late 14th century. 93x33 cm. Tretyakov Gallery, Moscow [12724].

From the Monastery of Saint Hypatius in Kostroma. In good condition. Halos covered with *assiste*. Ocher background and cornices with a bright yellow tone. On the old background there is an inscription in cinnabar: *Mother of God Orant*, repeated on the laminae, one of which is lost. The covering of the icon goes back to the fourteenth century and is a masterpiece of gold work. The hypothesis of V.I. Antonova seeking to link the icon with Kolomna does not appear convincing.

Bibliography: Antonova, V.I., "Ikonograficheskii tip Perivlepty i russkie ikony Bogomateri v XIV veke," in *Iz istorii russkogo i zapadnoevrapeyskogo iskusstva*, pp. 115–117; Lazarev, V.N., *Feofan Grek i ego shkola*, p. 100; Antonova, V.I. — Mneva, N.E., *Katalog drevnerusskoy zhivopisi*, t. I, n. 210, pp. 246–247, pl. 152; [Popov, G.V., 'Maloizvestnii pamyatnik stankovoy zhivopisi 'yugo-zapadnoy' shkoly XIV v. iz Kostromy," in *Sovetskoe slavyanovedenie*, 1969, n. 3, pp. 92–94; Lazarev, V.N., *Moskovskaya shkola ikonopisi*, p. 15, pl. 17].

93. THE CRUCIFIXION

Late 14th century. 107x83 cm. Andrei Rublev Museum of Early Russian Art, Moscow [kp 2250].

Origin unknown. In good condition. Lacunae on the old *levkas* in the lower part. Original cornice trimmed. The icon has been fitted into a new panel. It is one of the most Byzantinized images from the Moscow school.

Bibliography: Ivanova, I.A., *Muzey drevnerusskogo iskusstva imeni Andreya Rublyova*, M. 1968, p. 10, pls. 1, 2; Lazarev, V.N., *Moskovskaya shkola ikonopisi*, pp. 15–16, pls. 18, 19; [*Muzey drevnerusskogo iskusstva imeni Andreya Rublyova*, album, edited by A.A. Saltykov, M. 1981, pls. 30, 31, annotations on p. 243].

94. FEASTS (THE ANNUNCIATION, NATIVITY OF CHRIST, TRANSFIGURATION, RAISING OF LAZARUS, DESCENT INTO HELL, AND ASCENSION)

Late 14th century. 32x25 cm. Tretyakov Gallery, Moscow [13877].

In the S.P. Ryabushinskii collection. In relatively good condition. Additions of new *levkas* along the borders. The icon has been fitted into a new panel and thus the cornice has become notably larger. Small icons depicting the *Feasts* were very widespread in Byzantium in the fourteenth century (Lazarev, V.N., *Storia della pittura bizantina*, figs. 489, 490, 502, 503; Sotiriou, G. and M., *Icônes du Mont Sinaï*, vol. I, figs. 208–216), the sign of a more personal approach to the veneration of images. The author of the icon was a miniaturist who was accustomed to working on a small sheet of parchment.

Bibliography: Alpatov, M.V., "Eine russische Ikone mit 6 Festbildern der Sammlung S.P. Rjaybushinsky in Moskau," in *Belvedere*, 1929, fasc. 2, pp. 34–39 [Russian text in Alpatov, M.V., *Etyudy po istorii russkogo iskusstva*, 1, pp. 99–102 ("Ikona vremeni Andreya Rublyova"]; Yagodovskaya, A., "K voprosu o nekotorych osobennostyach izobrazheniya deystvitelnosti v moskovskoy ikonopisi kontsa XIV — nachala XV veka," in *Gos. Tretyakoskaya galereya. Materialy i issledovaniya*, II, pp. 47–48; Antonova, V.I. — Mneva, N.E., *Katalog drevnerusskoy zhivopisi*, t. I, n. 222, pp. 263–264, pl. 170; [Lazarev, V.N., *Moskovskaya shkola ikonopisi*, p. 16, pl. 21; Alpatov, M.V., *Drevnerusskaya ikonopis*, pl. 73, p. 304].

95. PROCHOR OF GORODETS
FEASTS: THE LAST SUPPER; THE CRUCIFIXION; THE ENTOMBMENT; THE ASCENSION; THE DESCENT INTO HELL; PENTECOST

1405. 80x61, 80.5.x61, 81x62.5, 81x63.5, 81x61, 81x63 cm. Cathedral of the Annunciation, Kremlin, Moscow [5015 sob/zh-1409, 3249 sob/zh-1402, 3250 sob/zh-1403, 3252 sob/zh-1405, 3251 sob/zh-1404, 3253 sob/zh-1406].

These six icons from the register of *Feasts* of the iconostasis in the Cathedral of the Annunciation form a stylistically unified group, of which the figure of Saint Demetrius of Thessalonica is also a part. All the icons reveal the hand of a single master, still closely tied to the artistic culture of the fourteenth century. The best preserved is the *Last Supper*, even though it has many lacunae on the gold background, the buildings, and the faces and clothing of the apostles. Two longitudinal cracks in the *levkas* are noticeable. We also find the same cracks in the icon of *Pentecost*, which, like the *Ascension*, is very poorly preserved (serious damage in the clothing, faces, and buildings, and especially on the originally golden background). According to M.K. Tichomirov ("Andrey Rublyov i ego

epocha," in *Voprosy istorii*, 1961, n. 1, pp. 6–7), Prochor was from Gorodets on the Volga River, which at one time had been an important center in Suzdal territory. Prochor may have formed part of the brigade of painters associated with the court of the grand prince, even though he was a monk from a Moscow monastery.

Bibliography: Grabar, Igor, *O drevnerusskom iskusstve*, pp. 87 and 92–93 (in the essay "Teofane il Greco") 178, 180 and 182 (in the essay "Andrey Rublyov"); Lazarev, V.N., *Andrey Rublyov i ego shkola*, M. 1966, pp. 19, 68, 114–116; [Id., *Moskovskaya shkola ikonopisi*, p. 18, pl. 23]; Plugin, V.A., "Nekotorye problemy izucheniya biografii i tvorchestva Andreya Rublyova," in *Drevnerusskoe iskusstvo. Chudozhestvennaya kultura Moskvy i prilezhashchich k ney knyazhestv. XIV–XVI vv.*, pp. 73–75 [the same in Plugin, V.A., *Mirovozzrenie Andreya Rublyova. (Nekotorye problemy). Drevnerusskaya zhivopis kak istoricheskii istochnik*, M. 1974, pp. 10–13; Betin, L.V., "Ikonostas Blagoveshchenskogo sobora i moskovskaya ikonopis nachala XV v.," pp. 35, 37 and 39].

96. ANDREI RUBLEV
FEASTS: THE ANNUNCIATION; THE NATIVITY OF CHRIST; THE PRESENTATION IN THE TEMPLE; THE BAPTISM; THE TRANSFIGURATION; THE RAISING OF LAZARUS; THE ENTRY INTO JERUSALEM

1405. 81x61, 81x62, 81x61.5, 81x62, 80.5x61, 81x61, 80.8x62.5 cm. Cathedral of the Annunciation, Kremlin, Moscow [3243 sob/zh- 1396, 3244 sob/zh-1397, 3255 sob/zh-1408, 3245 sob/zh-1398, 3248 sob/zh-1401, 3246 sob/zh-1399, 3247 sob/zh-1400].

These seven icons from the register of *Feasts* of the iconostasis in the Cathedral of the Annunciation also form a stylistically unified group. All the icons were seriously damaged in the seventeenth century, partially peeled off, cut on the rest of the painting with deep scratches, and painted over. Cleaned in 1918–1920, the icons show a great deal of damage on the upper layer of colors (especially in the gold backgrounds, clothing, mountains, and the architectural structures at the sides, less on the faces, although many are half gone). The fragments of paint which are preserved allow us to see a very skilled author. Whether viewed iconographically or stylistically, the *Feasts* are very close to the works of Byzantine iconography. Once again, this suggests the hand of a relatively young master who had not yet had the time to assimilate fully the impressions acquired from Byzantine art. In Rublev's life, this development took place a little later, around the year 1408. There is no stylistic foundation to Yu.A. Lebedeva's attempt (Lebedewa, J., *Andrej Rublyow und seine Zeitgenossen*, pp. 35–36, 38–39, 67–68) to attribute to young Rublev the icon of the *Virgin of Tenderness* in the Russian Museum, the miniature depicting the Pantocrator in the Evangeliary in the Saltykov-Shchedrin State Library in Saint Petersburg, and the miniature depicting an angel in the *Chitrovo Evangeliary* of the Lenin State Library of Moscow. See critical observations in my book *Andrey Rublyov i ego shkola* (p. 58, note 29).

Bibliography: Grabar, Igor, *O drevnerusskom iskusstve*, p. 201 (in the essay "Andrey Rublyov"); Alpatov, M.V., *Andrey Rublyov*, M. 1959, pp. 11–13; Ilin, M.A., "Izobrazhenie Ierusalimskogo chrama na ikone 'Vchod v Ierusalim' Blagoveshchenskogo sobora," in *Vizantiiskii vremennik*, 17, M. 1960, pp. 105–113; Stoyakovich, A., "Ob izuchenii architekturnych form na materiale nekotorych russkich ikon," ibid., 18, pp. 116–123; Lebedewa, J., *Andrej Rublyow und seine Zeitgenossen*, pp. 34–39; Lazarev, V.N., *Andrey Rublyov i ego shkola*, pp. 19–22, 111–113; Vzdornov, G.I., *Zhivopis*, pp. 332–333; [Lazarev, V.N., *Moskovskaya shkola ikonopisi*, pp. 18–20, pls. 25, 26; Alpatov, M.V., *Andrey Rublyov,*

M. 1972, pp. 20, 28, 32–33, pls. 3–10; Plugin, V.A., *Mirovozzrenie Andreya Rublyova. . .*, pp. 57–58; Alpatov, M.V., *Drevnerusskaya ikonopis*, pls. 28, 74–77, pp. 297, 304–305].

97. ANDREI RUBLEV
THE ASCENSION

1408. 125x92 cm. Tretyakov Gallery, Moscow [14249].

From the register of *Feasts* from the Cathedral of the Dormition in Vladimir. In mediocre condition (much damage on the surface layer of colors). From the cycle of *Feasts*, very rich in its time, only five icons are preserved (besides the two reproduced here, the *Annunciation, Baptism,* and *Descent Into Hell*). They are icons of such varied quality and so dissimilar in their pictorial styles that there is no doubt in attributing them to different masters. As with the *Deesis,* the icons in the tier of *Feasts* must also have been executed by more than one artist and not by Daniil and Rublev alone, these simply limiting themselves to directing the work. They painted only those icons which they considered the most important or were more akin to their liking, in other words, the icons which corresponded to their personal inclinations. The *Ascension* is the best in terms of quality, and there are good reasons to attribute it to Rublev himself. He took his inspiration from the icon on the same subject by Prochor in the Cathedral of the Annunciation.

Bibliography: Grabar, Igor, *O drevnerusskom iskusstve,* pp. 174, 176 (in the essay "Andrey Rublyov"); Lebedewa, J., *Andrej Rublyow und seine Zeitgenossen,* pp. 53, 54; Antonova, V.I. — Mneva, N.E., *Katalog drevnerusskoy zhivopisi,* t. I, n. 225, p. 274, pl. 183; Lazarev, V.N., *Andrey Rublyov i ego shkola,* pp. 30–31, 130, pl. XI; [Id., *Moskovskaya shkola ikonopisi,* p. 21, pl. 29].

98. STUDIO OF ANDREI RUBLEV
THE PRESENTATION IN THE TEMPLE

1408. 124x92 cm. Russian Museum, Saint Petersburg [2135].

From the register of *Feasts* from the Cathedral of the Dormition in Vladimir. In mediocre condition. Much damage with additions of new *levkas* (on Joseph's head, the baldachin, Simeon's clothing, and lower parts of the panel). Almost nothing is left of the gold on the background and the halos. The upper layers of paint are chipped (especially on Joseph's face). The slightly rigid composition, lacking the marvelous rhythm of Rublev, suggests the hand of a pupil rather than that of the master himself.

Bibliography: Dmitriev, Yu., *Gos. Russkii muzey. Putevoditel. Drevnerusskoe iskusstvo,* p. 43; Lebedewa, J., *Andrej Rublyow und seine Zeitgenossen,* p. 53; Lazarev, V.N., *Andrey Rublyov i ego shkola,* pp. 30, 131; [Alpatov, M.V., *Andrey Rublyov,* M. 1972, p. 74, pl. 61].

99. ANDREI RUBLEV AND HELPERS
DEESIS: CHRIST IN GLORY; THE VIRGIN; SAINT JOHN THE BAPTIST; THE APOSTLE PETER; THE APOSTLE PAUL

1408. 314x220, 313x106, 313x105, 311x104, 312x105 cm. Tretyakov Gallery, Moscow (with the exception of the icons of the Apostles Paul and Peter) [22961, 22125, 22960]; Russian Museum, Saint Petersburg (Apostles Peter and Paul) [2134, 2722].

From the Cathedral of the Dormition in Vladimir. The *Deesis* includes the images of Christ, the Virgin, Saint John the Baptist, the Archangels Michael and Gabriel, the Apostles Peter, Paul, Andrew, and John the Theologian, and the Bishops Basil the Great, Gregory the Theologian, John Chrysostom, and Nicholas the Wonderworker. M.A. Ilin's supposition, according to which the original *Deesis* was composed of twenty icons, has no foundations. According to I.E. Grabar and V.I. Antonova, the *Deesis* could have concluded at both ends (as in the Cathedral of the Annunciation) with the images of Saints Demetrius and George, which are lost today; in this case, there would have been fifteen icons. But this hypothesis is not supported by proof. Five icons of the *Deesis* were in the light of the sanctuary arch; another six, in groups of three, were in the arches of the prothesis and diaconicon; and finally, one or two were on the east walls of the outer naves, added by Vsevolod Big Nest. In fact, there is no record that the icons of the *Deesis* were arranged as an uninterrupted frieze from the north to south walls, as suggested by M.A. Ilin's rather debatable reconstructions. The columns of the sanctuary, decorated with frescoes, separated the icons in the arch of the sanctuary from those in the arches of the prothesis and diaconicon; and the columns of the latter, from the icons on the walls of the outer naves. Therefore, it was not an uninterrupted, closed iconostasis as in the Cathedral of the Trinity in the Monastery of the Trinity of Saint Sergius. The condition of most of the images is mediocre. The icons, partly repainted in the seventeenth century, were radically renewed in 1708, and then roughly restored by N.I. Podklyuchnikov in 1852. The scientific restoration began after 1920 and lasted until the 1950s. Great lacunae were found in the surface layer of colors. Many small repairs and additions of new *levkas* with successive retouching of the colors. In the places where the original paint was completely lost, the paint from another, later period was left (for example, in the icon of the *Savior,* the gold background, the text of the Gospel, the addition next to the lower border which brushes against the left foot, and the stool; in the icon of John the Baptist, the entire right hand, painted at the beginning of the eighteenth century; in the icon of the Virgin, the fingers of the left hand, repainted in the early eighteenth century). The outlines of the figures of the Apostles Peter and Paul were slightly modified when the contours were cut from the remnants of the old *levkas.* In composing the figures of the *Deesis,* Rublev and Daniil used as models some icons of Theophanes the Greek in the iconostasis of the Cathedral of the Annunciation (for example, those of the *Savior,* the *Virgin,* and *Saint Peter*). The most typical of Rublev's style are the icons of the *Savior, Saint John the Baptist,* and the *Apostles Peter and Paul.*

Bibliography: Grabar, Igor, *O drevnerusskom iskusstve,* pp. 174, 177 (in the essay "Andrey Rublyov"); Lebedewa, J., *Andrej Rublyow und seine Zeitgenossen,* p. 55; Antonova, V.I. — Mneva, N.E., *Katalog drevnerusskoy zhivopisi,* t. I, n. 223, pp. 267–272, pls. 179, 181, 182; Lazarev, V.N., *Andrey Rublyov i ego shkola,* pp. 29–30, 127–129; Ilin, M.A., "Ikonostas Uspenskogo sobora vo Vladimire Andreya Rublyova," in *Drevnerusskoe iskusstvo. Chudozhestvennaya kultura Moskvy i prilezhashchich k ney knyazhestv. XIV–XVI vv.,* pp. 29–40; [Lazarev, V.N., *Moskovskaya shkola ikonopisi,* pp. 20–21, pls. 27, 28; Alpatov, M.V., *Andrey Rublyov,* M. 1972, pp. 70, 74, pls. 53–59; Plugin, V.A., *Mirovozzrenie Andreya Rublyova. . .*, pp. 102–107].

100. ANDREI RUBLEV
THE SAVIOR; THE ARCHANGEL MICHAEL; THE APOSTLE PAUL

1400–1410. 158x108, 158x108, 160x110 cm. Tretyakov Gallery, Moscow [12863, 12864, 12865].

All three icons were rediscovered in 1918 in a woodshed near the Cathedral of the Dormition in Gorodok in Zvenigorod. They were part of a

Deesis with half-length figures which also included icons of the Virgin, Saint John the Baptist, the Archangel Gabriel, and the Apostle Peter. Judging from the size of the remaining images, this *Deesis* must have decorated a fairly large church even though we do not know which one (accurate dimensions have proven that it could not be the Cathedral of the Dormition in Gorodok, nor that of the Monastery of Saint Savva in Storozhi in Zvenigorod). The icons are very damaged; however, the preserved parts of the old paint are in good condition. On the Savior's face there is a crack in the old *levkas;* the upper layer of color is noticeably chipped on the hair and beard. Traces of scratches are visible on the archangel's face; on his chest, lacunae in the original gold. On Paul's face there are insignificant losses in the surface layer of color with new additions on the beard. A new addition of *levkas* near the neck of the chiton. The gold backgrounds are lost for the most part. The rendition of Christ's face especially stands out because of its decisive character, and it has such typically Russian features that the most probable date for this icon and for the whole cycle of the *Deesis* certainly goes back to the years 1410–1415 (in any case not before 1408, when Rublev worked on the frescoes of the Cathedral of the Dormition in Vladimir).

Bibliography: Grabar, Igor, *O drevnerusskom iskusstve,* p. 192 (in the essay "Andrey Rublyov"); Ainalov, D., *Geschichte der russischen Monumentalkunst zur Zeit des Grossfürstentums Moskau,* pp. 97–98; Alpatov, M.V., *Andrey Rublyov,* M. 1959, pp. 14–15; Lebedewa, J., *Andrej Rublyow und seine Zeitgenossen,* pp. 77–78; Onasch, K., *Ikonen,* pls. 94–97, pp. 387–388; Antonova, V.I. — Mneva, N.E., *Katalog drevnerusskoy zhivopisi,* t. I, n. 229, pp. 282–285, pls. 187–189; Ilin, M.A., "K datirovke 'zvenigorodskogo' china," in *Drevnerusskoe iskusstvo XV — nachala XVI veka,* pp. 83–93; Boyar, O.P., "K voprosu o 'zvenigorodskom' chine," in ibid., p. 93; Lazarev, V.N., *Andrey Rublyov i ego shkola,* pp. 32–33, 132–134; [Id., *Moskovskaya shkola ikonopisi,* pp. 21–22, pls. 30–34; Alpatov, M.V., *Andrey Rublyov,* M. 1972, pp. 74, 87, pls. 62–69; Plugin, V.A., *Mirovozzrenie Andreya Rublyova. . .,* pp. 79–101; Alpatov, M.V., *Drevnerusskaya ikonopis,* pls. 80, 81, p. 305; Sergeev, V.N., "Zvenigorodskii chin," in *Pamyatniki otechestva,* 1980, 1, pp. 113–121; Andreev, M.I., "Ob ikonografii Zvenigorodskogo china," in *Restavratsiya i issledovaniya pamyatnikov kultury,* 2, pp. 42–51].

101. ANDREI RUBLEV
THE TRINITY

About 1411. 142x114 cm. Tretyakov Gallery, Moscow [13012].

From the Cathedral of the Trinity in the Monastery of the Trinity of Saint Sergius, where it was the principal icon of the local tier. In relatively good condition. The gold background is lost in many parts. Many losses in the layer of surface colors in the lower part of the icon, on the right foot and right hand of the angel to the right, on the left sleeve of his chiton, on the mountains and building in the background, on the chiton and cloak of the angel in the center, on the chiton and cloak of the angel to the left, and also along the left vertical crack. The faces, hair, and most of the garments are better preserved, but the faces have been reconditioned by a very expert restorer, to the detriment of the purity of the Rublevian type in the angel to the left (exaggerated line of the nose). The facial expression of the angel to the right has been rendered slightly impersonal. All of this was disclosed with the help of N.A. Nikiforaki's special technical equipment. On the background, borders, halos and around the chalice, traces of the nails of the old covering can be seen (the icon was "covered with gold" by Ivan the Terrible in 1575, and in 1600, Boris Godunov gave it a new and even more precious covering;

see Nikolaeva, T.V. "Oklad s ikony 'Troitsa' pisma Andreya Rublyova," in *Soobshcheniya Zagorskogo gos. istoriko-chudozhestvennogo muzeya-zapovednika,* 2, Zagorsk 1958, pp. 31–38). The problem of the date of the icon is more controversial. I.E. Grabar cautiously placed the *Trinity* between 1408–1425; Yu.A. Lebedeva, 1422–1423; V.I. Antonova, 1420–1427; and G.I. Vzdornov, 1425–1427. The dating of the icon depends upon whether one considers it a work from the period of Rublev's greatest productivity or a work of his mature years. Stylistically, the icon cannot be far removed in time from the frescoes of the Cathedral of the Dormition, done in 1408. On the other hand, the icon is much more stable in its design and more perfect in its execution than the best icons in the Cathedral of the Trinity, painted between 1425 and 1427, and already marked by the decline of old age. The period when Rublev's art was most flourishing was from 1408 to 1420, and not from 1425 to 1430. This is why the most probable date for the icon is around 1411, when a new church, also made of wood, was built in place of the wooden church burned by the Tartars, or the following year, when the masonry church appeared (this problem, confronted by L.V. Betin, is still debatable). If the stone cathedral was built later (in 1423–1424), the icon of the *Trinity* was transferred from the wooden church of 1411 to this stone church of a later period. See Vzdornov, G.I., "Novootkrytaya ikona Troitsy iz Troitse-Sergievoy lavry i 'Troitsa' Andreya Rublyova," in *Drevnerusskoe iskusstvo. Chudozhest-vennaya kultura Moskvy i prilezhashchich k ney knyazhestv. XIV–XV vv.,* pp. 135–140, and also the works, not yet published, of L.V. Betin and V.A. Plugin (about the problem of the 1411 date of the *Trinity*).

Bibliography: Sychev, N., "Ikona sv. Troitsy v Troitse-Sergievoy lavre," in *Zapiski Otdeleniya russkoy i slavyanskoy archeologii imp. Russkogo archeologicheskogo obshchestva,* t. X, Pg. 1915, pp. 58–76; [Shchekotov, N.M., *Stati, vystupleniya, rechi, zametki,* M. 1963, pp. 36–43 (essay "Troitsa Rublyova")]; Grabar, Igor, *O drevnerusskom iskusstve,* pp. 168–169, 172–174, 204 (in the essay "Andrey Rublyov"); Ainalov, D., *Geschichte der russischen Monumentalkunst zur Zeit des Grossfürstentums Moskau,* pp. 94–97; Alpatov, M.V., "La 'Trinité' dans l'art byzantin et l'icône de Roublëv," in *Echos d'Orient,* n. 146, 1927, pp. 150–186; Antonova, V.I., "O pervonachalnom meste 'Troitsy' Andreya Rublyova," in *Gos. Tretyakovskaya galereya. Materialy i issledovaniya,* I, M. 1956, pp. 21–43; Eckhardt, Th., "Die Dreifaltigkeitsikone Rublevs und die russische Kunstwissenschaft," in *Jahrbücher für Geschichte Osteuropas,* vol. 6, fasc. 2, Munich 1958, pp. 146–176; Alpatov, M.V., *Andrey Rublyov,* M. 1959, pp. 21–27; Lazarev, V.N., *Russkaya srednevekovaya zhivopis. Stati i issledovaniya,* pp. 292–299 (essay "'Troitsa' Andreya Rublyova"); Lebedewa, J., *Andrej Rubljow und seine Zeitgenossen,* pp. 77–81; Onasch, K., *Ikonen,* pls. 98–101, pp. 388–389; Antonova, V.I. — Mneva, N.E., *Katalog drevnerusskoy zhivopisi,* t. I, n. 230, pp. 285–290, pls. 190–192; Demina, N.A., *'Troitsa' Andreya Rublyova,* M. 1963 [see also reprint in the text, *Andrey Rublyov i chudozhniki ego kruga,* pp. 45–81]; Alpatov, M.V., *Etyudy po istorii russkogo iskusstva,* 1, pp. 119–126 (essay "O znachenii Troitsy Rublëva"); Mainka, R.M., *Andrej Rublev's Dreifaltigkeitsikone. Geschichte, Kunst und Sinngehalt des Bildes,* Munich 1964; Lazarev, V.N., *Andrey Rublyov i ego shkola,* pp. 33–41, 134–137; Vzdornov, G.I., "Novootkrytaya ikona Troitsy iz Troitse-Sergievoy lavry i 'Troitsa' Andreya Rublyova," pp. 115–154; Lazarev, V.N., *Moskovskaya shkola ikonopisi,* pp. 22–27, pls. 35–38; Vetelev, A., "Bogoslovskoe soderzhanie ikony 'Svyataya Troitsa' Andreya Rublyova," in *Zhurnal moskovskoy patriarchii,* 1972, n. 8, pp. 63–75 and n. 10, pp. 62–65; Alpatov, M.V., *Andrey Rublyov,* M. 1972, pp. 98–100, 104, 108, 110, 104–126, 167–169, pls. 70–78; Id., *Drevnerusskaya ikonopis,* pls. 67, 82, 83, p.

303; *Troitsa Andreya Rublyova*. Anthology edited by G.I. Vzdornov, M. 1981 (in it, the best texts on the *Trinity* are gathered and all the early bibliography on the work is included).

102. ANDREI RUBLEV
CHRIST IN GLORY

1400–1410. 18x16 cm. Tretyakov Gallery, Moscow [22124].

In the P.I. Sevastyanov collection. In good condition. The borders of the panel are eaten away by woodworms. The icon goes back to the similar image by Theophanes the Greek in the Cathedral of the Annunciation, Kremlin, Moscow, and it is helpful in specifying the lost details in the icons of the iconostasis from Vladimir and of the iconostasis in the Cathedral of the Trinity in the Monastery of the Trinity of Saint Sergius. Cf. the profoundly dramatic character of the face of Christ in the fresco of the Cathedral of the Dormition in Vladimir, which decorates the great vault of the central nave of the cathedral (Lazarev, V.N., *Andrey Rublyov i ego shkola*, pls. 40–42).

Bibliography: Antonova, V.I. — Mneva, N.E., *Katalog drevnerusskoy zhivopisi*, t. I, n. 227, pp. 278–279, pl. 184; Lazarev, V.N., *Andrey Rublyov i ego shkola*, pp. 41–42, 137; [Id., *Moskovskaya shkola ikonopisi*, pp. 27–28, pl. 39; Alpatov, M.V., *Andrey Rublyov*, M. 1972, pp. 155–157, pl. 104].

103. ANDREI RUBLEV AND FOLLOWERS
THE DEESIS: THE APOSTLE PETER; THE APOSTLE PAUL; THE ARCHANGEL GABRIEL; SAINT DEMETRIUS OF THESSALONICA

1425–1427. 189x83, 189x82, 189.5x89.5, 189x80 cm. Cathedral of the Trinity in the Monastery of the Trinity of Saint Sergius, Sergiev Posad (Zagorsk) [3044, 3037, 3036, 3048].

The *Deesis* is composed of fifteen figures (the Pantocrator, the Virgin, John the Baptist, the Archangels Michael and Gabriel, the Apostles Peter and Paul, John the Theologian and Andrew, the Bishops Basil the Great, John Chrysostom, Gregory the Theologian and Nicholas the Wonderworker, the holy Martyrs Demetrius and George). The original gold of the backgrounds is almost completely lost. Several lacunae and chipping in the surface layer of colors. Partial additions of new *levkas*. The icon of the *Apostle Paul* is the best preserved. The icons of the *Archangel Gabriel* and especially of the *Apostle Peter* are in the worst condition. In the icon of the *Archangel Gabriel*, the face is fairly well preserved, but it is also damaged by the addition of new *levkas*. In the icon of the *Apostle Peter*, many losses of the surface layer of colors are noticeable. The face is the best preserved part. The icons of the *Archangel Gabriel* and the *Apostle Peter* refer back to the similar images from the Cathedral of the Dormition (as do the icons of the *Pantocrator* and *Saint Basil the Great*). The entire complex was executed by different masters. The figures of John the Baptist and the Apostle Andrew are attributed to a master of the older generation. But the figure of Demetrius of Thessalonica, which concludes the register of the *Deesis* to the left, was painted by a younger artist. Its radiant, pure colors and the face, charming in its youthful freshness, reveal the hand of an exceptional master who probably worked around the 1430s. Of all the icons in the *Deesis*, that of Saint Demetrius of Thessalonica is the best preserved (only small lacunae in the upper layer of colors on the ground and the cloak are visible). Writing about the iconostasis of the Trinity when the restoration was not yet finished, I.E. Grabar inferred some rather rash conclusions about the identification of the works of Andrei Rublev and Daniil Chernyi. But, an essential fact did not escape his careful examination. "First of all," I.E. Grabar wrote, "it is perfectly clear that the two masters are no longer at the peak of their energy and talent, but are in the declining years of their lives; their creativity approaches its twilight" ("O drevnerusskom iskusstve," p. 185). This observation is quite essential in providing a reliable date for the *Trinity*. A scientific classification of the icons in the Cathedral of the Trinity, with a relatively certain identification of individual authors, is being done for the first time by N.A. Demina and the undersigned. Unfortunately, the writing of Yu.A. Lebedeva on the work of Rublev and his contemporaries, published in German in 1962, did not advance the question at all, but on the contrary, further confused the point by a series of opinions without sufficient foundation.

Bibliography: Olsufev, Yu., *Opis ikon Troitse-Sergievoy lavry*, Sergiev 1920, pp. 3–9; Grabar, Igor, *O drevnerusskom iskusstve*, pp. 185–186, 204 (in the essay "Andrey Rublyov"); Ainalov, D., *Geschichte der russischen Monumentalkunst zur Zeit des Grossfürstentums Moskau*, p. 100; Alpatov, M.V., *Andrey Rublyov*, M. 1959, pp. 28–30; Lebedewa, J., *Andrej Rublyow und seine Zeitgenossen*, pp. 86–122; Lazarev, V.N., *Andrey Rublyov i ego shkola*, pp. 44–51, 138–146; *Troitse-Sergieva lavra. Chudozhestvennye pamyatniki*, M. 1967, pp. 80–81; [Nikolaeva, T.V., *Sobranie drevnerusskogo iskusstva v Zagorskom muzee*, L. 1969, pp. 36–37; Lazarev, V.N., *Moskovskaya shkola ikonopisi*, p. 30, pls. 42, 43; Alpatov, M.V., *Andrey Rublyov*, M. 1972, p. 127, pl. 79; Nikolaeva, T.V., *Drevnerusskaya zhivopis Zagorskogo muzeya*, M. 1977, p. 33, nos. 6–8, 18, pp. 46–47, 49].

104. SCHOOL OF ANDREI RUBLEV
FEASTS: THE PRESENTATION IN THE TEMPLE; THE ENTRY INTO JERUSALEM; THE WASHING OF THE FEET; THE LAST SUPPER; THE COMMUNION WITH BREAD; THE COMMUNION WITH WINE; THE ENTOMBMENT; THE WOMEN AT THE LORD'S TOMB; THE ASCENSION

1425–1427. 87.5x66, 88x66.5, 88x68, 88x67.5, 87.5x68, 87.5x67, 88.5x68, 88.2x66, 87.5x65, 88x66 cm. Cathedral of the Trinity in the Monastery of the Trinity of Saint Sergius, Sergiev Posad (Zagorsk) [3065, 3061, 3059, 3049, 3060, 3050, 3053, 3055, 3056, 3058].

The register of *Feasts* in the Cathedral of the Trinity is composed of nineteen icons: *Annunciation, Nativity of Christ, Presentation in the Temple, Baptism, Transfiguration, Raising of Lazarus, Entry into Jerusalem, Washing of the Feet, Last Supper, Communion with Bread, Communion with Wine, Crucifixion, Descent from the Cross, Entombment, Women at the Lord's Tomb, Descent into Hell, Ascension, Pentecost, Dormition.* It is suggestive of the increase in the gospel cycle by the introduction of scenes such as the Communion with Bread and with Wine, the Washing of the Feet, the Descent from the Cross, the Entombment, the Women at the Lord's Tomb. These served to reinforce the specific impact of the Passion. The state of preservation of the icons is not uniform and is mediocre in most cases (a great deal of chipping and other damage in the surface layer of colors, additions of new *levkas*, traces of the nails of the cover on almost all the backgrounds, from which the gold has largely disappeared. In order to complete the *Feasts* more rapidly, an entire brigade of masters worked on the icons. Some of these masters (for example, the authors of the *Last Supper* and *Ascension*) belonged to the older generation. Most worked under the influence of Rublev. N.A. Demina has formulated the most convincing classification of these icons according to their various masters.

Bibliography: Olsufev, Yu., *Opis ikon Troitse-Sergievoy lavry*, pp. 29–30; Alpatov, M.V., *Etyudy po istorii russkogo iskusstva*, 1, pp. 138–145 (essay "Ikona Sreteniya iz Troitse-Sergievoy lavry. K izucheniyu chudozhestvennogo obraza v drevnerusskoy zhivopisi"); Id., *Andrey Rublyov*, M. 1959, pp. 28–30; Lebedewa, J., *Andrej Rublyow und seine Zeitgenossen*, pp. 111–120; Lazarev, V.N., *Andrey Rublyov i ego shkola*, pp. 44–49, 138–142; *Troitse-Sergieva lavra. Chudozhestvennye pamyatniki*, pp. 81–83; [Lazarev, V.N., *Moskovskaya shkola ikonopisi*, pp. 30–31, pl. 45; Demina, N.A., *Andrey Rublyov i chudozhniki ego kruga*, pp. 82–164 (study "Prazdnichnyi ryad ikonostasa Troitskogo sobora Troitse-Sergieva monastyrya"]; Nikolaeva, T.V., *Drevnerusskaya zhivopis Zagorskogo muzeya*, p. 33, nos. 19, 24, 25 and 32, pp. 51, 53–54 and 56–57ff.]

105. THE ASCENSION

1410s–1420s. 71x59 cm. Tretyakov Gallery, Moscow [12766].

In the S.P. Ryabushinskii collection. In good condition, but the icon is unfortunately overly restored according to a practice widespread in the early twentieth century when collectors preferred to have works without lacunae or defects. The composition goes back to Prochor's icon in the Cathedral of the Annunciation and to Rublev's icon in the series of the *Feasts* from the Cathedral of the Dormition in Vladimir. Our icon was part of the same iconostasis which also included the *Nativity of Christ* in the Tretyakov Gallery (from the Church of the Nativity in the suburb of the Nativity in Zvenigorod; see *Masterpieces of Russian Painting*, pls. XX, XXII; Antonova, V.I. — Mneva, N.E., *Katalog drevnerusskoy zhivopisi*, t. I, n. 231, pp. 290–292, pl. 193; [Lazarev, V.N., *Moskovskaya shkola ikonopisi*, pp. 28–29, pl. 40]), and perhaps also the famous *Deesis* "of Zvenigorod." It is also possible that the series of *Feasts* with fourteen icons was added at a later date, in the 1420s, to the half-length *Deesis*. Typical of the *Ascension* is a certain weakening in the forms, which leads us to think that it was not Rublev's work, but rather that of one of his followers, an exponent of the younger generation.

Bibliography: Alpatov, M.V., "Ikona Vozneseniya byvsh. sobr. S.P. Ryabushinskogo, nyne Istoricheskogo muzeya," in *Pervyi Moskovskii gos. universitet. Trudy Etnografo-archeologicheskogo muzeya*, M. 1926, pp. 26–27 [variant revised and expanded in Alpatov, M.V., *Etyudy po istorii russkogo iskusstva*, 1, pp. 170–174]; Ainalov, D., *Geschichte der russischen Monumentalkunst zur Zeit des Grossfürstentums Moskau*, p. 93; [Antonova, V.I. — Mneva, N.E., *Katalog drevnerusskoy zhivopisi*, t. I, n. 252, pp. 311–312; Lazarev, V.N., *Moskovskaya shkola ikonopisi*, pp. 28, 29, pl. 41].

106. CHRIST IN MAJESTY

Second quarter of 15th century. 30x25 cm. Tretyakov Gallery, Moscow [13016].

From the Monastery of the Trinity of Saint Sergius, where it was placed in 1575 by the layman Foma Simonov, the administrator of the landed properties of the *lavra*. In very good condition. The covering is from the same period. The face of the Savior, painted with extraordinary refinement, is very reminiscent of the *Savior* of Zvenigorod by Rublev. This icon probably reproduces the same iconographic type. A certain weakening of form is beginning to emerge in the execution of the flesh tone. Rublev's style was more essential and characterized.

Bibliography: Olsufev, Yu., *Opis ikon Troitse-Sergievoy lavry*, p. 90; Lebedewa, J., *Andrej Rublyow und seine Zeitgenossen*, p. 86; Antonova, V.I. — Mneva, N.E., *Katalog drevnerusskoy zhivopisi*, t. I, n. 236, pp. 296–297; Lazarev, V.N., *Andrey Rublyov i ego shkola*, pp. 52–53, 147, 186, pl. XVIII; [Id., *Moskovskaya shkola ikonopisi*, pp. 31–32, pl. 47].

107. SAINT JOHN THE BAPTIST

Second quarter of 15th century. 105x83.5 cm. Andrei Rublev Museum of Early Russian Art, Moscow [kp 822].

From the Monastery of Saint Nicholas on the Peshnosa in the vicinity of Dmitrov. In good condition. Along his face and hair, there is a narrow crack with *levkas* from the seventeenth century. Of the original golden background, only fragments of the old gold of a superb color are left. Additions of new *levkas* from the seventeenth and eighteenth centuries in the upper part of the icon and on the background (near the right eye). A new wooden cross bar has been added at the bottom. The icon was part of a *Deesis* and is the work of an excellent master.

Bibliography: Ilin, M.A., "K izucheniyu ikony Ioanna Predtecha iz Nikolo-Peshnoshskogo monastyrya," in *Sovetskaya archeologiya*, 1964, n. 3, pp. 315–321; Lazarev, V.N., *Andrey Rublyov i ego shkola*, pp. 52–53, 146–147, pls. 184, 185; Ivanova, I.A., *Muzey drevnerusskoko iskusstva imeni Andreya Rublyova*, pls. 3, 4; [Lazarev, V.N., *Moskovskaya shkola ikonopisi*, p. 31, pl. 46; Alpatov, M.V., *Andrey Rublyov*, M. 1972, pp. 127–128, pls. 80, 81; Id., *Drevnerusskaya ikonopis*, pl. 5, p. 292; *Muzei drevnerusskogo iskusstva imeni Andreya Rublyova*, album, edited by A.A. Saltykov, pl. 11, annotation on p. 242].

108. THE VIRGIN OF VLADIMIR

First quarter of 15th century. 102x68 cm. Cathedral of the Dormition, Kremlin, Moscow [3229 sob/zh-310].

We do not know when it arrived at the Cathedral of the Dormition. It is mentioned for the first time in a description from the early seventeenth century. In good condition. The gold background is lost and there is a crack in the center, which has been repaired with new *levkas*. It was protected by a gold covering until 1904. In this unconstrained copy of the Byzantine icon of the *Virgin of Vladimir*, the proportions of the head and face are greatly modified.

Bibliography: Antonova, V.I., "Rannee proizvedenie Andreya Rublyova v Moskovskom Kremle," in *Kultura drevney Rusi. Sbornik statey k 40-letiyu nauchnoy deyatelnosti N.N. Voronina*, pp. 21–25; [Lazarev, V.N., *Moskovskaya shkola ikonopisi*, p. 33, pl. 50; Tolstaya, T.V., *Uspenskii sobor Moskovskogo Kremlya*, p. 49, pl. 86].

109. THE VIRGIN HODEGETRIA, THE TRINITY, AND SAINTS

Mid 15th century. 32x28 cm. Tretyakov Gallery, Moscow [13015].

From the Monastery of the Trinity of Saint Sergius. In good condition. Irrelevant losses in the layer of surface colors. Embossed silver covering from the same period, with crowns in silver filigree inlaid with precious stones and pearls. On each side of the Trinity, inspired by Rublev's icon, we can see two angels wearing the *loros*. Full-length figures of Saints Evfimii and Sergius of Radonezh flank the Virgin. At the bottom, the half-length figures of Evfimii of Suzdal, Varlaam of Chutyn (?), Demetrius of Prilutsk, Cyril of Belozersk, and Paul of Obnora (?) are depicted. The theme of the icon shows its close connection with the monastic milieu. The refined execution of the faces is characteristic of the post-Rublev period.

Bibliography: Onasch, K., *Ikonen*, pl. 83, p. 383; Lebedewa, J., *Andrej Rublyow und seine Zeitgenossen*, p. 125, pl. 87; Antonova, V.I. — Mneva, N.E., *Katalog drevnerusskoy zhivopisi*, t. I, n. 255, pp. 314–315, pl. 199; [Popov, G.V., *Zhivopis i miniatyura Moskvy serediny XV — nachala XVI veka*, pp. 33–36, pl. 30; Alpatov, M.V., *Drevnerusskaya ikonopis*, pl. 86, p. 306].

110. THE ARCHANGEL MICHAEL WITH SCENES FROM HIS DEEDS

1400–1410. 235x182 cm. Cathedral of the Archangel, Kremlin, Moscow [22 sob/zh-469].

We do not know when the icon came to the Cathedral of the Archangel. In mediocre condition. The layer of surface colors is very chipped and there are also partial lacunae with addition of new *levkas*, especially along the vertical cracks. The lower part of the legs has been repainted. Additions on the sides of the icon. According to what is reported in the *Stepennaya kniga*, the icon represented a vision of Princess Evdokiya, Evfrosiniya in religious life. The icon was placed in the Church of the Nativity of the Virgin in the Kremlin. In the border scenes, we do not see a chronological succession of biblical episodes. The scenes include the following subjects: the Trinity, the synaxis of the archangels, the prophecy of Ezekiel, Daniel's vision, the struggle for Moses' body, Jacob's ladder, the three youths in the fiery furnace, the appearance of the archangel to Joshua, Michael freeing Saint Peter from jail, the appearance of the angel to Pachomius the Great, Jacob's struggle with the angel, the destruction of Sodom, the angel routing the Assyrian armies, the deluge (?), David sending Uriah to war, David and Bathsheba, King David's punishment, and the miracle of Chonae. V.S. Mashnina and K.G. Tichomirova have made a remarkable contribution in identifying the subjects.

Bibliography: Gordeev, N.V. — Mneva, N.E., "Pamyatnik russkoy zhivopisi XV v.," in *Iskusstvo*, 1947, n. 3, pp. 87–88; *SSSR. Drevnye russkie ikony*, pls. XXVI, XXVIII; Mashnina, V.S., *Ikona 'Archangel Michail s deyanyami' iz Archangelskogo sobora Moskovskogo Kremlya*, album, L. 1968; Tichomirova, K.G., "Geroicheskoe skazanie v drevnerusskoy zhivopisi," in *Drevnerusskoe iskusstvo. Chudozhestvennaya kultura Moskvy i prilezhashchich k ney knyazhestv. XIV–XVI vv.*, pp. 7–28; [Lazarev, V.N., *Moskovskaya shkola ikonopisi*, pp. 33–34, pls. 51–55; Alpatov, M.V., *Drevnerusskaya ikonopis*; pls. 68–71, p. 303].

111. THE VIRGIN OF YAROSLAV WITH THE TRINITY AND HALF-LENGTH FIGURES OF ANGELS AND SAINTS

Central part of an icon with three antas

1466. 35x30 cm. Tretyakov Gallery, Moscow [17302a].

From the Church of the Prophet Elijah in the village of Sandyri near Kolomna, a former possession of the Sheremetev family. The condition of the central image (the Virgin of Yaroslav inscribed in a two-toned circular mandorla with seraphim) is relatively good. The figures in the medallions (two archangels, Aleksii, a man of God, and Tecla) and the *Trinity* are in poor condition. In the lower part of the icon, addition of new *levkas*, where a nineteenth century inscription appears on the red background. It probably reproduces, at least partially, an earlier inscription which is lost: *In the year 6975 (1466) on the first day of December, in memory of the holy prophet Naum, this icon with antas was painted MR FU. Restored on March 23, 1814.* V.I. Antonova proposes reading the original date as 1491, but this definitely contradicts the style of the icon. In all likelihood, it was painted in the Monastery of the Trinity of Saint Sergius.

Bibliography: Antonova, V.I. — Mneva, N.E., *Katalog drevnerusskoy zhivopisi*, t. I, n. 273, pp. 328–329, pl. 208; [Popov, G.V., *Zhivopis i miniatyura Moskvy serediny XV — nachala XVI veka*, p. 60, pls. 74–76].

112. HEAD OF THE VIRGIN

Second half of 15th century. 55x41 cm (dimensions of the entire icon). Tretyakov Gallery, Moscow [dr 85].

From the Cathedral of the Trinity in the Monastery of the Trinity of Saint Sergius. In the sixteenth century, evidently a fragment of a damaged fifteenth-century icon of the *Deesis* was used by mounting it on a new panel and adding to it the bust-length figure of the Virgin (so-called "embedding"). The fragment is in good condition and stands out because of the high quality of its execution.

Bibliography: Antonova, V.I. — Mneva, N.E., *Katalog drevnerusskoy zhivopisi*, t. I, n. 261, p. 320, pl. 203.

113. THE VIRGIN OF YAROSLAV

Second half of 15th century. 54x42 cm. Tretyakov Gallery, Moscow [12045].

In the I.S. Ostrouchov collection. In good condition. Golden background and cornices. Icon of excellent quality. It shows no effect from any Italian influence, as claimed by N.P. Kondakov and D.V. Ainalov.

Bibliography: Muratov, P.P., *Drevnerusskaya ikonopis v sobranii I.S. Ostrouchova*, p. 22; Ainalov, D., *Geschichte der russischen Monumentalkunst zur Zeit des Grossfürstentums Moskau*, p. 103; Antonova, V.I. — Mneva, N.E., *Katalog drevnerusskoy zhivopisi*, t. I, n. 235, p. 296, pl. 194; [Alpatov, M.V., *Drevnerusskaya ikonopis*, pl. 21, p. 295].

114. THE VIRGIN OF TENDERNESS

Last third of 15th century. 22.5x17 cm. Monastery of the Trinity of Saint Sergius, Sergiev Posad (Zagorsk) [5601].

Offered to the Monastery of the Trinity by Mariya Chlopova, who in 1579 donated a *votchina* in memory of her deceased husband. On the verso of the panel there are traces of the old one-line ink inscription, in which the word "Chlopova" can be read. In good condition. Embossed covering of gilded silver from the same period as the icon.

Bibliography: Olsufev, Yu., *Opis ikon Troitse-Sergievoy lavry*, n. 71/12, p. 107; *Rostovo-Suzdalskaya shkola zhivopisi* [catalogue of the Tretyakov Gallery exhibition], M. 1964, n. 62, p. 97, ill. on p. 68; *Troitse-Sergievoy lavra. Chudozhestvennye pamyatniki*, pl. 104; Nikolaeva, T.V., *Sobranie drevnerusskogo iskusstva v Zagorskom muzee*, L. 1968, n. 27, p. 60, ill. on p. 61; [Id., *Drevnerusskaya zhivopis Zagorskogo muzeya*, p. 34, n. 108, p. 82].

115. DIONYSII
THE VIRGIN HODEGETRIA

1482. 135x111 cm. Tretyakov Gallery, Moscow, [12799].

From the Cathedral of the Monastery of the Ascension, Kremlin, Moscow, founded in 1407 by Evdokiya, the widow of Dmitri Donskoy. In relatively good condition. Chipping in the layer of surface colors (especially on Christ's feet, the Virgin's left hand, the angels' faces and garments). Light green azure background, with the borders of a more intense tone. Small additions of new *levkas* on the background and cornice. Among the Greek icons, Dionysii obtained his inspiration precisely from the prototype of the *Virgin, Salvation of Souls,* in the Ochrid National Museum (*Frühe Ikonen*, pl. 159) and the *Virgin Hodegetria* in the monastery of Saint Catherine on Mount Sinai (Sotiriou, G. and M., *Icônes du Mont Sinai,* vol. 1, fig. 226).

Bibliography: Antonova, V.I. — Mneva, N.E., *Katalog drevnerusskoy zhivopisi*, t. I, n. 274, pp. 330–331, pl. 214; Onasch, K., *Ikonen*, pl. 107, p. 391; Danilova, I.A., *Dionissi*, pp. 51–60; [Lazarev, V.N., *Moskovskaya*

shkola ikonopisi, pp. 41–42; pls. 59, 60; Popov, G.V., *Zhivopis i miniatyura Moskvy serediny XV — nachala XVI veka*, pp. 91–92].

116. THE DORMITION
About 1497. 145x115 cm. Tretyakov Gallery, Moscow [28626].

From the local tier of the iconostasis of the Cathedral of the Dormition in the monastery of Cyril of Belozersk, whose construction was finished in 1497. Around that time, the new large iconostasis, which O.V. Lelekova is striving to reconstruct, was executed. In good condition. Irrelevant losses in the surface layer of colors, accurately restored. The gold background has not been very damaged by time. Traces of the nails of the covering have been plastered and repainted. The tablet has been warped and two cracks have appeared in it. Although in the seventeenth-century sources (parochial register of the expenditures for making the *riza* [covering] in 1614 for the icon of Blessed Cyril and the inventory of the goods of the monastery in 1621) the icon was attributed to Rublev, this one was painted later, but not around 1430, as supposed some time ago; rather, toward 1497, when the iconostasis of the new cathedral was executed. Numerous artists worked on this iconostasis, including Muscovite and Novgorodian masters. The tier of the *Deesis* included twenty-one icons. The author of the *Dormition* was probably a Muscovite master who was very familiar with Novgorodian art. We do not seem to have sufficient reasons to attribute the icon to a local master from Belozersk, or to Daniil Chernyi as I.E. Grabar does.

Bibliography: Grabar, Igor, *O drevnerusskom iskusstve*, p. 192, 194–195 (in the essay "Andrey Rublyov"); Lebedewa, J., *Andrej Rublyow und seine Zeitgenossen*, pls. 48–49; Antonova, V.I. — Mneva, N.E., *Katalog drevnerusskoy zhivopisi*, t. I, n. 228, pp. 280–28l, pl. 186; Lazarev, V.N., *Andrey Rublyov i ego shkola*, pp. 53, 147–148; [Lelekova, O.V., "O sostave ikonostasa Uspenskogo sobora Kirillo Belozerskogo monastyrya," in *Soobshcheniya Vsesoyuznoy tsentralnoy nauchno-issledovatelskoy laboratorii po konservatsii i restavratsii muzeynych chudozhestvennych tsennostey*, 26, (1970), M. 1971, pp. 96–97; Id., "Ikonostas 1497 g. iz Kirillo Belozerskogo monastyrya," pp. 190–191; Alpatov, M.V., *Drevnerusskaya ikonopis*, pl. 7, p. 292; Popov, G.V., *Zhivopis i miniaturya Moskvy serediny XV — nachala XVI veka*, p. 63, pls. 86, 87].

117. STUDIO OF DIONYSII
THE METROPOLITAN PETER WITH SCENES FROM HIS LIFE
1480s. 197x151 cm. Cathedral of the Dormition, Kremlin, Moscow [3228 sob/zh-258].

We do not know when the icon came to the Cathedral of the Dormition, but in all probability in the 1480s, as was the case with the icon of Metropolitan Alexius. In good condition. Irrelevant chipping in the layer of surface colors. All the inscriptions have been restored. Golden backgrounds in the border scenes and central part. To this day, it is the oldest known hagiographical icon of Metropolitan Peter.

Bibliography: Borin, V., "Dve ikony novgorodskoy shkoly XV veka svv. Pyotra i Aleksiya iz Uspenskogo sobora v Kremle v svyazi s russkoy agiografiey" in *Trudy Otdela drevnerusskoy literatury Instituta russkoy literatury (Pushkinskii Dom) Akademii nauk SSSR*, XXIII, L. 1968, pp. 199–216; Vzdornov, G.I., *Zhivopis*, pp. 367–369; Danilova, I.E., *Dionissi*, pp. 29–49; [Lazarev, V.N., *Moskovskaya shkola ikonopisi*, pp. 43–45, pls. 62–65; Kochetkov, I.A., "O printsipach izobrazheniya architektury na ikonach mitropolitov Pyotra i Aleksiya," in *Sovetskaya archeologiya*,

1973, n. 4, pp. 123–134; Popov, G.V., *Zhivopis i miniatyura Moskvy serediny XV — nachala XVI veka*, pp. 116–120, pls. 183–186; Kochetkov, I.A., "Kogda byli napisany ikony mitropolitov Pyotra i Aleksiya iz moskovskogo Uspenskogo sobora?" in *Srednevekovaya Rus. Sbornik statey pamyati N.N. Voronina*, pp. 310–316; Tolstaya, I.V., *Uspenskii sobor Moskovskogo Kremlya*, p. 50, pls. 91–96].

118. STUDIO OF DIONYSII
THE DEPOSITION OF THE VIRGIN'S BELT AND ROBE
About 1485. 60x55.5 cm. Andrei Rublev Museum of Early Russian Art, Moscow [vp 57].

From the Church of the Deposition, of the garment, in the village of Borodava near the Monastery of Ferapont, consecrated in 1485 and built by Ioasaf (at the time of Prince Isaak Michaylovich Strigin-Obolenskii), successor of Archbishop Vassian of Rostov, who commissioned the icons for the iconostasis of the Cathedral of the Dormition in the Kremlin, Moscow, from Dionysii in 1481. In good condition. Insignificant chipping in the surface layer of colors on the faces.

Bibliography: *Rostovo-Suzdalskaya shkola zhivopisi* [catalogue of the Tretyakov Gallery exhibition], n. 78, p. 102, ill. on p. 59; Ivanova, I.A., *Muzey drevnerusskogo iskusstva imeni Andreya Rublyova*, pl. 30; [Lazarev, V.N., *Moskovskaya shkola ikonopisi*, p. 42, pl. 61; Popov, G.V., *Zhivopis i miniatyura Moskvy serediny XV — nachala XVI veka*, pp. 96, 121, pl. 192; Popov, G.V., "Moskovskaya ikona 1485 goda iz sela Borodavy" (K izucheniyu vedushchego napravleniya stolichnoy zhivopisi kontsa XV veka), in *Drevnerusskoe iskusstvo XV–XVII vekov. Sbornik statey*, M. 1981, pp. 80–96; *Muzei drevnerusskogo iskusstva imeni Andreya Rublyova*, album, edited by A.A. Saltykov, pl. 46, annotation on pp. 244–245].

119. STUDIO OF DIONYSII
THE METROPOLITAN ALEXIUS WITH SCENES FROM HIS LIFE
1480s. 197x152, Tretyakov Gallery, Moscow [dr 1100].

It is not known when the icon came to the Cathedral of the Dormition. In good condition. Insignificant losses in the upper layer of colors. Golden backgrounds in the border scenes and central part. It seems to me that the date of the early sixteenth century proposed by V.I. Antonova is too late.

Bibliography: Antonova, V.I. — Mneva, N.E., *Katalog drevnerusskoy zhivopisi*, t. I, n. 279, pp. 336–340, pls. 224, 225; [Kuskov, V.V., "Dionysii — 'citatel' zhitiya Aleksiya," in *Trudy Otdela drevnerusskoy literatury Instituta russkoy literatury (Pushkinskii Dom) Akademii nauk SSSR*, XXIV, L. 1969, pp. 175–179]; Goleyzovskii, N. — Yamshchikov, S., *Dionisii*, M. 1970 (album of the series "Obraz i tsvet"), pls. 5–14; [Lazarev, V.N., *Moskovskaya shkola ikonopisi*, pp. 43–45, pls. 66–68; Alpatov, M.V., *Drevnerusskaya ikonopis*, pls. 150–154, p. 316; Tolstaya, I.V., *Uspenskii sobor Moskovskogo Kremlya*, p. 50, pls. 88–90]; also see the bibliographies with pls. 208–210.

120. STUDIO OF DIONYSII
SAINT CYRIL OF BELOZERSK WITH SCENES FROM HIS LIFE
Late 15th century. 152x117 cm. Russian Museum, Saint Petersburg [2741].

From the Cathedral of the Dormition in the Monastery of Cyril of Belozersk. In good condition. In the border scenes there is a detailed ac-

count of Cyril's life, which was especially popular in northern Russia. In comparison with the icons of Metropolitans Peter and Alexius, the chromatic range preserves denser and darker tones, whereas the compositions in the border scenes are less rarefied and less rhythmical.

Bibliography: Dmitriev, Yu.N., *Gos. Russkii muzey. Putevoditel. Drevnerusskoe iskusstvo*, p. 48; SSSR. *Drevnye russkie ikony*, p. 28, ill. on p. 19; Danilova, I.E., *Dionissi*, p. 50; [Popov, G.V., *Zhivopis i miniatyura Moskvy serediny XV — nachala XVI veka*, p. 121, pl. 194].

121. STUDIO OF DIONYSII
SAINT DEMETRIUS OF PRILUTSK WITH SCENES FROM HIS LIFE

Late 15th century. 139.5x111 cm. Regional Ethnographic Museum, Vologda [1593].

From the cathedral in the Monastery of Prilutsk near Vologda. In good condition. A crack in the upper right corner can be seen, and also the traces of the nails of the covering on the background. The problem of the date is still controversial. In the 1503 Chronicle of Vologda, a not too dependable piece of information is preserved, according to which Ivan III took this icon with him in the campaign against Kazan. V.A. Bogusevich states that the icon goes back to 1485/87–1503. In his unpublished essay on Dionysii, N.K. Goleyzovski, supposing that in the Vologda Chronicle the Dionysii in question was Dionysii of Glushchitskii, proposes an early sixteenth-century date. The style of the icon is reminiscent of the works from the 1480s (hagiographical icons of the Metropolitans Peter and Alexius), from which it clearly differs in its darker colors.

Bibliography: Bogusevich, V.A., "Zhivopis kontsa XV stoletiya v privolgodskom rayone," in *Severnye pamyatniki drevnerusskoy stankovoy zhivopisi*, Vologda 1929, pp. 14–17; Danilova, I.E., *Dionissi*, p. 50; [Vzdornov, G., *Vologda*, pp. 63–64, pls. 36–38 on pp. 59–61; Popov, G.V., *Zhivopis i miniatyura Moskvy serediny XV — nachala XVI veka*, pp. 113–116, pls. 181, 182; *Zhivopis Vologodskich zemel XIV — XVIII vekov*, catalogue, edited by I. Pyatnitskaya, N. Fedyshin, O. Kozoderova, L. Charlampenkova, M. 1976, n. 21; Rybakov, A.A., *Chudozhestvennye pamyatniki Vologdy XIII — nachala XX veka*, p. 13, pls. 41–43].

122. STUDIO OF DIONYSII
SAINT CYRIL OF BELOZERSK

Early 16th century. 122.5x62.5 cm. Russian Museum, Saint Petersburg [2733].

From the Monastery of Cyril of Belozersk. In good condition. A crack runs through the center, which also affects the face. Covering from the same period. In their interpretation of the faces of hermits and ascetics, Dionysii and the masters of his circle elaborated a preferred type which was repeated with minimal variations, yet still sufficient to express a barely perceptible individual nuance each time.

Bibliography: Alpatov, M.V. — Brunov, N., *Geschichte del altrussischen Kunst*, Augsburg 1932, vol. I, p. 324, vol II, pl. 250; Lazarev, V.N., "Dionisii i ego shkola," in *Istoriya russkogo iskusstva*, t. III, p. 514, ill. on pp. 498 and 499; [Lazarev, V.N., *Moskovskaya shkola ikonopisi*, p. 50, pl. 79; Popov, G.V., *Zhivopis i miniatyura Moskvy serediny XV — nachala XVI veka*, pp. 99–100, pl. 141; *Dionisii i iskusstvo Moskvy XV–XVI stoletii*, catalogue, L. 1981, p. 45, n. 44, pl. 40].

123. DIONYSII'S FOLLOWERS
SAINT ANDREW YURODIVYI [GOD'S FOOL] WITH SCENES FROM HIS LIFE

Early 16th century. 132x101 cm. Russian Museum, Saint Petersburg [2009].

In the N.P. Lichachev collection. In mediocre condition. The surface layer of colors is chipped in many places. Two deep vertical cracks. Except in the scene of the Virgin of Mercy, representations of Andrew Yurodivyi are quite rare in early Russian painting. In spite of the lacunae, the coloring, with a predominance of soft pistachio green, has kept most of its original charm.

Bibliography: Lichachev, N.P., *Materialy dlya istorii russkogo ikonopisaniya*, atlas, part I, pl. CLXX; [Lazarev, V.N., *Moskovskaya shkola ikonopisi*, pp. 50–51, pls. 81, 82; *Dionisii i iskusstvo Moskvy XV–XVI stoletii*, catalogue, pp. 58–59, n. 78].

124. DIONYSII
THE CRUCIFIXION

1500. 85x52 cm. Tretyakov Gallery, Moscow [29554].

From the tier of *Feasts* of the iconostasis from the Cathedral of the Trinity in the Monastery of Paul of Obnora, founded in 1415 by Paul of Obnora (d. 1429), a disciple of Saint Sergius of Radonezh. In good condition. The background and cornice were golden. Traces of the nailed covering are seen on the background. The *levkas* on the bottom and right borders is lost. Left border trimmed. Since the Cathedral of the Trinity, from which the icon came, was built in the years 1505–1516 by Vasilii III, the date (1500) on the verso of the icon of *Christ in Glory* from the same cathedral seems doubtful. We would have to assume that the icons of an earlier iconostasis were placed in the cathedral. The use of icons from the early fifteenth century as models is very indicative of Dionysii's style. [Another icon from the same register of *Feasts* has recently been disclosed, the *Unbelief of Thomas*, preserved in the Russian Museum; see Kochetkov, I.A., "Eshche odno proizvedenie Dionisiya," in *Pamyatniki kultury. Novye otkrytiya. 1980*, L. 1981, pp. 261–267; concerning this icon, see also: Eding B., "Obraz 'Fomino ispytanie' v Rumyantsevskom muzee," in *Starye gody*, April–June 1916, pp. 125–128].

Bibliography: *Masterpieces of Russian Painting*, pl. XXXII, pp. 116–117; Antonova, V.I., *Novootkrytye proizvedeniya Dionisiya v. Gos. Tretyakovskoy galeree*, M. 1952, pp. 6–15; SSSR *Drevnye russkie ikony*, pl. XXX, p. 28; Antonova, V.I. — Mneva, N.E., *Katalog drevnerusskoy zhivopisi*, t. I, n. 277, pp. 333–334; [Alpatov, M.V., "L'interprétation des icônes russes (à propos de la 'Crucifixion' de Dionysios)," in *L'information d'histoire de l'art*, t. 13, 1968, pp. 151–169) (in Russian, see Alpatov, M.V., *Etyudy po vseobshchey istorii iskusstv*, M. 1979, pp. 167–183)]; Danilova, I.E., *Dionissi*, pp. 98–102; Goleyzovskii, N. — Yamshchikov, S., *Dionisii*, pls. 1–4; [Lazarev, V.N., *Moskovskaya shkola ikonopisi*, pp. 46–47, pl. 69; Vzdornov, G., *Vologda*, pp. 63, 64, pl. 39 on p. 62; Alpatov, M.V., *Drevnerusskaya ikonopis*, pls. 155, 156, p. 316; Popov, G.V., *Zhivopis i miniatyura Moskvy serediny XV — nachala XVI veka*, pp. 97–98, pls. 137–140; Orlova, M.A., "Nekotorye zamechaniya o tvorchestve Dionisiya," in *Drevnerusskaya iskusstvo. Problemy i atributsii*, pp. 321–334, sec. "K izucheniyu ikony 'Raspyatie' iz Pavlo-Obnorskogo monastyrya (1500 god)"].

125. DIONYSII
THE VIRGIN HODEGETRIA

1502. 141x106 cm. Russian Museum, Saint Petersburg [3095].

From the local tier of the iconostasis from the Cathedral of the Nativity of the Virgin in the Ferapont Monastery. In good condition. Two deep vertical cracks. Addition of new *levkas* on the halos. The gold background is very damaged. The preparatory design can be distinctly seen through the fine layer of colors on the face. After the icon of the *Virgin Hodegetria* from 1482, this is the most unquestioned work of Dionysii.

Bibliography: Pertsev, N.V., "O novootkrytom proizvedenii Dionisiya," in *Drevnerusskoe iskusstvo. Chudozhestvennaya kultura Moskvy i prilezhashchich k ney knyazhestv. XIV–XVI vv.*, pp. 155–173; Smirnova, E.S., *Zhivopis drevney Rusi. Nachodki i otkrytiya*, pls. 28–30; Danilova, I.E., *Dionissi*, p. 60; [Lazarev, V.N., *Moskovskaya shkola ikonopisi*, pp. 47–48, pls. 70, 71; Popov, G.V., *Zhivopis i miniatyura Moskvy serediny XV — nachala XVI veka*, pp. 111–112, pls. 175, 176].

126. STUDIO OF DIONYSII
IN YOU EVERYTHING REJOICES

Early 16th century. 146x110 cm. Tretyakov Gallery, Moscow [28640].

From the Cathedral of the Dormition in Dmitrov. In good condition. Remnants of gold on the background and cornices. The tendency toward the standardization of iconographic methods and the types of faces clearly appears in this icon. In the Cathedral of the Dormition in the Kremlin, Moscow, there is a slightly earlier and qualitatively better icon on the theme *In You Everything Rejoices,* which also came from Dionysii's workshop (Danilova, I.E., *Dionissi*, pl. 16).

Bibliography: *Masterpieces of Russian Painting*, pl. LI, p. 123; Antonova, V.I. — Mneva, N.E., *Katalog drevnerusskoy zhivopisi*, t. I, n. 280, pp. 341–342, pls. 226–229; [Onasch, K., *Ikonen*, pl. 108, p. 392]; Danilova, I.E., *Dionissi*, pp. 61–62; Goleyzovskii, N. — Yamshchikov, S., *Dionisii*, pls. 15–17; [Alpatov, M.V., *Drevnerusskaya ikonopis*, pls. 169, 170, p. 318].

127. STUDIO OF DIONYSII
DEESIS: THE VIRGIN; SAINT JOHN THE BAPTIST; THE ARCHANGEL MICHAEL; THE ARCHANGEL GABRIEL; SAINT GREGORY THE THEOLOGIAN; SAINT DEMETRIUS OF THESSALONICA

1502. 155x62, 157x60, 157x60, 157x66, 157x59, 157x60 cm. Tretyakov Gallery, Moscow (the Virgin, Saint John the Baptist, the Archangel Michael, Saint Demetrius of Thessalonica) [28627, 28628, 28631, 28632]; Russian Museum, Saint Petersburg (the Archangel Gabriel, Saint Gregory the Theologian) [3090, 3089].

From the iconostasis of the Cathedral of the Nativity of the Virgin in the Ferapont Monastery. The *Deesis* consisted of fifteen figures, now in the Tretyakov Gallery, the Russian Museum, and the Historical Art Museum of the Monastery of Cyril. In good condition. Irrelevant losses in the surface layer of colors, repaired during restoration. On the chipped gold background there are traces of the nails of the covering. Most of the figures go back to Rublevian models, which confirms once again the primacy of tradition in the art of Dionysii and the masters of his circle.

Bibliography: Antonova, V.I. — Mneva, N.E., *Katalog drevnerusskoy zhivopisi*, t. I, n. 278, pp. 334–336, pls. 212, 216–223; Smirnova, E.S., *Zhivopis drevney Rusi. Nachodki i otkrytiya*, pls. 23, 24; Danilova, I.E., *Dionissi*, p. 97, pls. 79–83; Goleyzovskii, N. — Yamshchikov, S., *Dionisii*, pls. 17–20; [Lazarev, V.N., *Moskovskaya shkola ikonopisi*, p. 49, pls. 74–76; Alpatov, M.V., *Drevnerusskaya ikonopis*, pls. 101–104, 165, p. 307; Popov, G.V., *Zhivopis i miniatyura Moskvy serediny XV — nachala XVI veka*, p. 108, pls. 151–164; *Dionisii i iskusstvo Moskvy XV–XVI stoletii*, catalogue, pp. 40–41, n. 33].

128. DIONYSII AND PUPILS
THE DESCENT INTO HELL

1502. 137x99.5 cm. Russian Museum, Saint Petersburg [3094].

From the local tier of the iconostasis from the Cathedral of the Nativity of the Virgin in the Ferapont Monastery. In good condition as a whole. Irrelevant chipping and losses in the surface layer of colors (especially in the figure of the "gloriole" around Christ) and in the gold on the background and cornice.

Bibliography: Laurina, V.K., "Vnov raskrytaya ikona 'Soshestvie vo ad' iz Ferapontova monastyrya i moskovskaya literatura kontsa XV v.," in *Trudy Otdela drevnerusskoy literatury Instituta russkoy literatury (Pushkinskii Dom) Akademii nauk SSSR*, XXII, pp. 165–187; [Goleyzovskii, N.K., "Zhivopisets Dionisii i ego shkola," in *Voprosy istorii*, 1968, n. 3, p. 217]; Smirnova, E.S., *Zhivopis drevney Rusi. Nachodki i otkrytiya*, pls. 25–27; Danilova, I.E., *Dionissi*, pp. 102–110; [Lazarev, V.N., *Moskovskaya shkola ikonopisi*, pp. 47–49, pls. 72, 73; Popov, G.V., *Zhivopis i miniatyura Moskvy serediny XV — nachala XVI veka*, pp. 111–112, pls. 177–180; *Dionisii i iskusstvo Moskvy XV–XVI stoletii*, catalogue, p. 41, n. 35, pl. 38].

129. FOLLOWER OF DIONYSII
THE FEAST DAYS OF THE WEEK

Early 16th century. 110x91 cm. Tretyakov Gallery, Moscow [12058].

In the I.S. Ostrouchov collection (from Vologda). In relatively good condition. The icon was recently cleaned, which has been very beneficial. Chipping on the surface layer of colors is visible. Most lacunae are seen on the background and cornice, where very little of the original gold is left.

Bibliography: Muratov, P.P., *Drevnerusskaya ikonopis v sobranii I.S. Ostrouchova*, pp. 24–25; Antonova, V.I. — Mneva, N.E., *Katalog drevnerusskoy zhivopisi*, t. I, n. 281, pp. 342–344; [Lazarev, V.N., *Moskovskaya shkola ikonopisi*, p. 50, pl. 80; Alpatov, M.V., *Drevnerusskaya ikonopis*, pls. 157, 158, p. 316].

130. SAINT NICHOLAS OF ZARAYSK WITH SCENES FROM HIS LIFE

First half of 14th century. 128x75 cm. Tretyakov Gallery, Moscow [dr 46].

From the village of Pavlov near Rostov Velikii. In relatively good condition. Losses in the surface layer of colors and insignificant additions of new *levkas* are visible. Borders trimmed, lower border added later. Ocher background on the central part and white background on the border scenes. This is one of the most spontaneous and expressive examples of "primitive" Russian art.

Bibliography: Antonova, V.I., "Moskovskaya ikona nachala XIV v. iz Kieva i 'Povest o Nikole Zarayskom,'" in *Trudy Otdela drevnerusskoy literatury Instituta russkoy literatury (Pushkinskii Dom) Akademii nauk SSSR*, XIII, M.-L. 1957, p. 383, fig. 3; Antonova, V.I. — Mneva, N.E., *Katalog drevnerusskoy zhivopisi*, t. I, n. 164, pp. 205–206, pls. 118–122; Rozanova, N.V., *Rostovo-Suzdalskaya zhivopis XII–XVI vekov*, pls. 16–19; [Alpatov, M.V., *Drevnerusskaya ikonopis*, pls. 50, 51, 58, p. 301].

131. THE HOLY FACE

First half of 14th century. 89x70 cm. Tretyakov Gallery, Moscow [25540].

From the Church of the Presentation in the Temple in Rostov Velikii, where it came from a wooden church in the district of Boris and Gleb,

burned down at the beginning of the sixteenth century. In good condition. There are partial lacunae on the white background and cornice. Two vertical cracks with addition of a new *levkas*.

Bibliography: Antonova, V.I. — Mneva, N.E., *Katalog drevnerusskoy zhivopisi*, t. I, n. 161, p. 201, pl. 114; Rozanova, N.V., *Rostovo-Suzdalskaya zhivopis XII–XVI vekov*, p. 8; [Vzdornov, G.I., *Zhivopis*, p. 264].

132. CHRIST WITH THE APOSTLES

Second half of 14th century. 92x64 cm. Tretyakov Gallery, Moscow [dr 52].

The icon came to the Tretyakov Gallery from the Museum of Regional Art in Yaroslav, where it had probably come from Rostov. In mediocre condition. Extensive chipping in the surface layer of colors. On the upper and lower borders and also to the left, we find additions of new *levkas* and restoration of the painting. Ocher background and borders, bright yellow halos. It is one of the few icons from Rostov (?) in which Byzantine influence is felt. The elongated face of Christ is characterized by its great refinement.

Bibliography: [*Drevnosti. Trudy Komissii po sochraneniyu drevnych pamyatnikov imp. Moskovskogo archeologicheskogo obshchestva*, t. IV, M. 1912, pp. 224–229 (from Plovni, property of A.I. Musin-Pushkin in the vicinity of Rostov)]; Antonova, V.I. — Mneva, N.E., *Katalog drevnerusskoy zhivopisi*, t. I, n. 167, pp. 208–209, pls. 124, 125.

133. SAINT NICHOLAS THE WONDERWORKER WITH SCENES FROM HIS LIFE

15th century. 122x80 cm. Tretyakov Gallery, Moscow [28747].

From the Church of the Presentation in the Temple in Rostov Velikii. In relatively good condition. Partial lacunae in the original paint and losses in the surface layer of colors. Additions of new *levkas* along the two vertical cracks and in the lower part of the tablet. The background of the central part is pale green, the halo is white, and the backgrounds of the border scenes are white. The central part is surrounded by a decoration of letters from an alphabet which V.I. Antonona regards as a cryptogram, not yet deciphered, composed of letters from the Zyrian alphabet. The elegant and slender proportions of the half-length figure of Nicholas, with his fine face, are in contrast to the primitive and sturdy figures in the border scenes.

Bibliography: Antonova, V.I. — Mneva, N E., *Katalog drevnerusskoy zhivopisi*, t. I, n. 175, pp. 217–218.

134. THE NATIVITY OF THE VIRGIN

Late 14th century. 32x24 cm. Russian Museum, Saint Petersburg [2131].

From the Monastery of the Virgin of Mercy in Suzdal. In good condition. Fourteenth-century covering in embossed silver. Together with the *Virgin Hodegetria* from the same monastery, this icon has a particular stylistic character which is more reminiscent of the works from the region of Pskov and Novgorod than of those from the artistic centers of Central Russia.

Bibliography: Dmitriev, Yu.N., *Gos. Russkii muzey. Putevoditel. Drevnerusskoe iskusstvo*, p. 48; *SSSR. Drevnye russkie ikony*, p. 26, ill. on p. 15; Rozanova, N.V., *Rostovo-Suzdalskaya zhivopis XII–XVI vekov*, pl. 48; Vzdornov, G.I., *Zhivopis*, p. 356; Popov, G.V. — Ryndina, A.V., *Zhivopis i prikladnoe iskusstvo Tveri. XIV–XVI veka*, pp. 134–135, catalogue, n. 8, pp. 279–281, ill. on pp. 386 and 387.

135. THE ARCHANGEL MICHAEL

Late 14th century. 86x63 cm (insert, size of the original tablet 83x59 cm). Tretyakov Gallery, Moscow [12869].

From the Church of the Resurrection on Lake Myachino in Novgorod, from where it went to the S.P. Ryabushinskii collection. In good condition. Two vertical cracks, repaired with new *levkas*. The left eye has been repainted by the restorer. Small additions of new *levkas* on the cloak, left wing, and right hand. Silvery background and cornice. Even though the icon came from Novgorod, it stands out from the group of Novgorodian works because of its pictorial style as well as its silvery color. N.P. Sychev would be inclined to link it with the school of Vladimir-Suzdal; I.E. Grabar and E.S. Smirnova, with the school of Suzdal [subsequently of Novgorod]. This attribution may be accepted only with some reservations since there are not many icons from Suzdal stylistically close to the one in question which might support this hypothesis. The interpretation of the face is somewhat reminiscent the icon of *Boris and Gleb* in the Russian Museum, as N.P. Sychev has accurately observed, but the latter icon can be traced to an earlier time.

Bibliography: Sychev, N.P., "Ikona archangela Michaila iz sobraniya S.P. Ryabushinskogo," in *Russkaya ikona*, 2, Spb. 1914, pp. 99–100; Grabar, Igor, *O drevnerusskom iskusstve*, p. 161, note 70 (in the essay "Andrey Rublyov"); Antonova, V.I. — Mneva, N.E., *Katalog drevnerusskoy zhivopisi*, t. I, n. 22, pp. 91–92, pl. 56; Smirnova, E.S., *Zhivopis Obonezhya XIV–XVI vekov*, p. 56, note 98 on p. 53; Goleyzovskii, N. — Ovchinnikov, A. — Yamshchikov, S., *Sokrovishcha Suzadlya*, p. 107; Rozanova, N.V., *Rostovo-suzdalskaya zhivopis XII–XVI vekov*, p. 47; [Alpatov, M.V., *Drevnerusskaya ikonopis*, pl. 2, p. 292]; Smirnova, E.S., *Zhivopis Velikogo Novgorada. Seredina XIII — nachalo XV veka*, p. 98, catalogue, n. 23, pp. 230–232, ill. on p. 338].

136. RECTO: THE SAVIOR
VERSO: THE VIRGIN HODEGETRIA

1360s. 68x46 cm. Tretyakov Gallery, Moscow [12767].

From the Monastery of the Virgin of Mercy in Suzdal. In relatively good condition. Partial chipping on the surface layer of the face, hands, and garment. Vertical crack repaired with new *levkas*. Bright yellow halo, straw-colored background, pink borders. The half-length figure of Christ adorns the recto of the icon, and the *Virgin Hodegetria* is depicted on the verso. The refined design of Christ's face anticipates in many of its characteristics the Rublev model of the Savior in the *Deesis* "of Zvenigorod." The artist who painted this two-sided icon undoubtedly knew the best Byzantine paintings. It is known that after having transferred the capital of his principality from Suzdal to Nizhnii Novgorod in 1350, the Prince of Suzdal, Konstantin Vasilevich, placed in the Cathedral of the Transfiguration in this city, a Byzantine icon of the Savior brought from Suzdal, and perhaps echoes of that painting are felt in our icon.

Bibliography: Kondakov, N.P., *Russkya ikona*, t. IV, text, pt. 2, p. 329; Antonova, V.I., "Ikonografischeskii tip Perivlepty i russkie ikony Bogomateri v XIV veke," in *Iz istorii russkogo i zapadnoevropeyskogo iskusstva*, pp. 109–110; Antonova, V.I. — Mneva, N.E., *Katalog drevnerusskoy zhivopisi*, t. I, n. 170, pp. 211–212, pls. 128, 129; Rozanova, N.V., *Rostovo-suzdalskaya zhivopis XII–XVI vekov*, pl. 45.

137. THE VIRGIN OF MERCY

Second half of 14th century. 68x44 cm. Tretyakov Gallery, Moscow [12755].

From the Monastery of the Virgin of Mercy in Suzdal. In very poor condition. Many lacunae and losses in the surface layer of colors. White background, yellow borders. For the iconography on the Virgin of Mercy, see the bibliography given in note 19.

Bibliography: Ainalov, D., *Geschichte der russischen Monumentalkunst zur Zeit des Grossfürstentums Moskau*, p. 89; Antonova, V.I. — Mneva, N.E., *Katalog drevnerusskoy zhivopisi*, t. I, n. 171, pp. 213–214; Rozanova, N.V., *Rostovo-suzdalskaya zhivopis XII–XVI vekov*, pl. 44; [Alpatov, M.V., *Drevnerusskaya ikonopis*, pl. 32, p. 297].

138. THE PROPHET ELIJAH WITH SCENES FROM HIS LIFE

Late 14th century. 135x83 cm. Museum of Fine Arts, Nizhnii Novgorod (Gorkii) [3].

From the G.M. Pryanishnikov collection in Gorodets on the Volga, where it came from the Church of the Prophet Elijah of the Old Believers in the same city. According to the studies of Yu.A. Olsufev, the icon was in the Monastery of the Triumph of the Cross in Nizhnii Novgorod, founded in the fourteenth century. The preservation of some border scenes is rather good. Many lacunae in the lower part of the panel. Vertical cracks repaired with new *levkas*. This is one of the oldest Russian icons of Elijah with scenes from his life. The following events are shown in the border scenes: 1. the birth of Elijah and the vision of his father Sivach; 2. the instruction of Elijah; 3. the pagans' accusation; 4. Elijah in the desert; 5. Elijah in conversation with God; 6. the sacrifice offered by the pagan priests; 7. Elijah's sacrifice; 8. Elijah invites the priests to convert; 9. the appearance of the angel to Elijah in the dream; 10. the raising of the widow's son; 11. Elijah and Elisha crossing the Jordan. In pictures 13, 14, and 15, the following scenes may have been shown: Elijah introducing himself to King Ahab, Ahab's slain body transported in the chariot, and Elijah punishing the king's soldiers. In the central part, we find an unusual bringing together of the Virgin of the Sign with two angels and Elijah ascending to heaven in the fiery chariot. The heavenly chariot is drawn by four winged horses, and Elijah, seated in the chariot, expresses his compassion for Elisha. The icon is painted in an extraordinarily bold and dynamic style which has no close stylistic analogy in all the iconography of the fourteenth century. Its ample pictorial style and the expressive "continuous" shapes of the figures recall the frescoes of Theophanes the Greek, who worked in Nizhnii Novgorod during the 1380s. The faces are painted with a decisive hand on the dark *sankir,* and the eyes are underlined with bright white brush strokes. The local artist interpreted Theophanes the Greek's art in his own way, translating it into a more primitive formal language, while at the same time preserving all its expressiveness.

Bibliography: Mneva, N.E., *Drevnerusskaya zhivopis Nizhnego Novgoroda*, p. 32; [*Rostovo-suzdalsakaya shkola zhivopisi*, catalogue, M. 1967, p. 87, n. 31, ill. on p. 43]; Vzdornov, G., *O zhivopisi Severo-Vostochnoy Rusi XII–XV vekov*, pls. 76–79; [Balakin, P., "Zhivopisnyi pamyatnik geroicheskoy epochi," in *Iskusstvo*, 1982, 6, pp. 67–70].

139. THE DEESIS

Second half of 15th century. 102x90 cm. Tretyakov Gallery, Moscow [12124].

In the I.S. Ostrouchov collection. In good condition. Normally attributed to the Novgorod school, although N.E. Mneva does not connect it to Nizhni Novgorod with convincing arguments. The *Deesis*, painted on a single panel, had the figures of the Archangels Michael and Gabriel (now found in the Museum of Nizhni Novgorod) at the sides. P.P. Mu-

ratov rightly wrote that the author of this icon had "a personality not very marked, but at least significant and above all original."

Bibliography: Muratov, P.P., *Drevnerusskaya ikonopis v sobranii I.S. Ostrouchova*, pp. 10–11; Mneva, N.E., *Drevnerusskaya zhivopis Nizhnego Novgoroda*, p. 34; Antonova, V.I. — Mneva, N.E., *Katalog drevnerusskoy zhivopisi*, t. I, n. 123, pp. 169–170.

140. SAINTS BORIS AND GLEB

Early 14th century. 154x104 cm. Russian Art Museum, Kiev [zh-1].

From the Church of the Ascension in the Monastery of Saint Savva on the River Vishera, founded in the fifteenth century by people from Tver. From there, the icon went to the P.I. Charitonenko collection and was kept in his name in the village church of Natalevka, governorship of Charkov. In relatively good condition. There are many small areas of plaster and repair in the damaged areas. Very little is left of the original silvery background. In the fourteenth (?) century, a red background was spread over it, which was removed in the restoration. The halos, the fibulae, and the hilts of the swords were inlaid with precious stones (the hollowed-out traces can be seen). The faces are the best preserved parts, with sharp highlightings applied like fine white lines (this method is slightly reminiscent of the Tver royal doors in the Tretyakov Gallery, see n. 142). The icon is usually attributed to the Novgorod school, but its color is completely different from the works of the Novgorodian masters. G.I. Vzdornov (his essay dedicated to this icon has not been published) attempted to relate it to the works from Tver. Although it gravitates more toward the art of the thirteenth century, this icon, nevertheless, could not have been executed before the early part of the fourteenth century.

Bibliography: Onasch, K., *Ikonen*, pl. 20, pp. 353–354; Chernogubov, N.N., "Ikona 'Boris i Gleb' v Kievskom muzee russkogo iskusstva," in *Drevnerusskoe iskusstvo XV — nachala XVI veka*, pp. 285–290; Popov, G.V., "Puti razvitiya tverskogo iskusstva v XIV — nachala XVI veka (zhivopis, miniatyura)," in *Drevnerusskoe iskusstvo. Chudozhestvennaya kultura Moskvy i prilezhashchich k ney knyazhestv. XIV–XVI vv.*, p. 314; [Evseeva, L.M. — Kochetkov, I.A. — Sergeev, V.N., *Zhivopis drevney Tveri*, M. 1974, pp. 10–12, pls. 1–3; Popov, G.V. — Ryndina, A.V., *Zhivopis i prikladnoe iskusstvo Tveri. XIV–XVI veka*, pp. 32–41, catalogue, n. 1, pp. 252–259, ill. on pp. 371–373].

141. THE NATIVITY OF CHRIST; THE RAISING OF LAZARUS; THE ASCENSION

Mid 15th century. 103x81, 103x80, 102x81 cm. Tretyakov Gallery, Moscow [17297, 22039]; Russian Museum, Saint Petersburg (the Raising of Lazarus) [2723].

From the Tver Cathedral, where they came from the Cathedral of the Resurrection in Kashin. In good condition with the exception of lacunae on the lower borders. The icons formed part of the tier of *Feasts* in the iconostasis, from which we also have the following: the *Presentation in the Temple* and *Baptism* (Russian Museum), the *Entry into Jerusalem* and *Descent into Hell* (Tretyakov Gallery). Also belonging to the same iconostasis were eleven icons in the *Deesis* and nine in the register of *Prophets* (Russian Museum) with the *Virgin of the Sign* in the center (Tretyakov Gallery). Many masters worked on the iconostasis of the Cathedral of the Ascension. They were under the twofold influence of Moscow and Novgorod. Most of these masters must have been natives of the area since the icons of the *Feasts* are characterized by a particular style and structure of composition.

Bibliography: Protasov, N.D., "Kashinskie pamyatniki," in *Izvestiya Rossiiskoy akademii istorii materialnoy kultury*, t. I, Pg. 1921, pp. 32–40; *Masterpieces of Russian Painting*, pl. XXXI, p. 116; Dmitriev, Yu.N., "Kashinskie pamyatniki," in *Soobshcheniya Gos. Russkogo muzeya*, II, L. 1947, pp. 43–45; Voronin, N.N. — Lazarev, V.N., "Iskusstvo srednerussisch knyazhestv XIII–XV vekov," in *Istoriya russkogo iskusstva*, t. III, pp. 32, 34, 36, ill. on pp. 35, 37, 39; Onasch, K., *Ikonen*, pl. 115, p. 393; Antonova, V.I. — Mneva, N.E., *Katalog drevnerusskoy zhivopisi*, t. I, n. 207, pp. 240–242, pls. 149, 150; Popov, G.V., "Puti razvitiya tverskogo iskusstva v XIV — nachala XVI veka (zhivopis, miniatyura)," pp. 348–350; [Evseeva, L.M. — Kochetkov, I.A. — Sergeev, V.N., *Zhivopis drevney Tveri*, pp. 41–45, pls. 56–68; Popov, G.V., "Kashinskii chin i kultura Tveri serediny XV veka," in *Drevnerusskoe iskusstvo. Problemy i atributsii*, pp. 223–262; Guseva, E.K., "Ob ikone 'Znamenie' iz Kashinskogo china," ibid., pp. 263–272; Popov, G.V. — Ryndina, A.V., *Zhivopis i prikladnoe iskusstvo Tveri. XIV–XVI veka*, pp. 150–174, catalogue, n. 14–16, ill. on pp. 404–432, with the article by S.I. Golubtsev, "K voprosu o proischozhdenii kashinskogo ikonostasa," on pp. 366–368, as an appendix].

142. THE ROYAL DOORS WITH IMAGES OF SAINTS JOHN CHRYSOSTOM AND BASIL THE GREAT

Second half of 14th century. 111.5x36, 111.5x35 cm. Tretyakov Gallery, Moscow [12002 and 29560].

The left anta comes from the I.S. Ostrouchov collection, the right, from the Tver Museum of History and Architecture. In good condition. Flaking of the paint can be seen in the lower part (in the right anta a small piece of the panel has been cut off). The upper part of the doors has not survived. Yellow background with black outline. Professor N.M. Karpinskii points to Southern Slavic elements in the inscriptions. The royal doors, which paleographers are inclined to date back to the late fourteenth century, clearly indicate how, in comparison with Moscow, Tver was behind in terms of its artistic development.

Bibliography: Muratov, P.P., *Drevnerusskaya ikonopis v sobranii I.S. Ostrouchova*, pp. 12–13; Antonova, V.I. — Mneva, N.E., *Katalog drevnerusskoy zhivopisi*, t. I, n. 199, pp. 233–235, pls. 138, 139; Popov, G.V., "Puti razvitiya tverskogo iskusstva v XIV — nachala XVI veka (zhivopis, miniatyura)," pp. 320–322; [Evseeva, L.M. — Kochetkov, I.A. — Sergeev, V.N., *Zhivopis drevney Tveri*, p. 18, pls. 10, 11; Popov, G.V. — Ryndina, A.V., *Zhivopis i prikladnoe iskusstvo Tveri. XIV–XVI veka*, pp. 70–77, catalogue, n. 4, pp. 265–268, ill. on pp. 378 and 379].

143. SAINT HYPATIUS OF GANGRA WITH SCENES FROM HIS LIFE

First half of 15th century. 112x81 cm. Tretyakov Gallery, Moscow [6135].

Origin unknown. In good condition except for some lacunae in the gold on the background and cornice. The icon has been reliably attributed by N.E. Mneva to the group of Tver works. Hypatius of Gangra is a saint rarely represented in Russian iconography. In the border scenes, the apocryphal account of the "seven deaths" of Hypatius is illustrated (see Tichonravov, N., *Pamyatniki otrechennoy russkoy literatury*, II, M. 1863, pp. 121–145). The narrative unfolds in this sequence: 1. Hypatius instructs the clergy of Gangra; 2. the soldiers enter into the church to escort Hypatius to the emperor; 3. Hypatius stands before the emperor; 4. Hypatius baptizes the pagans; 5. Hypatius raises the hegemon's [ruler's] wife; 6. with the cross, Hypatius tames the "deep" serpent coming out of the sea; 7. Hypatius is roasted "like a fish"; 8. Hypatius is dragged over the rocks by horses; 9. Hypatius is burned in the statue of an ox cast in copper; 10. Hypatius drives the devil away; 11. Hypatius is buried alive and tin is poured down his throat; 12. Hypatius in prison has a vision of the Savior; 13. Hypatius is boiled in a pot; 14. Hypatius' hands and feet are cut off; 15. Hypatius before the hegemon; 16. Hypatius' seventh death by being crushed under heavy stones.

Bibliography: Antonova, V.I. — Mneva, N.E., *Katalog drevnerusskoy zhivopisi*, t. I, n. 204, pp. 238–239, pls. 147, 148; Popov, G.V., "Puti razvitiya tverskogo iskusstva v XIV — nachala XVI veka (zhivopis, miniatyura)," pp. 328–330; [Popov, G.V. — Ryndina, A.V., *Zhivopis i prikladnoe iskusstvo Tveri. XIV–XVI veka*, pp. 222, 226–227, catalogue, n. 26, ill. on pp. 224, 225 and 447–451].

General Bibliography

Abel, U., *Russische Ikonen aus dem Nationalmuseum*, Stockholm-Berlin 1978.

Ainalov, D., *Geschichte der russischen Monumentalkunst zur Zeit des Gross-fürstentums Moskau*, Berlin-Leipzig 1933.

_____, Review of the book: O. Wulff — M. Alpatoff, *Denkmäler der Ikonenmalerei*, Hellerau (Dresden) 1925, in *Bizantinische Zeitschrift*, vol. XXVI, 1926, pp. 414–419.

_____, Review of the catalogue: *Vystavka drevnerusskogo iskusstva, ustroennaya v 1913 godu v oznamenovanie chestvovaniya 300-letiya tsarstvovaniya doma Romanovych* (M. 1913), in *Bibliograficheskaya letopis*, I, Spb. 1914, sec. "Kritika i bibliografiya," pp. 30–34.

_____, Review of the following: *Russkaya ikona*, 1 and 2, Spb. 1914, in *Bibliograficheskaya letopis*, II, Spb. 1915, sec. "Kritika i bibliografiya," pp. 27–33.

Ainalov, D.V., *Istoriya russkoy zhivopisi s XVI po XIX stoletie*, ed. Studencheskogo komiteta pri Istoriko-filologicheskom fakultete S. Petersburgskogo universiteta, Spb. 1913.

Alpatoff, M., "Probleme der byzantinischen und russischen Kunstgeschichte. Forschungen in Russland 1914–1924," in *Belvedere (Forum)*, August-December 1924, pp. 84–91.

Alpatov, M. — Brunov, N., *Geschichte der altrussischen Kunst*, I–II (volume of texts and volume of plates), Augsburg 1932.

Alpatov, M.V., *Altrussische Ikonenmalerei*, Dresden 1958.

_____, *Andrey Rublyov*, M. 1972.

_____, "Byzantinisches Erbe in der altrurussichen Ikonenmalerei," in *Actes du XIIIᵉ Congrès international d'histoire de l'art*, I, Budapest 1972, pp. 233–248.

_____, "Chudozhestvennyi mir drevnerusskich ikon," in Alpatov, M.V., *Etyudy po vseobshchey istorii iskusstv*, M. 1979, pp. 161–166.

_____, *Drevnerusskaya ikonopisi*, M. 1974; 2nd ed., M. 1978.

_____, *Etyudy po istorii russkogo iskusstva*, t. 1, M. 1967 [essays "Iz istorii russkoy nauki ob iskusstve," "Feofan v Moskve," "Rublyov i Vizantiya," "Klassicheskaya osnova iskusstva Rublyova," "K voprosu o zapadnom vliyanni na drevnerusskoe iskusstvo," "Russkaya zhivopis kontsa XV v. i antichnoe nasledie v iskusstve Evropy," and others].

_____, *Feofan Grek*, M. 1979.

_____, *Le icone russe. Problemi di storia e d'interpretazione artistica*, Turin 1976.

_____, *Iskusstvo Drevney Rusi. Pamyatniki XI–XVII vv.*, M. 1969.

_____, *Kraski drevnerusskoy ikonopisi*, M. 1974.

_____, Review of the book: P. Muratov, *La pittura russa antica*, Prague-Rome 1925, in *Izvestiya na Bulgarskiya Archeologicheski institut*, IV (1926–1927), Sophia 1927, pp. 348–351.

_____, *Sokrovishcha russkogo iskusstva XI–XVI vekov (zhivopis)*, L. 1971.

_____, "Voprosy izucheniya i istolkovaniya drevnerusskogo iskusstva," in *Iskusstvo*, 1967, n. 1, pp. 64–70.

_____, *Vseobshchaya istoriya iskusstv*, t. III, *Russkoe iskusstvo s drevneyshich vremen do nachala XVIII veka*, M. 1955.

Alpatov, M.V. — Zonova, O.V., Chelyubeeva, Z.P., *Uspenkii sobor Moskovskogo Kremlya*, M. 1971.

Ancient Russian Icons from the XIIth to the XIXth Centuries. Lent by the Government of the USSR to British Committee and Exhibited by Permission at the Victoria and Albert Museum. 18th November to 14th December, 1929, London 1929.

Andersson, S.I., "Esquisse d'une théorie mathématique de l'icône," in *Les pays du Nord et Byzance (Scandinavie et Byzance). Actes du colloque à Upsal 20–27 avril 1979*, Upsala 1981, pp. 295–297.

Andreev, N., *Studies in Muscovy: Western Influence and Byzantine Inheritance*, London 1970 (in the series "Variorum Reprints") [essays "Pagan and Christian Elements in Old Russia," "Filofey and His Epistle to Ivan Vasilyevich," "O dele dyaka Viskovatogo," "Mitropolit Makarii kak deyatel religioznogo iskusstva," "Ioann Groznii i ikonopis XVI veka," "Inok Zinovii Otenskii ob ikonopochitani i ikonopisanii," "Literatura i ikonopis," "Nikon and Avvakum on Icon Painting"].

Andreeva, M., Review of book: N. P. Kondakov, *Russkaya ikona*, t. I–III, Prague 1928–1931, in *Byzantinoslavica*, III, Prague 1932, pp. 521–524.

Andreeva, M.A., "Noveyshie trudy po istorii russkoy ikony, vyshedshie v tsentralnoy Evrope," in *Tsentralnaya Evropa*, n. 6–7, Prague 1932, pp. 393–397.

Andrey Rublyov i ego epocha. Sbornik statey pod red. M. V. Alpatova, M. 1971 [essays by M. V. Alpatov, I.E. Danilova, A.I. Klibanov, V.D. Kuzmina, and N. A. Demina].

Anisimov, A., "Les anciennes icônes et leur contribution à l'histoire de la peinture russe," in *Fondation E. Piot. Monuments et mémoires publiés par l'Académie des Inscriptions et Belles-Lettres*, t. XXX, Paris 1929, pp. 151–165.

_____, "Domongolskoy period drevnerusskoy zhivopisi," in *Voprosy restavratsii*, II, M. 1928, pp. 102–182.

_____, *Gos. Istoricheskii muzey. Putevoditel po vystavke pamyatnikov drevnerusskoy ikonopisi*, M. 1926.

_____, "O sudbe starych ikon v Rossii," in *Trudy Vserossiiskogo sezda chudozhnikov v Petrograde, dekabr 1911 — yanvar 1912*, t. II, Pg. [1914], pp. 153–156.

_____, "Raskrytie pamyatnikov drevnerusskoy zhivopisi," in *Izvestiya Obshchestva archeologii, istorii i etnografii pri Kazanskom universitete*, t. XXX, 3, Kazan 1920, pp. 267–280.

Anisimov, A.I., "Die altrussische Ikonenmalerei. (Anlässlich der Ausstellung von Denkmälern altrussischer Malerei)," in *Ost-Europa*, year 4, fasc. 7–8, April–May 1929, pp. 444–449.

_____, "La peinture d'icônes en Russie," in *Formes*, 1930, IV, April, pp. 11–14.

_____, "Russian Icon-Painting: Its Bloom, Over-Refinement and Decay," in *Masterpieces of Russian Painting*, London 1930, pp. 61–91.

Antonova, V.I., *Drevnerusskoe Iskusstvo sobranii Pavla Korina*, M. 1967.

_____, "Stankovaya zhivopis srednevekovoy Rossii," in *Trista vekov iskusstva. Iskusstvo Evropeyskoy chasti SSSR*, M. 1976, pp. 144–206.

Antonova, V.I. — Mneva, N.E., *Katalog drevnerusskoy zhivopisi* [at the Tretyakov Gallery], t. I., *XI — nachala XVI veka*, M. 1963.

Babic, G., *Ikone. 64 reprodukcije u boji*, Zagreb 1980.

Bêlaev, N., "Les plus ancienne icônes russes," in *Congrès international des études byzantines*, Athens 1932, p. 363–371.

Belyaev, N., "Vystavka russkich ikon," in *Seminarium Kondakovianum*, III, Prague 1929, pp. 308–314.

Belyaev, N.M., "Drevnerusskaya ikonopis," in *Trudy V-go sezda russkich akademicheskich organizatsii za granitsey v Sofii 14–21 sentyabrya 1930 goda*, pt. 1, Sophia 1932, pp. 229–232.

Benua, A., "Ikony i novoe iskusstvo," in *Rech*, 1913, n. 93, p. 2.

_____, "Russkie ikony i Zapad," in *Rech*, 1913, n. 97, p. 2.

Betin, L., "K voprosu ob organizatsii rabot drevnerusskich zhivopitsev," in *Srednevekovaya Rus. Sbornik statey pamyati N.N. Voronina*, M. 1976, pp. 278–283.

Blankoff, J., *L'art de la Russie Ancienne*, Brussels 1963.

Blankov, Zh., "Iskusstvo Drevney Rusi i zapadnye slavisty," in *Trudy Otdela drevnerusskoy literatury Instituta russkoy literatury (Pushkinskii Dom) Akademii nauk SSSR*, XXII, M.-L. 1966, pp. 11–17.

Bréhier, L., "Les icônes dans l'histoire de l'art Byzance et la Russie," in *L'art byzantin chez les slaves*, II, Paris 1932, pp. 150–173.

Bulgakov, S., *Ikona i ikonopochitanie. Dogmaticheskii ocherk*, Paris 1931.

Buslaev, F.I., *Soch.*, t. I–II, Spb. 1908–1910.

Catalogue of Russian Icons Lent by American-Russian Institute. December 22, 1931, to January 17, 1932, Chicago 1932.

Concheva, M. — Ivanova, V., *Drevnoruski maystori. Teofan Grek. Andrey Rublov. Dionissii*, Sophia 1974.

Conway, M. "The History of Russian Icon Painting," in *Masterpieces of Russian Painting*, pp. 11–32.

Danilova, I.E., *Dionissi*, Dresden 1970; Vienna 1971.

Demina, N., *"Troitsa" Andreya Rublyova*, M. 1963.

Demina, N.A., *Andrey Rublyov i chudozhniki ego kruga. Sbornik, statey*, M. 1972 [essays "Natsioinalnye istoki tvorchestva Andreya Rublyova," "Istoricheskaya deystvitelnost XIV–XV vv. v iskusstve Andreya Rublyova i chudoznikov ego kruga," "Troitsa Andreya Rublyova," "Prazdnichnyi ryad ikonostasa Troitskogo sobora Troitse-Sergieva monastyrya," "Nasledie velikoy epochi"].

Denkmäler altrussischen Malerei. Russische Ikonen vom 12.–18. Jahrhundert. Ausstellung des Volksbildungskommissariats der RSFSR und der Deutschen Gesellschaft zum Studium Osteuropas in Berlin, Köln, Hamburg, Frankfurt a.M., Februar-Mai 1929, Berlin-Königsberg 1929.

Dionisii i iskusstvo Moskvy XV–XVI stoletii, catalogue of the exhibition, ed. T. B. Vilinbachova, V.K. Laurina, G.D. Petrova, L. 1981.

Dmitriev, Yu.N., *Gos. Russkii muzey. Putevoditel. Drevnerusskoe iskusstvo*, L.-M. 1940.

_____, *O tvorchestve drevnerusskogo chudozhnika*, in *Trudy Otdela drevnerusskoy literatury Instituta russkoy literatury (Pushkinskii Dom) Akademii nauk SSSR*, XIV, M.-L. 1958, pp. 551–556.

_____, *Ob istolkovanii drevnerusskogo iskusstva*, in ibid., XIII, M.-L. 1957, pp. 345–363.

_____, "Teoriya iskusstva i vzglyady na iskusstvo v pismennosti drevney Rusi," in ibid., IX, M.-L. 1953, pp. 97–116.

Drevnerusskaya zhivopis. Novye otkrytiya (iz chastnych sobranii), catalogue of the exhibition [at the Andrei Rublev Museum of Early Russian Art], ed. A. Loginova, M. 1975.

Drevnerusskoe iskusstvo [Sbornik statey]: [t. 1] *Drevnerusskoe iskusstvo XV — nachala XVI vekov*, M. 1963; [t. 2] *XVII vek*, M. 1964; [t. 3] *Chudozhestvennaya kultura Novgoroda*, M. 1968; [t. 4] *Chudozhestvennaya kultura Pskova*, M. 1968; [t. 5] *Chudozhestvennaya kultura Moskvy i prilezhashchich k ney knyazhestv. XIV–XVI vv.*, M. 1970; [t. 6] *Chudozhestvennaya kultura domongolskoy Rusi*, M. 1972; [t. 7] *Rukopisnaya kniga*, 1, M. 1972; [t. 8] *Rukopisnaya kniga*, 2, M. 1974; [t. 9] *Zarubezhnye svyazi*, M. 1975; [t. 10] *Problemy i atributsii*, M. 1977; [t. 11] *Monumentalnaya zhivopis XI–XVII vv.*, M. 1980; [t. 12] *Rukopisnaya kniga*, 3, M. 1983; [t. 13] *Drevnerusskoe iskusstvo kontsa XIII–XV vekov*, M. 1983.

Drevnye ikony staroobryadcheskogo kafedralnogo Pokrovskogo sobora pri Rogozhskom kladbishche v Moskve, M. 1956.

Ehlich, W., "Russische Ikonenumrahmungen," in *Byzantinoslavica*, XXX, 2, Prague 1969, pp. 246–252.

Evdokimov, P., *L'art de l'icône. Théologie de la beauté*, Paris 1970; Italian ed.: *La teologia della bellezza*, Rome 1971.

Evseeva, L.M. — Kochetkov, I.A. — Sergeev, V.N., *Zhivopis drevney Tveri*, M. 1974; 2nd ed., M. 1982.

Fedorov-Davidov, A., "Iz istorii drevnerusskogo iskusstva," in *Iskusstvo*, 1940, n. 5, pp. 73–96.

Felicetti-Liebenfels, W., *Geschichte der russischen Ikonenmalerei in den Grundzügen dargestellt*, Graz 1972.

Filatov, V.V., *Russkaya stankovaya tempernaya zhivopis. Technika i restavratsiya*, M. 1961.

Filimonov, G., "Ikonnye portrety russkich tsarey," in *Vestnik Obshchestva drevnerusskogo iskusstva pri Moskovskom Publichnom muzee*, 1875, n. 6–10, sec. "Issledovaniya," pp. 35–66.

_____, *Tserkov sv. Nikolaya Chudotvortsa na Lipne, bliz Novgoroda. Vopros o pervonachalnoy forme ikonostasa v russkich tserkvach*, M. 1859.

Florenskii, P., "Ikonostas," in *Bogoslovskie trudy*, 9, M. 1972, pp. 83–148; Italian ed.: *Le porte regali. Saggio sull'icona*, Milan 1977.

Fry, R., "Russian Icon Painting from the West European Point of View," in *Masterpieces of Russian Painting*, pp. 35–58.

Galavaris, G., *The Icon in the Life of the Church. Doctrine-Liturgy-Devotion*, Leiden 1981.

George R. Hann Collection, The, 1. *Icons and Russian Works of Art* [catalogue by Christie], New York 1980.

Georgievskii, V., *Pamyatniki starinnogo russkogo iskusstva Suzdalskogo muzeya*, M. 1927.

Georgievskii, V.T., "Ikony novgorodskogo tserkovno-istoricheskogo drevlechranilishcha," in *Svetilnik*, 1915, n. 9–12, pp. 1–5.

_____, "Obzor vystavki drevnerusskoy ikonopisi i chudozhestvennoy stariny," in *Trudy vserossiiskogo sezda chudozhnikov v Petrograde, dekabr 1911 — yanvar 1912*, t. III, Pg. [1914], pp. 163–168. See also: "Katalog vystaki drevnerusskoy ikonopisi i chudozhestvennoy stariny," ibid., pp. 169–174, plates I–L, LXXI–LXXV.

Gerhard, H., *Welt der Ikonen*, Recklinghausen 1957.

Goleyzovskii, N., "Dionisii i ego sovremenniki," in *Iskusstvo*, 1980, n. 6, pp. 57–61.

Goleyzovskii, N.K., "Isichazm i russkaya zhivopis XIV–XV vv.," in *Vizantiiskii vremennik*, 29, M. 1969, pp. 196–210.

_____, "Zametki o Dionisii," in *Vizantiiskii vremennik*, 31, M. 1971, pp. 175–187.

Goleyzovskii, N. K — Ovchinnikov, A. — Yamshchikov, S., *Sokrovishcha Suzadlya*, M. 1970.

Goleyzovskii, N.K. — Yamshchikov, S., *Dionisii*, album, M. 1970.

_____, *Feofan Grek i ego shkola*, album, M. 1970.

_____, *Novye otkrytiya moskovskich restavratorov*, album, M. 1971.

Golubtsov, A.P., *Iz chtenii po tserkovnoy archeologii i liturgike*, posthumous ed., pt. I, *Tserkovnaya archeologiya*, Sergiev Posad 1918.

_____, *Sbornik statey po liturgike i tserkovnoy archeologii*, Sergiev Posad 1911.

Gordienko, E., *Novgorod. Muzey. Drevnerusskaya zhivopis*, M. 1974.

Gordinskii, S., *Ukraïnska ikona 12–18 stolittya*, Philadelphia 1973.

Gos. Russkii muzey. Vystavka novych postuplenii. Drevnerusskoe iskusstvo, catalogue, sec. on iconography ed. T. B. Vilinbachova, V.K. Laurina and A. A. Maltseva, L. 1978.

Grabar, A., "L'icône russe," (review of book by N. P. Kondakov, *The Russian Icon*, trans. E. H. Minns, Oxford 1927), in *Byzantion*, VI, 2, 1931, pp. 912–918.

_____, "Scientific Restoration of Historic Works of Art," in *Masterpieces of Russian Painting*, pp. 95–105.

Grabar, A.N., "Kreshchenie Rusi v istorii iskusstva," in *Vladimirskii sbornik 988–1938*, Belgrade 1938, pp. 73–88.

_____, "Zametka o metode ozhivleniya traditsii ikonopisi v russkoy zhivopisi XV–XVI vekov," in *Trudy Otdela drevnerusskoy literatury Instituta russkoy literatury (Pushkinskii Dom) Akademii nauk SSSR*, XXXVI, L. 1981, pp. 289–294.

Grabar, I., *L'art du Moyen Age en Europe Orientale*, Paris 1968.

_____, "Die Malerschule des alten Pskow," in *Zeitschrift für Bildende Kunst*, year 63, fasc. 1, 1929–1930, pp. 3–9.

Grabar, Igor, *O drevnerusskom iskusstve. Sbornik statey*, M. 1966 [essays "V poiskach drevnerusskoy zhivopisi," "Feofan Grek," "Andrey Rublyov," "Chudozhestvennaya shkola drevnego Pskova," "Raskrytie pamyatnikov zhivopisi," "Restavratsiya u nas i na Zapade," and others].

Grigorov, D.A., "Russkii ikonopisnyi podlinnik," in *Zapiski imp. Russkogo Archeologicheskogo obshchestva*, n.s., t. III, 1, Spb. 1888, pp. 21–167.

Grishchenko, A., *Voprosy zhivopisi*, 3. *Russkaya ikona kak iskusstvo zhivopisi*, M. 1917.

Gusarova, E.B., "Russkie poyasnye deisusnye chiny XV–XVI vekov (Opyt ikonograficheskoy klassifikatsii)," in *Sovetskoe iskusstvoznanie*, 78/1, M. 1979, pp. 104–131.

Hackel, A., *Les icônes dans l'Eglise d'Orient*, Friburg in Breisgau 1952.

Hackel, A.A., *Das russische Heiligenbild. Die Ikone*, Novomagi, 1936.

Halle, F.W., *Altrussische Kunst*, Berlin 1920.

Hamilton, G.E., *The Art and Architecture of Russia*, Harmondsworth 1954.

Hendrix. P — Skrobucha, H. — Janssens, A., *Ikonen*, Amsterdam-Brussels 1960.

Iamchtchikov, S., *La Carélie. Musées*, s.l. 1972.

_____, *Rostov le Grand. Musée*, s.l. 1972.

Ikonopisnyi podlinnik novgorodskoy redaktsii po Sofiiskomu spisku kontsa XVI veka, M. 1873.

Ikonopisnyi podlinnik svodnoy redaktsii XVIII veka, ed. Obshchestvo drevnerusskogo iskusstva pri Moskovskom Publichnom muzee, ed. G. D. Filimonov, M. 1876.

Illin, M.A., *Iskusstvo Moskovskoy Rusi epochi Feofana Greka i Andreya Rublyova*, M. 1976.

_____, "Problemy issledovaniya drevnerusskogo iskusstva," in *Chudozhnik*, 1970, n. 7, pp. 34–39.

Istoriya russkogo iskusstva, t. I–III, M., ed. Academy of Sciences of the USSR, 1953–1955; German ed.: *Geschichte der russischen Kunst*, I–III, Dresden 1957–1959.

Istoriya ukraïnskogo mistectva, t. 1, Kiev 1966.

Ivanov, V.V., "Motivy vostochnoslavyanskogo yazychestva i ich transformatsiya v russkich ikonach," in *Narodnaya gravyura i folklor v Rossii XVII–XIV vv. K 150-letiyu so dnya rozhdeniya D. A. Rovinskogo. Materialy nauchnoy konferentsii (1975)*, M. 1976, pp. 268–287.

Ivanova, I.A., *Muzey drevnerusskogo iskusstva imeni Andreya Rublyova*, album, M. 1968.

Jagoditsch, R., "Das Wesen der altrussichen Ikonenkunst," in *Belvedere*, 1934–1937, n. 1–2, pp. 22–31.

Jamschtschikow, S., *Nowgorod. Museum*, s.l. 1970.

Jonas, H., "Die russische Ikonenausstellung in Deutschland," in *Ost-Europa*, year 4, fasc. 7–8, April–May 1929, pp. 464–477.

Kamenskaya, E.F. *Sedevry drevnerusskoy zhivopisi*, album, M. 1971.

Kirpichnikov, A.L., *Vzaimodeystvie ikonopisi i slovesnosti narodnoy i knizhnoy*, in *Trudy VIII archeologicheskogo sezda v Moskve, 1980 g.*, t. II, M. 1895, pp. 213–229.

Kjellin, H. *Ryska ikoner i svensk och norsk ägo*, Stockholm 1956; 2nd ed., Stockholm 1964.

Kochetkov, I.A., "Ikonopisets kak illyustrator zhitiya," in *Trudy Otdela drevnerusskoy literatury Instituta russkoy literatury (Pushkinskii Dom) Akademii nauk SSSR*, XXXVI, L. 1981, pp. 329–347.

_____, *Kategoriya vremeni v zhitii i zhitiynoy ikone*, in *"Slovo o polku Igoreve." Pamyatniki literatury i iskusstva XI–XVII vekov*, M. 1978, pp. 227–236.

Kolchin, B.A., Choroshev, A.S., Yanin, V.L., *Usabda novgorodskogo chudozhnika XII v.*, M. 1981.

Kondakov, N.P., *Ikonografiya Bogomateri*, t. I, Spb. 1914; t. II, Pg. 1915.

_____, *Litsevoy ikonopisnyi podlinnik*, t. I. *Ikonografiya Gospoda Boga i Spasa nashego Iisusa Christa*, Spb. 1905.

_____, Review of text: N. P. Lichachev, *Materialy dlya istorii russkogo ikonopisaniya. Atlas*, (pts. I–II, Spb. 1906), in *Zhurnal Ministerstva narodnogo prosveshcheniya*, April 1907, rubric "Kritika i bibliografiya," pp. 416–431.

_____, *The Russian Icon*, Oxford 1927.

_____, *Russkaya ikona*, t. I, text, pt. 1, Prague 1928; t. II, album, pt. 2, Prague 1929; t. III, album, pt. 1, Prague 1931 (on pp. XI–XXI, there is a long "List of Works on the History of Russian Icons"); t. IV, text, pt. 2, Prague 1933.

Kornilovich, K., *Iz letopisi russkogo iskusstva o proslavlennych pamyatnikach nashego drevnego zodchestva i zhivopisi, knizhnogo i yuvelirnogo dela i o sozdavshich ich iskusnych masterach*, M.-L. 1960.

_____, *Okno v minuvshee*, L. 1968.

Korzhenevskaya, L., "Severnye pisma," in *Dekorativnoe iskusstvo SSSR*, 1965, n. 8, pp. 21–26.

Kovalenskaya, N., and others, *Gos. Tretyakovskaya galereya. Putevoditel po iskusstvu feodalizma*, 1, M. 1934.

Kreidl, D., "Zur Frage der Bewertbarkeit der Bildträger innerhalb der Ikonenmalerei," in *Jahrbuch der österreichischen Byzantinistik*, 28, Vienna 1979, pp. 229–240.

Krug, G., *Mysli ob ikone*, Paris 1978.

Kunstsammlungen der Stadt Recklinghausen. Ikonen Museum, 3rd ed. rev., Recklinghausen 1965.

Küppers, L. *Ikone. Kultbild der Ostkirche*, Essen 1964.

Kuznetsova, L.V., "O pigmentach drevnerusskoy tempernoy zhivopisi," in *Chudozhestvennoe nasledie. Chranenie, issledovanie, restavratsiya*, 3(33), M. 1977, pp. 63–82.

Lasareff, V., *Russian Icons from the Twelfth to the Fifteenth Century*, New York-Milan 1962 (in the series "A Mentor — UNESCO Art Book").

Lazarev, V.N., *Andrey Rublyov i ego shkola*, M. 1966; Italian ed.: Lazarev, V., *Andrej Rublëv*, Milan 1966.

_____, *Feofan Grek i ego shkola*, M. 1961; German ed.: *Theophanes der Grieche und seine Schule*, Vienna-Munich 1968.

_____, *Istoriya vizantiiskoy zhivopisi*, I–II, M. 1947–1948; Italian ed., expanded and revised: *Storia della pittura bizantina*, Turin 1967.

_____, *Moskovskaya shkola ikonopisi*, M. 1971; 2nd ed., M. 1980; German ed.: Lazarew, V., *Ikonen der Moskauer Schule*, Berlin 1977.

_____, *Novgorodskaya ikonopis*, M. 1969; 2nd ed., M. 1976; 3rd ed., M. 1982.

_____, "O metodologii sovremennogo iskusstvoznaniya," in *Sovetskoe iskusstvoznanie*, 77/2, M. 1978, pp. 311–316.

_____, "O printsipach nauchnogo kataloga," [review of book: V. I. Antonova — N. E. Mneva, *Katalog drevnerusskoy zhivopisi v Gos. Tretyakovskoy galeree*, t. I–II, M. 1963], in *Iskusstvo*, 1965, n. 9, pp. 66–71.

_____, *Russkaya srednevekovaya zhivopis. Stati i issledovaniya*, M. 1970 [essays "Russkaya ikona," "Drevnerusskie chudozhniki i metody ich raboty," "Rannie novgorodskie ikony," "Dva novych pamyatnika russkoy stankovoy zhivopisi XII–XIII vekov (k istorii ikonostasa)," "O metode sotrudnichestva vizantiiskich i russkich masterov," "O nekotorych problemach v izuchenii drevnerusskogo iskusstva," and others].

_____, *Vizantiiskoe i drevnerusskoe iskusstvo. Stati i materialy*, M. 1978 [essays "O metode raboty v rublyovskoy masterskoy," "Vizantiya i drevnerusskoe iskusstvo," "Rasprostranenie vizantiiskich obraztsov i drevnerusskoe iskusstvo," "Zametki o metodologii izucheniya drevnerusskogo iskusstva"].

Lebedewa, J. *Andrej Rublyow und seine Zeitgenossen*, Dresden 1962.

Lelekov, L.A., *Iskusstvo Drevney Rusi i Vostok*, M. 1978.

_____, "Istoriya nekotorych syuzhetov i motivov drevnerusskogo iskusstva," *Chudozhestvennoe nasledie. Chranenie, issledovanie, restavratsiya*, 7(37), M. 1981, pp. 214–225.

Lichachev, D., "K diskusii o metodach restavratsii pamyatnikov drevnerusskoy zhivopisi," in *Iskusstvo*, 1972, n. 2, pp. 34–37.

Lichachev, D.S., *Poetika drevnerusskoy literatury*, 2nd ed., L. 1971, pp. 24–41 [chapter "Drevnerusskaya literatura v eyo otnosheniyach k izobrazitelnym iskusstvam"].

Lichachev, N.P., *Istoricheskoe znachenie italo-grecheskoy ikonopisi. Izobrazhenie Bogomateri v proizvedeniyach italo-grecheskich ikonopistsev i ich vliyanie na kompozitsii nekotorych proslavlennych russkich ikon*, Spb. 1911.

_____, *Kratkoe opisanie ikon sobraniya P.M. Tretyakova*, M. 1905.

_____, *Manera pisma Andreya Rublyova*, [Spb.] 1907.

_____, *Materialy dlya istorii russkogo ikonopisaniya*, atlas, pts. I–II, Spb. 1906.

Logvin, G. — Milyaeva, L. — Sventsitska, V., *Ukraïnskii serednovichnii zhivopis*, Kiev 1976.

Lossky, W., see Ouspensky, L. — Lossky, W.

Lukyanov, P.M., "Kraski v drevney Rusi," in *Priroda*, 1956, n. 11, pp. 77–82.

Malitskii, N.V., *Drevnerusskie kulty selskochozyaystvennych svyatych po pamyatnikam iskusstva*, L. 1932 (= *Izvestiya Gos. Akademii istorii materialnoy kultury*, t. XI, 10).

Maslenitsym, S.I., *Yaroslavskaya ikonopis*, M. 1973; 2nd ed., M. 1982.

Masterpieces of Russian Painting, London 1930 [essays by M. Conway, R. Fry, A.I. Anisimov, I.E. Grabar, and Yu.A. Olsufev].

Matsulevich, L., "K istorii russkoy nauki ob iskusstve (otvet N. Shchekotovu)," in *Russkaya ikona*, 2, Spb. 1914, pp. 143–149.

Matthey, W., *Russische Ikonen*, Munich-Ahrbeck 1960.

Mayasova, N.A., *Drevnerusskie shite*, M. 1971.

_____, "Metodika issledovaniya pamyatnikov drevnerusskogo litsevogo shitya," in *Gos. Muzei Moskovskogo Kremlya. Materialy i issledovaniya*, I, M. 1973, pp. 111–131.

Mneva, N.E., "Drevnerusskaya zhivopis Nizhnego Novgoroda," in *Gos. Tretyakovskaya galereya. Materialy i issledovaniya*, II, M. 1958, pp. 28–36.

_____, *Iskusstvo Moskovskoy Rusi*, M. 1965.

_____, "Monumentalnaya i stankovaya zhivopis," in *Ocherki russkoy kultury XVI veka*, pt. 2. *Duchovnaya kultura*, cit. on pp. 310–351.

Mneva, N.E., see Antonova, V.I. — Mneva, N.E.

Molè, W. *Ikona ruska*, Warsaw 1956.

Mouratow, P. *L'ancienne peinture russe*, Rome 1925; Italian ed.: Muratov, P., *La pittura russa antica*, Rome 1925.

Muratoff, P., *Trente-cinq primitifs russes. Collection J. Zolotnizky,* Paris 1933.

Muratov, P., "Blizhayshie zadachi v dele izucheniya ikonopisi," in *Russkaya ikona,* 1, Spb. 1914, pp. 8–12.

_____, *Drevnerusskaya ikonopis v sobranii I. S. Ostrouchova,* M. 1914.

_____, *Les icônes russes,* Paris 1927.

_____, "Otkrytiya drevnego russkogo iskusstva," in *Sovremennye zapiski,* XIV, Paris 1923, pp. 197–218.

_____, "Puti russkoy ikony," in *Perezvony,* n. 43, Riga 1929, pp. 1360–1367.

_____, "Russkaya zhivopis do serediny XVII veka," in Grabar, Igor, *Istoriya russkogo iskusstva,* VI, M. [1914], pp. 5–406.

_____, "Vystavka drevnerusskogo iskusstva v Moskve, I. Epochi drevnerusskoy ikonopisi," in *Starye gody,* April 1913, pp. 31–38.

Muzey drevnerusskogo iskusstva imeni Andreya Rublyova [album], author of text and ed. A. A. Saltykov, L. 1981.

Myslivec, J., "A propos de la littérature récente sur la peinture des icônes," in *Byzantinoslavica,* XXXI, 2, Prague 1970, pp. 244–258 [in particular on the albums by V. N. Lazarev, *Novgorodskaya ikonopis,* and by I. A. Ivanova, *Muzey drevnerusskogo iskusstva imeni Andreya Rublyova,* and also on the book by M. A. Reformatskaya, *Severnye pisma*].

_____, "Bemerkungen zu einem Ikonenwerk," in *Ostkirchliche Studien,* vol. 17, 1968, pp. 325–337 [on the book by K. Onasch, *Ikonen,* Berlin 1961].

_____, "Drei Veröffentlichungen über altrussische Kunst," in *Byzantinoslavica,* XXIX, 2, Prague 1968, pp. 379–399 [in particular on the books by V. N. Lazarev, *Andrey Rublyov i ego shkola,* and by V. I. Antonova, *Drevnerusskoe iskusstvo v sobranii Pavla Korina*].

_____, *Icona,* Prague 1947.

_____, "Iconographia Ecclesiae Orientalis," in *Byzantinoslavica,* XXVIII, 2, Prague 1967, pp. 408–424.

_____, "Liturgické hymny jako namety ruskych ikon," in *Byzantinoslavica,* III, 2, Prague 1933, pp. 462–499 (see also the review by V. Rozov on this essay in the magazine *Slavia,* XII, 3–4, Prague 1933–1934, pp. 512–515).

_____, Review of book by O. Wulff — M. Alpatoff, "Denkmäler der Ikonenmalerei," Hellerau (Dresden) 1925, in *Byzantinoslavica,* III, pp. 527–531.

_____, Review of edition by Antonova, V.I. — Mneva, N.E., *Katalog drevnerusskoy zhivopisi [v Gos Tretyakovskoy galeree],* t. I–II (M. 1963), in *Byzantinoslavica,* XXVII, 2, Prague 1966, pp. 423–427.

Nekrasov, A., "Altrussische Malerei in der Tretyakow Galerie," in *Slawische Rundschau,* 1933, n. 3, pp. 155–164.

Nekrasov, A.I., *Drevnerusskoe izobrazitelnoe iskusstvo,* M. 1937.

Nemitz, F., *Die Kunst Russland,* Berlin 1940.

Nikolskii, T., *Istoriya russkogo iskusstva,* pref. P. P. Muratov, Berlin 1923.

Nikolaeva, T.V., *Drevnerusskaya zhivopis Zagorskogo muzeya,* M. 1977.

_____, *Sobranie drevnerusskogo iskusstva v Zagorskom muzee,* L. 1968.

Novgorod Icons. 12th–17th Century, pref. D. Likhachov, introd. V. Laurina and V. Pushkariov, Saint Petersburg 1980.

Okunev, N., review of book by Ph. Schweinfurth, *Geschichte der russischen Malerei im Mittlealter,* The Hague 1930, in *Byzantinoslavica,* III, pp. 240–244.

Olsufev, Yu.A., *Opis ikon Troitse-Sergievoy lavry do XVIII v. i naibolee tipichnych XVIII i XIX vv.,* ed. Komissiya po ochrane pamyatnikov iskusstva i stariny Troitse-Sergievoy lavry, Sergiev 1920.

_____, "Voprosy form drevnerusskoy zhivopisi," in *Sovetskii muzey,* 1935, n. 6, pp. 21–36; 1936, n. 1, pp. 61–68 and n. 2, pp. 39–59.

_____, *Zametki o tserkovnom penii i ikonopisi kak vidach tserkovnogo iskusstva v svyazi s ucheniem tserkvi,* Tula 1918.

Olsufiev, Y., "The development of Russian Icon Painting from the Twelfth to the Nineteenth Century," in *The Art Bulletin,* XII, 1930, December, pp. 347–373.

Onasch, K., *Ikonen,* Berlin 1961.

_____, *Die Ikonenmalerei. Grundzüge einer systematischen Darstellung,* Leipzig 1968.

_____, *Liturgie und Kunst der Ostkirche in Stichworten,* Leipzig 1981.

_____, "Zum Problem der Ästhetik in der altrussischen Ikonenmalerei," in *Bizantinische Beiträge,* Berlin 1964, pp. 413–427.

Ouspensky, L., *Essai sur la théologie de l'icône dans l'Eglise orthodoxe,* Paris 1960.

_____, *La théologie de l'icône dans l'Eglise orthodoxe,* Paris 1980.

_____, *Theology of the Icon,* Crestwood, N.J. 1978.

Ouspensky, L. — Lossky, W., *Der Sinn der Ikonen,* Bern-Olten 1952; English ed.: *The meaning of Icons,* Boston 1969.

Ovchinnikov, A. — Kishilov, N., *Zhivopis drevnego Pskova,* album, M. 1970.

Ovchinnikov, A.N., *Opyt opisaniya proizvedenii drevnerusskoy stankovoy zhivopisi. Technika i stil,* 1. *Pskovskaya shkola. XIII–XVI veka,* M. 1971.

Papaioannou, K., *La pittura bizantina e russa,* Milan 1967; English ed.: *Byzantine and Russian Painting,* London 1968.

Pavlutskii, G., "O proischozhdenii drevnerusskoy ikonopisi," in *Universitetskie izvestiya,* Kiev 1914, n. 6, pt. III, pp. 1–14.

Pertsev, N.V., "Drevnerusskie krasnofonnye ikony," in *Drevnerusskoe iskusstvo. Problemy i atributsii,* pp. 83–90.

_____, "O nekotorych priemach izobrazheniya litsa v drevnerusskoy stankovoy zhivopisi XII–XIII vv.," in *Soobshcheniya Gos. Russkogo muzeya,* VIII, L. 1964, pp. 89–92.

_____, "O vosstanovlenii pamyatnikov drevnerusskoy zhivopisi," in *Vosstanovlenie pamyatnikov kultury. (Problemy restavratsii),* M. 1981, pp. 145–166.

Plugin, V.A., *Mirovozzrenie Andreya Rublyova (Nekotorye problemy). Drevnerusskaya zhivopis kak istoricheskii istochnik,* M. 1974.

Podlinnik ikonopisnyi, pub. S. T. Bolshakov, ed. A. I. Uspenskii, M. 1974.

Podobedova, O.I., *Moskovskaya shkola zhivopisi pri Ivane IV,* M. 1972.

Pokrovskii, N.V., *Evangelie v pamyatnikach ikonografii preimushchestvenno vizantiiskich i russkich,* Spb. 1892 (*Trudy VIII archeologicheskogo sezda v Moskve, 1890 g.,* t. I).

_____, *Siiskii ikonopisnyi podlinnik,* I–IV ed., Spb. 1895–1898 (in the series "Pamyatniki drevnerusskoy pismennosti," CVI, CXIII, CXXII, and CXXVI).

_____, *Tserkovno archeologicheskii muzey S.-Peterburgskoy Duchovnoy akademii,* Spb. 1909.

Popov, G.V., *Chudozhestvennaya zhizn Dmitrova v XV–XVI vv.,* M. 1973.

_____, *Zhivopis i miniatyura Moskvy serediny XV — nachala XVI veka*, M. 1975.

Popov, G.V. — Ryndina, A.V., *Zhivopis i prikladnoe iskusstvo Tveri. XIV–XVI veka*, M. 1979 (in the series "Tsentry chudozhestvennoy kultury srednevekovoy Rusi").

Popova, O.S., *Iskusstvo Novgoroda i Moskvy pervoy poloviny chetyrnadtsatogo veka. Ego svyazi s Vizantiey*, M. 1980.

_____, "Svet v vizantiyskom i russkom iskusstve XII–XVI vekov," in *Sovetskoe iskusstvoznanie*, 1977/1, M. 1978, pp. 75–99.

Porfiridov, N.G., *Gos. Russkii muzey. Drevnerusskoe iskusstvo. Kratkii putevoditel*, L. 1947.

_____, "O putyach razvitiya chudozhestvennych obrazov v drevnerusskom iskusstve," in *Trudy Otdela drevnerusskoy literatury Instituta russkoy literatury (Pushkinskii Dom) Akademii nauk SSSR*, XVI, M.-L. 1960, pp. 36–49.

Putsko, V.G., "Novye napravleniya v russkom iskusstve XIV veka," in *Russia medievalis*, IV, Munich 1979, pp. 35–70.

_____, "O tendencjach zachodnich w malarstwie ikonowym Rusi 12–13 w.," in *Biuletyn historii sztuki*, XLI (1979), n. 4, pp. 327–338.

_____, "Zametki o rostovskoy ikonopisi vtoroy poloviny XV veka," in *Bizantinoslavica*, XXXIV (2), Prague 1973, pp. 199–210.

Punin, N., "Andrey Rublyov," in *Apollon*, 1915, n. 2, pp. 1–23. Rpt. in: Punin, N.N., *Russkoe i sovetskoe iskusstvo*, M. 1976, pp. 33–51.

_____, "Ellenizm i Vostok v ikonopisi. Po povodu sobraniya ikon I. S. Ostrouchova i S. P. Ryabushinskogo," in *Russkaya ikona*, 3, Spb. 1914, pp. 181–197.

_____, "Zametki ob ikonach iz sobraniya P. N. Lichacheva," in *Russkaya ikona*, 1, Spb. 1914, pp. 21–47.

Raushenbach, B.V., *Prostranstvennye postroeniya v drevnerusskoy zhivopisi*, M. 1975.

_____, *Prostranstvennye postroeniya v zhivopisi. Ocherk osnovnych metodov*, M. 1980.

Redslob, E., "Die altrussische Malerei und ihre Bedeutung für unsere Gegenwart," in *Ost-Europa*, year 4, fasc. 7–8, April–May 1929, pp. 459–463.

Reformatskaya, M., "O nekotorych osobennostyach razvitiya pskovskoy shkoly zhivopisi XIV–XV vekov," in *Gos. Tretyakovskaya galereya. Voprosy russkogo i sovetskogo iskusstva. Materialy nauchnych konferentsii*, I, M. 1971, pp. 7–12.

Reformatskaya, M.A., *Pskovskaya ikonopis XIII — nachala XV vekov. (K uyasneniyu ponyatiya "mestnaya shkola"). Avtoreferat disertatsii na soiskanie uchenoy stepeni kandidata iskusstvovedeniya*, M. 1979.

_____, "Pskovskaya shkola," in *Tvorchestvo*, 1971, n. 7, pp. 15–17.

_____, *Severnye pisma*, M. 1968.

Rempel, L.I., *Iskusstvo Rusi i Vostok kak istoriko-kulturnaya i chudozhestvennaya problema*, Tashkent 1969.

Rerich, N.K., "Zapiskie listki chudozhnika," in *Iskusstvo*, January 1905, pp. 3–5.

Retkovskaya, L.S., *Vselennaya v iskusstve drevney Rusi*, M. 1961.

Rice, D. Talbot, *Beginnings of Russian Icon-Painting*, Oxford 1938.

_____, *A Concise History of Russian Art*, London 1963.

_____, *Icons and their Dating. A Comprehensive Study of their Chronology and Provenance*, London 1974.

_____, *Russian Icons*, London 1963; London 1974.

Rostovo-suzdalskaya shkola zhivopisi [catalogue of the Tretyakov Gallery exhibition], M. 1967.

Rothemund, B., *Handbuch der Ikonenkunst*, Munich 1966.

Rovinskii, D.A., *Obozrenie ikonopisaniya v Rossii do kontsa XVII veka*, Spb. 1856; complete ed.: Spb. 1903.

Rozanova, N.V., *Rostovo-suzdalskaya zhivopis XII–XVI vekov*, album, M. 1970.

Russische Ikonen. Aus der Ikonen-Sammlung Zeiner Henriksen (Norwegen) Munich 1954.

Russkaya ikona, 1, Spb. 1914 [essays by P. Muratov, N. Punin, P. Neradovskii]; 2, Spb. 1914 [essays by N. Sychev, A. Sobolevskii, N. Shchekotov, L. Matsulevich]; 3, Spb. 1914 [essays by L. Matsulevich and N. Punin].

Ruzsa, G., *Ikonok könyve*, Budapest 1981.

Ryabova, M.P., "Vosstanovlenie i rekonstruktsiya drevnerusskogo shitya," in *Vosstanovlenie pamyatnikov kultury. (Problemy restavratsii)*, pp. 207–217.

Ryabushinski, S.P., "Zametki o restavratsii ikon," in *Seminarium Kondakovianum*, IV, Prague 1931, pp. 289–295.

Ryazanovskii, V.A., *Ob izuchenii drevney russkoy zhivopisi*, Charbin 1934 (reprint from *Izvestiya Yuridicheskogo fakulteta v. g. Charbine*, n. XI).

Rybakov, A.A., *Chudozhestvennye pamyatniki Vologdy XIII — nachala XX veka*, L. 1980.

Saltykov, A.A., "'Dobroe masterstvo' drevnerusskoy zhivopisi," in *Slovo o polku Igoreve. Pamyatniki literatury i iskusstva XI–XVII vekov*, pp. 238–250.

Saltykov, A.A., "O nekotorych prostranstvennych otnosheniyach v proizvedeniyach vizantiiskoy i drevnerusskoy zhivopisi," in *Drevnerusskoe iskusstvo XV–XVII vekov. Sbornik statey*, M. 1981, p. 32–55.

Σαρδελῆ, Κ., Θεοφάνες ὁ Ἕλληνας, Ἀθῆναι 1978.

Saveleva, N.P., "Iz nablyudenii nad upotrebleniem imenovanii so znacheniem 'zhivopisets,'" in *Uchenye zapiski Gos. Pedagogicheskogo instituta imeni V. I. Lenina*, 423, M. 1971, pp. 120–126.

Scheffer, N., "Days of the Week in Russian Religious Art," in *Gazette des Beaux-Arts*, XXVI, 1944, pp. 321–334.

_____, "Historic Battles on Russian Icons," in ibid., XXVIII, 1946, pp. 193–206.

_____, "Religious Chants and the Russian Icon," in ibid., XXVII, 1945, pp. 129–142.

_____, "Symbolism of the Russian Icon," in ibid., XXVI, 1944, pp. 77–94.

Schekotov, N., "Ikonopis kak iskusstvo. Popovodu sobraniya ikon I. S. Ostrouchova i S. P. Ryabushinskogo," in *Russkaya ikona*, 2, Spb. 1914, pp. 115–142.

Schekotov, N.M., *Stati, vystupleniya, rechi, zametki*, M. 1963 [essays "Nekotorye cherty stilya russkich ikon XV veka," "Ikonopis kak iskusstvo," "Troitsa Rublyova," "Ikonostas XV veka"].

_____, "Vystavka drevnerusskogo iskusstva v Moskve, II, Nekotorye cherty stilya russkich ikon XV veka," in *Starye gody*, 1913, April, pp. 38–42.

Schmidt, V.J., *Russische Ikonenmalerei und Medizin*, Munich 1980.

Schmit, Th., "Der Werdegang der russischen Malerei," in *Ost-Europa*, year 4, fasc. 7–8, April–May 1929, pp. 477–493.

Schneider, I. — Fedorov, P., *Die Ikonenmalerei. Technik und Vorzeichnungen*, ed. and rev. H. Skrobucha, Recklinhausen 1978.

Schweinfurth, Ph., *Geschichte der russischen Malerei in Mittelalter*, The Hague 1930.

_____, *Icônes russes*, Paris 1953; English ed.: *Russian Icons*, Oxford 1953.

Sergeev, V.N., *Andrey Rublyov*, M. 1981 (in the series "Zhizn zamechatelnych lyudey"); Italian ed.: *Andrej Rublëv*, Milan 1994.

_____, *Dorogami starych masterov*, M. 1982.

_____, "Novye otkrytiya v Rublyovskom muzee," in *Pamyatniki otechestva*, 3, M. 1977, pp. 256–264.

_____, "Zhivopis stremitsya zagovorit," in *Russkaya rech*, 1970, n. 3, pp. 83–89.

Skrobucha, H., *Meisterwerke der Ikonenmalerei*, Recklinghausen 1961.

Smirnova, E.S., *Zhivopis drevney Rusi. Nachodki i otkrytiya*, L. 1970.

_____, *Zhivopis Obonezhya XIV–XVI vekov*, M. 1967.

_____, *Zhivopis Velikogo Novgoroda. Seredina XIII — nachalo XV veka*, M. 1976 (in the series "Tsentry chudozhestvennoy kultury srednevekovoy Rusi").

Smirnova, E.S. — Laurina, V.K. — Gordienko, E.A., *Zhivopis Velikogo Novgoroda. XV vek*, M. 1982 (in the series "Tsentry chudozhestvennoy kultury srednevekovoy Rusi").

Smirnova, E.S. — Yamshchikov, S.V., *Drevnerusskaya zhivopis. Novye otkrytiya. Zhivopis Obonezhya XIV–XVIII vekov*, L. 1974.

Sokol, V.P., "Ikonograficheskii i zhivopisno-formalnyi metody izucheniya russkoy ikonopisi," in *Izvestiya Obshchestva archeologii, istorii i etnografii pri Kazanskom universitete*, t. XXXII, 2, Kazan 1923, pp. 187–218.

Sokolov, V.P., *Yazyk drevnerusskoy ikonopisi*, I, *Obraznye odezhdy*, Kazan 1916 (rpt. from *Izvestii po Kazanskoy eparchii*, 1916, n. 17–20).

Sokolov, Vl., "Raschistka drevnerusskoy ikony," in *Kazanskii muzeynyi vestnik*, n. 2–4, Kazan 1920, pp. 34–38.

Sperovskii, N., "Starinnye russkie ikonostasy," in *Christianskoe chtenie*, 1891, November–December, pp. 337–353; 1892, January–February, pp. 1–23, March–April, pp. 162–176, May–June, pp. 321–334, July–August, pp. 3–17, November–December, pp. 522–537; 1893, September–October, pp. 321–342.

SSSR. Drevnye russkie ikony, New York–Milan 1958 (in the series UNESCO "Universal Art") [pref. by I. Grabar, essays by V. Lazarev and O. Demus].

Sto ikon iz fondov Ermitazha. Zhivopis russkogo Severa XIV–XVIII vekov, catalogue of the Hermitage exhibition [at the Hermitage], ed. A. S. Kostsova, L. 1982.

Stroganovskii ikonopisnyi podlinnik (kontsa XVI i XVII veka), [M. 1869].

Stuart, J., *Ikons*, London 1975.

Svirin, A.N., *Drevnerusskaya zhivopis v sobranii Gos. Tretyakovskoy galerei*, M. 1958.

_____, *Drevnerusskoe shite*, M. 1963.

Sychev, N., "Drevlechranilishche Russkogo muzeya imperatora Aleksandra III," in *Starye gody*, 1916, January–February, pp. 3–35.

Sychev, N.P., *Izbrannye trudy*, M. 1976.

Taborsky, F., *Ruské umeni*, Prague 1921.

_____, *Slovo o ruské ikone*, Prague 1925.

Taylor, J., *Icon Painting*, London 1979.

Teteriatnikov, V., *Ikons and Fakes. Notes on the George R. Hann Collection*, 1–3, New York 1981.

Thom, R., "De l'icône au symbole," in *Modèles mathématiques de la morphogenèse*, Paris 1974, pp. 229–251.

Thon, N., *Ikone und Liturgie*, Trier 1979.

Tolstaya, T.V., *Uspenskii sobor Moskovskogo Kremlya*, M. 1979.

Trenev, D.K., *Ikonostas Smolenskogo sobora moskovskogo Novodevich ego monastyrya. Obraztsovyi russkii ikonostas XVI–XVII vekov. S pribavleniem kratkoy istorii ikonostasa s drevneyshich vremen*, M. 1902.

_____, "Neskolko slov o drevney i sovremennoy russkoy ikonopisi," in *Ikonopisnyi sbornik*, 1, Spb. 1907, pp. 1–34.

Troitskii, N.I. "Ikonostas i ego simvolika," in *Pravoslavnoe obozrenie*, 1891, April, pp. 696–719.

Trubetskoy, E., "Rossiya v eyo ikone," in *Russkaya mysl*, 1918, January-February, pp. 21–44.

_____, *Tri ocherka o russkoy ikone*, Paris 1965 (new ed. of last three essays].

Trubetskoy, E.N., *Dva mira v drevnerusskoy ikonopisi*, M. 1916.

_____, *Umozrenie v kraskach. Vopro o smysle zhizni v drevnerusskoy religioznoy zhivopisi*, M. 1916; Italian ed.: *Contemplazione nel colore*, Milan 1977; see also German ed.: Trubetzkoi, E., *Die religiöse Weltanschauung der altrussischen Ikonenmalerei*, Paderborn 1927.

Tugendchold, P., "Vystavka drevney ikonopisi v Moskve," in *Severnye zapiski*, 1913, May–June, pp. 215–221.

Tvorogov, O.V., "O vzaimodeystvii literatury i zhivopisi v Drevney Rusi," in *Russkaya literatura*, 1981, 4, pp. 95–106.

Uspenskii, B.A., *Filologicheskie razyskaniya v oblasti slavyanskich drevnostey. (Relikty yazychestva v vostochnoslavyanskom kulte Nikolaya Mirlikiiskogo)*, M. 1982.

_____, "K sisteme peredachi izobrazheniya v russkoy ikonopisi," in *Uchenye zapiski Tartuskogo gos. universiteta*, n. 181 (*Trudy po znakovym sistemam*, II), Tartu 1965, pp. 248–257.

_____, "Kult Nikoly na Rusi v istoriko-kulturnom osveshchenii. (Spetscifika vospriyatiya i transformatsiya ischodnogo obraza)," in *Uchenye zapiski Tartuskogo gos. universiteta*, n. 463 (*Trudy po znakovym sistemam*, X), Tartu 1978, pp. 86–140.

_____, "O semiotike ikony," in *Uchenye zapiski Tartuskogo gos. universiteta*, n. 284 (*Trudy po znakovym sistemam*, V), Tartu 1971, pp. 178–223; see also English ed.: Uspensky, B., *The Semiotics of the Russian Icon*. Lisse 1976.

_____, *Poetika kompozitsii. Struktura chudozhestvennogo teksta i tipologiya kompozitsii formy*, M. 1970.

_____, "'Pravoe' i 'levoe' v ikonopisnom izobrazhenii," in *Sbornik statey po vtorichnym modeliruyushchim sistemam*, Tartu 1973, pp. 137–145.

_____, "Prolegomena k teme: Semiotika ikony. Beseda s B. A. Uspenskim," in *Rossija-Russia. Studi i ricerche a cura di V. Strada*, 3, Einaudi, Turin 1977, pp. 189–212.

Uspenskii, L., "Isichazm i rastsvet russkogo iskusstva," in *Vestnik russkogo zapadnoevropeyskogo ekzarchata*, n. 60, 1967, October–December, pp. 252–270.

_____, "Rol moskovskich soborov XVI veka v tserkovnom iskusstve," in *Vestnik russkogo zapadnoevropeyskogo ekzarchata*, n. 64, 1968, October–December, pp. 217–250.

_____, "Smysl i yazyk ikony," in *Zhurnal Moskovskoy patriarchii*, 1955, n. 6, pp. 55–64; n. 7, pp. 53–65; n. 8, pp. 50–58.

_____, "Vopros ikonostasa," in *Vestnik russkogo zapadnoevropeyskogo ekzarchata*, n. 44, 1963, October–December, pp. 223–255.

Uspensky, B., *The Semiotics of the Russian Icon*, Lisse 1976.

Vagner, G.K., "Metodologicheskie preposylki izucheniya stilya drevnerusskogo iskusstva," in *Sovetskoe iskusstvoznanie*, 77/2, M. 1978, pp. 266–290.

_____, *Problema zhanrov v drevnerusskom iskusstve*, M. 1974.

Velmans, T., "Rayonnement de l'icône au XII^e et au début du XIII^e siècle," in *Congrès international d'études byzantines. Rapports et co-rapports*, III, *Art et archéologie*, Athens 1976, pp. 195–227.

Voloshin, M., "Chemu uchat ikony?" in *Apollon*, 1914, n. 5, pp. 26–29.

Voronin, N.N., *Drevnerusskoe iskusstvo*, M. 1962.

Vostokov, P., "Les travaux soviétiques sur l'art russe ancien," in *Le monde slave*, 15, 1938, pp. 62–87.

Voyce, A., *The Art and Architecture of Medieval Russia*, University of Oklahoma Press 1967.

Vsesoyuznaya konferentsiya "Teoreticheskie printsipy restavratsii drevnerusskoy stankovoy zhivopisi." Doklady, soobshcheniya, vystupleniya uchastnikov konferentsii i prinyatie resheniya. Moskva, 18–20 noyabrya 1968 g., M. 1970. The same text, illustrated album, M. 1970.

Vystavka drevnerusskogo iskusstva, ustroennaya v 1913 godu. . ., M. 1913.

Vzdornov, G., "O zhivopisi Severo-Vostochnoy Rusi XII–XV vekov" [overview of the exhibition of icons prepared at the Tretyakov Gallery in 1967], in *Iskusstvo*, 1969, n. 10, pp. 55–62.

Vzdornov, G.I., *Feofan Grek. Tvorcheskoe nasledie*, M. 1983.

_____, "O ponyatiyach 'shkola' i 'pisma' v zhivopisi Drevney Rusi," in *Iskusstvo*, 1972, n. 6, pp. 64–68.

_____, "O severnych pismach," in *Sovetskoe iskusstvozanie*, 80/1, M. 1981, pp. 44–69.

_____, "Vologodskie ikony XIV–XV vekov," in *Soobshcheniya Vsesoyuznoy tsentralnoy nauchno-issledovatelskoy laboratorii po konservatsii i restavratsii muzeynych chudozhestvennych tsennostey*, 30, M. 1975, pp. 125–153.

_____, "Zhivopis," in *Ocherki russkoy kultury XIII–XV vekov*, pt. 2, *Duchovnaya kultura*, M. 1970, pp. 254–377.

Vzdornov, G.I., (with V. N. Lazarev), "O nekotorych aktualnych voprosach restavratsii," in *Chudozhnik*, 1970, n. 9, pp. 43, 60.

Weidlé, W., *Les icônes byzantines et russes*, Milan 1962.

Weitzman, K. — Alibegashvili, G. — Volskaya, A. — Chatzidakis, M. — Babic G. — Alpatov, M. — Voinescu, T., *The Icon*, London 1982.

Wendt, C., *Ikonen-Wesen und Wirklichkeit*, Baden-Baden 1951.

Werner, A., *Icons. Religious Art of Eastern Europe*, New York-Bern 1949.

Whittemore, Th., "The Place of Four Icons in the History of Russian Art," in *L'art byzantin chez les slaves*, II, pp. 212–217.

Winkler, M., "Die Ikone als Quelle zur russischen Kulturgeschichte," in *Ost-Europa*, year 4, fasc. 7–8, April–May 1929, pp. 453–459.

Wulff, O., "Russische Ikonenmalerei," in *Seminarium Kondakovianum*, III, Prague 1929, pp. 25–40.

Wulff, O., and Alpatoff, M., *Denkmäler der Ikonenmalerei*, Hellerau (Dresden) 1925.

Yakovleva, A.I., "Priemy lichnogo pisma v russkoy zhivopisi kontsa XII — nachala XIII v." in *Drevnerusskoe iskusstvo. Monumentalnaya zhivopis XI–XVII vv.*, pp. 34–44.

Yamshchikov, S., *Drevnerusskaya zhivopis. Novye otkrytiya*, album, M. 1966; 2nd ed., M. 1969.

_____, *Opis proizvedenii drevnerusskoy zhivopisi, chranyashchichsya v muzeyach RSFSR (materialy dlya restavratsionnogo kataloga)*, pt. 1 (*Pskovskoy istoriko-chudozhestvennyi muzey, Novgorodskii istoriko-chudozhestvennyi i architekturnyi muzey-zapovednik, Kirovskii kraevedcheskii muzey, Ryazanskii kraevedcheskii muzey, Ryazanskii chudozhestvennyi muzey*), M. 1970; pt. 2 (*Rostovskii istoriko-chudozhestvennyi i architekturnyi muzey-zapovednik, Uglichskii istoriko-chudozhestvennyi muzey, Pereslav-Zalesskii istoriko-chudozhestvennyi muzey. Gorkosvskii chudozhestvennyi muzey, Totemskii kraevedcheskii muzey, Kostromskoy muzey izobrazitelnych iskusstv, Kostromskoy istoriko-architekturnyi muzei-zapovednik)*, M. 1972.

_____, *Pskov. Muzey. Drevnerusskaya zhivopis*, M. 1973.

_____, *Russkich Muzey. (Ikony iz sobraniya Russkogo muzeya)*, M. 1970.

_____, *Suzdal. Muzey.* [M. 1968].

Yamshikov, S., *Pskov. Art Treasure and Architectural Monuments. 12th–17th Centuries*, Saint Petersburg 1978.

Yanin, V.L., "V masterskoy srednevekovogo chudozhnika Oliseya Grechina," in *Nauka i chelovechestvo, 1981*, M. 1981, pp. 37–53.

_____, *Ocherki komplesnogo istochnikovedeniya*, M. 1977.

Yaroslavskaya ikonopis XIII–XVIII vekov, catalogue of the exhibition [Yaroslav Fine Arts Museum], ed. I. Bolottseva, Yaroslav 1981.

Zhegin, L.F., *Yazyk zhivopisnogo proizvedeniya. (Uslovnost drevnego iskusstva)*, pref. B. A. Uspenskii, "K issledovaniyu yazyka drevney zhivopisi," M. 1970.

Zhidkov, G.V., *Moskovskaya zhivopis serediny XIV veka*, M. 1928.

Zhivopis domongolskoy Rusi, catalogue of the exhibition [at the Tretyakov Gallery], ed. O. A. Korina, M. 1974.

Zhivopis drevnego Novgoroda i ego zemel XII–XVII stoletii, catalogue of the exhibition [at the Russian Museum], text and ed. V. K. Laurina, G.D. Petrova, E.S. Smirnova, L. 1974.

Zhivopis vologodskich zemel XIV–XVIII vekov, catalogue of the exhibition [at Andrei Rublev Museum of Early Russian Art], ed. I. Pyatnitskaya, N. Fedyshin, O. Kozoderova, L. Charlampenkova, article by A. Rybakov, M. 1976.

* Edited by G. I. Vzdornov. The specific bibliography concerning individual works is given in the notes to the text and in the notes on the plates.